China's hidden century

China's hidden century
1796–1912

Edited by Jessica Harrison-Hall and Julia Lovell

University of Washington Press *Seattle*

Published to accompany the Citi exhibition
China's hidden century at the British Museum
from 18 May to 8 October 2023

Supported by Citi

Additional support by:
The Huo Family Foundation
Min Zhu
Whang Shang Ying
Ida Chow
Zheng He Management Group

Research and publication supported by the UKRI
Arts and Humanities Research Council

This exhibition has been made possible as a
result of the Government Indemnity Scheme.
The British Museum would like to thank HM
Government for providing Government Indemnity,
and the Department for Digital, Culture, Media
and Sport and Arts Council England for arranging
the indemnity.

First published in the United Kingdom in 2023 by
The British Museum Press
A division of The British Museum Company Ltd
The British Museum
Great Russell Street
London WC1B 3DG
britishmuseum.org/publishing

Published simultaneously in the United States in
2023 by University of Washington Press
uwapress.uw.edu

China's hidden century: 1796–1912
© 2023 The Trustees of the British Museum
ISBN 978 0 295 75185 6 HB

A catalogue record for this book is available from
the Library of Congress
LCCN 2023931676.

Designed by James Alexander / Jade Design
Colour reproduction by Altaimage, London
Printed in Poland by Drukarnia Dimograf

Images © 2023 The Trustees of the British
Museum, courtesy of the British Museum's
Department of Photography and Imaging, unless
otherwise stated on pp. 327–9.

Further information about the British Museum and
its collection can be found at britishmuseum.org.

Frontispiece
Detail of *kesi* robe with Japanese-style
decoration (see fig. 1.49), *c.* 1880–1908, China.
Kesi (silk) with embroidery. © The Metropolitan
Museum of Art/Art Resource/Scala, Florence

Front cover
Unidentified artist, *Portrait of Lady Li (Lu Xifu's
Wife)*, *c.* 1876, Guangzhou area. Ink and colours
on paper. © Royal Ontario Museum

Back cover
Festival collar, 1870–1900, China. Appliqué silk,
satin embroidery and gold threads. © The Teresa
Coleman Collection

Endpapers
Ren Xun, *Chrysanthemums* (菊花卷圖),
c. 1870–93, Shanghai. Ink and colours on paper.
© Michael Yun-Wen Shih

The papers used in this book are natural,
renewable and recyclable products and the
manufacturing processes are expected to
conform to the environmental regulations of the
country of origin.

Director's foreword

This exhibition is the first to bring together the full range of material and visual culture from China's 'long 19th century' (1796–1912). The end of the Qing empire was scarred by violence but it was also a period of extraordinary cultural creativity and resilience – marked by political, social and technological change, as well as exchange and conflict with the wider world and competing empires.

The themes that unfold in *China's hidden century* resonate today. What happens when central control and legitimacy break down and people can no longer rely on traditional leaders? Why and how do migrant communities drive creativity that in turn defines a city? How do new patterns of work and technologies transform everyday life? And perhaps most pressingly, how can a society riddled with inequalities continue to function?

Here we present over 300 exceptional objects and artworks and the people that used or created them: the court; the military; artists; urbanites; and global communities.

The exhibition would not have been possible without generous loans from thirty private and institutional lenders. It opens with a beautiful blue map, made from a series of vertical scrolls, on loan from The British Library. This object shows the territory ruled by the Qing in 1800 – a vast land mass even larger than China today – in which about 400 million people lived. Queen Victoria's contemporary, the Empress Dowager Cixi, is a commanding figure. Her robe, loaned by The Metropolitan Museum of Art, reveals much about the originality of 19th-century court costume, with its new colour palette and designs reflecting close

connections with Japan. The large and intricate battle scene, on loan from His Majesty The King, conveys the sheer scale of military engagement in the 19th century.

The exhibition is a key outcome of a significant research project conducted by the British Museum in partnership with Birkbeck, University of London and funded by the UKRI Arts and Humanities Research Council: 'Cultural Creativity in Qing China 1796–1912'. We are grateful to our colleagues from China and nineteen other countries who have contributed to this unique project by generously sharing their expertise, and to the exhibition's private lenders: Anthony J. Hardy; Chris Hall Collection; Jacqueline Simcox; Michael Yun-Wen Shih; Nanshun Shanfang, Singapore; The Teresa Coleman Collection; Trevor Ford; and the Water, Pine and Stone Retreat Collection. *China's hidden century* would not have been possible without the generosity of our long-term supporter Citi, as well as the exhibition's additional supporters: the Huo Family Foundation, Min Zhu, Whang Shang Ying, Ida Chow and Zheng He Management Group. I would additionally like to thank The Sir Percival David Foundation Academic and Research Fund for their continued support of research into Chinese history and art. We are also enormously grateful to individual supporters and to the public, who help to keep innovative research at the heart of the British Museum.

Hartwig Fischer, Director, British Museum

China's long 19th century

Julia Lovell

China's 'long 19th century' stretches from the accession of the sixth emperor of the Qing dynasty, Jiaqing 嘉慶 (r. 1796–1820), to the abdication of the eleventh, Xuantong 宣統 (also known as Puyi 溥儀, r. 1909–1912). Few in the Qing empire, either at the end of the 18th or start of the 20th centuries, would have measured time by the European, Gregorian calendar.[1] But major political events fall close enough to the turns of these centuries to justify considering this period an analytically coherent stretch of historical experience and change. In 1796, the elderly Qianlong 乾隆 emperor (r. 1735–1796) abdicated to permit the accession of his son Jiaqing, a moment that – with hindsight – has been identified as marking the close of the exuberantly self-confident 'high Qing' and giving way to a period of protracted crisis. In 1912, after the revolution of the previous year, the last emperor, Xuantong, stepped down, bringing some 2,000 years of dynastic rule to an end and making way for a republic.

For decades, many anglophone and sinophone histories defined this era as one of political, military and economic catastrophe and humiliation, and of cultural stagnation. Historical compendia of Chinese art have skated over, or even stopped abruptly before, the 1796–1912 period. It has predominantly received attention for negative reasons: to instantiate and illuminate when, where and how China – for much of human history one of the largest, most successful states in the world – was knocked from its long-standing position of regional dominance. In China, this view of history has often been didactic in intent: to inform the Qing's successors – politicians, militarists, civilians – about what went wrong, in order to help the country regain its traditional 'place in the sun', which it lost in

the wilderness years of the 19th century. Particularly in official histories authored under the People's Republic of China, founded in 1949, histories of the 19th century have served a powerfully legitimating purpose. The period has been firmly categorised as one of unprecedented calamity and defeat caused by exploitative rulers and foreign, imperialist victimisation, which only the radical measures of the Chinese Communist Party could bring to an end.[2]

Popular anglophone narratives have had their own historical biases. Until recent decades, Anglo-American histories were preoccupied with 'the impact of the West' on late imperial China and, above all, with the Qing's perceived failure to respond to the Western presence – economic and military – sooner and more effectively. Since the 1980s, however, anglophone historians have championed a 'China-centred' approach (facilitated by the greater accessibility of late imperial primary sources). This development has generated far more dynamic views of the interplay between imperial tradition and modernisation, communicating the variety of responses of individual Chinese thinkers to the political, economic, military, environmental, social and cultural challenges that faced a multi-ethnic Qing empire. This book aspires to convey both the external and internal cataclysms suffered by China, and the diverse, innovative reactions that these crises provoked. For indeed, the experiences of the 'long 19th century' form a crucial bridge to Chinese modernity. Across these 116 years, the imperial state fundamentally re-envisioned its role: building on centuries of experience, it transformed from a light-touch, understaffed bureaucracy to a centralising, interventionist state. The borders of contemporary China firmed up. Ethnically diverse Xinjiang to the

northwest – which the Qing had only formally taken over in 1768 – shifted from being a culturally devolved protectorate to a province integrated into the political centre. Political participation expanded, especially on the part of the Han Chinese majority. Government and governed engaged in new debates about the balance of power between monarch and bureaucracy – the fundamentals of constitutionalism. High politics, elite culture and everyday life opened to global influences and exchanges. Artistic and literary traditions were challenged, dismantled, added to and remade – the amalgam of and dislocation between old and new generated a cosmopolitan cultural modernity. Mass urban audiences devoured modern newspapers and pictorials, bestselling novels and accessibly priced art prints. Historians have long identified the May Fourth era (*c.* 1915–25) as the crucible of Chinese transformation: when the politics, culture and society of China became mobilised into a modern (republican) nation. But many of the standout changes associated with this period began in the late Qing: the shift towards the vernacular as the language of publishing and education; exposure to and voracious consumption of global news and culture; arguments for feminist emancipation and ethnic autonomy; and a new understanding of China, not as a world in itself but as a nation in the world.

Qing statecraft

In 1796, the Qing empire was – outwardly at least – a glittering success story (fig. 0.1). By the middle of that century (little more than a hundred years after the armies of the ethnically Manchu regime had poured into Beijing from their powerbase in the Manchu

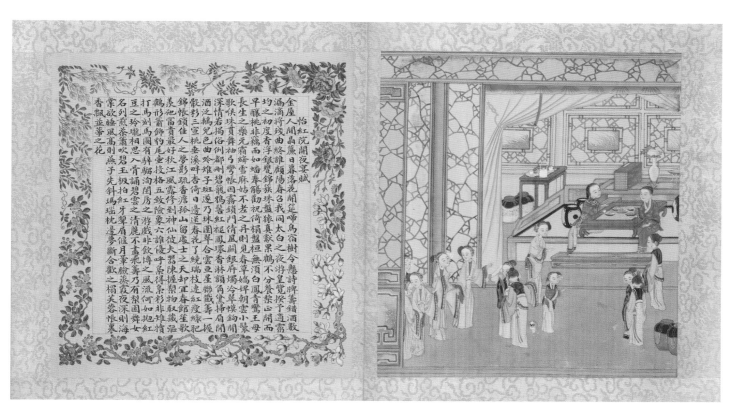

0.1
Cao Xueqin 曹雪芹 (1710–1765), *Dream of the Red Chamber* (紅樓夢)
This image of a beautiful home – with two women dining together on a raised dais – comes from a 19th-century illustrated edition of *Dream of the Red Chamber*, the greatest Qing-era novel. Originally written in the second half of the 18th century, it describes the luxurious prosperity enjoyed by the Qing Chinese elite during the heyday of the dynasty. Chinese is read right to left and vertically from top to bottom. 1830–50, China. Ink and watercolour on silk. H. 34.5 cm, W. 28.5 cm, D. 4.4 cm (closed volume). Chester Beatty, Dublin, C 1354

northeast through a pass in China's great frontier wall), the three great emperors of the high Qing, Kangxi 康熙 (r. 1661–1722), Yongzheng 雍正 (r. 1722–1735) and Qianlong, had more than doubled the dimensions of the Chinese empire inherited from the Ming, their predecessors. To the south, Manchu cavalry pushed down into Burma (Myanmar), Vietnam and Taiwan; to the north, the Qing added the forests and steppes of the dynasty's Manchurian homeland, and the scrubby expanses of the Gobi desert and Mongolia. Westwards, the empire swung out over the tall, glaciated Tianshan mountains and into the deserts and steppes of the Jungaria and Tarim basins, before stretching down through Tibet. Old 'China proper' became only the territorial core within the greater 'Pax Manchurica'. The story of the Qing, then, is of a great colonial enterprise, in which a conquest minority ruled a vast patchwork of other ethnic groups for over two and a half centuries (fig. 0.2).

The origins of the Manchus, like the empire they came to rule, were heterogeneous. The future Qing sprang out of hunting, fishing, farming, pearl-gathering, semi-Mongolicised tribes known as Jurchens, for whom the Ming empire used the nervous shorthand 'wild people'.[3] The architect of the Manchu state, Nurhaci 努爾哈齊 (1559–1626), began his career as a ginseng trader in the 1580s, with only thirteen suits of armour to protect his followers. Both he and his extraordinarily tough son, Huang Taiji 皇太極 (1592–1643), possessed the accommodating pragmatism invaluable to hungry empire builders, attracting and rewarding literate Chinese immigrants to the northeast to run the increasingly complex machinery of their rising state, formally established in 1616. By the time these tribal chiefs turned their ambitions, and their formidable horseback armies (disciplined into banners – military units each around 60,000-strong), towards China, they had succeeded in incorporating into their fighting ranks Chinese, Koreans and Mongols, as well as Manchus.

Although China – with its high agricultural yields, urban economies and educated elites – was a fine prize, it was only one of the land masses that the Qing bolted together across the 17th and 18th centuries. Even as Manchu forces were pushing south through the 1620s and 1630s, they looked west too. By 1634, Huang Taiji had incorporated Inner Mongolia into his empire, organising its fighting men into eight further banners that would play a crucial role in extending Qing frontiers out through Central Asia. Later, scenting trouble from an alliance between the western Mongols and Tibetans, the Kangxi emperor occupied and garrisoned Tibet, transforming the Dalai Lama into a Qing protégé and marking the end of the territory's political independence – all the while seeing off a Romanov attempt to edge down into Manchuria, and bringing to heel a Ming-loyalist regime on Taiwan. Between

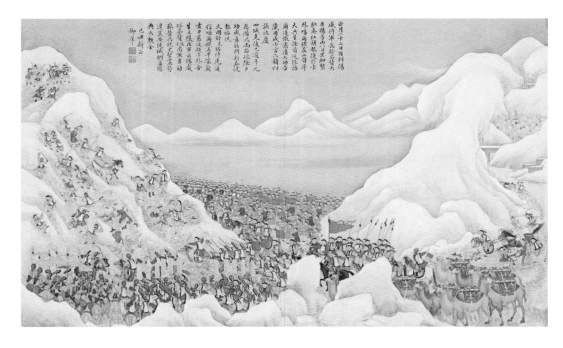

0.2
Unidentified artist, *Capturing Jahangir Khoja*
This painting commemorates the victory of the Qing over Jahangir Khoja, a tribal leader from East Turkestan who declared jihad against the Qing. The Qing conquered the region in the mid-18th century, naming it Xinjiang ('new frontier'). In the suppression of the 1820s rebellion, as in the original 18th-century war of conquest, camels were crucial pack animals. They even carried cannons over frozen mountains and, when lying down, formed a defensive barrier (駱城, 'camel wall') from which soldiers fired arrows and guns.

1829, Beijing. Ink and colours on paper. H. 51.4 cm, W. 89.4 cm. Palace Museum, Beijing, Gu.0000633

1680 and the 1750s, Manchu rulers undertook decades of brutal campaigning through mountain, forest and desert to incorporate into the Qing empire what is now Chinese Xinjiang. By the end of this extended period of conquest, Qing emperors could realistically proclaim themselves the Lord of Lords: the Confucian Son of Heaven, the Khan of the Mongol Khans and the Patron-in-Chief of Tibetan Buddhism.

The Qing were true political omnivores, taking an intense interest in any source of cultural, technical or religious leverage, whether Confucian, Central Asian, Buddhist or European, over its various peoples. First, Manchu emperors worked hard to keep alive their traditional shamanism and warlike Manchu Way, lecturing their bannermen on the martial traditions (archery, horse riding, proficiency in the Manchu language) that China's conquerors needed to cultivate to justify their possession of the empire. Bannermen were kept deliberately aloof from China's civilian populations, segregated in walled garrisons that might occupy half of a city's area (fig. 0.3). The Qing was an institutionally multilingual state – Qianlong himself spoke six languages. All key government documents were written in at least Manchu and Chinese, and often in Mongolian and Tibetan also. Manchuphone channels between the emperor and grassroots governance – outside Chinese lines of communication – were reserved for high-security intelligence. Well aware of the political advantages of multilingualism, the Qing did its best to obstruct suspect non-residents from acquiring Chinese and Manchu, and therefore the means to communicate independently with the native population. In early 19th-century Guangzhou (Canton, the city to which European traders were officially restricted at the time), teaching a foreigner Chinese remained a capital offence.

Qing government also harnessed a collection of ideas and practices about managing the world that could be termed Confucian. Immediately after the founding of the Qing dynasty in 1644, the people of China proper were compelled – on pain of death – to adopt the badge of submission to their foreign conquerors (shaved forehead and long braid, or queue). But the Qing were at the same time anxious to prove themselves faithful inheritors of ancient Chinese statecraft, using Confucian precepts as the moral glue to hold together a country originally subdued by violent conquest.

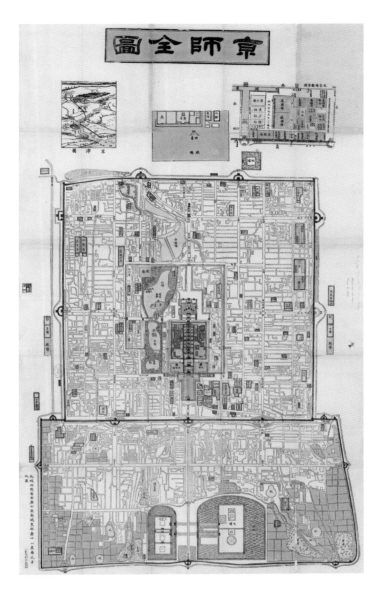

0.3
Plan of Beijing
This plan of Beijing shows the divisions of the city, along ethnic lines, imposed by Qing rule after 1644. The rectangle with an orange square in its centre is the Forbidden City palace complex; the surrounding walled square is the section of the city reserved for Manchus; Chinese residents lived in the southern walled part of the city. This system of residential segregation was replicated in other cities that housed Manchu banner garrisons, although it was realised in different ways.

c. 1900, Beijing. Ink on paper. H. 95 cm, W. 54 cm. The British Library, London, Maps X.490

Confucius – according to millennia of interpretations by Chinese imperial statesmen – preached a philosophy of harmonious submission. The Chinese world, this reading of his ideas held, would flourish not through violence but through careful maintenance of hierarchy. His great, popularising innovation was to scale his political philosophy down into the manageable analogy of family relationships: to equate the bond between father and son (or elder brother and younger brother; husband and wife) with that between ruler and subject. Good fathers and sons, his logic went, make good rulers and subjects, bringing the empire back to its rightful state of peaceful unity; perform your own social role properly, and the country will prosper. At the centre of all these relationships sat the emperor, whose mandate to rule depended on his own cultivation of the values of Confucian scripture (fig. 0.4).

Since the Han dynasty (202 BC–AD 220), imperial regimes had used the works attributed to Confucius and his key disciples to promote these sociopolitical values. Kangxi, who took the throne in 1661, was not only trained in martial skills but also given a Confucian education. He was thus able to promote the philosopher's virtues (obedience, loyalty, thrift and hard work) and to publicise to Chinese elites his own diligent efforts to master the Confucian classics.

He reinstated the civil service examinations – the tests based on those classics that had arbitrated the paths to wealth and social success for centuries, and the basic mechanism by which (through the promise of salary and status) scholars and writers were integrated into the state machinery. By 1679, the majority of China's aspiring elites – some exceptions notwithstanding – had been drawn towards the establishment, either through the civil service itself or through state-commissioned publishing projects. Manchu candidates enjoyed positive discrimination: if bannermen (for whom a quota of passes was reserved) found the competitive Han curriculum too challenging, they had the option of simply translating passages from the Chinese classics (which they had memorised) into Manchu. But others became, by any standards, brilliant sinophone authors. The bannerman Wanyan Linqing 完顏麟慶 (1791–1846) wrote the remarkable *Tracks in the Snow* (鴻雪因緣圖記), a travelogue-diary hybrid that offers exceptional insights into everyday life, relationships, belief and technology in the first half of the 19th century.

When it came to governing the peoples of Inner Asia, the Qing reached far beyond Confucian culture to bolster their authority. Qing rulers additionally understood themselves to be the descendants of the founder of the Mongol empire, Genghis Khan,

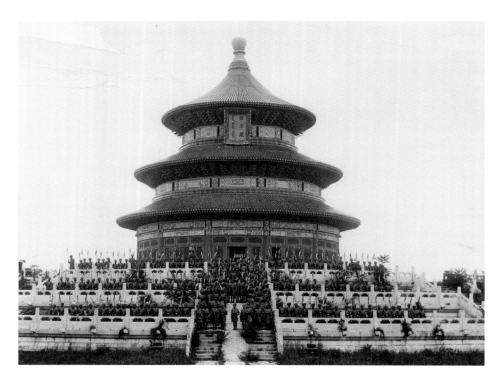

0.4
Temple of Heaven in 1900
The Qing dynasty inherited from their Ming predecessors this complex of religious buildings in the southern part of Beijing. Qing emperors took on the Chinese imperial role of 'Son of Heaven', making twice-yearly sacrifices to Heaven at the temple, to pray for bountiful harvests. In 1900, during the Boxer War, this sacred imperial space was invaded and occupied by foreign armies; here, soldiers from the 16th Bengal Lancers of the British Indian Army line the steps of the central building.

1900, Beijing. From an album of 104 photographs. National Army Museum, London, NAM. 1957-05-28-2-42

were active patrons of Tibetan Lamaism, and also earthly mediators with the Buddhist spirit guide of the dead – all in the interests of wielding spiritual (and therefore political) power over Tibet and Mongolia. Qianlong advertised – and saw – himself not only as the Confucian Son of Heaven and the Khan of Khans, but also as the messianic 'wheel-turning king' (*cakravartin*) of Tibetan Buddhist scripture, whose virtuous conquests were rolling the world on towards salvation. He appointed religious leaders for the Mongols, and selected and brought up child Dalai Lamas in Beijing.[4]

In the interests of state-strengthening, the Qing borrowed from Europe also. Taking advantage of Catholic Europe's eagerness to gain access to a vast empire of potential converts, 17th- and 18th-century Qing emperors made use of a series of talented Jesuit priests – Belgians, French, Germans, Italians – who rose to the many tasks set them by the imperial will: in astronomy, engineering, surveying, weapon-building, chemistry, hydraulics, medicines and architecture. In the wake of conquests, the Jesuits drew up maps – using the latest cartographic techniques – communicating the frontiers of the Qing triumph to regional competitors such as the Romanov empire.

Hybridity ran through virtually all levels of the state. The basic shape of Qing government – often known as the 'outer court' (外庭) – was borrowed from its Ming predecessor. The highest internal executive office was the Grand Secretariat (內閣), which processed communications between the emperor and his officials, including those scattered across the provinces, relating to day-to-day local governance. Serving below the Grand Secretariat were the Six Boards: Revenue (戶部), Personnel (吏部, a form of Qing human resources, assigning individuals to posts), War (兵部), Justice (刑部), Public Works (工部) and Rites (禮部). Two further institutions completed this level of government: the Censorate – auditors and whistleblowers – and the Hanlin Academy, a holding school for the most elite graduates of the civil service examination. The most senior provincial administrators were governors-general and governors, beneath whom served prefects, followed by county magistrates, the lowest rung of the bureaucracy. Each magistrate was responsible, on average, for governing around a million citizens. These administrators were in theory all holders of

civil service examination degrees, fluent in classical texts identified as upholding the core principles of Confucius. Until the end of the 19th century, this culturally and politically indoctrinating system arguably held the empire together in a community of shared educational experience and expectation.

The Qing also founded and relied on 'inner court' (內庭) institutions, which were not staffed by those who had come up through the civil service bureaucracy but were dominated instead by bannermen. In order to handle the frontier regions beyond China proper (Mongolia, Tibet and Xinjiang), the Qing founded the Court of Colonial Affairs. At least partly for security reasons, this department's staff mostly excluded Han Chinese, and operated in Manchu, Mongolian and Tibetan; their broad mission was to assert a common identity between the dynasty and the peoples of Inner Asia. In addition, the Qing rebuilt the Imperial Household Department (內務府), now dominated by trusted bannermen responsible for serving the emperor and securing his financial and material interests. But throughout the 18th century, arguably the most powerful of the 'inner court' institutions was the Grand Council (軍機處, literally the 'Office of Military Planning'): an elite inner cabinet, between three and five members strong, usually all Manchu and the closest associates of the emperor. The Grand Council had access to a fast track of urgent, secret palace memorials, which circumvented the rest of the bureaucracy.

In managing the world outside its borders, the Qing used a similarly diverse playbook. The theory of Chinese statecraft for nearly two millennia preceding the Qing upheld what is known as the 'tribute system'. By this reckoning, China was a universal empire (天下, 'all under heaven'), whose authority – cohering around elaborately literate political and cultural traditions – in theory radiated indefinitely outwards to civilise non-Chinese neighbours. According to Han-dynasty political geography, since the time of the mythical Xia dynasty (supposedly the third and second millennia BC) China had been divided into five concentric zones: the inner three were ruled directly by the Chinese sovereign, while the outer two were occupied by barbarians; all five zones owed tribute and ritual obeisance to the universally sage Chinese emperor, thereby affirming their status as vassals. The world, according to the Sino-centric ideal at least, revolved around China.

With some adaptations and simplifications, the Qing dynasty inherited the principle and spirit of the Ming version of the tribute system, using it to regulate relations both with its more familiar neighbours (Korea, Ryukyu, Vietnam, Thailand) and sometimes with new visitors from Europe eager to trade for China's prized exports (tea, silk and fine arts such as ceramics and lacquerware). But the tribute system coexisted with the far more pragmatic realities of economic incentives and state-to-state diplomacy.

In 1793, Britain's first embassy to China – demanding free trade and a permanent diplomatic presence in Beijing – reached the Qing empire. After it failed in its objectives (for complex reasons that included conflicts over ritual, geopolitical tensions and incompatible interests around trade and security), the frustrated British ambassador George Macartney responded by denouncing Qing China as an arrogant, isolationist, ritual-obsessed empire that wanted blasting 'with a couple of frigates' into the modern, 'civilised' world.[5] This caricature became enormously influential on Euro-American perceptions of the Qing, and helped justify several military campaigns against them over the following century. But it was a long way from the truth. Qing China was dependent on international commerce for many important products: rice, pepper, sugar, copper and wood came from Southeast Asia, Taiwan, Japan and Korea, and New World silver had transformed the economy and the tax base that supported the government and its armies.[6] Early 19th-century European travellers around China's fringes reported the population's eagerness for trade and for all foreign goods (洋貨) – copper, paint, linen, fur, wool, opium, even Bible tracts. China's booming population spilled across the seas in search of business and labouring opportunities (boatbuilding, sawmilling, mining, pawnbroking, hauling), mostly in Southeast Asia, Ceylon or Africa. By the close of the 18th century, observes historian William Rowe, the Qing empire 'was possibly the most commercialised country in the world'.[7] Regional specialities developed, including cotton from Jiangnan, Shandong, Hebei and Hubei, rice from Jiangxi and Sichuan, tea from Hunan and tobacco from Shaanxi. A boom in cash crops fuelled handicrafts such as spinning, weaving, papermaking and dyeing. New networks of credit developed mines. Market towns mushroomed, and with them new urban cultures: of

trade, philanthropy, socialisation, consumption and public performances such as storytelling and operas.

On the eve of its 'long 19th century', then, the Qing ruled over a large and powerful multinational empire built by ideas and institutions of technological, political and cultural sophistication. The state was held together by coercive cosmopolitanism: by a sense of confident entitlement to rule and control, justified by command of the Confucian tradition, the Manchu Way, Tibetan spirituality and traditional firepower. The foundation stones of the empire – economy, culture and family – were strong, and success seems to have kept this multi-ethnic balancing act in place. But as inherent weaknesses and new challenges emerged at the close of the 18th century, the whole edifice of empire began to shake.

The seeds of decline

Unaffected by the horrors that afflicted the 17th-century Ming empire – wars, plagues, brutal crop failures – and nourished by hardy New World staples (corn, sweet potatoes, peanuts) that flourished on land exhausted by wheat and barley, the Chinese population under the Qing at least doubled between 1650 and 1800, to reach some 300 million; by 1850, it had increased to 450 million. By the end of the 18th century, the empire was approaching its limits, as this demographic explosion led to fierce competition for work and resources, ecological degradation, price rises, bureaucratic overload and official corruption. As the costs of maintaining and managing the spiralling population grew, the machinery of government began to seize up.

China's mid- to late imperial state (from the 7th to the 18th centuries) was impressively effective relative to its limited size. A small government proved often able to control a vast empire through efficient infrastructure (such as the Grand Canal, linking Beijing with the southeast), strong social institutions and the broad circulation of Confucian ideas about the blessings of social harmony and compliance. But these advantages were no longer enough to secure the final, 116 years of Qing rule. Overpopulation, social conflicts and the ruthless inter-state competition fostered by the Euro-American system of international relations were overwhelming; political survival necessitated a state that could make use of a far greater proportion of its

resources, both material and human, than the existing skeleton administration permitted.

The maths behind political and social dysfunction in the early 19th-century Qing was thus simple: the government had not expanded to catch up with population rise, and seemed locked into a low-taxation, small-bureaucracy model. The most significant taxation commodity was land, calculated by size of holding rather than on an individual basis. Deep into the 19th century, land rates remained fixed at a level determined in 1713.[8] Much of the economy – housing, manufacturing, retail – was only minimally taxed. With population booming, land exhaustion (per capita acreage declined almost 50 per cent between 1753 and 1812), the state's failure to invest sufficiently in industry and a rise in those passing the civil service examinations but unable to find government jobs all led to surging social unrest.[9] (By 1800, although 1.4 million had passed the relevant exams, the number of government posts to fill had stagnated, at 20,000.[10]) The underemployed and disaffected helped stir up local disputes; in an extreme case in the mid-19th century, this led to a rebellion – the Taiping – that evolved into the most destructive civil war in human history.

The top of the imperial bureaucracy became ever more susceptible to corruption in the last quarter of the 18th century, when the elderly Qianlong grew increasingly dependent on a younger Manchu favourite named Heshen 和珅 (1750–1799). In control of access to the emperor, Heshen accumulated a vast personal fortune, substantially through embezzlement and selling political favours. As patronage and profiteering became a deciding principle in political life, public-works budgets began to melt away.[11] The emperor's once fat privy purse had been greatly depleted by wartime expenses and extravagance. Local bureaucracies inched out of central control, daring to ignore or even resist the emperor's directives, burying them in administration or concealing information. To keep the system functioning, the bureaucracy became swollen with secretaries, clerks and enforcers outside state payroll and control, whose income depended on raising extra levies to pass onto the population at large.

Critically, things began to go wrong in the Qing military. The root cause of decline was the same as in other spheres of government: overextension and lack of funds. The military backbone of the Qing remained its banner forces, bankrolled by the dynasty. As the frontiers expanded, so did the banners, stationed in Beijing and in a web of some forty garrisons around the empire. After the middle of the 18th century, the task of keeping up with rising banner costs proved too much. Growing impoverishment dented Manchu morale and prestige, with banners slashing item upon item from their budgets: first pensions, paper and ink; then food; finally, even weapons. Banner soldiers were supposedly supported by Han Chinese 'Green Standard' forces, but the latter too were overstretched, their pay suppressed by inflation and officer-level corruption, their morale dented by poor discipline and a fragmented command structure.

As the empire began to malfunction, so the population began to protest. In the first half of the 19th century, the Qing empire was often far too busy maintaining its costly frontiers and interior to assess new, well-armed European and American threats along the coast. First-hand Chinese-language accounts of the mid-century reveal a divided, distrustful society, with multiple groups in conflict with each other: Han with Manchu officials; Han settlers with minority mountain peoples; provincial gentry with central government officials. For much of the 19th century, Qing China was a society often at war with itself, as well as with European, American, Japanese and Russian invaders.

The Jiaqing reign

Although the Jiaqing emperor was nominally ruler from the moment of Qianlong's abdication in 1796, in reality he was only able to take over the reins of government after his overbearing father's death in 1799. At the first possible opportunity, within a month of Qianlong's passing, Jiaqing pronounced a death sentence on Heshen and confiscated his phenomenally extensive property: 'After Heshen fell, Jiaqing ate well', went one scrap of contemporary doggerel.[12] But long after he had obeyed the emperor's command to commit suicide, Heshen continued to leave his mark on Qing politics. After decades of scholarly grind, many civil service graduates were anxious to make profitable use of their years in bureaucratic power. In addition to a fixed salary, an official post offered civil servants abundant opportunities for self-enrichment: in bribes and favours extracted from and granted to cronies, in access to

public funds and goods, and in unofficial extra charges and taxes passed onto the general populace. This burgeoning culture of corruption generated economic, political and military malaise for the Qing, which crystallised in the mishandling of the first major crisis faced by Jiaqing, the White Lotus (白蓮教) Rebellion (the government label given to a proliferation of major revolts of the late 18th century). Its fractured leadership notwithstanding, the conflict sprawled expensively and destructively on until 1804, largely due to the venality of military and civil officials, who prolonged the discord in order to extract unaudited war funds from the state, which then melted away into their and their cronies' pockets.[13] The suppression cost the Qing treasury 120 million ounces of silver – two and a half times annual income during the Qianlong reign.[14] The throne's and the state's finances never recovered. The uprising also represented a missed opportunity for overhauling the Qing military system in time for a century during which it would be tested against powerful external and internal opponents. Rather than reform the army into a professional, mobile, empire-wide force, Jiaqing baulked at the cost; emotionally, it would also have been challenging to enforce, as it would have entailed standing down the hereditary military elite, the bannermen.[15] The rebellion constituted a milestone crisis, in which the Qing centre revealed itself unable to control and effectively operate its generals and armies on the ground.

Such challenges notwithstanding, the Jiaqing reign also witnessed serious attempts by the state to reform the bureaucracy and develop more flexible religious, trade and diplomatic policies. In order to shore up his own authority and diminish the agency of the regular bureaucracy, Qianlong had empowered a personal circle of senior officials, whose careers covered the most powerful positions in the Qing court. But this promotion of cliques militated against long-term, stable bureaucratic checks and balances by boosting factionalism and personal power play. Although the state continued to struggle with chronic underfunding, corruption and local disturbances, the early decades of the 19th century ushered in pragmatic attempts to punish flagrantly corrupt officials. Of necessity, Jiaqing – rumoured to wear patched imperial robes – reined in his grandiose father's spending habits. In a shift that would transform the landscapes of power, Jiaqing limited the opaque, personal powers of members of the Manchu nobility in institutions such as the Grand Council and promoted carefully educated and trained (Han Chinese) bureaucrats with personal experience of frontier and post-conflict governance.

Expanded political participation by Han elites – one of the most significant sociopolitical developments of the 19th century – gradually undermined Manchu power and legitimacy, with long-lasting consequences. These new generations of promoted officials – graduates of the civil service education and training – placed particular emphasis on institutional discipline, bureaucratic process and provincial power. As emperors became less fertile and long-lived through the 19th century, experienced, resourceful administrators would play key roles in maintaining a stable, functioning state. Han military commanders became more prominent, and Han rank and file more numerous, in the formerly Manchu-dominated army. Jiaqing was also responsible for adapting Qing foreign policy to a more precisely delimited sphere of intervention, foreshadowing the Qing's acceptance later in the 19th century of the principle of national territorial sovereignty. During the 18th century, the Qing had periodically involved itself in costly conflicts within traditional 'tributary states', such as Vietnam; in turning down requests for similar interventions, Jiaqing tellingly declared: 'both China and her vassal states have definite boundaries that should not be violated'.[16]

Beyond the frontiers

The early decades of the 19th century saw the Qing dynasty begin to come to terms with its own limitations: overpopulation, overextension, undertaxation, under-government and environmental exhaustion. These were redoubtable but not entirely insurmountable challenges. But foreign trade, hitherto a source of profit for officials, businessmen and the throne, was – thanks to opium – about to become a near-fatal liability. Moreover, another external factor – the expansion of Europe, the United States and later Japan – would prove beyond the control of Qing rulers and their empire-management manuals. Two systemic developments drove the rise of the West and its conflict with the Qing empire. The first was the acceleration of industrial manufacturing, and

trading ambitions, in Britain. Now that commodities such as textiles could be deliberately overproduced, this new economic logic of overproduction sought fresh markets open to the principle of 'free trade'. The empire of China – huge, populous, and with the vigour of its consumer economy vividly evidenced in the minds of British traders by Britain's long-established addiction to commodities such as silk and porcelain – was an obvious target. A second political development also drove economic competition. The French Revolutionary Wars and then the Congress of Vienna in 1815 established the pre-eminence of a powerful, centralised, armed nation state as the base unit of universal political organisation, civilisation and war.[17] The more trade a nation carried out, the richer and more powerful its citizens, government and armies (through tax and duties) would be. To loud, sinophobe voices in countries like Britain, the Qing empire, with its very different system of foreign relations, seemed to flout this new ideal of political organisation, and needed urgent reform – if necessary, by violent means. As Rowe analyses, Western nations such as Britain were now 'in possession of the motives (a need for foreign markets), the ideological justification (the comity of nations and free-trade liberalism), and the means (new military technologies) to force the "opening" of the Great Qing empire'.[18]

Following the collapse of diplomatic avenues of communication between Britain and the Qing from the 1810s and the 1830s, the trigger for conflict was the illegal opium trade. Until the early years of the 19th century, Britain ran a trade deficit with China: while China's government was willing to service the growing British tea addiction, it seemed to want little in return except the beneficial flow of silver. The British conquest of India after 1757 had incurred debts in London of £28 million; between 1780 and 1790, the combined returns of the India and China trades came to less than £2 million. But the British thought they had found a solution to their economic difficulties in China, in the form of Indian opium, for which Chinese consumers developed a taste in the early decades of the 19th century. In 1773, Britain's East India Company had established an opium monopoly in eastern India, forcing local Indian farmers to sign contracts for poppy cultivation. Raw opium sap was processed in British-run factories, then sold for silver by private merchants in

Guangzhou. This silver would in turn secure tea for the English market. And before the tea disappeared into British cups, the government would exact its import duties. Through the 19th century, these duties would be put to careful use: they covered a substantial part of the costs of the Royal Navy, which kept the British empire afloat. The opium trade also directly generated income for the government of India; by 1857–8, opium brought in almost 22 per cent of India's total revenue.

British India's opium trade with China grew with extraordinary speed between the late 18th century and the 1830s. In 1780, a British ship could not break even on a single opium cargo shipped to Guangzhou. By 1839, imports were topping 40,000 chests per annum. Although British traders and politicians gladly profited from China's growing appetite for opium, Qing rulers were understandably anxious about the corrupting effects of a booming illegal drug culture (recreational use of opium had been officially but ineffectually banned in 1729) and the even more destabilising outflow of silver on which their economy had come to depend. In 1838, the Daoguang 道光 emperor (r. 1821–1850) – Jiaqing's son – cracked down decisively on opium, panicked by reports that the ranks of the Qing armies were riddled with addicts. He dispatched an incorruptible Special Commissioner, Lin Zexu 林則徐 (1785–1850), to Guangzhou to suppress the trade. After arriving in early 1839, Lin blockaded British opium traders within their warehouses until they agreed to hand over all their stocks of the drug.

When Britain's Whig government learned about these events at a cabinet meeting in Windsor in the early autumn of 1839, it responded by sending a fleet to China, partly to avenge the perceived insult to British citizens, but primarily to recoup the money for the lost opium. Between late 1839 and early 1840, the British pro-war party – mostly opium traders – launched a campaign to demonise China in public opinion. They presented the conflict – dubbed the Opium War by its critics – as a clash of civilisations: xenophobic, arrogant China versus free-trading, progressive Britain. They claimed that Britain had a moral case to go to war; in reality, the conflict was driven by the need to protect profit margins in an illegal trade. Many (especially Protestant) missionaries lent their voices to the war party, eager for the British navy to open Qing China by force, thereby giving access to its vast population.

The military impact of the war is discussed in Chapter 2 of this book. But the conflict also had far-reaching economic and political consequences. By the summer of 1842, the firepower of British gunboats had forced Daoguang to negotiate. He handed over $21 million in compensation for the costs of the war and the destroyed opium, as well as the island of Hong Kong. Britain's foreign secretary, Lord Palmerston, took advantage of the opportunity to extract more than just opium compensation from the Qing empire – he wanted terms for trade that were far more favourable to Britain. He demanded and received rights of trade and residency for British citizens at five ports along China's south and east coasts, along with consular representation for the British there. On the back of these concessions, French negotiators demanded equal privileges and succeeded in cancelling the Qing imperial prohibition on Christianity, in effect since 1724.

It took only fourteen years for a second conflict to break out between China and Britain – the Second Opium War – and the causes were again primarily economic. Between 1842 and 1856, export of British manufactures to China declined while sales of tea and silk to Britain soared; only rising profits from the opium trade saved the British balance of payments from ruin, just as the reversal in the Qing balance of payments was sending it into a depression. Yet opium was still officially illegal in China and high-ranking British officials feared a new crackdown in the early 1850s. Anxious to open the whole of China to British traders and missionaries, in 1856 Palmerston (now prime minister) seized upon a legally murky pretext to launch a fresh expedition against China, this time with French cooperation. A treaty was agreed in 1858, but did not hold – the Qing military opened fire on the fleet sent to ratify the document in June 1859. Anglo-French forces returned vengefully in 1860, overrunning Beijing and sacking and burning the emperor's Summer Palace northwest of the city (fig. 0.5). In subsequent histories, this destruction has become one the most notorious acts of European imperialism against China; the objects plundered became the foundations of many public and private imperial Chinese art collections in the West. A new treaty, ratified in October 1860, quadrupled the indemnities agreed in 1858. It gave Britons – and the other Western nations with which the Qing had signed a 'most favoured nation' clause – the right to establish

an embassy in Beijing, plus freedom to travel and work beyond the treaty ports, and legalised opium, adding the drug to a list of legitimately dutiable goods (fig. 0.6).

Between 1860 and 1900, and especially after 1880, missionary Christianity boomed: Protestant missionaries surged from eighty to more than 3,000, belonging to some sixty societies. Missions were founded for the first time in fourteen provinces. Other examples of imperialist aggression in China proliferated over the same period: wars with France (1884–5) and Japan (1894–5) proved enormously destructive to the Qing military, with the latter power exacting an enormous, impoverishing indemnity. The climax of external aggression came with the Boxer War of 1899–1901 when, after a provoked conflagration of anti-Christian, anti-foreign violence across north China, an allied force drawn from six Western powers plus Japan and Russia brutishly occupied Beijing and Tianjin, drove the Qing court into a temporary internal exile, vandalised the capital and extracted yet another punitive indemnity.

The two Opium Wars between the Qing and foreign powers (Britain, then Britain and France) set highly disadvantageous precedents for the Qing empire's subsequent interactions with Europe, the United States and Japan. They established the principle by which the

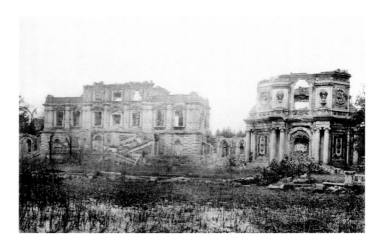

0.5
Thomas Child (1841–1898), The ruins of the Yuanmingyuan
This photograph depicts the desolate, burnt facade of the 'Western Mansions', one of the spectacular buildings in the Yuanmingyuan (Old Summer Palace) complex, designed by Jesuit priests at the court of the Qianlong emperor and sacked in 1860 on the orders of James Bruce Elgin, the British plenipotentiary on the final campaign of the Second Opium War.

1870s, Beijing. Photograph. H. 18 cm, W. 23 cm. Loewentheil Collection of Early China Photography

Qing treasury would have to pay out vast sums simply because they had lost a war. Particularly from the 1880s, when such indemnities became increasingly brutal, the growing indebtedness of the Qing state jeopardised necessary but expensive reform and modernisation. The terms of treaties from 1842 onwards also prevented the Qing government from setting its own tariffs and enabled Western nation states to dump surplus manufactures on China, to the detriment of domestic industrialisation. After the First Opium War, Britain and other Western nations became ever more covetous of what they imagined to be a gigantic Chinese 'market' and wealth of natural resources. Westerners were ambitious to mine China for raw materials, and to build factories and railways staffed by cheap Chinese labour – and repatriate the profits. Chinese

industrialisation was thus deprived of this reinvestment capital. The burgeoning missionary presence also often heightened domestic conflict: the ideology behind both the Taiping war as a direct response to missionary preaching and the Boxer War was partly provoked by missionary manoeuvres to acquire land and shield their converts from local justice. From the 1860s, periodic violence against missionaries and Chinese Christians had become a feature of Qing local society, in turn triggering militant intervention from the gunboats and soldiers of Euro-American powers.

But these traumatic events also gradually transformed late Qing understanding of the world beyond its frontiers. While struggling to comprehend the strategy and objectives of the British, Lin Zexu had commissioned pioneering translations of texts about geography and international law, as well as foreign newspapers. This trailblazing collection of information was synthesised by the historian-geographer Wei Yuan 魏源 (1794–1857) in the 1840s into a strategic programme of foreign policy, and compiled into his ground-breaking *Illustrated Treatise on the Maritime Kingdoms* (海國圖志). Writers like Wei Yuan were exceptional for piecing together a confusing jigsaw of geographical information and texts on Western military technology (such as landmines, torpedoes and artillery) into an integrated foreign policy picture, providing a clearer view of the Western-dominated international system into which Britain had violently drawn Qing China.[19]

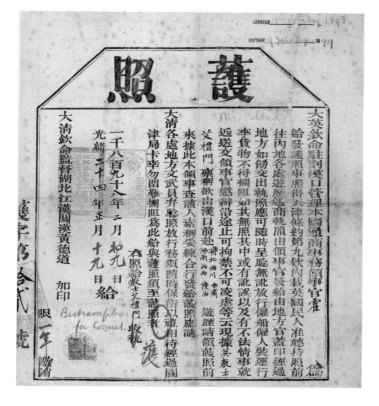

0.6
Passport
The treaties that concluded the Second Opium War (1856–60) permitted Westerners to travel and trade all over China (from 1757 to 1842, they had been restricted to part of the city of Guangzhou; from 1842, they had been limited to five treaty ports on the south and east coasts). This Qing passport

was issued in 1898 by the powerful Imperial Maritime Customs to an English missionary to travel and work in six provinces.

1898, Wuhan, Hubei province. Printing ink on paper. H. 52 cm, W. 44 cm. British Museum, London, As1987,14.35.b. Donated by Mrs Katie Bailey

Rebellion and recovery

Overpopulation and competition for resources had intensified local tensions and destabilised local society in the first half of the 19th century. Increased violence following the First Opium War militarised these conflicts. The most destructive example was the Taiping Civil War, which ravaged swathes of southern and eastern China between 1851 and 1864 and which, directly and indirectly, cost between 20 and 70 million lives. The war originated in the visions of a failed civil service examination candidate from south China called Hong Xiuquan 洪秀全 (1814–1864). Delirious with disappointment, Hong re-envisioned himself – with the help of a Chinese Christian pamphlet – as Jesus Christ's younger brother, directed by God to rid China of the

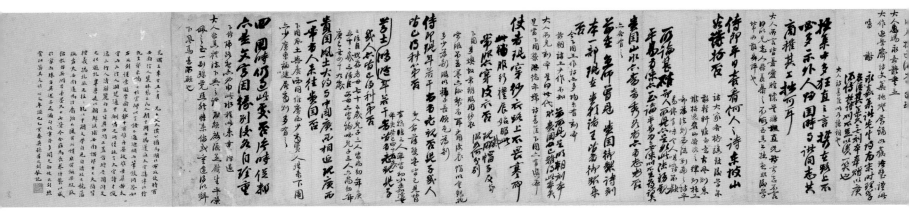

demonic Qing. The important role played by Chinese, rather than Western, Christians in communicating doctrine is worth noting; in the early decades of the 19th century, Chinese Catholicism survived largely due to the talent and hard work of ethnically Chinese priests, such as Li Zibiao 李自標 (1759–1828) in the northwest. Hong Xiuquan learned about Christianity through Bible summaries written by the Cantonese Protestant preacher Liang Fa 梁發 (1789–1850), in *Good Words to Admonish the Age.*

Hong recruited followers from desperate, marginalised migrant communities, especially from the Hakka (from which he himself came), a hard-working, often socially mobile population group from southern China with distinct customs and language. He preached a simple, reassuring doctrine of salvation, promising followers a puritanical, egalitarian society based on universal brotherhood and sisterhood among God's children. All resources – food, land and clothes – were to be shared out. This promise was a direct answer to the threats such communities faced to their very survival by local conflict for resources. Hong and his associates borrowed from ancient Chinese vocabularies of religious revolt. The foretelling of a new era of Great Peace ('Taiping' 太平) placed Hong in an age-old tradition of Chinese millenarianism. But the conspicuously foreign, Christian elements of Taiping ideology gave the movement a far more radical iconoclasm than the many other sectarian rebellions that shook the empire through the 19th century. In 1850, Hong openly declared war on the Qing government. Within another three years, Taiping armies had stormed across south-central China, capturing the old imperial capital at Nanjing, which they held for the next eleven years, while they planned military expeditions north and tried to rebuild a new, collectivised socio-economic order in the territory they occupied.

In 1861, the outlook for the Qing dynasty was bleak. The Xianfeng 咸豐 emperor (r. 1851–1861) died in exile beyond the Great Wall, having fled British and French soldiers rampaging through Beijing, looting and burning the Summer Palace. Most of the prosperous southeast had been occupied for the past eight years by Taiping forces determined to annihilate the Qing. Dali, a major city in the far southern province of Yunnan, had become the capital of another breakaway regime under Muslim rule. Xianfeng's only son and heir, Zaichun 載淳 (the future Tongzhi 同治 emperor, r. 1862–1874), was a five-year-old boy, leaving the ruling house vulnerable to factional intrigue as courtiers fought to fill the power vacuum.

Rather than watch dynastic rule collapse, an effective coalition of regents took over: the new emperor's mother, a concubine called Yehonala who after Xianfeng's death became known as the Empress Dowager Cixi 慈禧 (1835–1908); Xianfeng's brother Yixin, Prince Gong 恭親王 (1833–1898), who had negotiated the Qing out of the Second Opium War; and Zeng Guofan 曾國藩 (1811–1872), architect of a new military strategy that enabled the Qing to defeat the Taiping armies and re-exert control over the empire's frontiers. A period of striking innovation and development ensued. This series of reforms was known as Self-Strengthening – a serious, systematic attempt to master the modernising technologies and statecraft of Western nations, facilitated by a coterie of hard-working Han Chinese officials – Zeng Guofan, Li Hongzhang 李鴻章 (1823–1901) and Zuo Zongtang 左宗棠 (1812–1885)

0.7

Poems by Sun Yiyan and visiting scholars from Vietnam
(湖北布政史孙衣言与越南使者笔谈卷)
The scroll reports a meeting in the second month of 1877 between Sun, an official from southeast China, and three visiting Vietnamese scholars, in which they discussed geography and culture in Vietnam under the Nguyen dynasty (and compared it with conditions in Qing China), along with Chinese poetry, philosophy and essays. The conversation was summarised and mounted into a handscroll as commemoration. It indicates the sense of cultural closeness – based on literary Chinese as a shared language – that still existed between educated elites in China and not only Vietnam but also Japan and Korea.

1877, China. Ink on paper. H. 24.5 cm, W. 261 cm. Zhejiang Museum, Hangzhou, 016145

among them. Li, Zuo and others were protégés of Zeng Guofan and were rapidly promoted (outside the traditional civil service hierarchy) to top government positions between the 1860s and 1890s, thanks to their commands of locally based anti-Taiping military campaigns. After the suppression of the Taiping and other civil wars and insurrections, these men played major roles in post-conflict reconstruction. Cixi, meanwhile, became the dominant power in the court and state until her death in 1908, ushering in a period of female leadership almost without dynastic precedent.

In the post-1861 period of recovery, the Qing began actively participating in the Western-dominated international system. Foreign ambassadors finally took up residence in Beijing, and the Qing began reciprocating with its own ambassadors. A de facto foreign office was created, the Zongli Yamen 總理衙門, under the leadership of Prince Gong. (Aspects of the old foreign relations system remained, however: as late as 1894, the Qing court was still receiving, alongside Western and Japanese diplomats, 'tributary envoys' from Korea at a frequency similar to earlier phases in the dynasty (fig. 0.7).)[20] Western governments, having wavered until the aftermath of the Second Opium War, chose to side with the Qing in the Taiping conflict, offering valuable military and technical support. Trade with the West intensified and far more Chinese individuals became involved in transactions, as suppliers and agents to Western merchants. Such 'compradores' often became highly influential, wealthy individuals – Charlie Soong 宋嘉澍 (1861–1918), the father-in-law of China's first republican president Sun Yat-sen 孫中山 (1866–1925), was a notable example (fig. 0.8). Some men also played active roles in reforming politics and society, such as Zheng Guanying 鄭觀應 (1842–1922), who became an advocate for women's education at the turn of the 20th century. Foreign 'concessions' – parcels of land that were effectively mini-colonies governed by Western nations (joined, after the 1890s, by Japan) – proliferated in treaty ports opened not only on the coast, but also deep into central China, in cities along the Yangzi. They generated a cosmopolitan hybridity that in turn fascinated and troubled Chinese urbanites. In 1861, Prince Gong founded the Imperial Maritime Customs Service; although directed by foreigners, it became the Qing's tax authority for trade with the West. Translation from Western languages into Chinese also became more systematised, thanks to a government Translation Bureau founded in 1862 (fig. 0.9).

The missionary presence began to play a more constructive, less militantly imperialist role in Qing society. Missionaries contributed to new translation bureaus, taught foreign languages to Chinese people, rendered books of science, medicine, maths, law and

economics into Chinese, and served as interpreters at government arsenals. They founded schools (with ground-breaking facilities such as the first modern laboratories in China), spreading scientific as well as religious knowledge in the classroom, and embarked on new publishing ventures full of useful, secular information (the first Western-style newspapers in China sprang from missionary presses). Musical education through the translation and performance of hymns – as well as music theory classes, choirs, instrument lessons and orchestral rehearsals – introduced the idioms of European classical music into China, and drove innovation in new notation systems for indigenous music. Inhabitants of the Qing empire also began to travel abroad to study; in the 1870s, the government sent classes of young Chinese men to study in Connecticut, with some joining the school's baseball team. The first Chinese woman to earn a Western medical degree (in 1896) was Ida Kahn 康愛德 (Kang Aide, 1873–1931), the adopted daughter of an American woman missionary.

0.8
Charles (Charlie) Song (Soong)
Born in tropical Hainan province, Charlie Soong 宋嘉澍 (1861–1918) went with a relative to Boston, Massachusetts, to work in a family business. While in the United States, Soong studied for a theology degree and became an ordained Methodist minister. After he moved to Shanghai in 1886, he left the Christian mission to start a successful business career as a comprador to foreign enterprises as well as a publisher. In the final years of the Qing, Soong became an important supporter and funder of Sun Yat-sen's revolutionary movement. Soong's US-educated daughters (Ailing, Qingling and Meiling) all became important players in republican politics in China after 1912.

c. 1880–86, United States. Photograph. Duke University Library, Durham, North Carolina, RL.01025, 003309370

0.9
Raimund von Stillfried (1839–1911), Interpreter of the legation for the Austro-Hungarians
After defeat in the Second Opium War, the Qing government allowed foreign delegations to be built in Beijing, created a de facto foreign office, the Zongli Yamen, and initiated a new Translation Bureau to facilitate Western-style diplomatic relations with foreign countries.

1870s, China. Albumen silver print from glass negative with applied colour. H. 23.7 cm, W. 19.2 cm. The Metropolitan Museum of Art, New York, 2005.100.505.1 (3a)

The import of European and American ideas about medicine – especially surgery and public health – drove innovations in clinical practice within the Qing empire (fig. 0.10). By 1916, Protestant missions ran 265 hospitals and 386 dispensaries, and provided 420 doctors and 127 nurses.[21] Overseas Chinese trained in the British empire returned to add to the mix. The late Qing was the moment at which Chinese and Western medicine began to coexist with and draw from each other – a situation that persists today in China, and beyond. It witnessed the first major public health and hygiene projects within the country, and the earliest modern medical associations for clinicians and pharmacists.

Muslims resident across contiguous stretches of northwest China and Xinjiang rebelled against Qing rule in the 1860s. Following success against Taiping armies, Zuo Zongtang suppressed these breakaway regimes in campaigns that – through their hunger for financial resources – led to dramatic innovations in banking and finance by China's business class. The Qing government for the first time, through the efforts of an extraordinary merchant-pharmacist-banker called Hu Xueyan 胡雪岩 (1823–1885), negotiated foreign loans, backed by the collateral of provincial taxation revenues. After reconquest, the style of Qing government in Xinjiang was transformed. This time, the principal architects and functionaries of Qing Xinjiang were not the multi-ethnic Central Asians of the high Qing but rather Han Chinese, who consciously sinicised the northwest, projecting sinophone politics and culture through education, language, intermarriage, publishing and government. The old Manchu homeland in the northeast was similarly transformed by vast Chinese migration after 1860. This closer integration of Xinjiang, Taiwan and Manchuria as 'provinces' of China, directly ruled from Beijing, irrevocably changed rulers' assumptions about what 'China' was. No longer either a Chinese core occupied by the old Ming polity, or a sprawling Central Asian universe of the Great Qing, the empire was becoming the multi-ethnic but Han-dominated China familiar to us today. During these decades, elite Han Chinese finally began to see Xinjiang – for the previous century and a half of Qing rule, an expensive colonial acquisition – as an integral part of China.

The careers of Chinese officials such as Zeng, Li and Zuo had mixed consequences for state power. On the one hand, they mobilised local elites and resources

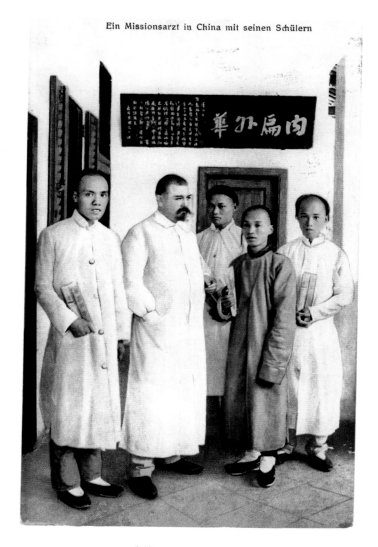

Ein Missionsarzt in China mit seinen Schülern

0.10
Postcard of Dr John Dudgeon and his trainees
This image, from the late 19th century, depicts a British missionary doctor, John Dudgeon 德贞 (1837–1901), with his Chinese students. The placard over the door (probably gifted by an appreciative patient) acclaims the mission to be as skilful as two celebrated ancient Chinese doctors. The import of European and American ideas about medicine changed clinical practice within the Qing empire.

Late 19th century, Beijing. Printed card. Collection of Professor Bridie Andrews

to build disciplined, effective forces, which re-established government control over regions stricken by civil war. But on the other hand, the military reforms of these men – several of whom built regional armies personally devoted to them and other local leaders – created patterns of loyalty to individual provincial commanders that arguably underpinned the fragmentation of China into warlord fiefdoms after the Revolution of 1911. The Qing had become too dependent on such men to be able to limit their powers or terms of office. In the past, senior officials would have been rotated every three years, partly to prevent their creation of regional powerbases. Instead, Li Hongzhang and others like him retained their pre-eminent regional positions for years, even decades at a time, coming to dominate all aspects of government bureaucracy – including new arsenals, shipyards and local tax revenue – in their jurisdictions.

The end of the war against the Taiping in the 1860s transformed not only Qing politics and economy but also society and culture. In addition to its vast human cost, the conflict had destroyed the physical infrastructure of south and southeast China: fields, government offices, temples, community halls, irrigation and flood control. Economy and internal trade were badly disrupted. The port of Shanghai became the centre of operations for savvy southeastern merchants displaced from the cities ravaged by the Taiping war

(Suzhou, Ningbo, Shaoxing, Yangzhou and Nanjing). Between 1810 and 1910, the city's population grew from a few hundred thousand to 1.3 million. Artists, writers, musicians and opera stars followed the money as well as the excitement of modern, cosmopolitan cultures. New markets for literature and the arts boomed, above all in Shanghai and Tianjin (figs 0.11–0.12). In the post-Taiping decades, a remarkable succession of painters – including Ren Xiong 任熊 (1823–1857), Ren Yi 任頤 (known as Ren Bonian 任伯年, 1840–1895) and Wu Changshi 吳昌碩 (1844–1927) – remade repertoires of painting both technically and thematically, combining old-style ink brushwork with photographic detail and new colours, and injecting fresh individuality, informality and naturalistic candour into portraiture.

New readerships and new media also drew writers into new literary forms. Beginning in the 1870s, urban readers devoured newspapers, periodicals and tabloids churned out by presses in the treaty ports. *Shenbao* 申報 – literally, the 'Shanghai News' – was one of the first, founded in 1872 by a British businessman called Ernest Major (but placed under Chinese editorial control) to inform Chinese readers about current affairs, business and culture (fig. 0.13). Lithography also found its way into Shanghai publishing via missionary schools. The last three decades of the 19th century were a golden age for this technology in China, a time when

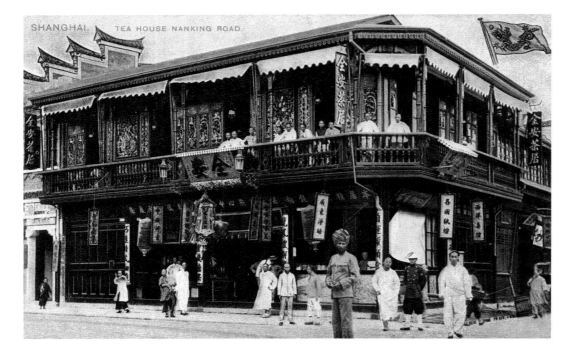

0.11
Shanghai street scene
A Shanghai teahouse, in around 1900, on the major commercial thoroughfare of Nanjing Road. Note the Sikh policeman in the foreground, one of hundreds of such individuals who came from India to police the International Settlement (under British and American control) in the city. Hand-colouring, as here, was the easiest and most popular way of producing colour photographs between the late 19th and mid-20th centuries.

c. 1900, Shanghai. Hand-coloured photograph

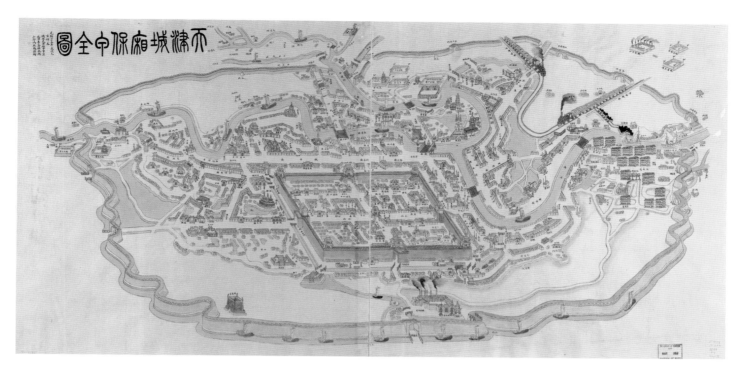

0.12

Feng Qihuang, Complete map of the community self-defence system of the walled city of Tianjin and its environs (天津城廂保甲全圖)

This 1899 map of Tianjin, a treaty port from 1860, demonstrates how the older Chinese city, surrounded by square walls in the centre of the image, coexisted with newer foreign concessions (of which, during the final years of the Qing dynasty, there were nine) on its eastern fringes. The large number of non-Qing national and imperial concessions generated a striking architectural hybridity, taking in British banks and trading houses, white spired Austro-Hungarian mansions, a French Catholic cathedral and a candy-pink German club. Note the recently built railway, modern arsenals to east and west. After the Qing's epochal defeat by Japan in 1894–5, military leader Yuan Shikai 袁世凱 (1859–1916) built the empire's new modern army near the city.

1899, Guangxu. Printing ink on paper. H. 55 cm, W. 111 cm. Library of Congress, Washington, D.C., G7824.T5A3 1899 .F4 col.

entrepreneurial publishers often combined lithographic precision and detail with the panoramic drama of old-style woodblocking. In 1884, Major founded another publishing institution of the late Qing, *Dianshizhai huabao* (點石齋畫報, 'Pictorial from the Touchstone Studio'), a thrice-monthly lithographic extravaganza filled with illustrations of the latest marvels and dramas from around the world – whether hot-air balloons, New York firemen, earthquakes in southeast England, French battleships or Shanghai cinemas. This new press drew attention to, and encouraged a sense of national solidarity with, disasters in distant parts of the empire; heart-breaking reports and images of famine in the northwest, for example, were instantaneously reproduced in the southeastern press.

Fiction – for centuries, millennia even, a disreputable choice with which few respectable literati would want to be publicly associated – became a viable, independent profession. The growth of treaty ports, enriched and modernised by foreign trade and its beneficiaries, was principally responsible, since it created urban communities of eager, paying readers whose increasingly cosmopolitan tastes had spread to many parts of China by the end of the 19th century. Some 2,000 or more works of fiction were written and circulated between 1898 and 1911 alone, published through at least four channels (newspapers, tabloids, fiction magazines and books).

More than 170 presses provided reading matter for an audience of 2 to 4 million readers.[22] For some crusading reformers, the job of print media was to educate people in domestic and international affairs and to create soberly informed citizens. But many readers fell in love with fiction for more escapist reasons, to devour wild tales of banditry, corrupt judges, grotesque officials, brothel adventures, revolutionary female assassins, miracle-working detectives, technological fantasies (robots, guided missiles, sorcerers), time and space travel, goblins and fox spirits, and feminist utopias. The new fiction often reflected, with comic sarcasm, the perplexing, frightening, sometimes supernatural strangeness of the late 19th century: the deficiencies of the patriarchy, the quest for female equality and the amoral flamboyance of late 19th-century Shanghai. *Fin-de-siècle* fiction helped readers encounter and make sense of a world turned upside down.

In addition to engaging with new ideas and objects, Qing China also reached out to the world. In 1860, the Treaty of Beijing legalised Chinese migration; millions of Chinese people left the Qing empire during the remaining decades of the 19th century. Some 7 million (a conservative estimate) left for Southeast Asia, Australia and the Americas alone.[23] The wealthy made their way through trading networks across East and Southeast Asia – to Japan, the Malay peninsula, Borneo, Java, French Indochina and Siam. The impoverished and the desperate were often indentured into exploitative 'coolie' labour contracts, building railways, farming sugar cane, gathering guano for fertiliser and toiling in mines, in every continent. The dramatic rise in emigration posed new challenges for the imperial state. The state had previously taken no

responsibility for its subjects abroad, but in 1869 it intervened when Chinese workers in Peru protested against the appalling conditions they suffered as indentured labourers in the sugar and guano industries. Following a Qing diplomatic delegation to Cuba in 1874, a treaty ending the coolie trade was signed (fig. 0.14). The state's motivations for defending its citizens abroad, however, were not exclusively humanitarian. Doing so was a signifier of 'modern civilisation' that the Qing was eager to demonstrate to Euro-American powers; the state was also beginning to realise that wealthy migrants might prove a useful source of revenue and expertise. Multiple consulates were founded abroad between the 1870s and 1900s; an important function of such institutions was to ensure that overseas Chinese could easily transfer money back to their homeland, contributing to disaster relief and public works projects.[24] After the 1890s, exiled opponents of the Qing, such as Kang Youwei 康有為 (1858–1927), Liang Qichao 梁啟超 (1873–1929) and Sun Yat-sen, also courted the loyalties (and pocketbooks) of overseas Chinese communities. This era saw the beginning of a process that is still under way: the ongoing negotiation of the relationships between large ethnic Chinese communities all over the world, the state in China and rival political causes.

As the Qing built up its diplomatic presence abroad, ever more literate individuals travelled outside China, penning hundreds of first-hand travelogues of worlds far beyond the Qing. Some were written by Han Chinese women, a group whose horizons had previously been severely constrained by patriarchal conservatism. The author Shan Shili 單士厘 (1858–1945), who regularly sojourned abroad with her diplomat husband, not only embraced Japan as 'home' but travelled along

0.13

Shenbao, The brewing of public opinion
The explosion of new print culture in Shanghai at the end of the 19th century had a deep and extensive political, social, economic and cultural impact. This cartoon from *Shenbao* – the first modern Chinese newspaper published in the Qing empire – depicts the way

that the press presented itself (in sinologist Barbara Mittler's words) as 'a transmission belt for public opinion, a marketplace of ideas' and a forum for national political debate.

1907, Shanghai. Printing ink on paper

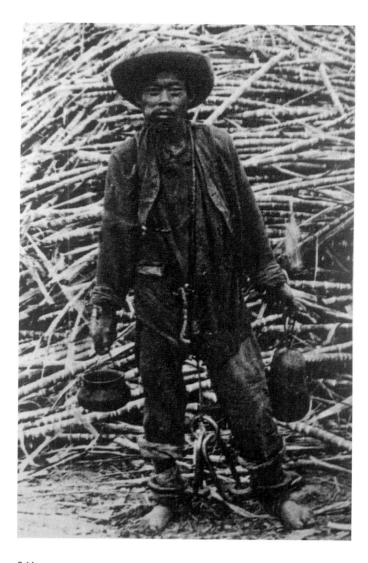

0.14

An unidentified Chinese labourer
In the second half of the 19th century, South American agricultural businesses – for example, those producing sugar and guano fertiliser – sought, in an era of abolition, to replace formerly enslaved people with hundreds of thousands of 'coolie' labourers trafficked from China. Such workers – one of whom is depicted in this photograph, possibly from the Chilean army newspaper *El Mercurio* – were treated with horrifying harshness. In 1874, as part of its adaptation to a modern, Western-dominated diplomatic system, the Qing government dispatched a multinational delegation to Cuba (then a possession of the Spanish crown), whose investigations and remonstrations helped end this highly exploitative trade. This episode represented a significant political victory for the Qing against a European-held state, at a time when the dynasty was suffering successive military defeats on the part of foreign aggressors.

1881, Peru. Printed photograph

the Trans-Siberian Railway to Russia. Her writings showcased an intricate knowledge of Roman, Jewish, Byzantine and Catholic art, and explored topics usually out of bounds for women, such as history and politics. The genre of travellers' tales popularised by writers like Shan crossed over to inspire one of the biggest novelistic hits of the late Qing, *Flower in a Sea of Retribution* (孽海花), which maps out the vicissitudes of a diplomat and his beautiful concubine, who move fluidly through European royal circles, befriending along the way a Russian anarchist (based on Sophia Perovskaya, one of the revolutionaries who plotted the assassination in 1881 of Tsar Alexander II).

The push for nationalistic reform

Historians have been critical of the Qing's efforts to modernise after 1860. They have blamed conservatism, inefficiency and extravagance at court, underinvestment in the latest technologies, and economic imperialism. But historical contingency and sheer bad luck also derailed hard work and early success. The Qing were defeated in three intensely draining conflicts between 1884 and 1901: the Sino-French, the Sino-Japanese and Boxer Wars. Although the Qing administration made strategic errors in all three, the violence was forced upon the regime by outsiders: by ambitious imperialists and aggressive missionaries. Forced into warfare at a premature point in its military modernisation, the Qing suffered massive destruction of its incipient industrial firepower, above all its navy and shipyards, and was forced to pay vast indemnities that sapped finance from modernisation programmes.

The last two catastrophes in particular – the Sino-Japanese and Boxer Wars – provoked intellectual, political and cultural introspection that steadily eroded the authority of Qing rule. It is hard to overestimate the impact of the 1894–5 defeat by Japan on China's educated classes. It galvanised the nascent national press: news of the 1895 Treaty of Shimonoseki spread rapidly from the coastal cities (where most of China's newspapers and books were produced) and into the countryside, in second-, third- and fourth-hand copies of periodicals avidly read by anyone literate enough to understand their shocking message. Reports of the war losses moved the population at large in a way that earlier

foreign conflicts had not. 'The Shanghai newspapers carried news about the war with Japan every day,' remembered one provincial reader. 'Previously young Chinese people paid no attention to current events, but now we were shaken … [Now] most educated people, who had never before discussed national affairs, wanted to discuss them: why are others stronger than we are, and why are we weaker?'[25] Concerned Chinese drew one conclusion from the defeat: that the last thirty years of 'Self-Strengthening' had been full of futile half-measures, and that more urgent, more daring, more thoroughgoing reform had to take place.

One of the more extraordinary personalities who responded to this sense of national emergency was the brilliant Cantonese scholar Kang Youwei. Both steeped in the Confucian classics and fascinated by Western models for organising society (directly experienced on visits to colonial Hong Kong), through the 1890s Kang grew famous for embedding radical plans in traditional learning. He published a reading of Confucius that re-envisioned the sage not as a curator of antiquity but rather as a flexible, practical theorist, who had himself adapted political ideas to suit his own context. This interpretation implicitly legitimised classical scholars like himself to outline radical new blueprints for political and social organisation. To suit the demands of his age, Kang sought forms of political organisation that would mobilise the citizens of the Qing to build a strong new state. He argued for greater self-governance, to give local communities more control and agency, which would in turn release their energies to strengthen the polity as a whole. This self-governance would be regulated by democratically elected officials and representative citizens' assemblies. But central government had a role to play, too: organising its citizens in the realms of defence, development and education. Kang and his most brilliant pupil, the polemical thinker-journalist Liang Qichao, developed innovative forms of political mobilisation themselves, that challenged existing legal limits and the once-unanswerable authority of the Qing. They mass-circulated and submitted protest petitions, and they founded study societies and newspapers in the empire's biggest, best-connected cities, in order to amplify conversations about reform.

In autumn 1898, Kang and Liang fled China for Hong Kong and Japan with a price on their heads.

That summer, they and a group of associates had briefly won the ear of the young Guangxu emperor 光緒 (r. 1875–1908), who succeeded to the throne in the early 1890s, bringing to an end some thirty years of regency by his aunt, the Empress Dowager Cixi. For three feverish months in the summer of 1898, Guangxu had announced a range of Westernising reforms overhauling education, commerce, the army, industry and government, before Cixi put him under house arrest and executed radical leaders who failed to flee her crackdown, effectively regaining power through a putsch. But Liang was not silenced. By the early 1900s, he had established himself as the most brilliant and influential writer of his generation, a founding figure in modern Chinese journalism. He drew a direct (if arguably naive) line between newspapers and national vigour: 'The more the people read the press, the more intelligent they become; the greater the press, the stronger the nation.'[26]

Kang and Liang were only the most prominent voices in a broader reform movement that re-evaluated the role of the state in Chinese society, and its relationship with ordinary people. Although this movement was diverse and disputatious, it can be broadly labelled nationalist. It built on the ideas of the first generation of intellectuals and translators who had participated in the post-1860 modernising reforms in a world of competing nations. Foremost was Yan Fu 嚴復 (1854–1921), who had graduated in 1871 at the top of his class from the Fuzhou Shipyard School, one of the Qing's first new-style academies of Western science and technology. During and after a stint at the Greenwich Naval College in the United Kingdom, he read deeply and widely in European political theory (Adam Smith, John Stuart Mill, Montesquieu, Thomas Huxley and Herbert Spencer). Men like Yan Fu were responsible for propagating a new and influential set of nationalistic ideas for reforming China in the closing decades of the 19th century: an ambitious blueprint for transforming the Qing empire into a muscular, cohesive society. Yan Fu, and many of those whom he influenced through his translations of Social Darwinism into exquisitely laconic classical Chinese, believed that the Qing Chinese body politic needed to be bonded into the same species of social and political unit that had strengthened the West and Japan: the nation. He wrote that Qing citizens must learn to 'live together, communicate with and rely on

each other, and establish laws and institutions, rites and rituals for that purpose … we must find a way to make everyone take the nation as his own.'[27] This required a reorganisation of the minimalist imperial state – which had devolved so many of its powers and resources to non-state actors – into a centralised, interventionist polity that could mobilise individuals and wealth to compete with other nations.

Here, the modernising, nation-building model of Japan was particularly influential. In less than thirty years following the Meiji Restoration of 1868, Japan had overturned centuries of decentralised, feudal rule and remade itself as a 'rich country and strong army' (富國強兵) able to defeat the Chinese empire, which across centuries, if not millennia, had dominated the East Asian region. Japan's Meiji reformers were unafraid to abandon the 'superstitions of the past' and 'seek knowledge from around the world to strengthen Japan', and declared that an essential part of this process was to 'involve all levels of society … in the affairs of the state'.[28] By the 1890s, Japan had developed a national taxation system and a constitution that legislated the rights and responsibilities of Japanese people with regard to the central state. The achievements of this process, for both Japanese and non-Japanese people, seemed clear by the 1890s. Japan's modernisation – military, industrial, transport, all funded by the national tax system – had been internationally validated. It had renegotiated unequal trade treaties with Western nations, and developed a strong, modern, national conscript army that enabled it to defeat China and begin building a colonial empire (the island of Taiwan had been wrested from the Qing in 1895). Compulsory, universal primary education, which by the end of the 19th century was underpinning a growth in higher education, increasingly tied the population into a community of modern knowledge and aspiration.

The Japanese model seemed particularly relevant to China, not just because of their shared East Asian heritage but also because it had modernised while retaining the emperor as supreme figurehead. Much of the theory and practice of late Qing modernisation was – literally – translated from Japan. Through the 1890s and 1900s, an earlier imperial term for China – *Zhonghua* 中華 – was combined with a Japanese neologism *minzu* 民族 (standing for the Western idea of a nation) to invoke 'the Chinese nation'; this new term began to appear

with increasing regularity in the writings of radicals and revolutionaries. Other powerful, modern political terms followed: constitution, republic, revolution.

New policies

The pace of change for the Qing accelerated after the twin crises of the Sino-Japanese and Boxer Wars. Empress Dowager Cixi – on returning to Beijing from Boxer-induced exile in 1901 – enacted a series of reforms more radical than the policies she had crushed in 1898. The post-1901 reforms – 新政, 'New Policies' – greatly increased the size of the state. Redundant bureaucratic positions were abolished and cabinet ministries replaced the Six Boards. A professionalised, independent Ministry of Justice, along with Ministries of Trade, Education, Police, and Post and Communications, were created (fig. 0.15). Infrastructure logistically unified the country: some 5,000 kilometres of railtrack were laid in the first five years of the 20th century (fig. 0.16).

Enrolment in an empire-wide system of new schools rose from 7,000 in 1902 to almost 3 million in 1912; roughly 60,000 more attended Protestant missionary schools.[29] Arguably, the New Policies' most iconoclastic educational act came in 1905 with the abrupt abolishment of the centuries-old civil service examinations, focused on orthodox classical texts, and their replacement by a curriculum of politics, technology, geography and national and international history based on Western knowledge. A domestic textbook industry – originating with missionaries and translations from Japan – boomed. The teaching of history and geography played a key socialising, politicising role, furnishing citizens of the Qing with a unified sense of a deep past, in which convictions about the historical and geographical dominance of a Han majority, and not a Manchu elite, were becoming steadily stronger. A new national flag reinforced this sense of community cohesion.

A key battleground was the choice of language for instruction. In the last years of the Qing, Chinese was identified for the first time as the 'national language' (國語), a term previously used to identify the Manchu language. Influenced by the propagation of a standard English and German vernacular in those respective

0.15

One of the last stamps of imperial China

The modern version of China's postal service has its origins in the system developed in the 1860s by Robert Hart, the first Inspector-General of the Imperial Maritime Customs Service, to convey consular mail between treaty ports. Between the 1870s and 1890s, this evolved into a public Imperial Postal Service. Its emergence illustrates the Qing's absorption of international communications systems in the final decades of the 19th century, and also the growth of mechanisms for integrating the empire, which partly drove the rise of a more cohesive national consciousness towards the end of the dynasty. This three-cent blue-green stamp of 1910, in English and Chinese, featured a coiling dragon, symbol of the emperor.

1910, China. Printing ink on paper. H. 2.4 cm, W. 2 cm. The British Library, London, Murray Collection Vol 1 f058r

national education systems during the 19th century, reformers wanted to replace the classical language with a more accessible version that was gaining prestige and potency through a growing publishing sector. The vernacular had a political edge too, as the preferred language for Chinese nationalists and revolutionaries in the 1900s in both public speaking and writing. Several of the radical intellectuals who would become celebrities in the May Fourth 'enlightenment' era (c. 1915–25) cut their teeth in new press start-ups in the last decade of the Qing, including Cai Yuanpai 蔡元培 (1868–1940), Chen Duxiu 陳獨秀 (1879–1942), Lu Xun 魯迅 (1881–1936) and Hu Shi 胡適 (1891–1962).[30] The post-Boxer national education system taught modern knowledge that made many impatient with the traditions of dynastic rule. The new schools were meant to teach two kinds of loyalty: to the nation and to the Qing emperor; but by the 1910s, ever greater numbers of their graduates decided to dispense with the latter.

The New Policies aimed to strengthen the government's control over the country's resources, for the purposes of total mobilisation. To that end, the court was willing to consider political and military transformation. In 1907, it founded a Commission to Study Constitutional Government, and delegations travelled to Japan, the United States and Europe to research foreign political systems. Representative assemblies – local, provincial and even national – were planned. The army was overhauled. The malfunctioning banner and Green Standard forces were replaced with a business-like, modern New Army: disciplined, ideologically cohesive, well-armed and well-paid. The officer corps was professionalised, through attendance at new military academies, and

given elite status. Taking a military education seemed the way of the future, while studying for the Confucian curriculum was likened to 'sitting at home like a rotting log'.[31] In the hope of increasing provincial support for the centre, the state tolerated a growth in the social institutions of civil society: local societies sprang up for the prohibition of opium, for the abolition of foot-binding, and for women's rights.

For those able to access government funding or pay their own way, Japan was the first choice for a prestigious, overseas education. By 1905, up to 9,000 were studying in the country.[32] There, they were not just schooled in technical knowledge – medicine, engineering, chemistry – but also in radical political ideas such as revolution, anarchism, nihilism and terrorism. When students radicalised by their experiences in Japan returned to China – a minority among the Qing student population as a whole – they spread their ideas to their contemporaries (fig. 0.17). In Japan, students could attend lectures given by exiled Chinese reformers such as Liang Qichao or read newspapers and magazines published by self-proclaimed revolutionaries.

The breakdown of old certainties that accelerated in the 1890s produced not only reformers but also out-and-out revolutionaries: men devoted to overthrowing the entire imperial system. Most prominent of these was a Cantonese Hakka man (the same ethnic group to which Hong Xiuquan had belonged) later called Sun Yat-sen. Educated in Hong Kong and Hawaii, in 1895 he founded a secret revolutionary cell, the 'Revive China Society', dedicated to overthrowing the Manchus. After his first planned uprising in 1895 failed disastrously, he fled China under sentence of death and began a career as a professional itinerant revolutionary,

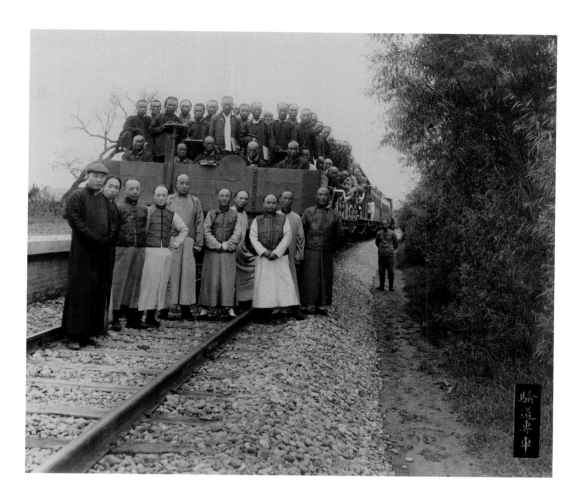

0.16

Completion of the Beijing–Zhangjiakou Railway
While the expansion of modern infrastructure unified late Qing China, and facilitated greater economic integration (the completion of the line to Inner Mongolia is recorded in this photograph), it also enabled anti-Qing nationalism to coalesce and mobilise. Conflict over ownership of and investment in the railways drove regional protests in 1911 that merged with the revolutionary uprisings of that autumn.

1909. Photograph. H. 20.5 cm, W. 26.5 cm. National Library of China, Beijing

developing his vision of a republican, nationalist state that would in later decades help win him a place in modern Chinese history as 'father of the nation'. Over the course of the next sixteen years, Sun moved readily between countries (Britain, France, Japan, the United States) and social groups (bandits, pirates, monarchists, anarchists, foreign ministers, missionaries, overseas Chinese businessmen, American mercenaries), soliciting money and aid for his anti-Manchu revolution.

Female reformers – a few of whom studied in Japan also – contributed to the radical upsurge of the empire's final two decades. The first public Chinese feminists tended to be men, due to the prescriptions against women entering public life. Their arguments for greater female education and emancipation were often nationalistically patriarchal: only 'enlightened mothers and wise wives' would nurture strong, patriotic sons. If women were physically and intellectually maimed (through foot-binding and exclusion from education), how could they produce and sacrifice for the nation?

Female activists seized this opening in order to take part in new study groups and political organisations, to found girls' schools and dozens of 'women's magazines' (女報) in China and Japan, and to popularise ideas such as economic independence, free love and gender equality. One of the most extraordinary examples was Qiu Jin 秋瑾 (1875–1907), a southeastern feminist who preferred archery to embroidery. She abandoned an arranged marriage to study in Japan, where she experimented with multiple identities: cross-dressing as a Chinese scholar-official, as a suit-wearing Western man, or as a sword-carrying Japanese samurai. Qiu paid the ultimate price for her activism: in 1907, she was beheaded by the Qing for her involvement in a conspiracy to assassinate a high-ranking official. But other educated women of the late Qing survived to take public roles in the post-1911 republic, such as the suffragist Tang Qunying 唐群英 (1871–1935), the journalist Lin Zongsu 林宗素 (1878–1944) and the educationalist Zhang Mojun 張默君 (1884–1965). In the fighting that erupted at the time of

the 1911 Revolution, seasoned female activists physically fought for the republic; and when the post-imperial regime broke its promise to give women the vote, an enraged veteran revolutionary stormed the republican congress and struck the double-crossing politician in question hard on the head with her fan.[33] Without the mobilisation that had taken place in the last two decades of the Qing, this assertive political feminism would be impossible to imagine.

The end of the Qing

The Qing's efforts at reform and modernisation thus contained the seeds of the dynasty's destruction. Discontent with the government was building through the early 1900s. One focus was anti-imperialism, a cause that increasingly entered the vocabularies and

0.17

Chinese and Japanese students at the Sendai Medical School

This 1906 photograph shows, on the far left, Zhou Shuren 周樹人 (1881–1936, the future 'father of modern Chinese literature' Lu Xun) during his time studying at a Japanese medical school in rural Sendai. Zhou is often celebrated as a cultural pioneer of the republican period; the formative nature of his experiences in the final years of the Qing is sometimes sidelined. After receiving a Western-style education at a Nanjing naval academy, Zhou – like many ambitious and patriotic young men of his generation – left to study science in Japan. There, he had a radical political awakening about the intellectual paralysis and malaise of Qing China, and resolved to transform and modernise Chinese culture.

1906, Sendai, Japan. Printed photograph

the activities of Chinese people: through dramas, in public demonstrations, in newspapers, pamphlets, songs, and via boycotts of foreign goods. Although much of this emotion was directed at the behaviour of the Great Powers in China, it was also often diverted into dissatisfaction with the ruling house: into a sense that the alien Qing were treacherously selling China's national interests out to foreigners. The logic of nation-building at the end of the 19th century gave a far more active political role to Han Chinese in the empire. In some ways, this was the culmination of institutional developments that began a hundred years earlier. Increasingly trusted by the imperial centre to carry out high-stakes missions in combating the opium trade, raising armies against massive internal rebellions, and promoting industrialisation, Han Chinese provincial officials grew in confidence throughout the 19th century. The sheer volume of post-Taiping reconstruction, especially in southeast China, energised local (Han) powerholders (including newly enriched merchants, some with international trading empires) to drive and manage local projects, rebuilding agriculture, irrigation and schools. All this successful, hands-on experience began to convince such elites that they were just as competent at national and international governance as the beleaguered Qing administration, if not more so. Pro-Han, anti-Manchu sentiment – always latent in the Qing empire – had been stoked by the Taiping war and resurfaced in the dynasty's last twelve years. Many radicalised Han students were motivated by a virulent hatred. 'Kill! Kill! Kill!' proclaimed a future revolutionary martyr in 1903. 'If the Manchus help the foreigners kill us, then first kill all the Manchus.'[34] The Qing were no longer the fearsome custodians of the empire but racially 'other' and enslavers of questionable competence.

The Qing's modernisation of communications at the turn of the century (including railways, postal services and telegraph lines) and relative permissiveness towards civil society enabled nationalist passions to coalesce and mobilise. Overseas communities and educational opportunities gave student revolutionaries the freedom to conspire. The modernisation of the military was yet another double-edged sword. On the one hand, the new armies enhanced dynastic power; but on the other, the reforms created new breeds of ambitious, modernised men to whom imperial tradition

seemed increasingly pointless. Once the Qing's reforms began, it was hard to know where to draw the line – to decide which parts of the dynastic past should be kept while others were discarded. The Qing also contended with a more basic logistical problem. Reforms were expensive and the government was bankrupt; the money had to be squeezed – through raised taxes – out of resentful provinces.

A change in revolutionary strategy helped transform a generalised sense of disaffected impatience into a formal revolt against the Qing. In around 1908, revolutionary organisations began infiltrating the new, modernised army: their aim, to turn the loyalty of China's military elite to the anti-Manchu cause. But chance and error played a greater role in the outbreak of the 1911 Revolution. Anti-Qing feeling was intensified in 1911 by the formation of a cabinet dominated by panicked Manchu aristocrats, ruling the country on behalf of the toddler Xuantong emperor enthroned in 1908. Rightly or wrongly, Han elites assumed that this government would be ruled by narrow, non-Chinese interests, and the government became a target for Chinese nationalism. Also that year, the cabinet revealed that the railways would be nationalised, but using foreign loans. This decision alienated a broad variety of political constituencies: it seemed not only unpatriotic but also insufferably autocratic. Local elites who had invested in the railways lost out financially as well, since they were insufficiently compensated by the centre. Anger was particularly intense in Sichuan, in west China, where a full-scale riot kicked off. Bad weather spread discontent further: crop failures due to heavy rain meant that by early 1911, perhaps 3 million people were at risk of starvation.

Finally, on 9 October 1911, a group of New Army revolutionaries making bombs in Hankou, a major city in central China, accidentally detonated one of their explosives. As the Qing set to hunting down the conspirators, the revolutionary ring decided to act quickly before they were arrested and executed. After a day of mutiny in nearby barracks, the forces loyal to the Qing were defeated, and the revolt spread chaotically through army headquarters up and down the country. Manchus were massacred in their garrisons in a brief but intense outbreak of racial hatred. In one hospital in Hankou, for example, wounded revolutionary soldiers allegedly strangled Manchus in neighbouring beds.

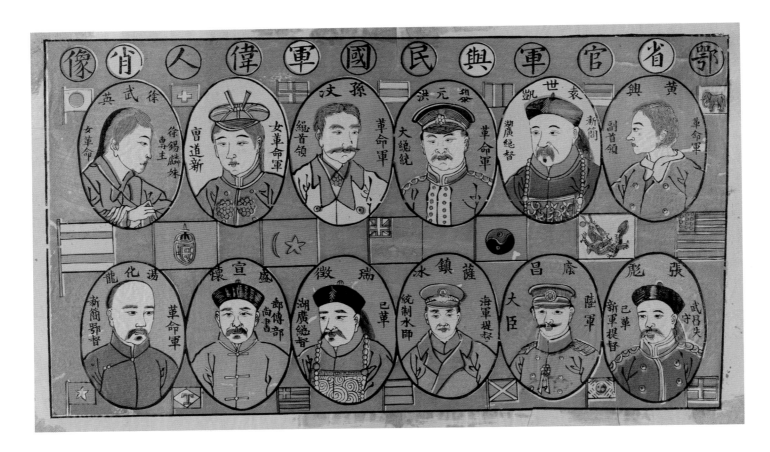

0.18

Key protagonists of the Hubei Governmental and Republican Armies (鄂省官軍與民國軍偉人肖像)

As revolutionary mutinies spread throughout China in the autumn and winter of 1911, Shanghai's popular print publishers created cheap woodblock illustrations to inform citizens about political and military events, and major personalities in the revolution. This late-1911 print includes depictions of: (top row, right to left) Huang Xing 黃興 (1874–1916), Yuan Shikai 袁世凱 (1859–1916), Li Yuanhong 黎元洪 (1864–1928), Sun Yat-sen 孫逸仙 (Sun Wen 孫文) (1866–1925), Cao Daoxin 曹道新 (n.d.) and Xu Wuying 徐武英 (n.d.); (bottom row, right to left) Zhang Biao 張彪 (1860–1927), Yinchang 廕昌 (1859–1928), Sa Zhenbing 薩鎮冰 (1859–1952), Ruicheng 瑞澂 (1863–1915), Sheng Xuanhuai 盛宣懷 (1844–1916) and Tang Hualong 湯化龍 (1874–1918). The inclusion of women is notable, signalling the ways in which female participation in radical politics emerged in the final decade of the Qing.

1911, China. Ink and colours on paper. H. 32 cm, W. 56.5 cm (sheet). Princeton East Asian Library, New Jersey, .191

A political vacuum lay at the heart of this sudden, unplanned civil war. To begin with, it lacked even a leader. Eventually, the highest-ranking officer in Hankou was forced – on pain of death – to take charge of the rebellion. Sun Yat-sen, the self-proclaimed leader of the revolutionary movement, was abroad in the United States, negotiating an anti-Qing conspiracy with an American adventurer called Homer Lea (1876–1912). Sun read about the events of 9 October in a newspaper while breakfasting at the foot of the Rocky Mountains. He did not return to China until 1 January, when he was inaugurated as the first president of the republic. But by this point, a leading figure in the old Qing military machine and favourite of the late Cixi – a Chinese general called Yuan Shikai 袁世凱 (1859–1916), who controlled the army garrisons centred on Beijing – had artfully inserted himself as chief intermediary between the revolutionaries and the dynasty, eventually forcing the abdication of the last, child emperor on 12 February 1912 (fig. 0.18).

The conflicts and defeats that scarred the Qing's last 116 years, together with the aftermath of the 1911 Revolution that ended the dynasty (decades of political instability and administrative fragmentation), have arguably diminished appreciation of the extraordinary transformations that China underwent between 1796 and 1912. These same challenges stimulated a striking flexibility and hybridity in art, literature and everyday life that creatively fused the local and the foreign, the aesthetic and the commercial, the elite and the popular. A female ruler, Cixi, came to direct a male-dominated court. Education opened itself to texts and ideas translated from the West. New interest groups – bankers, merchants and industrialists – grew rich, influential and often generously philanthropic. Entrepreneurs steeped in China's cultural history embraced new, Western and Japanese ways of organising the world, to achieve a dazzling cosmopolitanism. Many of the experiences and outcomes of China's 'long 19th century' have defined the country's preoccupations since: how to combine the values of the deep Chinese past with the powerful technologies, polities and cultures of rival states; how to design a legitimate, constitutional state able to draw on the country's resources to respond to domestic and international threats; and how to bridge tensions between nationalism and ethnic diversity, between centre and provinces, and between women and patriarchal norms. For much of this period, China's destination was in doubt, but the journey that it undertook was remarkable.[35]

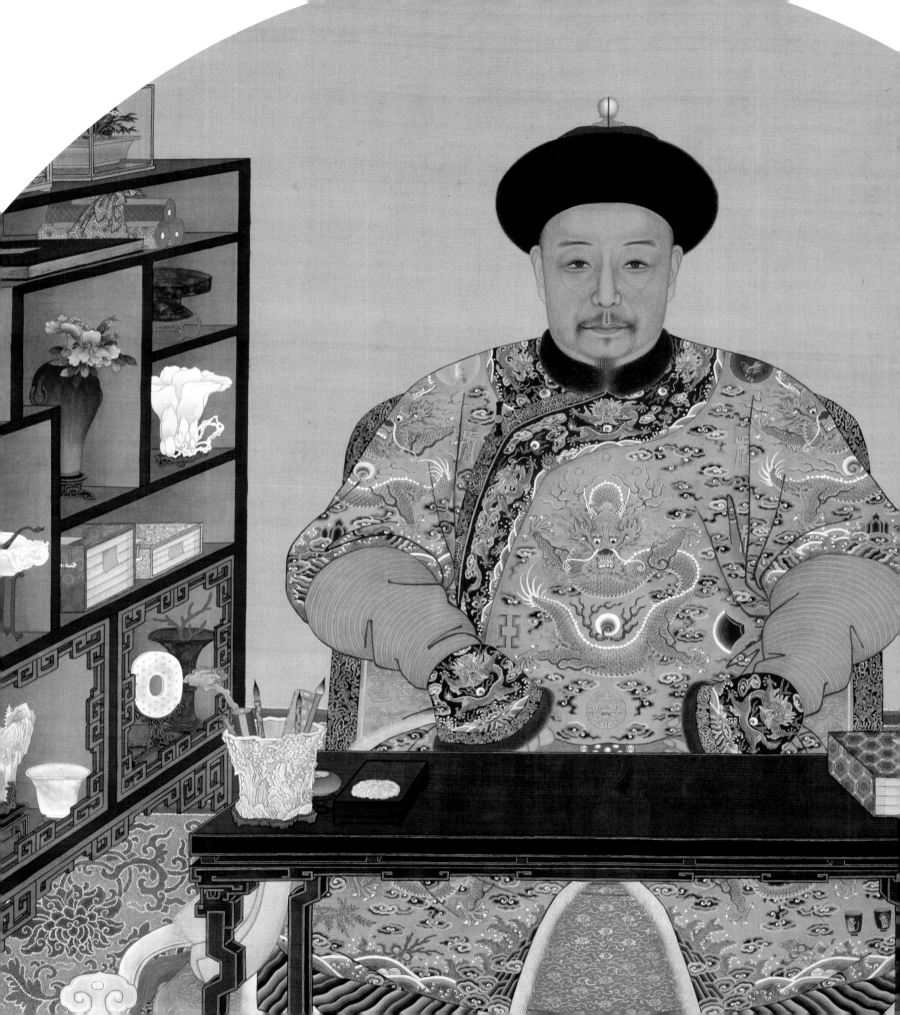

Chapter 1

The court

Mei Mei Rado

When the Qianlong emperor abdicated the throne in 1795 in his sixtieth year of reign, the Qing empire was the largest, wealthiest and most populous political entity in the world. Its vast territory extended from the Pacific Ocean coastlines in the east to the Zunghar Khanate and Tarim Basin of Inner Asia in the west, and from the Russian borders in the north to the Himalayas in the south (fig. 1.1). Although the Qing government ceded large areas to Russia and lost Taiwan to Japan in the 19th century, by the end of the dynasty in 1912, the empire still occupied a land of approximately 11 million square kilometres,

1.1
All-under-heaven complete map of the everlasting unified Qing empire
(大清萬年一統地理全圖)
Artists made this detailed map using a traditional Chinese rubbing technique; the white areas show the colour of the paper where there is no blue ink. The depiction of states is not to scale but represents their relative importance to the Qing emperors. Europe is just visible in the margins. Originally, the eight sections were mounted onto a screen or wall. Names of the countries include 'the land of the great western sea' (Portugal), 'the homeland of Islam' (the Middle East) and 'the land of red beards' (Holland).

c. 1800 (based on a map of 1767), Beijing. Ink on paper. H. 123 cm, W. 231.6 cm. The British Library, London, 1540.b.14 ff1–8

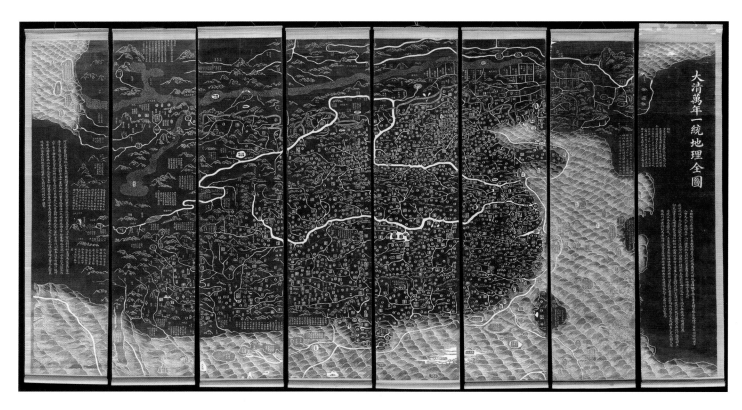

1.2
**Detail of Manchu and Chinese
imperial scroll conferring titles**
(候選員外郎加二級李立德之本生父母)
The Jiaqing emperor records in this bilingual
scroll that the parents of the meritorious official
Li Lide 李立德 are elevated to the second degree
of official rank and awarded posthumous titles.
The scroll bears Manchu and Chinese imperial
seals. Little changed in the design of such official
documents over the 1800s. The Manchu reads
from the left, the Chinese from the right.

Dated 20 January 1806, Beijing. Coloured ink
on paper-backed silk, wood. H. 31.9 cm,
W. 362.1 cm. The British Library, London,
Or 4574 f006r

inhabited by some 450 million people. Manchus, the conquest elite, held the Qing throne. Conceiving of themselves as universal rulers, the Qing monarchs governed a multi-ethnic empire, comprising Manchus, Han Chinese, Tibetans, Uyghur Muslims, Mongols and indigenous groups in frontiers and inlands.

The Qing imperial administrations and belief systems reflected the empire's cultural, linguistic and religious pluralities. The court composed documents in both Manchu and Chinese languages, which were often not duplicates of one another (fig. 1.2).[1] The multilingual imperial dictionaries – in Manchu, Mongolian, Tibetan, Chinese and Eastern Turki (spoken in the Uyghur regions) – functioned as practical references for learning and celebrated Qing cultural inclusiveness and widespread literacy (fig. 1.3).[2] In the Qing court's belief systems and rituals, Confucianism, shamanism, Tibetan Buddhism, Daoism and popular beliefs coexisted, each lending the Qing monarch an indispensable mechanism for demonstrating legitimacy, while offering him a unique set of cultural vocabularies to engage with different ethnic groups.

The Qing imperial domains encompassed multiple locations inside and outside the capital Beijing. The Forbidden City (紫禁城), at the very core of Beijing, served as the emperor's residence and central place

1.3
**The imperially commissioned
*Pentaglot Dictionary***
(御製五體清文鑑)
This dictionary is printed in Manchu,
Chinese, Tibetan, Mongolian and
vernacular Chagatai or Eastern Turki
(spoken in the Uyghur regions).
Manchu, based on a script used to
write Mongolian, was written down
as part of state-building policy in
northeast Asia in the early 1600s.
It remained the official state
language for over 250 years.
Manchu–Chinese dictionaries
have many words with no exact
equivalences. These pages show
food names: from left to right,
grape-coloured puff pastry, red
puff pastry, goji berry with milk and
sugar wrap, grape sugar wrap,
white sugar wrap and sesame oil.

1794, Beijing. Ink on paper, with
imperial yellow silk covering.
H. 40.9 cm, W. 24.2 cm (page).
The British Library, London,
Or. 8147 ff2453v–2454r

for state affairs. It consisted of the 'outer' and 'inner' courts. The emperor's throne hall, ceremonial hall dedicated to agriculture, and audience hall constituted the 'outer court', which occupied the southeast corner of the Forbidden City. The rest of the palace was the walled 'inner court', restricted to the imperial family, servants and a small number of high officials and princes. The emperor also conducted daily business in his studios in the 'inner court' (fig. 1.4).[3] Two important

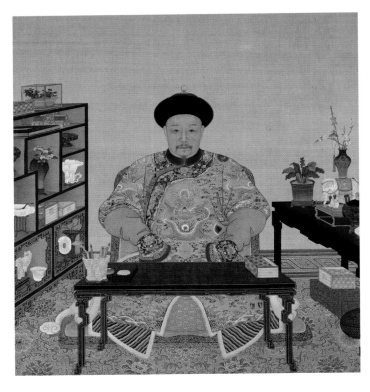

1.4

Unidentified court artist, *The Jiaqing emperor in his study* (清人畫顒琰吉服像軸)

In this court-commissioned image, we see the emperor wearing a robe (吉服, *jifu*) that was more informal than the court robe worn for the most important official occasions (朝服, *chaofu*). The fur trimming and 'horse-hoof' (rounded, extending) cuffs of the robe are typical of the early 19th century. Jiaqing's reign was later looked back on as a 'golden age', but it suffered revolts such as the White Lotus Rebellion, widespread corruption, tension in frontier areas of the empire, the decline of the bannermen armies and reliance on local officials, which lessened the power of the court.

c. 1820, Beijing. Ink and colours on silk. H. 224 cm, W. 174 cm (mounted). Palace Museum, Beijing, Gu.00006529

altars for Confucian state rituals stood in the south of the Forbidden City – the Temple of the Ancestors (太廟) and the Altar of Land and Grain (社稷壇). The Imperial City also included three lake palaces and several Buddhist temples.[4] Immediately surrounding the Forbidden City was the Imperial City (皇城), where the Imperial Household Department was located.

The three emperors of the high Qing – Kangxi, Yongzheng and Qianlong – constructed several scenic imperial villas in a sprawl of land on the northwest outskirts of Beijing. In historical documents written in European languages, this complex was often referred to as the Summer Palace. The Franco-British allied force looted and burned down these villas in 1860 during the Second Opium War (see p. 20). From the mid-1880s to 1895, the Empress Dowager Cixi rebuilt a villa, the Garden of Nurtured Harmony (頤和園) (fig. 1.5).[5] The structure of the Forbidden City largely remained intact during the 19th century, except for a project in 1859 that reconfigured the Palace of the Initial Auspice (啟祥宮) and the Palace of Eternal Spring (長春宮) into one compound.[6] After the Qing dynasty ended in 1912, the deposed emperor, Xuantong, continued to live in the Forbidden City, maintained a small court, and held his imperial wedding there in 1922. In 1924, the warlord Feng Yuxiang 馮玉祥 (1882–1948) evicted this pared-down court, and in 1925 turned the Forbidden City into a public Palace Museum.

The Qing rulers valued archery and hunting skills as essential parts of the Manchu ethnic heritage and the key to their superior military power. Kangxi established Rehe (today's Chengde) and the adjacent forest of Mulan, 230 kilometres northeast of Beijing and outside the Great Wall, as the imperial hunting resort (fig. 1.6). In the high Qing period, the annual imperial autumn hunt there provided an important occasion for Manchu emperors to strengthen ties with Mongol, Tibetan and other Central Asian leaders. During the 19th century, Jiaqing was the only emperor to organise the autumn hunts, and he died during the trip in 1820.[7] The Daoguang emperor abolished the autumn hunt event in 1824,[8] but the Rehe villa continued to be used by the imperial family as a summer retreat. In the autumn of 1860, the Xianfeng emperor and his court fled there during the Franco-British invasion of Beijing.[9]

The core of Qing state institutions consisted of the Six Boards under the Grand Secretariat: Revenue,

Personnel, War, Justice, Public Works and Rites. The Board of Rites was the most powerful, overseeing not only imperial sacrifices, etiquettes and protocols entailed by Confucian doctrines, but also the civil service examination system and matters relating to education and public morality. In addition, the so-called tribute system – which governed Qing diplomatic relations with vassal states and some other countries – fell under the jurisdiction of the Board of Rites.[10]

An administrative bureau particularly important to court life and culture was the Imperial Household Department, the emperor's private agency staffed with bondservants (包衣) – the servile population at the lower end of the hierarchy within the upper three banners of the Manchu banner system. The Department maintained a wide range of responsibilities: the emperor's personal service, the imperial family's daily activities and expenses, the buildings of the imperial residences, the Imperial Workshops at the court and in regional establishments, the Customs Service, the salt administration, and so forth.[11] The Department's highly organised systems and efficient operations of myriad tasks have led scholars to view it as both the 'brain' and 'hand' of the Qing 'palace machine'.[12]

The Qing Imperial Workshops (造辦處) under the Imperial Household Department oversaw the production of paintings, material objects and furnishings for the court.[13] The Workshops had two major functions. Firstly, they maintained specialised studios and manufactories located in the palaces or the Imperial City, responsible for a wide range of works in various media and techniques, such as clockwork, glassmaking, enamelling, mounting paintings, and creating embroideries and accessories. The Imperial Painting Academy (如意館) not only produced all kinds of paintings commissioned by the monarchs, but also provided design underdrawings for various types of objects. In 1758, the Qianlong emperor consolidated the forty-two workshops at court into fifteen branches.[14] Bondservants of different ranks of lineage served as supervisors, keepers or foremen in the Imperial Workshops, which employed hundreds of artists and artisans, including eunuchs and those recruited from Manchu, Chinese, Uyghur, Tibetan and European communities.[15] European missionaries played a prominent role in Qing court arts and crafts during the 18th century, but the Daoguang emperor expelled those few who remained in 1827 and demolished their churches.[16]

Secondly, the Imperial Workshops coordinated the emperor's orders that were to be made in specialised regional imperial manufactories, for example, silk textiles in Jiangnan (the areas to the south of the lower reaches of the Yangzi river) and porcelains in

1.5
Carpet of the Garden of Nurtured Harmony (頤和園) or New Summer Palace
The Garden of Nurtured Harmony was a favourite haunt of the Empress Dowager Cixi. In its construction, Cixi paid attention to Daoist ideas in the landscaping (*fengshui*) but also built private Mongol-Buddhist spaces. It was designed around gardens created by the Qianlong emperor, the Garden of Clear Ripples (清漪園), which in turn were modelled on the landscape of Hangzhou. Cixi had the garden restored to celebrate her 60th birthday in 1894. Although the complex was badly damaged during the Boxer War of 1899, many features, including a 728-m painted walkway along the edge of Kunming Lake, are still enjoyed by visitors today.

1875–1908, Beijing. Wool and cotton with ink and dye. H. 900 cm, W. 1150 cm. Palace Museum, Beijing, Gu.00212354

Jingdezhen. From the late 18th century onwards, the Imperial Workshops had become less active compared to the heyday of the Yongzheng and Qianlong reigns, a tendency reflecting the weakened economy and greater political instability. The Daoguang emperor dismissed a large number of artisans, especially southern Chinese, as part of his measures to reduce expenses.[17] The situation worsened in the 1850s and 1860s when the Taiping Civil War largely destroyed manufacturing centres in Jiangnan and Jingdezhen, resulting in damaged facilities and a lack of skilled personnel. Beginning in the late 1860s, however, the Imperial Workshops and manufactories saw a revival under Cixi's patronage.

Six emperors reigned in the 'long 19th century' of the Qing dynasty – Jiaqing (r. 1796–1820), Daoguang (r. 1821–1850), Xianfeng (r. 1851–1861), Tongzhi (r. 1862–1874), Guangxu (r. 1875–1908) and Xuantong (r. 1909–1912) – but the most powerful sovereign was undoubtedly the Empress Dowager Cixi, who was the de facto ruler at the court from 1861 until her death in 1908.[18] This eventful century was marked by recurrent and entangled themes of crisis, reformation and revival. Facing a succession of domestic insurrections and foreign assaults, the Qing court manifested financial and military vulnerability but at the same time showed extraordinary resilience as a centre of imperial governance.

Enormous crises dominated the Jiaqing and Daoguang periods, but alarming signs of domestic political dysfunction and international conflict had already emerged in the late 18th century. Jiaqing fully assumed authority only after Qianlong's passing in 1799. He immediately carried out the difficult task of arresting and executing Heshen, the deeply corrupt official on whom Qianlong had come to rely. However, Jiaqing was unable to purge the large bureaucratic network of Heshen's cronies. Meanwhile, the White Lotus Rebellion (1796–1804) in northern China initiated a century-long series of internal uprisings

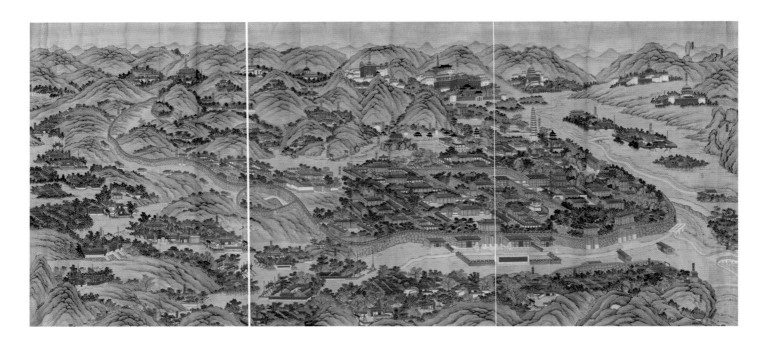

1.6
Panoramic view of the Rehe Imperial Palace (熱河行宮全圖)
Rehe was a retreat for the emperor, where he could hunt and escape the heat of Beijing. This Versailles-like complex was completed in 1790. Today, it is a UNESCO World Heritage Site and covers an area of 5,640,000 sq m, making it the largest royal garden in China. On this scroll, each of the buildings and their individual features are labelled, and they incorporate architectural styles from all over the empire, including a mini Tibetan Potala Palace. For security reasons, a large garrison was maintained permanently in nearby Chengde. In the 1700s, the penalty for being caught armed in the imperial hunting grounds near Rehe was perpetual exile, but in the 1800s it was, according to historian Jonathan Schlesinger, 'always half-full of poachers and wood cutters', and corrupt gamekeepers, who were supposed to keep thieves out, simply took their share of the booty.

1909, Beijing. Coloured ink on paper. H. 119 cm, W. 246 cm. Library of Congress, Washington, D.C., G7824.C517A3 1900.G8

that undermined Qing command; suppressing it devastated government and court finances.[19] Sinking into the economic depression caused by the opium trade, the Daoguang reign was marked by pragmatism and frugality. The emperor streamlined the palace personnel and suspended programmes and productions that were considered extravagant. The difficulties were exacerbated by the Qing defeat in the First Opium War (1839–42) against Britain and the commencement of a series of unequal treaties between the Qing state and foreign powers throughout the remainder of the 19th century, which involved increasingly exorbitant indemnity payments and concessions of treaty ports. As historians have observed, both Jiaqing and Daoguang were dutiful and capable emperors, and they both attempted reforms, but their indecisiveness at key moments and the overwhelming crises rendered some situations beyond their control.[20]

Xianfeng was arguably the weakest ruler in Qing history in terms both of physical constitution and political will. His reign was threatened by the destructive Taiping Civil War (1851–64), the Nian Rebellion (捻亂) (1851–68) in northern China, and the Second Opium War (1856–60), which ended with the siege of Beijing by British and French troops in the autumn of 1860. Xianfeng sought refuge in Rehe and left his brother Yixin, Prince Gong, in the capital to negotiate with Western invaders. On his deathbed in Rehe in 1861, Xianfeng named his five-year-old son, Zaichun 載淳 (the future Tongzhi emperor), as successor. Through a complicated coup, Xianfeng's empress Ci'an 慈安 (1837–1881) and consort Cixi assumed the regency as empress dowagers, in collaboration with Prince Gong. Born to a Manchu noble clan as Yehonala 葉赫那拉, Cixi entered the court in 1853 as a lower-rank consort of Xianfeng. Her status rose after giving birth to Xianfeng's only son and heir. Although the Tongzhi reign began with crises that seriously challenged the survival of the Qing empire, it segued into surprising prosperity by the late 1860s, which led contemporary Qing literati to proclaim it a 'restoration' (中興, literally, 'renaissance after depression').[21] The new trends of this era included further reciprocal diplomatic exchanges and increasing commerce between Qing and the West, a wave of learning Western science and technology, and the 'Self-Strengthening' movement of industrial and military reforms.[22]

In her regency, Cixi overpowered the young emperor Tongzhi, who died of smallpox in 1874 at nineteen years old by Chinese reckoning, leaving no heir. Through her political manoeuvres, Cixi gradually alienated Prince Gong and shifted her favour to Yihuan 奕譞, Prince Chun 醇親王 (1840–1891), whose four-year-old son she selected as the new Guangxu emperor.[23] After Ci'an's passing in 1881, Cixi became the sole regent, eventually wielding absolute authority at court. When Guangxu reached adulthood in 1889, Cixi claimed retirement but in reality still held significant power. In the last quarter century of Qing rule, the aggression of Western imperialism in China intensified, and the inadequacy of the 'Self-Strengthening' movement also became clear following successive defeats by foreign powers. The crises culminated in the 1895 victory over the Qing by Japan, a newly modernised country building its own empire in East Asia.[24] In search of ways to save the Qing empire, Guangxu in 1898 led the 'Hundred Days' Reforms', a movement proposed by Chinese intellectuals to radically Westernise the country's juridical, bureaucratic and educational systems. Afraid it would undermine the dynasty's and her own power, Cixi quashed and revoked the reforms, and punished the emperor and his comrades.[25]

The year 1900 saw a peak in rioting by the nativist organisation, the Righteous and Harmonious Fists (義和拳), also known as the Boxers (see p. 284). Cixi's miscalculated decision to support the Boxers' attacks on foreigners and Chinese Christians gave the Eight-Allied Nations (Austro-Hungary, the British empire, France, Germany, Italy, Japan, Russia and the United States) an excuse to invade Beijing.[26] The Qing court fled to Xi'an and did not return to the capital until early 1902. While still in exile, Cixi's political attitude changed dramatically. In 1901, she inaugurated a reform known as 'New Policies', promoting measures similar to those she had opposed in 1898: to modernise bureaucracy, law, foreign affairs, economy, industry, public education and the military.[27] In the early 20th century, Cixi also presented herself as a modern sovereign through painted and photographic portraits intended for a wide public audience. As historian Evelyn S. Rawski points out, Cixi's swings in political stances and policies reveal that 'she was a pragmatic ruler and not a conservative ideologue'.[28] While the

New Policies reforms eventually failed to resuscitate the Qing empire, their impact on education, culture and society extended beyond the Qing dynasty and continued to shape the Republican period (1912–49). Guangxu and Cixi died within two days of each other in November 1908. Guangxu's nephew Puyi, a two-year-old boy chosen by Cixi as heir, ascended to the throne in the following month. On 12 February 1912, he officially abdicated under the pressure of the Xinhai Revolution 辛亥革命 (10 October 1911– 12 February 1912) which led to the establishment of the Republican government in Nanjing on 1 January 1912, ending the Qing dynasty and China's two thousand years of imperial history.[29]

In addition to her profound influences on late Qing politics, Cixi played an instrumental role in revitalising court art and performance, which suffered some degree of stagnation in the first half of the 19th century. Cixi's directions and creativity blossomed especially from the 1870s onward, along with her rising supremacy at court. Her wide-ranging innovations encompassed portraiture, porcelain, architecture, interior decoration, textiles, dress and drama. Late Qing arts showed a tendency towards intensified exchanges between court and civilian culture, which was particularly salient in the decorative arts, fashion and theatre. The two-way traffic shaped aesthetic developments in both imperial and popular domains.

The palace could not function without its workforce, which comprised eunuchs, maids, craftsmen and other service personnel and labourers.[30] Many of these individuals were bondservants or bannermen. They were not permitted to work for Han Chinese commoners and thus formed an exclusive servile class for the Manchu court.[31] As castrated men, eunuchs held low social status but high power, existing as extensions of the imperial persons they served.[32] At court, they performed versatile tasks beyond looking after the imperial family and households. For instance, they served as dramatic actors and medical doctors as well as Buddhist and Daoist priests.[33] Palace maids were girls and women descended from the upper three bondservant banners. In the same annual draft system for qualified banner girls, those who were not selected as imperial consorts could be chosen as palace maids.[34] They entered the palace at the age of thirteen to fifteen and worked for a fixed term of five to ten years.[35]

Portraits of the imperial family

Unlike European royal images, which were displayed publicly and circulated widely through copies, prints and coins, formal and informal Qing imperial portraits were private and restricted, only accessible to the imperial family and a very small number of high officials on designated occasions. This taboo lasted until the twilight of the dynasty when the Empress Dowager Cixi broke it in 1903. The formal visages for documenting the imperial lineage had been primarily used during the sitter's lifetime and posthumously for the ritual purpose of ancestor worship. They followed a certain formulaic composition and style: the imperial sitter, always dressed in formal ceremonial attire (朝服 chaofu), posed statically in a throne or a grand chair with restricted expression, assuming a dignified presence like an icon.

By contrast, there were many varieties of informal likeness. The late Qing largely continued the themes and formats established in the 18th century, but new representational modes and visual styles developed over time. One unique format originated in the Kangxi period and represented the emperor in seated frontal view in an alcove space reading, writing or painting, flanked by shelves or tables rendered in pronounced linear perspective.[36] Starting from the Yongzheng reign, every emperor in this composition consistently wore a winter festive dragon robe (吉服 jifu), indicated by the fur-trimmed collar and cuffs. Jiaqing's portrait, in particular, depicts an interior populated by books, antiques, auspicious objects and early spring flowers (see fig. 1.4). This series of portraits did not simply showcase the emperor's cultural achievements. Indeed, the images' invariable composition, semi-formality and visual markers of spring suggest their possible association with the New Year season, likely for a special ceremonial display.

The Daoguang emperor especially favoured another type of informal but stately representation established by his grandfather, the Qianlong emperor: the equestrian portrait of the monarch in monumental scale. This iconography took inspiration from European representations of monarchs, themselves derived from the statuary of Roman emperors, while also celebrating the Manchu martial power rooted in its tradition of riding and hunting. Qianlong's two portraits painted

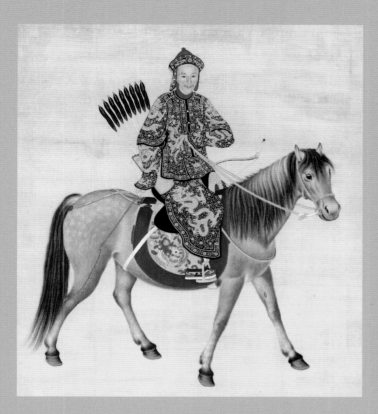

Key figure: Daoguang emperor (r. 1821–1850)

1.7
Unidentified court artist, Portrait of the Daoguang emperor in ceremonial armour riding a horse (清人畫旻寧戎裝像軸) (detail)
After the sudden death of the Jiaqing emperor, his adult son Daoguang inherited the throne in 1821 and ruled until 1850. International and domestic conflicts marred Daoguang's reign. This portrait shows the emperor on horseback, armed with a bow and arrows. He wears a jade thumb ring, which is a symbol of Manchu identity. The tradition of painting mounted rulers on horseback was European; equestrian portraits of Qing emperors are invariably compared to the now-famous painting of the Qianlong emperor by Castiglione.

c. 1825, Beijing. Ink and colours on paper. H. 281 cm, W. 172.5 cm; H. 370 cm, W. 209 cm (with mount). Palace Museum, Beijing, Gu.0006555

by the Italian missionary painter Giuseppe Castiglione, also known as Lang Shining 郎世寧 (1688–1766), were politically charged images completed for the occasions of Grand Military Reviews. Daoguang commissioned a number of large likenesses of himself astride a horse, each measuring 2.5 to 3 metres high. One of the earliest paintings, dated to around 1825, shows the emperor in a blue travelling outfit; several others, painted by the court artist Shen Zhenlin 沈振麟 (active 1821–1882) in the 1840s, depict him in both simple riding habit and full ceremonial armour (fig. 1.7).[37] Contending with aggravated economic decline and ominous threats from European expansionism, the ailing Daoguang, in his sixties, seemed to express a resolution through these images to restore the Qing imperial glory.

A large quantity of informal private imperial portraiture belonged to the genre conventionally known as 'pictures of merrymaking' (行樂圖), which represents sitters in a group or alone in leisure activities. A special genre depicting the imperial family gathering in a courtyard was already flourishing in the Qianlong period but, in the Daoguang reign,

it developed unprecedented refinement and a new visual mode characterised by realism and intimacy, only to fade away soon after. Paintings of this kind from the Qianlong reign were typically executed in a grand vertical format and predominantly focused on New Year celebrations, representing the emperor and young princes in Han Chinese garments but excluding imperial consorts and princesses (fig. 1.8).[38] As a fictional stereotype of 'ancient' style, the figures' clothing did not necessarily suggest Han ethnicity but imbued a sense of timelessness to the painting's message of spring renewal. By contrast, family portraits in the Daoguang period changed to the horizontal format and included lively vignettes of imperial women and both boys and girls around the emperor (fig. 1.9). All figures wore informal contemporary Manchu dress – a new way to depict imperial consorts. In earlier, high Qing 'pictures of merrymaking', the imperial family appeared only in imaginary Han Chinese costumes and occasionally in composite European ones. Free from the fictional tendency and loaded visual symbolism of Qianlong's image-making, Daoguang's family portraits

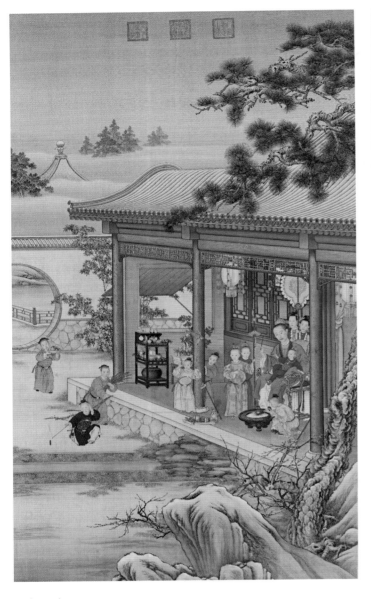

1.9
He Shikui 賀世魁 **(d. c. 1845),** *Fragrance of spring flowers: an imperial courtyard-garden scene* (御苑行樂圖)**, full view (above) and detail (below)**
The Daoguang emperor is depicted here in informal blue robes holding a jade snuff bottle and wearing an archer's thumb ring. He is the central character, on a marble-inlaid daybed, set on a verandah overlooking gardens and surrounded by his wives and children. The future Xianfeng emperor is shown in a brown robe in the foreground to the right. At this time, Qing emperors chose their primary wife and eight consorts of different ranks from among the Manchu and Mongol elite. The subtext of the image is that the emperor can afford to spend leisure time with the imperial family, has a secure succession and the dynasty is under control, all because he is diligent and attentive to his duties.

c. 1824–45, Beijing. Ink and colours on paper. H. 234.3 cm, W. 394.3 cm.
Private Asian Collection – Hong Kong

1.8 (above)
Unidentified court artist, *New Year painting of the Qianlong emperor at leisure with his family* (清人畫弘曆歲朝行樂圖像)
Informal, court-commissioned images of leisure activities within the palace have a long history in China. The Manchu imperial family are shown here in historical Han Chinese costumes. They have gathered around a brazier for warmth on a cold winter's day. The emperor is joined by his sons in colourful garments. The image is made using Western perspective and shading, while the colours are in the bright palette of grand court paintings.

1735–96, Beijing. Ink and colours on silk. H. 384 cm, W. 160.3 cm.
Palace Museum, Beijing, Gu6505

Unidentified court artist, *Portrait of the Tongzhi emperor as a Buddhist monk* (清人畫載淳僧裝像)

Tongzhi became emperor at the age of 5 and died at 19. He was the only surviving son of the Xianfeng emperor and Cixi. Empress Dowagers Cixi and Ci'an and Prince Gong ruled as regents early in his reign, but after Ci'an's death in 1881, Cixi emerged as the de facto ruler of Qing China. This image shows the teenage emperor in monastic robes holding a *ruyi* (auspicious sceptre). Beyond state-ordained ritual practices (such as sacrifices at the Temple of Heaven), individual court members had their own beliefs. These included shamanistic practices from their Manchu homelands as well as aspects of Buddhism and Daoism.

1862–74, Beijing. Ink and colours on silk.
H. 183.5 cm, W. 98 cm. Palace Museum, Beijing, Gu.00006612

1.10
Unidentified court artist, *Portrait of the Xianfeng emperor* (清人畫奕詝便裝行樂圖)

The young Xianfeng emperor (r. 1851–1861) succeeded to the throne at the age of 19 and had a short reign, dying at just 30. However, his long-lived consort, later the Empress Dowager Cixi, who entered the palace in 1853, ruled China from behind the throne for half a century after his death. She rose through the ranks of consort after the birth of her son (Xianfeng's only heir), who later became the Tongzhi emperor. In a tragically ironic symmetry, Xianfeng was born in the Summer Palace, the destruction of which by British and French troops hastened his demise. In this court painting, he is shown in a garden in informal robes holding a speckled feather fan and reaching for a snuff bottle, another symbol of Manchu identity.

1851–61, Beijing. Ink and colours on silk.
H. 167.1 cm, W. 80.5 cm. Palace Museum, Beijing, Gu.00006593

reveal quotidian life, celebrating natural and tender domesticity rare in Qing court painting.

Similar to ways in which literati-official elites chose to have themselves portrayed, the 19th-century 'pictures of merrymaking' often depicted the Qing emperor at leisure in a garden or engaged with cultural pursuits, such as a hanging scroll of Xianfeng in his twenties sitting by a lotus pond (fig. 1.10) and a painting of Guangxu writing in an elegant interior (fig. 1.11). In the latter, although the theme and setting are not new, the striking naturalism of the emperor's face reflected the novel aesthetic for visages inspired by photographic portraits. The methods for realistic facial depiction in Qing imperial portraits had changed over time. In the high Qing, Castiglione developed an eclectic Western technique by applying subtle highlights to parts of the face to create a sense of three-dimensionality, while minimising shadows that displeased Qianlong. In the 19th century, many court portraits used the widespread Chinese method originated by the late Ming painter Zeng Jing 曾鯨 (1564–1647), which built up physiognomic

Key figure: Guangxu emperor (r. 1875–1908)

1.11

Unidentified court artist,
Portrait of the Guangxu
emperor (清人畫載湉便服寫字像)
(detail)
When the Tongzhi emperor died, he
had no male heir, so Cixi's nephew
was declared the next emperor
with the reign name Guangxu. He
is described in Yu Deling's 裕德齡
(1881–1944) memoirs, *Two Years in
the Forbidden City*, as being rather
handsome, about 5 feet 7 inches
tall, and with nice teeth. In fact,
Guangxu only ruled independently
from 1889 to 1898. Encouraged
by radical thinkers such as Kang
Youwei, Guangxu instigated the
'Hundred Days' Reforms' after Qing
China's defeat in the Sino-Japanese
war (1894–5). However, he was
effectively under house arrest from
1898 onwards, as conservatives
regained power at court, supported
by Cixi. Together with Cixi, in
1900 he fled Boxer forces after
they entered the capital; he died
in 1908, aged 37, two days before
Cixi's death. A recent study of
the emperor's remains has shown
he died of arsenic poisoning.
Although there is no clear proof,
Cixi has always been the chief
murder suspect.

c. 1885–1908, Beijing. Ink and
colours on silk. H. 183.5 cm,
W. 95.5 cm. Palace Museum,
Beijing Gu.00006619

features through ink lines (fig. 1.12; see also figs 1.7 and
1.10). Guangxu's portrait employed a very different
technique – a full modelling with shading – to enhance
the verisimilitude of the image.

Another subgenre depicting Qing rulers in religious
garb, exemplified by an unusual portrait of the young
Tongzhi emperor meditating as a Buddhist monk
(fig. 1.12), reveals how emperors expressed different
faiths through costumed identities; perhaps in this case,
Tongzhi's choice of this iconography also suggested
his concern for health and longevity. Yongzheng first
initiated this genre, which developed greatly under
Qianlong and Empress Dowager Cixi's patronage.
In several aspects, Cixi significantly revived imperial
portraits, creating innovations in themes and
representational modes, breaking conventional gender
and visual boundaries, and embracing new media and
circulation channels. Like Qianlong, she fully explored
the political potential of portraiture for constructing
and celebrating her multiple identities as a female ruler,
while modernising this time-honoured visual tradition
for an expanding audience.

During the early years of Cixi's regency, in
portraits that appeared to be conventional 'pictures of
merrymaking', she strategically expanded the limited
visual codes associated with imperial women and
subtly asserted her political ambition. For example, she
incorporated masculine symbols such as the snuff bottle
and books, and had herself represented as a superior
rival of her son, Tongzhi, in a chess game.[39] As her
authority and power grew, Cixi posed in her portraits as
Guanyin 觀音 (Avalokiteśvara, the Buddhist bodhisattva
of mercy), a female deity widely worshipped in late
imperial China (figs 1.13–1.14). To an extent, Cixi's
Guanyin images echoed Qianlong's visual embodiment
as Mañjuśrī (the bodhisattva of compassion and
wisdom), a representation of himself as an incarnate
ruler. But the Empress Dowager did not simply aspire
to align herself with a patriarchal sovereign in this
image-making project. As art historian Yuhang Li
argues, the complexity of these staged paintings
(and her later photographic tableaux vivants) lay in
the undisguised theatrical tension in Cixi's religious
practice of turning herself into Guanyin, and in this
way Cixi highlighted her dual identities as female deity
and secular matriarch.[40]

In the early 20th century, Cixi engaged in a
revolutionary new project to modernise her portraits,

Key figure: Empress Dowager Cixi (1835–1908)

1.13

Unidentified court artist, *Portrait of Empress Dowager Cixi* (清人畫慈禧吉服像) (detail)
Xianfeng's consort, Cixi, was the de facto ruler of China from 1861 to 1908. She was a direct contemporary of Queen Victoria, and in this portrait, she is surrounded by a beautiful screen painted with bamboo. This setting promotes a sense of her femininity, but the yellow imperial robe that she is wearing is a potent emblem of male emperorship. Her crown, collar and the willow in the vase are all emblems of the bodhisattva of mercy, Guanyin, the Buddhist mother goddess. Cixi's reputation underwent a transformation after the 'Hundred Days' Reforms' in

1898. Before that coup, she was generally well-regarded within China, but afterwards she was often thought of as a power-hungry old woman.

1875–1908, Beijing. Ink and colours on paper. H. 130.5 cm, W. 67.5 cm. Palace Museum, Beijing, Gu.00006361

1.14

Unidentified court artist, *Cixi depicted as Guanyin in the Buddhist scripture* Heart Sutra (心經)
The *Heart Sutra* is the most frequently used and recited text in Mahayana Buddhism. Cixi personally wrote out the text for this edition. Sutra copying was a Buddhist way of accumulating merit. Such albums in Cixi's own hand were presented as personal gifts to officials. She had herself depicted as the bodhisattva of mercy, Guanyin – hearer of the cries of the world.

1904–05, Beijing. Ink and colours on paper, with brocade cover. H. 22.6 cm, W. 9.6 cm. Palace Museum, Beijing, Shu.00009216

turning to the media of photography and oil painting. Breaking the deep-seated taboo that restricted the public viewership of imperial visages, she now presented her portraits to an international audience. This sudden change of attitude and embrace of international decorum served to remedy her reputation as a xenophobic and conservative ruler, a negative image resulting from her support of the anti-foreign Boxer forces and her suppression of the Guangxu emperor's reforms. In 1903, she entrusted Yu Xunling 裕勛齡 (1874–1943), a Manchu noble who grew up in Europe and was a brother of her ladies-in-waiting Yu Deling 裕德齡 (1885–1948) and Yu Rongling 裕容齡 (1882–1973) (see fig. 1.77), to take her photograph for the first time, and within two years she had posed for more than thirty portraits, which were reproduced in about 600 prints (fig. 1.15; see fig. 1.78). Carefully staged, many of these scenes feature a composite iconography: Cixi's austere posture and the photographs' symmetrical composition recall the tradition of formal imperial imagery, whereas their dense furnishings and complex visual layers draw both from informal imperial portraiture and contemporary studio photographs of foreign monarchs. Cixi presented these photographs as diplomatic gifts

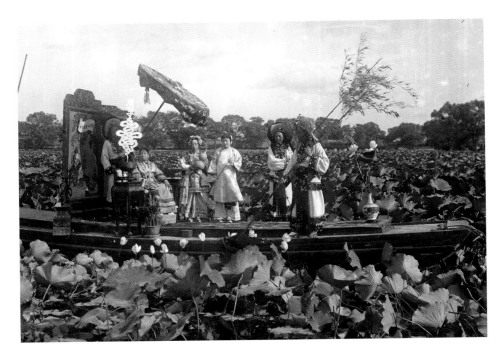

1.15

Yu Xunling, Empress Dowager Cixi and attendants on a barge on Zhonghai Lake, Beijing

The Archives of the Freer Gallery of Art and Arthur M. Sackler Gallery contain 36 of photographer Yu Xunling's original glass-plate negatives. Some of the images were given as presents while others were displayed within the palace. They were all carefully staged and then captured by the photographer, a brother of two of Cixi's ladies-in-waiting.

1903–04, Beijing. Glass-plate negative. H. 17.8 cm, W. 24.1 cm. Freer Gallery of Art and Arthur M. Sackler Gallery Archives, Smithsonian Institution, Washington, D.C., FSA A.13 SC-GR-243 (detail)

1.16

Ma Shaoxuan, Snuff bottle depicting Xuantong

This snuff bottle is inscribed 'Long Life to the Great Emperor Xuantong of the Great Qing Empire'. Dated 1911, the seal and signature are of the celebrated snuff bottle decorator, Ma Shaoxuan (see fig. 6.15). The two-year-old emperor, better known as Puyi (1906–1967), nominally ruled from 1908 until his forced abdication in 1912, when he was just six. The 1911 Revolution ended 2,000 years of imperial rule. From 1 July to 12 July 1917, Puyi was briefly restored to the throne and later was a puppet emperor for the Japanese military regime in Manchuria, the then-occupied ancestral homeland of the Qing rulers. Ma Shaoxuan was a Muslim craftsman working in the Ox Street Mosque area of Beijing. He had failed his civil service exams, which may have been why he turned to painting snuff bottles instead.

1911, Beijing. Inside-painted rock crystal with jade stopper. H. 6.2 cm. Private Collection

to foreign leaders, including US president Theodore Roosevelt (1858–1919). She also commissioned the American amateur painter, Katherine Carl (1865–1938), to paint a monumental portrait of her in oil (not a traditional Chinese medium) for display in the Qing pavilion in the 1904 St Louis World's Fair.[41]

Cixi's portrait projects were inextricably linked to the Qing court's New Policies reform movement, which the Empress Dowager herself initiated in 1901. The fostering of diplomatic exchanges with Western countries and Japan constituted a crucial part of this agenda, and Cixi transformed her public image to reinstate the Qing empire as an equal player on the international stage and to represent herself as a modern sovereign.

Beyond a targeted international audience, in the early 20th century Qing imperial photographic portraits also gained wide social visibility in China, consumed by the general public as reproduced images, thanks to the burgeoning modern print industry in treaty ports such as Shanghai and Tianjin.[42] The portrait of the child-emperor Xuantong, meticulously copied from a photograph and painted inside a petite snuff bottle by the master Ma Shaoxuan 馬少宣 (1894–1932), is a virtuosic work in its own right, and it epitomised the transferability and commodification of imperial visages (fig. 1.16).

Court beliefs and state rituals

As Evelyn S. Rawski states, 'The Qing constructed a personalistic empire, held together at its pinnacle by a charismatic ruler, who was able to speak directly in the cultural vocabularies of each of his major subject people.'[43] The diverse belief and ritual systems patronised by the Qing court mirrored the empire's multicultural structure comprising Han Chinese, Manchu, Mongol, Tibetan and Uyghur Muslim subjects. An eclectic mixture of Confucianism, shamanism, Daoism and Tibetan Buddhism, as well as popular beliefs, contributed to imperial legitimation, while helping the court maintain connections with various ethnic communities.[44]

Qing rulers adopted Confucianism and related state rituals from the Han Chinese culture of the conquered Ming dynasty. For Chinese subjects, the Manchu emperor presented himself as a sage Confucian monarch, who ruled both by the Mandate of Heaven and by virtue, in the long lineage of the Chinese dynastic tradition.[45] Confucian state rites institutionalised governing ideologies grounded in filial piety, the agricultural calendar cycle, and the emperor's role in harmonising human society and the cosmos (fig. 1.17). In the elaborate system of ceremonies overseen by the Board of Rites, the pre-eminent grand sacrifices included those to Heaven, Earth and imperial ancestors, which were led by the emperor at first-rank altars.[46] The only state ritual that was the prerogative of the empress was the sacrifice to the silkworm deity in the Altar of Sericulture (先蠶壇), a duty in accordance with the Confucian ideal of gendered labour division – 'Men till, women weave.' These rites established the imperial pair as the archetypal mother and father for their subjects.[47]

Beyond the rites dedicated to deities and ancestors, other state ceremonies concerned political and military affairs as well as events in the imperial family's life cycle,

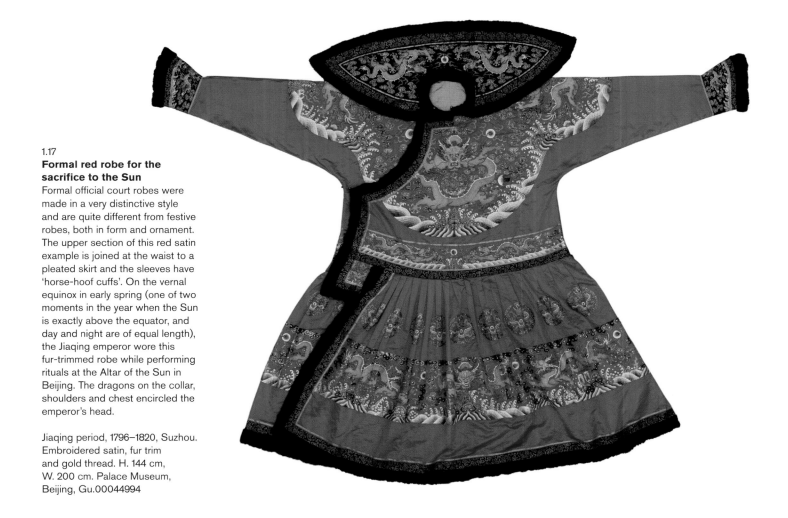

1.17

Formal red robe for the sacrifice to the Sun

Formal official court robes were made in a very distinctive style and are quite different from festive robes, both in form and ornament. The upper section of this red satin example is joined at the waist to a pleated skirt and the sleeves have 'horse-hoof cuffs'. On the vernal equinox in early spring (one of two moments in the year when the Sun is exactly above the equator, and day and night are of equal length), the Jiaqing emperor wore this fur-trimmed robe while performing rituals at the Altar of the Sun in Beijing. The dragons on the collar, shoulders and chest encircled the emperor's head.

Jiaqing period, 1796–1820, Suzhou. Embroidered satin, fur trim and gold thread. H. 144 cm, W. 200 cm. Palace Museum, Beijing, Gu.00044994

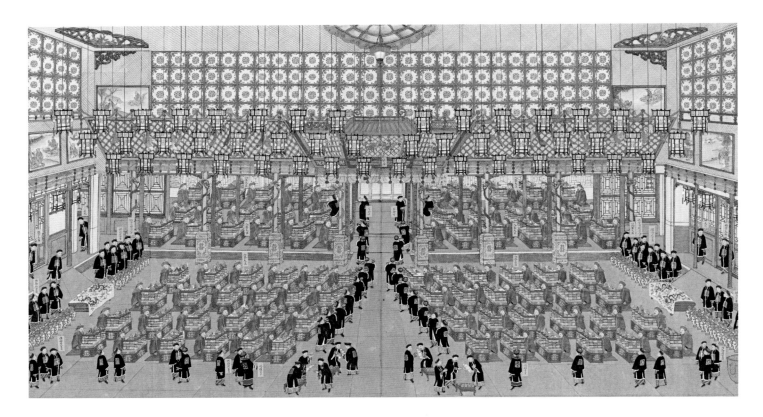

especially marriages, birthdays and deaths. Weddings, a pivotal component of the canonised four Confucian family rites – coming of age, matrimony, mourning and ancestral worship – marked the emperor's adulthood and political maturity. For Tongzhi and Guangxu, who ascended to throne at a young age, their marriages officially ended the regencies of the empress dowager(s), and only after that were they permitted to lead grand sacrifices at the first-rank altars.[48] Qing empresses and consorts were selected from the triennial draft of 'beautiful women' (秀女), a system for registering and presenting qualified banner women at the palace. Qing imperial marriages fundamentally served as a political strategy for the ruling house to form alliances with Manchu, Mongol and Chinese banner elites, while excluding ties with ordinary Han Chinese.[49] Choosing marriage candidates could be a naked power manoeuvre. For example, the Empress Dowager Cixi selected her own niece as Guangxu's empress in order to strengthen the link between Aisin Gioro 愛新覺羅, the ruling house, and her Yehonala clan.[50]

Called a 'Grand Wedding' (大婚), the reigning monarch's nuptials with his empress were a state ceremony involving complex logistics and a series of rituals from betrothal, announcement and wedding

1.18

Qingkuan 慶寬 (1848–1927) and other court painters, *Album leaves from the Guangxu emperor's wedding* (光緒大婚典禮全圖冊)

Vast numbers of officials, servants and eunuchs worked within the palace, as demonstrated by this album leaf painting, one of a series depicting the elaborate ceremonies held to celebrate the 1889 marriage of the Guangxu emperor to Jingfen 靜芬 (1868–1913), later known as the Empress Xiaoding Jing 孝定景皇后. These images record important state ceremonies that emphasised the status and ethnicity of the couple. The Qing emperors chose wives by selecting girls from a presentation of 'beautiful women', who were usually about 13. The wife-selection ceremony was held every three years within the palace. The Guangxu emperor chose Cixi's niece as his bride (although the story goes that his real love was a consort, Keshun 恪順皇貴妃 (1876–1900)). Once a bride was chosen, the emperor then presented gifts – money and textiles – to his prospective in-laws. As Manchus prided themselves on their horsemanship and military prowess, Qing emperors also gave dowry gifts of 10 horses with saddles and bridles and 10 pieces of armour. A lance, quiver, arrows and bow were placed above the entrance to the bride's home until she entered the Forbidden City for the wedding.

c. 1889, Beijing. Ink and colours on silk. H. 61 cm, W. 111 cm. Palace Museum, Beijing, Gu.00005886

ceremony, to post-wedding homages to deities, ancestors and the empress dowager (fig. 1.18). Wedding utensils and furnishings were planned and commissioned long before the ceremony. On the wedding day, the imperial couple performed rituals with origins in multiple traditions of beliefs. As the archives of Tongzhi and Guangxu's weddings reveal, the newly-weds venerated Heaven, Earth, ancestors, shamanic deities and the kitchen god, and the bride also worshipped Buddhist deities and the household gods in her new residence, while carrying out symbolic actions with objects representing good wishes.[51]

The Qing court practised shamanism as part of their Manchu heritage and identity. A belief system already widespread in northeast Asia by the 11th century, shamanism was based on the notion that human lives occupy the middle realm between the upper world of deities and the lower world of the deceased. Aided by animals, birds and ancestral spirits, shamans could summon the deities to descend to earth.[52] Under imperial patronage, shamanism provided the foundation myths of the Qing ruling house for legitimising the regime, while helping to strengthen ties with northeast tribal groups in the Manchu homeland. Qing court shamanic rites were performed in special sites called

tangzi 堂子, only accessible to Manchu nobles and elites. Women played an essential role in Qing imperial shamanism, as the rituals also took place in the empress's quarter, the Palace of Earthly Tranquillity (坤寧宮), and wives of Aisin Gioro, the ruling clan, served as the shamans.[53]

Tibetan Buddhism, a religion shared by the peoples of Tibet and Mongolia, also figured prominently in Qing imperial belief systems. Its concept of *cakravartin*, the king turning the dharma wheel, provided Qing monarchs with a model to present themselves as a divine, reincarnated lineage of universal rulers.[54] This alternative model of kingship unifying religious and secular authority, very different from Chinese Confucian emperorship, resonated with the vocabulary of ruling legitimacy in the Inner Asian tradition. Tibetan Buddhism was the personal religion of Qing rulers and they incorporated it into state infrastructure and deployed it to sustain alliances with and control over Tibet and Mongolia.

In the high Qing period, especially during the Qianlong reign, imperial patronage of Tibetan Buddhism reached its zenith, with systematic renovation and construction of monasteries, the founding of prayer halls and learning centres inside the palaces, and

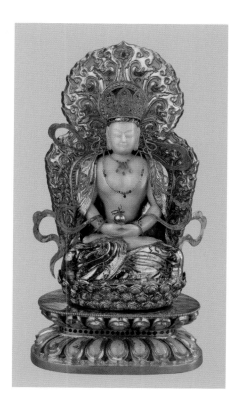

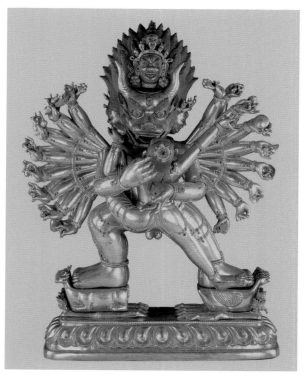

1.19 (far left)
Sino-Tibetan Buddhist figure
1800–1900, probably Beijing. Jade, gilt-bronze, turquoise, kingfisher feathers, coral, pearls, malachite and enamel. H. 37.5 cm, W. 20 cm, D. 14 cm. Royal Ontario Museum, Toronto, 921.21.524

1.20 (left)
Inscribed figure of Yamāntaka Vajrabhairava
Sino-Tibetan Buddhism was an important part of the Qing court's belief system, with Mongolian and Tibetan lamas and monks performing Buddhist rituals. The court supported temples outside palace walls, such as the Yonghegong 雍和宮 in Beijing, where this sculpture was once housed.

Dated 1811, Beijing. Gilt-bronze and cold painting in coral-red, blue and black pigment. H. 49 cm, W. 37 cm. British Museum, London, W.412. Donated by Dr George Witt

production of ritual objects.[55] During the 19th century, Qing imperial patrons added very little to existing sites, which underwent a significant decline due to the lack of financial support from the court.[56] The limited number of newly commissioned Buddhist statues and ritual objects largely followed the style of the 18th century (figs 1.19–1.20). Nonetheless, the administration of Tibetan religion continued to be an important part of Qing state affairs. Beginning in the late 17th century, Qing rulers had asserted their right to officially endorse the incarnate hierarchs in Tibetan Buddhism.[57] An early 19th-century album, likely produced by a Beijing workshop, depicts the finding of the ninth Dalai Lama in the year of 1808, from the auspicious vision of the reincarnated unborn child to the enthronement of the new Dalai (fig. 1.21). Several leaves show the close involvement of Qing court officials in the process of identification and inauguration.[58] At the end of the dynasty, Cixi's official sponsorship of Tibetan Buddhism was commemorated in the mural paintings in the mausoleum of the thirteenth Dalai Lama. Completed in about 1935, these images reimagine the event in 1908 when the Dalai Lama met with Cixi and Guangxu in Beijing. The representations clearly positioned the Empress Dowager in a superior hierarchy to both the Dalai Lama and the emperor, acknowledging her role as the divine universal ruler (fig. 1.22).[59]

Like high Qing sovereigns, Cixi's religious practices were driven by her actual beliefs while also functioning as political strategies for constructing legitimacy, which required different vocabularies and nuances pertinent to her gender. Her practice of Buddhism primarily

1.21
Unidentified court artist, *Selecting the Dalai Lama*
In the 18th century, Tibet became a protectorate of the Qing empire. The Qing court still had an active relationship with Tibet in the 19th century, as we can see from the presence of Qing officials in this album illustration recording the choosing of the ninth Dalai Lama.

1808, Beijing. Ink, colours and gold on paper. H. 42.3 cm, W. 39 cm, D. 2.2 cm (whole album). Harvard Art Museums/Arthur M. Sackler Museum, 1985.863. Bequest of the Hofer Collection of the Arts of Asia

1.22
Details of mural paintings from the Potala Palace, Lhasa
These murals depict the event in 1908 when the Dalai Lama (who was in exile, fleeing the invading British troops) met the Guangxu emperor and Empress Dowager Cixi in Beijing. Cixi is presented with a Wheel of the Law, symbolising the Buddhist scriptures. This gift perhaps acknowledges her role as a divine universal ruler.

c. 1935, Lhasa. Ink, pigments and gold on plaster. Potala Palace, Lhasa

focused on Guanyin in the Chinese Buddhist tradition instead of deities in Tibetan Buddhism. The portrait depicting Cixi as Guanyin inserted into a text of the *Heart Sutra* that she personally copied represented this dualism in her self-image: both as a devoted supplicant and an incarnate deity (see fig. 1.14). In addition to Buddhism, Cixi avidly supported Daoism, another long-institutionalised and widespread belief system in China, and she strengthened her political networks through liaison with prominent abbots in Beijing (fig. 1.23).

Daoist rituals were performed in the Qing court consistently from the beginning of the dynasty. As historian Vincent Goossaert points out, Daoism contributed 'to the protection of the imperial family and the country', and its most important role at court was 'imperial legitimation through the cult of the emperor as deity'.[60] The late Qing court mandated Daoist liturgical services in four circumstances: general holidays and ceremonial calendars; special needs, such as the emperor's health, the empire's welfare, or a time of drought; the life-cycle celebrations of the imperial family; and the worship of the emperor's personal destiny, especially his birthday (fig. 1.24).

Cixi was the keenest patron of Daoism after the Yongzheng emperor. In particular, she developed strong ties with the abbots of the White Cloud Monastery

1.23

Unidentified artist, *Portrait of a Daoist priest from the White Cloud Monastery*

Daoist priests exercised political influence within the court. For example, Empress Dowager Cixi had developed a close relationship with Zhang Yuanxuan, abbot of the White Cloud Monastery. This Daoist monastery in Beijing was the headquarters of the Quanzhen sect and a centre for discussing late Qing political reforms and state-building programmes. Zhang's successor, Gao Rentong, who wrote the inscription on the speckled paper above this portrait, also received Cixi's patronage and that of her favoured eunuch, Liu Chengyin 劉誠印 (d. 1894). In turn, Gao bestowed Daoist titles on Cixi. This painting shows a Daoist priest from the White Cloud Monastery, Zhang Chengwu, who served two temples near the palace. The priest is depicted wearing the blue cotton robe of his order and holding a fly-whisk in his right hand. His hair is worn long and is tied up in an elaborate topknot, and he is seated on a rug spread on a rock. Behind him are emblems of steadfastness and friendship: branches of pine, fruit trees (Prunus) and bamboo.

Dated 1886, Beijing. Ink and colours on paper. H. 178.4 cm, W. 83.8 cm (framed). Jacqueline Simcox Ltd

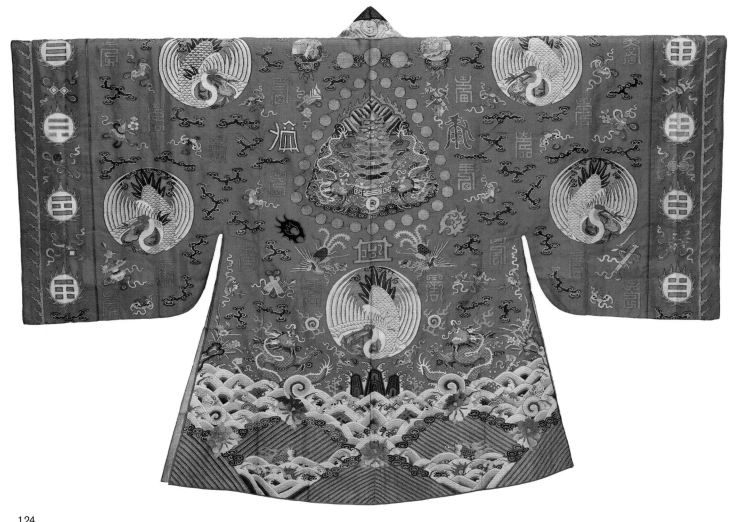

1.24
Daoist priest's robe (*daopao*)
This is a formal outfit for the
principal priest in a Daoist
ceremony. The white cranes
symbolise immortality and the
sleeves are edged by eight
trigrams (*bagua*, 八卦) – a series
of broken and unbroken lines
arranged in rows of three that
ultimately derive from the *Book
of Changes* (*Yijing*, 易經).

1821–50, Suzhou. Embroidered
satin and gold thread. H. 130 cm,
W. 186.3 cm. Minneapolis Institute
of Art, Minnesota, 42.8.118.
The John R. Van Derlip Fund

1.25
**Detail of Our Lady, from the White Cloud
Monastery**
This detail is taken from a set of 22 paintings
featuring new representations of the folk
goddess, Our Lady, commissioned by Abbot
Gao in 1890. The Empress Dowager Cixi was
a devotee of the goddess who was worshipped
both by the elite and the wider population as
she was believed to 'defend the state and
protect the people'. Cixi was also a close
friend of Abbot Gao and a patron of the
White Cloud Monastery (*Baiyun guan*).

1890, Beijing. Ink and colours on silk,
cotton paper mount. H. 182 cm, W. 74 cm.
White Cloud Monastery, Beijing

(白雲觀), the headquarters of the Quanzhen (全真, 'Complete Perfection') sect in Beijing, first with Zhang Yuanxuan 張圓璿 (1828–1887) and later his successor, Gao Rentong 高仁桐 (1841–1907). Abbot Gao conferred on Cixi the Daoist title Master of Broad Benevolence (廣仁子), a symbolic recognition of the Empress Dowager as a disciple of the sect.[61] In several staged photographs of Cixi with costumed attendants on a barge on the imperial Zhonghai lake, she conspicuously displayed her dual spiritual identities – 'Great Master Guanyin of Mount Putuo' (普陀山觀音大士) is inscribed on a screen while a plaque bearing her Daoist title (above the 壽 (shou, longevity) character) emerges from an incense burner (see fig. 1.15). A set of paintings featuring new representations of the folk goddess, Our Lady (娘娘), commissioned by Abbot Gao in 1890, epitomised the relationship between the White Cloud

Monastery and elite female believers. Art historian Liu Xun interprets Abbot Gao's gesture as a tribute to the personal piety of Cixi, his most eminent patron (fig. 1.25). The paintings served devotional and instructional purposes for the self-cultivation of inner alchemic transformation associated with the Primordial Sovereign of the Azure Cloud (碧霞元君), a popular local cult that appealed to the spiritual concerns of the monastery's female patrons.[62]

The dharma boat (法船), a distinctive mortuary spectacle-object primarily made of paper and intended for burning, encapsulated the increasing fusion of belief systems in late Qing court rituals and the significance of ephemeral materials in channelling religious beliefs.[63] Through the act of burning, the boat facilitated a transcendent journey for the deceased, simultaneously drawing on the traditions of Buddhism, Daoism and popular beliefs. Although long existing in commoners' ritual practices, the dharma boat first appeared in the Qing court during the Jiaqing reign. This ceremony was performed during the Festival of Hungry Ghosts (on the fifteenth day of the seventh lunar month) as well as a few months after the death of an emperor, empress, empress dowager or high-ranking consort. Following Cixi's passing on 15 November 1908, her dharma boat, which took months to construct and was set alight on the Festival Day of Hungry Ghosts in 1909, was flamboyantly extravagant, measuring 56 metres long and 6.7 metres wide and costing 14,700 silver taels (then £7,500).[64] It was elaborately composed of architectural structures, beasts, and figures of ghosts and attendants, while featuring in the archway the statue of the Holy Mother of Yulan (i.e. Guanyin in this context) – the female deity and ruler unmistakably identified with the Empress Dowager herself. The *Illustrated London News* vividly reported on this magnificent spirit boat and the spectacle of its later conflagration (fig. 1.26).

Court dress and accessories

The Qing court's dress system was essential to constructing Manchu identity and imperial authority. Since the founding of the dynasty, Qing sovereigns had stressed the importance of distinguishing Manchu from Han Chinese garments, rejecting the latter's wide sleeves as hampering shooting and riding – activities

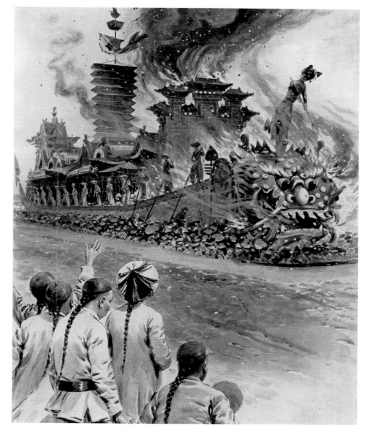

1.26
***Illustrated London News,
9 October 1909***
The extravagant spectacle of an enormous paper boat – measuring 56 m long and costing 14,700 silver

taels (then £7,500), set on fire to carry the spirit of the late Empress Dowager Cixi – was reported in the London papers.

1909, London. Printing ink on paper

pivotal to the Manchu heritage and the empire's martial strength.[65] The primary dress for Manchu men and women was a full-length, loose-cut, A-line robe with tapered sleeves and horse-hoof-shaped cuffs; initially designed to accommodate riding, it gradually became symbolic rather than practical. Manchu women's one-piece gown differed from the clothing favoured by Han Chinese women, typically consisting of a jacket and a skirt (or trousers towards the end of the 19th century). The late Qing period saw increasing Han Chinese influence on Qing court dress, especially after the 1860s and in the domain of informal wear. Notably, straighter and wider sleeves replaced the characteristic 'horse-hoof cuffs' in both male and female Manchu robes, except in formal ceremonial attire; in addition, both Han Chinese fashion and informal Manchu gowns for women developed ornate trims.

Supplied by the three official silk manufactories (織造) in the southern weaving centres of Suzhou, Hangzhou and Jiangning (today's Nanjing), the Qing

1.27
Mamiya Rinzō 間宮林蔵 (1775–1844), *A travel account of the eastern Mongolian region* (東韃地方紀行)
Throughout the 19th century, there was growing consumer demand for frontier products, which put pressure on the environment at, as well as far beyond, China's borders. Imports included swallow nests and gold from Borneo; sea cucumbers from Oceania; turtle shells from Sulawesi; sea otter pelts from California; sandalwood from Hawaii; jade from Xinjiang and Burma; sable fur from Russia; mushrooms from Mongolia; ginseng and pearls from Manchuria; wild Manchurian honey; and Mongolian alcohol and live animals. In 1804, the Jiaqing emperor was overjoyed at receiving two live adult Manchurian tigers from the military governor of Jilin. Mamiya Rinzō, a Japanese explorer, travelled to northeastern Manchuria in 1808; this illustration from his account of the journey shows local officials being presented with pelts for sale.

1808, Japan. Ink and colours on paper.
H. 20.2 cm, W. 30.3 cm. National Archives of Japan, Tokyo, Special 094-0002

imperial wardrobe mainly consisted of finest patterned silks such as damasks, brocades, tapestries or *kesi* (緙絲), and embroideries. The materials used for court attire and accessories also incorporated a wide variety of foreign and frontier products acquired as tributary and trade goods, which epitomised the empire's powerful control of territories and natural resources as well as its well-developed internal and global networks (fig. 1.27). Imported furs, ranging from sea otter, seal and sable to fox and squirrel, figured ubiquitously in winter wear, made into overcoats and riding jackets but also used as linings and trims.[66] The Qing court only used the finest parts of animal skins for garments, and some skilful designs featured patched or inlaid works combining two or more kinds of fur (fig. 1.28). In Qing imperial regulations, restrictions governing the use of different animal skins indicated imperial hierarchy. For example, only the emperor's formal overcoat (端罩) could feature both black fox and sable furs.[67] Wool – in forms such as camlet and broadcloth – was another imported textile widely used for court garments, practical for raincoats and travelling gear. After the

1.28
Man's reversible fur jacket with a yellow silk lining
Products from the peripheries of the Qing empire, such as imported fur from Russia, northeast China and Mongolia, were popular at court and made the emperors feel reconnected with their Manchurian origins. Furs were symbolic of the Manchu love of the wild borderlands and were also associated with their traditional hunting and combat. Fur jackets were symbols of imperial prestige. This one is lined with bright yellow silk, is reversible, and was probably worn during a wedding. It has 46 double happiness characters (*Shuangxi*, 雙喜) inlaid with silver mouse fur (鑲銀 鼠皮) and 'smoked' mink fur (熏貂皮). Sumptuary laws at court dictated the type of fur that could be worn. Military gifts for honoured soldiers included otter-fur war skirts, black fox-fur hats and sable riding gowns and floor mats.

By the early 19th century, half of all North American fur exports went to London and the other half to China, via Guangzhou or Kiakhta in Russia. However, over-hunting of the animals that produced the fur ultimately precipitated an environmental disaster. Consequently, due to their scarcity, fur tribute gifts had to be supplemented by gifts of other objects. Meanwhile, certain species disappeared altogether in China – sables in the 1820s and 1830s, and squirrels in the 1860s.

Jiaqing period, 1796–1820, China. Damask silk, mouse fur, mink, sable and ermine. H. 70 cm, W. 144 cm. Palace Museum, Beijing, Gu.00044967

First Opium War, Britain dominated the Chinese market for imported woollen fabrics.[68] For court jewellery, the most prestigious 'eastern pearls' (東珠), the Manchurian freshwater pearls reserved for the imperial family, came from the Qing rulers' homeland on the northeast frontier; and the iridescent turquoise kingfisher feathers used for women's hairpieces (see fig. 1.51), extremely difficult to obtain, relied heavily on supplies from Siam, among other Southeast Asian states with a tributary relationship with the Qing.[69]

By the 18th century, Qing court dress had developed elaborate regulations for formal wear, structured according to imperial hierarchy, occasions and seasons. Observing a strict dress code, these categories changed very little through the end of the Qing dynasty. The official court attire (*chaofu*), or ceremonial wear, was reserved for the grand sacrifices to Heaven, Earth,

Moon, Land, Grain and ancestors, during which the emperor wore particular colours of blue, red (see fig. 1.17), 'moon white' (月白) (sky blue) or yellow for different occasions. Other celebratory formal events, such as New Year and birthdays, required the donning of festive attire (*jifu*). The wearing of bright yellow was restricted to the emperor, empress and empress dowager, and only they, plus first-rank consorts, were allowed to wear robes bearing five-claw dragon motifs called 'dragon robes' (龍袍).[70] Court attire and festive dragon robes functioned to manifest the wearers' imperial identities through a set of cosmological and auspicious symbols that were effectively mapped out on their bodies (fig. 1.29).

Formal clothes for imperial children were miniature versions of those worn by adults, as exemplified by a dragon robe made for a boy emperor (fig. 1.30). Adult

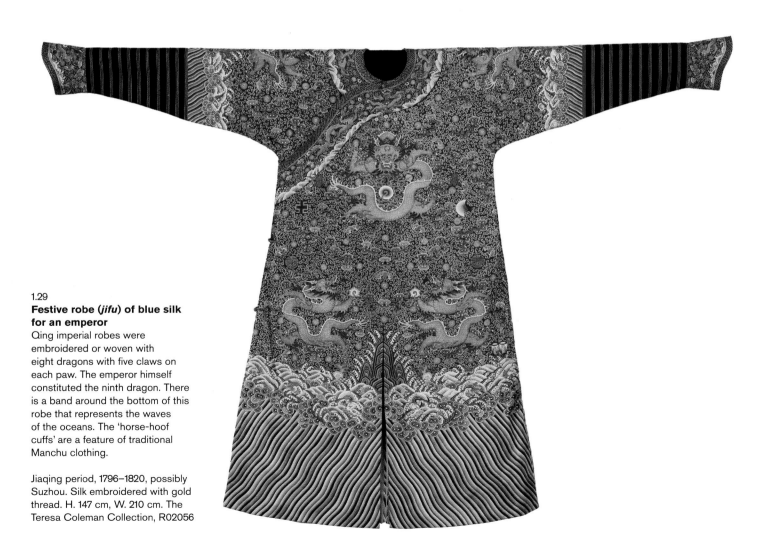

1.29
Festive robe (*jifu*) of blue silk for an emperor
Qing imperial robes were embroidered or woven with eight dragons with five claws on each paw. The emperor himself constituted the ninth dragon. There is a band around the bottom of this robe that represents the waves of the oceans. The 'horse-hoof cuffs' are a feature of traditional Manchu clothing.

Jiaqing period, 1796–1820, possibly Suzhou. Silk embroidered with gold thread. H. 147 cm, W. 210 cm. The Teresa Coleman Collection, R02056

Manchu men of imperial and noble ranks never wore a top and bottom ensemble; by contrast, young boys' informal outfits could consist of such a combination for mobility, and they sometimes displayed playfulness and symbols suitable for childhood (fig. 1.31).

Informal robes for men, versatile for occasions ranging from daily court business to private retreats, were primarily made of monochrome silk damask or gauze in blue, pale yellow or brown colours with medallion designs. This informal robe could be worn alone or combined with two types of hip-length upper wear – the riding jacket (馬褂) or the short vest (坎肩). The former was used for actual riding and travelling but also widely worn for everyday occasions; the latter, uncommon before the late Qing period, became especially popular from the Tongzhi reign onwards. A portrait of the Guangxu emperor at his desk illustrates a dapper look (see fig. 1.11): he sports an informal silk damask robe in bright blue, which had straight, un-cuffed sleeves and medallion patterns featuring the stylised character 壽 (longevity); on top of it an untrimmed vest made of a brown silk brocaded with the same 壽 characters in gold threads introduces a contrasting colour and projects understated luxury. Completing his refined yet casual look is a bejewelled black and gold melon-shaped hat with a red topknot and ribbons flying on the back, a pearl bracelet suspended from the second button of his vest, and a pair of black court boots with platform soles.

In the late Qing period, for the emperor and elite Manchu bannermen alike, indispensable accessories also included a pocket watch, a fabric pouch (荷包), a jade thumb ring and a snuff bottle.[71] The thumb ring, or 'finger bender' (扳指), began as an archer's tool for

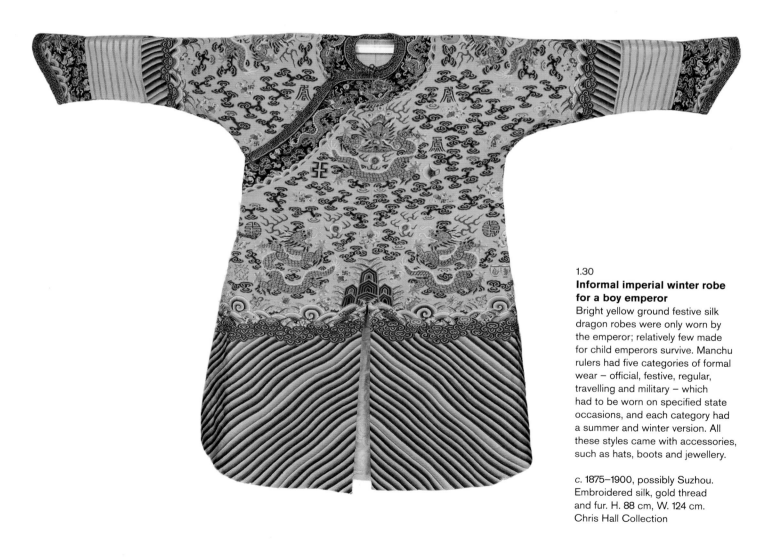

1.30
Informal imperial winter robe for a boy emperor
Bright yellow ground festive silk dragon robes were only worn by the emperor; relatively few made for child emperors survive. Manchu rulers had five categories of formal wear – official, festive, regular, travelling and military – which had to be worn on specified state occasions, and each category had a summer and winter version. All these styles came with accessories, such as hats, boots and jewellery.

c. 1875–1900, possibly Suzhou. Embroidered silk, gold thread and fur. H. 88 cm, W. 124 cm. Chris Hall Collection

1.31

Emperor Tongzhi's tiger jacket and trousers

Emperor Tongzhi ascended the throne at the age of five and died when he was 19. He wore this breathable gauze summer outfit when he was still a boy. Tiger stripes were hand-painted over the apricot-coloured patterned gauze. The Chinese word for tiger (虎, *hu*) has the same pronunciation (but a different character) as the Chinese word for to protect (护). Thus, the tiger is often used as an emblem of safeguarding through its natural strength and this play on words (see fig. 4.72). Even today in China, children are often dressed in tiger outfits or wear shoes decorated with tiger motifs. The trousers here have no seat; at the top of each leg is a cloth loop and a cloth strip which were fastened onto a cloth belt to secure the trousers, worn underneath the shirt so that only their lower parts were visible. This outfit would have been worn with a tiger hat embroidered with a tiger face and whiskers, and the character 王, meaning 'king', a reference both to the wearer and to the tiger (who is king of the beasts).

Tongzhi period, 1862–74, China. Woven and painted gauze. Jacket: H. 57 cm, W. 72 cm; trousers: L. 28 cm, W. 10.5 cm. Palace Museum, Beijing, Gu.00049269, Gu.00049272

facilitating the shooting of arrows (see fig. 2.5). By the mid-18th century, its function extended beyond archery to become a piece of decorative jewellery marking Manchu masculinity. The Qianlong emperor popularised the use of jade, which replaced bone as the rings' default material.[72] American tobacco was powdered into snuff and first introduced by Jesuit missionaries to the Qing court in the late 17th century. It was later regularly imported via the 'Canton trade' (see Chapter 5) through the city of Guangzhou. In China, it was appreciated for its medicinal effect on nasal congestion and headaches, and miniature bottles with small openings replaced European boxes for better protecting the snuff from moisture and preserving the smell (figs 1.32–1.43). Elite males carried exquisitely fashioned snuff bottles made of precious materials as personal accoutrements and collectibles, which they often brought out as conversation pieces, or for competitive display during social gatherings.[73] In the Jiaqing period, inside painting emerged as a novel technique for decorating snuff bottles, reaching a pinnacle of refinement towards the end of the dynasty (see fig. 1.16).

Most of the 19th century's sartorial innovations occurred in women's informal court wear, a domain not subjected to official imperial regulations (fig. 1.44). By the mid-19th century, several old as well as new informal styles had become firmly established, often worn in combination: the inner robe or *chenyi* (襯衣)

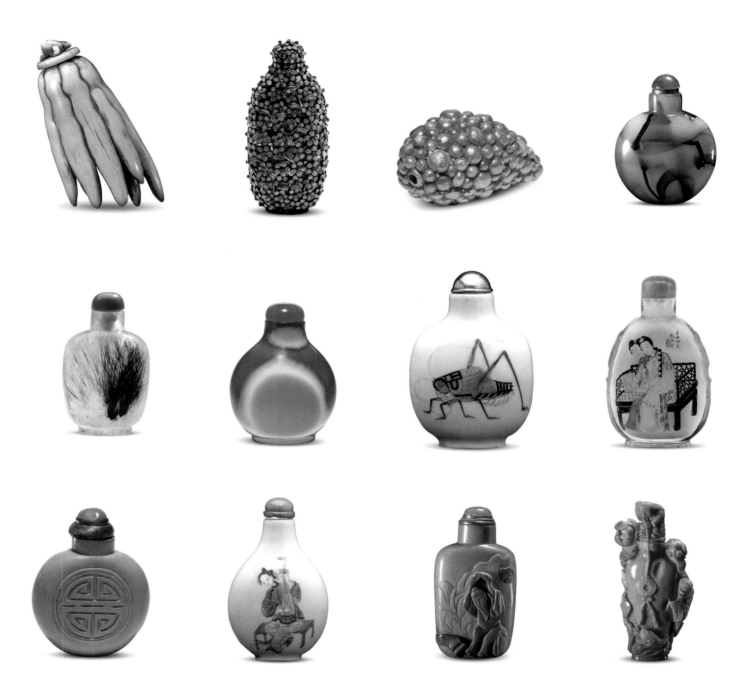

1.32–1.43

A group of twelve snuff bottles

Qing snuff bottles were designed to keep powdered tobacco dry. Before 1860, the elite officials, including bannermen, in the Qing government and wealthy merchants from Guangzhou were the main purchasers of high-quality snuff bottles. After 1860, they were more widely owned in urban communities across China. In his book *Researches Done during Spare Time into the Realm of Yonglu, God of the Nose* (勇盧閒詰), written between 1864 and 1868, the artist Zhao Zhiqian 趙之謙 (1829–1884) contrasts snuff with opium, writing that snuff

was the good drug from the Italians and opium the bad drug from the British. Snuff bottles were common gifts and fashionable male accessories. For the market outside the court, artists made bottles from less precious materials, including tangerine skin or coconut, which also indicated scholastic interest in the natural world. Bottles were also made at centres such as Yixing in Jiangsu, where educated men collaborated on their decoration.

c. 1820–1910, China. Ivory, kingfisher feathers, silver, pearl, glass, hardstone, porcelain, enamel and coral. H. 8.4 cm (tallest); H. 6 cm (smallest).

British Museum, London, 1945,1017.345, 1936,0413.78, 1886,0306.13, 1877,0502.27, 1936,0413.70, 1877,0116.52, Franks.646.+, 1945,1017.318, 1886,1013.8, 1945,1017.354, 1945,1017.300, 1936,0413.73. Bequeathed by Oscar Charles Raphael (1945,1017.300, 318, 345, 354); bequeathed by Reginald Radcliffe Cory (1936,0413.70, 73, 78); donated by Sir Augustus Wollaston Franks (1886,0306.13, 1877,0116.52, Franks.646.+, 1886,1013.8); bequeathed by Felix Slade (1877,0502.27)

(see figs 1.48–1.49), the outer robe or *changyi* (氅衣), the riding jacket (fig. 1.45), and long and short vests (fig. 1.46). The *chenyi* and the *changyi* shared a loose A-line shape, turned-back sleeves (挽袖), and decorative schemes. They only differed in that the latter had two side slits and could not be worn without the inner robe. The cut of these garments remained relatively consistent until the end of the dynasty, but changing textile designs, colour palettes and trims defined evolving court fashions.

We should interpret the word 'fashion' in a careful, limited way within the late Qing context. Unlike in Europe, there was no trickle-down mechanism in China for the court to set new fashion trends and influence popular style. The Qing imperial dress system was self-contained, fundamentally lacking an arena of public display, as exposure of Qing imperial women and their portraits outside a limited circle in the palaces was strictly forbidden until the start of the 20th century. However, court styles and civilian fashions cross-fertilised indirectly through systems of production and circulation, and noble Manchu women in Beijing who had access to the 'inner court' helped disseminate the imperial style. Certain trends in late Qing fashion swept through Han Chinese dress and Manchu court dress simultaneously. Notably, both embraced the bright shades of pink, purple, blue and green produced by synthetic aniline dye, which was discovered in Britain in 1858 and imported to China not later than the early 1870s.[74] In addition, Manchu and Han dresses were virtually indistinguishable in their fashionable adoption of multi-layered decorative sleeve bands, ornate borders trimmed with ready-made ribbons and foreign laces, and slits topped with a cloud-shaped decoration known as the *ruyi* (literally, 'everything as you wish') head (如意頭).[75]

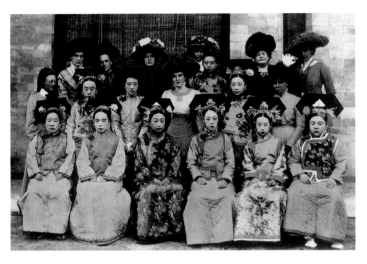

1.44
Palace Women and the wives of western diplomats in the Forbidden City
c. 1902–05, Beijing. Photograph with modern colourisation

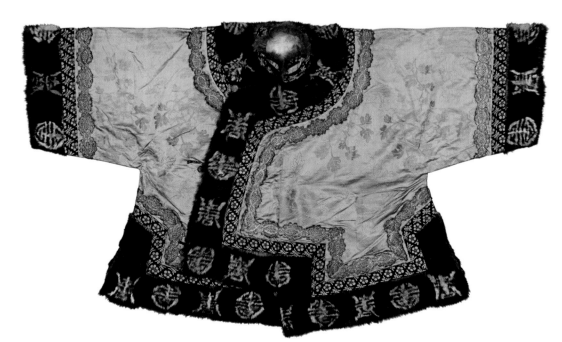

1.45
Woman's green riding jacket
The female wearer of this jacket combined the traditional Manchu taste for fur (it is inlaid with sable fur along the borders) with cosmopolitan Western fashion (it is woven with gold patterned ribbon and trimmed with European-style lace and the auspicious Chinese character *shou*, meaning long life). The bright green colour was also new, only being used after 1875. The Palace Museum still has uncut fabric for making such jackets, which were worn over full-length robes.

Guangxu period, 1875–1908, China. Satin, sable and lace. H. 75.5 cm, W. 124 cm. Palace Museum, Beijing, Gu.00049938

Some Qing court styles were closely tied to the Empress Dowager Cixi's vision and patronage, representing the matriarch's personal aesthetic and experimentation. Cixi exercised strong control over the design and production of imperial textiles. In 1890, displeased by the products supplied by the three imperial manufactories, she established her own textile workshop, the Pavilion of Magnificent Flowers (綺華館), in the Western Imperial Garden adjacent to the Forbidden City, recruiting skilled artisans from Suzhou and Hangzhou to weave designs under her supervision.[76] Extant uncut lengths of silk bearing the Pavilion label woven on the end borders range from patterned gauze to velvet for a riding jacket *à la disposition*.

Cixi's favourite motifs of orchid, bamboo and the character 壽 (*shou*, longevity) abounded in her garments, interior decorations and objects. Orchids (蘭) poetically asserted her identity, as her first court title as a lower-rank consort was 'Noble Lady Orchid' (蘭貴人, Lan Guiren). Bamboo's direct association with Water and Moon Guanyin – one of the bodhisattva's thirty-three manifestations – likely accounted for Cixi's predilection for this pattern.[77] Bamboo (竹, *zhu*) and the *shou* character together also formed the visual rebus of 'wishing for longevity' (*zhushou*, 祝壽). For her seventieth birthday in 1904, Cixi commissioned a number of vests featuring patterns of bamboo and rock (fig 1.46). At least six coloured underdrawings and several finished versions in *kesi* weave have survived. This design likely took inspiration from the Qing court theatrical costume for the stage role of Guanyin, which featured a blue robe with a large composition of bamboo and rock.[78]

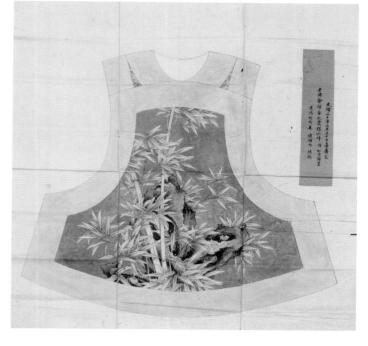

1.46

Woman's informal court vest with bamboo and rocks (left), and original drawing (above)

This sleeveless informal vest has a stand-up detachable collar and wide armholes. It features a pierced Taihu garden rock and bamboo on a bright blue ground with a patterned border of artemisia leaves against a geometric fret. This new late Qing style of outer garment was popular with both men and women, and was worn over a full-length robe. The form of the border and the design are similar to surviving drawings in the Palace Museum.

1895–1911, Beijing. Silk tapestry weave with metal-wrapped thread brocade; ink and colours on paper. Vest: H. 66.1 cm, W. 72.7 cm. University of Alberta Museums, Edmonton, 2005.5.6; Palace Museum, Beijing, Shu00003320. Gift of Sandy and Cécile Mactaggart (vest)

Towards the end of the dynasty, characteristic new styles associated with Cixi included vibrant, contrasting palettes, especially purple and yellow, and enlarged, asymmetrical patterns, inspired by court opera costumes (figs 1.47–1.48).[79] At the turn of the 20th century, contemporary Japanese arts for the high-end export market, which came to the Qing court as diplomatic gifts or were acquired on official imperial missions to Japan, inspired yet another dimension of innovation for Qing court dress, especially diagonally hovering, large auspicious birds across the garment's width (fig. 1.49). Thanks to auspicious symbols shared by Chinese and Japanese visual schemes, such as the crane, phoenix, peacock, bamboo and chrysanthemum, Japanese designs were harmoniously integrated into late Qing dress textiles, while distinctive Japanese touches brought visual novelty.[80] Cixi's photographic and oil portraits for diplomatic exchanges and international expositions offer an insight into the increasing importance of informal court robes in the late Qing period. In all these stately portraits serving political purposes, the empress dowager chose to wear informal gowns bearing auspicious motifs instead of formal or festive court robes with dragons. Carefully designed to avoid accusations

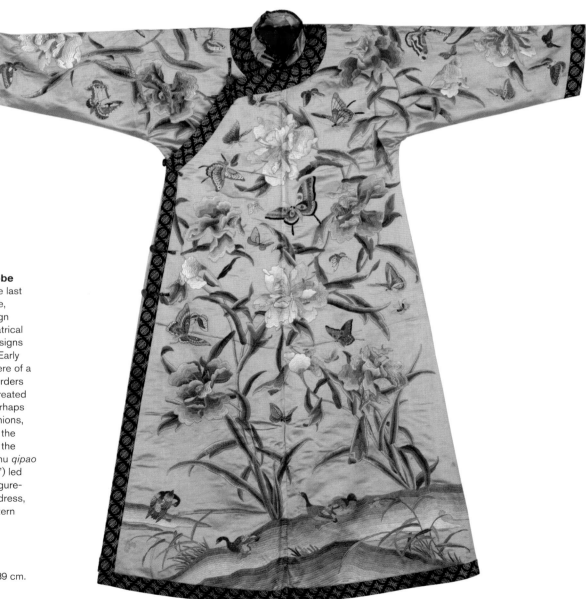

1.47

Woman's yellow court robe
This garment was new in the last decade of the Qing. Its large, non-symmetrical, floral design was influenced by both theatrical costumes and wallpaper designs exported from Guangzhou. Early 20th-century court robes were of a slimmer cut, with simpler borders and standing collars. This created a new, svelter silhouette, perhaps influenced by European fashions, which was adopted outside the court by urban women after the 1911 Revolution. Such Manchu *qipao* (旗袍, literally, 'banner robes') led to the development of the figure-hugging *cheongsam* (長衫) dress, which crossed over to Western fashion in the mid- to late 20th century.

c. 1900–12, China. Silk and embroidery. H. 131 cm, W. 139 cm. Palace Museum, Beijing, Gu.00045722

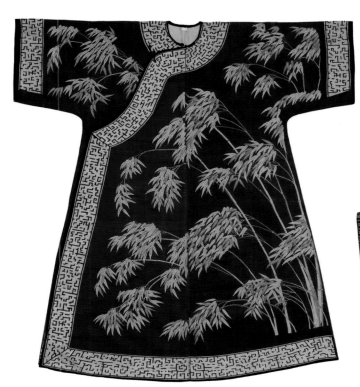

1.48 (above)
Purple silk tapestry weave robe
Cixi had 50 garments for every four
or five days, meaning she changed
her costume about 10 times every
day. She had hundreds of casual
robes with different patterns for
different seasons and occasions.
This unusual and innovative robe
has a design of bamboo, the
symbol of a Confucian gentleman
with moral integrity. The design is
asymmetrical, which is a feature
of some opera costumes, and the

geometric border looks rather like
animal fur. The aubergine purple is
part of the new colour palette of
the second half of the 19th century,
made possible by imported dyes.

1850–1900, China. Silk and metal-
wrapped thread tapestry weave.
H. 135 cm, W. 125.4 cm. University
of Alberta Museums, Edmonton,
2005.5.322. Gift of Sandy and
Cécile Mactaggart

1.49 (below)
**_Kesi_ robe with Japanese-style
decoration**
Made for the Empress Dowager
Cixi, this robe incorporates
Japanese Meiji period (1868–
1912) motifs, likely taken from
contemporary kimono designs,
including the phoenix swooping
down on the front and back. This
informal inner gown has a new
style of wide borders and makes
innovative use of bright and

eye-catching colours. This style
of robe was very popular among
imperial women of the late Qing
and its motifs and colours were not
regulated by formal codes.

c. 1880–1908, China. _Kesi_ with
embroidery. H. 134.6 cm,
W. 134.6 cm. The Metropolitan
Museum of Art, New York, 27.33.
Gift of Mrs William H. Bliss

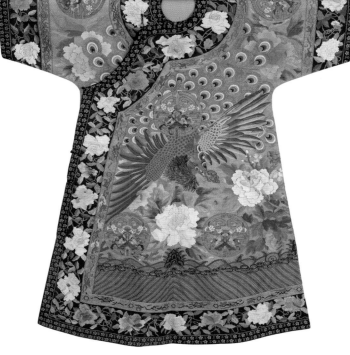

that she was transgressing into the emperor's role,
such choices also turned these flowery dresses into the
embodiment of late Qing sovereignty.

Manchu women at court and in elite households
wore a special coiffure known as the _liangbatou_ (兩把頭),
a looped hairdo that appeared as two handles. In the
first half of the 19th century, the style was relatively
modest and soft, suspended on two sides of the head.
As the century progressed, it gradually moved up
the head and increased in height. From the 1860s to
the 1890s, it became more exaggerated and rigid,
facilitated by a foot-long flat bar to achieve a sleek
even-topped structure with down-turned ends.[81]

At the turn of the 20th century, Cixi popularised
a grandiose headpiece made of black satin, which
acquired the colloquial name 'greatly stretched wing'
(大拉翅).[82] This headgear served as the foundation for
a profusion of hair ornaments, ranging from pearls
and natural flowers to jewels and tassels (fig. 1.50).
More formal than the 'petite coiffure' with looped hair,
and less formal than the crown, this grand headpiece
figured prominently in Cixi's photographic portraits
for diplomatic functions.[83] In fact, so iconic was this
end-of-dynasty headdress and so widely circulated in
images that it came to be seen as the quintessential
symbol of the Manchu tradition.

1.50
Manchu woman's headdress

Unlike Han Chinese women, who wore their hair in twin or single buns, Manchu ladies built their hair up, using wire frames which at court were very elaborate. This example is covered with kingfisher feathers, coral, pearls, jade and other precious stones. In Beijing in the early 19th century, there was an extensive market at Qianmen selling pearls, ginseng and furs. This market is mentioned in the 1845 'Guide to the Capital' (都門紀略). In the words of historian Jonathan Schlesinger, freshwater Manchurian pearls, like furs and wild meats, 'represented Manchus, their ways and homeland', and were prized by Qing dynasty rulers.

1861–1911, Beijing. Satin-weave silk on metal frame with kingfisher feathers, pearls, glass and coral. H. 25.4 cm, W. 51.8 cm. Asian Art Museum, San Francisco, 1988.32.23.a-.d. Gift of Mrs Ursula W. Bingham

Imperial consorts did not possess jewellery as personal assets. Upon death, except for the pieces chosen for burial or for melting down, all items were returned to Imperial Household storage and would be redistributed to other consorts.[84] This practice of recycling makes the dating of imperial jewellery particularly difficult. According to the research of art historian Chen Hui-hsia, filigree pieces figured prominently in the early 19th century, but from the Daoguang period onwards, larger ornaments decorated with kingfisher feathers ascended to the mainstream (fig. 1.51; see figs 4.43–4.45).[85] Towards the end of the dynasty, Cixi invented a new type of jewellery: lifelike hairpins composed of pearls, jadeite, corals and gems to resemble real flowers and birds (figs 1.52–1.56).[86] Motifs such as the nine phoenixes were reserved for the empresses and dowager empresses. At court, Manchu women, who did not bind their feet, wore intricately decorative platform shoes (fig. 1.57).

1.51
Dianzi (鈿子) headdress

This beautiful empress's headdress is fashioned on a woven rattan frame to showcase phoenixes and five naturally coloured semi-precious stones (symbolising the five elements: wood, fire, earth, metal and water) at the end of strings of pearls. The headdress is inlaid with kingfisher feathers.

Set against a woman's hair, the blue and gold colours were easily seen.

Guangxu period, c. 1871–1908, China. Gold, semi-precious stones, rattan, velvet and kingfisher feathers. H. 20 cm, W. 30 cm. Palace Museum, Beijing, Gu.00059708

1.52–1.56
A selection of hair ornaments, fingernail guards and earrings

On formal occasions, Manchu women wore three earrings in each earlobe, as a sign of their ethnicity. Hair ornaments made for court in the 19th century, such as those on the far left, are elaborate three-dimensional creations, some incorporating tassels and moving components. The nail guards (top right) are made of gold filigree, with a design of plum blossom.

1800–1911, Guangdong. Jade, coral, gold, pearls, kingfisher feathers and glass. L. 25 cm, (hair pin), L. 6 cm (smallest earring). Palace Museum, Beijing, Gu.00009960, Gu.00012158; British Museum, London, AF.64; The Teresa Coleman Collection, A06704, AO6430. Donated by Sir Augustus Wollaston Franks (AF.64)

1.57
Guangxu empress's platform shoes

Manchu women did not bind their feet, so their footwear is considerably larger than that of Han Chinese women. These yellow satin shoes have small-footed platforms, which gave the wearer the gait (considered alluring) of a woman with bound feet. Artisans decorated the platforms with multicoloured glass beads which form the character for long life (shou), as well as other images that bring good luck, such as bats and coins. The tips of the shoes bear the character for king 王 and the head of a tiger.

1875–1908, Beijing. Silk, embroidery and glass. H. 20.5 cm, L. 23 cm, W. 9 cm. Palace Museum, Beijing, Gu.00061568

Court objects and furnishings

Many categories of Qing imperial decorative arts, such as glasswork (figs 1.58–1.60), jade (fig. 1.61), lacquer (figs 1.62–1.64) and cloisonné enamel, also underwent transformation in the late Qing period. While techniques and styles reached their apogee during the 18th century in Imperial Workshops, court production underwent a decline from the Jiaqing to Xianfeng periods. In the face of political uprisings and financial crises, imperial demand for luxury objects also decreased during these decades, and the court increasingly relied on commercial manufactories for supplies. The direct result was inconsistent standards of production and homogeneity between objects used at the palaces and in civilian contexts. The Qing court no longer set the model for taste and design in such commodities, whereas private artisans' creativities and market trends permeated court aesthetics. The devastation caused by the Taiping Civil War in Jiangnan and Jingdezhen, where manufactories of imperial textiles, jade carving, lacquer and porcelain were located, led to the plummeting of major handicraft production in the mid-19th century. A revival began in the late 1860s, but court patronage no longer dominated such industries. With the expanded trade system and China's deeper international engagements following the Opium Wars, foreign market demands now played a pivotal role in influencing new directions in Chinese craft and fine arts production. Towards the end of the dynasty, the Qing court's participation in World's Fairs, as well as its expanding diplomatic exchanges with Europe, the United States and Japan, also led to a new definition and new vision of traditional goods. As part of the New Policies reforms, Guangxu established the Bureau of Crafts (工藝局) in 1906, under the newly founded Ministry of Agriculture, Industry and Commerce (農工商局), to oversee various manufactures.[87] A modern concept of 'craft' was directly borrowed from the Japanese word *kōgei* (工芸 or 工藝, literally, industry-art), which came from classical Chinese but acquired new meaning at this time. This term internalised the Western system to reclassify Japan's own traditional arts and manufactures.[88] This Qing imperial attempt to reframe and rebrand time-honoured handicraft traditions represented a new vision of national identity linked to art and industry, which continued to exert a strong impact after the fall of the dynasty.

The vicissitudes of cloisonné enamel (掐絲琺瑯) illustrate this late Qing trajectory. Qing imperial manufactories began to produce cloisonné during the Kangxi reign. A decorative technique that had flourished in China since the Yuan dynasty (1279–1368), cloisonné-making involved first soldering or gluing thin metal wires onto the surface of a metal plaque or vessel to outline the patterns, then filling coloured enamel pastes in the compartments created by the raised wires, and finally firing the piece at a temperature between 680 and 720 °C.[89] In the Qianlong period, the techniques and designs reached their peak. Extremely versatile, cloisonné objects functioned as ritual displays in palace halls and Tibetan Buddhist spaces, and as decorative items and domestic furniture. A wheeled dog cage topped by an ornament that resembles a Tibetan Buddhist bell attests to the hybrid repertoire and wide uses of cloisonné in the palace (fig. 1.65).

Dogs had long been one of the favourite animals of Manchu monarchs. Unlike Qianlong's majestic hounds, which were politically charged tributary gifts, late Qing imperial breeds appeared to be mostly lapdogs, such as the playful pets in Daoguang's family portraits and Cixi's small terriers (figs 1.66–1.67).[90] Following the sack of the Summer Palace in 1860, British soldier Captain John Hart Dunne presented Queen Victoria with a 'Lion' dog taken from an imperial villa, who was given the insensitive name 'Looty' (see fig. 2.45).

In 1789, the cloisonné workshop at court was dissolved due to the lack of commissions.[91] In the following reigns, these objects were primarily supplied by commercial manufactories, which were themselves in decline. Their manufacture and market began to revive in the 1870s, spurred by foreign fascination and demand. The British and French discovered the beauty of Chinese cloisonné works, included among the treasures plundered from the Summer Palace which were brought back to Europe and displayed in the 1867 Exposition Universelle in Paris.[92] The Chinese cloisonné industry now largely targeted the global market. In response to the mounting importance of cloisonné in trade and its salient status as a Qing cultural symbol, Guangxu established an export cloisonné workshop in 1906 under the new Bureau of Crafts. Large cloisonné pieces figured prominently in late Qing imperial diplomatic gifts for foreign leaders, for example, among Guangxu's wedding presents for the Crown Prince

1.58
Deep flaring blue glass bowl

Carved with a design of two fish in a lotus pond, this dish is an excellent example of fine 19th-century artistry. Glassmakers used a technique called monochrome cameo glass, making extremely fine carving on both sides to exploit the properties of clear and opaque glass. This was an innovation of the 19th century. Although glass was also made in ateliers outside the Forbidden City, some of the finest pieces were made in the Imperial Workshops. These had been set up in the late 17th century and flourished with input from Jesuits until about 1800. By 1827, all activities there had ceased – probably due to the financial difficulties of the dynasty – but Cixi's patronage revived imperial glassmaking later in the century.

1875–99, Beijing. Glass. H. 7.4 cm, diam. 33.2 cm (max). Corning Museum of Glass, New York, 64.6.2. Gift of Mr Howard C. Hollis

1.60
Glass bottle with bats and butterflies

The 19th-century artists who made this bottle used innovative colour combinations of overlay pink, dark blue, emerald-green, yellow and red glass on a turquoise ground. It was then carved and is festooned with auspicious visual puns – including a long-tailed bird, probably a magpie, which in Chinese art is a bringer of joy; a fish which represents abundance; bats which convey wishes for prosperity; peaches and butterflies which signify long life; and *ruyi*-shaped clouds which mean 'everything as you wish'. The flowers represent the four seasons: magnolia – spring, peony – summer, lotus – autumn and chrysanthemum – winter.

1800–1900, China. Glass. H. 21.7 cm, diam. 11.8 cm (max). Bristol Museum and Art Gallery, 1950 N4748

1.59
Glass vase with warriors

Artisans made this red and white glass vase using specialised technology. Firstly, glassmakers created the bottle shape by blowing snowflake glass, then they overlaid it with a thick layer of copper-red glass which was carved to reveal the white glass below. The images are from a Beijing opera which itself was based on a popular Qing novel, entitled *Eight Hammers* (八大錘). Opera functioned like TV, cinema or the Internet today in helping to circulate popular imagery and to influence fashion and taste. The vase depicts a legendary battle between the Jin-dynasty prince Lu Wenlong 陸文龍 (n.d.) (identifiable by his two spears and hat with pheasant tail feathers) and four subordinates of the Song-dynasty general Yue Fei 岳飛 (1103–1142). The name *Eight Hammers* comes from the two hammers that each of Yue Fei's four warriors carry. The very fine teak wood stand at the base of the vase is carved in the form of a lotus-seed pod, and individual glass seeds within the stand move when shaken.

1825–75, Beijing. Glass and teak. H. 49.2 cm, diam. 24 cm (max). Corning Museum of Glass, New York, 57.6.10. Gift of Benjamin D. Bernstein

1.61 (left)
Covered jade jar with musician figures
This very thinly carved jade vessel has a cover and phoenix-shaped side handles with rings. Between vertical lines of flower heads on each side lie panels each depicting a musician. The figures stand on one bare foot, dancing on a flaming wheel, which is a Buddhist symbol. They are overshadowed by giant poppies, and the male musician plays a flute and the female musician a lute. Their costumes and jewellery evoke Tang Buddhist paintings.

1875–1912, Beijing. Jade. H. 22 cm, W. 16.5 cm. Baur Collection, Geneva

1.62–1.64
Three *trompe-l'oeil* red lacquerwares
The Qianlong reign was arguably the most creative period for carved red lacquer production since the 1400s, but some extraordinarily innovative court lacquerwares were also produced in the 'long 19th century', exemplified by this group of boxes. Bats are a symbol for happiness and usually appear only as a decorative motif. The bottom-left box is unusual in being formed in the shape of a bat and bearing a double 'happiness' character, suggesting it was a marriage gift. The other boxes – one with auspicious characters, the other representing a stack of books – are examples of *trompe-l'oeil* lacquer.

1800–50, possibly Suzhou. Wood, lacquer and ivory. Top: H. 11.5 cm, W. 20.4 cm, D. 20.5 cm; bottom right: H. 25.6 cm, W. 21.1 cm, D. 33.3 cm; bottom left: H. 11.7 cm, L. 24.8 cm. National Museums Scotland, Edinburgh, A.1928.788, A.1928.691; Victoria and Albert Museum, London, 1147A/1-1875

1.66
Huang Jiming 黃際明 **and Li Tingliang** 李廷梁,
Nine dogs (九犬圖)
c. 1913, Beijing. Ink and colours on silk. H. 145 cm,
W. 67.5 cm. Palace Museum, Beijing,
Gu.00009192

1.65
Dog cage
Little indicates the luxury and extravagance of
the late Qing court better than this cloisonné
dog cage on wheels with jade rings and gilding.
Although the emperors used large, fast dogs for
hunting, they kept small Pekingese dogs within
the court. These pets are often depicted in family
portraits of the emperor, his wives and children.
Large-scale cloisonné items were manufactured
exclusively for the court in the workshops of the
Forbidden City.

1750–1820, Beijing. Brass, cloisonné enamel,
gilding and jade. H. 115.6 cm, W. 81.3 cm,
D. 62.9 cm. Philadelphia Museum of Art,
1964-205-1. Gift of the Friends of the
Philadelphia Museum of Art

1.67
Green satin coat for a small dog
This embroidered satin coat was attached
to the dog by tying the ribbons around its
neck and body. The Department of Internal
Affairs of the Qing Imperial Household
(內務府) had a dog-rearing section. According
to *Research on old Documents about the Capital*
(日下舊聞考), 'Indoor dogs were raised in the east
house at Qiandong Sansuo, at the Donghua
Gate … Outdoor dogs were raised in the south
house on Nanchizi, at the Inner Dong'an Gate.'
The dog-breeding office was supervised by the
Minister of Affairs.

c. 1880–1910, probably Suzhou. Embroidered
satin. H. 60 cm, W. 43 cm. Palace Museum,
Beijing, Gu. 00062752

1.68

Vase with dragons on carved wooden stand
Cloisonné was made predominantly in the
Ming and Qing dynasties to decorate imperial
halls and temples or to bestow as gifts. The
court of Xuantong, the last emperor of the
Qing, presented this vase (one of a pair) as a
diplomatic gift to King George V and Queen
Mary of England to commemorate their
coronation in June 1911. The base has an
apocryphal Qianlong seal mark.

1908–11, Beijing. Cloisonné enamel on copper.
H. 172.5 cm, diam. 80 cm (max). The Royal
Collection, London / HM King Charles III,
RCIN 605, 2

George of England in 1893,[93] in Xuantong's gifts for
the same recipient's coronation as King George V in
1911 (fig. 1.68),[94] and in 1895 to honour the accession to
the throne of Russia's last tsar Nikolai II Alexandrovich
Romanov (r. 1894–1917).

Expanded foreign relations meant that diplomatic
gifts reached the Qing court in great quantities towards
the end of the dynasty, and its collections were enlarged
by purchased samples and gifts that Qing envoys
gathered during official missions abroad. Cixi was
particularly enthusiastic about Meiji-period Japanese
artworks used for diplomacy and the high-end export
market, which she viewed as epitomising the successful
Japanese model of industrial reforms as well as imitable
strategies for future Qing presentations at international
expositions.[95] In several of her photographic portraits,
Cixi showcased a magnificent embroidered screen
made by the Japanese art textile company Takashimaya
(高島屋), a gift from the Meiji emperor in 1903 (fig. 1.69).[96]
While investigating measures for modernising and
institutionalising Chinese embroidery, in 1904 Cixi
dispatched the female embroidery master and educator
Shen Shou 沈壽 (1874–1921) on a mission to Japan to
inspect textile workshops and schools.[97] Shen then
invigorated Suzhou embroidery with the 'drawing from
life' approach, and in 1906 she served as chief instructor
of the embroidery school under the new Ministry of
Agriculture, Industry and Commerce, promoting
modern teaching methods.[98]

The Imperial Kilns in Jingdezhen supplied all
porcelain wares for daily use at court, for ceremonial
occasions such as birthdays and weddings, and as
diplomatic gifts. Despite his advocacy of frugality,
Daoguang invested heavily in porcelain manufacture,
aiming to restore the glory once enjoyed by Qianlong's
wares. In the early years of his reign, he increased
the budget for Jingdezhen, which had been reduced
during the Jiaqing period, to the same level as in the
Qianlong reign. After the First Opium War, however,
the budget plunged again.[99] The kilns produced some
very fine pieces, especially in the category of *famille
rose*, of a quality comparable to Qianlong-era wares
(figs 1.70–1.72).[100] Daoguang also innovated by featuring
the names of his own residential studios and halls as the
marks for the vessels he commissioned. These names,
such as the Hall of Prudent Virtue (慎德堂), expressed
the high-minded pursuits and moral cultivation at the

1.69

Embroidered peacock screen from Japan

This Meiji-era six-panelled screen with peacocks among peonies appears
as a backdrop to several photographic portraits of the Empress Dowager
Cixi from 1903. It has a label on the back in gold which reads: 'made with the
supervision of Iida Shinshichi [Shinshichi IV (1859–1944)] of Takashimaya in
Kyoto of the Great Nippon'. Takashimaya was a company specialising in
top-quality decorative textiles for export and international fairs. Prince Qing
慶親王, also called Aisin Gioro Zaizhen 愛新覺羅·載振 (1876–1947), led a
diplomatic mission to the Japanese court on 21 May 1903, and the Meiji
emperor gave him this embroidered screen and a pair of silver vases
as a diplomatic gift for Cixi. By posing in front of the screen, Cixi
presented herself as a cosmopolitan ruler in a new international
arena of foreign diplomacy. The small birds surrounding the peacocks
were made later of painted cut-out paper and pasted onto the screen.
At the 1904 St Louis World's Fair, the Takashimaya Company exhibited
similar screens with peacock motifs.

c. 1903, Japan. Silk embroidery, wood, lacquer and mother-of-pearl.
H. 268 cm, W. 456 cm. Palace Museum, Beijing, Gu00210763

1.70–1.72 (upper three bowls)
Group of three Jiaqing and Daoguang rice bowls
Before the Taiping Civil War, Jingdezhen – the headquarters of high-class porcelain manufacture in central China – continued to receive large-scale commissions from the Imperial Household. Crockery for the court was made to specific designs and shipped in vast sets to Beijing. This group of *famille rose* rice bowls demonstrates the range of enamel colours employed, each signifying use by a different rank of courtier.

Sir Augustus Wollaston Franks, an antiquarian and keeper at the British Museum, collected these before 1876, when some were barely 20 years old.

1796–1850, Jingdezhen. Porcelain with overglaze enamels. H. 6.6 cm, diam. 9 cm (each bowl, approx.). British Museum, London, Franks.363, Franks.632.+, Franks.633.+a. Donated by Sir Augustus Wollaston Franks

heart of the Confucian-literati tradition; they suggest Daoguang's view of porcelain vessels as an embodiment of his personal virtue.

Cixi played a crucial role in reinvigorating the Imperial Kilns after their near destruction during the Taiping Civil War. In 1865, she allocated 130,000 silver taels and appointed Li Hongzhang, then Governor-General of Jiangsu, Jiangxi and Anhui, to reinstate the Jingdezhen facilities.[101] The first major task that Cixi oversaw was the production of Tongzhi's wedding wares for the 1872 ceremony, for which she exercised control

1.73 (below left)
Porcelain commissioned by the Empress Dowager Cixi
On Cixi's retirement from the regency in 1873, the Garden of Beautiful Spring (綺春園, *Qichun yuan*) was reconstructed within the Summer Palace, which had been mostly destroyed in the Second Opium War, as the Garden of Myriad Springs (萬春園, *Wanchun yuan*). It was dedicated to the two Empress Dowagers, Ci'an and Cixi. Cixi participated actively in the design, making her compound grander and more lavish than Ci'an's. The ongoing construction was called off in 1874 because of rising costs, and the Tongzhi emperor died shortly afterwards. However, the Imperial Kilns at Jingdezhen completed the colourful porcelain sets that had been ordered, and they arrived in Beijing

in 1875 and 1876. By ordering them, Cixi flouted convention, as making such commissions was traditionally the privilege of the emperor alone. She was an avid patron of the arts and these ceramics are based on paintings that she had also commissioned. The ceramics carry the marks of 'Eternal prosperity and enduring Spring' (永慶長春, *Yong qing chang chun*); 'The Studio of Utmost Grace' (大雅齋, *Daya zhai*), referring to her personal painting studio; and 'The whole world celebrating as one family' (天地一家春, *Tiandi yijiachun*).

1874–5, Jingdezhen. Porcelain with overglaze and grisaille enamels. H. 6 cm, diam. 12 cm. British Museum, London, 1963,0719.1. Donated by Irene Marguerite Beasley

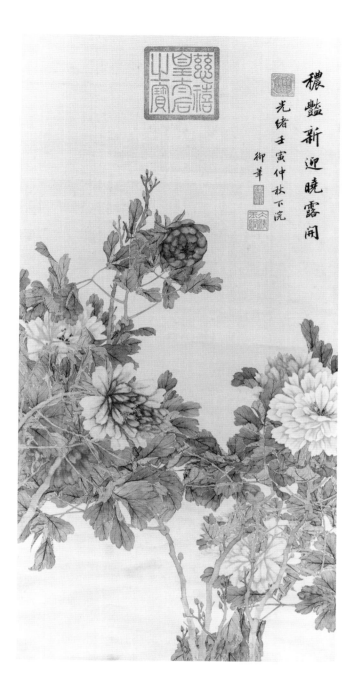

over the designs, techniques and quality.[102] In 1874, in an echo of Daoguang, she commissioned a set of wares that bore the inscription of her studio sobriquet, Studio of Utmost Grace (大雅齋, *Daya zhai*), marking an exceptional chapter in the history of porcelain in the late Qing (fig. 1.73). Consisting of a range of objects from small table vessels to large fish tanks and flowerpots, these wares feature polychrome flower-and-bird designs provided by the Embroidery Workshop. The motifs and colour schemes, such as wisteria and hydrangeas as well as the shades of purple and azure blue, echo Cixi's preferences for her personal clothing. In addition, the *Daya zhai* porcelains and paintings bearing Cixi's signature depicted flowers in similar ways: with extensive use of colour wash, delicately graded shades, and soft colouring, all of which created an exquisitely vivid effect.[103] Most of Cixi's paintings that served as imperial gifts were made by designated 'ghost' painters, notably her tutor Miao Jiahui 繆嘉蕙 (1842–1918), but they nonetheless conveyed a consistent style that Cixi envisioned as her own (fig. 1.74). As art historian Ying-chen Peng argues, Cixi was the first and only imperial woman to patronise porcelain production, an imperial monopoly that had long been a political privilege for male rulership.[104]

Cixi also left a deep personal imprint in another domain of late Qing court arts – palace architecture and interior decorations. During her long regency, she engaged in a series of construction and renovation projects, which allowed her to assert power through deployment of enormous funds and patronage of arts of all media. The most important project was the expansion of the small 18th-century Garden of Clear Ripples into the Garden of Nurtured Harmony (commonly known in English publications as the 'New

1.74

Empress Dowager Cixi, *Flowers*
(慈禧太后御筆花卉圖)

Cixi gifted many artworks, by herself or by official court 'ghost' painters, to visiting diplomats and other officials, particularly after the Boxer War when she tried to improve China's image abroad and strengthen ties with foreign countries. There are thousands of these mostly 'flower and bird' paintings of various natural subjects; in the Palace Museum alone there are 700 under her name, dated between 1888 and 1908. She used 'ghost' artists as mentors to improve her own artwork, as well as to meet the great demand

for imperially authored gifts. These painters included several female artists, such as her tutor and lady-in-waiting, Miao Jiahui, and through this circulation the artworks of this female group became more widely known outside the court context. This image is beautifully painted, featuring tree peonies in an attractive palette. It is dated 1902 and inscribed 'Extravagant beauty blossoms welcoming anew the morning dew' and has Cixi's large imperial seal impression. The painting comes in an exquisite, substantial wood box carved with dragons and lined with bright pink silk – a novel colour of the late Qing, favoured by the Empress Dowager. The hanging

scroll is mounted with silks with auspicious designs including a woven pattern of orchids, cloud-shaped *ruyi*, double happiness characters and bamboo.

1902, Beijing. Ink and colours on paper; underglaze blue porcelain scroll ends.
H. 257 cm, W. 84.5 cm (including scroll ends).
Royal Albert Memorial Museum & Art Gallery, Exeter, 44/1918. Donated by Willoughby Statham Smith of Harpford, East Devon

Summer Palace'), which took place between the mid-1880s and 1895 (see fig. 1.5). The Garden of Nurtured Harmony, where Cixi spent much of her later years, was a vast garden-palace complex, encompassing a totality of functions, from a place of audience, administration, ceremony, entertainment and religious worship to private residence and retreat (see fig. 1.78).

Inside the Forbidden City, Cixi organised the renovations of two palatial compounds – the Palace of Eternal Spring (長春宮) and the Palace of Preserved Beauty (儲秀宮) – her residences from 1867 to 1883, and after 1884, respectively.[105] For the former, she commissioned several *trompe-l'oeil* wall paintings for the interiors and corridors, including a stage ceiling full of dangling wisterias, which recalls Castiglione's work for Qianlong's retirement quarter, the Studio of Exhaustion from Diligent Service (倦勤齋).[106] A unique genre that once fascinated Yongzheng and Qianlong in the high Qing period, *trompe-l'oeil* painting using European techniques of linear perspective had largely disappeared from 19th-century court arts. Cixi renewed it, probably to express her own sense of heightened theatricality. The most impressive productions in the Palace of Eternal Spring were the eighteen wall paintings around the corridor and stage, representing episodes drawn from the popular novel *Dream of the Red Chamber*, of which Cixi was a fan.[107] Integrated with architectural elements to create a visual play between reality and deception, these paintings suggested a central theme of the book that depicts life as an illusion; this may, further, have been a provocative and ironic reflection of court life per se.

Cixi's aesthetics had a strong impact on interior decor and furnishing in late Qing palaces. Some new characteristics in the second half of the 19th century directly reflected her taste, including openwork doorframes with inserted gauze or glass panels, bat-shaped corners for framing paintings inside carved door panels, and three-quarter openwork carved partitions.[108] Similar to her informal court gowns and porcelain wares, Cixi's architectural ornamentations, interior partitions, furniture and furnishing textiles featured a plethora of her favourite motifs, including bamboo, orchids, the *shou* character as well as other auspicious flowers and birds, notably peonies and phoenix (fig. 1.75). The Empress Dowager moved in macro and micro visual environments saturated with

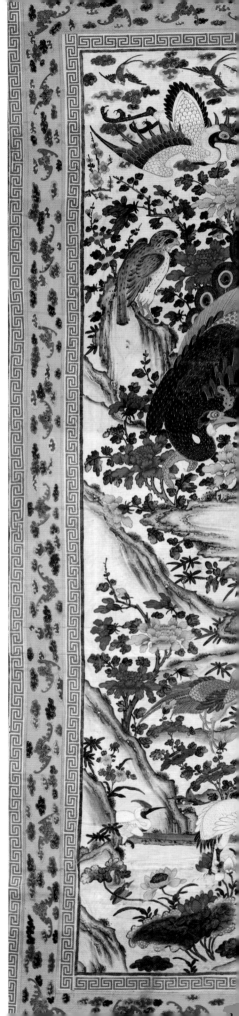

1.75
One hundred birds carpet
The colours used to create this large carpet – commissioned by the Empress Dowager Cixi during the Guangxu era – are vibrant and original. The theme is auspicious and possibly refers to a story about a phoenix who saved all the other birds in a time of drought – perhaps an allegory for Cixi herself. Most court carpets in China in the 19th century were woven rather than painted but some printed yellow, red and black carpets were made on new roller machines (invented in the 19th century in Western Europe and imported). Carpets were mostly used in the court as floor covers, bed covers and saddle cloths and were from Inner Asia.

Guangxu period, 1875–1908. Painted sheepskin. H. 490 cm, W. 560 cm. Palace Museum, Beijing, Gu00212458

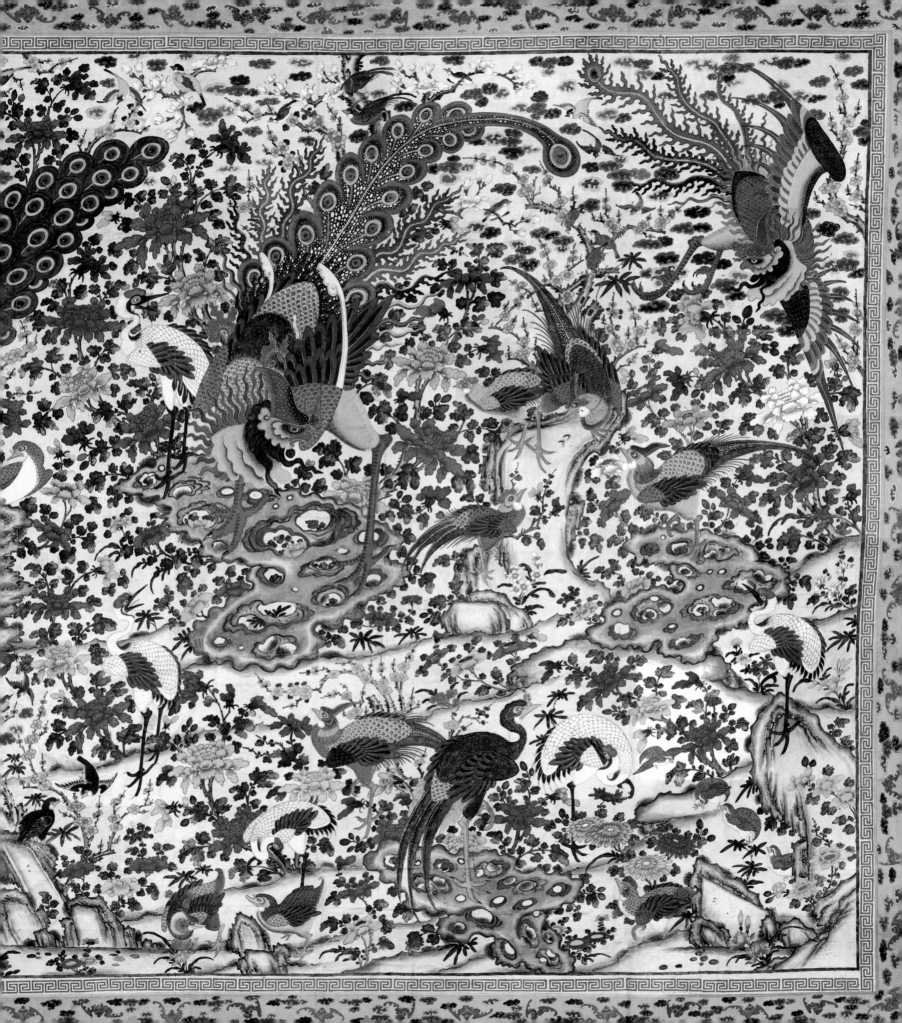

symbolic patterns that at once evoked general blessings and prestige while bearing specific personal meanings.

Court entertainments

Theatrical performances constituted an indispensable component of Qing court life and state-building projects, serving two intertwined purposes – ritual and entertainment. Court theatre productions synthesised music, singing, speaking, dancing, acrobatics and combat, featuring stylised costumes, make-up and stage settings. The extensive repertoire ranged from large-scale, lengthy dramas with spectacular pageantry and didactic themes to small-scale, private performances showcasing singing and acting skills. Except for during imperial mourning, when entertainments were forbidden for an extended period of time, dramas were performed at court all year round, at seasonal festivals, at ceremonies for life-cycle events, for diplomatic receptions, and during the imperial sojourns in Rehe. The Forbidden City, the Summer Palace and the Rehe resort all contained a number of permanent stages and, during major celebrations, temporary outdoor theatres were also erected. The three-tiered free-standing theatre represented the most grandiose type, but regular performances mostly took place on a single-storey stage or in a demarcated space inside a palace hall or courtyard.[109]

In the Qianlong period, at the pinnacle of Qing power, the court theatre developed an extensive troupe as well as large-scale pageantries; used for the glorification of both imperial magnificence and the emperor's benevolence, these were staged on the occasion of grand birthday ceremonies and guest rituals for tributary states and European embassies.[110] During the 19th century, court dramatic productions underwent significant changes, driven by individual rulers' aesthetic and ideological visions, while reflecting larger political and cultural challenges. As literary scholar Liana Chen's research reveals, new additions and revisions by the Jiaqing court focused on contemporary events. In recyclable ceremonial dramas inherited from the previous reign, Jiaqing incorporated real-time references into themes of immortality and loyalty, for the purposes of blessing and praising the emperor, such as the Qing troops' pacification of the White Lotus rebels or

victory over piracy in the South China Sea.[111] Through a lavishly bedecked theatrical rhetoric of imperial achievements, this self-extolling strategy seemed to provide reassurance in the face of mounting anxieties over military and political crises. In 1827, as part of the efforts to deal with reduced income by tightening expenditures, Daoguang established a drastically downsized imperial theatre bureau, the Bureau of Ascendant Peace (昇平署), and he also ceased to employ civilian performers from the Jiangnan region and only kept eunuch actors.[112] This reorganisation paved the way for the later recruitment of professionals in Beijing from the Xianfeng period onwards, which was a crucial factor in the late Qing dramaturgic transformations.

Under the direction of Cixi, an aficionado and connoisseur of dramatic performance herself, imperial theatre regained full strength in the 1880s and developed unprecedented dynamism in the last three decades of the Qing dynasty. A series of experiments reshaped the aesthetic, programming and function of court drama. Cixi founded her private troupe Universal Celebration (普天同慶), consisting of about 180 hand-picked eunuchs with comprehensive specialities in operatic music styles, role-types and acrobatic skills.[113] Alongside eunuch actors enlisted in the Bureau of Ascendant Peace and civilian practitioners, this core group shared the responsibility of meeting the rising demand at court for entertainments.[114] Cixi frequently invited commercial troupes and famous actors from the capital to perform at the 'inner court', while appointing outside professionals to train imperial troupes. The frequent exchanges between the court and popular theatre profoundly changed the focus of late Qing court drama from choreographed mass pageantry to individual stardom and virtuosity in performance.[115] This new emphasis demonstrates that, by the late 19th century, court theatre had succeeded in downplaying ideological agendas and become a pure form of entertainment and performance art.[116]

The Guangxu period saw the completion of another important transition in court drama resulting from the deep influence of popular performances in Beijing. Cixi's infatuation with and patronage of the popular *pihuang* (皮黃) style of opera led it to become the dominant dramatic type in the court repertoire, largely overshadowing the older, less exuberant Kunqu (崑曲) music and texts originating in Jiangnan and associated

1.76

Opera costume
Chinese operas were performed
at the Qing court in extravagant
fashion, as well as in cities on
permanent stages, and outdoors
at rural temple fairs. People often
celebrated birthdays with operas.
These all-male or all-female
performances were spectacular,
with colourful costumes and
headgear, elaborately made-up
faces, and a vast repertoire of
movements, including mime, dance,
stylised gestures, martial arts and
acrobatics, which accompanied the
songs and music. Unlike European
opera, which is structured by
specialist voice ranges, Chinese
opera is governed by several basic
role-types that can be played by any
voice range. These are *sheng* 生
(the male lead), *dan* 旦 (the female
lead), *jing* 淨 (the painted face) and
chou 丑 (the clown).

1800–1900, Suzhou. Silk and
embroidery. H. 133.5 cm. Palace
Museum, Beijing, Gu.00218387

with the refined culture of the literati.[117] Peking Opera
(京劇, *Jingju*), as we know it today, indeed grew out of
this *pihuang* music style and subsumed many late Qing
dramas to take its place in the vibrant theatrical culture
of *fin-de-siècle* Beijing.[118]

The spectacle of Qing court theatre was inseparable
from its splendid costumes, for which a sophisticated
system developed in the 18th century. Specified by type,
opera costumes and accessories were stylised and coded,
displaying the generic qualities that were embedded in
particular role-types, while subtly conveying an
individual character's identity (fig. 1.76). Often produced
in the same textile workshops that supplied court
dresses, imperial theatre costumes featured finely

Key figure: Yu Rongling (1882–1973)

1.77

Yu Rongling in a ballet costume

Yu Rongling was the younger daughter of the Manchu bannerman and official Yu Geng. When her father became China's ambassador to Japan in 1895, she accompanied him and learned Japanese traditional dances. When he was appointed ambassador to Paris in 1899, she accompanied him to France where she began to study ballet and later trained with Isadora Duncan, the famous American dancer, who was then performing and teaching in Paris. After three years, she took part in Duncan's dance dramas, studied at the Paris Music Institute and staged further public performances. In 1903, Yu Rongling returned to China, where she caught the eye of Cixi, who encouraged her to introduce Western-style dance to court. Cixi enjoyed watching Rongling and her sister Deling dance a waltz to her gramophone records but felt the Western habit of a man putting his hand around a woman's waist was inappropriate. Here, Rongling is shown in 1902 playing the part of the Butterfly Girl, in the 'Rose and Butterfly', a dance inspired by the American actress and dancer Loie Fuller (1862–1928). The photograph appeared in the Chinese magazine *New Observation* (新观察) in the 1950s. After the founding of the People's Republic of China in 1949, Rongling was nominated as an arts official in the State Council.

1902, original photograph possibly taken in Paris. Printed photograph. SOAS University of London, C Per 82379

woven or embroidered silks with intricate designs and luxury metallic threads. For the majority of role-types and characters, the costumes did not resemble either contemporary Manchu or Han dress but represented a free adaptation of Ming-dynasty sartorial styles, with added imaginary elements.[119] This unspecific 'ancient' dress style highlighted the remote temporality and ultimate illusionism of theatre. In late Qing drama costume, some new decorative schemes and styles emerged, especially bright colours and enlarged patterns – new trends shared by imperial ladies' informal dress.

From 1902 onwards, with Cixi's more receptive attitudes towards foreigners and international decorum, Western-style parties and entertainments enriched the court activities. In 1903, Cixi appointed the Yu sisters, Deling and Rongling, as her ladies-in-waiting, to advise her on Western customs and to serve as her personal interpreters. Daughters of the Manchu nobleman and Qing Minster of Foreign Affairs, Yu Geng 裕庚 (1843–1905), and a mixed-raced, multilingual

mother from Shanghai, the siblings lived in Japan and France, following their father's ambassadorial posts; their brother was Cixi's photographer Yu Xunling. Talented and widely travelled, they spoke fluent English, Japanese and French, and were well versed in salon music, ballroom dance and the fashions of Western society culture. Rongling, in particular, studied classical Japanese dance, ballet and modern dance – the last with none other than Isadora Duncan (1877–1927) (fig. 1.77).[120] In her private leisure time, Cixi delighted in the 'curious' Western entertainments demonstrated by the Yu sisters, including playing foreign tunes on the piano and dancing the waltz to gramophone music.[121] In June 1904, Cixi enjoyed a special performance in which Rongling presented three dances from her repertoire. First, in a yellow satin dress and a red tasselled shawl, Rongling danced the Italian tarantella; next, she demonstrated a Chinese-style dance holding a prop *ruyi* sceptre, in a red Manchu python gown and the *liangbatou* headdress; she concluded her show with

an Isadora Duncanesque Greek dance.[122] Mediating between Chinese and Western cultures, and connecting tradition and modernism, the worldly and energetic Yu 'princesses' became Cixi's shortcut to a modern Western lifestyle and art, while exemplifying an ideal image of new cosmopolitan Manchu elites.

Starting in 1902, as a friendly gesture to the Diplomatic Corps in Beijing, Cixi began to host an annual spring Garden Party in the Summer Palace for ministers and officers of foreign legations and their wives. Gentlemen and ladies were invited on two separate days. The activities were the same, except that the Empress Dowager and female members of the imperial family did not attend the receptions for gentlemen. Both Yu Deling and Katherine Carl described the 1903 Garden Party for ladies in great detail in their memoirs. The event began with a formal audience with Cixi, followed by a luncheon held in the Throne Room. Alternate courses of foreign and Chinese dishes were served, together with champagne and table waters. Knives and forks were provided. The guests then enjoyed tea in the garden and toured the lake.[123] A fanciful coffee

set in the Palace Museum testifies to the new dining and drinking customs entailed by such novel types of court entertainment. A photograph likely taken during a smaller reception commemorated Cixi's amicable engagements with foreign diplomats' spouses. She held hands with Sarah Pike Conger (1843–1932), wife of the American Minister Plenipotentiary and Envoy Extraordinary to Beijing and an ardent promoter of Cixi's public reputation. A keen observer of foreign etiquettes and fashion, Cixi showed great interest in corseted Edwardian-style dress and even imagined herself in one, but ultimately concluded that the Manchu-style gowns were prettier and more becoming for stout figures (fig. 1.78).[124]

1.78

Yu Xunling, Photograph of the Empress Dowager Cixi with foreign envoys' wives

Cosmopolitan like his sisters Rongling and Deling, Yu Xunling captured the new openness and modernisation of Qing foreign policy after the Boxer War in this photograph, which was taken in the Hall of Happiness and Longevity (樂壽堂) in the Garden of Nurtured Harmony (New Summer Palace). Included in the party are Sarah Pike Conger and other ladies of the US Legation in Beijing. After the Boxer debacle, Cixi had a new agenda for modernisation and foreign engagement. She used photos such as this one to engage with the community of foreign diplomats.

1903–05, Beijing. Glass-plate negative. H. 17.8 cm, W. 24.1 cm. Freer Gallery of Art and Arthur M. Sackler Gallery Archives, Smithsonian Institution, Washington, D.C., FSA A.13 SC-GR-249

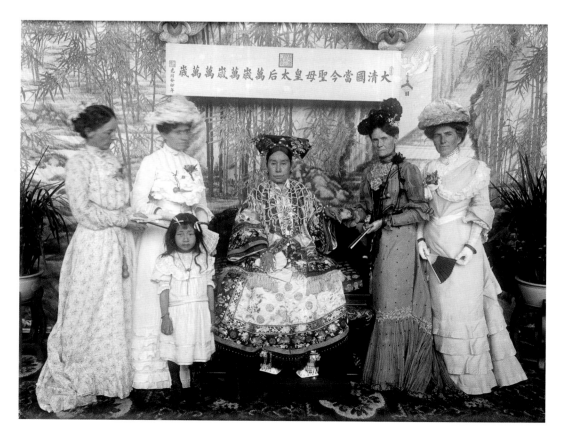

Chapter 2

The military

Stephen Platt

At the dawn of the 19th century, the Qing ruled over one of the largest and most prosperous empires not just in China's own history, but in the history of the world. The dynasty had reached new heights of territorial control in the late 1700s after a series of large-scale land campaigns in Central Asia under the Qianlong emperor that roughly doubled the size of the empire in comparison to the Qing dynasty's predecessor, the Ming. By the end of the Qianlong emperor's life in 1799, the empire seemed to face no more significant threats along its extensive borders, and the Chinese heartland had experienced more than a generation of relative peace. The 19th century would, however, turn out to be nearly the reverse of the 18th. The Qing dynasty's military forces were destined to be severely tested, both by foreign invasion and internal uprisings that would, by the century's end, bring the mighty Qing to the verge of collapse.

2.2

Unidentified artist, *Ancestor portrait of a bannerman*
(清人畫八旗將領像)

The bannermen were the most important part of the Qing military. This commander is sitting next to a spear on a round-backed armchair that is draped with a tiger skin. He is wearing padded silk ceremonial armour with protective brass studs and polished metal plates. A contemporary viewer of the portrait would recognise the eagle feathers and sable-tail plumes in his helmet as belonging to a senior officer. According to the official dress code in the *Illustrated Regulations for Ceremonial Paraphernalia of the Qing dynasty* (皇朝禮器圖式)

of 1759, which was commissioned by the Qianlong emperor, 'only Chamberlains of the Guards, Lieutenant-Generals of the Eight Banners, Commandants of the Left and Right Wings of the Vanguard Division, Captains-General, Provincial Governors-General and Governors' could wear helmets of this style.

c. 1796–1820, China. Ink and colours on silk. H. 240 cm, W. 140 cm (image); H. 325 cm, W. 155 cm (mounted). Royal Ontario Museum, Toronto, The George Crofts Collection, 921.32.75. Gift of Mrs H.D. Warren

Key figure: General Mingliang (1735–1822)

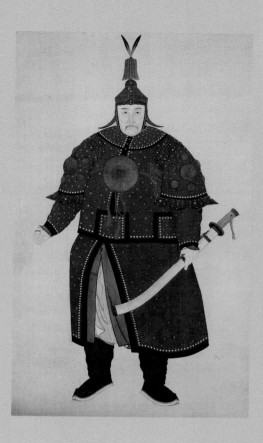

2.1

Ai Qimeng 艾啟蒙 (Ignatius Sichelbart, 1708–1780) and others, *Portrait of General Mingliang* (明亮像) (detail)
This is one of a series of 50 imperial portraits of generals, commissioned by the Qianlong emperor to celebrate his military campaigns, and captioned in Manchu and Chinese. General Mingliang (明亮) was a well-connected aristocrat of the Fuca Manchu clan, married to the great-granddaughter of the Kangxi emperor. Yet his career was something of a rollercoaster. He served in Jilin, Burma, Sichuan and Gansu, helped to suppress the White Lotus Rebellion in 1804 and was praised for his actions. But he was periodically stripped of his rank and even threatened with death for charges ranging from corruption to incompetence. Nonetheless, he survived to serve the Qing for a remarkable 70 years. This 1776 painting was originally kept in the Hall of Purple Radiance (紫光閣), which still stands to the west of the Forbidden City on the northwest shore of the Zhonghai Lake.

1776, Beijing. Ink and mineral pigments on silk. H. 147.5 cm, W. 91.5 cm. Museum of East Asian Art, Cologne, A 93,15

Against the notion that Chinese civilisation always privileged the civil over the military, and elevated the arts of peace above those of war, the Qing dynasty under the northern Manchus placed military culture at the very centre of its rule – especially as it pertained to the Manchus themselves, as distinct from the Han Chinese who made up the vast majority of the empire's population.[1] Reflecting these ethnic differences, the Qing rulers maintained two distinct and by no means equal militaries. The elite forces, which comprised only about a quarter of the dynasty's soldiers but received most of its military funding, were the hereditary armies of the Eight Banners (八旗), comprised of Manchus and Mongols as well as select families of Chinese whose ancestors had joined the Manchus before their conquest of the Ming dynasty in the 1630s and 1640s (fig. 2.1). The banner armies – descendants of the land forces that had carved out the broad borders of the empire in the 17th and 18th centuries – were the physical power behind the dynasty's continued rule (fig. 2.2). Most of them were concentrated in the region around the

capital, Beijing, with others stationed in permanent garrisons in the provinces. In the garrisons, the banner soldiers and their families occupied their own sections of major walled cities, kept largely separate from the masses of urban Chinese who lived around them.

The banner forces possessed the best armour (fig. 2.3), accessories (figs 2.4–2.5), weapons (figs 2.6–2.7) and horse equipment (fig. 2.8) – 'best' meaning not just the most effective but also of the richest craftsmanship and the most expensive materials – and their commanders were celebrated in literature and art. Possessed of a hereditary confidence in themselves as the empire's elite warriors, banner armies also had high morale. Their signature military skill was horse-mounted archery; when tests of this skill were finally abolished in 1905 (replaced by tests of proficient use of a rifle), it generated a noisy outcry from banner soldiers. It should be noted, however, that by the 19th century approximately only half the six-million-strong male banner population were soldiers. Many of the rest worked for the government, or as farmers.

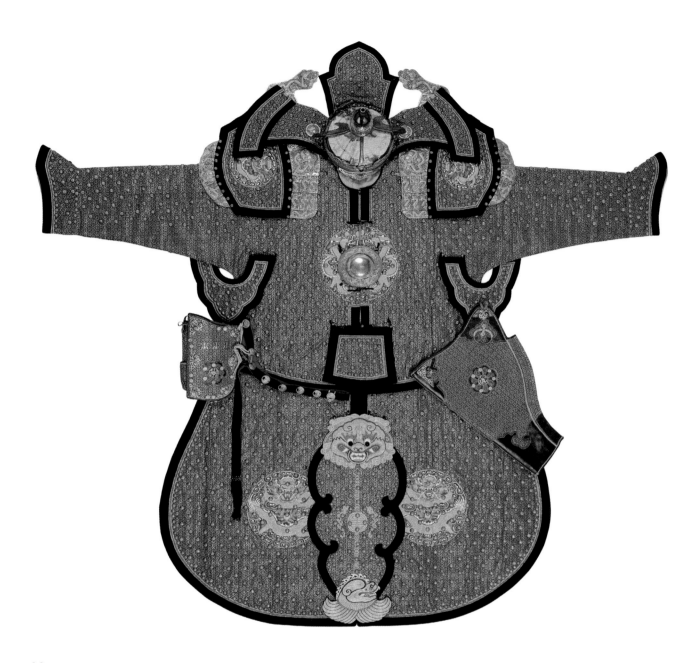

2.3

Military uniform of a bannerman

An officer of the Imperial Guards wore this silk ceremonial military uniform. It consists of a jacket, apron (skirt), helmet and quiver. Lined with soft blue cotton, the armour also has silk padding, with studs to keep the padding evenly distributed. The helmet is made from white metal, with protective flaps and yak hair. A label within its original lacquered box records that this armour was bought in the Established Sisheng Shop on Small Market Street in the provincial capital of Guangdong. Undoubtedly located within the banner garrison enclave of Guangzhou, the shop 'specialises in making family-use double-gilded heavy armour, full-length sabres for hanging at the waist, quivers, banners, saddles, and all kinds of suits of armour'.

c. 1840–80, Guangzhou. Cotton and silk, copper alloy, steel, gold, silver, wood, yak hair, leather, lacquer, paper and pigment. H. 76 cm, W. 201 cm (tunic); H. 100 cm, W. 124 cm (skirt). The Metropolitan Museum of Art, New York, 1936, 36.25.4a–t. George C. Stone Bequest

2.4

Pair of laced boots

These men's boots are unusual, with brass buttons in the form of lotus-seed pods and a fine green leather trim. Black silk-satin was used for the foot and a coarser brown cotton for the leg shaft.

c. 1800–40, China. Cotton, silk-satin, felt, leather and brass. H. 34 cm. British Museum, London, As1842,1210.16.a-b. Donated by Sir Edward Belcher, collected before 1841

2.5
Archers' thumb rings
Manchu archers commissioned rings in a variety of hard stones, glass, ceramic and carved organic materials. The Manchu thumb ring was used on the hand that pulled the bowstring to allow for a snappier release for archery on horseback, for example in the cavalry. It did not really protect the thumb, as the string still touched the flesh. In the late 19th century, the use of thumb rings spread to the merchant class and other elites, as a form of jewellery and a symbol of masculinity, rather than as a practical accessory. What had originated as a sign of Manchu ancestry also became an accessory for Han Chinese men.

1800–1900, China. Jadeite, lapis lazuli, chalcedony, ivory, silver, ceramic, glass, horn, boxwood and others. H. 4 cm (largest ring). British Museum, London, 2022,3037.1–21. Bequest of William Reid

2.6
Set of whistling arrows used for sport
To an arrow connoisseur, minor variations in the design of the wooden shaft, feathered tip and metal head give clues as to where and when arrows were made. Special forms were used for different activities, such as training, hunting or warfare. Military men used lighter-weight 'whistling arrows' (鲍箭) in a target archery game. A pierced bulbous cap at the end creates a high-pitched sound as the arrow is shot from a stringed bow. Specially made arrows were used to shoot different types of animal, with large and small holes producing a range of high-pitched noises.

1800–1900, China. Wood and feathers. L. 97 cm (each arrow, approx.). British Museum, London, As.3607–3612

2.7
Folding bow
Manchu bows were made with a wooden or bamboo core that was reinforced with horn. They had a layer of flexible sinew on the back of the bow, which snapped back into the non-extended state after the arrow was released. The different elements of the bow were joined together with strong animal or fish glue, then reinforced by being wrapped in silk, and finally birch bark was applied over the top as a barrier against damage. The bows were then painted and lacquered. It took up to three years to make a bow, as each part of the bow-making process had to be completed in the correct season, to ensure maximum durability, quality and functionality. The central folding mechanism of this bow would enable the archer to easily carry it.

1800–1900, China. Wood, lacquer, horn, iron, bark (cedar) and bone. L. 111 cm. British Museum, London, As,+.5454

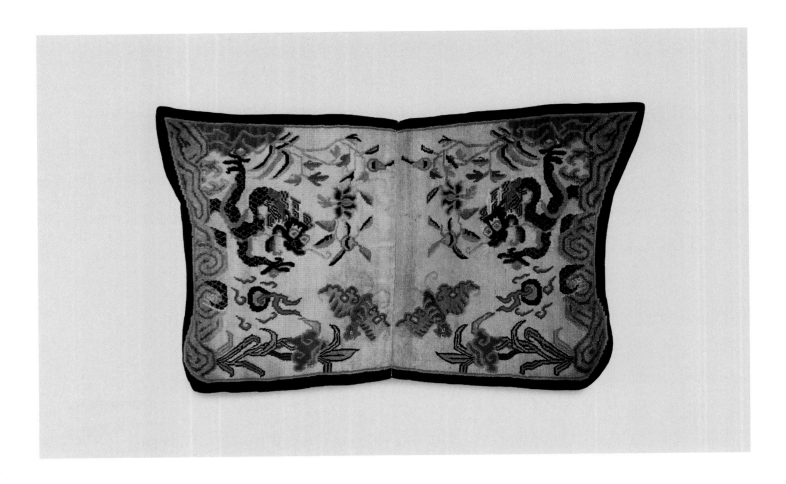

An illustrious example of the former profession was Wanyan Linqing 完顏麟慶 (1791–1846), a celebrated administrator and writer (fig. 2.9).

Below the banner forces, roughly three times as numerous but with less funding, was the Green Standard army (綠營兵), made up mainly of Han Chinese soldiers, its name deriving from the green flags that identified the units (fig. 2.10). It had been created during the Qing conquest as a means of absorbing the surrendered troops of the Ming dynasty while keeping them separate from the Manchus' own forces. By the 19th century there were about 600,000 Green Standard soldiers on the books, though fiscal corruption in the officer class meant that not all of those soldiers existed; some were mere fictions invented by commanders in order to pocket their salaries. In contrast to the celebrated bannermen, there was little glory to be found in serving as a soldier in the Green Standard – Qianlong, for one, openly disparaged them as cowards in comparison to the Manchus – and though they were not formally hereditary like the bannermen were, most

2.8
Under-saddle rug with dragons
This colourful rug is emblazoned with imperial emblems, butterflies and *lingzhi* fungus, but it was woven in Tibet for a rider from outside the imperial clan. In the 19th century, the use of the dragon motif was much more widespread outside the court than it had been in earlier eras. Before 1800, the Manchus and Mongols who administered the Qing empire's frontiers recorded information in their own languages and held a monopoly on frontier intelligence. However, after the Qianlong emperor's death in 1799 and in response to new crises, Han scholars published widely circulated essays on frontier geography and political affairs, a trend that continued until the end of the Qing dynasty.

1800–30, Tibet. Wool and cotton. H. 99 cm, W. 120 cm. The Teresa Coleman Collection, TB1989

2.9

**Wanyan Linqing, *Wild Swan Tracks
on Snow: An Illustrated Record of my
Pre-ordained Life* (鴻雪因緣圖記)**

Wanyan Linqing, a Manchu bannerman and
high-ranking official, wrote this book, which is
part travelogue and part diary. Between 1847 and
1850, his sons, Chongshi 崇實 and Chonghou
崇厚 put the finishing touches to the work and
had it printed in Yangzhou, with 240 engravings
by leading contemporary artists illustrating
episodes from their father's life. Linqing's
credentials are impressive. His family were
descended from the Jurchen imperial household
and he achieved the *jinshi* degree (the highest
possible) in 1809, aged just 18. He served
with distinction in the Hanlin Academy (the
government think tank for the empire's brightest)
and inner cabinet. The book shows how one man
used his travels to ruminate on and make sense
of his life. Linqing also wrote poetry and two
books on Yellow River conservancy, hydraulics
and dyke management. He assisted his mother
(pictured here next to Linqing, who stands by
the candlestick on the right) in the compilation
of *Guochao guixiu zhengshi ji* (國朝閨秀正始集),
an authoritative anthology of poems by women
writers of the Qing.

1847–50, Yangzhou. Printing ink on paper.
H. 30 cm, W. 18 cm; W. 43 cm (with foldout).
The John Rylands Library, University of
Manchester, Chinese Crawford 412

were recruited from the offspring of those who had
already served, for lack of better prospects.[2]

In a reflection of the mistrust the Manchu rulers
of the Qing dynasty felt towards the Han Chinese they
governed, the Green Standard forces were stationed
not as a unified army but as a vast constabulary with
disparate outposts scattered throughout the provinces.
They were broken into complex and conflicting
structures of command to ensure that a mutinous
Chinese commander could never unify them against
the Manchus who ruled from Beijing, but for that same
reason it was difficult to coordinate them in larger
campaigns. The Green Standard soldiers were poorly
paid and low in morale, their meagre salaries making it

2.10

**Green Standard army flag
with golden dragon**

Soldiers in the Green Standard
army were regarded and treated
as inferiors to the hereditary
Manchu bannermen. In the Green
Standard, officers rotated regularly,
so that personal loyalties could
not be easily formed. Their flag
features a four-clawed gold dragon
and pearl motif, surrounded by
clouds, with lightning flashes in

the border. This illustration comes
from the *Illustrated Regulations for
Ceremonial Paraphernalia of the
Present Dynasty* (皇朝禮器圖式), a
manuscript commissioned by the
Qianlong emperor; the main body
of the commission began in 1750
and was completed in 1759.

1759, Beijing. Ink and colours on
paper. H. 42.3 cm, W. 41.3 cm.
Victoria and Albert Museum,
London, 875&A-1896

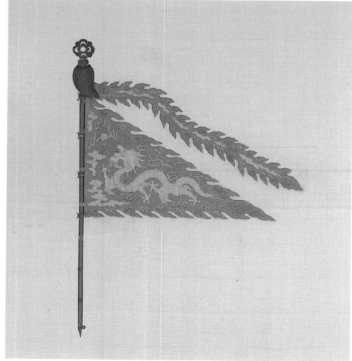

2.11

Military exercises

Men trained to use different weapons depending on whether they were in the cavalry or infantry. John Reeves (1774–1856), tea inspector for the East India Company from 1812 to 1831, commissioned Qing artists in Guangzhou to draw and paint flora and fauna, as well as subjects relating to popular religion, everyday life and occupations. The artists who created this set of images, which he also commissioned, paid meticulous attention to the uniforms and postures of the soldiers, and captioned them with the names of the weapons and activities shown:

trident (舞叉); double swords (舞雙刀); anvil lifting (舉大砧); musket shooting (打鎗); superintendence in the battlefield (督陣); advanced sword-fighting technique (打刀花); mounted archery (馬箭); long sword with curved blade (舞挑刀); long spear (打鎗); sword with shield (刀牌); infantry archery (步箭); and swallowtail-shaped shield (燕牌). 1800–30, Guangzhou. Ink on paper. H. 47.50 cm, W. 38 cm (each sheet). British Museum, London, 1877,0714,0.288-299, Ch.Ptg.413. Donated by Sarah Maria Reeves

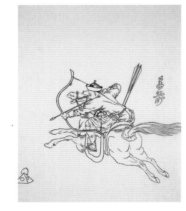
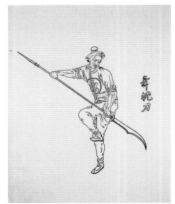
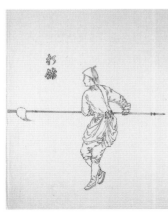
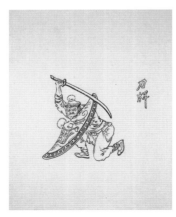

2.12 (right)
Curved steel sabre and ray-skin scabbard

This steel sabre has a scabbard of ray skin with metal fittings, and a hook for attachment to a belt. Its handle is made of wood, which is covered with cord binding, and its blade is thicker at the base. This weapon is typical of a type that was standard among Han officers from the Guangzhou area in the mid-19th century. As the academic James Bonk has proved, some sabres, which were passed down through the generations, were associated with family histories and had become objects of veneration by the early 19th century, even inspiring Han literati to write poetry about them. Later, some collected the swords of soldiers to whom they were not related but who had performed heroic deeds in battle. From the 1830s, they were collected to inspire Han Chinese pride in their martial traditions.

c. 1860s, China, probably Guangzhou. Ray skin, wood and steel. L. 80 cm. British Museum, London, OA+.7093

2.13 (far right)
Mace or sword-breaker with a spear tip, and scabbard

The Qing military trained elite groups of extremely physically fit men like modern-day commandos. The man who wielded this heavy weapon in battle would have been part of the Jianruiying or Scouting Brigade (健銳營), a small unit of specially selected Manchu soldiers. There were about 3,000 such fighters, hand-picked from the dynasty's vast standing army and employed on special operations. A weighty mace like this would have broken most metal swords, which were usually much thinner.

1750–1820, China. Steel, silver, gilding, ray skin, wood and black lacquer. L. 112 cm. British Museum, London, 1911,0407.21

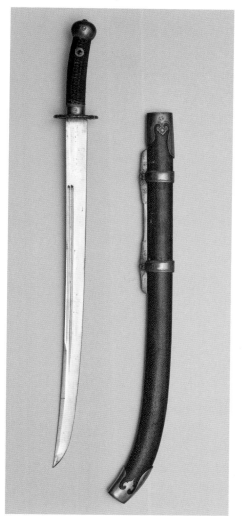
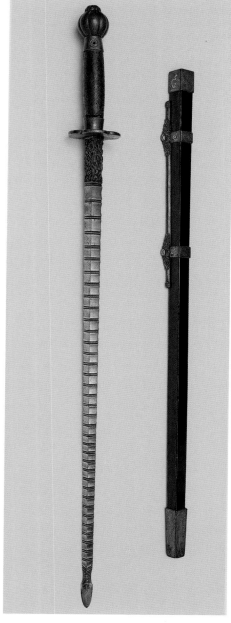

difficult to maintain or replace weapons (for which each soldier was personally responsible); by the early 1800s, many of their weapons were more than a hundred years old and their training exercises had changed little in centuries (fig. 2.11). Some carried swords so rusty they could barely be pulled from their scabbards, while others cherished out-of-date blades handed down from their forebears and worn with pride (figs 2.12–2.14).[3]

The first significant 19th-century test of the dynasty's armed forces was already under way when the century began. An uprising initiated by millennial Buddhist White Lotus sectarians had erupted in a mountainous region of west-central China in 1794 and by the year 1800 it was still uncontained (fig. 2.15). The emperor Qianlong had personally supervised the campaign until his death in 1799, but his final years of life coincided with the decline of his mental state. Without a strong and clear-headed ruler on the throne in Beijing, the officers who led the campaign against the White Lotus engaged in unprecedented levels of corruption, siphoning off massive amounts of funding, little of which was actually spent on fighting the rebels.

2.14

Group of three fancy short swords

These weapons are short *jian* (剑), double-edged straight swords, which were worn at the waist, suspended from a belt, and used for fighting one on one. Each is protected by a different, highly decorated scabbard. The green example is covered in shagreen, which is the untanned skin of a stingray. The mottled yellow and brown surface of the second example has a veneer of turtle-shell. The last bears the inscription 'Longquan' (龍泉), a place in Zhejiang province in eastern China famous for making weapons, but even better-known for its production of heavy, green-glazed ceramics.

1800–90, China

(Left to right)
Steel, brass and ray skin. L. 62 cm (in scabbard). British Museum, London, OA+.7428

Steel, horn, turtle-shell and brass. L. 60 cm (in scabbard). British Museum, London, 1892,1215.1

Brass, horn and wood. L. 60.3 cm (in scabbard). British Museum, London, 1878,1101.501. Donated by Lieutenant General Augustus W.H. Meyrick

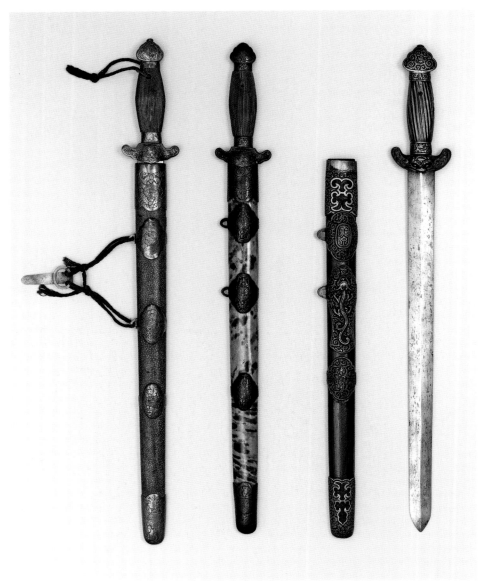

2.15

White Lotus Rebellion strategy map

Between 1796 and 1804, approximately 100,000 people lost their lives in loosely connected uprisings – inspired by popular Buddhist ideas and motivated in part by scarcity of resources and employment – which began on the borders of Henan and spread to the mountainous regions of adjacent provinces to the west. Sectarians who had associated themselves with popular 'White Lotus' teachings were responsible for small rebellions in the 17th and 18th centuries, and minority peoples of central China were more recently resisting Qing authority, so officials took these rebels very seriously. Jiaqing had encouraged the empowering of local militias alongside the Green Standard army to suppress these localised uprisings, but by doing so he arguably weakened Qing central control. A later branch of sectarian fighters broke into the Forbidden City and attempted to assassinate the Jiaqing emperor in 1813. The invasion, a short-lived but searing event, was repelled under the leadership of the future Daoguang emperor. This map shows coloured markers: yellow is for Hebei, red for Sichuan and pink for Shaanxi.

Jiaqing period, 1796–1820, Beijing. Ink and colours on paper. Palace Museum, Beijing

四營會哨

環山每年春秋兩次會哨拔兵三觀
寨一帥員弁齋集于箏巖浦駕
舟海上演炮合操贵赏為出奈吉狂
矩嚴日月全枝微三纪洋三教誠
太親山余為主人凞之赏牺勞

掌

2.16

Unidentified artist, *Album of an official career at land and sea*

Many graduates of the civil service exams were posted across the country to positions that included the supervision of troops. This illustrated album records the official postings of such a man (born in 1825), whose identity is as yet unknown. Places recorded in the album are all in the eastern province of Zhejiang. His activities include taking part in a celebratory feast with the army, inspecting the navy in exercises at sea,

admiring ancient inscriptions on stones, visiting a new school, sailing in the East China Sea and going to the Jingci temple (淨慈寺) on West Lake in Hangzhou to celebrate his 60th birthday and have sutras chanted for him.

Dated 1884, Zhejiang province. Ink and colours on paper. H. 40.4 cm, W. 134.5 cm. British Museum, London, 1938,1210,0.5.1-6. Donated by Mrs Alfred Wingate

In particular, they relied heavily on locally raised militias to fight in place of regular soldiers, wildly inflating their numbers until the militia salaries commanded most of the funding coming from the capital. Qianlong had refused to commit the elite Manchu banner forces to fight the White Lotus – to his mind, the bannermen were to be reserved for border wars and other territorial threats to the empire, not for the mere pacification of domestic uprisings – but he did give his Green Standard commanders nearly carte-blanche funding, and in return they gave him graft, dissemblance and reports of victories that never took place.[4]

After Qianlong's death, his son, the Jiaqing emperor, brought clear-minded leadership back to the throne and finally declared a successful conclusion of the White Lotus Rebellion in 1804 (though the sects themselves would continue). The suppression of the White Lotus did not mark the end of the dynasty's near-term troubles, however, for a separate threat had emerged along the eastern coastline while the Qing government was fully occupied inland. One of the long-standing misconceptions about China's military, dating from the 19th century, is that China was somehow inherently incapable of developing or maintaining effective naval forces (fig. 2.16). The basic fact was that China had not needed a seagoing navy for more than a century, and so it did not have one. After the Qing conquest of Taiwan in 1683, the dynasty had faced no meaningful

threats to its security from along the coast (fig. 2.17) – its major wars were all fought on land, primarily in Central Asia – so the Qing rulers naturally concentrated their financial resources on the maintenance of powerful land forces. The only need for coastal security was to control small-scale piracy, a task for which locally mustered self-defence forces funded by trading centres along the coast were usually quite adequate.

By 1805, however, a new threat had emerged along China's long eastern and southern coastline, in the form of an enormous coalition of pirate fleets that together was more than twice the size of the Spanish Armada. Local militias and Qing naval forces, such as they were, proved completely unable to match the strength of these fleets, which attacked at will up and down the coast and inland along major rivers (fig. 2.18). In the early 1800s, with the Beijing government's attention focused on the White Lotus Rebellion in the interior, the pirates were left to prey on the coastal Chinese cities almost without contest. They collected fees akin to taxes and roamed with impunity. It was only after the White Lotus rebels were suppressed that Jiaqing turned his full attention to the coast, where the dynasty's forces adopted a two-pronged strategy to suppress the pirates. Firstly, they began constructing more substantial and better-armed naval vessels, managed by more aggressive commanders than in the past, so as to fight the pirates head-on. Secondly, in light of the fact that the pirates were nominally subjects of

2.17
A coastal map of the seven provinces
(七省沿海全圖)
Commissioned by the Qing court in the late 1700s, this map has been described as a conceptual map of China's coast, because it is not scientifically plotted. Instead, it includes useful practical details on navigation and instructions for ships moving between eastern ports, recording distances between offshore islands, reefs and sandbars, as well as places vital for coastal defences. The Qing controlled the coast from the Bohai Sea, which was the nearest sea space to the Manchu homelands and the Qing capital at Beijing in the north, to the Guangdong coast in the south. Unusually, the land mass in this map is placed horizontally at the top, with the sea below painted in celadon-green watercolour, almost as a sailor would see it. In the early 19th century, Qing officials perceived the main threat to the coast as coming from pirates and natural disasters.

c. 1800–40, China. Ink and watercolour on paper. H. 34 cm, L. 960 cm (entire scroll). The British Library, London, Maps 162.o.2 f003r, f004r

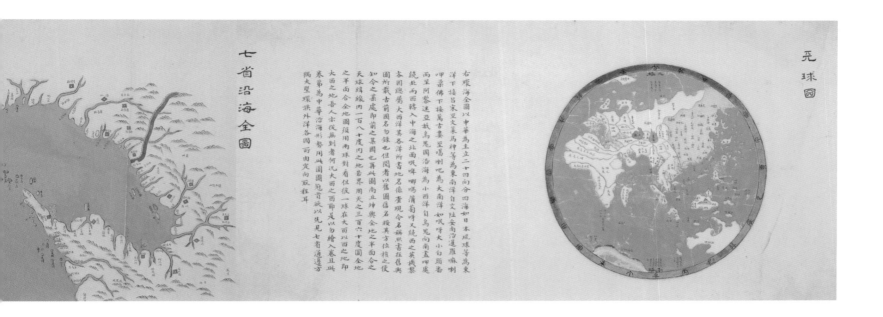

七省沿海全圖

坤輿全圖

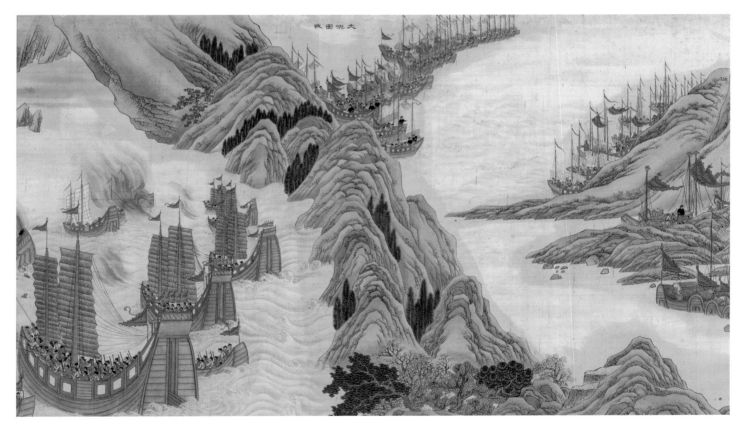

大團結戰

2.18

Unidentified artists, *Pacifying the South China Sea* (靖海全圖)

This scroll shows the southeastern coastline of Guangdong, which in the early 19th century was plagued by pirates and smugglers, who generally operated in large fleets with their families on board. Some were entrepreneurs, some were fishermen who were forced into a life of predation through misfortune, including suffering raids on their own homes. Shi Yang 石陽 (*c.* 1775–1844), for example, was arguably the most successful female pirate in history, in the early 1800s commanding 17,000 pirates on over 300 ships; when their families were counted, her pirate army totalled between 20,000 and 40,000 people.

To give a sense of her importance, the famous pirate Blackbeard's largest fleet consisted of just eight ships.

Jiaqing period, 1796–1820, China. Ink and colours on silk. L. 1820 cm, H. 58 cm. Hong Kong Maritime Museum, HKMM2004.0102.0001

the Qing empire rather than foreigners, the dynasty used offers of official appointments and financial rewards to lure the pirate commanders back to the side of the settled, peaceful population. Those who came back into the fold were then unleashed against their former brethren, and by 1810 the pirate scourge, as with the rebellion, was finally pacified.

It is notable that in both these crises of the early 1800s, Jiaqing was able to restore peace to the empire without need of any lasting transformations to the structure or equipment of the Qing military. If anything, the adequacy of the dynasty's existing armed forces had been reaffirmed. This restoration of confidence, however, would not serve the dynasty well in the long term. Once the suppression of the White Lotus and the pirates was complete, Jiaqing took stock of how much of the dynasty's wealth had been squandered through embezzlement and other forms of corruption during the war and responded by dramatically cutting back the funding of the military going forward. Jiaqing's austerity was beneficial to the empire's financial health in the short term, but it ensured that China would face the threats that were yet to come, both from abroad and from within its own borders, with even less military capacity than it had been able to muster in the past.

The First Opium War

After the pirate suppression, the coast of China was largely tranquil for nearly thirty years until a far more formidable threat arrived in the form of the British navy. The First Opium War of 1839–42 – the first war between Qing China and a Western European power – was a many-layered conflict that can be understood simultaneously as a war over trade, a war over drug smuggling and, most potently, as Britain's first imperial war in China (see pp. 19–20).

It began with trading tensions. British business, under the monopoly of the East India Company, had been conducted primarily on China's terms since the 18th century. In 1760, Qianlong restricted all British and most other European mercantile activity to the lone southern port city of Guangzhou (Canton), where there was a small compound of European-style buildings that the foreign merchants were allowed to inhabit during the trading season. From the standpoint

of the imperial government, the main reasons for restricting foreign commerce in this way were to protect the precious customs revenue from embezzlement by limiting the number of officials involved, and to forestall the possibility of disloyal Chinese subjects conspiring with foreigners against the interests of the dynasty. The foreigners who came to China to trade thus lived under extremely restrictive conditions and were forced to do business with a limited number of Chinese merchants who had monopoly privileges on the Qing side. Nevertheless, the trade at Guangzhou was one of the great economic engines of the early 19th-century world, supplying all the tea drunk in Great Britain – subject at times to taxation in excess of 100 per cent – and absorbing a great amount of the world's silver, which foreigners carried to China to exchange for their goods.

Tea was the primary product the British and Americans bought at Guangzhou, and they in turn sold it for considerable profit back home, but their greatest challenge was finding enough silver with which to buy it (fig. 2.19). Their situation became even more difficult after the outbreak of national revolutions in Latin America in the 1810s that shut down the world's richest silver mines and triggered a global silver shortage. There were a number of other products the foreigners could sell to the Chinese, but most were of limited supply or only of temporary demand and none commanded a market in China that could match the size of the British public's demand for tea. Nevertheless, as foreign dealers scoured the globe for products to sell, the effects of the China trade were felt far beyond China's own borders, in places such as the Pacific Northwest of the United States, where commerce in fur developed largely to supply China, as well as in islands of the South Pacific where battles were fought over resources such as sandalwood, used to decorate wealthy Chinese homes.

Ultimately, though, the East India Company found that the single product it could sell to Chinese buyers in seemingly limitless quantity was opium (fig. 2.20). Opium, long used as a medicine, was now illegal in China, though enforcement was lax and many of the officials responsible for preventing the trade were themselves complicit in it. Trafficking of the drug from British India to China developed into a vast international smuggling enterprise, with foreign merchants evading the confines of the

2.19
Unidentified artist, Tea-packing warehouse
This painting is from a set of 12 depicting the tea industry in China. It shows workers stamping on tea leaves in chests to maximise capacity, while a 'Hong' (行) merchant negotiates with a European buyer. These Hong merchants had the exclusive authority of the Qing government to trade with Europeans in Guangzhou between the late 18th century and 1842. China was the key supplier of tea to the entire world before about 1750. Such images idealised the conditions of working in such factories and were made in Guangzhou largely for sale to Western clients.

1800–20, Guangzhou. Watercolour and ink on paper. H. 40 cm, W. 54 cm. Victoria and Albert Museum, London, D.357-1894

2.20
Ball of opium
Poppies from which raw opium was extracted were grown in British India on an industrial scale. The processed drug was transported to China on company ships in large balls that were stamped with the official East India Company logo. In April 1840, William Gladstone (1809–1898) (see fig. 6.5) declared to the British Parliament of the First Opium War: 'a war more unjust in its origin, a war more calculated in its progress to cover this country with permanent disgrace, I do not know …'

1800–42, India. Opium. Diam. 20 cm (approx.). Science Museum, London, Wellcome Trust Collection, Materia Medica & Pharmacology, A657506

Canton trade by sailing the coast of China illegally to connect with Chinese criminal guilds, who in turn took responsibility for the distribution and sale of the drug within the country. The 'Honourable' East India Company produced and packaged opium wholesale in India, while growers in free states of India outside British control produced their own opium to compete with the Company's. The competition between the two sources would increase the supply of opium to China dramatically in the 1820s and 1830s even as it drove prices down. Throughout, however, it was the East India Company's 'Patna' opium – branded, unabashedly, with the Company's own seal – that commanded the highest price from wealthy drug users in China (fig. 2.21).

In 1838, the Daoguang emperor (son of Jiaqing and grandson of Qianlong) finally set his will on the suppression of opium and he deputed a high-ranking Chinese scholar-official named Lin Zexu (fig. 2.22) to travel down to Guangzhou in order to shut down the illegal traffic for good. Lin Zexu arrived in March 1839 and almost immediately took action against the

2.21
Lithograph after Walter Stanhope Sherwill, *A busy stacking room in the opium factory at Patna, India*
This image appeared in *Illustrations of the Mode of Preparing the Indian Opium Intended for the Chinese Market, from Drawings by Captain Walter S. Sherwill*. It shows only part of a vast room and the book tells us that 450 people worked there. 300,000 cakes of opium, valued at £900,000 at the time, were stored in the room the day the illustration was made.

1851, London. Lithograph. H. 20.2 cm, W. 27.6 cm. Wellcome Library, London, no. 25037i

2.22
Fa Kunhou 法坤厚 (n.d.),
Lin Zexu examining a
sword and drinking wine
(林則徐看劍引杯圖) (detail)
A talented administrator and versatile troubleshooter, scholar-official Lin Zexu is best remembered today for his role in the First Opium War. In 1838, the Daoguang emperor concluded that opium addiction was poisoning the empire and enfeebling the army, and that a crackdown on the illegal drug – brought to China by British and American merchants – was necessary. He commissioned Lin Zexu to eradicate foreign opium importation through the city of Guangzhou. In 1839, Lin wrote to Queen Victoria denouncing British involvement in smuggling and destroyed the city's opium stocks by mixing the drug with lime and flushing it out to sea. In response, the British Whig Cabinet decided to dispatch a fleet to China. In 1840, the imperial court exiled him to Ili, Xinjiang, as punishment for his perceived failings in handling the British, but soon recalled him to active service. He died en route to southwest China, where he had been sent to suppress the early stages of the Taiping war.

c. 1800–50, China. Ink and colours on paper. H. 34.5 cm, L. 127.8 cm (entire scroll). Palace Museum, Beijing, Xin00121676

British, surrounding the foreign trading compound with Chinese troops and demanding that the British merchants hand over for destruction all the opium in their possession. Holding firmly to the moral high ground, he wrote a letter to Queen Victoria (which the recently enthroned young queen herself likely did not read, though it was translated in *The Times*), in which he listed all the beneficial products China sold to the British and other foreign traders at Guangzhou, asking her: 'By what principle of reason, then, should these foreigners send in return a poisonous drug, which involves in destruction those very natives of China?'[5] The British merchants ultimately capitulated (after the British superintendent of trade promised them that their government would make good for their losses) and they handed over more than 20,000 chests of opium – well over a thousand tonnes of the raw drug, representing a value of £2 million. Lin Zexu promptly had it destroyed and flushed out to sea.

The British government responded by dispatching a war fleet. In the course of the three years of sporadic fighting between Chinese and British forces that followed, the Qing military would prove completely incapable of defending China's cities against the ships and guns of the British. In the negotiations that ended the war in August 1842, a Qing imperial envoy agreed to the Treaty of Nanjing – the first of what would be known as China's 'unequal treaties' with foreign powers (figs 2.23–2.24). Negotiated entirely on Britain's terms, the treaty imposed a series of humiliating concessions on China, among them the forced opening of five cities to British trade (a privilege that soon would be extended to other Westerners as well), and the payment of a large cash indemnity to reimburse the British for their expenses in waging the war as well as paying for all the opium that Lin Zexu destroyed.

One article the treaty did not include, however, was the legalisation of the opium trade – for even the most

2.23

Signature page of the Treaty of Nanjing

This treaty, signed on board HMS *Cornwallis* on 29 August 1842 while it was anchored off Nanjing, marked the end of the First Opium War. Here we can see the signature of the plenipotentiary in China and superintendent of British trade Henry Pottinger (1789–1856) and the wax impressions of the official seals. It was an unequal treaty between the Qing and foreign powers which put an end to the 'Canton System', whereby European and American traders were restricted to a small compound outside the major port city of Guangzhou (Canton). Guangzhou, as well as four other 'treaty ports' – Amoy (Xiamen), Fuzhou, Ningbo and Shanghai – were opened to the British empire by the treaty. It also ordered the Qing to pay Mex\$21 million (in instalments, over three years) as an indemnity to the British government and to cede the island of Hong Kong (which remained under British rule until 1997). The treaty was ratified by the Daoguang emperor and Queen Victoria, and ratification was exchanged in Hong Kong on 26 June 1843.

29 August 1842, Nanjing. Ink and wax on paper. H. 33.9 cm, W. 21.6 cm, D. 2.5 cm (closed). The National Archives, London, FO 93/23/1b, folio 13

adamant of the war's British proponents did not wish to acknowledge that it had been fought for the sake of drug smugglers. The British government had insisted throughout that the war in China was instead a war of honour, to protect the merchants at Guangzhou whom Lin Zexu had allegedly threatened with physical harm. The war's many critics in Great Britain, however, saw through the government's charade and pointed to the moral depravity of the opium trade, which they insisted was the true basis of the conflict. Significantly, the derogatory name of 'Opium War' was coined originally as an English phrase, used by *The Times* and other British critics of the war; it did not become common usage in China until the 20th century.[6] In any case, even though the Treaty of Nanjing did not formally legalise the opium trade, once the war was over the sale of opium continued growing apace.

The tragic mismatch between Chinese and British forces in the First Opium War was shocking not only because the British had been operating so far away from their home country (even their bases in India and Singapore were at some distance), but also because of China's enormous numerical advantage. In launching the war, Great Britain sent a relatively small fleet and a few thousand soldiers

to challenge the most populous empire on earth. But the British, as it turned out, possessed technological advantages that proved absolutely decisive. Only after the war did influential translations of Western books on military equipment and tactics begin to be published in China (fig. 2.25).

China and the nations of Europe had in fact been on relatively equal footing militarily in the early part of the 18th century, but after that they diverged widely. From 1760 to 1830, the heartland of China experienced an era of unprecedented peace, suffering fewer wars than in any period of its history going back to AD 900, and so there seemed little reason for officials to adopt newer, more expensive kinds of weaponry or seek ways to transform how they trained their soldiers.[7] Meanwhile, the Europeans had spent much of the same period improving their own ships, weapons and military tactics in the face of ongoing warfare in the western hemisphere. The very strength and power of the Qing dynasty in the 18th century would thus become a liability in the 19th, for by the time the First Opium War began, Britain's Royal Navy – recently victorious over Napoleon – was the largest and most advanced naval power in the world, while China possessed no modern naval forces to speak of.[8]

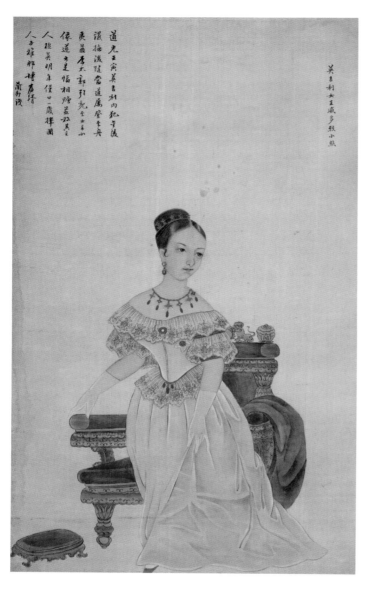

英吉利女主威多烈小照

2.24

Unidentified artist,
Small portrait of Queen
Victoria of England
(清人畫英吉利女主威多烈小照)

Qing officials were fascinated by the fact that, following the ascension to the throne of the young Queen Victoria in 1837, the British empire was ruled by a woman. After the signing of the Treaty of Nanjing in 1842, a Chinese artist from Guangzhou made a painted copy of a British print and inscribed it: 'In the *renyin* year of Daoguang reign (1842), the United Kingdom invaded Jinling [present-day Nanjing]. After negotiation and submission, our responsible official boarded their boat several times. The foreign chief, George Tradescant Lay 李太郭 (1799–1845), showed him a small portrait of his Queen, and gave it as a gift. He also praised his Queen as very talented, only 21 years old and having chosen a compatriot, Prince Albert (雅那博), as her consort. [Signed] Lan Dunqian (道光壬寅,英吉利內犯金陵。議撫後,隨 當道,屢登其舟。夷酋李太郭, 引觀其女主 小像,遂出是幅相贈,並稱其主:人極英 明,年僅廿一歲,擇國人子雅那博為壻。 蘭頓淺英吉利女主威多烈小照). Images of Chinese emperors, by contrast, did not circulate in private hands, and a portrait of a female ruler was undoubtedly quite a curiosity.

1842, Guangzhou. Ink and colours on silk. H. 200 cm, W. 57 cm (scroll); H. 71 cm, W. 43 cm (painting). British Museum, London, 1954,1009,0.14. Donated by E. Brake

In terms of equipment, China's troops at the time were armed predominantly with pre-industrial weapons: swords, bows and arrows, spears, and rattan or bamboo shields and helmets (see fig. 2.55). Only a third of soldiers carried guns, most of which were matchlock muskets built to a design dating from the 17th century that required the shooter to light a pan of gunpowder manually (figs 2.26–2.28). By contrast, the British troops carried flintlock and percussion-cap rifles and light field guns that were more accurate, more reliable and far quicker to fire. In naval engagements, Britain's ships carried new, highly destructive carronades that could fire with much greater rapidity than the cumbersome and inaccurate 17th-century bronze cannons in Chinese forts. The British used exploding shells and Congreve rockets that had never been seen before in China, as well as more powerful gunpowder. Most intimidating of all to China's defenders, the British sent in their first iron-clad, steam-powered warship, the *Nemesis*, which was virtually impervious to Chinese cannons (fig. 2.29).[9]

Furthermore, all the major engagements of the war took place at sites accessible by water, playing always to Britain's greatest advantages. Britain's land forces were not nearly so invincible once they were separated from their ships – witness the fact that, at the same time Britain's naval forces were pounding their way up and down the Chinese coast with impunity, 5,000 kilometres to the west an entire British army under

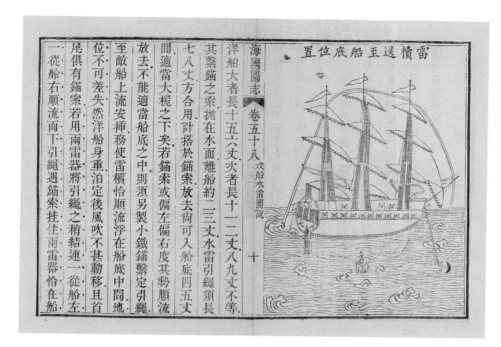

海國圖志 卷五十八 攻船水雷圖說 十

雷櫝送至船底位置

Wei Yuan and others, *Illustrated Treatise on the Maritime Kingdoms*

After the First Opium War, Western writings were translated into Chinese and gained in readership and authority. This 1844 book is regarded as the first significant Chinese work on the modern West and one of the key intellectual responses to the war. Compiled by scholar-official Wei Yuan and others, it is a substantial publication of 100 chapters, with maps and specific geographical details of both the western and eastern hemispheres. It includes observations about foreign customs, such as the dining habits of British and American people, based on initial translations of Western-language books and newspapers. Lin Zexu, famous for destroying the opium confiscated from the British, had originally commissioned the translations in the late 1830s. This page illustrates a Western ship and discusses the deployment of submarine mines (visible to the foreground of the vessel). The preceding pages in this section contain text and descriptions relating to the construction of such mines.

First published 1844, this edition 1849, possibly Yangzhou. Printing ink on paper. H. 29.2 cm, W. 18.6 cm, D. 5.3 cm (closed). The British Library, London, 15275.a.5

2.26

Musket with leather straps, pouch and fuse

A horseback musketeer would have used this highly effective weapon in battle. Although gunpowder was first invented in China, in the early 19th century the Qing military largely restricted its use in warfare to cannon. Their traditional enemies were the nomadic peoples of the steppes, who moved quickly on horseback, against whom muskets were less effective than archery, and whom the Qing had mostly absorbed into their imperium during the 18th century. This gun still has its leather pouch for the fuse attached.

c. 1820–60, China. Metal, wood and leather. L. 129.5 cm. British Museum, London, OA+.14236.a-c

2.28

Lacquered wooden powder flask

Originally, this flask would have been worn at the waist and filled with gunpowder. It is shaped like a horn but carved in openwork on one side with a design of plum blossoms and two birds; the side that rested against the body was smooth and it has a lion carved on the top. This flask is inscribed: 'Hunting in the spring and summer, [X] the result relies on effort (蒐苗[X]狩賴君功)'. ([X] denotes a character that cannot be read.)

1800–1900, China. Wood, lacquer and gilding. H. 11 cm, L. 24.2 cm, D. 5.2 cm. Private Collection – Wah Lee

2.27

Percussion musket

This 19th-century percussion musket was part of a tradition of Chinese weapon production stretching back nearly 300 years. It has a right-angled stock, of a shape and decoration similar to Ming-dynasty matchlocks. Soldiers still used matchlocks, alongside flintlock and percussion guns, as late as the Second Opium War of 1856–60. This gun is a luxury example, as it has imported ivory mounts and a barrel inlaid with silver and brass to create a plum-blossom pattern. An incised and red-stained inscription on the ivory butt in Chinese characters told the shooter what size and type of ammunition to use.

1800–84, China. Wood, metal and ivory. L. 142.7 cm. Pitt Rivers Museum, Oxford, 1884.27.4622G

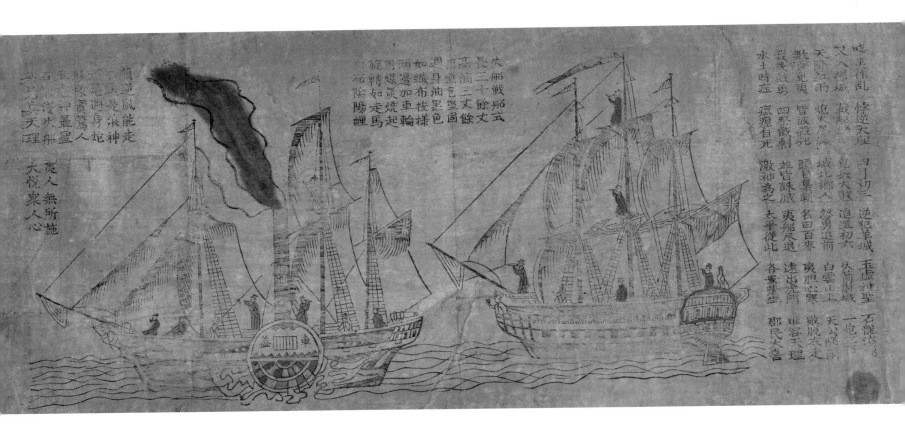

William Elphinstone was massacred in the mountains of Afghanistan as it retreated from Kabul. The Daoguang emperor, however, did not consider the coastal hostilities in distant Guangzhou significant enough to merit the risk of drawing the British forces inland, away from the reach of their naval artillery. If he had, then the course of the fighting might have gone differently.

As it was, the lopsided violence was horrific to all concerned. One British officer's journal described the actions of his own men as 'barbarous' and 'disgraceful', while in 1842 the admiral of the British fleet asked to be spared from attacking any more cities, as the slaughter of civilians was simply too gruesome to stomach. There was no honour to be found in combat that often seemed little more than murder.[10] Perhaps no episode in the entire war better captured the sheer, tragic one-sidedness of the fighting than a battle at the city of Ningbo, where British forces set up a light howitzer in a narrow alleyway, into which thousands of Qing forces rushed – among them 700 Sichuan troops dressed in textiles painted to resemble tiger skins and who, due to a miscommunication, did not even carry firearms, only knives (figs 2.30–2.32). The British blasted their howitzer into the Chinese soldiers from

2.29

Unidentified artist, *British barbarians cause chaos* (英夷作亂)
These East India Company ships are the iron-steamer, *Nemesis*, and a man-of-war, both of which are manned by small figures in the rigging and on deck, some with telescopes and others smoking pipes or maintaining cannons. There is a poem printed in Chinese and a handwritten English translation. The poem imagines a spectacular Chinese victory over the English in the First Opium War, describing events from a Chinese perspective: 'With Heaven on the Chinese side, divine intervention drove the English warships aground in a storm. Brave Chinese fighters ensured the invaders were killed in their hundreds. After the battle, many foreigners succumbed to diseases and perished.' The last part of the poem focuses on the *Nemesis*, which was encased in iron with a paddle wheel on each side, powered by coal and able to move with or without sails like a 'galloping horse', no matter what the wind's direction was. Although the poet admires the innovative technology that created the vessel, he sees the victory as a moral one – the gods drove *Nemesis* onto the rocks and the cowardly British soldiers ran away. In reality, no such Chinese victory took place.

c. 1841, probably Nanjing. Ink on paper.
H. 12.4 cm, L. 29 cm. The British Library, London, Or.70.bbb.16

2.30
Zhou Peichun 周培春 (active 1880–1910), Tiger soldiers
This image was signed and painted by Zhou Peichun, whose studio created albums of daily life in the closing decades of the Qing dynasty. It shows two soldiers, dressed as tigers, in martial positions and the explanatory captions read: 'This is the stance of leaping tiger with rattan shield' and 'This is the stance of fighting tiger with rattan shield'.

1880–1910, Beijing. Watercolour and ink on paper. H. 24 cm, W. 35 cm. British Museum, London, 1938,1210,0.7. Donated by Mrs Alfred Wingate

2.31
Tiger-face rattan shield
This shield, painted with the face of a tiger and the character 王, meaning 'king', presented a bold face towards the enemy. Shields like this one were produced for more than two centuries between about 1700 and 1900, with minor variations over that period. William Alexander, a British draftsman, painted images of soldiers with similar shields when he accompanied Lord Macartney as part of the First British Embassy to China and published one of them some years later in 1805 as 'A Soldier of the Chinese Infantry'. Such shields also feature in early 20th-century battles, testifying to the longevity of their design.

1860–83, China. Rattan, paint, iron, brass, hide and wood. Diam. 96 cm (approx.). British Museum, London, As1905,0118.5

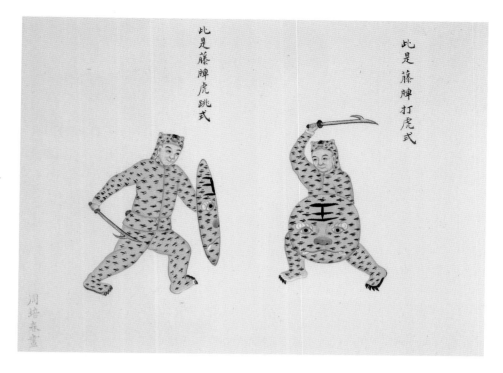

fewer than 20 metres away, with the wounded piling on top of the dead until they built up into such a mass of writhing, helpless, bloodied humanity that no more Qing soldiers could advance, and the British gun could find no more targets.[11]

The Taiping Civil War

The First Opium War has traditionally occupied centre stage in foreign histories of China for the simple reason that it involved Great Britain but, in the grand scheme of China's 19th-century military history, it was utterly dwarfed in significance and scale by the domestic conflict that convulsed China roughly a decade later: the Taiping Civil War, characterised at the time as a 'rebellion', and which caused upwards of 20 million deaths and nearly toppled the Qing dynasty. There were connections between the two conflicts. The region of South China where the Taiping originated had suffered from severe economic depression after the First Opium War, when much of the profitable foreign trade that had employed multitudes of labourers in Guangzhou and its environs shifted northwards to the new treaty port of Shanghai, leaving steep unemployment in its wake. The continued rise of the opium trade went hand in hand with a rise in criminal activity and loss of government

2.32
Soldier's tiger hat
Units of highly trained foot soldiers in the imperial Qing army wore hats, tunics and trousers with tiger-stripe markings in the 18th and 19th centuries. This hat was acquired by Captain (later Colonel) Francis Garden Poole (1870–1950) during the Boxer War. Very few examples of this uniform survive.

c. 1900, Beijing. Painted cotton. H. 44 cm, W. 52 cm (when flat and open), W. 25.5 cm (mounted, closed at front), D. 19 cm. National Army Museum, London, NAM. 1963-11-67-2

control over local society. Separately, competition between Han settlers and non-Han minority groups in overpopulated Guangxi and Guangdong provinces gave rise to violent social conflict in the region.

In this environment of social decay and economic hardship, a young man of the Hakka minority in Guangdong Province named Hong Xiuquan (fig. 2.33) had been preparing diligently for the Confucian civil service exams (see pp. 21–2). Hong was an exceptionally promising student from a poor family, and he had seemed bound for success but in the bitter competition for the limited numbers of provincial-level degrees, he failed the civil service examination several times in a row and eventually suffered a nervous breakdown. He slipped into a coma, from which he emerged with a belief that he was the son of the Christian God – the younger brother of Jesus Christ – with a twofold mission to destroy Confucianism and build a new Christian kingdom in China, and to topple the Manchu 'demons' who occupied his country and return it to the control of the Chinese.

Hong Xiuquan's uprising began from a core of his religious converts, and at its outset in 1851 it is best understood as a sectarian revolt largely made up of members of the Hakka minority. Hong proclaimed the founding of his own dynasty, the Heavenly Kingdom of Great Peace, or Taiping Heavenly Kingdom (太平天國), which grew and gained momentum as it absorbed downtrodden Chinese from other ethnic backgrounds – those who felt they had nothing to lose by following the rebels – and it soon exploded into a fully fledged rebellion with an army of tens of thousands of Chinese peasants wielding mostly home-made weapons, barrelling northwards through the walled cities of Guangxi and Hunan provinces, gathering more weapons and converts with each victory.

At the beginning of the war, the task of controlling the rebellion fell to the Green Standard army, but its complex structures of competing authority made it nearly impossible to coordinate an effective defence against a highly mobile peasant rebellion. Accounts from the early part of the conflict describe Green Standard forces collapsing in the face of the Taiping onslaught, the soldiers either deserting or, in many cases, joining up with the rebels. And, as it turned out,

Key figure: Hong Xiuquan (1814–1864)

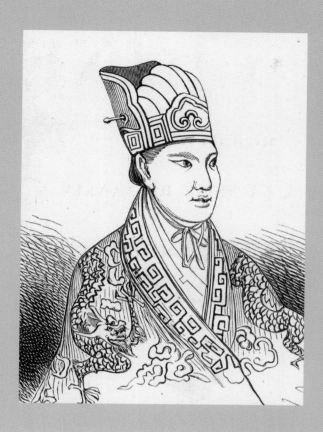

2.33
Unidentified artist, *Portrait of Hong Xiuquan*

A Hakka village schoolmaster and failed examination candidate, Hong Xiuquan was exposed in his early 20s to Christian teachings through a Chinese-language missionary pamphlet. After suffering a nervous breakdown during the late 1830s, he grew convinced that he was the younger brother of Jesus Christ, and appointed himself Heavenly King, effectively first emperor, of the Taiping. He formally declared war against the Qing in Guangxi in 1851; at its greatest extent, his Taiping Heavenly Kingdom occupied much of eastern China, with its capital in Nanjing. Women fought alongside men in the Taiping army, which was fervently anti-Manchu. In this protracted civil war, between 20 and 70 million people perished, and many more were displaced from their homes. No original authentic image of Hong Xiuquan survives, as sympathetic or original records of the Taipings were eradicated after they were vanquished. This imaginary rendition of Hong was used as the frontispiece of the book *History of the insurrection in China (L'insurrection en Chine depuis son origine jusqu'à la prise de Nankin)* by Joseph-Marie Callery (1810–1862) and Yvan Melchior-Honoré (1806–1873).

1853, Paris. Printing ink on paper. Bodleian Library, Oxford, (OC) 246 c. 83, frontispiece

even the elite banner forces were unable to contain them. In March 1853, an army of more than half a million Taiping followers captured the grand city of Nanjing – the original capital of the Ming dynasty – where they massacred the entire Manchu garrison army and proclaimed the city to be the capital of their Heavenly Kingdom. They held the city for eleven years before being finally and decisively overwhelmed by the Qing counterattack (fig. 2.34).

From 1853 onwards, what had begun as an explosive and fast-moving religious uprising transformed into a long and gruelling civil war between two powers battling for control of the country. Up north in Beijing (its name meaning literally 'northern capital'), the Qing government remained on the throne, while in Nanjing (the Ming-dynasty 'southern capital') the Taipings under Hong Xiuquan asserted their own dominance over some of the wealthiest and most densely populated provinces of eastern China. They cast themselves as a new kind of dynasty – holding exams, minting coinage (fig. 2.35), wearing dragon robes and accessories (figs 2.36–2.38), casting guns (fig. 2.39) and otherwise replicating many of the features of a traditional Chinese government (figs 2.40–2.43) – while promoting their own individual new religion based on Christianity (fig. 2.44).

The Taiping Civil War posed an existential threat to the Qing dynasty, but the government's insulation up in Beijing – which Taiping armies did not reach – ensured that loyal subjects throughout the empire would still look to them as the legitimate government. But even as the Qing rulers remained safe from Taiping attack in Beijing, the Taipings were not the only threat they faced. In 1856, well into the Taiping campaigns, the British and French took advantage of the dynasty's weakened state by finding excuses of their own to go to war against the Qing government, in what is often called the Second Opium War. At the climax of this conflict in 1860, a joint British and French expeditionary force carved a path overland to Beijing, smashing the elite banner forces of the capital who tried to stop them. The reigning emperor, Xianfeng (see fig. 1.10), son of Daoguang, fled into hiding as the foreign armies advanced.

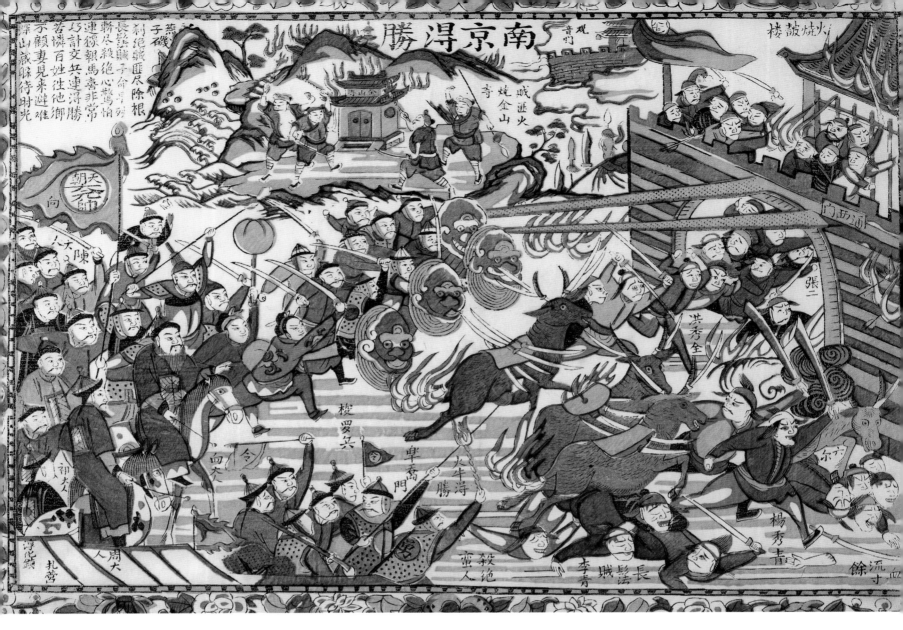

2.34

Popular print showing the defeat of the Taiping

The Taiping rebels made Nanjing their capital in 1853. This provincial
metropolis and former Ming-dynasty capital on the Yangzi was fortified by
a 37-km outer wall. In this print, we see the rebels making their last stand
in the summer of 1864, surrounded and under siege by the Hunan Army
led by Zeng Guofan. Hong Xiuquan is labelled by name and shown fleeing
from the Hunan troops; he had actually died a few months earlier, but Qing
authorities dug up the body and destroyed it.

c. 1864, China. Ink on paper. H. 35 cm, W. 46 cm. SOAS University of
London, CWP 12

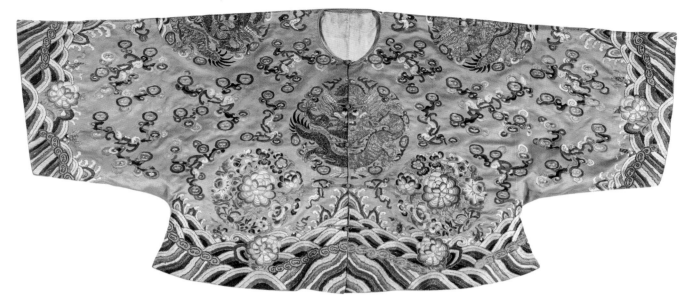

2.35 (below)
Gold Taiping Heavenly Kingdom coin
Ambitious to replace the Qing, the Taiping
distanced themselves from less radical rebellions
within the empire. As an aspiring state, they
cast their own coins in Nanjing, their capital.
The characters on this example read 'Taiping
Heavenly Kingdom (太平天國)' and 'Sacred
Treasure (聖寶)'. As part of their attack on the
Qing, the Taiping interrupted supply lines for
the metal used in Qing coins, thus disrupting
payments to the army and grain shipments that
provisioned urban centres in the north.

1860, Nanjing. Gold. Diam. 2.7 cm, weight 8.7 g.
British Museum, London, 1980,0801.1

2.36 (above)
Taiping imperial riding jacket (馬褂, *magua*)
Clothing used by the kings of the Taiping
Heavenly Kingdom is rare, but a few examples
survive. One imperial riding jacket is in the Taiping
Heavenly Kingdom Museum in Nanjing; another
is in National Museums Scotland in Edinburgh;
and a third is in the Royal Engineers Museum in
Kent, England. This one, held at the Cincinnati
Art Museum, was taken by the Hunan Army
General Xi Baotian 席寶田 (1829–1889) in October
1864, when he fought against the remnants of the
Taiping army in Jiangxi and captured the young
king Hong Tianguifu, Hong Xiuquan's eldest son.

The jacket is made of imperial yellow satin, and
its front, back and shoulders are embroidered
with a five-claw dragon. The whole jacket is
covered with images of bats and auspicious
cloud patterns, featuring bright colours and
exquisite craftsmanship.

1860–64, Nanjing. Embroidered silk. H. 61 cm,
W. 135.9 cm. Cincinnati Art Museum, 1929.170

2.37–2.38 (right)
Hood and boots for a Taiping king
This hood and pair of boots, made for a member
of the Taiping court, were of embroidered yellow
silk and white silk embroidered with five-clawed
dragons. Yellow was a colour reserved exclusively
for the Chinese emperors and the dragon
emblem was a traditional sign reserved for the
imperial family. These items were brought back
from China by Charles Gordon (1833–1885), who
helped fight the Taiping alongside Qing armies.

1860–64, Nanjing. Embroidered silk. H. 56 cm
(hood); H. 40.5 cm, W. 27 cm (boots). Royal
Engineers Museum, Kent, GGC284, 8201.1.23

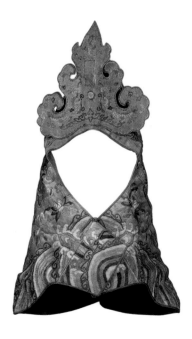
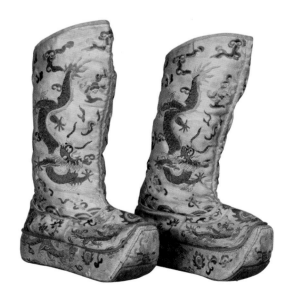

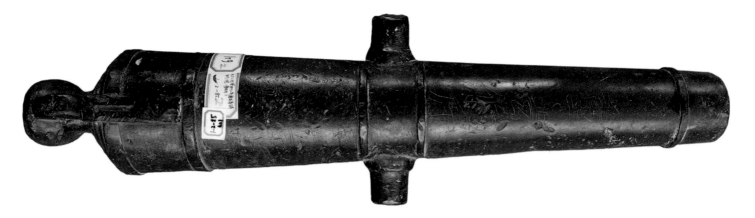

2.39
Bronze cannon of the Taiping Heavenly Kingdom
This cannon was cast with an inscription dating it according to the calendar of the Taiping Heavenly Kingdom. It is significant as it shows the Taiping had control of their own foundries and metal supplies, and that they had created their own calendar like a rival dynasty. Between 1853 and 1864, British and French smugglers supplied the Taiping army with foreign weapons which Taiping soldiers used in addition to those captured from the Qing.

1863, Nanjing. Bronze. L. 87.6 cm. Taiping Heavenly Kingdom History Museum, Nanjing

2.40
Taiping soldier's seal
All authority in China required seals for authentication. This wooden seal is carved with two five-clawed dragons chasing a flaming pearl that emerges from waves. It has been dipped into red seal paste and used. The inscription reads: 'Commander of the Left Rear Battalion of the First Central Battalion of the Army of the Taiping Heavenly Kingdom in Jiading county, Suzhou (太平天國軍蘇福省嘉定縣中壹營左營後旅帥)'. The seal came to Exeter just five years after the Taiping rebels were defeated, through the donation of Sir Walter Henry Medhurst (1822–1885), who was the British Consul in Shanghai.

c. 1851–64, Suzhou. Wood. H. 9.6 cm, W. 4.5 cm, D. 2.3 cm. Royal Albert Memorial Museum & Art Gallery, Exeter, E.1571

2.41
Hong Xiuquan's imperial decree
Another emblem of the Taiping's imperial claims, this is Hong Xiuquan's reply to a memorial submitted in 1861 by several high-ranking Taiping officials on behalf of British officer Aplin's request to present himself before the Taiping emperor's throne. 'Aplin' was Commander Elphinstone d'Oyley d'Auvergne Aplin (1821–1882) of HMS *Centaur*, who negotiated directly with the Taiping to ensure that Shanghai and British shipping and trade interests there were not attacked. Hong praised Aplin for being considerate and sent his regards. Most of the content of the decree is rather general, noting that God the Father, Jesus and Hong Xiuquan had brought peace to the earthly world, and that Taiping rule would last for thousands of years.

1 June 1861, Nanjing. Ink on silk. H. 105 cm, W. 78 cm. The British Library, London, Or. 12501 f001v

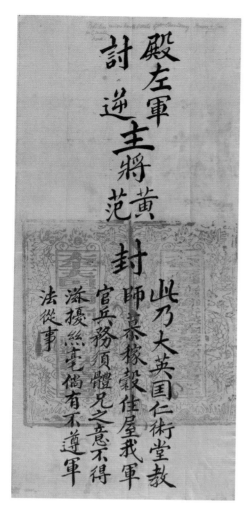

殿左軍
討逆主將范黃

封

此乃大英国仁術堂教
師慕稼穀住屋我軍
官兵務須體兄之意不得
溂擾絲毫倘有不遵軍
法從事

2.42

Taiping document forbidding destruction

This document with a prominent Taiping seal in red was pasted onto the house of a British missionary in Hangzhou by Taiping leaders, so that it would not be destroyed when their army occupied that city. It is inscribed in pencil: 'Protection under hand and seals of the Zhu Jiang [主將, Commanders] Huang and Fan for G. Moule's house.' Huang Wenjin 黃文金 (1832–1864) and Fan Ruzeng 范汝增 (1840–1867) were prominent figures in the Taiping movement, who were later promoted to 'Kings' and killed in battle. They are both mentioned in a vivid narrative written by Archdeacon A.E. Moule, which relates the circumstances in which this document was created.

1851–64, Hangzhou. Printing ink and pencil on paper. H. 54 cm, W. 25 cm. Cambridge University Library

2.43

Hong Xiuquan's handwriting

A letter by the British missionary Joseph Edkins (1821–1905) (its first page depicted above) was corrected in red ink by Hong Xiuquan. Edkins wrote in large script because Hong's eyesight was failing and he refused to wear spectacles. In one of his corrections, Hong strikes the word 'only' from a description of Jesus as 'the only begotten Son'. In contradiction to orthodox Christian doctrine, he writes: 'Christ and I were begotten by the Father'. There is a second page with Hong's comments.

1861, Nanjing. Ink on paper. H. 33 cm, W. 41.3 cm. The British Library, London, Or. 8143

2.44

The Taiping translation of the Bible's Books of Genesis and Exodus

Hong Xiuquan, founder of the Taiping, believed he was the non-divine, younger brother of Jesus Christ. Hong had Chinese editions of the Taiping Bible printed in the capital Nanjing. These volumes were stamped with a Taiping 'imperially approved' seal and Taiping imperial dragons, and used dates from the Taiping calendar.

1853, Nanjing. Ink on paper. H. 26.2 cm, W. 30.2 cm. The British Library, London, 15116.b.8 Imperial seal

2.45

Friedrich Wilhelm Keyl (1823–1873), *Looty*

Thought to have belonged to the Qing emperor, Looty was the first of what became known as 'Pekingese' dogs in Britain. He was brought back from China after the Second Opium War in 1860, having been taken in the looting and burning of the Summer Palace by Captain Dunne of the 99th Regiment, and presented to Queen Victoria in April 1861. Foreign soldiers, including British ones, were particularly keen to acquire personal items belonging to the emperor and his family. As the *London Illustrated News* of 1851 reported: 'Looty is considered by everyone who has seen it the smallest and by far the most beautiful little animal that has appeared in this country.' Captain (later Admiral) Lord John Hay (1827–1916) brought back four more Pekingese dogs and bred them at kennels at his residence, Fulmer Place in Buckinghamshire, and it was from these animals that all the pure Pekingese in England originated. Pekingese dogs were extremely fashionable in the early 20th century in Britain and in early dog competitions people competed to have the most attractive animal. The artist Friedrich Wilhelm Keyl was Edwin Landseer's only pupil and undertook many commissions for Queen Victoria; this painting of Looty by him was exhibited at the Royal Academy in 1862.

1861, England. Oil on canvas. H. 33.4 cm, W. 38 cm. The Royal Collection, London / HM King Charles III, RCIN 406974

2.46–2.47

Ceramic tiles from the ruined Summer Palace

Few items better evoke the 1860 loss and desolation of the beautiful Summer Palace than these glazed turquoise architectural tiles. Little was added to the complex in the 19th century, and the brick and stone ruins of the European-inspired buildings have become the defining symbol of European violence against 19th-century China. Other areas of the site have been built upon to accommodate parts of the campuses of Peking University (China's first modern university) and Tsinghua University.

c. 1747–70, Beijing. Turquoise glazed stoneware. H. 17 cm, W. 35.8 cm; H. 34.5 cm, W. 38 cm, D. 23 cm. British Museum, London, Franks.2543; Victoria and Albert Museum, London, C.382-1912. Donated by Sir Augustus Wollaston Franks (Franks.2543)

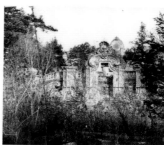
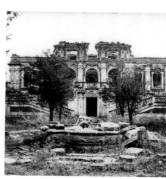

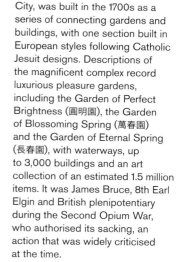

2.48
Ernst Ohlmer (1847–1927), Remains of the European-inspired buildings in the Summer Palace
The Summer Palace, some 8 km to the northwest of the Forbidden City, was built in the 1700s as a series of connecting gardens and buildings, with one section built in European styles following Catholic Jesuit designs. Descriptions of the magnificent complex record luxurious pleasure gardens, including the Garden of Perfect Brightness (圓明園), the Garden of Blossoming Spring (萬春園) and the Garden of Eternal Spring (長春園), with waterways, up to 3,000 buildings and an art collection of an estimated 1.5 million items. It was James Bruce, 8th Earl Elgin and British plenipotentiary during the Second Opium War, who authorised its sacking, an action that was widely criticised at the time.

c. 1873, Beijing. Glass-plate negatives. Hsu Chung Mao Studio

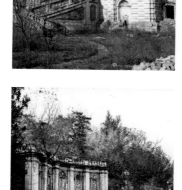
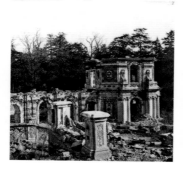
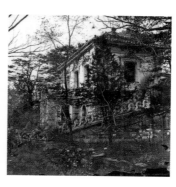

In October 1860 the British and French set up camp outside an imperial capital that was all but undefended. Just outside Beijing was the Summer Palace, a glorious and vast complex of pavilions and recreated landscapes and artworks; after they captured it in 1860, the foreign troops began systematically looting its treasures (fig. 2.45), and then, a few days later, in one of the most controversial episodes in the history of British–Chinese relations, the British plenipotentiary Lord Elgin (1811–1863) ordered his troops to burn the entire complex. Stone buildings survived in ruins, while wooden structures were destroyed (figs 2.46–2.48).

Elgin claimed that the destruction of the Summer Palace was a reprisal for the Xianfeng emperor authorising the kidnapping and murder of a group of British diplomatic negotiators during the march on Beijing; he insisted that destroying the palace was the only way he could punish the emperor of China directly without harming his subjects as well. These palaces were known in Europe from the writings of 18th-century Jesuits; few wanted to hear his excuses and his actions were heavily criticised back home in Britain. The author Victor Hugo (1802–1885), in exile from France, famously described the British and French forces at Beijing as a pair of bandits, looting and burning one of the great artistic wonders of the world. Today, the ruins of the Summer Palace are a potent site of nationalist memory in China, where Elgin's destruction of the complex in the Second Opium War serves as one of the most vivid and tangible symbols of China's oppression by European imperialists in the 19th century.

By the end of 1860, then, as the mammoth Taiping Civil War raged out of control in the Lower Yangzi region of eastern China, in the north the Qing emperor

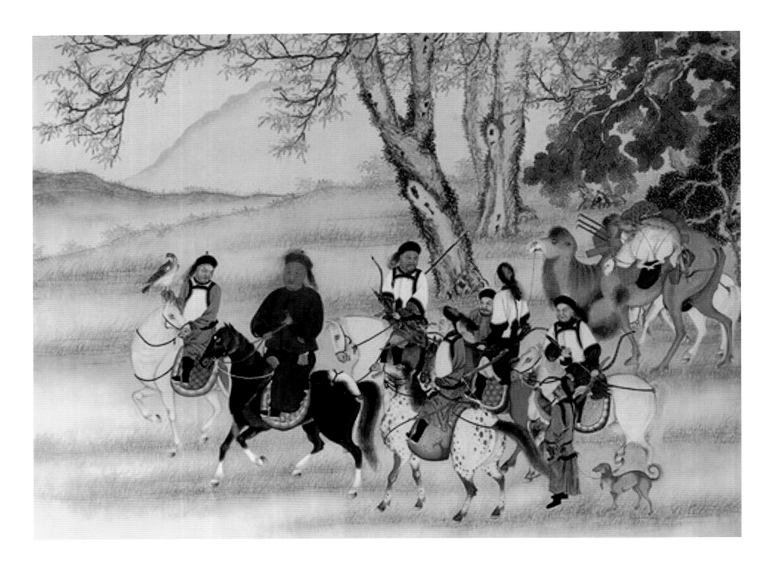

had fled to Rehe, the dynasty's resort in Manchuria (see fig. 1.6) – he would die there the following year – and the palace outside Beijing he had left behind was a smoking ruin, its treasures looted by foreign invaders. Both the Green Standard army and the banner forces of the capital had failed in their efforts to protect the dynasty's rule (fig. 2.49). To observers both within China and abroad, it seemed that the long reign of the Qing may have finally come to its end, destroyed by the confluence of domestic rebellion and foreign invasion. The Manchus by this time had already held power in China for more than two centuries – a respectable duration for one of China's great dynasties – and there was no reason to imagine they would survive much longer. 'A ruling house of two hundred years, endangered in an instant,' worried one loyalist in his diary. 'I never imagined the end would come so soon.'[12]

2.49
Unidentified artist, *Hunting scene with Sengge Rinchen*
Sengge Rinchen 僧格林沁 (1811–1865), Prince Zhong (depicted on the black horse), was a Mongol nobleman distantly descended from Genghis Khan, and a general who served the Qing dynasty during the reigns of the Daoguang, Xianfeng and Tongzhi emperors. He is best known for defeating the British in 1859 at the coastal Dagu Forts that protected sea access to Beijing. However, the subsequent battle at Baliqiao in 1860 resulted in a complete rout of the Qing forces by the British and French that opened the way to Beijing.

c. 1825–65, Beijing. Ink and colours on paper. Capital Museum, Beijing

In spite of appearances, however, the Qing dynasty would endure not just through the war with the Taiping but for another fifty years, into the second decade of the 20th century. The turnaround in its fortunes came from two new sources of support, neither of them directly tied to the traditional militaries of the empire. One was from the very same foreign powers that had assaulted the capital in 1860. After the conclusion of the Second Opium War, the British government suddenly reversed its policy and began helping the Qing dynasty against the Taiping rebels. The change was motivated partly out of guilt, for having destabilised the government of China, thereby effectively aiding the rebels. But more to the point it was motivated by self-interest, for the Qing dynasty was the government with which Britain had signed its highly favourable, one-sided treaties, and if the Qing should fall then those treaties – and thus the fruits of the two opium wars – would be lost.

After 1860, then, the British government judged that it had a vested interest in seeing the Manchu government survive its war with the Taiping. It supplied weapons and logistical support, at one point transporting an entire Chinese army down the Yangzi past the Taiping capital on British steamships (which the rebels, fearful of provoking the British, would not attack). Most colourfully, Queen Victoria authorised the service of a young officer of the Royal Engineers named Charles Gordon (1833–1885) (fig. 2.50) – remembered to posterity as 'Chinese Gordon' – to help train and command an army of Chinese soldiers who would carry British weapons and drill according to British methods. Gordon's forces were dramatically successful against Taiping strongholds in the Lower Yangzi region, though his cooperation with the Chinese government fell apart at the city of Suzhou, where Gordon negotiated a Taiping surrender by promising amnesty to a group of rebel leaders who then turned over control of the city. The Chinese general under whom Gordon served, however, promptly executed all of them. Gordon quit his service in a fit of pique, feeling his honour had been insulted, and spent the rest of the war as an observer.

Foreign intervention played an important role, but the most decisive source of support for the dynasty was an internal one: regional armies from Hunan and Anhui provinces of a kind never before authorised under the Qing. The mastermind of the army from Hunan, and the man who deserves the lion's share of credit for suppressing

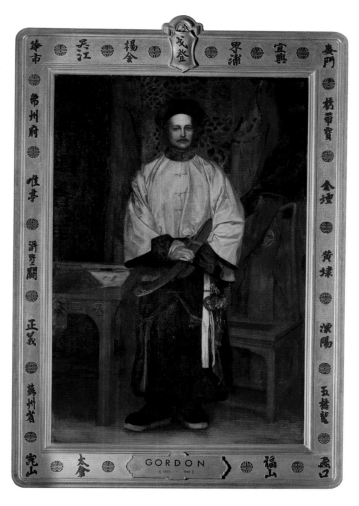

2.50
Unidentified artist, Portrait of General Gordon
The young British army officer, General Charles Gordon, received this official yellow robe, hat with ruby hat button and boots from the Tongzhi emperor in 1864, in thanks for his assistance during the Taiping Civil War. His 'Ever Victorious Army' was a mercenary force of Chinese, British and American men whose wages were paid by the Qing government. Tongzhi also gave Gordon the honorary title Brigade General (提督). Gordon had first travelled to China to fight in the Second Opium War and had been involved in the sacking of the Summer Palace in 1860. He then helped the Qing government to fight against the Taiping, partly in an effort to protect European interests in Shanghai that were threatened by the advancing Taiping forces, and partly because he was horrified at the civilian casualties who suffered at the hands of the Taiping. However, when the Qing slaughtered a group of Taiping prisoners to whom he had promised amnesty, Gordon also lost respect for the government armies.

1861–4, China. Oil on canvas. H. 270 cm, W. 190 cm (framed). Royal Engineers Headquarters Mess, Kent

Key figure: Zeng Guofan (1811–1872)

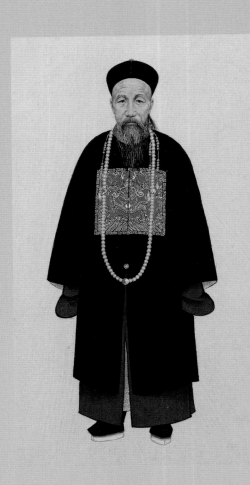

2.51
Unidentified artist,
Portrait of Zeng Guofan
(平定粵匪功臣像 曾國藩) **(detail)**
Zeng Guofan, who came from a well-to-do Chinese family, was both the holder of the highest examination degree and an accomplished general. He is best known for raising, organising and leading the Hunan Army, originally recruited in Zeng's native province, to take over from the failed imperial forces in fighting the Taiping rebels, and for his hard-won decisive victory over them in 1864. Hunan had been a backwater in the early 1800s. However, after the contribution of the Hunanese to the Qing victory over the Taiping, by the end of the century a great many of the empire's most powerful officials came from that province. Zeng also became a moderniser who helped launch the late Qing 'Self-Strengthening' movement. In the 1860s, he already believed that foreign science, technology and education (through studying overseas) could help the Qing state develop and survive. He was involved both in setting up an ironworks in Shanghai that later became the Jiangnan Arsenal, and in the establishment of the Fuzhou Shipyard. At the same time, he also consulted mediums for advice before battle and was a respected scholar of Confucian texts. Today, there is a museum dedicated to his life and work, but his contribution to Chinese history – as a Han Chinese official who faithfully served the 'foreign' Manchu Qing dynasty – has been hotly debated across the 20th and 21st centuries.

c. 1886–7, Beijing. Ink and colours on paper. H. 47 cm, W. 34 cm. National Palace Museum, Taipei

the rebellion, was a Hunanese scholar-official named Zeng Guofan (fig. 2.51), who had been tasked with organising the scattered homespun militia groups in his home province after the failure of the Green Standard. With the Hunan Army (湘軍), Zeng Guofan built a force of 120,000 Hunanese, bonded together less by their loyalty to the dynasty than by their loyalty to him and to each other. Soldiers served in units with neighbours, commanded by officers who had recruited them personally. At all levels, Zeng Guofan's army was built on personal, local ties – with himself at the top as supreme commander. The generals under him were his own brothers and close scholarly friends, displaying unbreakable bonds of loyalty that were replicated throughout his army. And as it turned out, this tightly knit force would prove far more capable and unified against the Taiping rebels than any of the imperial forces had been.

The rise, first, of Zeng Guofan, and then of his protégé Li Hongzhang, who raised an army modelled on Zeng's from his own home province of Anhui, posed a worrisome dilemma for the imperial government because Zeng Guofan's soldiers were, ultimately, loyal to Zeng himself, not to the dynasty. They represented their home province, not the empire writ large. As long as Zeng Guofan remained loyal to the dynasty, his army would fight on its behalf – but if his loyalty should ever waver, the Qing rulers had no corrective whatsoever they could use to control him. In the final years of the war, Zeng freely ignored orders from the capital if he felt he knew better what his army should do but, fortunately for the Qing government, his loyalty never did waver. Together, the Hunan Army under Zeng Guofan and the Anhui Army (淮军) under Li Hongzhang (which was the army to which Charles Gordon had attached himself) crushed the Taiping in 1864, bringing an end to the civil war that had left scores dead and nearly driven the dynasty to collapse (fig. 2.52).

Reconstruction and reform

The suppression of the Taiping rebels in 1864 was a watershed moment of the 19th century in China but it did not mark the end of the dynasty's internal troubles. Along with the Taiping there had been major rebellions in other parts of the Qing empire that took place simultaneously, profiting from the vacuum of power as the overwhelmed dynasty struggled to respond to the Taiping war and the foreign invasion. The most significant of these were still in play after the fall of Nanjing: one a bandit uprising known as the Nian Rebellion (1851–68) (fig. 2.53), which afflicted the region just to the north of the Taiping Heavenly Kingdom, and the other a series of revolts among the empire's Muslim populations, who defied Qing rule in the southwest and the far western reaches of the empire (fig. 2.54).

After the capture of the Taiping capital, the Qing government redirected the provincial forces of the Anhui and Hunan armies to restore order in the rest of the empire. The Anhui Army under Li Hongzhang led the campaign against the Nian, using new guns and

2.52
Wu Youru 吳友如 (also called Wu Jiayou 吳嘉猷, c. 1840–1894) et al., *Victory over the Taipings, Scene 12 – Capture of the junior traitor Hong Fuzhen* (幼逆洪福瑱就擒圖)
The Empress Dowager Cixi commissioned Zeng Guoquan 曾國荃 (1824–1890), the brother of Zeng Guofan, to engage artists to create a series of paintings that celebrated Qing military successes, rather as the Qianlong emperor had done in the 18th century. The images were reproduced in cheaper materials such as woodblock prints and lithographs and circulated widely. The production of the paintings in this album happened two decades after the actual battles were won, indicating how it was only then, after other rebellions had also been suppressed, that some confidence in the dynasty's survival was possible.

1886, Nanjing. Ink and colours on paper.
H. 50.5 cm, W. 87.5 cm. National Palace Museum, Taipei, 平圖021294

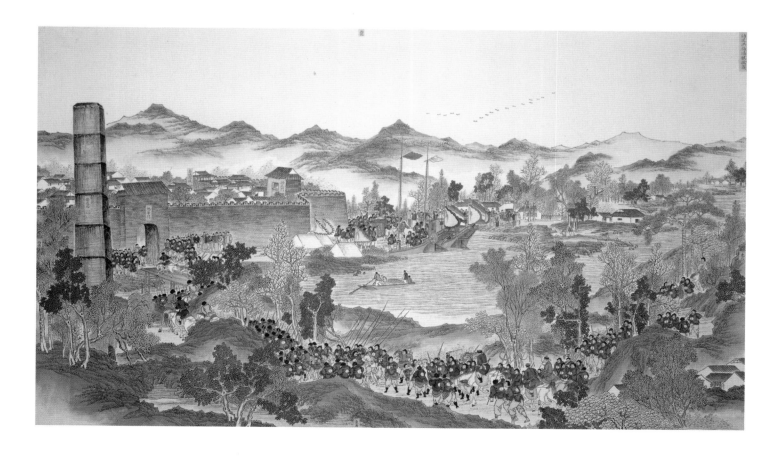

artillery imported from abroad as well as steam-powered gunboats on the rivers to bring the bandits under control by 1868. It would take much longer, however, to reconquer the territory in the far west known as Xinjiang, with a campaign through the 1870s led by Hunan Army general Zuo Zongtang. The Qing dynasty had originally conquered the region in the 18th century during Qianlong's reign, but by the 1860s it had broken away from Beijing's control and Zuo Zongtang mounted an enormous and destructive campaign that represented not just an attempt to suppress the Muslim leaders militarily, but also to plant the seeds of agricultural change and lay the foundation for a cultural transformation to assimilate the Muslim population to the Chinese culture of the empire's Han majority.[13] By the early 1880s, Xinjiang was back under Qing control, and it was formally made a province in 1884 (figs 2.55–2.58).

In the restoration of power to the Qing imperial government, the dominant role of Han Chinese commanders – most prominently Zeng Guofan, Li Hongzhang and Zuo Zongtang – posed a crisis of prestige for the Manchu rulers. The elite Manchu and

2.53
Qingkuan 慶寬 (1848–1927) et al.,
Battle scene from the Nian Rebellion
In the Nian Rebellion, insurgents from the North China Plain were driven to insurrection (but not revolution) by a devastating series of environmental disasters, which the Qing government was unable to deal with. Between 1851 and 1853, the Yellow river changed its course and flooded heavily, leading to food shortages and the displacement of large numbers of people. Although probably inspired by the Taiping example, these rebels were less well organised and lacked a unified ideology, but their mounted roaming bands were difficult to wipe out. Li Hongzhang finally crushed the Nian Rebellion in 1864. In this painting, the rebels are dishevelled, have only swords, and wear red turbans and colourful tunics. In reality, the Nian cavalry were their strength; an eyewitness recorded: 'They used long spears and halberds as weapons.' Women fighters among the Nian rebels were extremely brave and skilled at using bows and arrows.

Late 1870s, Beijing. Ink and colours on silk. H. 149.3 cm, W. 314.2 cm. University of Alberta Museums, Edmonton, 2004.19.49. Gift of Sandy and Cécile Mactaggart

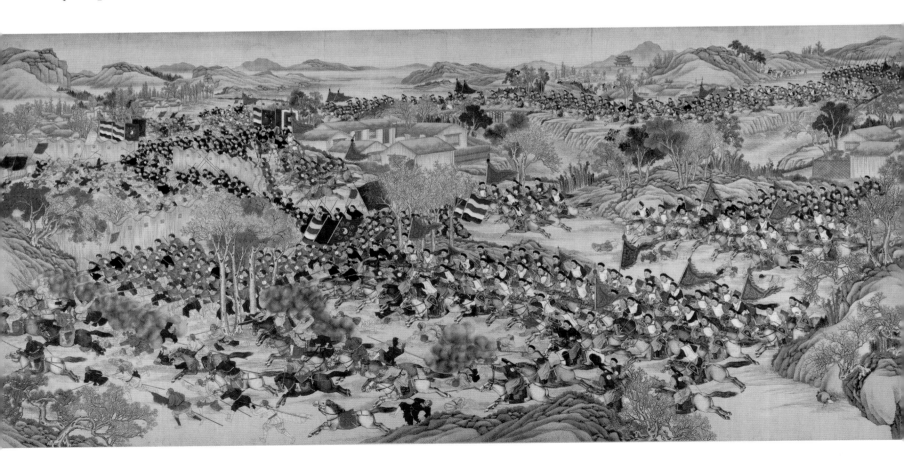

2.54

Qingkuan et al., Battle at the Wei River

The Empress Dowager Cixi commissioned court artists in the Imperial Household Department to produce a set of epic paintings, celebrating historic Qing victories in civil wars with Taiping, Nian and Hui (Muslim) forces. This battle shows Commander Duolong'a 多隆阿 (1817–1864), (wearing a yellow jacket on horseback to the far left of the painting), leading the Qing government troops to victory against Muslim insurgents at Putaowa (eastern Shaanxi province) in August 1863. The large triumphal painting was created as part of a series some years after the Qing victory over the Nian, as a court commission between 1886 and 1890. Each important soldier is named in a caption, and details of different ranks are indicated through their uniform and equipment. The Qing army is fighting with both modern guns and historic pikes, bows and arrows. Local militia are fighting alongside the official Qing troops.

c. 1886–90, Beijing. Ink and colours on silk.
H. 149.9 cm, W. 322.6 cm. The Royal Collection, London / HM King Charles III, RCIN 94417

Mongol banner armies that had been the dynasty's most powerful forces in the 17th and 18th centuries had proven incapable of meeting the new challenges of the 19th, and the post-war government in Beijing had to make its peace with the discomfiting, but inescapable, fact that the dynasty had been saved from the Taiping by ethnically Chinese regional forces under the personal control of non-Manchu generals. In the face of this embarrassment, it took more than twenty years after the fall of Nanjing for the major victories against the Taiping to be commemorated in the capital, in grand panoramic battle paintings whose creation was spearheaded not by the Manchu court but by Zeng Guofan's younger brother Zeng Guoquan, who had served under him in the war and outlived him.[14]

In a practical sense, the legacy of the Taiping era was a dramatic increase in the power of provincial leaders, a devolution of power from the centre to the provinces – and from Manchus to Han Chinese – that reflected the outsized role the regional armies from Hunan and Anhui had played during the war itself. Yet these regional leaders remained unquestionably

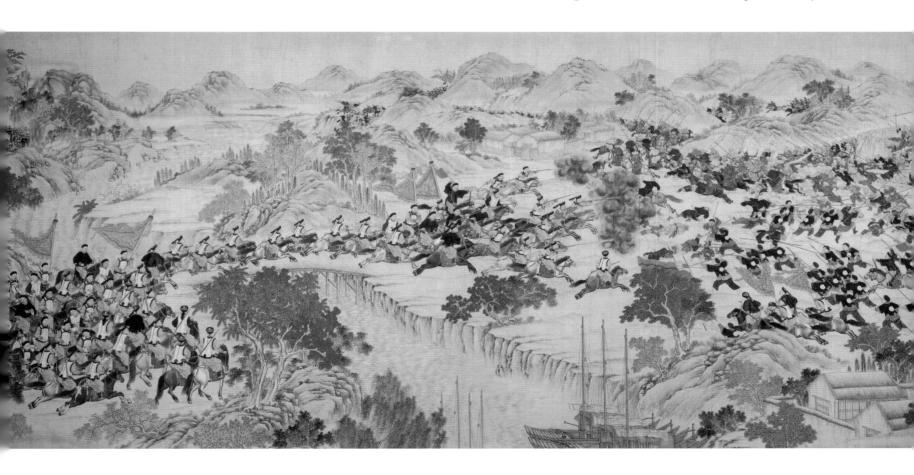

2.55
Soldier's conical bamboo helmet
Painted in various colours and made of bamboo, hats were worn by millions of foot soldiers in Qing China. This example was collected by Richard Brinsley Hinds (1811–1846), who was a British naval surgeon, botanist and malacologist (mollusc specialist). He sailed on the 1835–42 voyage by HMS *Sulphur* to explore the Pacific Ocean, and edited the natural history reports of

that expedition. The symbols, known as *yinyang*, are protective emblems of good fortune.

1830–50, China. Painted bamboo. H. 15 cm, W. 29 cm. British Museum, London, As1842,0126.8. Donated by Richard Brinsley Hinds

2.56–2.57
Foot soldiers' jackets
The distinguishing feature of these mid-19th century soldiers' jackets are the roundels in lacquered paper or fabric inscribed in black or red ink, which are attached to the central chest area and on the back, and identify which unit the soldier is from. The ink inscription on the white and red jacket tells us that it was worn by a soldier of the Huai Army from Anhui (one of the regional forces raised to battle the Taiping), whereas the inscription on the red and black jacket indicates a soldier in the border defence troops. Such jackets were worn over an undershirt and with loose trousers, socks and shoes. Officers wore round hats with tassels and infantry often wore turbans to wrap up their long queue (the plait that the Manchu Qing obliged all men to wear as a badge of submission to the dynasty).

c. 1860–95, Anhui and Shandong. Cotton twill, linen, oiled paper and wool. H. 82 cm, W. 169 cm; H. 87.5 cm, W. 156.5 cm. British Museum, London, As1928,-.3; The Box, Plymouth, PLYBX.1912.129.5. Donated by Miss F. Champagnac (As1928,-.3)

2.58
Military waistcoat
Soldiers, especially cavalry, wearing this type of waistcoat are commemorated in 19th-century Qing battle paintings. This waistcoat was collected from a Muslim soldier in Yunnan before 1870 by Colonel Sir Edward Bosc Sladen (1827–1890). The waistcoat was worn with loose trousers, which Qing soldiers were proud of; indeed, they believed that British soldiers were vulnerable because their trousers were, by contrast, too tight for them to move freely. Mongolian official and Jiangsu governor-general

Yuqian (1793–1841) remarked: 'Their waist is stiff and their legs are straight. The latter further bound with cloth, can scarcely stretch at will. Once they have fallen down, they cannot stand up again.' Qing soldiers also trained in martial arts, which involved complex leg movements, for which loose clothing was ideal.

1850–70, Yunnan. Leather, velvet, cotton and silver. H. 73 cm, W. 68 cm. British Museum, London, As.7175. Donated by Colonel Sir Edward Bosc Sladen

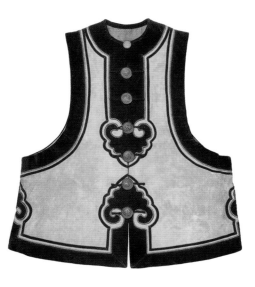

loyal to the dynasty. Zeng Guofan was viewed like a god in his home province, and many of his followers hoped that at the end of the war he would throw off the broken, dilapidated Qing dynasty and establish himself in Nanjing as China's new emperor. He did not do so, however – indeed, he began implementing plans to disband key units of his personal army, and with it his major source of individual power, even before the capture of Nanjing from the Taiping was complete. In doing so, he showed himself to be a Confucian whose highest devotion was to the continuance of Chinese civilisation, of which he saw the ruling Manchus as the proper stewards in his time.

Zeng Guofan would be the most influential Chinese military figure for generations to come – in the 20th century, Chiang Kai-shek 蔣介石 (1887–1975) would study Zeng's writings assiduously and use them as a textbook for military cadets, while Mao Zedong 毛澤東 (1893–1976) – who came from the same part of Hunan province as the 19th-century general – told his teacher when he was a youth that Zeng Guofan was the man he admired most in the world (though it is worth noting that later, after Mao became a communist revolutionary, his sympathies would shift in favour of the peasant rebels of the Taiping). For all Zeng Guofan's accomplishments as a military leader, however, it was his Confucian scholarship that he was most proud of. As a historical figure he cannot be understood as a military commander alone, separate from his parallel personas as a Confucian scholar, as a minister of government and as a father. The letters Zeng Guofan wrote to his sons during the Taiping Civil War are beloved as classics of the family-letter genre, and in the end, for all of his talents as a military commander, he taught them that the only truly worthwhile goal in their lives should be the pursuit of scholarship.

The employment of European weaponry by certain Chinese forces during the Taiping Civil War inspired an experiment in military reform that would dominate the immediate post-war era. Known generally as the 'Self-Strengthening' movement, its goal was to equip some of China's military forces with the same cutting-edge weapons and ships used by the British and French so the dynasty could prevent another major rebellion like the Taiping from succeeding, as well as – significantly – to ensure that China could not be bullied by the European powers any longer (fig. 2.59).

The primary drive behind the modernisation movement was, therefore, not admiration of the Western powers, but mistrust of them. One of its leading proponents was Zeng Guofan, who explained to the court in 1861 that Chinese troops were terrified by British steamships and long-range cannons mainly because they had never encountered such things before; the very strangeness of the technology made it especially effective. The solution, he explained, was for China to procure the same weapons and ships for itself. 'If we can buy them and make them our own,' he wrote, 'then the Chinese will become accustomed to seeing them and they won't be afraid of them anymore. Then, the British and French will lose their edge.'[15]

Zeng Guofan was ambivalent about the adoption of foreign weapons during the war itself. Foreigners, to his eye, could sometimes be useful as mercenaries, but he thought they were morally inferior and did not trust them. When his younger brother Zeng Guoquan, who led the siege of Nanjing, asked Zeng Guofan in 1862 to purchase foreign rifles for his troops, Zeng sent him a scathing response. 'A true beauty doesn't fuss over pearls and jade, and a great writer needs no more than brush and ink,' he wrote. 'If a general is truly skilled at war, why should he go grasping for foreign weapons?'[16] Nevertheless, he did purchase some European rifles for his brother's forces, and began experimenting as well with construction of a small steam-powered boat on the Yangzi.

By 1863, Zeng Guofan was sufficiently convinced of the utility of modern weapons that he sent a young man named Yung Wing 容閎 (1828–1912), who had studied abroad at Yale University in the 1850s, on a mission to the United States to purchase the industrial machinery necessary to establish a modern munitions factory in China. That equipment became the foundation of the Jiangnan Arsenal (江南機器製造總局) (fig. 2.60) which, at its peak, was capable of building steam-powered gunships as well as modern artillery and small arms. Several similar projects followed in the years after the fall of the Taiping, including a major shipyard spearheaded by Zuo Zongtang, with equipment and advisers imported from France. The Fuzhou Shipyard (福州造船廠), as it was known, employed thousands and had an attached school to train naval engineers and navigators (fig. 2.61).

One of the lingering myths from this era is that Confucianism itself was somehow antithetical to

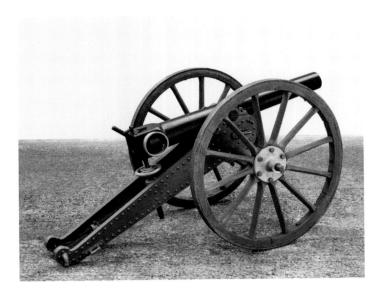

2.59

Qing breech-loading gun on carriage (top left) and detail (bottom left)

After the Second Opium War, Qing China began to manufacture new, European-style weapons, such as this 6 cm Berg-Kanone Krup, partly in response to the superior equipment used by its foreign opponents. Previously, cannons were often kept and maintained for centuries.

1900–01, Nanjing. Bronze. Musée de l'Armée, Paris, 5997.1l; N539

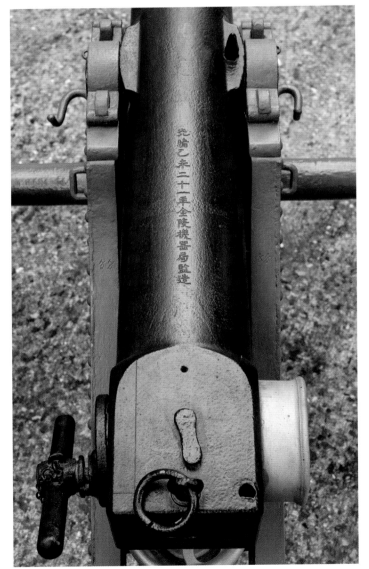

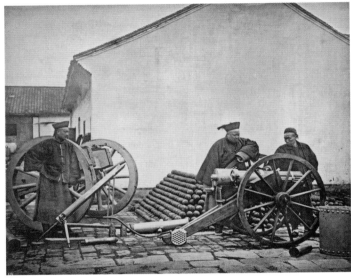

2.60 (above)

John Thomson (1837–1921), Scene in Nanjing Arsenal

The Nanjing and Shanghai arsenals were established in the 1860s as major arms manufacturing centres, as well as places for the study of Western languages and technical literature. Opened as part of the Qing Self-Strengthening movement, they began as ironworks, with their machinery purchased from abroad and Western instructors employed to advise and teach. By 1870, these arsenals were among the largest and most productive in Asia. This photograph appeared in John Thomson's four-volume work *Illustrations of China and its People*, published in 1873–4.

1874, Nanjing. Collotype. H. 23.3 cm, W. 28.6 cm. J. Paul Getty Museum, Los Angeles, 84.XB.757.3.3.18

2.61 (opposite)

Panorama of the Fuzhou Shipyard

This image shows the shipyard, harbour, buildings and a building site, Mamoi (now Mawei), near Fuzhou.

1867–70/71, Fuzhou. Three albumen silver prints joined to form a panorama. H. 23.8 cm, W. 84.7 cm. Canadian Centre for Architecture, Montreal, PH1979:0153:001–003

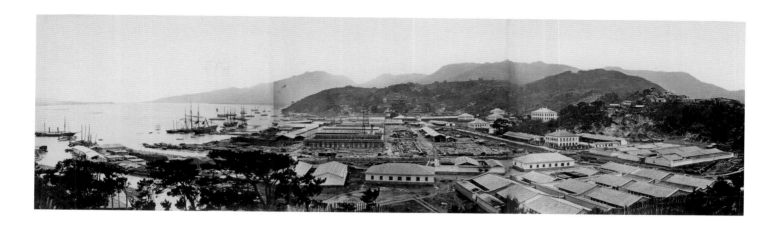

military reform in China. On the contrary, the officials who drove the Self-Strengthening movement were in no way less Confucian than their critics – and indeed, as measured by their success in the civil service examinations, the proponents of reform included some of the most eminent classical scholars in the empire. The political divide that would ultimately limit the scope of the reforms had nothing to do with a dichotomy between Confucianism and Westernisation, but rather between pride and pragmatism. What distinguished the proponents of military reform from their critics at court was their appreciation of the importance of technology to foreign military power at the time, as well as their pragmatism in accepting that Chinese engineers could gain useful knowledge by studying developments in the contemporaneous West. It is no coincidence that the leading champions of military reform had served with great distinction in the war against the Taiping; they, unlike most of their critics, knew whereof they spoke.

The Self-Strengthening reform movement would ultimately be remembered as a failure, but it did not have to be. At one level, it suffered in the later 19th century from a loss of patronage, especially after the death of Zeng Guofan in 1872. Zuo Zongtang, likewise, was removed from the stage once he became fully absorbed in his long campaign to reconquer the far west. At another level, it suffered from financial challenges that might have existed regardless of who was in charge. The funding for the reform institutions came from maritime customs and a new internal transit tax known as the *lijin* (厘金), but once those sources were fully committed, there was no excess to fund further growth (foreign loans, another possible

option, were reserved for emergencies only).[17] These limitations on funding became especially acute when China's government had to balance its separate needs for developing military power both on land and at sea – in particular, the financial needs of China's modernising navy in the 1870s came into direct conflict with the huge demands of Zuo Zongtang's campaign to reconquer Xinjiang. Advocates for the inland campaign in the far west would win out at court, with the result that the navy (and thus China's coastal security) would be underfunded going forward.[18] Finally, yet another constraint to the financing of new military ventures was the necessity of continuing to maintain the masses of China's traditional armed forces, who could not be equipped and trained with the new weapons, but also could not simply be disbanded.[19]

Nevertheless, China's ability to defend its interests was increasing. By the 1880s, China's modernised navy – armoured and steam-powered – was considered one of the top ten naval institutions in the world. In 1881, Zuo Zongtang's forces in the west successfully drove the Russians to remove themselves from their occupation of the Yili valley and sign a treaty acknowledging Qing control of the region. And in contrast to the humiliating outcomes of the two opium wars, in 1884–5 China fought a war with France which, while it hardly ended in victory for the Qing, at least reached a stalemate in which China neither had to pay an indemnity nor cede any of its territory (fig 2.62).[20]

However, a shocking loss to Japan in the Sino-Japanese War of 1894–5 would permanently upend the perception of the Qing dynasty's rising military strength (figs 2.63–2.66). The dynasty was forced to concede a massive amount of territory to Japan after that war,

2.62

Tao Tao 陶濬 **(1825–1900) and Wu Dacheng**
吳大澂 **(1835–1902)**, *The Qing army's victory in Jiaomen* (蛟門奏凱圖)

The Sino-French war lasted just seven months (from August 1884 to April 1885), a result of the French invasion of the Qing tributary state in modern Vietnam. In the course of negotiations, France moved the war north and then destroyed much of the new Fuzhou Shipyard when negotiations broke down, eventually gaining control of north Vietnam, then called Tonkin in English. This painting was made two years after the war and celebrates a victory of the Qing army in the battle of Zhenhai at Jiaomen near the port of Ningbo. There, a French warship had been defeated by Chinese land guns under the direction of General Ouyang Lijian 歐陽利見 (1825–1895). The painting is a collaborative work by two men. Wu Dacheng was a painter of the orthodox landscape school, poet, scholar-official and celebrated antiquarian. He was originally from Suzhou but migrated to Shanghai to escape the Taiping Civil War. In 1868, he obtained the highest civil service degree and joined the prestigious Hanlin Academy. He served as Secretary to Li Hongzhang in Hubei, Educational Commissioner in Shaanxi and Gansu, and Circuit Superintendent in Henan. Another native of Suzhou, Tao Tao was born into an elite family and is best known for his landscape paintings.

1887, Suzhou. Ink and colours on paper.
H. 40.4 cm, W. 134.5 cm. Zhejiang Museum, Hangzhou, 013703

2.63

Wu Dacheng, *Reading at the secluded pine studio* (松隱盦讀書圖)

In the 1880s, the multi-talented Wu Dacheng defended the Qing borders and handled foreign affairs with Russian, Japanese and Korean officials. He led Qing forces to defeat during the Sino-Japanese War in 1894–5 and was forced to retire from his government positions. This intimate sketch was made behind the lines of battle in the Sino-Japanese war and is part of an album created by an ensemble of scholar-officials. One leaf was by Hu Gongshou 胡公壽 (1823–1886), the great traditional-style painter who made such an impression on visiting Japanese artists that, inspired by his example, they returned to Japan to revitalise traditional painting. The inscription reads: 'White clouds cut across many sloping peaks, on the slope of the hill was built a hut that is partially covered. The chanting and reciting were heard travelling through empty valley afar. My home lies amid the depths of thousands of pine trees …' (白雲橫截數峯斜, 結屋依山半面遮. 尋到書聲空谷遠, 萬松深處是吾家. 伯雲二兄大人屬畫 暑傲烏目山人意併題一絕句 請正. 吳大澂 清卿[印]).

After Wu's defeat, critics jibed that his obsession with antiques and classical culture made him fundamentally unqualified to lead armies: 'He catalogues antique jades and publishes drawings of bronze vessels … Now he takes out his Han [official] seal and strokes it over and over / Oh! My seal! My seal! What can I do now?'

1895, possibly painted at Shanhai Pass during the Sino-Japanese War. Ink and colours on paper.
H. 21.5 cm, W. 32.5 cm. Yale University Art Gallery, New Haven, 1990.38.5, 1990.38.14. Purchased with a gift from the B. D. G. Leviton Foundation and Archer M. Huntington, M.A. (HON.) 1897, Fund

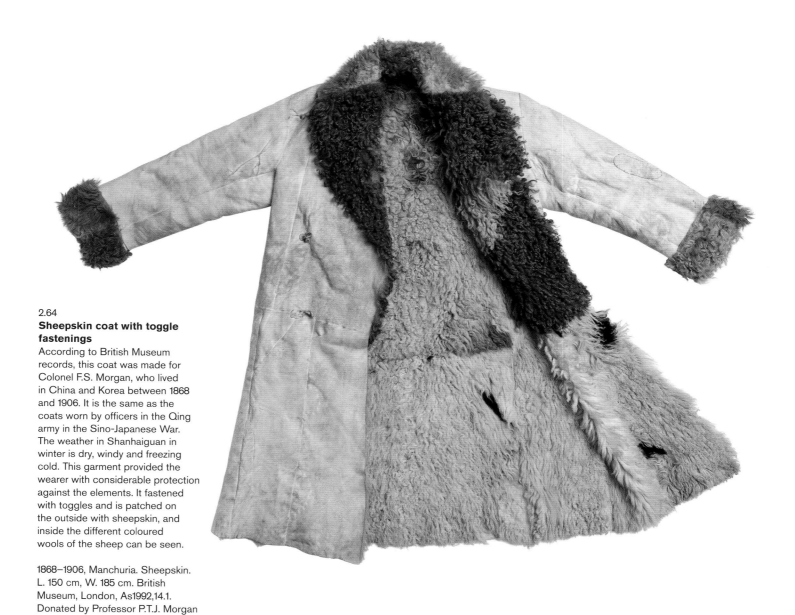

2.64
Sheepskin coat with toggle fastenings

According to British Museum records, this coat was made for Colonel F.S. Morgan, who lived in China and Korea between 1868 and 1906. It is the same as the coats worn by officers in the Qing army in the Sino-Japanese War. The weather in Shanhaiguan in winter is dry, windy and freezing cold. This garment provided the wearer with considerable protection against the elements. It fastened with toggles and is patched on the outside with sheepskin, and inside the different coloured wools of the sheep can be seen.

1868–1906, Manchuria. Sheepskin. L. 150 cm, W. 185 cm. British Museum, London, As1992,14.1. Donated by Professor P.T.J. Morgan

2.65
Charles Edwin Fripp (1854–1906), *Shanhai Pass target practice*

Fripp covered the Sino-Japanese War for *Graphic*, a British illustrated newspaper in which this image was later published. It shows a Qing officer watching his men fire their guns at a target in the strategically vital garrison town at Shanhai Pass, where the Great Wall meets the sea. Fighting in the Sino-Japanese War centred on which power would dominate Korea. Meiji Japan claimed it needed control of Korea for security and Qing China was unwilling to relinquish influence over

its last tributary state. In September 1894, the Japanese army defeated Qing forces at Pyongyang and on the Yalu river. These were followed by Qing defeats in November at Port Arthur (Lüshun, now part of Dalian) and in February 1895 at Weihaiwei in Shandong. In April 1895, the Qing conceded overall defeat by accepting the punitive Treaty of Shimonoseki in which Taiwan became a Japanese colony.

1894 (published 1901), England. Ink on paper. H. 39 cm, W. 29 cm (mounted). Private Collection – John Cloake

高麗月夜大戰牛陣得勝全圖

2.66

Unidentified artist, *Victory with cattle during the night in the Korean war*
(高麗月夜大戰牛陣得勝全圖)

On 23 July 1894, a few days before the outbreak of the Sino-Japanese War on 1 August, *Shenbao*, the Shanghai newspaper, published an article entitled 'Chinese Soldiers Can Win Victory over Japan' and readers were encouraged to expect as much. In this propaganda battle print of 1894,

the Qing army are shown winning such a victory. Cattle with lighted explosives strapped to their backs are used to stampede the enemy. Barefoot troops armed with guns and wearing turbans advance behind an official on horseback. In the upper right-hand corner, soldiers fight with swords in hand-to-hand combat and the pile of severed heads shows that the Qing soldiers have won. The large battle flags indicate the right and left battalions. War pictures produced in the

19th century rarely depict casualties on the Qing side.

1894, China. Printing ink on paper. H. 31.9 cm, W. 54.2 cm. The British Library, London, 16126.d.4 (13)

2.67

Soldiers of the Qing dynasty's 'New Army'

This striking photograph, taken in 1911 in Chengdu, depicts soldiers of the modernised army (centre) and a group of male onlookers (right). The soldiers' Japanese-style uniforms and modern guns contrast with the onlookers' traditional dress.

including the entire island of Taiwan, and had to pay the largest indemnity it had ever suffered. Outside observers had expected China to win the war handily but the Qing dynasty's forces were outclassed both on land and at sea by the Japanese who – in contrast to the restrictive scope of reform in China – had in the decades leading up to the war pursued an all-out Westernisation of their military, culturally as well as technologically, that enabled them to best the much larger forces of China with relative ease. The humiliation of the loss to Japan in 1895 seemed the ultimate failure of Self-Strengthening, and paved the way for deeper, more sustained reforms to the culture of the Qing dynasty's armed forces – most importantly the founding of a so-called 'New Army' starting in 1895, which would be commanded by a highly educated officer class trained in modern military and naval academies (fig. 2.67).

The final challenge to the dynasty came in the early 20th century with the rise of young Chinese revolutionaries calling for the overthrow of the Manchus. Reviving the Taiping's incendiary rhetoric of racial difference between the Han Chinese and the Manchus, these young nationalists upended the verdict on the great generals of the 19th century, declaring that men like Zeng Guofan and Li Hongzhang should no longer be seen as heroes who had saved China from the Taiping – rather, the new nationalists declared, they were traitors to the Han race, Chinese generals who had slaughtered their fellow Chinese (the Taiping rebels) in order to keep the Manchus on the throne. The Taiping were their new heroes, and friends of the revolutionary leader Sun Yat-sen gave him the nickname Hong Xiuquan.

The late 19th-century reforms to the military that Zeng Guofan and Li Hongzhang had bequeathed to China strengthened the Qing empire in many ways though, ironically, they would also prove to be the dynasty's undoing in the end. The educated officer class of the New Army that was the pride of China's *fin-de-siècle* military reforms turned out to be an exceptionally receptive audience for the Han-nationalist propaganda of the student radicals. And so, the anxiety of earlier Manchu rulers who worried that the loyalties of their ethnically Chinese troops could not be fully trusted would be confirmed at the end. When the revolution finally came in 1911, bringing with it a violent conclusion to the more than 250-year rule of the Qing dynasty, it began not, as it had been planned, with the bomb-throwing plots of radical students, but with an uprising from within the ranks of the New Army.

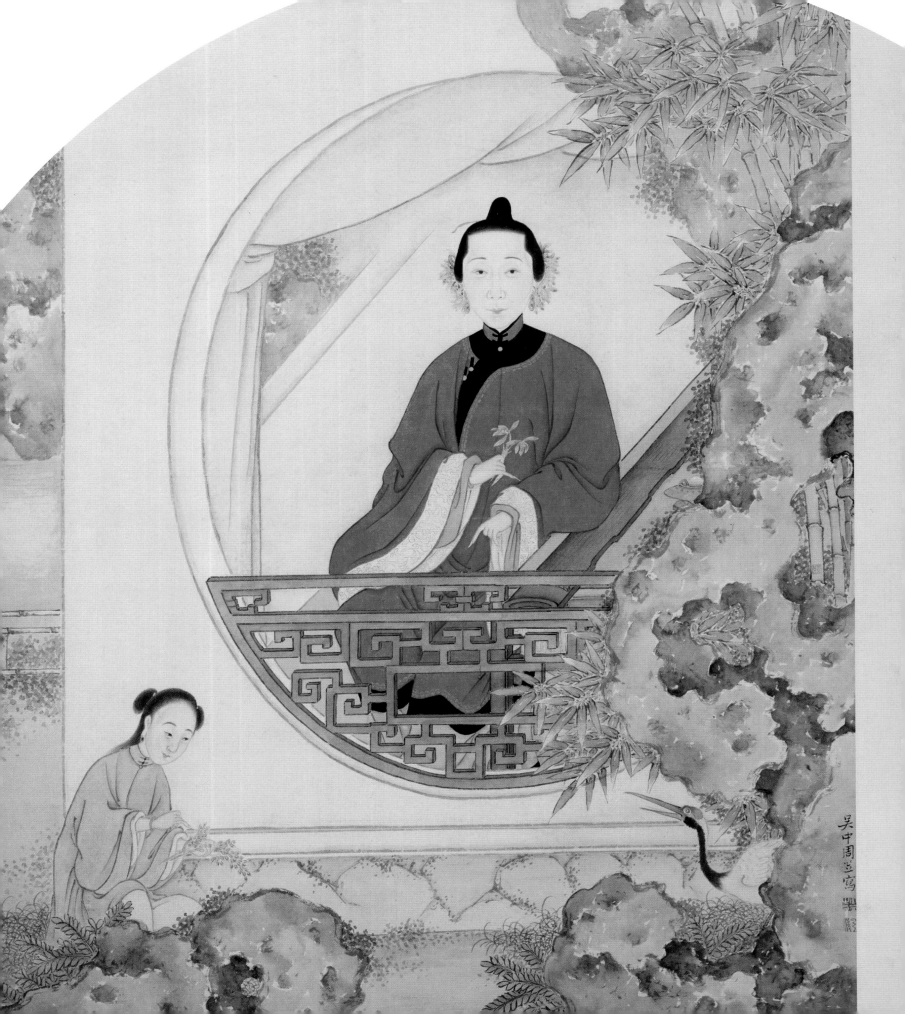

Elite art

Chia-ling Yang

In important ways, the elite art of China's 'long 19th century' reflects the crises that the country underwent during this period. Indeed, it is impossible to understand the trajectory of elite art without linking it to the particular political, social, economic and cultural contexts in which painters found themselves. 'Crisis in a society gives rise to two contradictory processes,' writes philosopher Edgar Morin. 'The first stimulates imagination and creativity in the search for new solutions. The second is either the search for a return to past stability, or the adherence to a providential salvation or to the naming of a real or imaginary culprit that must be eliminated.'[1] Across many areas of intellectual life, late imperial turmoil generated fresh ideas about reform; within elite artistic circles these galvanised a return to antiquarian studies. The development of Chinese painting and calligraphy offers an excellent case study of cultural transformation, illuminating how artists negotiated between continuity and change, and internal and external stimuli.

In its early years, the Qing dynasty introduced into the civil service examinations (see pp. 14–15) the requirement that all students answer questions drawn from a narrowly defined canon of texts attributed to Confucius and his disciples, using the 'eight-legged essay' form (八股文). This was a rigidly structured, even formulaic style of writing demanding great literary skill but arguably no profound or original knowledge. Every candidate, moreover, was required to write from memory the Kangxi emperor's 1670 *Sacred Edict* – his ubiquitously distributed summary of Confucian thought, emphasising social harmony and submission – in order to instil loyalty, morality, duty and obedience. The examination system, as the Qing's

instrument for disciplining the educated elite, sought both to establish intellectual orthodoxy and to hold out the promise of social mobility, to reduce resentment of class distinctions; in theory, the system was meritocratic, offering even the poor and humble the opportunity to become, through natural brilliance and dedicated study, top administrators. But the demands of the exam curriculum often proved problematically abstract: successful candidates and would-be officials were rewarded for their literary proficiency rather than problem-solving administrative competence (see figs 6.27–6.31).

The system also stifled freedom of expression. After 1652, not long after its initial conquest of the Chinese empire, the Manchu Qing government had prohibited formal intellectual gatherings and societies, in order to assert central control over elite sinophone culture. In response to political oppression, many intellectuals turned away from contemporary administrative practicalities, and towards empirical research on ancient texts that extended into phonology, geography, history, astronomy, mathematics, governmental institutions and artefacts. A rediscovery and reassessment of China's cultural heritage resulted: ancient texts – including those at the core of late imperial Confucian orthodoxy – were authenticated and studied; forgeries and later additions were identified. A version of this backwards turn can be seen in trends in fine art during the first century and a half of the Qing era. Educated elites of the Qing empire favoured the so-called 'Orthodox School' of painting, which stressed proficiency in imitating the style of previous masterpieces rather than advancing one's individual creativity.

Key figure: Ruan Yuan (1764–1849)

3.1
Zhou Zan 周瓚 (n.d.), *Scroll of accumulating antiquities* (積古齋圖) (detail)
This detail from a larger scroll features a portrait of Ruan Yuan 阮元 (centre), a native of Yangzhou (eastern China) and one of the most celebrated scholar-officials of the first half of the 19th century. He passed the civil service exams at the highest, *jinshi* level in 1789 and later entered the Hanlin Academy, the Qing imperial government's elite think tank. Through much of his career, he

collected and published knowledge in a variety of fields, including astronomy, mathematics, history, geography and epigraphy. Between 1817 and 1826, he served as Viceroy of Liangguang (governing the southern provinces of Guangdong and Guangxi), with his headquarters in the city of Guangzhou. Like many of his peers, he was a connoisseur of antiques such as the Shang- and Zhou-dynasty ritual bronzes, bells and jades shown in this painting; he is said to have owned 460 bronzes made between 1600 BC and AD 220.

Ruan Yuan's study of such artefacts established him as a leading representative of 'evidential' scholarship, which prized empirical research and knowledge, derived from careful analysis of ancient inscriptions. Ruan Yuan's focus on such inscriptions furthermore shaped the development of calligraphy through the 19th century.

1803, Hangzhou. Ink and colours on silk. H. 38 cm, W. 264 cm (entire scroll). National Library of China, Beijing, Shanta188

The throne's ability to enforce central control over intellectual life, however, was tailing off by the end of the 18th century. With growing mobility within and between communities (a feature of the Qing 18th century more broadly), educated elites created new networks and shared their cultural passions – for poetry and the creation and collection of fine art – in both intimate and more formal social gatherings. Collective projects in literature and the fine arts (publishing, collecting, composition) became fashionable. Consequently, such gatherings and societies – populated by highly educated men and women – grew in number and became crucial forums for disseminating artistic works and techniques, and debating art, poetry, history and ethics. In the

early decades of the 19th century, these conversations sometimes spilled over into practical, political discussions; the 'Spring Purification Circle', founded in 1829 to write and admire poetry and calligraphy, counted among its adherents ambitious Han Chinese statesmen like Lin Zexu (see fig. 2.22), who possessed confident, thoughtful visions for solving the many crises besetting the empire. The 18th century had also seen the rise of popular culture and commercialisation in painting following the increase in new communities of middle-class art consumers (especially in the prosperous Yangzi delta regions), leading to greater diversity of artistic practices and audiences. While central imperial control waned through the 19th century, China's vibrant

educated communities developed new artistic techniques and modes for representing and interpreting the changing worlds of the late empire, especially in the wealthy cities of the east coast.

The 19th century witnessed an intensification of antiquarian studies (fig. 3.1), which in turn shaped painterly and calligraphic art in very particular ways, and in the final decades of the dynasty this 'antiquarian aesthetic' fused with Western technology (new colours, new photographic techniques and new printing methods such as lithography) to forge a fresh, modern relationship with a 'Chinese' artistic identity. This chapter begins by tracing how antiquarianism and 'evidential scholarship' (考證) came to dominate Qing intellectual life and artistic production. From the Jiaqing era onwards, the study of ancient artefacts – a precursor to modern archaeology – encouraged the rise of the new 'Stele School' (碑派) in calligraphy, and a close interest in nature inspired new modes of painting. The chapter goes on to explore the impact of social and political instability and urbanisation on artistic style, and on the commissioning and consumption of art.

New centres for artistic creativity also emerged during this period. For example, a wave of artists was driven to Shanghai, especially after the outbreak of the Taiping Civil War in 1850. The later-named Shanghai School sheds light on the coexistence (and commingling) of traditional and innovative art trends in this treaty port. This chapter will show how the tastes (and sponsorship) of the scholarly elite of China in the southern Yangzi river region gradually replaced imperial patronage, which had been in decline since the death of the Qianlong emperor in 1799 and was arguably not revived until Empress Dowager Cixi's later years. Changing patterns of patronage shifted the cultural centre from Beijing to Shanghai's international settlements. In a further important change, paintings, poems and calligraphy by women gained wider recognition as the century progressed.

Epigraphical studies and antiquarianism

Intellectuals of the early Qing dynasty were broadly divided into two circles. One group supported the Song dynasty School of Neo-Confucianism (宋學) following the teachings of men like Cheng Hao 程顥 (1032–1085),

Cheng Yi 程頤 (1033–1107) and Zhu Xi 朱熹 (1130–1200). This group was sponsored by the Qing government in order to rationalise and disseminate the political virtues of loyalty, order, duty and obedience by which they hoped to rule the empire. The other group of scholars favoured instead the 'Han Learning' (漢學) endorsed by men loyal to the former Ming dynasty (1368–1644), such as Gu Yanwu 顧炎武 (1613–1682), who refused to serve the Manchu Qing rulers. Such thinkers rejected the metaphysical abstractions of Neo-Confucianism, and returned to more practical subjects and learning of the pre-Tang eras (that is, prior to the 8th century) through empirical, evidence-based scholarship.[2] Gu Yanwu emphasised three approaches key to scholarship: one must 'prize originality' (貴創), 'find extensive evidence' (博證) and 'find practical applications' (致用).[3] Inscribed stone steles located across the empire were valued as authentic evidence of the ancient past, to be used in historical and literary 'evidential scholarship'. Historian Bai Qianshen has suggested that visits to steles and ancient sites reflected a sense of being 'left-over' Ming-dynasty loyalists (遺民): individuals trying to recover – through studying objects such as steles – the splendid past of a conquered nation.[4] Epigraphic and antiquarian study of inscribed ancient bronzes and steles, epitomised by the so-called Study of Metal and Stone (金石學) movement, supported the understanding of history and antiquity, and would become the key measure of erudition during the late Qing dynasty. The function of such epigraphic studies was to accurately record historical events from the deep past, to pass on moral messages from ancient inscriptions to later generations, and to glorify meritorious acts. Because of its close links to the writing of history and to uncovering the origins of the Chinese script, the study of epigraphy came to loom large in Qing-dynasty sinophone education. The second half of the 18th century saw a boom in antiquarian publications which emphasised the study and aesthetic appeal of calligraphy inscribed on bronzes, stone steles and other ancient objects. By the final quarter of the 19th century, epigraphy had been formally classified as a specialised discipline within historical study.[5]

The study of epigraphy reached its zenith between the late Qianlong and Xianfeng eras. Scholars used ancient objects and the inscriptions found on relics to supplement their study of early Chinese history and

civilisation. Some reproduced inscriptions through rubbings to help them read the contents of these texts and make links with other early historical writings. Others studied the development of the Chinese script system and were much taken by the aesthetics of inscriptions incised on bronze vessels from the first millennium BC. They particularly admired steles from the Han dynasty (202 BC–AD 220), whose style underpinned the so-called Stele School of calligraphy and seal carving in the mid-19th century. From the late 18th to 19th centuries, several places served as hubs for

antiquarian activities and publishing projects: Beijing, regions along the Yellow river and the Huai river in Shandong, Shaanxi and Henan provinces, Yangzhou and Nanjing, Suzhou, Wuxi and Changzhou, and Hangzhou and the surrounding region. These hubs grew out of clusters of informal private secretaries (幕府, educated men unable to find formal employment in the imperial bureaucracy) working for regional governors (who were employed by the court) such as Bi Yuan 畢沅 (1730–1797) of Henan and Shandong, and Xie Qikun 謝啟昆 (1737–1802) of Guangdong and

3.2
Deng Shiru, *Calligraphy in four hanging scrolls* (自作詩四條屏)
Deng Shiru was a Chinese calligrapher and seal carver born into a poor family in Anhui province. His upbringing meant he did not receive a formal education or official position within the Qing bureaucracy. He is best known as a man at the vanguard of stele studies (碑學), which took inspiration from the inscribed stone steles of the Northern dynasties (AD 386–581), rather than from examples of classical calligraphers' writing transmitted imperfectly on silk and paper. Deng Shiru's standard script (in the

far-right panel) is squarish with sharp-edged corners, acknowledging the techniques of stele inscriptions of the Six Dynasties (AD 220–589). His seal script, by contrast (second panel from the right), shows influence from the Stele of Mount Yi (嶧山碑, erected in 219 BC by Li Si 李斯 (c. 280–208 BC), a senior Qin official); it was seen as archaic and exuberant, with slender, elongated lines and deploying the 'upturned brush' (逆筆) technique for horizontal strokes. Deng preferred to use a long brush made of goat hair, which is soft yet requires greater wrist control, and raw *xuan* (soft, specialist) paper. His technique, therefore, advocated innovation within tradition.

These four calligraphy panels were not originally made as a set but are dedicated to different friends of Deng.

1801 (far-left scroll); 1796 (all others), Anhui. Ink on paper. H. 86.8 cm, W. 35.3 cm (each scroll). Palace Museum, Beijing, Xin.00156365

Guangxi. Ruan Yuan, who held many senior official posts in north and south China, was one of the most important builders of such antiquarian networks (see fig. 3.1). His publications became important theoretical works underpinning the Stele School that revolutionised Chinese calligraphy. Later epigraphers, active in the 1830s to 1860s, paid more attention to the materiality and aesthetics of a wider range of pre-Tang objects, and applied their stylistic characteristics to their calligraphy, seal carving and painting. Such practice also directly stimulated the Stele School and helped promote a taste for archaism in Chinese painting.

Revolution in Chinese calligraphy: the Stele School

Prior to the 19th century, there were three dominant trends in the practice of calligraphy, which had changed little since the late Ming. The first had an enhanced appreciation for the individualist, expressive and untrammelled styles associated with the artists Wang Duo 王鐸 (1592–1652) and Fa Ruozhen 法若真 (1613–1696), as well as Ming loyalists such as Fu Shan 傅山 (1606–1684), Zhu Da 朱耷 (1626–1705) and Song Cao 宋曹 (1620–1701). The second trend admired the calligraphy of Dong Qichang 董其昌 (1555–1636) and his Huating School 華亭派 (or Songjiang School 松江派) and enjoyed great popularity under the patronage of the Kangxi emperor. This style was later dubbed the 'examination-hall style' (館閣體), most favoured by candidates for the civil service examination. The third trend followed the late Ming calligraphers Zheng Fu 鄭簠 (1622–1693) and Zhu Yizun 朱彝尊 (1629–1709) in studying ancient stele inscriptions.

Inspired by Zheng Fu and Zhu Yizun's antiquarian approach, acclaimed calligraphers of the 'long 19th century', such as Deng Shiru 鄧石如 (1743–1805) (figs 3.2–3.3), Gui Fu 桂馥 (1736–1805) and Yi Bingshou 伊秉綬 (1754–1815) (figs 3.4–3.5), reinstated the aesthetics of inscribed pre-Tang steles, in particular stone-drum

3.4 (above)
Yi Bingshou, *Studio of well-informed friends* (友多聞齋)

According to art historian Yan Weitian, this calligraphic placard records the studio name of Ye Menglong 葉夢龍 (1775–1832) in Beijing. A renowned art collector, Ye came from a distinguished and wealthy merchant family in Guangzhou. His father, Ye Tingxun (1753–1809), was an influential Hong merchant who conducted international business with many important companies from Europe and the United States. Executed in thick, compact and homogeneous brushstrokes, the piece of writing features four monumental clerical-script characters on a horizontal plaque. The phrase derives from a Confucian lesson on friendship in the *Analects*: 'Confucius said, three kinds of friends are beneficial; three kinds are harmful. Straightforward friends, sincere friends, well-informed friends – these are beneficial. Hypocritical friends, sycophantic friends, glib-talking friends – these are harmful (子曰：益者三友，損者三友。友直，友諒，友多聞，益矣。友便辟，友善柔，友便佞，損矣).' The character 聞 (*wen*, third from the right), literally 'to hear and observe' (but here denoting 'well-informed'), also puns on the acoustic environment of the text's original location. At the time, Ye Menglong lived in the Jia Family Alley in the Xuannan district of Beijing, densely settled by Han Chinese from all over the empire. Ye's residence was adjacent to several important guilds, regional associations that each welcomed a diverse range of fellow provincials, including degree-seeking students and sojourning merchants.

1804, Beijing. Ink on paper. H. 47.9 cm, W. 167 cm. Asian Art Museum, San Francisco, The Yeh Family Collection, 2007.102

3.5 (right)
Calligraphy of Yi Bingshou inscribed on a vase in the form of an ancient bronze bell

An example of 19th-century antiquarian taste, this vase is modelled after an Eastern Zhou-dynasty bronze bell of the 4th century BC, complete with inscriptions in ancient forms. The scholar-official and calligrapher Yi Bingshou, who came from Ninghua, inland Fujian province, inscribed it, including its place and date of manufacture. After receiving his first degree at the age of 16, Yi enjoyed a 45-year career as a Qing government official and was posted to Beijing, Guangdong and Yangzhou. Between 1811 and his death in 1815, he was based in Fujian, where this vase was made. At that time, scholars regarded his calligraphy as highly experimental. He was part of the empire-wide antiquarian Study of Metal and Stone or epigraphy movement.

1812, Tingzhou fu (now Changting), Fujian province. Stone. H. 33.8 cm, diam. 18.5 cm. British Museum, London, 1910,0615.1. Donated by William Cleverly Alexander

3.3 (facing page)
Huang Jingfeng 黃景峰 (active 1780–1803) and Yan Zhubin 閆竹賓 (active 1780–1803), *Portrait of Deng Shiru* (完白山人放鶴圖)

This portrait of Deng Shiru (known as Wanbai Mountainman) at the age of 61 was painted by Huang Jingfeng and supplemented by Yan Zhubin on four panels in which Deng is depicted holding a fishing rod and accompanied by a servant. The fishing rod, the boat, the flying crane and the pine trees indicate Deng's integrity and status as a hermit. The middle years of the Qing dynasty saw dramatic change in calligraphic styles, to which Deng Shiru – a calligrapher and seal carver – was a versatile contributor. Through intensive study of Qin and Han dynasty seals, and of the calligraphy of the Three Kingdoms and Northern Wei eras (*c.* 3rd–6th centuries AD), he developed a new style of running script, which had a deep creative influence on the late Qing Stele School of calligraphy. His clerical and standard script projected an angular energy that broke with the smoothness favoured by many of his Qing predecessors; his seal and stone-drum scripts had a more rounded, flowing quality.

1803, probably Anhui. Ink and colours on paper. H. 118 cm, W. 60 cm (each panel). Anhui Provincial Museum, Hefei

3.6
Tao Zhaosun 陶兆蓀 (active c. 1850–1875), *Portrait of Bao Shichen* (包世臣像) (detail)
Bao Shichen, a Qing administrator, Confucian scholar and calligrapher, was deeply concerned by the socio-economic crisis of the late Qing and proposed reforms of government and laws, the tribute grain transport system between central China and Beijing, the salt monopoly and the illegal opium trade. He was also an active scholar of ancient bronze and stone inscriptions, the styles of which he imitated in his own calligraphy. Although he repeatedly failed the highest civil service exams, and therefore held no senior post, his counsel was much prized by leading officials.

This posthumous portrait by Tao Zhaosun captured Bao's image (unusually) as a reflection in either a mirror or a crystal ball placed on an ornamental stand. Bao is shown holding an antique bronze bell, following the antiquarian fashion of his era. Surrounding the image are inscriptions that comment on the close relationship between artist and sitter.

1853 or later, China. Ink and colours on paper. H. 93.5 cm, W. 38.4 cm. Palace Museum, Beijing, Xin.00054036

script (石鼓文) from the late Spring and Autumn period (771–476 BC), distinctive for the elongated structure of characters (consisting of a short radical on the left and a long counterpart on the right), and small-seal script, commonly used during the Qin dynasty (221–206 BC), in which all lines were executed with uniform thickness. Deng considered that by studying stone-drum script one could achieve smooth and free brushwork; that bronze inscriptions would illuminate the evolution of scripts; and that the practice of calligraphy as studied from inscribed steles of the Qin and Han would enhance skill in writing varying script styles.[6] 'Confucian art criticism,' writes historian Shana Brown, 'valued calligraphy as the expression of an artist's education, political views, and inner character.' The rectilinear, regular calligraphy of many ancient inscriptions was thus valued for the way it signalled moral rectitude and steadiness.[7]

The study of inscribed steles and other artefacts led to new theories and practices of calligraphy. Four crucial publications were *The Treatise on the Northern and Southern Schools of Calligraphy* (南北書派論, 1814) and *The Treatise on the Northern Steles and Southern Model-Calligraphy-Book* (北碑南帖論, 1819), both by Ruan Yuan, *The Paired Oars of the Boat of Art* (藝舟雙楫, 1848) by Bao Shichen 包世臣 (1775–1855) (fig. 3.6), and *Expanded Argumentation of 'The Paired Oars of the Boat of Art'* (廣藝舟雙楫, 1889) by Kang Youwei. While Chinese intellectuals had long seen their writing system as undergoing an extended period of historical development, a lack of convincing theoretical discussion in earlier scholarship had prevented scholars from reconstructing a reliable history of the script system and calligraphy. To resolve controversies about interpreting and verifying the canon of documents and writings associated with Confucian orthodoxy, publications by Ruan and others debated the

Wu Changshi, Calligraphy couplet in stone-drum script

Wu Changshi was an artist, calligrapher and seal carver as well as an influential promoter of the study of ancient scripts from the 12th century BC to the 2nd century AD. His calligraphy is distinctively innovative, as he elongates each character and adds 'flourishes of the brush'.

He also manipulates the position of individual characters so that they spill out of the strict grid system used by more conventional calligraphers to give each character its own equal space. Most of Wu's family were killed by Taiping troops when the latter rampaged through his home village in Zhejiang in 1860. He accompanied the Qing official and antiquarian Wu Dacheng (no relation but a significant artistic influence on him) on an

unsuccessful mission to defend northeast China in 1894 at the start of the Sino-Japanese War. After moving to Shanghai in 1913, Wu Changshi became celebrated as one of the pre-eminent modernists of Chinese painting.

1914, Shanghai. Ink on paper. H. 133 cm, W. 28 cm (each panel). Shanghai Museum

authenticity of the ancient Chinese script associated with 'high antiquity' (古文), dating to the 3rd–1st millennia BC, and aimed to clarify the transition and transmission of scripts between late Eastern Han (AD 25–220) and Jin dynasties (AD 265–420). It is also worth noting that from the late 19th to the early 20th centuries, scholarship on the evolution of the Chinese script system greatly advanced thanks to discoveries of oracle bones and bronze inscriptions unearthed from Anyang in Henan, inscriptions on bamboo or wooden slips from the Warring States (476–221 BC) and Han periods, and the sutra-style script (寫經體) in Buddhist paintings and manuscripts in the Dunhuang Cave Temples and along the Silk Road. Ruan Yuan and Bao Shichen, however, were too early to benefit from these archaeological breakthroughs in their own explorations of the history of the Chinese script.

These new histories of the Chinese script and aesthetic evaluations of calligraphy provided a theoretical basis for the Stele School. The script style of Eastern Han and Northern Wei (AD 386–534) stone steles was promoted, as opposed to the Model-Calligraphy-Book School (帖派), which studied reproductions of calligraphy on silk or paper by masters of the Eastern Jin dynasty (AD 317–420) calligraphic tradition. In calligraphic practice, tracing, scrutinising and reading an ancient master's original work are the main ways of mastering a particular style. Between the medieval and early modern periods, the model-calligraphy compendia (法帖) and edited copybooks of collections of rubbings from revered Eastern Jin-dynasty calligraphy became the canonical method of learning the art form. But by the late 18th century, repeated recopying of these compendia had reduced their

3.8

Su Renshan, *Riding dragons* (乘龍跨鳳圖)

Su Renshan was the son of a painter and came from Guangzhou. Like many great artists of imperial China, he failed the imperial civil service exams multiple times, which prevented him from taking up an official career. He died aged 36, while in prison on charges of 'filial impiety'. Su derived his unique, cartoon-like style from painting manuals and woodblock prints, and prominently signed his work, all of which broke radically with the conventional painting style of educated elites. This large composition challenges artistic tradition in its evocation of a fantastical utopian world. Its calligraphic inscriptions parody the archaic writing styles revered in the 19th century by antiquarians such as Ruan Yuan and Bao Shichen.

c. 1848, Guangzhou. Ink on paper. H. 254 cm, W. 118 cm. Art Museum, The Chinese University of Hong Kong, 73.614. Gift of Mr Ho Iu-kwong, Mr Huo Pao-tsai, Mr Lai Tak and others

3.9

Su Renshan, *Leading the phoenixes by playing the flute* (吹簫引鳳圖)

The last seven or eight years of Su Renshan's life were spent in Wuzhou and in prison in Shunde (Guangdong), where his mental health deteriorated. This large-scale ink painting is the pair to the painting illustrated in fig. 3.8. A male and female immortal are shown facing each other and flying on the backs of phoenixes, surrounded by inscriptions. Some of the inscriptions (written in a variety of scripts, as if added by a succession of connoisseurs) are not related to the painted images. Su's outlandish composition and dry angular brushwork border on the eccentric.

c. 1848, Guangzhou. Ink on paper. H. 278 cm, W. 120 cm. Art Museum, The Chinese University of Hong Kong, 73.615. Gift of Mr Ho Iu-kwong, Mr Huo Pao-tsai, Mr Lai Tak and others

accuracy and use as models for study. Calligraphers of the Stele School turned away from these flawed records to undistorted inscriptions on bronze vessels, steles, clay seals, tomb epitaphs, bricks, tiles, and sculptures in Buddhist grottos, and to large-character calligraphy engraved on cliffs. They considered such inscriptions to be more authentic representations of canonical styles than could be found in the model-calligraphy books.

The publications of scholar and government adviser Bao Shichen drove a phenomenal growth after the 1840s in Stele School studies and calligraphy from pre-Qin (pre-221 BC) to Northern Wei styles. He Shaoji 何紹基 (1799–1873), Wu Xizai 吳熙載 (1799–1870), Yang Xian 楊峴 (1819–1896), Xu Sangeng 徐三庚 (1826–1890), Zhao Zhiqian 趙之謙 (1829–1884) and others successively imbibed the Northern Wei style of forceful, intense brushwork. Wu Changshi devoted much of his calligraphic study to small-seal and stone-drum scripts and applied them to his boldly energetic cursive writing (草書) (fig 3.7). The Stele School also acquired followers in south and west China. Wu Rongguang 吳榮光 (1773–1843), the governor of Hunan, brought an impressive collection of rubbings and objects back to his hometown in Guangdong and encouraged similarly minded scholarship and art in the south. The calligraphy of the Cantonese Su Renshan 蘇仁山 (1814–c. 1850) showed a strong affinity (at times, bordering on parodic) for the inscriptions of Han-dynasty seals, with its centred, upright, controlled clerical script (figs 3.8–3.9). The cursive calligraphy that he added to his figure paintings, by contrast, has an unconventional wildness reminiscent of the script found on Daoist talismans.

The rise of the Stele School also inspired new seal-carving techniques.[8] For thousands of years, seals had been embodiments of political power, moral authority and cultural cachet; impressed on paintings and three-dimensional objects, they testified to their owner's identity and authority. They were thus prized artefacts, whose calligraphy – requiring exceptional skill to execute in miniature – communicated moral and aesthetic sophistication. There were two main schools of seal carving in the 19th century: the *Huipai* 徽派 (or *Wanpai* 皖派, Anhui School of seal carving), represented by Deng Shiru, and the *Zhepai* 浙派 (Zhejiang School of seal carving from Hangzhou), represented by Huang Yi 黃易 (1744–1802), Ding Jing 丁敬 (1695–1765) (fig. 3.10), Jiang Ren 蔣臣 (1743–1795),

Xi Gang 奚岡 (1764–1803), Chen Yuzhong 陳豫鍾 (1762–1806), Chen Hongshou 陳鴻壽 (1768–1822), Zhao Zhichen 趙之琛 (1781–1852) and Qian Song 錢松 (1807–1860), known collectively as the Eight Masters of Seal Carving in Hangzhou (西泠八家).

Deng Shiru applied the 'abrasive blade' (衝刀) technique in his seal carving to generate curved, fluid lines: by holding the knife sideways, the artist would push the angled knife into the stone quickly and continuously, using the power of both wrist and fingertips. The engraved lines, as exemplified in Deng's seal *Enjoying the pursuit of antiquity* (古歡), are clean, flowing and elongated, manifesting suppleness and elasticity (fig. 3.11). A passionate antiquarian, Deng Shiru emphasised that the quality of one's seal carving depended on one's knowledge of the ancient script system and training in calligraphy.[9]

The 19th-century Zhejiang School of seal carving mainly used the 'cutting blade' (切刀) technique: the artist held the knife vertically upright, pointed the knife at one end of the stroke and cut forward along the intended line. Strength was applied directly from wrist to knife to cut one line after another on the face of the stone without a pre-drafted sketch. Hence the strokes would be executed in a mixture of short and long cuts at variable speed during the movement. This technique emphasised a rhythmic and recurring action, which transmitted the strength of the wrist through to the material; each cut should connect naturally to the previous one.[10] Building on this technique, Zhao Zhichen pressed his knife heavily in slower motion to bring out the visual effect of scratchy strokes.

The creation of the seal *Bowing for a salary of five bushels of rice* (為五斗米折腰) in around 1865 marked Zhao Zhiqian's maturity in seal carving (fig. 3.12). Zhao applied Deng Shiru's abrasive blade technique to carve this seal with firm, fluent strokes, well-balanced between curved and straight, and sloping and upright strokes.[11] The multi-directional carved marks around the character 米 (*mi*) suggest that Zhao might also have incorporated the dual/multiple-direction carving (雙刀) technique, turning the seal stone while carving strokes in one direction. Zhao extended and slanted the downward strokes on the lower part of his characters, echoing the needle-shaped bases of characters on the *Stele of the divine prognostication sent from heaven* (天發神讖碑, AD 276), a stele rediscovered and

3.10

Ding Jing, Carved seal

Ding Jing carved this two-sided seal when he was 64 years old for his much younger friend Shi Mingzhong 釋明中 (c. 1717–1767). The square-based seal is made from a white stone, stained with red ink. On one end are the four characters 賜紫沙門 ('Monk Awarded the Purple Silk Garment') in Ding Jing's distinctive archaic script. The other end of the seal reads 南屏明中 ('[for] Reviving [Buddhism] on Mount Nanping'). An innovation of the 19th century was the addition of inscriptions on the side of the seal, as in this example: 龍泓外史丁敬，為茭虛中禪師製，用助雲煙巨幅之緣也。戊寅臘八日，記于硯林 ('Ding Jing made this [seal] for the Chan Buddhist master, Ying Xuzhong, to complement his large landscape paintings. Recorded on the eighth day of the twelfth month of the Wuyin year [1758], recorded in [his studio] the Forest of Inkstones'). The calligraphy on this fire-damaged seal was published by the Xiling Seal Engravers' Society in 1877, in *Selected Seals of the Eight Masters of Xiling*.

1758, China. Wood. H. 4 cm, W. 5.8 cm, D. 5.9 cm. Shanghai Museum

3.11

Impression and rubbing of Deng Shiru's five-faced seal, *Enjoying the pursuit of antiquity* (古歡)

This is an imprint from a small stone seal with five seal faces carved by Deng Shiru (with the characters 子輿 Ziyu, 燕翼堂 Yanyitang, 雷輪 Leilun, 古歡 Guhuan and 守素軒 Shousuxuan). Although double-sided seals were common, five-faced examples were much rarer. This seal was for Deng's personal use, bearing his self-styled and studio names. Carved in a range of styles drawn from Qin to Tang examples, the calligraphy documents Deng's varied interests in ancient writing styles. The last, blank face was completed by Bao Shichen with an engraved inscription, here with its imprint in darker ink, when the seal passed to him.

c. 1770–90, China. Seal paste and ink rubbing on paper. H. 6.9 cm, W. 2.3 cm, L. 2.2 cm (seal). Xiling Seal Engravers' Society, Hangzhou

3.12

Zhao Zhiqian, *Bowing for a salary of five bushels of rice* (為五斗米折腰) seal

This seal by Zhao Zhiqian was made to mark his departure from Beijing to Jiangxi, when he was overwhelmed by corrupt politics, wanting to quit his post but unable to afford to do so. He never passed the top degree in the civil service examinations and so his opportunities for official postings were limited. The seal's inscription conveys the steely will of an incorruptible Confucian bureaucrat under duress.

c. 1865, Nanchang, Jiangxi province. Qingtian stone (青田石, local to Hangzhou). H. 5.3 cm, W. 4.8 cm, D. 4.8 cm. Jinmotang Calligraphy Research Foundation, Hong Kong

3.13

Impression of Zhao Zhiqian's *Slave to seals* (印奴)

The name of this seal denotes Zhao Zhiqian's self-mockery of his economic reliance on carving seals for paying customers. Although the seal itself is lost, its impression survives in a book published in Hangzhou by the Xiling Seal Engravers' Society in 1877.

1863, Nanchang, Jiangxi province. Ink on paper

prized by antiquarians like Ruan Yuan and Bao Shichen. As the author himself noted on this personal seal, the inscription satirised Zhao's failure to live up to the anti-establishment values of the recluse Tao Yuanming 陶淵明 (AD 365–427), who famously refused to bow to his political superior in order to collect a meagre salary as a government servant. Such virtuosic adaptation of diversified styles has earned Zhao a unique place in Chinese art history. His contemporary, Shen Shuyong 沈樹鏞 (1832–1873), praised him for being the first 'in six hundred years to create a new path for seal artists'.[12] His seal making was an acknowledged inspiration to later masters such as Wu Changshi. Ironically, Zhao's seal-carving calligraphy – the appreciation of which was so steeped in aesthetic values – was also profoundly commercialised. In the early part of his career, Zhao supplemented his scant salary as a government official by churning out seals for admiring customers, who proudly used them to leave their mark on documents and paintings; as small, portable objects, they were convenient cultural status symbols to carry around. Zhao carved *Slave to seals* (印奴) for another seal-carving friend, joking that both of them were slaves to the seal-making industry (fig. 3.13).[13] In 1886, Wu Changshi made a similarly sarcastic joke with his seal *Slave to painting* (畫奴), which he presented to the most celebrated late 19th-century Shanghai artist, Ren Yi (known as Ren Bonian), who also sold his artistic talent (this time as a painter) to make a living.[14] The execution of the character 奴 (*nu*, slave) in Wu's work is almost identical to that of Zhao's earlier version; Wu was clearly mimicking Zhao's self-deprecating, humorous gesture.

19th-century artists transformed and elevated seal carving, turning it into a core genre of creative art-making. Their seal calligraphy borrowed and acquired new aesthetic prestige from inscribed antiquities. They also began to add long inscriptions to the side of their own and their colleagues' seals, again mimicking inscriptions on the sides of bronze vessels (銘文) that commemorated their manufacture. In their own versions of such inscriptions, late Qing seal carvers recorded their personal experiences and friendships with the seal owners, expressed their opinions on contemporary art and politics, and even engaged in academic debate. Such inscriptions can be read as personal notes to the original owner, transmitted on an intimate medium almost invisible to the naked eye.[15]

Antiquarianism and composite rubbing in paintings

Studies of antiquarianism and the Stele School during the Qing have distinguished three separate modes of antiquarian painting from the late 18th century: visual records of visits to landscapes of particular historic interest; portraits depicting collectors and their antiques in their studios; and the incorporation of composite rubbings of antiquarian objects into original paintings. From the mid-19th century onwards, ancient relics were also adapted as auspicious symbols to decorate flower paintings and portraits. The Shanghai School developed such novel combinations into an original type of art sold or given as gifts around New Year.

Late Qing antiquarianism's greatest innovation was its development of three-dimensional composite rubbing. Previously, antiquarians had often reproduced objects through trace-copy drawing (摹繪) or trace-copy carving (摹刻), for image-based catalogues of antiques. The new technique of composite rubbings (全形拓), also called 'full-form rubbings' (全型拓本) or 'three-dimensional rubbings' (立體拓本), started to appear in the last years of the 18th century and later became widely used in scholarly circles.[16] Composite rubbing was an elaborate process. It is neatly described by art historian Michele Matteini: it 'usually began by casting the vessel's shadow to outline its silhouette on paper. Some parts were then rubbed, and others printed or painted in lustrous black ink. The final effect is astonishing: the three-dimensional object appears to be real within the two-dimensional piece of paper, making viewers feel as if they are standing in front of the real thing.'[17] The Buddhist monk Liuzhou 六舟 (also known as Dashou 達受, 1791–1858) not only pioneered the process, but also combined composite rubbings with traditional bird-and-flower painting (a favourite genre of elite painting that depicted a wide range of natural subjects).[18] Liuzhou was renowned for making unidentified ancient inscriptions or patterns visible and clear once he had committed a rubbing to paper. He is shown at work in a picture co-authored with Chen Geng 陳庚 (active 1821–1861), *Cleaning the lamp* (剔鐙圖), depicted as a tiny figure first inspecting a Han-dynasty goose-foot lamp stand (雁足鐙) then cleaning the vessel and making the inscriptions visible on the upside-down lamp in the second section (fig. 3.14). Such an animated composition provides a delightfully faithful

representation of the antiquarian work that Liuzhou (and his keen friends) carried out on ancient artefacts.

Liuzhou's masterpiece *One hundred years* (百歲圖), made in 1831, assembled a large group of rubbings of small metal and stone objects, scattered in different, seemingly disordered directions on the same sheet of paper (fig. 3.15).[19] As was usual practice, Liuzhou had moved the paper around, rubbing different facets of each object onto a single sheet; he then used ink in varying quantities to make the rubbing clearer (in the case of damage to the original object), later adding red seal stamps and brush lines to achieve the illusion of depth, intensity, contrast between light and dark, and a three-dimensional quality. Their arrangement in this scroll – acclaimed by Liuzhou's antiquarian peers as highly innovative – required great skill, patience and time. Liuzhou subsequently attributed the inspiration for this intricate composition to the *jinhuidui* (錦灰堆, literally, 'pile of brocade ashes', or assembly of treasures) technique associated with the 13th-century literatus Qian Xuan 錢選 (*c.* 1235–before 1307).[20]

One of Qian Xuan's surviving *jinhuidui* scrolls juxtaposes drawings of lotus, hibiscus, crab apple, tulips, radish, butterflies and other creatures piled on top of each other.[21] That painting projects a naturalistic spirit, unconfined by neat schemas of classification.

Jinhuidui is sometimes linked with the *bapo* (八破, 'eight brokens') style, which became popular in folk art, porcelain and snuff-bottle design in the late nineteenth century.[22] While Qian Xuan's *jinhuidui* featured images from the natural world, *bapo* depicted elements such as scraps of old paper, charred remnants of ancient calligraphy, copies of fragments of famous ancient paintings, or corroded pages from rare books. The aesthetics of *bapo* drew attention to, even celebrated, the enigmatic incompleteness of history and lived experience; scholars such as Nancy Berliner have drawn a direct connection between the flourishing of *bapo* and the physical and cultural destruction wrought by the insurrections of the 19th century, especially the Taiping Civil War. But Liuzhou's work, although demonstrating superficial similarities, pre-dates *bapo* and is technically

3.14

Liuzhou and Chen Geng, *Cleaning the lamp* (剔燈小像)

Totally innovative to the 19th century in subject matter and composition, this image places the antiquarian and epigrapher monk Liuzhou within the image of the rubbing while engaged in the act of making it. He pioneered the technique of three-dimensional rubbings and also the inclusion of painting within compositions of rubbings. To create a rubbing, moist paper was pressed onto the carved surface and into its depressions. Once the paper was almost dry, the maker took an inked ball of raw silk or cotton, wrapped in cotton, and then gently patted it all over the surface, until the inscriptions or designs appeared as white on a dark ink ground. The inked ball was then pressed onto paper to make the rubbing. Such rubbings were greatly valued as authentic reproductions of original texts.

1836 (rubbing), 1837 (painting), She county, Anhui province. Ink and colours on paper, and rubbing. H. 31 cm, W. 70 cm. Zhejiang Provincial Museum, Hangzhou, 022499

3.15

Liuzhou, *One hundred years* (百歲圖)

Liuzhou made this masterpiece, the title of
which implies wishes for longevity for his friend,
the epigraphy enthusiast Yan Fuji. To create it,
Liuzhou made rubbings of 86 different objects,
all on one sheet of paper. Ancient coins, seals,
roof tiles and other inscribed items are carefully
placed within what appears to be a haphazard
arrangement. The eclectic mix of scholarly
and everyday text-related imagery includes an
1808 five-kopek Russian coin. The tradition
of making rubbings of calligraphy engraved
in stone or bronze already had a history of
almost a thousand years, but it was only in the
late 18th or early 19th century that Liuzhou and
his peers began making rubbings of three-
dimensional objects. The innovative Liuzhou
also experimented with multimedia works that
combined paintings and rubbings with new
types of artistic composition. The composition
here seems to foreshadow the later *bapo* (八破,
'eight brokens') illusionistic painting motif, which
depicted damaged scraps of classical writings,
artworks and inscribed ephemera as if arbitrarily
tossed onto the surface of the medium used
by the artist. The act of cherishing paper (or
collecting fragments of paper) was associated
with popular belief in Wenchang 文昌 (the God
of Literature). A Cherishing Paper Association
(惜紙會), established and promoted by scholar-
officials Zhao Shenqiao 趙申喬 (1644–1720), Peng
Dingqiu 彭定求 (1645–1719) and Ji Dakui 紀大奎
(1746–1825), encouraged people with baskets
to collect scraps of paper from households and
streets to be recycled or reused.

1831, Haining. Ink and colours on paper.
H. 136 cm, W. 61.6 cm. Zhejiang Provincial
Museum, Hangzhou, 025654

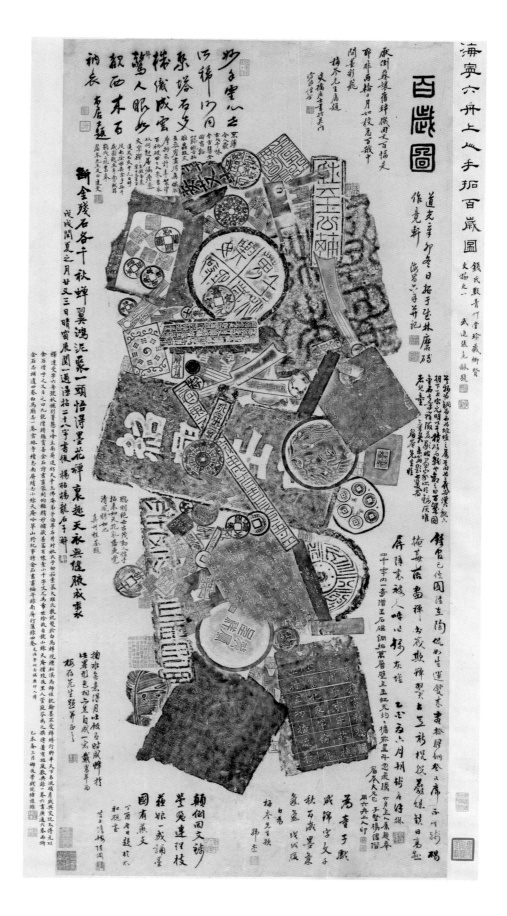

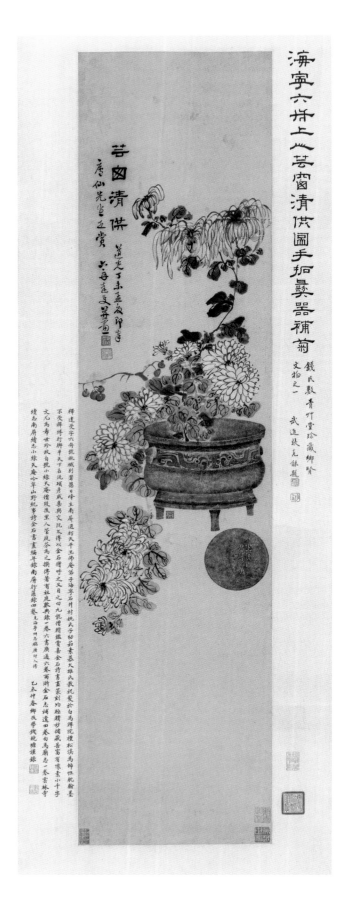

distinct, demanding more elaborate planning and execution, since his *jinhuidui* pictures consist of as many as a thousand rubbings of actual antique objects, and not merely painted images.

Liuzhou was also one of the first artists to combine composite rubbings of inscriptions and ancient bronze vases with coloured flowers in a single painting. In his *Flowers arranged in the Dou Vessel of Boshan of Western Zhou* (周伯山豆補花卉) of 1827–8, and *Festival offerings by the cloudy window* (芸窗清供圖) of 1847, seasonal flowers such as camellias, plum blossoms and *lingzhi* fungus add cheerful colour to the serious scholarly composite rubbing and its complex epigraphical inscription (fig. 3.16). Artists such as Yang Xian, Wu Tingkang 吳廷康 (1799–*c.* 1873) and Zhang Xiong 張熊 (1803–1886) spread this antiquarian mode of painting to later artists active in Shanghai and nearby cities. Liu Deliu 劉德六 (1806–1875), Ren Xiong, Zhu Cheng 朱偁 (1826–1900), Zhao Zhiqian, Ren Xun 任薰 (1835–1893), Ren Bonian, Wu Changshi and Huang Shiling 黃士陵 (1849–1908) followed Liuzhou in creating images that combined rubbings of antiques with paintings of flowers. Zhu Cheng's set of four scrolls of *Paintings of bronze vessels and flowers* (博古花卉四條屏) is a good example (fig. 3.17). The bright, seasonal flowers added vitality to the representations of the two antique vessels, while the rubbing of the inscriptions expressed the objects' historical value. This kind of juxtaposition communicated the aesthetics of antiquarianism far beyond scholarly research. Rather than mounting them in the album leaves or handscrolls, in *Composite rubbings of a bronze and stone collection* (金石集拓) the celebrated calligrapher, painter and antiquarian

3.16
Liuzhou, *Festival offerings by the cloudy window* (芸窗清供圖)
In 1847, Liuzhou returned home to Zhejiang from Beijing. This picture was inspired by the journey and describes in the inscription the travails of the road – the dust from the horses and carriages, and his exhaustion and frustration at how long it is taking him to arrive. He rested in a friend's house for a few days before creating this picture.

1847, Haining. Ink and colours on paper. H. 130.3, W. 30.8 cm. Zhejiang Provincial Museum, Hangzhou

3.17

Zhu Cheng, *Four paintings of bronze vessels and flowers* (博古花卉四條屏)

This type of art, combining a composite three-dimensional rubbing of ancient bronzes with painted flowers, was an innovation of the late 18th to early 19th centuries. There was growing interest in the display of inscriptions on ancient bronze ritual vessels and stone steles, which reflected the scholarly interests of their owners. The more conventional flowers represent the four seasons. Together, the images create visual puns for good wishes, using popular phrases from the second half of the 19th century – *jijin leshi* (auspicious metal and happy stone), or *jinshi*

yannian (metal prolongs life), or *shouru jinshi jiaqie haoxi* (may life be like metal and stone, wonderful and joyful).

1872, Shanghai. Ink and colours on paper.
H. 177.5 cm, W. 46.9 cm (each painting).
Michael Yun-Wen Shih

3.18
Wu Dacheng, *Composite rubbings of a bronze and stone collection* (金石集拓)
The hanging-scroll format for displaying these rubbings is a 19th-century innovation. Here, a combination of jades, a mould for making Chinese coins, and small chariot fittings, many dating to the Eastern Zhou period (770–256 BC), are shown together. Each object is accompanied by a beautifully spaced calligraphic inscription. Wu Dacheng's antiques collection contained more than 3,200 items, including bronzes, jades, coins, seals, porcelains, paintings and rubbings. Some of the jades pictured here are now in the Royal Ontario Museum, part of the missionary Bishop White's (1873–1960) collection. He bought them through a Shanghai dealer who in turn had obtained them from Wu Dacheng's daughter, who was married to Yuan Shikai's eldest son.

One panel dated 1885, others undated; possibly Shanghai. Ink and rubbing on paper. H. 131 cm, W. 34 cm (each panel). Private Collection

3.19
Sun Mingqiu 孫鳴球 (1823–after 1903), *Congratulatory wishes for longevity* (慶壽圖)
Sun Mingqiu was born in a small town to the south of Tianjin in Hebei province. Although well versed in the classics, he never passed his civil service exams and, in his 50s, he turned his attention to *bapo* art. This collage-style *trompe-l'oeil* painting, created when he was nearly 70, is an example of a traditional love of ancient things rendered in an innovative style that combined paintings of the popular Eight Daoist Immortals with rubbings of antiquities.

1892, Beijing. Ink and colours on paper and rubbing. Diam. 25 cm (image); H. 40.5 cm, W. 32 cm (album). British Museum, London, 1973,0917,0.59.44

3.20–3.22
Teapot, brush pot and vase with seals and inscriptions

Interest in epigraphy and collecting seals created a fashion for seal impressions as a pattern on porcelain in the 19th century. This teapot is decorated with two different kinds of iron-rich pigment – red and black – and is gilded around the lid edge and knob. Its texts come from 'My Humble Hut' (陋室铭) by the Tang-dynasty poet Liu Yuxi 劉禹錫 (AD 772–842), a prose poem describing a cultured life in a simple dwelling. The brush pot has an iron-red Qianlong mark on the base and the seals painted on it are in a heavily stylised seal script. They are connected to the eight famous scenic spots in Xiuning county near Mount Huang in Anhui province.

Teapot: 1875–1908, Jingdezhen, Jiangxi province. Porcelain with red and black enamels and gilding. H. 10.2 cm, W. 16 cm. British Museum, London, Franks.644.+. Donated by Sir Augustus Wollaston Franks

Brush pot: c. 1800–1900, Jingdezhen, Jiangxi province. Porcelain with clear glaze and iron-red overglaze. H. 9.3 cm, diam. 7.6 cm. The Sir Percival David Foundation of Chinese Art, PDF,A.776

Vase: Tongzhi period, c. 1862–74, Jingdezhen, Jiangxi province. Porcelain, coloured enamels and glaze. H. 19.1 cm. The Metropolitan Museum of Art, New York, 79.2.662

Wu Dacheng presented his composite rubbings of a wide range of antiquities with long inscriptions in four panels of hanging scrolls (fig. 3.18). Wu aimed to communicate the twin pleasures of collecting and scholarship in a format that could be displayed in a public space in the home. As knowledge of antiques was a shared scholarly passion between educated men, paintings that combined elements of rubbings, historical figures and texts were gifted to convey good wishes and cement friendships (fig. 3.19). Interest in studies of seal script and ancient inscriptions also spread to non-elite collectors and consumers, with whom impressions from seals and ornaments in the *bapo* style on textiles and ceramics became popular (figs 3.20–3.22).

New concerns in landscape painting before the Taiping Civil War

For 19th-century artists, the past was a source of inspiration as well as a point of departure. Patronised by the Kangxi and Qianlong emperors, the six leading painters of the 17th and 18th centuries were known as the Four Wangs – Wang Shimin 王時敏 (1592–1680), Wang Jian 王鑑 (1609–1677), Wang Hui 王翬 (1632–1717) and Wang Yuanqi 王原祁 (1642–1715) – together with Wu Li 吳歷 (1632–1718) and Yun Shouping 惲壽平 (1633–1690). Beginning in the 17th century, they established as painterly orthodoxy an amateur literati style that originated from centres of culture and fine arts

production in Jiangsu and that affirmed the dominance of landscape painting in art of the educated elite prior to the 19th century. These early Qing artists created their landscape paintings in the confines of their studios, perfecting the techniques and composition of past masters instead of going out to draw from nature themselves. By the final century of the dynasty, such an approach had become – in the eyes of some – too formalised, provoking a counter-reaction from 19th-century artists such as Zhang Yin (see p. 153). Artists like Zhang were also dissatisfied with the conventional, repetitive nature of 18th-century landscape painting, which they felt had become disconnected from reality and emotional immediacy.

3.23
Qian Du, *The pristine and verdant garden* (碧梧山館圖卷)

As the Qing government faced growing financial crises in the 19th century, fewer and fewer civil service jobs – the traditional career path for educated men – were available. Scholars had to rely more than ever on personal connections and the generosity of acquaintances who still had well-paid jobs or independent wealth. This ink and

light colour painting was made in 1809 by Qian Du in response to an 1800 monochrome ink painting by Xi Gang, to which it is attached. The colophons (handwritten texts at the end of the painting) read like a roll call of scholar-official patrons important to this generation of educated elite: Ruan Yuan, Chen Wenshu 陳文述 (1771–1843), Chen Hongshou, Gai Qi 改琦 (1774–1829), Qian Lin, Guo Lin, etc. This style of collaborative painting follows a long scholarly tradition.

1809, China. Ink and light colour on paper.
H. 24.9 cm, W. 60.6 cm. Palace Museum, Beijing, Xin.00098021

Before the outbreak of the Taiping Civil War in the 1850s, the Qing dynasty saw a growing number of regional schools of art and professional artists earning their living in the prosperous cities along the Grand Canal and Yangzi river. The Anhui-based Xin'an School (新安畫派) imitated the spare, solemn landscapes executed in highly refined brushwork by the artist-monk Hongren 弘仁 (1610–1664) and others. The Xuancheng School (宣城畫派) absorbed Mei Qing's 梅清 (1623–1697) depiction of irregular mountain shapes. The Gushou School (姑熟畫派), established by artist Xiao Yuncong 蕭雲從 (1596–1673) and continued by Huang Yue 黃鉞 (1750–1841), specialised in painting Anhui's famously beautiful Huang Mountain wreathed in pale blue misty air, executed in fine, articulated brushwork. Nanjing's Jinling School (金陵畫派) was famed for its 'accumulating ink' (積墨) technique, involving applying layers of ink wash on the same spot to create a sense of volume (a conscious break with then-established conventions in literati painting). The Jiangxi School (江西畫派) was renowned for its figure painting and collaborations with local porcelain artisans. In Hangzhou, Xi Gang, Qian Du 錢杜 (1763–1844) and Dai Xi 戴熙 (1801–1860) were talented in both seal carving and painting, and famed for their reformation of literati painting. Xi Gang used short, almost pointillist strokes in light ink to sketch out the shapes of mountains. Qian Du imitated the colour schemes of Ming artist Wen Zhengming 文徵明 (1470–1559), combining a thin base layer of ochre wash with light mineral green and blue on the top to achieve a well-defined and brighter visual effect (fig. 3.23). Dai Xi developed a signature 'cicada wing' technique, in which brushstrokes in dry pale ink created a translucent effect, on top of which layers of ink wash and darker lines evoked the texture of rocky mountains (fig. 3.24). In Zhejiang, the Shen Quan School (沈銓畫派), which also acquired a strong following in Japan, developed the gorgeous, meticulous style of 'bird-and-flower' painting popularised by Song-dynasty court painters. The bird-and-flower, bamboo and figure paintings of the Yangzhou School (揚州畫派) presented a more playful, individual artistic vision to new audiences, such as middle-class merchants. Their popular subject matter and free-wheeling techniques wielded a profound

3.24
Dai Xi, *Recalling the pines* (憶松圖)
Born into a scholarly family in Hangzhou, Dai Xi was an official and painter, a Hanlin scholar who served in the emperor's 'Southern Study' (an elite, policy-making brains trust). He achieved high office, served both the Jiaqing and Daoguang emperors, and was asked to serve the Xianfeng emperor but demurred on the grounds of ill health. He was twice Education Commissioner for Guangdong, including during the First Opium War, when he was also the official responsible for coastal defences against the British. In 1853, he became leader of local Qing forces defending his Hangzhou home from Taiping rebels, and despite his ill health raised money and trained the soldiers himself. In 1860, the Taiping captured Hangzhou and Dai Xi took his own life in despair, preferring suicide to capture, a Qing loyalist to the last.

1847, Guangzhou. Ink and colours on paper. H. 37.7 cm, W. 123.2 cm. Palace Museum, Beijing, Xin.00061449

春流出峽圖

3.25

Zhang Yin, *Spring streams flowing through mountain cataracts* (春流出峽圖)

Zhang Yin was from a wealthy elite family in Zhenjiang on the Yangzi river in Jiangsu, but in his 50s, around the time this image was made, the family lost its wealth during catastrophic flooding. Through his painting in ink and colours he created an innovative style in which he tried to harness the energy of the landscape while paying homage to the celebrated landscape painters of the Northern Song dynasty, who conventionally inspired later literati artists. This painting's sharp peaks and violent torrents may reflect his emotional recollection of recent natural disasters.

1817, Zhenjiang. Ink and colours on paper. H. 146 cm, W. 64.1 cm. Nanjing Museum, Su 24-1127

influence on subsequent painters. These diversified aesthetic schools underpinned the vibrancy of the Qing art scene in the first half of the 19th century.

The most representative landscape painters of the early 19th century are Zhang Yin 張崟 (1761–1829) (figs 3.25–3.26) and Gu Heqing 顧鶴慶 (c. 1830–1766) of the Jingjiang School (京江畫派) in Zhenjiang. For centuries, Zhenjiang – located at one of the two junctions between the Grand Canal and the Yangzi river – had attracted wealthy merchants and art collectors. Zhang Yin came from a wealthy textile-merchant family with a renowned antique collection. His painting style was influenced by Wang Wenzhi 王文治 (1730–1802) and Pan Gongshou 潘功壽 (1741–1794), who sought to revitalise landscape painting – overly formalised by the Four Wangs of the early Qing – with more individualistic styles inspired by Ming painters. Zhang's early work shows a strong affinity with Wen Zhengming's delicate brushwork and pale pigmentation. In middle age, however, Zhang's palette was darkened by thicker, voluminous brushstrokes influenced by Wu Zhen 吳鎮 (1280–1354).

Zhang's true significance lies not in his technical originality, but in his determination to draw local landscape from life. The visual realism of his *Three mountains near Jingkou* (京口三山圖卷) (fig. 3.26), which depicts the famous view of three mountains near the intersection of the Yangzi and the Grand Canal, also expressed the intellectual, political concerns of Daoguang-era 'statecraft officials', who proposed that scholarship should focus on solving practical government problems like that of water management.[23] (In the context of a Manchu Qing government that had long sought to control and limit practical political intervention by Han Chinese officials, this view represented a potentially subversive rebalancing of power to Chinese scholars.) The painting was dedicated in 1827 to Tao Shu 陶澍 (1779–1839), governor of Jiangxi, at a time when the Grand Canal was too devastated by floods to transport grain to the capital in the north. The crisis forced the government to accept the recommendations of senior Han officials Tao Shu and Lin Zexu to ship grain by sea, and also brought great suffering to local populations (the impact of such natural disasters and environmental degradation fuelled internal insurrections throughout the late Qing). The proposals of Tao Shu, Lin Zexu and other provincial governors were typical of the newly practical interventions of state officials.

Zhang's painting provided a visual record of the changing socio-economic circumstances that such officials' reports communicated to Beijing, evidencing the impact of political circumstances on elite painting

3.26
Zhang Yin, *Three mountains near Jingkou* (京口三山圖卷)
This work, painted by Zhang Yin at the age of 67, just two years before he died, represents three small mountainous islands (Beigu, Jiao and Jin) in or near the Yangzi river junction with the Grand Canal. A 'forest of steles' is located on Mount Jiao, a favourite place for antiquarians to take rubbings. The painting may also have subtly evoked the political crisis at the time surrounding expensive repairs to the increasingly dysfunctional canal.

1827, Zhenjiang. Ink and colours on paper. H. 29.3 cm, W. 193 cm. Palace Museum, Beijing, Xin.00082115

in the first half of the 19th century. Zhang Yin had personally suffered from the flooding of 1815, which destroyed most of his family wealth.[24] The *Album of water* (繪水圖), painted in 1824 by Jiang Baoling 蔣寶齡 (1718–1841) and endorsed by a long 1833 preface by Lin Zexu, then governor of Jiangsu, also recorded several massive floods that devastated the Yellow river between 1823 and 1833 (fig. 3.27). This album was composed to accompany the three-volume *Collected Essays on Water* (繪水集), contributed to by numerous writers from across the empire.[25] This new 'commiseration with catastrophe' (憫烖) style in landscape painting illuminates late Qing intellectuals' changing responses to domestic crises and their sense of socio-economic and political responsibility, which imprinted itself on their art and went beyond the formalised, abstract, ivory-tower traditions of earlier literati painting.

New views of nature

Especially in the second half of the 19th century, visual culture developed new understandings not only of Chinese antiquarianism, but also of freshly accessible Western scholarship and technologies. A painter like

Zhao Zhiqian (fig. 3.28) expanded the scope of the 'broad study of antiquity' (博古, *bogu*, referring to the antiquarian passion of many of his peers) to include the Chinese empirical scholarly tradition of 'broad learning about [all] things' (博物, *bowu*). (The term *bowu* had its origins in texts from the 3rd century AD, referring to empirical information on subjects as diverse as geography, geology, plants and animals, rarities and strange stories, local costumes and anthropological accounts of peoples.)[26] Zhao's 1861 *Strange fish of different species* (異魚圖) depicted rare ocean species and distinctive botany from Wenzhou in a style that broke with traditional literati choices of subject matter and presentation (fig. 3.29).

Shortly before *Strange fish of different species* was composed, Zhao was out of work and desperately looking for a new position to support his family. With help from friends, he was appointed adviser to the county magistrate of Rui'an in Wenzhou prefecture in the spring of 1861 (fig. 3.30). Shaoxing, Zhao's native town, lies inland around 332 kilometres west of Rui'an, so exposure to the humidity, natural resources and the unfamiliar coastal landscape of the East China Sea dazzled the artist. Complaints about the abundance of ants, rats and poisonous snakes, and the frequency

3.27

Jiang Baoling, *Album of water* (繪水圖)
Jiang Baoling recorded the severe flood in the Lower Yangzi river of 1823/4 in this rare album. The surviving eight leaves (out of the original 12) depict destroyed villages, flooded rice fields, people panicking in wrecked boats awaiting rescue, corpses floating in the water, people finally receiving food aid from local government and donors, and the ravaged, post-disaster landscape. Lin Zexu commented on and wrote poems about this disaster. Such subject matter was quite new for the 19th century and reflects an engagement with the plight of people suffering from natural disasters.

1824–33, Zhenze county, Jiangsu province. Ink and colours on silk. H. 26 cm, W. 34 cm (image); H. 79.6 cm, W. 36.4 cm (mounted). Shanghai Museum, 34429

Key figure: Zhao Zhiqian (1829–1884)

3.28
Wang Yuan 王綠 (active c. 1862–1908), *Portrait of Zhao Zhiqian* (王綠 趙之謙肖像 軸) (detail)

Zhao Zhiqian was one of the most talented calligraphers, seal carvers and artists of the 19th century. He came from Shaoxing in Zhejiang province but little is known about his training. In 1850, when he was 21, Zhao went to Hangzhou to avoid the early turmoil of the Taiping Civil War, but eventually found safety in Wenzhou (also in east China). His patron, a prominent official called Miu Zi 繆梓 (1807–1860), died defending Hangzhou from the rebels, and in 1862 Zhao's wife, daughter and other relatives were killed back in Zhejiang, and his old home was completely destroyed. Due to the insufficiency of his official salary, Zhao operated in a thoroughly commercialised world, collecting financiers and merchants as patrons. He probably viewed export watercolours from Guangzhou or other treaty ports, which influenced his commercially attractive style, employing flat colours and dynamic forms. One of the great innovators in seal carving and painting of the late 19th century, he became a model for other contemporary northern Zhejiang artists, such as Pu Hua 蒲華 (c. 1834–1911) and Wu Changshi, who were a little younger, and active in the Shanghai market. In this image, he is shown in the informal blue robe of a scholar. Wang Yuan inscribed a moving text on his portrait: 'If the world praises me, I shall not accept such praise; of those who try to destroy me, I shall not complain. Only the painter can capture my likeness. Hanging on the wall it will inspire people to call out, "It is Zhao, it is Zhao!" I neither walk nor sit but stand alone, and with a smile say nothing.'

1871, possibly Beijing. Ink and colours on paper. H. 106 cm, W. 33.7 cm (entire scroll). The Metropolitan Museum of Art, New York, 1986.267.30

of typhoons, often featured in his letters and poems from this time.[27] His *Miscellanea from Zhang'an* (章安雜說) of 1861 recorded many unusual animals, fish and plants, and his paintings from this period show a similar fascination with the natural world.[28] Zhao's stated objective in painting *Strange fish of different species* – a work more than 3 metres long – borrowed the empiricism of Ming-dynasty *materia medica* in aiming to 'offer correct views on the study of terminology'. Zhao's close friend Hu Shu 胡澍 (1825–1872) also wrote at the start of the scroll that Zhao was enthusiastic about the 'Study of Statecraft' (經世之學, literally, the 'study of principles for ordering the world'), and that the purpose of this painting was not to show off his passion for exotic, uncommon things, but 'to share a wider range of information and to amend the inventory [of words and things] (廣見聞資考訂)'. (The influential 'Statecraft' group of scholar-officials formed in centres like Beijing in the early 19th century; its adherents sought to use their intellect and readings of the Confucian canon to pursue practical solutions to the empire's many domestic and foreign problems.) Showcasing the interest in art and natural history shared by Zhao and his intellectual circle, *Strange fish of different species* carefully depicted the physical peculiarities of rare species and included brief identification notes about their habitat and biology, and fisheries drawn both from textual research and empirical observation. Some of the species featured were only registered scientifically around Zhao's time, or even later.[29] Drawing on Chinese compendia, local gazetteers and knowledge transmitted orally by natives of Wenzhou, such descriptive paintings of nature can be seen as an extension of Zhao's pursuit of evidential scholarship, developing from the empirical investigation of antiquity to that of the natural world. Zhao's interest in natural history – apparent in this painting – evidenced how, during this period, earlier Chinese traditions of *bowu* practice encountered translated texts and the activities of foreign naturalists in coastal China to develop into a recognisably modern science.

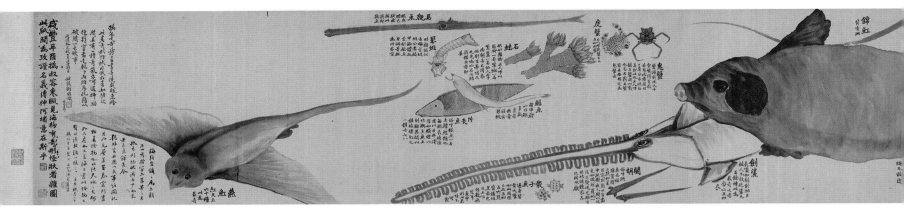

3.29

Zhao Zhiqian, *Strange fish of different species* (異魚圖)

In the 1850s, Zhao Zhiqian was invited by friends to travel to Wenzhou, a refuge at the time of the Taiping Civil War. There, he observed an extraordinary variety of plants, fish and insects. Many of the fish and crustaceans that he recorded in this painting were consumed in local Wenzhou cuisine. Each of the specimens is painted in a highly novel style, and the remarkable colour palette was influenced by trade paintings from Guangzhou. The beautiful calligraphy for the frontispiece is by Hu Shu, a brilliant scholar and expert in hermeneutics (the study of the interpretation of texts). An expression of the 19th century's *bowu* (broad learning about things) vogue for studying nature and inanimate objects, the painting seems almost an extension of the calligraphy. The painter adopted the so-called 'boneless' (沒骨) technique, applying vivid colours directly onto the paper without clear outlines. The painting zooms in on the details of the creatures, mixing vibrant colours and blunt-edged brushwork. Despite the candid three-dimensionality of the image, Zhao's juxtaposition of unrelated aquatic creatures and botanical species raises questions about whether he drew them from life. Each species bears a title and short description of its scientific name or local nickname; in the Chinese tradition of 'bird-and-flower' (nature) paintings, such scientific identifications were rarely appended.

1861, Wenzhou. Ink and colours on paper. H. 35.5 cm, L. 315 cm. Wenzhou Yanyuan Museum

3.30

Zhao Zhiqian, Magistrate's judgment (趙之謙硃堂判文書橫幅)

This document, a judgment at a court hearing involving the Wan lineage, is evidence of Zhao Zhiqian's life as a county-level magistrate. Zhao's handwriting is in red and the names of the people involved are in black ink on the right of the document (Zhao has added the age of each witness). The document was collected by the great calligrapher, painter and official, Wu Changshi, who added an inscription to it.

3 August 1884, Nancheng. Ink on paper. H. 27.4 cm, W. 227.1 cm. Zhejiang Provincial Museum, Hangzhou, 021829

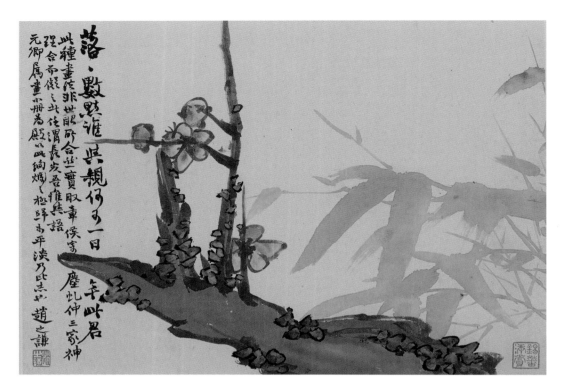

3.31
Zhao Zhiqian, *Album of flowers*
(花卉圖冊)

Zhao came from a merchant
background, but studied hard
and passed two levels of the civil
service exams just before the
Taiping Civil War. He painted this
beautiful and innovative album
in 1859 when he was an aide to
Miao Zi 繆梓 (1807–1860), who
was his mentor in studying for the
exams and who was denounced
for failing to defend Hangzhou
against the Taiping army the
following year, despite dying in the
conflict. Some of the bold colours
used, including the red, were new
pigments introduced from Europe.
The compositions are fresh and
powerful, strikingly different from
earlier, more saccharine and
idealised images of plants.

Dated 1859, Hangzhou. Ink and
colours on paper. H. 22.4 cm,
W. 31.5 cm (each image);
H. 64.4 cm, W. 44.8 cm (mounted).
Shanghai Museum, 66143

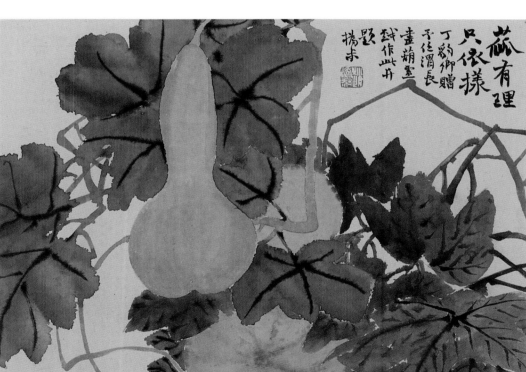

3.32
Zhao Zhiqian, *Album of flowers*
(花卉圖冊)
The most strikingly original aspect
of this album, apart from its very
vibrant palette, are the artist's
viewpoints. Zhao creates fresh and
innovative compositions by painting
the flowers and plants from unusual
and very close-up angles.

1859, China. Ink and colours on
paper. H. 22.9 cm, W. 31.9 cm (each
image). Palace Museum, Beijing,
Xin. 00017245

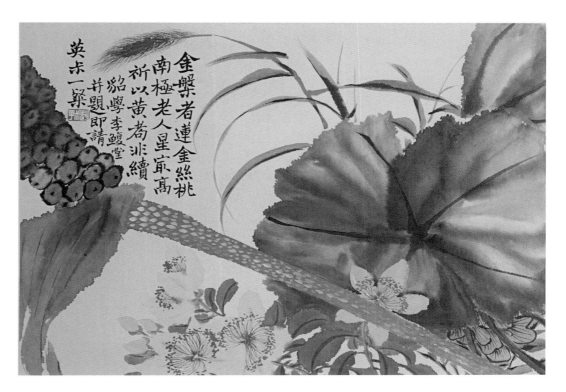

Between the 17th and 19th centuries, Jesuits and foreign communities in coastal ports made significant contributions to the development of modern technology and natural science in China through trading, translation, publishing and education. Men like Robert Morrison (1782–1834) and John Reeves, who arrived in south China in 1807 and 1812 respectively, dedicated themselves to the study of flora and fauna. While expanding the East India Company's library collection in natural history, stored in the office/warehouse space on the riverfront at Guangzhou (Canton), Morrison assembled around 800 volumes of Chinese medical works and interviewed Chinese doctors in order to research the region's *materia medica*. In the late 1820s, British naturalists attached to the Company also proposed to set up a 'British Museum in China' or a cabinet of curiosities that would encourage the Chinese to take an interest in Western-style natural history.[30] As the century wore on and more parts of China were made accessible through military campaigns and the opening of new treaty ports, British collectors were sent out – as part of an informal empire-building project – from Kew Gardens and the Horticultural Society of London to hunt for new species of plants.[31] There are fascinating differences between British schools of natural-history drawing and Zhao Zhiqian's depictions. While the paintings Reeves commissioned from Cantonese artisans are indebted to European techniques of scientific drawing, Zhao's blunt-edged brushwork achieves a more characterful result. Reeves' more precise, 'scientific' drawings were an aid to classification and identification in the Western tradition. Nevertheless, Zhao's paintings achieved a more naturalistic pictorial statement: his art can be seen as a living, breathing process of 'making' and 'knowing' the natural world, by a scholar rooted in late Qing evidential scholarship.[32] Zhao's take on natural history evinces traditional scholarly rigour, while departing from the orthodox representational canon of pre-19th-century elite Chinese painting (figs 3.31–3.34).

Although mastery of scientific knowledge was not a high priority within the system of learning sanctioned by the Qing government and enshrined in China's system of examinations for public office, 19th-century scholars from the Lower Yangzi region incorporated natural history and other scientific fields into the classical *bowu* tradition of investigation. Jiangnan

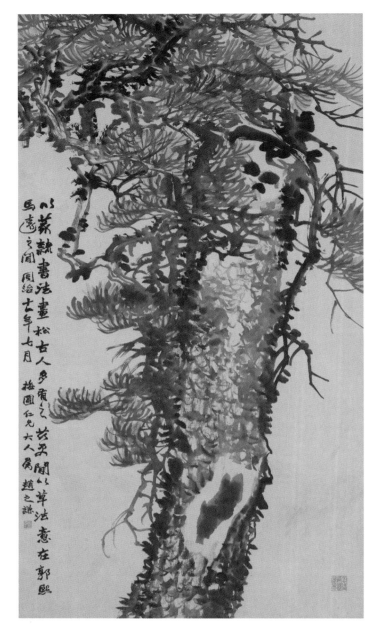

3.33
Zhao Zhiqian, *Old pine tree*
(墨松圖)
In the inscription on this painting, Zhao Zhiqian states that 'in the past, many have painted pine trees using brushwork techniques drawn from seal and clerical scripts. By adding cursive-script brushwork to this repertoire, I wish to align my work with paintings by Guo Xi [*c.* 1020–1090] and Ma Yuan [1160–1225]'. The positioning of the tree in a gentle diagonal across the scroll and the thick-ink spiky needles are reminiscent of the Song-dynasty paintings that Zhao identified with. Instead of painting the tree in full, however, Zhao focuses on just a section of the trunk. Curved strokes in varying shades animate the trunk's surface texture. The twigs are executed with short, broken, regular strokes that connect to produce a visual exuberance. Zhao painted the branches from the base upwards.

Dated 1872, China. Ink and colours on paper. H. 176.5 cm, W. 96.5 cm. Palace Museum, Beijing, Xin. 00100396

3.34
Zhao Zhiqian, *Bookstack cliff* (積書岩圖)

The composition of this painting vividly illustrates Zhao's turbulent life experience, above all the loss of his family and home during the Taiping Civil War. The texture of the bookstack-like cliff is executed in 'ghost-face brushwork' (鬼臉皴). The mountain looks like it is built out of piles of skulls; with the addition of the swirling waters beneath, the painting seems to be haunted by the author's restless sense of death. Bookstack cliff is an actual location in Hebei, but Zhao had never seen it himself. Although the painting is undated, he may have composed this work from imagination, following a commission from his patron-friend Pan Zuyin 潘祖蔭 (1830–1890) when they both lived in Beijing in 1863–72.

c. 1863–72, Beijing. Ink and colours on paper. H. 69.5 cm, W. 39 cm. Shanghai Museum, 19321

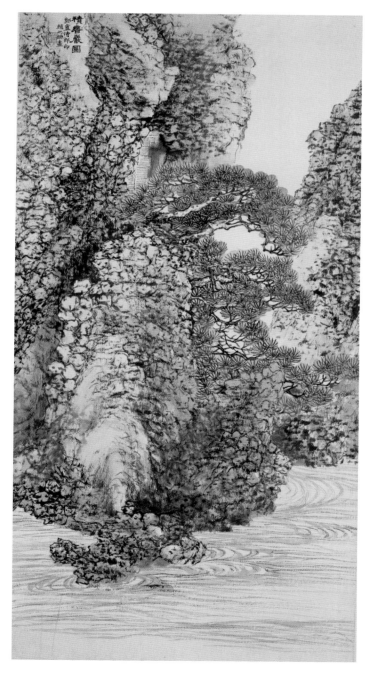

evidential scholars, their contemporary John Fryer (1839–1928) wrote, were 'determined to push their investigations in a more useful and promising field by endeavouring to become acquainted with the great laws of nature, and to gather as much information as they possibly could respecting the various branches of science and art … without organising themselves into a Society these aspirants for intellectual light used to have occasional meetings of an informal kind for mutual improvement, each person explaining any new facts or ideas he had acquired.'[33] In the late Qing, the 'investigation of things' essential to evidential scholarship embraced new approaches for acquiring knowledge, as a response to the changing world in which Chinese intellectuals dwelled.[34]

Inspired by translations by Protestant missionaries in mathematics, astronomy, medicine and natural history that appeared after 1850, chemist Xu Shou 徐壽 (1818–1884) joined the mathematicians Hua Hengfang 華蘅芳 (1833–1902) and Li Shanlan 李善蘭 (1811–1882) and the reformist Wang Tao 王韜 (1828–1897) in Shanghai, working at the Inkstone Press (墨海書館, Mohai shuguan) established by the London Missionary Society, and translating scientific books with the British Protestant missionaries Alexander Wylie (1815–1887), Alexander Williamson (1829–1890) and Joseph Edkins.[35] They completed translations of many staple scientific works, which introduced Western medicine and natural history to elite Chinese readers through creative fusions of East Asian and Western terminology. Eventually, in 1902, the Qing government officially adopted the ancient Chinese concept of *bowu* to translate modern natural sciences, taught in new-style academies – a neat illustration of how traditional Chinese scholarship merged with Western ideas to generate new categories of knowledge and inquiry in China's 'long 19th century'.[36]

Artistic communities of men and women before the Taiping Civil War

In the first half of the 19th century, a still-affluent Qing state offered a relatively peaceful and comfortable environment for antiquarian scholars in the Lower Yangzi river region. Many literary societies were sponsored by provincial officials, merchants and local gentry. In 1792, for example, the senior official

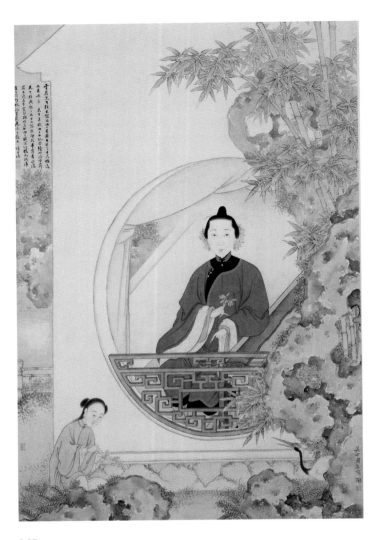

3.35
Zhou Li 周笠 (active late 18th century),
Portrait of Cao Zhenxiu **(曹貞秀像)**
Cao Zhenxiu was an author and poet famous in her day then forgotten for many generations. She married another celebrated scholar, Wang Qisun 王芑孫 (1755–1817) and collaborated with many well-known artists of the late 1700s and early 1800s. This painting represents the work of three artists: the portrait through the moon gate by Zhou Li, the calligraphy written and composed by Wang Jisun, and the bamboo and the auspicious crane added by Cao Zhenxiu herself. The text on the left of the image explains that it was painted after a snowfall had been cleared away and that the artist worked from life and completed the piece in half a day. The orchid in her hand, the zither beside her and bamboo are all symbols usually associated with male scholars.

1809, Suzhou. Ink and colours on paper.
H. 138.8 cm, W. 79 cm. Palace Museum, Beijing, Xin.00147377

Li Tingjing 李廷敬 (d. 1806) founded the Mountain Villa on the Horizon Society for Calligraphy and Painting (平遠山房書畫會) in Shanghai; the society continued to be active until the 1820s. In Hangzhou, between 1824 and 1835, Wang Yuansun 汪遠孫 (1789–1835) – another senior bureaucrat – hosted the monthly gathering of the Poetry Society of the Eastern Chamber (東軒吟社), the region's foremost literary society, with seventy-six members. As Shi Bohua 施柏華 (1835–1890) later commented, people had greater economic freedom and ease; members of wealthy, successful families could indulge themselves writing and socialising with friends, without needing to seek paid employment.[37] Such a leisured atmosphere is conveyed by an 1833 volume of portraits of the Poetry Society of the Eastern Chamber by Fei Danxu 費丹旭 (1801–1850), showing twenty-seven members enjoying music, painting and literary discussions in their regular monthly gatherings in the gardens of their host, Wang Yuansun.[38]

Continuing trends from the Kangxi and Qianlong eras, during the Daoguang reign there were also literary societies organised by elite women for elite women, such as the Chanting Society of Autumn Leaves (秋紅吟社) in Beijing, the Society of Washing [Clothes] (浣社) in Chengdu, the Society of Fragrant Chanting (香吟社) in Huichang (Jiangxi) and the Society of Cherishing Time (惜陰社) in Haining (Zhejiang). Talented educated women such as Cao Zhenxiu 曹貞秀 (1762–*c.* 1822) (figs 3.35–3.36) were patronised by well-known male scholars such as Wang Wenzhi, Yuan Mei 袁枚 (1716–1797) and Chen Wenshu. The gatherings of Yuan Mei's female students at the West Lake in 1790 and 1792 were illustrated in *Thirteen female disciples seeking instruction at the lake pavilion* (十三女弟子湖樓請業圖) by You Shao 尤詔 and Wang Gong 汪恭 (both active 1780–1790s) in 1796.[39] That scroll provides a visual index to a group of famous women celebrated for both their talent and beauty. However, in Yuan Mei's colophon, each woman is still introduced as a dependant of her male family member – as a 'talented wife' or a 'talented daughter'. Women's writing had very limited circulation at the time, and depended on sponsorship by their families.[40]

Of Yuan Mei's female disciples, Xi Peilan 席佩蘭 (1760–1829), Sun Yunfeng 孫雲鳳 (1764–1814), Luo Qilan 駱綺蘭 (1756–1820), Liao Yunjin 廖雲錦 (1766–1835) and Yan Ruizhu 嚴蕊珠 (1766–1820) were accomplished painters as well as poets. Unfortunately, very few

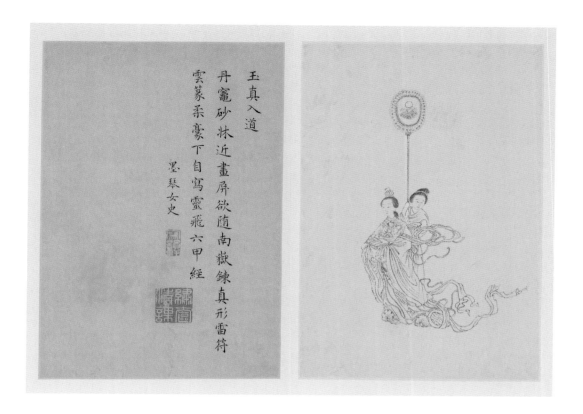

3.36

Poem by Cao Zhenxiu with painting by Gai Qi: *Famous women* (列女圖冊)

There is a long tradition of women writing annotated biographies of famously virtuous women to set an example of womanly ideals, above all loyalty, chastity and self-sacrifice for one's family. Cao Zhenxiu composed 16 poems and in 1799 had the young artist Gai Qi, then in his mid-20s, create the delicate images of women which accompany the poems in this album. These are not the usual selection of famous women of history and legend. Cao has clearly focused on selecting clever female artists, calligraphers and warriors from the past to project a new idea of the ideal woman. The illustrations – some of interiors, others of gardens or landscapes – are unusually refined and quite original.

1799, Jiangnan. Ink on paper. H. 24.8 cm, W. 16.8 cm (each leaf). The Metropolitan Museum of Art, New York, 2016.362a–t

3.37

Liao Yunjin, *The hollyhocks* (蜀葵圖)

The talented female artist Liao Yunjin painted these hollyhocks in a very naturalistic way using a wide range of colours. Women were encouraged to produce beautifully observed images of subjects from the natural world and flowers were considered a traditionally suitable subject for women.

1799, Shanghai. Ink and colours on paper. H. 64.2 cm, W. 30 cm (image); H. 205 cm, W. 59 cm (mounted). Shanghai Museum, 74546

of their works or their biographical materials have survived, or can be confidently authenticated. Extant works particularly favour bird-and-flower designs executed in refined brushwork. *The hollyhocks* (蜀葵圖), a 1799 painting by Liao Yunjin, a native of Qinpu (Shanghai), renders the petals' texture in extremely delicate, sheer lines (fig. 3.37). The variety of tones she uses for the petals – ranging from yellow and green to mineral blue – gives vitality to her picture.

Changzhou, a city between Zhejiang and Nanjing in Jiangsu province, home to the famous early Qing painter Yun Shouping, generated an exceptionally cohesive school of female artists. Yun passed on his painting skill to members of his family, including the women. His granddaughter Yun Bin 惲冰 (active 18th century) was praised as one of the best female painters in Jiangnan (her works were collected by the Qianlong emperor). Local gentry families also supported women's artistic education, and several studied painting seriously under celebrated tutors. Zuo Xixuan 左錫璇 (1829–1859) became particularly well-regarded for exuberant flower painting using the 'boneless' (沒骨) technique, in which the artist applies an ink wash without first drawing outlines.

The first half of the 19th century saw greater promotion of female talent through literary networks and publishing. Together with her granddaughter, the eminent female poet and Changzhou painter Yun Zhu 惲珠 (active *c.* 1829) edited the ground-breaking 1831 volume *A Preliminary Anthology of Poems by Qing-dynasty Women of the Inner Chambers* (國朝閨秀正始集). Over three years, the two women collected more than 3,000 poems by Qing female writers. In 1844, *Collected Poems by Qing-dynasty Women of the Inner Chambers* (國朝閨閣詩抄), edited by Cai Dianqi 蔡殿齊 (1816–1888), included fifty female poets of the early 19th century. Yet while there was a boom in publishing women's writing, this support did not spill over into male literati interest in acquiring their paintings. It is far from clear whether the works of women artists like Liao Yunjin and Dong Wanzhen 董琬真 (1776–1849) could be seen in public or outside their close circle.

It was fashionable among male artists to depict women of inferior social status, such as concubines or courtesans, as women of cultural accomplishment; educated women artists did not depict such subjects. Fei Danxu's *Confessions in silk damask* (懺綺圖) depicts Yao Xie 姚燮 (1805–1864), a well-known Zhejiang artist, writer and patron, enjoying music, drink and poetry with courtesans in a garden (fig. 3.38). The painting, along with anecdotes about its composition, evokes a world of elite male cultural and sexual connoisseurship, in which women are depicted according to fixed gender stereotypes.

3.38

Fei Danxu, *Confessions in silk damask*
(懺綺圖)

Fei Danxu was born into a family of professional artists in northern Zhejiang province. He was known for his portrait paintings and images of beautiful women. The subject of this fine figure painting is Yao Xie, an esteemed professional literatus and well-known commentator on the celebrated novel *Dream of the Red Chamber* (紅樓夢). Yao Xie was a patron of Ren Xiong and other Shanghai artists, and was also known for his deep devotion to Buddhism; he is depicted here surrounded by beautiful women.

1839, Zhenhai, Zhejiang province. Ink and colours on paper. H. 31 cm, L. 128.9 cm. Palace Museum, Beijing, Xin.00016598

As the 19th century wore on, internal conflicts increasingly disrupted the social, political and cultural order. This turmoil was intensified by the traumatic disruptions of the First Opium War (1839–42) (see p. 100). While such warfare left a clear imprint on contemporary writing, it was rarely explored in visual art. One curious example is the painting entitled *Wealth and longevity*, jointly composed by Fei Danxu, Zhang Xiong and Weng Luo 翁雒 (1790–1849), on which Jiang Guangxu's 蔣光煦 (1813–1860) inscription dated 1841 indicated the distress brought by the First Opium War in just four laconic characters: '海氛甚警', 'tensions extremely high on the coast' (fig. 3.39). Completion of this sequentially painted collaborative work was interrupted by the war due to the obstruction of coastal waterways, making it impossible for individual artists to meet. However, the cheerful subject of flower and animal in pleasantly harmonising tones conveys no emotional anxiety concerning foreign invasion, as if the artists were disconnected from the turbulent times through which they were living.

Domestically, the growth of Han Chinese proto-national sentiment against the Manchu administration grew steadily through the century, as a succession of rebel groups rose up against Manchu rule. The Taiping Civil War – the most brutal of such conflicts – was particularly destructive of public and private art collections in the Lower Yangzi river region. Important libraries and antique collections, including Tianyige Library in Ningbo, and Wenlan'ge Library (Pavilion of Billowing Literature) and Monk Dashou's Lütian'an (Green-Sky Hut) in Hangzhou, were destroyed by fire. Guan Tingfen's 管庭芬 (1797–1880) diary sorrowfully recorded the fate of Jiang Guangxu's Biexiazhai (Studio of the Motivated Learner) collection. Jiang was a leading antiquarian-collector and a close contact of Ruan Yuan, Liuzhou and Zhang Tingji 張廷濟 (1768–1848). Soon after Jiang's entire collection, of more than 100,000 books and numerous paintings, pieces of calligraphy and antiques, was smashed by Taiping forces in Zhejiang in 1860, he vomited blood and died (apparently of grief).[41] Guan Tingfen further commented that after Taiping troops raided the city of Haining, Qing soldiers plundered any remaining property. Hence, nine out of ten houses and shops were destroyed, many were killed, young men were dragged away by the rebels and women were either kidnapped

3.39 (left)
Fei Danxu, Zhang Xiong and Weng Luo, *Wealth and longevity* (富貴耄耋圖)

This is a rare example of a painting that directly refers to the fighting of the First Opium War through its inscription. Although at first glance it looks as if it is just a painting of a flower and a cat, the inscription reads 'tensions extremely high on the coast' (海氛甚警), referring to the British bombardment of the forts along the coastline of east China, where the artists lived. The cat was drawn in 1841, but because of the war preventing the artists travelling to meet each other, the painting was not completed until 1843.

1841–3, Haining, Zhejiang province. Ink and colours on silk. H. 106.4 cm, W. 34.1 cm. Zhejiang Provincial Museum, Hangzhou, 021431

3.40 (opposite)
Tang Yifen, *Garden of pleasure* (愛園圖) (detail)

A personal tragedy can be read into this orthodox-style painting. Tang Yifen, artist and soldier, was also a talented poet, swordsman and musician who, like his father and grandfather, had served in many military posts across the empire before retiring from service to Nanjing, where he built this beautiful garden. In 1853, five years after he painted the scene, Tang took his own life by drowning, having failed to defend Nanjing against the Taiping forces, who captured the city and turned it into their capital for the following 11 years.

1848, Nanjing. Ink and colours on paper. H. 59 cm, L. 1580 cm (whole painting). British Museum, London, 1938,1210,0.1

or committed suicide to avoid rape.[42] Sixty per cent of the population of Hangzhou starved to death in the war; half of the remainder died of plague.[43]

This cataclysm shattered the lives of numerous artists and destroyed art collections in what was once the empire's most economically and culturally prosperous region. Among the elites depicted in Fei Danxu's portraits of the Poetry Society of the Eastern Chamber, Tang Yifen 湯貽汾 (1778–1853) – a master of the Changzhou School of painting – committed suicide by drowning when Taiping troops entered Nanjing in 1853 (fig. 3.40). Most of his family, including his wife Dong

Wanzhen, his son Tang Shouming 湯綬名 (1802–1846) and daughter Tang Jiaming 湯嘉名 (c. 1803–1853) (all famed for their artistic talent) also committed suicide.[44] Dai Xi (see fig. 3.24) drowned himself in a pond after losing a battle against Taiping forces in Hangzhou in 1860. Seven further members of Dai Xi's family, including his grandmother, mother, siblings, nephew and daughter-in-law, committed suicide along with him.[45]

Xugu 虛谷 (1823–1896) (see p. 306), a painter and native of Yangzhou, was said to have served in the army as an officer fighting against the Taiping. Traumatised by his wartime experiences, he subsequently became a

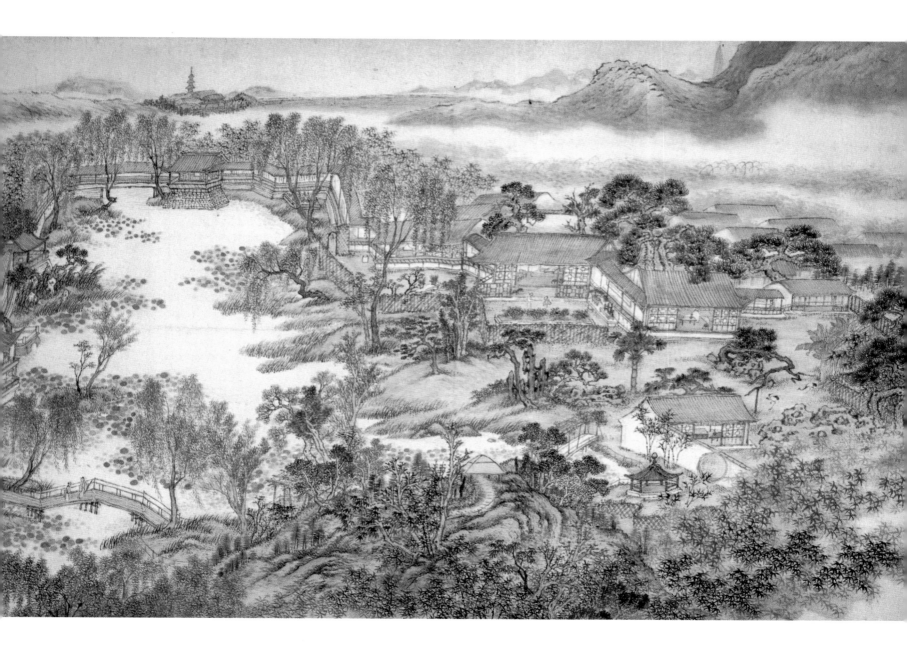

Buddhist monk.[46] With the old networks of patronage destroyed, numerous painters drifted from place to place before ending up in Shanghai. Ren Bonian is thought to have lost his father during the war when Taiping troops invaded his hometown, Shaoxing, in 1861. The bereaved Ren was then conscripted as a standard bearer in the Taiping army. As a young boy, the artist's son Ren Jin once drew a picture of two armies fighting; his father scolded him severely. As a result of his traumatic wartime experiences, Ren Bonian could not abide even an image of battle.[47]

Wu Changshi – a native of Zhejiang and later renowned as a founder of Chinese artistic modernism – recalled that when he was seventeen, he took refuge for two and a half years in unpopulated mountain areas. Bodies and skeletons were piled along the roads, and there was a desperate shortage of food. His fiancée stayed behind to look after her in-laws; when Wu returned in 1862, his mother pointed at an osmanthus tree in the backyard, telling him his fiancée was buried beneath it.[48] His yearning for reunion was expressed in many of his poems and personal seals completed across the remaining decades of his life, such as *Your former life was the moon* (明月前身), carved after a dream about his fiancée thirty-seven years after her death.[49] Long after the conflict was ended by Qing troops in 1864, Wu named his dwelling 'Studio of Eating Flowering Garlic Chives and Weeds' (飯菁蕪室) as a reminder of his painful wartime past. A sense of wretchedness and misery haunted him for the rest of his life. But outside his writing and some seal inscriptions, Wu's desolate wartime experiences did not manifest in his work; the artist's decision not to represent the breakdown of his inner and external worlds in his creative art is curious.

The Taiping Civil War also changed the culture and practice of collecting in the Yangzi river delta. The uncertainty driven by the conflict, Guan Tingfen believed, led people 'to place greater value on material property, such as gold and silk, and to attach less importance to painting and calligraphy. And because most of the art collections in southeast China were destroyed by fire, who was capable of discussing the masterpieces of Song and Yuan paintings anymore?'[50] The destruction of steles, painting and calligraphy collected in south China prior to the Taiping arguably inclined connoisseurs to collect bronze vessels, Buddhist sculptures, coins and other unearthed objects from burials and ruins in the north, a part of the empire much less affected by the conflict. A wider range of antiquities thus came to be appreciated as valuable artefacts, and the market value of rubbings of lost objects soared.

The Shanghai School and *fin-de-siècle* innovations in art

As the biggest treaty port in late Qing China, Shanghai in the 1850s and 1860s became a commercial centre for wealthy Chinese and foreign merchants, and compradors (Chinese middlemen, who operated between locals and foreigners). Its prosperous economy, high levels of consumption and relatively stable environment during a period of domestic rebellions and foreign wars also provided favourable conditions for cultural development (fig. 3.41). Shanghai in the second half of the 19th century offered refugee artists and intellectuals new ways of making a living; many migrated there. An 1883 list of famous artists (Huang Xiexun's 黃協壎 (1851–1924) 'Jottings on Songnan' (淞南夢影錄)) showed that migrants fleeing the Taiping Civil War had come to outnumber native Shanghai painters in the city.

The founding of new art societies (soon outnumbering those in the older cultural centres of Suzhou and Hangzhou) and shops underpinned the business of art in late Qing Shanghai (figs 3.42–3.43). Feidange (飛丹閣), an art society active from around 1865 to 1905, based in the east of West Garden (Xiyuan), exemplified this new dynamic. Feidange was very different from the earlier scholarly societies mentioned above: it not only offered a chance for artists to meet and exchange ideas, but was also a serious commercial concern, running a hotel and shop where its members – including Hu Gongshou, Ren Bonian, Wu Changshi, Zhu Cheng, Wang Li 王禮 (1813–1879), Wu Qingyun 吳慶雲 (d. 1916), Wu Tao 吳滔 (1840–1895), Wu Guxiang 吳穀祥 (1848–1903), Ren Yu 任預 (1854–1901), Pu Hua and Wu Youru – worked and shared customers. They also negotiated the price of their artworks and displayed paintings for sale.[51] Shanghai's flourishing economy, stable sociopolitical environment, modern amenities and open art market attracted and encouraged both professional artists and consumers.

The opening of art shops selling a variety of fine arts and supplies (antiques, seals, pigments, paintings

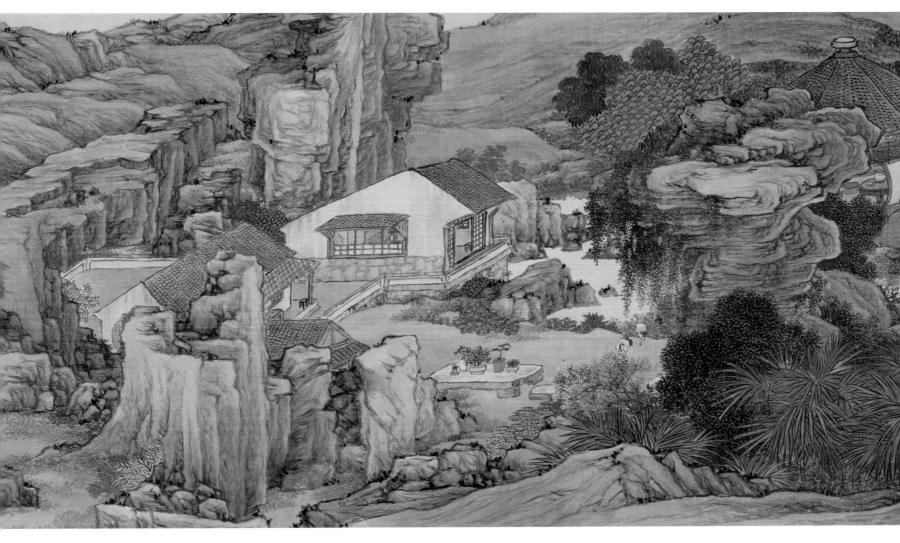

3.41

Ren Xiong, *Picture of the thatched cottage at Lake Fan*
(范湖草堂圖) **(detail)**

In 1855, at the peak of his creativity, Ren Xiong painted this beautifully imagined, uninhabited estate for his patron and friend Zhou Xian 周閑 (1820–1875), whose career included both civil and military positions. Around this time, Ren Xiong was living in Zhou Xian's house. This long handscroll combines a highly innovative palette, with autumnal trees depicted in red, purple and white, and hills and land painted in blue and green. It also presents the imaginary estate – populated only by cranes, a traditional Chinese emblem of immortality – from multiple viewpoints, enabling the viewer to tour the lake, gardens and buildings simultaneously. Three years after the painting was completed, Zhou Xian attached a text to it, describing each space in detail. Creating an entirely imagined landscape, one that was not based on a legend, a poem, a novel or an earlier painting, was an artistic practice new to 19th-century China. The peace envisioned here contrasts sharply with the actuality of civil war contemporary with the painting.

Dated 1855, Hangzhou. Ink and colours on silk. H. 35.8 cm, L. 705.5 cm (entire scroll). Shanghai Museum, 35977

3.42 (opposite)

Leaf from *The ten myriads* (十萬圖冊) by Ren Xiong

Ren created a small dramatic album of 10 leaves on gold-flecked paper using a palette dominated by traditional blues and greens but also featuring pinks and oranges. Each leaf shows imagined scenes based on the natural landscape around Suzhou. Ren painted them when the Taiping army was advancing northwards across the Lower Yangzi. Each image has the word 'ten thousand' (萬) in its title to suggest it is a universal record of natural beauty. This leaf, *Ten-thousand bamboo in clouds and rain*, imagines the scenery of the Xiao and Xiang rivers in Hunan.

c. 1850–6, possibly Hangzhou. Ink, colours and gilding on gold-flecked paper. H. 26.3 cm, W. 20.5 cm. Palace Museum, Beijing, Xin.00053926

3.43 (above)

Ren Xiong, *Album of paintings after poetry by Yao Xie* (姚大梅詩意圖冊)

At the peak of his career in the mid-1850s, Ren Xiong received a vast commission to create 120 album-leaf paintings illustrating the poems of Yao Xie, a patron in whose home Ren was staying. Each one is captioned with a line of his host's poetry. The compositions are highly original, the brushwork fine and the colours strong. They demonstrate an extraordinary range of techniques, many with unusual viewpoints. Subject matters include kittens playing, antique vessels, flowers in flowerpots, fantasy, figures from history, insects and flowers.

1851, Zhenhai. Ink, colours and gilding on silk. H. 27.3 cm, W. 32.5 cm (each image). Palace Museum, Beijing, Xin. 00101255

and calligraphy) also benefited the artists, who sought their livelihood through the sale of paintings in the second half of the 19th century. Manyunge (漫雲閣), established in 1829, was the first calligraphy and painting shop in Shanghai. During the Tongzhi period, shops selling art supplies and fans – sometimes designated 'fan shops' for short – became very popular (fig. 3.44).[52] These shops also supplied lodgings for visiting artists and allowed them to sell their work on the shop premises. They changed the art business: paintings were no longer only available to the rich or officials by private commission or through agents, but were on public display for sale. Shanghai thus created a market that sold works of art to anyone who could afford them. Friendships, cultural ties and business interests closely intersected in these new commercial hubs.

According to Ge Yuanxu 葛元煦 (active 1870–1880s), a contemporary observer, most of the famous art and fan shops had already opened in the busy streets of the foreign settlements by the 1870s; these were more exclusively and intensely commercial spaces than had existed in the 18th-century centres of artistic production such as Yangzhou.[53] This suggests the city's cultural centre had already moved from the old Chinese walled city to the highly commercial, multicultural society of the foreign concessions that had grown up after 1842. This relocation inevitably deeply influenced the aesthetics of the artists later called the 'Shanghai School', whose patrons included both Chinese and foreign sponsors. During his visits to China in 1867–1890, Kishida Ginkō 岸田吟香 (1833–1905) – Japanese journalist, publisher, calligrapher, art patron and owner of the Rakuzendō pharmacy 樂善堂 and its various branch stores throughout China that supported numerous Japanese drifters – was a patron to Shanghai School artists such as Ren Bonian (fig. 3.45), Hu Gongshou and Zhang Zixiang 張子祥 (1803–1886). In 1867, at the end of Kishida's first stay in Shanghai, Zhang Zixiang created a painting, *Parting at Song River* (淞江送別圖; now lost), as a gift; Ren Bonian's fan painting, *Landscape painting after the style of Shen Zhou*, was also dedicated to the Japanese entrepreneur.

Shanghai School artists often favoured populist themes to cater to a broad public: 'bird-and-flower' compositions, beautiful women, historical figures, and folk legends and beliefs familiar to ordinary people.

3.44
Advertisement for Nine Treasures Hall (九華堂) letter paper and fan shop
In 1889, China's first illustrated journal, *Dianshizhai huabao*, advertised the Nine Treasures Hall letter paper and fan shop. In the image, paintings are clearly visible for sale. Through shops selling art supplies and also through fan emporiums (selling both blank fans and fans with fine-art illustrations), customers were able to commission artworks without having any personal connection with the artist, and the artist could even be commissioned to add personalised inscriptions and dedications. Even foreigners could buy artworks in commercial outlets in Shanghai, many of which were located in the foreign concessions.

1889, Shanghai. Printing ink on paper

Key figure: Ren Yi (1840–1895)

3.45
Ren Yi (Ren Bonian), *Picture of*
three friends (三友圖) **(detail)**
Traditionally, networks of artists
were created by friendships
and connections made through
work, leisure, marriage or shared
hometowns. Ren arrived in
Shanghai in the late 1860s as a
refugee and was dependent on
creating new networks and gaining
the support of commercial shops
that would sell his work to local
Shanghai residents, Cantonese
and Fujianese financiers, and
businessmen. The three men in this
intimate gathering demonstrate the
complex dynamics of relationships
between artists and agents.
The men are identified in the
accompanying inscription: 'Two
gentlemen, [Zhu] Jintang and [Zeng]
Fengji, requested [Ren] Yi paint
their portrait, then permitted [him]
to sit [with them], calling it [a picture
of] Three Friends. Very fortunate,
very fortunate.' Ren painted himself
(right), with the businessman and
art-lover Zhu Jintang 朱錦堂 (active
1880–1890) (left) and Zhu's friend
Zeng Fengji 曾鳳寄 (n.d.) (centre),

who was possibly another artist.
Surrounded by artworks, they sit
close to one another on the floor,
which, it has been suggested, gives
the men an intimate and 'exotic'
or even Japanese air, as Chinese
scholars are generally shown
sitting on chairs. The official and
calligrapher Zhong Dexiang 鐘德祥
(1840–1905) inscribed the painting
in 1884; the calligrapher Xu Yunlin
徐允臨 (active 1880–1890) added the
title in archaic script two years later.

1884, Shanghai. Ink and colours
on paper. H. 64.5 cm, W. 36.2 cm.
Palace Museum, Beijing,
Xin.00100946

Ren Bonian, for example, drew over eighty portraits
for celebrated men (and women) of letters, 500 figure
paintings and 1,200 bird-and-flower paintings over his
four-decade career. The choice of subject matter was
closely related to the demands of an open art market
and the tastes of changing urban patrons. The image
of immortals offering good wishes, for example, was
often commissioned as a birthday gift, as seen in various
versions of this auspicious subject by Ren Xiong, Ren
Xun and Ren Bonian (figs 3.46–3.47). The appetite for
images of beautiful women, in particular, was shared
by male audiences from all backgrounds; and more
seductive representations of women reflected the
nightlife of the city's entertainment quarters
(fig. 3.48). Works of the Shanghai School strike a
cheerful, colourful tone, sometimes even using gold-foil

paper or extravagant gold ink on a dark surface to
achieve greater visual immediacy (fig. 3.49).

Artists of the 'Canton School', led by Ju Chao
居巢 (1811–1865) and his younger cousin Ju Lian 居廉
(1828–1904), were also affected by new patterns in
patronage (figs 3.50–3.51). Their works – predominantly
bird-and-flower paintings of local flora, insects and fish
– are wrought in soft tones with delicate brushwork and
'boneless' inkwash (without using outlines). Ju Lian
collected specimens to observe closely. By the late
19th century, the art in treaty ports was no longer
an elite and elitist product but rather, like the
prints and illustrated pictorials that proliferated
contemporaneously, a commodity designed for
practical, day-to-day purposes, such as education
and business, and mass-market consumption.

3.46

Ren Yi (Ren Bonian), *Immortals offering their birthday wishes*
(群仙祝壽)

This large-scale work, depicting Immortals and the Queen Mother of
the West, exemplifies Ren's early painting style from 1865 to 1878. The
composition reflects his keen interests in painting manuals, popular
woodcut book illustrations of dramas and even early Qing playing cards.
Such commercial reproductions enabled men like Ren from modest
backgrounds to study the work of past masters. Ren's father was an
aspiring scholar who earned a living as a portrait artist. Painters from
wealthier, more conventionally literati backgrounds – such as the sons
of high-ranking officials, like Pan Zuyin or Qi Junzao 祈寯藻 (1793–1866)
– would have had opportunities to study original works through contacts
with elite art collectors. This painting originally bore a fake signature of
the famous artist Tang Yin 唐寅 (1470–1524) to boost its value for the art
market, but this was later erased and replaced by the 'Seal of Ren Yi'
(任頤印). The work might have been melted down for its gold-foil surface
and destroyed in the early 1950s had it not been for the timely intervention
of Qian Jingtang 錢鏡塘 (1907–1983), the Shanghai-based collector, who
paid the dealer a higher price to preserve it.

c. 1865–78, Shanghai. Ink and colours on gold-foil paper. H. 206.8 cm,
W. 59.5 cm (each scroll). Shanghai Artist Association

3.47

Ren Yi (Ren Bonian), *Zhong Kui* (鍾馗圖)

Zhong Kui is a legendary figure who quells demons and protects people from sickness and misfortune. There are several versions of his origin story, reaching back 1,000 years. His image is displayed on the fifth day of the fifth lunar month. Ren Yi was a prolific commercial artist, as demonstrated in this work. The auspicious subject matter and bright colours reflect the tastes of the newly rich merchants who increasingly bought works by Shanghai artists.

1880, Shanghai. Ink and watercolour on paper. H. 131 cm, W. 66 cm. Michael Yun-Wen Shih

3.49

Ren Yi (Ren Bonian), *Lotus and birds*
(列女圖冊)

Ren was originally from Shaoxing in Zhejiang province, but came to epitomise the Shanghai School of painting. Not from a scholar-official family, he initially trained with his father, a portrait painter who died in the Taiping Civil War. Later, around 1864, Ren Yi learned painting from his relative Ren Xun. In 1868 Ren Yi moved to Shanghai. In a complete break with Chinese tradition, Ren Yi sketched from life using a pencil, a habit he learned from a friend who had worked at the French Catholic College of Art at Tushanwan in Shanghai. Ren was a career artist whose work could be both beautiful and exciting but also unashamedly commercial. This painting is extremely unusual and is possibly influenced by Japanese lacquer in the colour combination of black and gold as well as the powdery effect of the leaves. It is unusual in its use of gold- and blue-foil paper, which catch the light and the viewer's eye.

Summer 1890, Shanghai. Gold paint on gold- and blue-foil paper. H. 153 cm, W. 41 cm. National Art Museum of China, Beijing

3.48

Ren Yi (Ren Bonian), *Lady and plum blossom* **(梅花仕女)**

Ren here shows something of his debt (in general, subject-matter terms) to his predecessor the famous portraitist Fei Danxu, whose fragile-looking female figures are often drawn with slim shoulders, an expressionless face and elegant posture. In this painting, the sitter's stance is rather informal and seductive, and her eyes gaze directly at the viewer. Judging by the romantic content of the text on the painting written by the late Qing official Zhu Xiaozang 朱孝臧 (1857–1931), it is possible that the image shows a high-ranking Shanghai courtesan. Selecting such a subject demonstrates that educated men were closely involved with the pleasure pavilions and paid-for professional female companions would join them on social occasions.

1884, Shanghai. Ink and colours on paper. H. 96 cm, W. 42.6 cm. Liaoning Provincial Museum, Shenyang

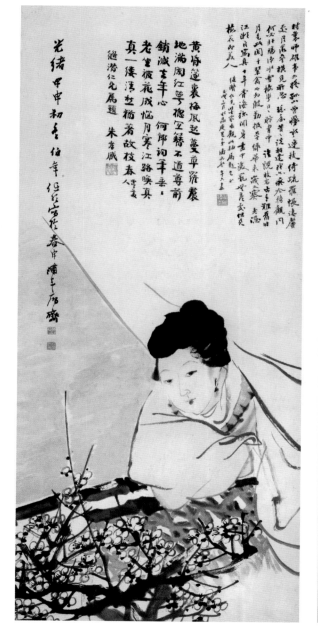

3.50
Ju Chao, Fan album leaf with egrets in a lotus pond

During the Taiping Civil War, Ju Chao, who was born in Guangdong to a family of minor officials, became secretary to the official, Zhang Jingxiu 張敬修 (1823–1864), in nearby Guangxi. After Zhang retired in 1856, Ju Chao and his cousin Ju Lian lived at Zhang's garden estate at Dongguan, just east of Guangzhou city, and taught painting. Together with his cousin, Ju Chao used a new style of mixing water with powdered paint to construct wonderful tonal gradations of colour, which enabled the creation of beautiful light and shaded hues to depict insects and plants of the Lingnan (Guangdong) area in which they lived. He sketched from life, which at the time was a European convention. Here, the textures of the leaves and feathers of the egrets are realistically depicted but, at the time, this approach drew criticism for both its realism and the trivial nature of the subject matter.

1847–64, Guangzhou. Ink and colours on silk. H. 18.5 cm, W. 53.5 cm. Guangzhou Art Museum

3.51
Ju Lian, Album of eight leaves of insects and flowers

Another Guangzhou artist, Ju Lian incorporated elements of the export style of early 19th-century images produced in that city into his own work. However, in his studies of plants and insects, he uses new colours in a naturalistic way, as here. The compositions themselves are also innovative, as they are shown from unusual or incomplete angles. Ju Lian applies the colours in soft blousy hues, yet somehow this album is suffused with light. Many Lingnan School masters (based in Guangzhou), from whom the *guohua* ('national art') of the early 20th century developed, studied first with Ju Lian and then in Japan (*c.* 1906–11).

c. 1848–1904, Guangzhou. Ink and colours on paper. H. 31.4 cm, W. 36.2 cm (each leaf). The Metropolitan Museum of Art, New York, 1986.267.73a–h

Art and the commercial press

From the late 1870s, modern publishing houses and newspapers, in particular the British-owned *Shenbao* – China's first modern newspaper – gave artists opportunities to advertise reproductions of their art and painting manuals in the new medium of lithography.[54] Lithography was first introduced to Shanghai by the Belgian Jesuit Leopaldus Deleuze 婁良材 (1818–1865), based in Tushanwan, a complex of schools and workshops in a Catholic community in the French Concession area. In the late 1870s, *Shenbao*'s owner Ernest Major sent technicians to Tushanwan to learn the technique before he launched his own enormously popular lithographic studio, the Dianshizhai Lithographic Publisher, in 1879.[55] That year, Ren Bonian advertised for the first time one of his paintings in lithographic reproduction on the front page of *Shenbao*. A second advert the following year consisted of four lithographic images in hanging-scroll format, offering paintings in both colour and ink monochrome, mounted and unmounted, at affordable prices. The newspaper's editor promoted the work further by adding that the subject had been chosen especially for the upcoming New Year and that he had paid a large commission to Ren Bonian, the most celebrated artist of the time. Dianshizhai also printed works for sale by other artists, for instance, Zhao Zhiqian's 1879 calligraphic works *Thesis on Qin music* (琴旨) and *Biography of Lady Chen* (陳夫人家傳) and Ren Xun's 1887 *Portraits of eminent generals through the centuries* (歷代名將圖). This new form of advertisement suggests close cooperation between artists, the commercial lithographic studio and the press. In their choice of subject matter for the products offered, such artists were clearly catering to the general public.

When the first volume of Major's own lithographically illustrated newspaper, *Dianshizhai huabao*, was launched in 1884, it drove a boom in pictorial publication beyond Shanghai.[56] It was issued at intervals of ten days, each edition usually consisting of eight leaves. Although it contained some fiction and light *belles-lettres*, it was primarily pictorial. Some of the drawings are of a high quality, by artists of considerable reputation such as Wu Youru, Zhang Zhiying 張志瀛 and Tian Zilin 田子琳 (both active 1880–1890s). Their drawings combined traditional linear techniques with Western-style perspective. The wide circulation of the newspaper increased the fame of these print-culture Shanghai artists. Such new collaborations between artists, the printing industry and the press demonstrate the highly commercially oriented art world that Shanghai artists inhabited.

Living in an urban environment teeming with new Western technologies, and architectural and commercial influences, Shanghai artists absorbed and reflected Western painting styles and modes of representation studied from photography.[57] Ren Xiong's *Self-Portrait* (自畫像) of 1851 demonstrates shading along the face and neck to highlight the contrast between light and dark (fig. 3.52); this breaks noticeably with older orthodoxies of Chinese portraiture, which omitted such shadowing over the face (as seen in the *Portrait of Cao Zhenxiu*, see fig. 3.35). Mixing different shading to delineate three-dimensional features, Ren Xiong produced a spectrum of colours evocative of watercolour. His representation in colour wash of the naked body – exposed flesh and contoured muscles – was also an audacious rupture with the conventions of Chinese elite painting. Ren Bonian's 1878 *Portrait of Wu Gan* (吳淦像) similarly renders the face of the middle-aged calligrapher in light flesh-coloured tints and ink shading that model the muscles precisely and accentuate the subject's tensely drawn high cheekbones and gaunt face (fig. 3.53). The anatomical detail of the face is reminiscent of a late 19th-century sketch manual, *Easy Introduction to Painting* (繪事淺說), which explained Western technique and composition with step-by-step illustrations.[58] It is known that Ren Bonian was interested in Western painting techniques, including the practice of direct observation and sketching. He carried a painting album in his pocket and would sketch in pencil scenes he encountered when he went out.[59] (Chinese artists traditionally never used pencils but rather sketched with charcoal improvised from scraps of burnt paper.) In this, Ren was doubtless influenced by his close friend Liu Bizhen 劉必振 (known as Dezhai 德齋, 1843–1912), chief artist of the Painting Studio at the Art and Craft School of Tushanwan Orphanage (土山灣孤兒工藝場) in the French Concession. Made up of six departments – woodcraft, metal, shoes and clothes, painting, printing and photography – the Tushanwan School is considered the cradle of Western arts and crafts in China.[60] Its painting studio, founded in 1868, was the first institution to offer systematic

Key figure: Ren Xiong (1823–1857)

3.52

Ren Xiong, *Self-Portrait* (自畫像)
This arresting and possibly life-sized work by an artist who died aged just 34 from tuberculosis presents the most extraordinary self-portrait in the history of classical Chinese art. Ren Xiong has rendered his face, exposed shoulder and chest in a realistic style that is almost photographic, whereas the razor-sharp folds of the grey martial arts-style robe and wide white trousers are calligraphic and sit sculpted wide of the body. His stance is confrontational, with his feet apart and his hands resting on what art historian Richard Vinograd has described as sword-like pleats, as if he is about to take the viewer on in a fight. Yet Ren's gaze and the inscription suggest he is deep in thought. Zhou Xian, a scholar patron, opened his residence in Qiantang near Hangzhou to Ren between 1848 and 1851, and described him as 'good at horsemanship, archery, and wrestling; he moved among military men, some of them his patrons'. Ren Xiong's inscription on the self-portrait reveals an intensely uncertain, even nihilistic worldview: 'With the world in turmoil, what lies ahead of me? I smile and bow, I go around flattering people in the hope of making connections. But what do I know of the world? Amid the great confusion, what can we hold fast to, on what can we rely? How easy it is merely to chat aimlessly about this! Recall the great faithful clans [of the Han] Jin, Zhang, Xu, and Shi: how many such loyalists are still with us today? Black eyebrows [turn grey] in the mirror, dust covers white-haired heads, and still we gallop along without goals. How pitiful! Worse again, historians haven't recorded a single word, not even derogatively [about such transient people and matters]. As for the gentlemen Pingxu [Emptiness] and Xiyou [Scarcely Exists, both fictional characters in ancient Chinese literature], it's impossible to find true friends like them today. Powerless, I just loosen my hair and dance. The country is in decline, thanks to our arrogant, loathsome government. I remember I didn't feel this way when I was young. I had a sense of purpose, I used to portray the ancients [as paragons]. But now who are the ignorant, who are the sages? In the end, I have no idea. All my glancing eyes see is the boundless void.'

1851, Shanghai. Ink and colours on paper. H. 177.5 cm, W. 78.8 cm. Palace Museum, Beijing, XIN00146208

instruction in oil painting, watercolours, glass painting, photographic portraits, wall painting and Western-style printed illustrations.

Shenbao frequently featured advertisements for Western painting supplements and other foreign goods in the 1870s (see fig. 5.54).[61] The convenient availability of foreign pigments enabled Shanghai painters to build the colourful, vigorous and appealing palettes of the bird-and-flower paintings for which they are celebrated. Although foreign pigments had long been known in China through land and maritime trade routes, their import boomed after the First Opium War. By 1851, foreign blue (洋藍) and Grumbacher-brand foreign green (洋綠), both made in Germany, and carmine (洋紅), many types of which were made in Japan, England

and Germany, were in general use in Shanghai. Since they were inexpensive and easy and rewarding to use, these foreign pigments were in wide circulation in textile dyeing, murals and folk art.[62] Wu Changshi's disciple Pan Tianshou 潘天壽 (1897–1971) observed that Wu inherited his habit of applying highly refined carmine to his bird-and-flower paintings from Ren Bonian, who pioneered the use of this imported pigment in Shanghai.[63] Ren Bonian painted Wu Changshi on several occasions in some highly innovative portraits (figs 3.54–3.55).

The introduction of photography transformed the aesthetic repertoire of Chinese artists. In the final years of the dynasty, the Empress Dowager Cixi grew very fond of photography, posing for portraits to provide records of court life (see figs 1.15 and 1.78).[64] In 1904, many such

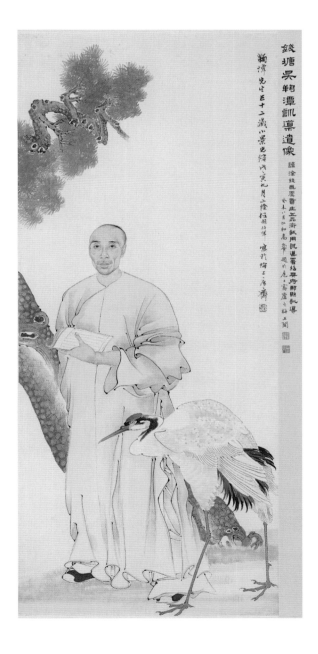

3.53
**Ren Yi (Ren Bonian), *Portrait of Wu Gan*
(吳淦像)**
Ren's portrait of the middle-aged calligrapher
Wu Gan 吳淦 (1839–1887) pays great attention to
the shape of the face and its bone structure. Ren
was interested in Western art and techniques
of shading to create a more three-dimensional
effect, particularly for the face. Chinese artists did
not use pencil to sketch but instead used ink and
a brush, but Ren broke with convention and often
made charcoal or pencil sketches of people and
places he observed at first hand.

1878, Shanghai. Ink and colours on paper.
H. 130 cm, W. 56 cm. Palace Museum, Beijing,
Xin.00100945

court images were reproduced in a Shanghai-published
volume and advertised in the local press. Two years
later, the same publisher reproduced a larger album
containing some 200 pictures of eminent contemporary
Chinese figures, including portraits of the empress, the
Guangxu emperor and other senior officials.

In the treaty ports of Guangzhou, Fuzhou,
Shanghai and Hong Kong, photography seems to
have been more fashionable, less exclusive, and more
accessible to ordinary consumers.[65] In 1859, the
pioneering translator and journalist Wang Tao described
encountering (for the first time) shots of two Qing
diplomats Gui Liang 桂良 (1785–1862) and Hua Shana
花沙納 (1806–1859) by the Cantonese photographer Luo
Yuanyou 羅元佑 (active 1850s, d. 1861).[66] While he was
impressed by the realism of the new technology, he
also revealed how little he knew about it, calling Luo
a 'painter' and photography 'the Western method of
painting'.[67] However, only three years later, Wang – a
voracious student of foreign customs and techniques
– was able to explain in detail the technicalities of
photography. He even wrote a poem alluding to its
popularity and suggested that photographs presented
a better, more realistic and natural result than painted
portraits.[68] Other writings show growing familiarity
with the production process, and an appreciation of
the precision with which photography could represent
the 'spirit' of an individual.[69]

In the 1870s, snaps of famous actors and courtesans
were sold or used as calling cards as a way to advertise
their attractions.[70] Some consumers mounted
photographs into blank hanging scrolls and added
colophons, treating the image as a painted portrait.
Art historian Richard Vinograd suggests that Ren
Bonian's awareness of photography is manifested in
his *Picture of three friends* (see fig. 3.45). Here, the three
subjects are seated on the floor against an almost
empty background, wearing monk-like white robes
and facing towards the viewer instead of having eye
contact with each other. Their pose and the direct
interaction between the three sitters and the viewer
are reminiscent of the ways late Qing photographers
arranged groups of subjects.[71] An 1888 photograph of
Ren Bonian kept by his descendants was taken when he
was aged forty-nine, and the image was later translated
into an oil painting by Xu Beihong 徐悲鴻 (1895–1953).
Photography not only gained popularity through its

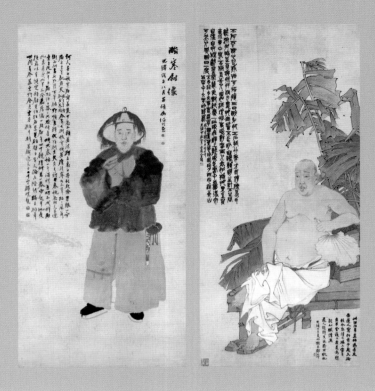

3.54–3.55
Ren Yi (Ren Bonian), Portraits of Wu Changshi

Wu Changshi was from a literati family in Zhejiang province and was known as a painter, calligrapher and seal carver. He founded the Xiling Seal Engravers' Society (西泠印社) in 1904. Between the 1910s and 1920s, he came to be acclaimed as one of China's greatest modernist painters. He had an international clientele with links to Japanese and Korean patrons, so for Ren to depict him as an impoverished scholar must have been quite shocking in 1888 when *A miserable and shabby official* (酸寒尉像) (left) was painted. In Qing China there is no tradition of painting respectable people, men or women, naked or semi-naked; and many portraits were for use only in ancestral rituals. But in *Enjoying the shade of the banana palms* (蕉蔭納涼圖) (right), also painted in 1888, Wu Changshi is shown half-naked in the sweltering heat of summer in southern China. There is little indication of his status and respectability as he sits with his belly on display beneath the banana palms. Ren Yi's images of Wu illustrate a dramatic shift within late 19th-century Chinese portraiture towards greater realism and naturalism.

1888, Shanghai. Ink and colours on paper. H. 129.5 cm, W. 58.5 cm; H. 164.2 cm, W. 77.6 cm. Zhejiang Provincial Museum, Hangzhou

factual representation of the subject but also – by generating a preference for precise images – influenced taste and technique in painting. The photograph-like illustrations in *Dianshizhai huabao* presented in a newly exact, documentary fashion the here and now of events and customs in Shanghai, shoring up a new pursuit of realistic representation.

While engraved illustrations lifted from foreign writings circulated in translations of religious and scientific books, the adroit Shanghai press also adopted and adapted such Western pictures and photographs in their own publications. Many of the engraved pictures in the new journals of the 1870s and 1880s, such as *Xiaohai yuebao* (小孩月報), *Huanying huabao* (瀛寰畫報), *Tuhua xinbao* (圖畫新報) and *Dianshizhai huabao*, recalled and copied Western and Japanese pictorial sources (fig. 3.56). For example, the 'Portrait of Zeng Jize' (曾紀澤 – a late Qing diplomat) published in *Dianshizhai huabao* in 1884 is a copy of a picture first published in the *Illustrated London News*.[72]

Although Shanghai artists freely explored Western pigments, techniques and technologies, oil painting and artistic realism did not spontaneously develop in their early works. It was not until the crisis of the Sino-Japanese War in 1894–5 that intellectual elites began to call for aggressive modernisation across late imperial politics, society and culture. As part of this generalised programme of transformation, critics proposed a reform of Chinese painting by more fundamentally integrating Western and Chinese techniques. Kang Youwei used passionate advocacy of the accuracy and precision of Western art to attack China's long tradition of studio-based landscape painting. Reacting against the highly formalised nature of early Qing painting, Kang prized accuracy above all else, while denigrating blunt, unrealistic representations of nature. He thought highly of the Qianlong emperor's Italian Jesuit painter Giuseppe Castiglione, who was the first to seek a harmonious union between Western drawing technique and perspective and Chinese media, thereby incorporating a freshly realistic visual effect into Qing court painting.[73] In his efforts to domesticate and normalise oil painting, Kang even claimed that the form was first invented in China.[74] Perhaps by making oil painting Chinese, he hoped to avoid denunciation by his peers as a worshipper of suspect foreign ways. Kang's polemical statements arguably aimed to unite Chinese and Western art forms, rather than completely

Westernising the former. In so doing, they perhaps reflected the wishes of many who sought an effective modernisation of China that could confront both new Western stimuli and challenges from Japan. But conflicts over the reception of foreign elements and the desire to preserve their culture's 'national essence' deeply troubled Chinese intellectuals after the Sino-Japanese War and the failure of Kang's 'Hundred Days' Reforms' in 1898. Nonetheless, the final decade of the dynasty saw an intensification of intellectual and artistic internationalisation, for example in the rapid increase in the number of Chinese people visiting or studying in Japan; many provinces also hired Japanese teachers for guidance as they began to promote education in Western art.[75] As in many forms of modernisation, including the Westernisation of knowledge, Japan – with its flourishing translation industry and vigorous self-modernisation since the 1870s – was an important model for late Qing China.

The function and raison d'être of elite painting moved through multiple phases during the Qing. It evolved through the early Qing government's censorship of individual expression, the 18th century's quest to accommodate the tastes of an emerging stratum of middle-class consumers especially in Yangzi delta cities, and the pursuit of antiquarianism and an 'authentic' cultural identity drawn from intensive study of the literature and fine arts of China's 'high antiquity' and early empire. Breaking with the 18th century's limited 'orthodox school' of literati painting, 19th-century art developed a diverse and populist style better suited to a burgeoning, modernising, Westernising urban culture. In its institutions and market structures, the late Qing witnessed ever closer interactions between painting, commerce and the press, the integration of new technologies and traditional practices, and an increasingly hybrid identity for scholar-officials and professional painters struggling to make a living in the transformed social, economic and political landscapes of the dynasty's final half-century. In this process, the emergence of Shanghai as a new artistic and commercial centre, after the cataclysm of the Taiping Civil War, arguably constituted the most critical turning point for artistic production, transforming elite artistic creation into a hard-headed, media-oriented business.

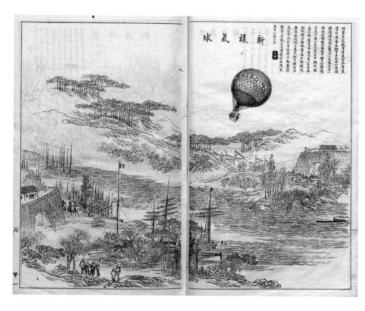

3.56

A new type of gas balloon (新樣氣球)**, from** *Dianshizhai huabao*

This 1884 image is captioned: 'In the past people only told tales of wonderful workmanship; now we have the real thing. Formerly, when France and Prussia went to war [1870], they used gas balloons for spying. We understand that these balloons were made out of leather. Now, they are made out of pure silk. The interior is filled with chemical gas, and underneath hangs a basket in which people sit. Later, fearing that the balloon might accidentally fall into the sea, they replaced the basket with a boat, rigging it with sails and oars. Now even if it falls into the sea, the balloon can ride the waves and sail the seas without any fear of sinking. Now we have boats that can travel under the water, and balloons that can float in the blue sky. Even though the ancient sage Liezi could ride on the wind, we feel that his skills were not yet completely refined. Those who come later can surpass him. (巧奪天工之說, 昔有是言, 今有是事。從前普法相爭, 用氣球以為間諜。據傳此球之製向以皮為, 今用上好純絲織造而成, 而中實以藥煉之氣, 下垂一筐, 人坐筐中。嗣恐球落之時, 適當洋面, 乃易筐而為船, 帆櫓具備, 即墜海亦能破浪乘風, 無沈溺之患。夫船可游於水底, 球可浮於青空, 列子御風而行, 猶覺其藝之未盡精純, 而後來者可以居上矣。)' This mixture of closely observed reality embellished with fantasy is typical of *Dianshizhai huabao*.

1884, Shanghai. Printing ink on paper. H. 22 cm, W. 12 cm (approx., closed). SOAS University of London, E Per 81267

Vernacular culture

Jessica Harrison-Hall

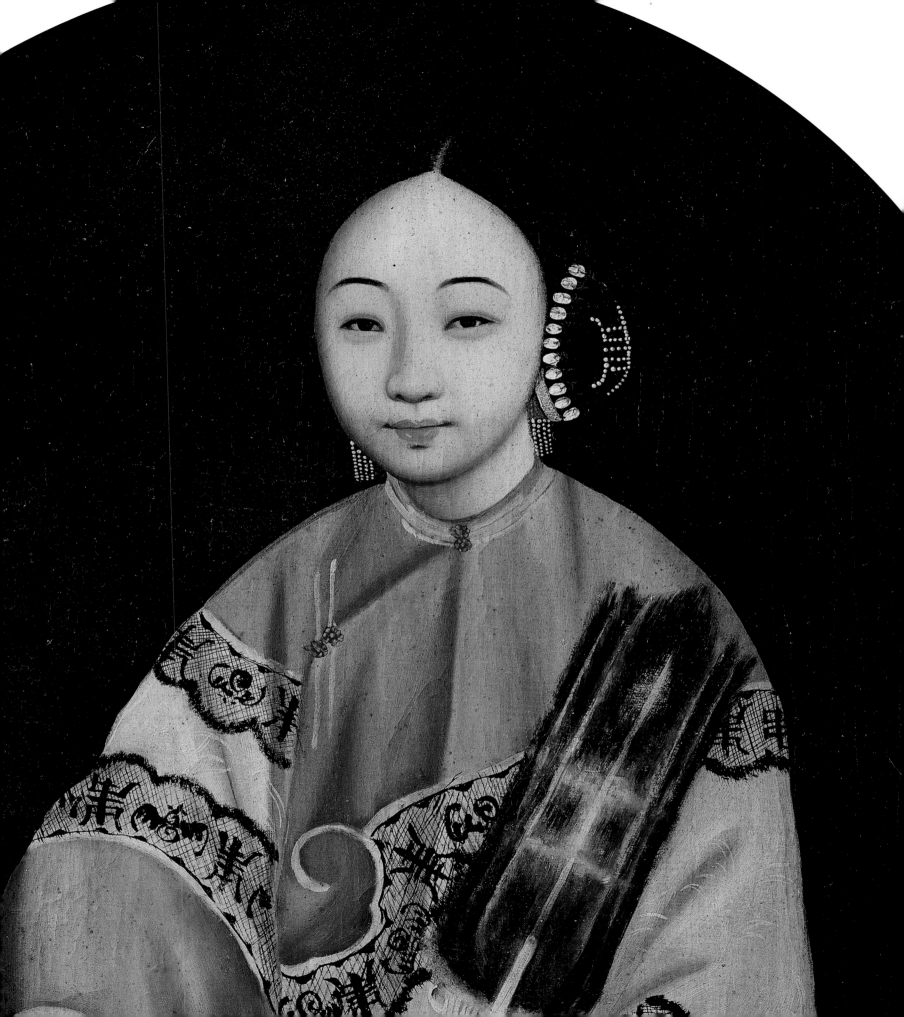

Society in the late Qing was divided in many ways: between socio-economic classes, different regions, and urban and rural populations. People at the bottom of society entered the written record far less often than those who were part of the court, military and cultural elites; women, for example, were very rarely recorded at all. Yet for the 19th century we have far more surviving material culture than for any other period of Chinese imperial history and it is these 'things' that are used to evoke the texture and experiences of everyday life in this chapter. Despite the terrible socio-economic and military woes of the period, a vibrant consumer culture demonstrated creativity and resilience throughout the century, and made desirable commodities available to an expanding range of social groups.

Social change in the 'long 19th century' was driven by its many domestic and foreign conflicts, as well as by repeated environmental disasters. Survivors of fighting, floods and famines migrated in vast numbers, the majority to borderlands and highland areas, taking over land previously sparsely populated and cultivated. As the historian William Rowe has shown, from 1890 to the early 1900s alone, 25 million people moved from Shandong and Hebei to Manchuria in the northeast. Others moved to cities, establishing new social networks and finding new livelihoods – both officials and common people became increasingly business-oriented, with greater political and economic control devolving to local and regional interests.

Despite the violence and displacement endured, this period saw – in parts of Qing society – a revitalisation of material and consumer cultures. The Qing empire was already deeply commercialised, an intensive producer of handicrafts in workshops. After 1860,

Western-style industrialisation began to be adopted, using foreign engineers, machines and managers. Officials planned, while private merchants and local grandees saw to the financial detail and day-to-day running of such enterprises, often getting rich in the process. Historian Rachel Silberstein argues that living conditions improved for a substantial minority – upper-class elites and the middle class – during the Qing dynasty and that, for example, commercialisation expanded the numbers of those who could afford luxury goods. While the upper class consisted of successful or aspiring civil service officials, the middle class was 'more heterogeneous in income and identity. At upper levels it included teachers, head clerks, merchants, shop owners, artisans; at lower levels, it included clerks and runners. But all these groups could supplement salary through family investments in land or business.' Silberstein draws attention to economic advances and a growth in education that enhanced social mobility (individuals could travel down as well as up social strata). As the 19th century wore on, elites (and former elites) often complained about lower-status individuals flaunting luxury products in once exclusive fabrics and colours; changing patterns of dress illuminated broader patterns of socio-economic fluidity.[1]

For comfortable urbanites, luxury goods, medicines and elaborate leisure activities were available. Traditional arts, such as opera and puppetry, were revitalised. Imagery from performances circulated through popular printing, creating new fashions in dress and interior decoration. Wholly new arts, including photography and lithographic printing, created novel mass media, in the form of newspapers and illustrated magazines, and advertised new lifestyles to their

readerships. Popular fiction described, in loving detail, the gorgeous textile fashions sported by its protagonists. By the closing decades of the 19th century, educated urbanites had access to ever more knowledge about the world beyond the Qing empire.

Many below the ranks of the elite are marginalised by or omitted from written records; here, we attempt to conjure up their worlds through the materials they left behind. It is harder to reimagine the world of illiterate and poor groups partly because of collectors' bias towards the material culture of the wealthy, and partly because the poor had so little which could be passed down. This chapter uses the material traces of everyday activities – of both the poor and the more well-to-do – to draw out the details of vernacular life beyond the limits of written sources. It begins with the rural population, which accounted for some 400 million out of a total population of 450 million. It then looks at the visual world of men, women and children living in Qing cities by examining their images, homes, furnishings, dress and leisure activities. A picture emerges of a culturally rich, regionally and socio-economically diverse society, in which older ways of life coexisted with newer forms springing from local and foreign innovations and novelties.

The rural poor

Living with both the actuality of violence and the aftermath of war, survivors of conflicts and environmental catastrophes experienced the many upheavals of the period between the close of the Qianlong reign and the 1911 Revolution in different ways, but they were the lucky ones. In the late 1800s, average life expectancy for the Qing empire's population was just forty. Conflicts, natural disasters and diseases caused the death of tens of millions; conservative estimates suggest that 20 million died in the Taiping Civil War alone. Climate change, including a fall in temperature and the high variability of precipitation, adversely affected harvests. The 19th century suffered four extreme droughts, each of which lasted for more than two years, whereas the previous century had seen only one such episode.[2] The Great Northern Famine of 1876–9, which followed a three-year drought, claimed at least 9.5 million lives and possibly as many as 13 million.[3]

Due to a rise in population and soil exhaustion, per capita acreage decreased almost 50 per cent between 1753 and 1812.[4] Diseases were rife. For example, bubonic plague broke out in Yunnan and spread to Guangxi and Guangdong with devastating consequences, coinciding with large-scale conflicts with Muslim communities (1855–73).[5] The late Qing thus saw chronic land shortage and rural poverty.

The rural majority, many of whom struggled for a livelihood, dressed in coarse cotton clothes with straw, palm-fibre or coconut-fibre capes, bamboo hats and grass slippers (fig. 4.1). Cotton was grown in areas which could not support food production because of the quality of soil and local conditions. Cotton clothing was produced in China for a thousand years from the Song dynasty (AD 960–1279), but it became worn more widely in the Qing. Museum collections generally preserve the finest textiles rather than the ones worn day-to-day, so cotton clothing – especially garments belonging to those who worked with their hands – is today very rare. To reimagine everyday cotton costumes, we rely on photographs from the 1870s onwards. Cotton could be grown, or acquired in a raw form and homespun into fabric (mostly by women), or purchased as finished cloth, or bought as ready-made garments.[6] From the 1870s, machine-made cotton, recognisable for its very regular weave, became available from domestic suppliers in Shanghai and Tianjin or was imported, and soon out-sold handmade cloth.[7] A man's cotton set, belonging to a 19th-century cook, is one of the few surviving examples to indicate the sartorial world of ordinary working people (fig. 4.2).

Average literacy levels in Qing China were perhaps surprisingly high, particularly in wealthy regions such as Jiangnan, south of the Yangzi river. Elementary education was accessible even in rural areas to those who sought it. Between 30 and 45 per cent of men and between 2 and 10 per cent of women knew how to read and write by the late 1800s.[8] Elite literacy in classical Chinese, tested through the imperial examination systems, required a full knowledge of classical literature and the ability to compose in traditional formulaic styles (see Chapter 3). Below this came a functional literacy that enabled shopkeepers and traders to earn money through their knowledge of a more limited but often specialised written vocabulary. Further below this, some could only recognise a few hundred characters;

4.2 (below)
A cook's jacket and trousers
This simple working person's jacket and short trousers are made from blue and white cotton. Both are fastened using thread loops and buttons. As collectors and museums generally prefer more highly decorated Qing textiles, this well-preserved set of working clothes is extremely rare.

1890–1905, China. Cotton. Jacket: H. 90 cm, W. 143 cm; trousers: H. 98 cm, W. 51 cm. British Museum, London, As1945,03.6.a–b

4.1 (above)
Palm- and rice-fibre coat, bamboo hat and basket
In rural areas, fishermen and farmers had worn this type of waterproof, palm-fibre raincoat and large-brimmed hat for centuries. In urban settings, poorer people, including porters, street cleaners and labourers, also tried to protect themselves from the elements with these garments. Regional variations existed, depending on which plants were readily available locally. In the far south, for example, palm leaves or coconut fibres were used instead of rice or millet. The coat was made by folding layers of straw or leaves, then stitching them to the layer above using thread made from rice straw, and the top layers were made wider to form a cape, which kept rain away from the body; the front sections are separate and tied to the neck. The hat is made of woven bamboo strips.

Coat: 1800–60; hat: 1850–98; basket: 1840–80; China. Chinese windmill-palm and rice straw; bamboo and palm-leaf strips; bamboo and other plant fibres. Coat: H. 145 cm, W. 95 cm; hat: H. 21 cm, diam. 69 cm; basket: H. 50.5 cm, W. 31 cm, D. 35 cm. British Museum, London, As1960,10.413, As1896,0319.14, As1843,1209.18. Transferred from Kew Gardens (coat); presented by Dr W.G.K. Barnes (hat)

many more knew none. People with only limited education were confronted with texts and characters on a daily basis. They were able to 'read' shop signs or numbers written in characters or patterns that they needed for their work (fig. 4.3). The illiteracy of many agricultural labourers is illustrated by a contract for the sale of land, signed with hand and fingerprints (fig. 4.4). In this instance, the land was sold by an indigenous tribesman from Taiwan to an immigrant of Han ethnicity from Guangzhou or Fujian.

Wages and living standards in China compared unfavourably to much of western Europe by the 19th century and were more akin to those of southern Europe. Average wages were stagnant for most of the 1800s.[9] In 1820, China's economy was the largest in the world and six times as large as Britain's, but by 1870 it had lost that position and shrunk by a third.[10] Most financial transactions were paid for using copper coins. For larger amounts, coins were strung together and, to discharge even greater debts (and tax payments to the state), silver ingots were paid. Keeping the silver to copper ratio stable was a constant challenge, especially during the depression of the 1830s and 1840s.

The impact of conflict on the land and agricultural production was catastrophic, and many starved as crops were lost to warfare and natural disasters, and peasants fled fighting. Some sought new opportunities abroad, while domestic migration put an enormous strain on natural resources and the environment. As borderland communities and cities absorbed thousands of newcomers, who would have been easily identified as different because they spoke other dialects of Chinese, social tensions intensified. (The violence of the Taiping Civil War has its roots, in part, in tensions between local populations and ethnically distinct Hakka immigrants.)

External conflicts had fiscal as well as physical consequences. By the early decades of the 19th century, silver seemed to be running low in the empire; the metal was crucial to the economy because it was the currency in which taxes were paid. If silver became scarce and therefore more expensive relative to the copper currency used for small, everyday transactions, the tax-paying populace struggled and businesses folded. Riots resulted: 110 incidents of mass protest took place between 1842 and 1849, largely because the rising cost of silver was increasing the tax burden. At the same time, the silver famine left the government short of funds for spending on the armies and public works that would control or mitigate public unrest. 'Since the beginning of history,' went one official complaint of 1840, 'never has there been a people as arrogant or unwilling to obey imperial orders as that of today.'[11] Contemporary observers blamed the silver shortage on rising opium purchases from British, American and Indian suppliers.

4.3
Baker's shop sign
This sign is made of carved wood and features an inscription of three raised black characters on a red background. The top two characters are the name of the shop and read '萬和 Wan He' ('Peace to all'). The large character below reads '餅' ('cakes'). The sign has a carved openwork border of flowers with yellow blooms and green leaves. The reverse is identical so it can be read in either direction, suspended from a pole outside the shop by an iron ring.

c. 1860–1912, southern China.
Painted wood. H. 80 cm, W. 40 cm.
Horniman Museum and Gardens,
London, 10.5.51/1

4.4
Detail of a handprint 'contract'
This handprint was made by an illiterate person; between the fingers it has an inscription which reads 'Handprint willingly [made] as a record' (手摹甘愿[願] 為記). The actual contract was probably written by a literate scribe or an educated acquaintance of one of the parties. This piece of paper would accompany the contract as proof of consent. The man or woman who made this contract was of such lowly birth that even their name is not written down. Similar contracts survive for marriages and for other transactions.

1894, Taiwan. Ink on paper.
H. 41.3 cm, W. 48 cm (entire sheet).
Pitt Rivers Museum, Oxford,
1895.34.1

4.5

Zhu Angzhi 朱昂之 (1764–c. 1840), *Disaster administration in Wumen (Suzhou)* **(吳門荒政)**

Local elites took on state roles to build institutions for needy scholars, as well as constructing orphanages, repairing city walls and handing out disaster relief. Zhu Angzhi, an artist who was originally from Changzhou in Jiangsu, illustrated the album from which this leaf comes with a very unusual set of idealised landscape paintings in the blue-and-green style of the Southern Song dynasty (1127–1279). They depict scenes of flood- and famine-relief measures, peasant life, refugees and meetings of officials with peasants. Lin Zexu, then Governor of Jiangsu and stationed in Suzhou, who later was known for his role as a catalyst in the First Opium War, was the official at the centre of this album. Although corrupt, neglectful officials generated much misery for local populations in the 19th century, highly competent, diligent administrators like Lin strove to find practical solutions to the empire's problems.

Album dated 1834–9, Suzhou. Ink and colours on paper. H. 28.3 cm, W. 39.2 cm. Staatliche Museen zu Berlin, 5809

Between 1805 and 1839, imports of opium increased considerably more than tenfold, from 3,159 to 40,200 chests per annum. At the same time, China's previously favourable international balance of payments went into deficit: between 1828 and 1836, around $38 million travelled out of China.[12] Observers guessed that China's wealth had been reduced by 50 per cent. The increasingly punitive indemnities extracted from the Qing state from the First Opium War onwards further robbed the government of funds that could otherwise have been diverted into industrialisation and maintenance of the domestic infrastructure.

Natural disasters also forced people from their homes. For many years, a weakened Qing state had not invested in infrastructure projects to safeguard livelihoods from environmental catastrophes such as flooding. In the 'long 19th century', local educated elites and wealthy merchants took over this role from the state, ensuring that food and other supplies reached those suffering from famine or severe floods (fig. 4.5). Some of these socio-economically concerned local officials, such as Lin Zexu, are better known for their high-level political activities.[13] Philanthropic organisations such as the local privately organised 'benevolent halls' (善堂), run by urban men of means outside the gentry class, provided support for local people to rebuild their economy and homes after disasters.[14] 'Native place associations' (會館) in towns and cities also played an important philanthropic role, providing charity to migrants from particular areas when state relief was not forthcoming. These developments chime with concurrent undertakings in Victorian England, where philanthropists were often driven by philosophical or religious beliefs to make such interventions; so too in Qing China the gentry and merchants believed they had a moral responsibility to the poor.

The destruction of human life caused by war created a sense of a country haunted by 'Hungry Ghosts' – a term describing deceased men and women who were without living relatives to perform proper Confucian ancestral rites and Buddhist services. The impact of the fighting is recorded in series of printed books produced to raise money to help those made destitute by war and natural disasters (fig. 4.6). Published in the late 1870s, *Pictures of Jiangnan to Draw Tears from [a Man of] Iron* (江南鐵淚圖) is illustrated with images of people forced to sell family members into prostitution and resorting

4.6

Yu Zhi 余治 (1809–1874), *Pictures of Jiangnan to Draw Tears from [a Man of] Iron* (江南鐵淚圖)

The pamphlet from which this illustration comes was produced to raise funds for poor people suffering from the destruction caused by the Taiping Civil War. Its author, the philanthropist Yu Zhi, describes corpses being piled so high that they prevented boats from moving down a river, or people being so afraid of capture by soldiers that they killed their own children if they cried out while in hiding. Woodblock-printed illustrations of horrendous ordeals are accompanied by descriptions. The text on this page reads: 'Starved corpses fill the road; [People] vie to slice them up.' Such disasters compelled many to dismantle their homes to sell raw materials, to sell family members and even, in the most extreme cases, to resort to cannibalism.

Late 1870s, Suzhou. Printing ink on double-leaf Chinese-style paper. H. 24.5 cm, W. 15 cm. Bodleian Library, Oxford, Backhouse 630, leaf 6

to cannibalism to stay alive. Some of these woodblock-printed pamphlets were translated into English and circulated among foreign communities in the treaty ports, further raising awareness of the plight of the rural poor in the Qing empire.[15] In Shanghai, the disasters across China were reported in newspapers such as *Shenbao* and read about by the growing number of city dwellers, arguably driving a greater sense of national integration and solidarity by the end of the century.

City life

Qing cities were densely populated, multi-ethnic and multi-faith spaces. In the 1830s, Beijing, Suzhou, Wuhan, Nanjing, Guangzhou and Hangzhou each had a population of between 500,000 and 1,000,000 people; Fuzhou, Chongqing, Chengdu and Xi'an each had populations of between 300,000 and 500,000.[16] Residents of 19th-century Beijing included people from other provinces across China and from abroad. The city was home to Manchus, Tibetans, Mongolians and Uyghurs, all speaking different languages, and to Han Chinese communicating in a range of regional dialects; European and Southeast Asian languages, including Russian, Japanese and Korean, would also have been heard in the streets. The religious architecture of the city's Daoists, Buddhists and Muslims were also apparent in the urban landscape, in the form of temples, monasteries and mosques.

As of 1825, more than 23,000 bannermen – the Manchu military elite – protected the city of Beijing, enforcing law and order among the civilian population. Beijing police, working in shifts, guarded the gates to the city and the internal gates between its different sectors, as well as the wooden gates that controlled entry to different streets. They walked the alleyways in foot patrols and registered households in groups of ten. At night, they guarded the street gates and only let people in or out in exceptional circumstances.[17] The police were easily distinguished from soldiers, as they wore taller hats and longer robes and often carried a whip or knuckledusters (fig. 4.7). After 1842, urban settlements in treaty ports expanded and modernised rapidly (see p. 264). The 'foreign concession' at Shanghai acquired its first sewer in 1852, by which point the settlement had grown to 200 commercial ventures: banks, builders,

4.7

Raimund von Stillfried, Portrait of private guards

This photo is from an album of portraits of Japanese and Chinese people by the Austrian photographer Raimund von Stillfried. The images were shot largely in a studio setting in the 1870s. The men shown here are likely to be private guards for a wealthy person in Shanghai, or official gendarmes (policemen). We know that they are not soldiers because of their uniforms and their very distinctive high hats. Men wearing similar hats are also seen in paintings outside courtrooms in Guangzhou, so this is not a Shanghai-specific uniform.

1870s, Shanghai. Albumen silver print from glass negative with applied colour. H. 23.6 cm, W. 19.3 cm. The Metropolitan Museum of Art, New York, 2005.100.505.1 (27a)

publishers, steamship agents, watchmakers and shopkeepers, alongside opium trading houses. China's urban modernisation began in places like Shanghai, with new financial institutions, gaslights, electricity, telephones, running water and automobiles becoming part of the city between 1848 and 1901.

The migration of high art culture to Shanghai (described in Chapter 3) has its counterpart in the production of aesthetics for everyday life. The old class divisions, between literati, merchants and officials, were breaking down, as smart, educated men found new career paths as journalists, publishers, commercial artists and writers. Their patrons were businessmen who had grown rich working for foreign enterprises. 'Often self-made from lowly families, they lacked the educational background to fully partake in literati tastes and gradually evolved their own more exaggerated and ostentatious taste, which was also more popular in subject matter.'[18] Although only a tiny proportion of the population lived in cities, those inhabiting market towns and villages were economically intertwined with them.

Centres of craft workshops sold goods to interregional and international markets. More and more bought commodities made by craftspeople they did not know.[19]

Urban people

Many people earned a living as itinerant workers in the cities. Chinese artists created watercolour images on paper of generic professions to sell to new foreign clients. These images show sanitised and idealised versions of women's and men's occupations and places of work. Mobile traders walked the streets with minimal equipment; in one watercolour, a female dentist or tooth extractor carries a large umbrella to give her clients shade and holds a board hung with stringed rows of teeth that she has successfully extracted, to advertise her trade (fig. 4.8). Such mobile dentists could repair teeth or replace them with false ones, and teeth were often extracted in the street rather than in a surgery.[20] In the 1800s in Qing China, tongue and tooth diseases were

4.8

Puqua 普呱 (active c. 1785–1810), *An itinerant dentist*

Many Chinese people had itinerant trades that fascinated foreigners and a whole industry developed, initially in Guangzhou but later in Beijing and other port cities, of painting sets of tradespeople in vibrant colours and sometimes with commentaries. This female tooth extractor, for example, is carrying a placard that reads 牙科 ('dental work'), with strings of teeth she has pulled dangling from it like trophies. Over her shoulder she carries a parasol with the text 鳳陽取牙虫 ('Phoenix tooth worm'). Popular belief held that toothache was caused by a worm which burrowed into the tooth. The most important general medical development in the late 19th century was the transmission of Western-style dentistry into China from Japan and the United States. *A New Manual on Dental Care* from Japan and the parts about dentistry in *A Manual of Therapeutics and Pharmacy* from the United States also added to knowledge about dental hygiene from the 1890s.

1800–20, Guangzhou. Ink and colours on paper. H. 36 cm, W. 46 cm. Victoria and Albert Museum, London, D.73-1898

common; oral hygiene was limited to gargling and the use of toothpicks, which upper-class women carried in a vanity set hung from their waist.

Qing society perpetuated the conservative ideas about women of previous dynasties. Peasants, tradespeople and courtesans (see p. 225) were the only women seen by men outside their own households. Nonetheless, as more men left homes to find work abroad during the 19th century, women inevitably took on new responsibilities, both inside and outside the home. Photographers, mostly from abroad, made studies of anonymous women at work, particularly in traditional textile craft activities (fig. 4.9).[21] Even elite women were given little attention in most family genealogies and they leave few individual traces behind, beyond their images for often generic ancestral portraits. Educated women were limited to using embroidery, painting or poetry as a means of recording their lives, friendships and achievements.

The histories of most of the named women we know about come to us through the careers of their husbands or sons, through their heroic actions (such as Qiu Jin, see p. 299), through their published writings and artworks (such as Cao Zhenxiu, see p. 162) or

through their notoriety or commercial sex lives (such as Sai Jinhua, see p. 227). Such women are largely unrepresentative of the general female population; most were neither heroic nor well-educated nor courtesans. The inscription on an ancestor portrait, made in around 1876 in the Guangzhou area to commemorate one Lady Li at a family shrine, reveals something of the self-image of comfortably-off urban women (fig. 4.10). It tells us that she maintained good relationships with her husband's (fig. 4.11) concubines and parents, educated their children and, as a devout Buddhist, embroidered images of the Buddha. She was well known locally for her charitable work and being willing to support people who were in need, even if she had scant supplies herself. 'She was not parsimonious and was as kind as Feng Xuan [a famously enlightened official from the past] who had burned the receipts of the peasants' loans to show his master's generosity.' Many women were remembered through oral family history and Confucian ritual practice of the veneration of ancestors.

Before the mid-1800s, most ancestral portraits were made after death. Generic faces were chosen from albums of different facial types and then painted with appropriate clothing to create an accurate likeness

4.9

William Saunders (1832–1892), Studio portrait of a woman working on a traditional loom

More so than for previous eras, thanks to watercolours and photography from the mid-19th century, we are able to see how different types of people made a living through both traditional skills and new technologies. The original photographs from this period were black and white, but after being developed some were hand-coloured, creating a hybrid image such as this one, which shows a woman weaving at a hand loom. Such images were staged in the studio because of the time it took to capture them and because early photographic equipment was cumbersome. Portable cameras transformed representations of daily life and enabled far more widespread use of photography from around 1900 onwards.

c. 1865, China. Hand-coloured printed photograph. H. 21 cm, W. 27.3 cm. Loewentheil Collection of Early China Photography

Key figures: Lady Li and Lu Xifu (*c.* 1800–1876)

4.10–4.11
Unidentified artist, *Portraits of Lady Li and Lu Xifu* (陸禧甫及夫人像) (details)
These Confucian ancestral portraits were painted in a new style, inspired by photography, possibly while the couple were still alive. They are painted in smart blue garments and Lady Li has pretty gold and jade accessories. Their

nephews, who were recognised cultural figures in the Foshan area near Guangzhou, inscribed the top of the portraits, recording the details of a lifetime's achievements. Lu Xifu ran a successful business, and his wife managed his household, but little else is known of their lives. Such formal portraits would be hung in a family shrine.

c. 1876, Guangzhou area. Ink and colours on paper. H. 116 cm and 109 cm, W. 55 cm (max). Royal Ontario Museum, Toronto, 976,46.1–2

(fig. 4.12).[22] These portraits were venerated by descendants in a family temple or ancestral hall. They were not displayed permanently like a Western-style oil painting but only hung for set times of the year. However, the advent of photography in the mid-19th century, together with a fashion for realistic Western imagery in the cities, transformed the ability of painters and sculptors to record family members accurately for ancestral portraits and some were even made while the men and women were still alive.[23] The new

Western style of oil painting also became extremely successful in the port cities. Sitters adopted poses from photographers' studios (fig. 4.13); such oil paintings on canvas could be bought by either foreign or local clients.

It was common for women to share their husbands with other women in polygamous marriages. They could be part of a marriage contract that was sealed by the handprints of their father and their husband-to-be. If they shared a husband with other women, they were often at the mercy of pre-existing wives, who were

ranked higher up in the household hierarchy. Divorce was generally decided by the husband. A man could divorce his wife if she failed to produce a son, caught a disease, was a criminal or did not behave appropriately within the family. In theory, he could not cast her off if she had no family to return to, but she could be married off to another partner against her wishes. Women had little control over their lives or possessions.[24]

There are many more ancestral images of men than there are of women; those that survive are mostly two-dimensional paintings and ink sketches. In the West, sculpture is regarded as one of the highest art forms used for portraits and images of deities, but in China this is not the case. Carvings in the round of popular local and national Buddhist and Daoist deities are common in China, but three-dimensional portrait sculpture (including for ancestral images) is comparatively rare before the 19th century. But from around 1800, artists in the fertile region of Jiangnan, south of the Yangzi river, produced new portrait sculptures in soft stone and woods that were easy to carve, such as boxwood, with quite precise representations of bone structure, and even distinctive hairstyles. One such sculpture portrays an unidentified man wearing his hair in a mandatory queue or plait, with the front of his head close-shaved (fig. 4.14). After overthrowing the Ming dynasty, Qing China's new Manchu rulers had forced male citizens to wear their hair in this style. By the 19th century, it had become accepted as normal. In the early 1900s, cutting the braid off was regarded as a revolutionary act; and keeping it in the 1920s was a sign of being a Qing loyalist in the Republican era.

Other distinctions between Han Chinese and Manchu styles of dress and appearance existed, as illustrated throughout this chapter. Qing male elite dress differed from that of the previous dynasty, the Ming, when loose-fitting, wide-sleeved robes were favoured. Manchu male robes (旗袍, *qipao*) were more fitted over the chest, then flared out into an A-line with slits, and long, slim sleeves ended in 'horse-hoof cuffs' to protect the back of the hands – all these features had their origins in the old Manchu way of life, of which horse riding was an integral part. Robes were worn over trousers, and sometimes topped with a short riding jacket (馬褂, *magua*). Conical bamboo hats were worn in summer; round caps with fur-trimmed brims in winter.

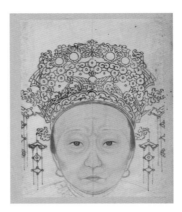

4.12
Woman's portrait from a sketchbook of faces
Customers looked at faces, headdresses and hats and chose an image best suited for their own relative's ancestral portrait.

Late 19th–early 20th century, China. Ink and colours on paper. H. 20 cm, W. 13 cm (image); H. 29.8 cm, W. 18.2 cm (album). Royal Ontario Museum, Toronto, 994.31.1.2. Purchase funded by the ROM Foundation

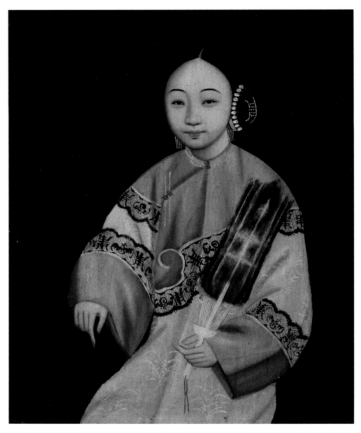

4.13
Unidentified artist, Painting of a woman holding a fan
Oil painting was introduced to China by Jesuit missionaries in the late 1500s. Portrait painting in oils became a speciality of workshops in Guangzhou in the 1700s, some of which made designs based on Western prints or produced watercolours for the export market. The simple background and limited props here are reminiscent of portrait photography. The robe is edged with imported black lace and the fan is made from feathers in a style popular in the second half of the 19th century.

c. 1850–1900, Guangzhou. Oil on canvas. H. 85 cm, W. 64 cm. British Museum, London, 2022,3030.2. Purchased with the Brooke Sewell Permanent Fund

Although Han Chinese men outside officialdom were not compelled to dress in the Manchu style, by the 19th century many had in fact 'Manchuified' their clothing. Manchu and Han Chinese women's clothing remained more distinct, even as late as the 19th century; Manchu women wore long robes and built their hair up into 'bat-wing' shapes (see fig. 1.50), 'using wire frames, false hair and ornate decorations'. Modish Han women, by contrast, wore two-pieces: a long tunic or jacket over a

pair of trousers, with hair combed and coiled back into a bun. Han Chinese women also bound their feet (see p. 217), whereas Manchu (and Hakka) women allowed their feet to grow naturally. Inevitably, however, in women's as in men's clothing, substantial assimilation between Han and Manchu styles had taken place by the 19th century.[25]

The American photographer Milton Miller (1830–1899) worked mostly in Hong Kong and travelled to

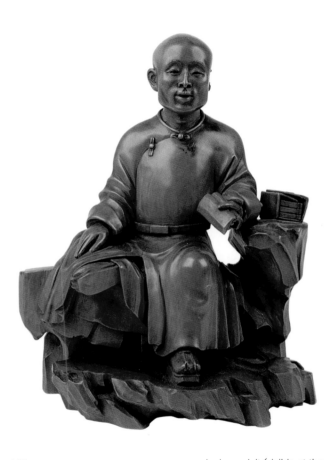

4.14
Portrait figure
Figures of gods and goddesses have a long tradition in China, but three-dimensional portrait sculptures are much rarer, although three-dimensional figures of ancestors were sometimes made. According to a neat inscription on the back, this small sculpture was made by Chen Tingrong from Yanguan (in modern Zhejiang province) in the first lunar month of 1805 (塩官陳廷榮鑄嘉慶乙丑春王). The figure has a shaved forehead

and a long plait (visible at the back of the sculpture), and is portrayed wearing a traditional scholar's robe, with a pile of books perched on rocks.

Dated 1805, Zhejiang. Boxwood. H. 16.5 cm, W. 18 cm, D. 13.2 cm. Wolverhampton Art Gallery, OC67

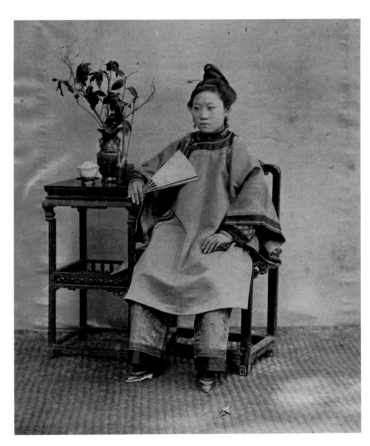

4.15
Milton Miller, Chinese woman with a fan
This studio portrait features generic staging props, including a vase with flowers, tiered table, covered tea cup and fan.

1865, China. Hand-coloured vintage albumen print from collodion negative. H. 23.4 cm, W. 17.8 cm. Allan Klotz Gallery, New York

Macao and Guangdong from 1859 to 1863. He made 'life-size' images of financially successful men, and some women (fig. 4.15), as did the British photographer John Thomson. (Wu Hong and other scholars have now proved these to have been staged in studios rather than commissioned portraits.)[26] By the second half of the 19th century, many businessmen were self-made entrepreneurs, with powerful local connections and large disposable incomes. They had not gained success in the traditional way, through passing the local, provincial and imperial exams and taking up official government appointments in areas far from their hometowns. Instead, they made a living through the lucrative salt trade or by selling other commodities,

products and services. They spent much of their wealth on their gardens and homes, equipping them with the latest foreign and domestic furniture. Their wives produced children and did charitable work. Some of these men commissioned new commercial portraits, including an extremely fine embroidery portrayal of an as yet unidentified businessman, which imitates the black-and-white tones of a portrait photograph (fig. 4.16). Embroidery, therefore, was influenced by the visual exactitude of photography, as was painting.[27] In the 1800s, embroidery changed from being predominantly a domestic activity to becoming a commercialised process. Indeed, from the late 1700s, many men gained employment in some regions of

4.16

Embroidered portrait

In previous centuries in China, social prestige accrued to people of landed wealth and success in the national examination system; this served also as the ideal for merchants who made fortunes in long-distance trade or government contracts. However, after the mid-19th-century Taiping Civil War, a new social class emerged of well-to-do, middle-class businessmen who enjoyed significant local prestige without such status markers. This portrait of just such a man is entirely stitched but copies a photograph precisely in its shading and oval framing. Black-and-white photography was a new art introduced into China after the 1840s; by the 1870s, rich people were sitting for their portraits and, by the close of the Qing dynasty, even more of the population could afford to be recorded in this way. Embroidery as a craft was influenced by photography, just as painting was, yet stitched portraits are very rare and such an image would have taken many months to complete by hand.

1860–1900, Suzhou. Silk embroidery. H. 60 cm, W. 45 cm. The Teresa Coleman Collection, E07998

Key figures: Lai Fong (*c.* 1839–1890)

4.17
Afong Studio, Portrait of Lai Fong
Lai Fong 黎芳 was often professionally known by his studio's name, Afong 阿芳. According to his obituary, Lai moved to Hong Kong from his native Gaoming in Guangdong province to escape the Taiping Civil War. In his Hong Kong studio he employed Western as well as Chinese photographers. In addition to photographing subjects for portraits, he also took images of generic tradespeople, landscapes and events. In 1883, Lai became a naturalised British subject. Photography businesses in the late 19th century were extremely competitive and it was common practice to buy up old stock from other studios as they went out of action, and then to rebrand it and sell it on, hence the number of images attributed to the Afong brand is vast.

c. 1865–80. Albumen print. H. 13.2 cm, W. 10 cm. Scottish National Portrait Gallery, Edinburgh, PGP R 871.1. Gift of Mrs Riddell in memory of Peter Fletcher Riddell

China in particular sectors of the embroidery industry, an occupation previously dominated by women working at home. The Imperial Textile Manufactories in Suzhou and Hangzhou of the early 1800s supplied the court with embroidered textiles.

Lai Fong 黎芳 (*c.* 1839–1890) is probably the best-known Chinese photographer of the 19th century (fig. 4.17). Relatively little is known about his early life in Guangdong, but he migrated to Hong Kong during the Taiping Civil War and created a successful business there. He produced beautiful landscape photographs, pioneering panoramic views, and images of sites across China, as well as very fine studio shots of people and recordings of events. Compositionally, his landscape images absorbed the tradition of Chinese painting, while his portraits included images of famous men of the day – statesmen such as Li Hongzhang, as well as Peking Opera stars.[28] John Thomson, whose Hong Kong studio was established later in the same street as Lai's studio, said Lai was 'a man of exquisite taste' who 'produces work that would enable him to make a living even in London'.[29]

Urban homes

Popular prints from centres such as Tianjin and Suzhou, line drawings, sketches, reverse glass paintings and watercolours from Guangzhou, and photographs from Shanghai provide us with more information on how people lived and decorated their houses in the 19th century than we have for any earlier era of Chinese history. Although style manuals were invented in China in the late Ming period, lifestyle magazines were new to the 19th century and, by the late 1800s, were selling in great numbers in the port cities. Courtesans who had been invisible to all but their special clients began to be more widely known through publishing.[30] Images of them wearing new clothing styles within modishly decorated rooms and gardens in turn set fashions for a wider audience. Life in the treaty ports fed a desire among ordinary urbanites for the novel and foreign, a desire that had started in the late 1700s but spread outside elite circles in the 1800s.[31]

Those who survived the mid-century catastrophes with at least some of their wealth intact enjoyed

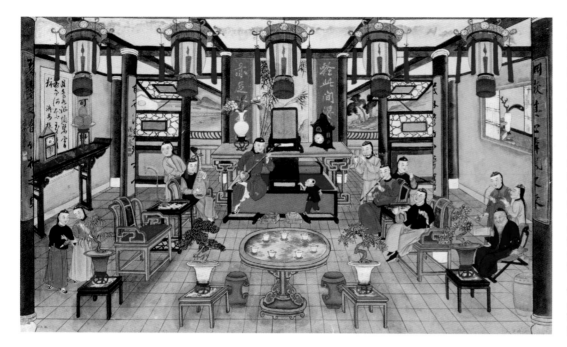

4.18

Album page illustrating a Ningbo home

This popular painting of the idealised interior of a salt merchant's home comes from a series of large watercolours with strong hues, shading and perspective, which was commissioned before 1898. The roots of this image lie in the exquisite Suzhou prints of the previous century, which show wealthy estates filled with auspicious good things: beautiful women, healthy male children and luxury goods. Here, the timepieces and lanterns with clock face details indicate a fashion for all things foreign.

1840–98, Ningbo. Watercolour on paper. H. 40 cm, W. 65 cm. Victoria and Albert Museum, London, D.23-1898

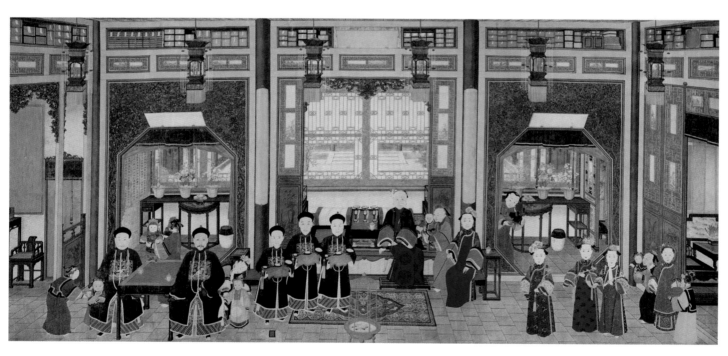

4.19

Wall-sized family portrait in a fashionable interior

Four generations of an elite northern family, probably in Beijing or Tianjin, are shown here in winter costumes in a reception room, on the occasion of the 70th birthday of the most prominent woman (a widow). The men are all wearing their official court robes with rank badges, court necklaces and hats. The women of the family are wearing full-length Manchu robes; their feet do not show. The matriarch's three grandsons bring her nine jade-inlaid wooden *ruyi* sceptres, which are a symbol of good fortune and wishes. The servants are shown facing away from the viewer and wear two-piece costumes typical of Han Chinese dress, distinct from Manchu style. The enclosed interiors are shown with sumptuous details, from the woven dragon carpet, perhaps from Inner Asia, to the attractive lanterns hanging from the ceiling. Small anterooms can be seen off the main hall, with flowers growing in celadon-green pots and calligraphy on the walls. A brazier in the foreground of the picture warms and scents the room.

c. 1853, North China. *Tieluo*, ink and colours on paper. H. 185.5 cm, W. 384 cm. University of Alberta Museums, Edmonton, 2007.23.1

both traditional and new recreational activities. Their home furnishings and dress reflected both an increased engagement with different regions across the Qing empire and with foreign countries. Much of the material evidence of regional home interiors and furnishings comes to us through idealised paintings and prints, initially through Western-commissioned export watercolours purchased from specialist workshops in Guangzhou and latterly through albums of paintings ordered from other ports further up the east coast, such as Ningbo (fig. 4.18).[32] Until the 1840s and the opening of the treaty ports, foreigners were largely confined to Guangzhou (see Chapter 5). Consequently, for the first half of the 19th century, we have more surviving visual evidence of life in the south than in the north; images of northern homes are much rarer. Architectural styles and interior furnishings reflect the local climate and availability of materials. For example, southern homes had an open style of construction to allow for the circulation of air in the hot, humid summer. China's vast land mass, almost equivalent in size to that of Europe, and consequent climate differences led to highly divergent circumstances in cities such as Beijing or Tianjin in the north, Shanghai on the east coast, Guangzhou in the south or Chongqing in the west.

People lived in multi-generational family units. In an image commissioned to celebrate an elderly female family member's birthday, we can see the interactions between the Manchu family (dressed in full-length robes) and their Han servants (wearing two-piece outfits of skirts and jackets) (fig. 4.19).[33] Han women were mostly confined to their courtyard houses and endured restricted movement, both physically (because of their bound and consequently crippled feet) and as a result of social convention. Manchu women were less restricted and did not bind their feet, but wore distinctive shoes on platforms to hide their large feet and to produce the same small-step walk of elite Chinese women.

Furnishings

Much furniture was portable, including wooden equipment used for businesses that could be set up in any street, such as a barber (fig. 4.20). Numerous barbers worked to maintain the official Manchu hairstyle that was imposed on men of all ethnicities in Qing China. Indoors, spaces within rooms were sometimes defined by folding screens. Many new designs for such pieces were created in the 1800s, some of them adapted from elite art. Innovation sat alongside tradition, as demonstrated by the use of carpentry tools of much older design (fig. 4.21)[34] and a collection of miniature wooden and textile furnishings for a bedroom, reception room, dining room, washing room and family shrine (figs 4.22–4.24). Artisans made this set for a tomb to

4.20

Zhou Peichun, watercolour of an itinerant barber

The portable barber's set depicted in this watercolour consists of a wooden basin on a stand, a seat for customers with compartments, and signpost. A large number of barbers was necessary to maintain the compulsory male hairstyle of a long plait and shaved top and sides of the head imposed on men of all ethnicities in Qing China, and they were a popular subject for Western photographers and other foreigners who took an interest in collecting everyday objects. Such visitors were eager both to document daily life and to communicate it to audiences back home, unlike earlier collectors, who focused on luxury goods and curiosities.

c. 1890, Beijing. Ink and colours on paper. H. 26 cm, W. 34.5 cm. Wellcome Library, London, 571507i

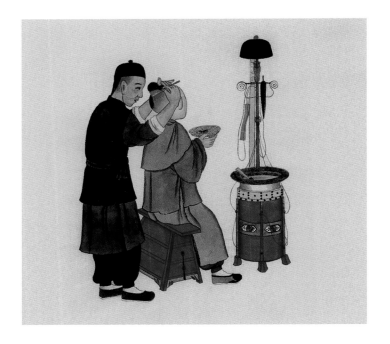

4.21

Carpenters' tools

These tools were collected by the Reverend Robert John Davidson (1864–1942) and his wife, a trained nurse and midwife, Mary Jane Davidson (1847–1918), who were Quaker missionaries at the Friends' Foreign Mission Association in Chongqing, Sichuan, from 1890 to 1894. In 1895, they gave a lecture tour at Quaker meetings around Britain about life and customs in China. During these lectures, they dressed up and acted out aspects of Qing life. For example, their six-year-old son Robin demonstrated the use of chopsticks. They visited the Horniman Museum in London and spoke with Frederick Horniman, himself a Quaker, who bought 338 items from their collection for £81. They returned to China in 1896.

1850–94, Chongqing. Wood and metals. L. 78 cm, W. 61 cm (largest tool). British Museum, London, see p. 329 for registration and donor details

4.22–4.24

Group of miniature grave furniture items

This traditionally formed miniature furniture is arranged into rooms: (clockwise from top left) bedroom, family shrine and reception room; (not pictured) dining room and washing room. There were many other items in a wealthy household, including clocks, lamps and lanterns, tableware, textiles, paintings and screens. These commodities had varied forms, depending on their price and the regions in which they were made, bought and sold. The objects shown here were originally made for a tomb to represent the items that the dead would want to take into the afterlife.

1800–1900, China. Wood and textiles. H. 28 cm, W. 22.2 cm, D. 16 cm (largest piece). British Museum, London, see p. 329 for registration details

evoke the lavish furniture of the deceased's home, so it contains, albeit on a small scale, the key items of furniture in a late Qing house, as described in some of the most widely read novels.[35] As had been the practice for millennia, tombs were furnished as if they were residences of the living, full of signifiers of the occupant's wealth and status. Once popular ceramic models were rarely buried in graves of the 1800s and inexpensive paper money and images of objects were burned as offerings instead.

After 1842, home furnishings in the treaty ports reflected growing engagement with international influences. Foreign materials such as wool were used for interior hangings and furniture covers. As people interacted with foreigners, a new mass fashion developed for hybrid (Chinese–Western) as well as imported goods. Some traditional Chinese objects were given a foreign makeover and people displayed foreign

objects in their homes as a statement of modernity and cosmopolitanism. Western clocks, which in the 1700s had been exclusively owned by the court, having been presented as diplomatic gifts or replicated by Guangzhou craftsmen, were particularly fashionable.[36] We see this in the domestic interiors portrayed in some beautifully printed books and magazines, such as the copper-engraved printed depictions of Shanghai courtesans in *Mirror Reflections and Flute Sounds* (鏡影簫聲初集), which was first published in 1887 (fig. 4.25).[37] The exquisite table clock visible on the courtesan's dressing table in figure 4.25 is a hybrid object, similar to an example in the British Museum collection that combines a Swiss clock face with a Chinese carved rosewood case and stand (fig. 4.26). Despite conflicts with Western nations, Westernised or semi-Westernised styles, such as those displayed on a large 'Euroiserie' pewter container, appealed to consumers (fig. 4.27).[38] Fun was poked at

4.25

Page from *Mirror Reflections and Flute Sounds* (鏡影簫聲初集)
Although most sex workers in Qing China endured miserable lives, those at the top of their profession enjoyed great luxury, and these celebrated prostitutes set fashions for dress and interior design which spread to women outside the industry. *Mirror Reflections and Flute Sounds*

was printed in Japan and introduces brief biographies of fashionable Shanghai courtesans. It was illustrated with intricate copper-engraved images, which competed with local woodblock-printed and lithographic ones, and were intended to be fantasies rather than realistic portrayals. The idealised courtesan, affordable in person only for the wealthy few, became accessible to many more people in the late Qing through the

publishing of photographs and even guidebooks of Shanghai.

1887, printed in Tokyo. Copperplate-engraved printed book. H. 19.5 cm, W. 15 cm. Library of Congress, Washington, D.C., MFC Orien China F/CH 1527

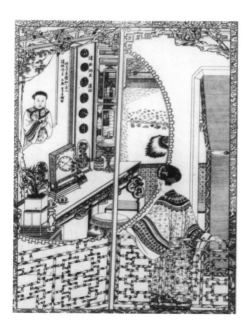

4.26

Bracket clock
In the 18th century, foreign clocks came to Guangzhou and Beijing as tributes for the court or as high-quality trade goods, but by the second half of the 19th century there was a wider market for imported luxury goods. The illustration of a courtesan in a beautiful interior in fig. 4.25 includes a similar clock, and timepieces appear as motifs on popular textiles and in watercolours of interiors. This bracket clock has a Swiss face and a Chinese case. In the 19th century, contemporary writers noted, the craze for foreign (洋, *yang*) things increased. The writer Liang Zhangju 梁章鉅 (1775–1849) remarked that people were crazy about: '*yang* copper, *yang* porcelain, *yang* paint, *yang* linen, *yang* cotton, *yang* blue, *yang* red, *yang* marten, *yang* otter, *yang* paper, *yang* pictures, *yang* fans, the list is endless …'

1815–25, case: China; movement: Switzerland. Rosewood, metals and enamel. H. 43 cm, W. 25.4 cm. British Museum, London, 1958,1006.2059. Purchased through funds donated by Gilbert Edgar CBE

the foreign communities too, as a handmade stoneware urinal neatly demonstrates; depicting a Western male, it was glazed in the Shiwan kilns in Guangdong (fig. 4.28).[39]

Opium use became gradually more widespread from the early 19th century; many smokers became addicted, with all the misery that such dependence brought. Opium-smoking is now regarded as 'a plague on the Chinese people', weakening the military and sapping the people's energies but, as elsewhere in the world, the story is not as clear-cut as this view suggests.[40] Before the 19th century, poppies had been grown in China for centuries on a relatively small scale and opium was traditionally used for its medicinal properties. The new habit of smoking the drug was not legalised until 1860, after the Second Opium War, and for the wealthy it became a regular part of home entertaining. Between 1860 and 1887, high taxes were levied on imported opium from India, which was brought to China through the treaty ports of Fuzhou and Xiamen. By then, home-grown opium was cultivated in many provinces, including Fujian, Sichuan and Yunnan. Zhang Daye 張大野 (n.d.), an eyewitness to the Taiping Civil War and its aftermath, wrote of coastal Zhejiang: 'The people of Taizhou use their most fertile fields for poppies nowadays. Some say that as long as it brings a handsome profit, what harm could there be in growing poppies? They little understand that poppies are poisonous, and that, after their juice saturates the soil for a long time, it is no longer possible to plant anything else there.'[41] Locally cultivated opium was cheaper than the Indian-imported drug and consequently was smoked by poorer people.

4.27
'Euroiserie' pewter vessel
As the Qing empire expanded in the 1700s and global trade increased, miners migrated to the southwest frontiers of the empire and even into Southeast Asia, bringing their mining technology with them. In turn, imported tin from Southeast Asia inspired Chinese pewter artisans to invent new styles and techniques of metalworking. Contact in port cities brought about a new hybrid style of home furnishings, especially after 1842. This extraordinary object made of pewter, inlaid with brass and chased with floral decoration, is topped with a coronet (the original Christian cross on top is missing) and has eight drawers arranged in two four-sided tiers, which are positioned so that they are not in line with one another. The drawers have lion knob handles and rings. When the coronet is removed, a cylindrical box in two divisions can be seen. Perhaps a wealthy merchant used it for storing spices or salt.

1800–50, probably southern China. Pewter chased and inlaid with brass. H. 43 cm, diam. 17 cm. Victoria and Albert Museum, London, 1454-1903. Given by Mr O. Marriage

4.28
Urinal
Shiwan kilns, located in the manufacturing town of Foshan near Guangzhou, exported wares to Southeast Asia, Europe and North America. This urinal is modelled in the form of a foreigner but made for a local Chinese client as a joke. Potters at Shiwan produced large numbers of such glazed stoneware vessels for the Chinese market that mocked foreign merchants by showing them in subservient positions or even, as here, by depicting them as urinals.

1800–1900, Foshan (Fatshan), Nanhai county, Guangdong province. Glazed stoneware. H. 14.9 cm, W. 18.4 cm. Private Collection – Anne and Albert Cheng

4.29

Large carved-wood daybed inlaid with marble

Opium-smoking was widespread in China in the 19th century. Horrified officials such as Lin Zexu denounced it as a scourge on Chinese society. The habit also, however, generated beautiful objects to accompany consumption. This reclining couch or low-backed daybed is often referred to as an opium couch. In late Qing literature, characters are described as lying down on such furniture to take an opium pipe. The left side was considered the honoured side and the right side the humble side, a judgement which determined who lay on which part of the couch. The marble inlay together with woven bamboo pillows would be cooling in summer and the imported shell inlay reflected the light. The cabriole legs suggest the influence of Western furniture style.

1800–1900, probably Guangzhou or Shanghai.
Rosewood, marble and mother-of-pearl.
H. 114 cm, W. 198 cm, D. 128 cm.
Guangdong Museum, Guangzhou

For wealthy recreational smokers, lighting up an opium pipe was a social activity and in well-to-do homes it was accompanied by elaborate, expensive equipment. A particularly fine example is provided by a low, dark and hardwood couch or daybed (fig. 4.29). Its form has been adapted from court furniture styles but combines Chinese and European features: marble and mother-of-pearl inlay is a typical feature of southern Chinese furniture, whereas the cabriole legs derive from European furniture.[42] Two people could lie with a small, low table in between them to hold a tray with a pipe, a lamp, an opium bowl, cleaning tools for the pipe, drinks and some snacks. These daybeds are quite different from beds made for sleeping, which originally would have had curtains and other textile features (fig. 4.30).

Beautiful watercolour-illustrated albums of furniture and interiors were produced in China's port cities and these help us understand how objects related to one another in 19th-century interiors. Fine calligraphy, written in ink on paper by the educated elite and one of the most prestigious forms of visual art, was expensive but urbanites without prestigious cultural

4.30
Moon-shaped bed
Held together not by nails but
by interlocking joints, this bed is
shaped like a full moon – a device
also used in garden construction
in China. It is intricately carved
and was made in Ningbo for the
Philadelphia Centennial Exhibition
of 1876 (the first official World's
Fair to be held in the United States,
and which celebrated 100 years
of American independence
from Britain).

c. 1876, Ningbo. Satinwood,
other imported Asian woods
and ivory. H. 260 cm, W. 257cm,
D. 168 cm. Peabody Essex Museum,
Salem, 1977 E80259. Gift of
Robert W. Sarnoff

connections or deep pockets substituted more affordable
store-bought glazed porcelain tiles, which could be
displayed all year round either hung on walls or
embedded in wooden screens.

Dress

In the first half of the 19th century, dress styles changed
relatively little, even while wearers and observers of
clothing remained conscious of fashion and status.
However, male and female fashions in dress, hairstyles
and accessories changed dramatically in the fifty years
before 1912. Diverse social groups used different textiles
for clothing. The poorest wore hemp or cotton, while the
wealthy wore embroidered silks and satins; some used
imported wool and lace. Fur and feathers were used as
trimming for hats, fans and other accessories. Furs and
skins were worn both as outer garments and as luxury
linings for extra warmth in winter (see figs 1.28 and
2.64). Velvets and voided velvets were worn as jackets to

provide extra layers. And bamboo beads were threaded
together to create cool undergarments such as vests and
undershirts for use in summer (fig. 4.31).

Tools for sewing – including scissors, thimbles
and needles – varied in design from region to region
(fig. 4.32). Although natural dyes were appreciated
before this period for their bright hues, perhaps
the most eye-catching changes came through the
introduction of colours derived from imported chemical
dyes (figs 4.33–4.34).[43] These new dyes broadened the
palette available, did not fade like organic dyes and
had the same revolutionising effect on textiles that the
introduction of the *famille rose* enamels had on porcelains
from the 1720s onwards. New fabrics (British wool,
Indian cotton, American trims) and different kinds of
surface decoration created novel effects (embroidery,
gilded thread, appliqué or painted flowers).

Time-consuming embroidery demonstrated a
woman's skill as a seamstress, her virtuous nature,
her good use of her time and her love for her family.[44]

4.32 (below)
Sewing tools
Professional tailors and amateur sewers wore a ring thimble on the second joint of the middle finger and kept needles in wooden cases, such as those seen here. Each region produced local tools, with minor variations. At the end of the century, machine-made scissors and needles were imported, severely impacting local production and the diversity of styles.

1850–1900, Yunnan, Chongqing and Shanghai. Copper, iron, cane, brass and wood. L. 28.7 cm (max). British Museum, London, As,Bs.65, As1896,-.54-55, As1847,0827.6, As1896,-.56.a-d, As1896,-.59-60. Donated by Captain Sir Everard Home (As1847,0827.6), Sir Augustus Wollaston Franks (As1896,-.56.a-d, As1896,-.59-60)

4.31 (above left)
Bamboo jacket
This jacket is made from a series of 4-mm-long fine tubular bamboo beads which are threaded together in a net-like structure. It was designed as a man's undergarment, providing coolness next to the body and separating the skin from the silk outer robe; the latter would otherwise have been stained easily in hot and sticky summer months. The seasoned bamboo selected for the beads is very fine and a garment such as this would use over a thousand beads all stitched together by hand.

1860–69, southern China. Bamboo, silk and cotton thread. H. 60.5 cm, W. 160.6 cm. British Museum, London, As.3606. Donated by Henry Christy

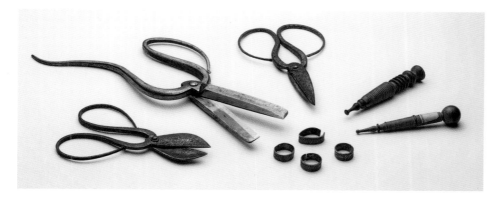

4.33 (above)
Naturally dyed silks
These silk skeins demonstrate that Chinese dyeing techniques were already producing bright and vibrant hues in the 1840s, using metallic as well as vegetable colours. To some degree, each region of China had its own distinctive style of embroidery: Su embroidery came from the Suzhou region in Jiangsu; Yue embroidery was focused on Chaozhou in Guangdong; Shu embroidery came from Chengdu in Sichuan; and

Xiang embroidery came from the Changsha area in Hunan province. Other styles included Jing embroidery from Beijing, Hang embroidery from Hangzhou and Lu embroidery from Shandong.

1840s, China. Silk. L. 14 cm (each skein). Victoria and Albert Museum, London, FE.67:43-2009. Given by Janet, Annie and Colin Simpson in honour of their great-great-grandfather, Dr Lawrence Holker Potts

4.34 (above)
Aniline dyes in original printed colour packaging
Synthetic aniline dyes were used on textiles such as silk, wool and velvet to produce a range of hues from crimson to lilac, including bright yellows, blues and greens. Mineral oxides were combined with alcohol and aniline derived from coal tar. The first person to patent aniline dyes and produce them commercially was an 18-year-old British chemist, William Perkin (1838–1907) who, in 1856, accidentally created a new purple colour. By 1860, the new aniline colours were widely available and very popular in China. By 1877, Germany accounted for half of world dyestuff production and it went on to dominate the industry until the start of the First World War in 1914.

1875–1900, Germany. Printing ink on paper and dye. H. 5 cm, W. 14 cm, D. 7 cm. Chris Hall Collection

4.35

Embroidered sleeveless jacket with ancient and modern coins

The novel design of this small vest jacket is made with a collage of overlapping coins, rather like an elite *bapo* painting (see pp. 144–9). The colours are in the new aniline palette imported from Europe. The jacket is lined with pretty cotton printed with stripes and images of butterflies, which was possibly imported. The stand-up collar, derived from Western fashion, helps us to date the jacket to the late Qing.

c. 1875–1908, probably Shanghai. Printed cotton plain weave lining, silk and gold metallic embroidery, gilded braid. H. 57 cm, W. 51.5 cm (max). Philadelphia Museum of Art, 1940-4-730. Purchased with the John T. Morris Fund from the Carl Schuster Collection

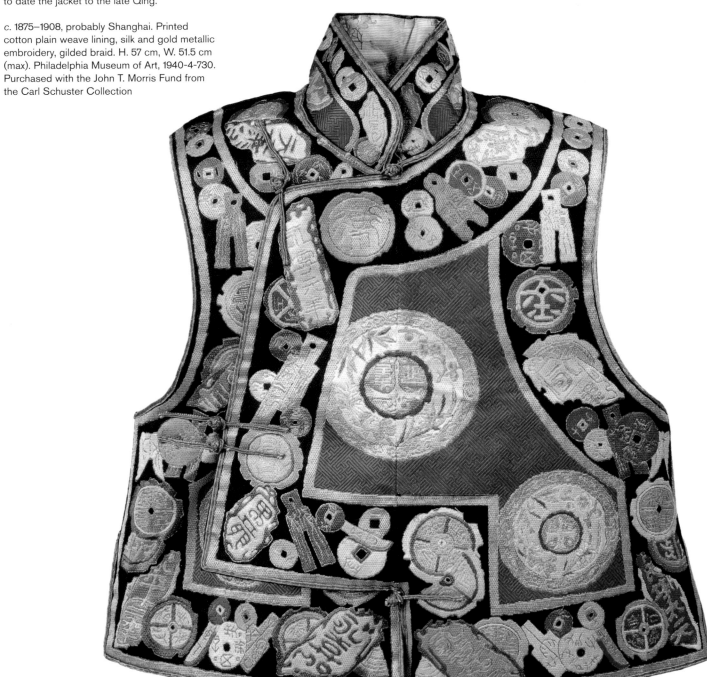

Initially, women embroidered at home, but as demand for embroidery grew throughout the second half of the 19th century, a cottage industry was transformed into something that operated on a much larger scale.[45] In a highly commercialised environment, and in addition to an expanding repertoire of domestic motifs (fig. 4.35), embroiderers also drew on foreign imagery. A very rare child's bib, for example, features a colourful foreign timepiece on a bright yellow background, while a heavily embroidered sleeveless jacket has 'clock buttons' (figs 4.36–4.37).[46]

Qing trendsetters, such as members of the Manchu elite and courtesans, initially wore imported woollen textiles made up as accessories or capes. These imported woollen fabrics first arrived in China in the 18th century as diplomatic or trade goods through Beijing or Guangzhou. After the 1840s, luxury goods were traded through the series of newly opened treaty ports and

4.36

Child's bib embroidered with a foreign clock

Beautiful clocks were made in 19th-century China with elaborate surrounds imitating earlier Western clocks. This child's bib unbuttons at the left shoulder and fits over any garment, leaving the arms free. It is difficult to identify the exact timepiece that was the inspiration for the design, but it was perhaps one with an attractive cloisonné or hardstone casing.

1830–80, China. Cotton, silk and embroidery. H. 26 cm, W. 23.5 cm. Chris Hall Collection

4.37

Embroidered sleeveless jacket with 'clock buttons'

This petite jacket was worn over a long one-piece Manchu-style robe as an outer garment. Boundaries between Manchu and Han fashion become blurred during the 1800s, as Manchu people appropriated Han fashions and the Han took on some Manchu ways of dressing. The enamel 'clock buttons' on the yoke and sides (each showing a different time) are innovative and part of the fashion for all things Western (洋, *yang*). The construction of the jacket is a fashionable late 19th-century cut known as

a 'one-piece vest'. The whole of the front panel detaches from the back rather than fastening at the side. Gold threads were made by wrapping glue-covered paper in sheets of gold leaf, which was cut into strips with a fine knife. They were then laid on the surface and attached with tiny stitches.

1862–74, possibly Beijing. Silk embroidered with silk and gold threads, silk damask lining. H. 39.4 cm, W. 44.5 cm. Victoria and Albert Museum, London, T.110-1964. Given by HRH Queen Mary

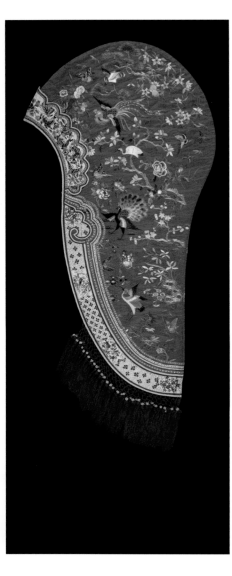

4.39

Purple hood embroidered with birds and flowers

Vernacular embroidery became increasingly commercialised in the 19th century, moving from a home craft to large-scale workshops for production and specialised shops for distribution. For the first time in 1821, a woman called Ding Pei 丁佩 (active 1796–1830) from Huating (near modern Shanghai) published a technical manual for embroidery, titled *Xiu Pu* 繡譜 (*Notes on Embroidery*); before this point, embroidery knowledge had been handed down through practice and oral instruction. The repertoire of designs expanded dramatically. Women responded swiftly to changes in fashion in the 19th century, embracing a new colour palette while incorporating both traditional auspicious motifs and foreign designs. This beautiful hood is festooned with visual puns and images that were supposed to bring good luck: seed-filled pomegranates convey the wish for many sons, pine trees and cranes represent a desire for long life, butterflies and peacocks stand for happiness and wealth, and pairs of mandarin ducks for marital harmony. Orchids, asters, fruit trees (Prunus) and magnolia are all finely embroidered, and the edge of the cap is trimmed with a contrasting cream-embroidered ribbon and blue tassels.

1800–1900, China. Satin-weave silk embroidered with silk and silver-gilt threads. H. 79 cm, W. 40.6 cm. Victoria and Albert Museum, London, T.109-1964. Given by HRH Queen Mary

4.38

Red wool flannel hood with fur trim and embroidery

This winter hood is edged with ribbon trimmings, fur and embroidery. Brightly coloured wool fabrics imported from England and Russia were particularly popular in the late Qing. Having once been reserved for the wealthy, they were worn more widely by men, women and children in the 19th century, blurring social boundaries. Women wearing similar hoods can be seen in contemporary late 19th-century popular prints.

1840–1900, China. Wool flannel, fur and cotton. H. 44 cm, W. 22.5 cm; H. 55 cm (including blue ties). National Museums Scotland, Edinburgh, A.1966.516

their use became far more widespread across China.[47] Foreign woollen cloth substituted for padded cottons for lower income groups or for furs in higher income groups (furs became less common in the late 1800s, because of over-hunting). Coloured woollen cloth was used for interior hangings, furniture coverings, outer garments and accessories, including a child's hood, which was fashioned from British red wool cloth (fig. 4.38). (Decorative and pattern innovation could also be seen in the use of traditional Chinese silk and satin fabrics (fig. 4.39).) British factory owners were desperate to sell their textiles in what they imagined as the vast market of Chinese consumers; if Chinese people wore their shirts just an inch longer, ran the saying, 'the mills of Lancashire could be kept busy for

4.40 (below)
Earmuffs

These embroidered earmuffs, which have a soft fox-fur trim and are lined with blue cotton, were designed for ladies to wear in the cold winters of northern China. On the back of each muff is a semicircular pocket which fitted over the ear, and they are tied together with a cord. Earmuff designs provided an opportunity for women to showcase their innovative embroidery.

1880–1900, Beijing. Cotton, fox fur and silk embroidery. H. 7.5 cm, W. 7.5 cm. British Museum, London, As1957,07.1. Donated by Mrs I.C. Turnbull

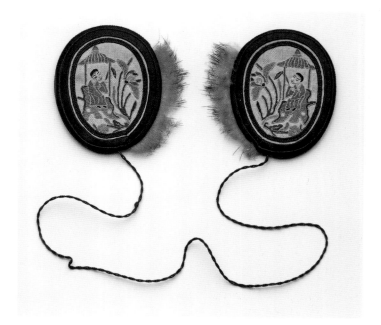

4.41–4.42 (above)
Hairpiece and hair extension

Chinese women wore their hair in local fashionable styles. Complicated hairdos, sometimes supported with wooden frames, were held in place by beautifully ornamented hairpins, bandanas, flowers and other accessories. Hairpieces, usually made from woven horsehair, were oiled and attached to the wearer's natural hair and helped to create a more structured form. These examples are combed straight, plaited at the sides and stitched at the top and bottom. Few such items survive, but these have been preserved as they were given to the Royal Albert Memorial Museum in 1860.

c. 1860, China. Horsehair. H. 23.5 cm (max), W. 12 cm (max). Royal Albert Memorial Museum & Art Gallery, Exeter, E.476.1–2. Given by Miss Pearce

a generation'. American, Indian and later Japanese merchants also promoted sales of their cotton at the end of the 19th century.

Women's accessories and headdresses varied greatly from region to region in 19th-century Qing China. Fur-trimmed embroidered earmuffs were suitable for Beijing's cold winters (fig. 4.40), while black bandanas with sewn-on red glass beads were worn by women born south of the Yangzi river. Hair could be extended into fancy shapes using hairpieces to reflect local fashion (fig. 4.41–4.42). Books of portrait photographs distinguish women from Shanghai, Guangzhou or Chongqing by their hairstyles, but urban fashion was quick to absorb styles through interaction between people of different classes, regions or nationalities across the social spectrum and through new media. For example, court headdresses from Beijing, which were embellished with bright-blue kingfisher feathers, were initially adapted for the opera stage and then further adapted by the wider elite as bridal wear or for other special occasions, with a design to suit a range of budgets (figs 4.43–4.45).[48] By contrast, 'cloud collars', which had a long history including in operatic costume, transformed any outfit with elaborate textile layers, embroidered details, applied beads and floating ribbons (functioning a little like a piece of statement jewellery); they also, more prosaically, protected expensive garments from hair-oil stains and hid signs of wear (figs 4.46–4.51). Handkerchiefs came in both European-style square forms and traditional rectangular Chinese styles.[49]

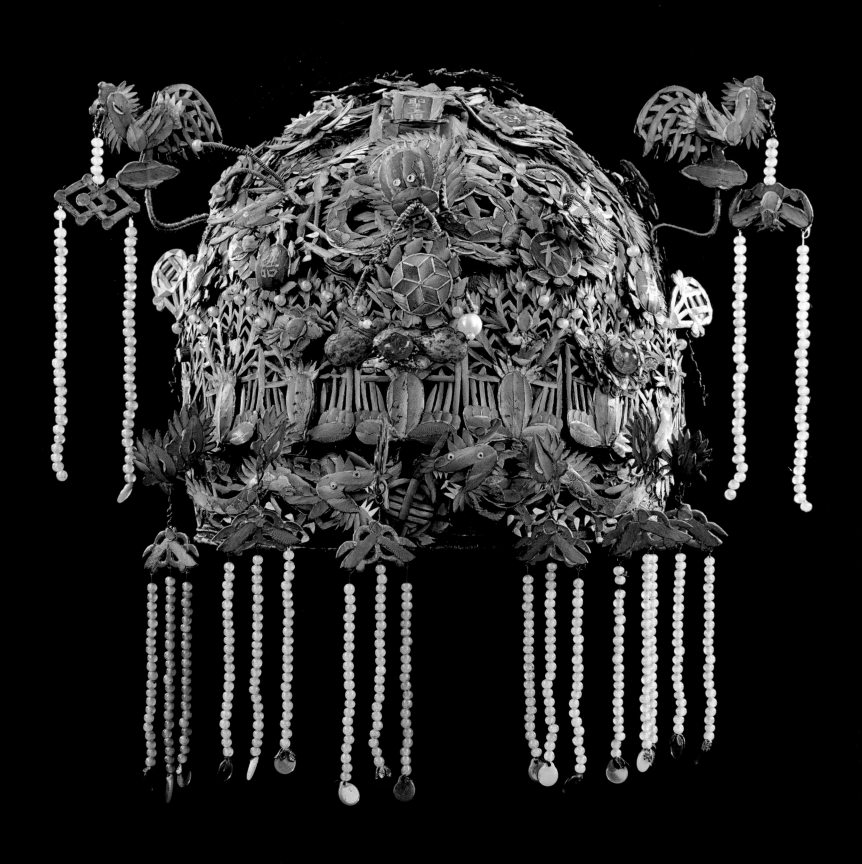

4.43 (opposite)
Woman's headdress of kingfisher feathers
In the Qing era, this type of headdress was worn by women on special occasions such as weddings, its design derived from the elaborate phoenix crowns worn at court by Ming-dynasty aristocratic women. The metal frame is covered with black silk satin and then various ornaments are sewn on, including kingfisher feathers and semi-precious stones such as jade, pearls, coral and lapis lazuli.

1780–1850, China. Gilding, kingfisher feathers, jade, tourmaline, coral, turquoise, lapis lazuli, bone, pearl, glass, resin, silk-satin weave and silk plain weave. H. 25 cm, W. 22 cm, D. 19 cm. National Museums Scotland, Edinburgh, A.1969.399

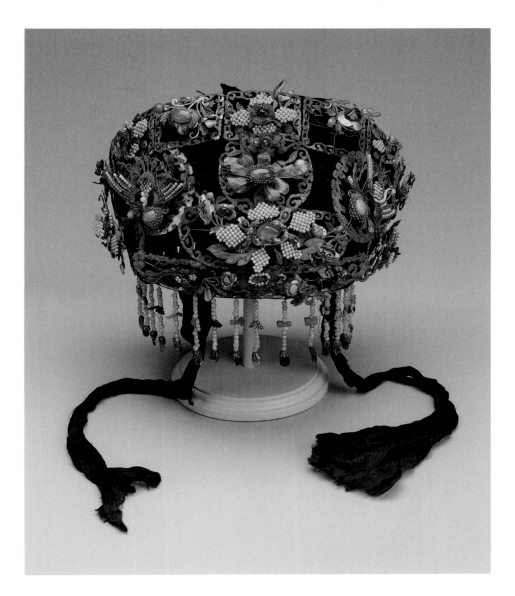

4.44–4.45
Two kingfisher feather headdresses
Headdresses of varying quality and complexity were made to suit a range of budgets. They also appealed to Western collectors and many are held by European and American museums. Popular styles included the box hat worn on the top of the head (top right) or the headband worn quite far back on swept-back hair (bottom right).

Box hat: 1800–1900; headband: 1850–1900, China. Gilding, kingfisher feathers, jade, tourmaline, coral, turquoise, lapis lazuli, bone, pearl, glass, resin, silk-satin weave and silk plain weave. Box hat: H. 21.6 cm, W. 24.8 cm; headband: H. 19 cm, W. 22 cm. Museum of Fine Arts, Boston, RES.55.48; The Teresa Coleman Collection, A06682. Bequest of Miss Lucy T. Aldrich (box hat)

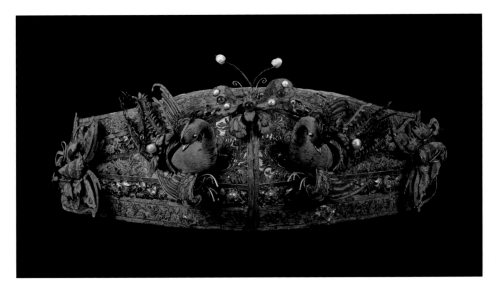

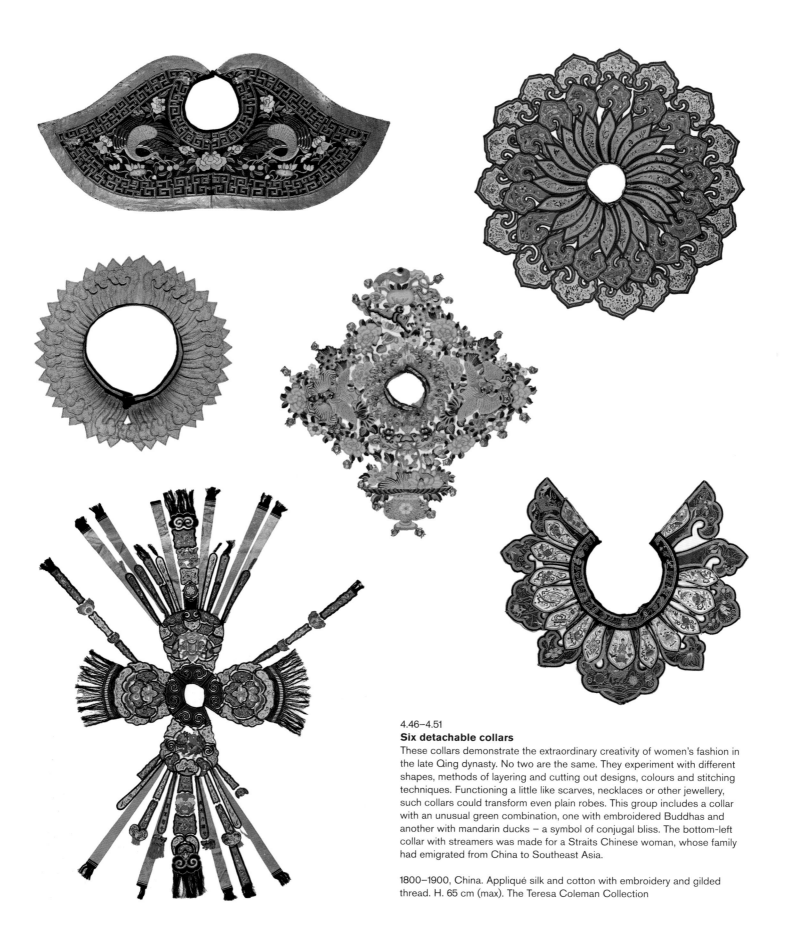

4.46–4.51

Six detachable collars

These collars demonstrate the extraordinary creativity of women's fashion in the late Qing dynasty. No two are the same. They experiment with different shapes, methods of layering and cutting out designs, colours and stitching techniques. Functioning a little like scarves, necklaces or other jewellery, such collars could transform even plain robes. This group includes a collar with an unusual green combination, one with embroidered Buddhas and another with mandarin ducks – a symbol of conjugal bliss. The bottom-left collar with streamers was made for a Straits Chinese woman, whose family had emigrated from China to Southeast Asia.

1800–1900, China. Appliqué silk and cotton with embroidery and gilded thread. H. 65 cm (max). The Teresa Coleman Collection

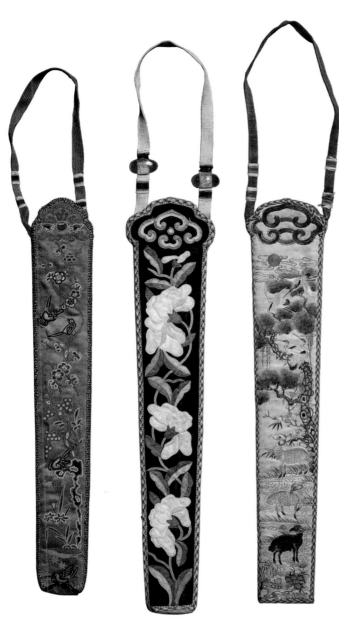

At home, most women learned how to embroider small objects, such as shoes, purses and fan cases (figs 4.52–4.57). Wide and narrow sleeve bands could be added to garments in multicoloured combinations and provided women with an opportunity to showcase their stitching skills.[50] Some examples use a traditional auspicious 'one hundred boys' motif and an innovative design of figures with poems (figs 4.58–4.60).

Perhaps the most obvious signifiers of a woman's Han identity were her tiny bound feet (fig. 4.61).[51] From about eight onwards, a girl had her feet bound, with the toes tucked underneath the sole. Eventually, this caused the bones to break and the foot to be deformed into a tiny stump. Women had to be helped to walk or tottered about on their stumps, and very small feet thus advertised wealth and social status. Manchu women and working women did not bind their feet. Towards the end of the 19th century, foot-binding was opposed both by foreign missionaries and by some members of the educated

4.52–4.57
Embroidered fan cases and purses
Such small objects were perfect for showing off a woman's talents for needlework and could be suspended from the wearer's waistbelt by a loop. The women who made them used a variety of motifs, from rabbits, horses, butterflies and flowers to figures from popular stories.

1800–1900, China. Embroidered silk, glass and wood. H. 33 cm, W. 7 cm (fan covers, max); H. 12 cm, W. 12 cm (each purse, approx.). The Teresa Coleman Collection

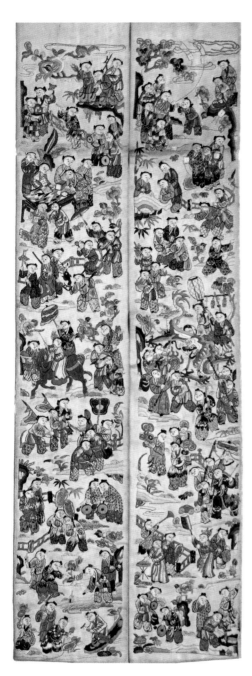
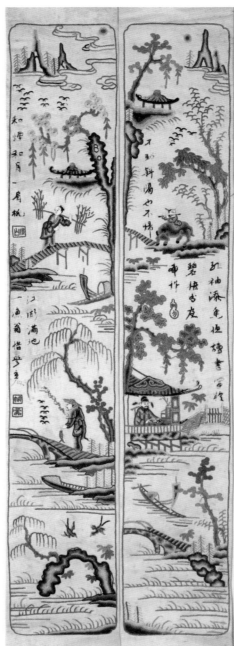
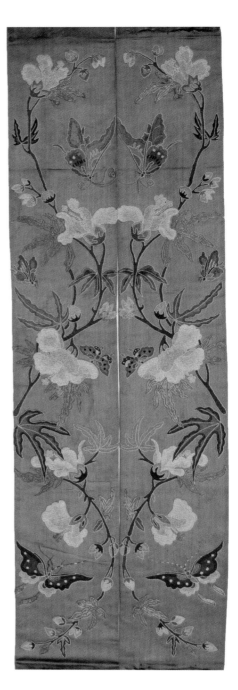

4.58–4.60

Sleevebands

These bands, created in complementary or sometimes mirrored pairs, were applied in contrasting colours to the edges of both Manchu and Han women's garments. Han women's jackets had wide sleeves and the bands were attached to form an extended cuff; thinner bands could be sewn onto the sleeve either side of a wider band or used elsewhere on the garment. Such bands and ribbons significantly extended the life of a garment and could be changed to create varied looks. These unusual examples depict scenes with stitched poems, demonstrating the maker's literacy; from left to right, they feature the 'one hundred boys' motif, which conveys a wish for many sons, scenes from popular stories and auspicious emblems. Some designs were created following a printed pattern, others came from a traditional repertoire or showed newly imagined scenes.

1800–1900, China. Embroidered silk. Left to right: L. 91 cm, W. 9.5 cm; L. 71 cm, W. 9.5 cm; L. 59 cm, W. 9 cm. The Teresa Coleman Collection, E07014, E07008, E06999

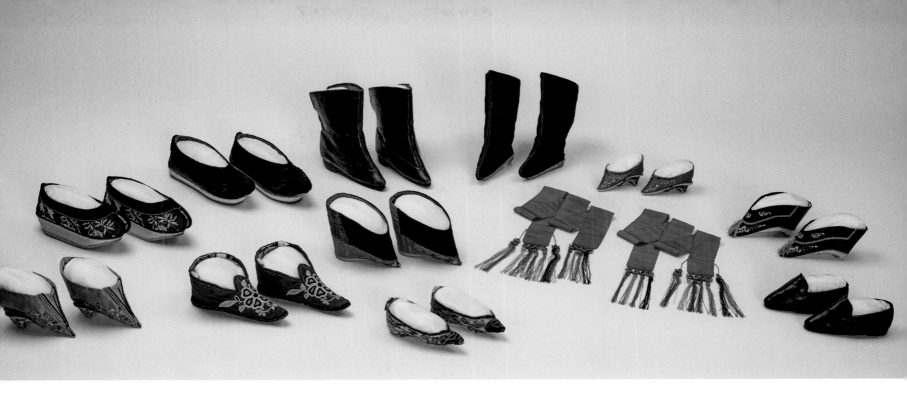

4.61

Group of women's shoes and boots
The tiny silk-embroidered shoes and boots
illustrated here were made for Han women with
bound feet (the larger examples are for women
who had not been subjected to foot-binding).
The disabling practice of foot-binding was very
common among elite families in 19th-century
China. Young girls had their feet tied by their
mothers and other female members of the
household using strips of cloth, with their toes
broken and tucked under the soles. The feet were
thus moulded into tiny 'lotus' stumps that were
'ideally' just 10 cm long. Although this effectively
crippled women, it was believed to make them
more attractive and therefore capable of marrying
more advantageously. The embroidery on the
shoes showed women's technical skills and
creativity. Foot-binding was not practised by
Manchus, or by adherents of the Taiping;
see fig. 1.57 for an example of elite Manchu
women's footwear.

1800–1900, China. Cotton, silk and embroidery.
H. 20 cm, W. 5 cm, L. 14 cm (tallest boots);
L. 10 cm (smallest shoes). British Museum,
London, As1977,09.10.a-b, 2021,3002.9,
2021,3002.3, As1997,40.42.a-b, 2021,3002.4,
As1977,09.8.a-b, 2021,3002.1, 2021,3002.2,
2021,3002.6, 2021,3002.8, 2021,3002.7,
2021,3002.5. Donated by the Reverend Keith R.
Parsons (As1997,40.42.a-b); donated by Miss
Vera T.P. Day (As1977,09.10.a-b, As1977,09.8.a-b)

elite. Anti-foot-binding campaigns were an important
feature of popular political mobilisation in the closing
years of the Qing dynasty and in the 20th century.

As the 19th century drew to an end, gowns became
tighter-fitting, giving women a more defined silhouette.
This style of dress was developed through increasing
encounters with close-tailored Western dress and
corseted waists. The first Chinese man in Hong Kong
to wear a Western suit is said to have been He Qi 何啓
(1859-1914), a British-trained doctor and lawyer who
returned to the colony with a British bride in the early
1880s. Post-1898, photographs of political exiles from
the Qing wearing Western suits, such as Liang Qichao,
acclimatised their viewers to foreign sartorial styles.
Unlike in Japan, however, late imperial China did not
see a decisive shift towards Western dress, but rather
hybrid styles and combinations. Furthermore, items that
had hitherto been exclusive to the Manchu aristocracy
came to be worn in the wider urban communities,
such as the Manchu *qipao* (literally, 'banner robe'),
as evidenced by an example with a decorative border
embroidered with the Cyrillic alphabet (fig. 4.62).[52] The
letters are enjoyed as an exotic pattern without meaning,
in a 'Euroiserie' reversal of 'Chinoiserie'. Such one-
piece garments contrasted with Han women's traditional
three-piece sets (jackets, skirts and leggings), all stitched
with many embroidered bands (figs 4.63–4.65).[53]

Qipao dress with Cyrillic letters

The *qipao*, a side-fastening, full-length woman's garment, is now regarded as a quintessentially Chinese dress and is still made today. However, the name literally means 'banner robe', referring to its Manchu origins. This bruised-pink silk dress is extremely unusual, as the neckline, button closure and cuff borders are embroidered with letters from the Cyrillic alphabet, which was used to write a number of Eurasian languages, including in Central and Northern Asia. These glyphs do not form a coherent phrase, but are used for their exotic foreign look. The slimmer silhouette created by wearing a *qipao* was possibly influenced by the increasing accessibility of tighter-fitting Western women's clothes, as well as knowledge of Western tailoring spread through treaty port cities. This garment could be said to be in a 'Euroiserie' style.

1909–20, China. Embroidered silk. H. 100 cm, W. 150 cm. Chris Hall Collection

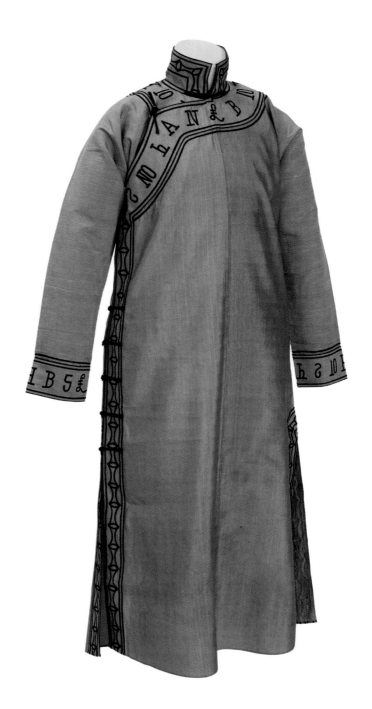

The embroidered roundels on Han women's robes depicted references to plots of opera plays or novels, whether the entire story or snippets.[54] Opera was performed in excerpts as well as in complete plays that lasted for several days. One colourful robe's embroidery draws on scenes from the *Romance of the Western Chamber* (fig. 4.66). The ubiquity of literary references in and on late Qing clothing, including female costume, shows how – despite widespread illiteracy – 'literacy cast a wide shadow in Qing society'.[55] Similar literary images appear in printed urban songs, popular prints, and carved in the wooden architecture of city houses. There were many different kinds of performance, all providing sources for female dress.[56] They included Peking Opera (京剧, *Jingju*) – see p. 83 for the 19th-century emergence of this genre – which brought together music, singing, recited lines, mime, dance and acrobatics; Shanxi clapper opera (梆子, *bangzi* or 晉劇, *jinju*) which included folk songs, such as those for planting rice; southern drama (傳奇, *chuanqi*, literally 'transmission of the strange'); string ballad story telling (彈詞, *tanci*) which alternated spoken storytelling and sung ballads; and Cantonese opera (粵劇, *Yue ou*) which featured many love stories and was performed in southern dialect.

Patterned or voided velvets were popular with both men and women. Velvet consists of a foundation weave with an extra warp, which is woven over wires; when the wires are withdrawn, tiny loops of thread remain.[57] If the entire surface of the fabric is covered in these loops (cut or uncut), it is called solid velvet, but if there are areas where the ground is visible it is known as voided velvet (fig. 4.67). Innovations in male fashion are perhaps less obvious because, although bright colours were worn, most male dress was in a more subdued

4.63
Woman's jacket embroidered with opera scenes

During the 19th century, the repertoire of clothing designs expanded dramatically and images of theatrical characters and performances or scenery from the Jiangnan area were embroidered onto garments and accessories for wealthy men, women and children. The stitched vignettes of actors in theatrical costumes conveyed themes such as romance and morality, and came to be used in clothing and costume by way of New Year prints.

1800–1900, China. Embroidered silk. H. 110 cm, W. 127 cm. The Teresa Coleman Collection, R01531

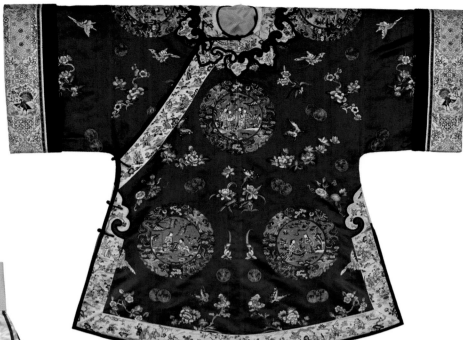

4.65
Women's leggings

Leggings of this type covered the leg from the thighs to the calves, and were more for decoration than practical use, as they were worn over under-trousers and under a long robe or skirt. A loop at the top was secured with a waistbelt, and ribbons at the bottom kept the leggings in place. Similar garments can be seen on fashionable ladies in the illustrated periodical *Dianshizhai huabao*, which was published in Shanghai from 1884 to 1888.

1880–1900, China. Orange damask with blue and black silk satin borders, embroidered with silk and metal-wrapped threads. H. 74.8 cm, W. 44.4 cm (each legging, max). University of Alberta Museums, Edmonton, 2005.5.151–2. Gift of Sandy and Cécile Mactaggart

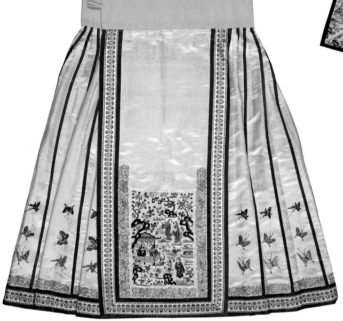

4.64
Horse face skirt (馬面裙)

Only Han women wore this style of pleated, wraparound skirt. It is made up of a series of embroidered silk panels, with a wide central panel at the front and back, and narrower pleated side panels, which were sewn onto a cotton waistband, secured by buttons and worn with a short jacket and trousers in contrasting colours. It is called a horse face skirt because the pleats made it easy to ride horses or donkeys decorously. Han women had bound feet and rarely walked.

Commercial patterns from popular prints or manuals were used as sources for the designs. As the 19th century progressed, courtesans led the way in fashion, as each one strove to distinguish herself from contemporaries or rivals.

1870–90, China. Silk, embroidery and metallic thread. H. 97.7 cm, W. 101.5 cm. Art Institute of Chicago, 1957.546. Gift of Mrs Chauncey McCormick

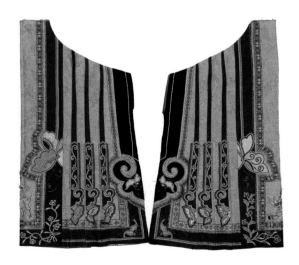

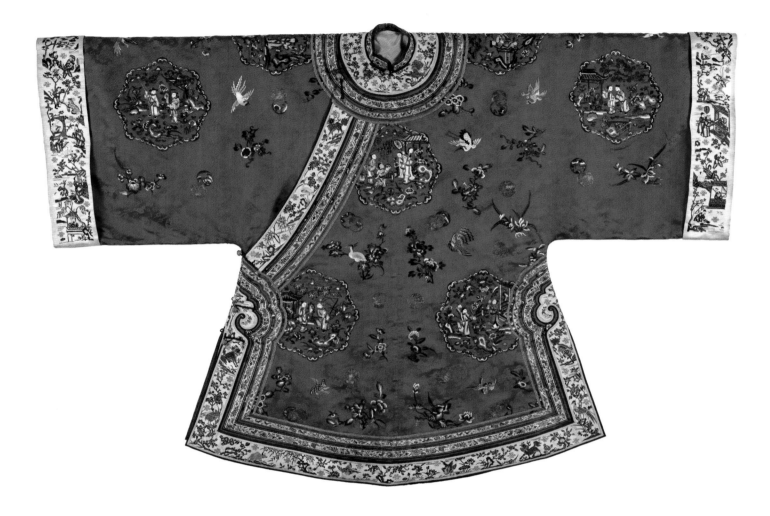

4.66

Bright pink silk robe with embroidery from the *Romance of the Western Chamber*

Typical of late Qing fashion for Han women, this side-fastening jacket in an eye-catching colour is embroidered with roundels, showing figures from a popular novel. The garment is trimmed with contrasting sleevebands and ribbons, each one embroidered with figures and auspicious emblems such as storks and peacocks.

1800–1900, China. Embroidered silk satin. H. 106.5 cm, W. 157 cm. The Teresa Coleman Collection, R01348

palette (figs 4.68–4.69) and collectors typically preserved many more women's costumes. Men's winter robes were either padded with cotton, or were lined with fur or sheepskin (fig. 4.70).

For those who could afford it, children's fashion in the 'long 19th century' was a focus for creativity, with garments made from imported wool or embroidered with motifs and shapes taken from the court, the elite and global communities, as well as from traditional vernacular sources (figs 4.71–4.73). Women included auspicious motifs such as tigers, the word for which is a homophone for the word 'to protect', to guard their children from harm, as well as imagery to promote their chances of succeeding in life (fig. 4.74).

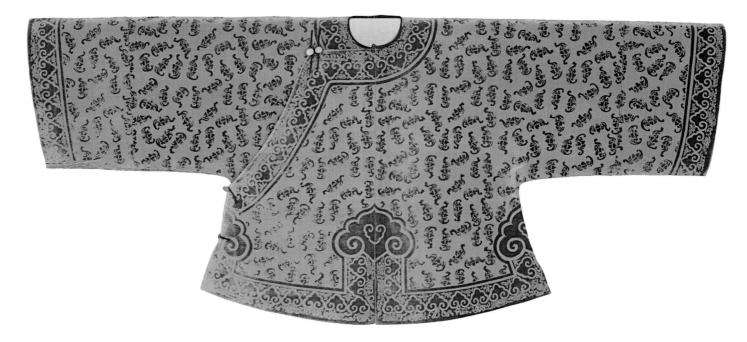

4.67 (above)
Riding jacket
This bright green velvet riding jacket has a round neck and right side-fastening, with a broad trim ending in a *ruyi* (wish-fulfilling) motif. It is covered with a design of bats, a popular 19th-century emblem of prosperity or good fortune, which is woven into the velvet fabric. Both men and women wore velvet jackets in the second half of the 19th century, but they were cut differently. Some have a side fastening and some central fastenings. The innovative aniline dyes and form of the jackets originated at court in Beijing; the fashion for wearing them then spread to wealthy urban areas.

c. 1875–1912, China. Cut and uncut velvet. H. 81.9 cm, W. 177.2 cm. Philadelphia Museum of Art, 1940-4-831. Purchased with the John T. Morris Fund from the Carl Schuster Collection

4.68 (below)
Man's jacket with cranes and plantains
Voided velvet is woven with areas of pile-free smooth satin ground and areas of raised pile that are soft to the touch. Here, the design combines traditional auspicious imagery of cranes, chrysanthemums, plantains and *lingzhi* fungus. The asymmetrical design originated in court opera costume designs and slowly spread to fashion outside the court.

1875–1908, China. Silk-voided velvet and silk satin. H. 62.2 cm, W. 167 cm. Philadelphia Museum of Art, 1940-4-832. Purchased with the John T. Morris Fund from the Carl Schuster Collection

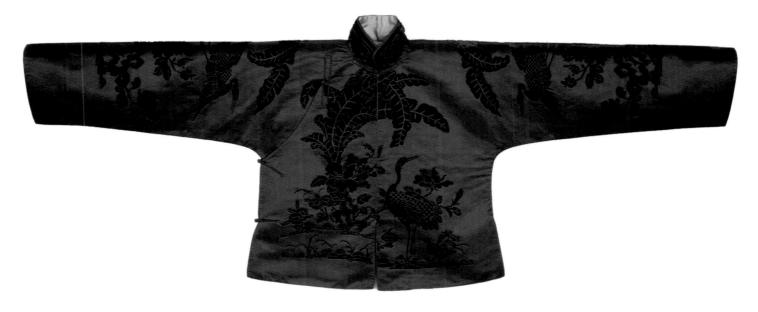

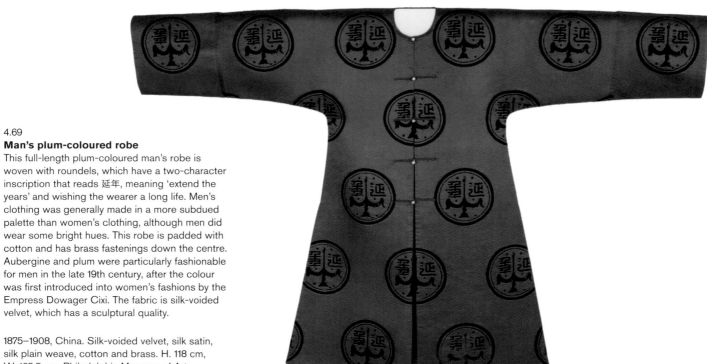

4.69

Man's plum-coloured robe

This full-length plum-coloured man's robe is woven with roundels, which have a two-character inscription that reads 延年, meaning 'extend the years' and wishing the wearer a long life. Men's clothing was generally made in a more subdued palette than women's clothing, although men did wear some bright hues. This robe is padded with cotton and has brass fastenings down the centre. Aubergine and plum were particularly fashionable for men in the late 19th century, after the colour was first introduced into women's fashions by the Empress Dowager Cixi. The fabric is silk-voided velvet, which has a sculptural quality.

1875–1908, China. Silk-voided velvet, silk satin, silk plain weave, cotton and brass. H. 118 cm, W. 168.5 cm. Philadelphia Museum of Art, 1940-4-830. Purchased with the John T. Morris Fund from the Carl Schuster Collection

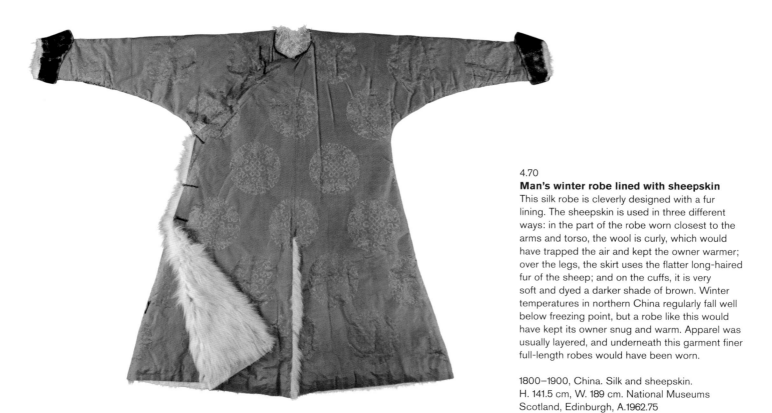

4.70

Man's winter robe lined with sheepskin

This silk robe is cleverly designed with a fur lining. The sheepskin is used in three different ways: in the part of the robe worn closest to the arms and torso, the wool is curly, which would have trapped the air and kept the owner warmer; over the legs, the skirt uses the flatter long-haired fur of the sheep; and on the cuffs, it is very soft and dyed a darker shade of brown. Winter temperatures in northern China regularly fall well below freezing point, but a robe like this would have kept its owner snug and warm. Apparel was usually layered, and underneath this garment finer full-length robes would have been worn.

1800–1900, China. Silk and sheepskin. H. 141.5 cm, W. 189 cm. National Museums Scotland, Edinburgh, A.1962.75

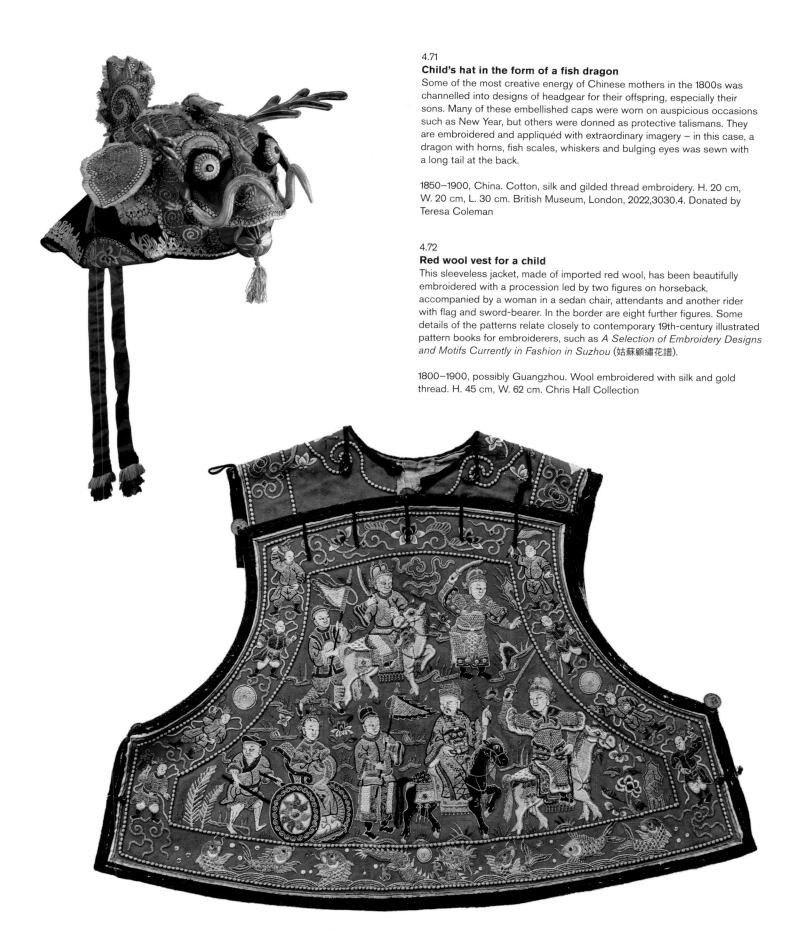

4.71
Child's hat in the form of a fish dragon

Some of the most creative energy of Chinese mothers in the 1800s was channelled into designs of headgear for their offspring, especially their sons. Many of these embellished caps were worn on auspicious occasions such as New Year, but others were donned as protective talismans. They are embroidered and appliquéd with extraordinary imagery – in this case, a dragon with horns, fish scales, whiskers and bulging eyes was sewn with a long tail at the back.

1850–1900, China. Cotton, silk and gilded thread embroidery. H. 20 cm, W. 20 cm, L. 30 cm. British Museum, London, 2022,3030.4. Donated by Teresa Coleman

4.72
Red wool vest for a child

This sleeveless jacket, made of imported red wool, has been beautifully embroidered with a procession led by two figures on horseback, accompanied by a woman in a sedan chair, attendants and another rider with flag and sword-bearer. In the border are eight further figures. Some details of the patterns relate closely to contemporary 19th-century illustrated pattern books for embroiderers, such as *A Selection of Embroidery Designs and Motifs Currently in Fashion in Suzhou* (姑蘇顧繡花譜).

1800–1900, possibly Guangzhou. Wool embroidered with silk and gold thread. H. 45 cm, W. 62 cm. Chris Hall Collection

4.73

Child's jacket and trousers

The chequered design here (百家衣), derived from operatic costume, was believed to confuse the eye and thus keep evil forces away from the wearer. The patchwork is created from lozenges, sewn into a three-dimensional cube effect. The jacket is further embellished with a beautifully embroidered ribbon border around the cuffs and edges. The chequered pattern has existed since at least the Song dynasty (AD 960–1279), when it was found on temple walls, and later it appeared as a design on robes worn by Buddhist priests. During the 17th century, elite women wore fashionable patchwork clothes (水田衣, 'rice paddy robe') and the design is still quite common in the 21st century among people making patchwork home furnishings in several regions across China, such as Shaanxi in the northwest.

1800–1900, China. Cotton and silk. Jacket: H. 50 cm, W. 46 cm; trousers: H. 55 cm, W. 35 cm. British Museum, London, 2022,3030.1. Purchased with the Brooke Sewell Permanent Fund

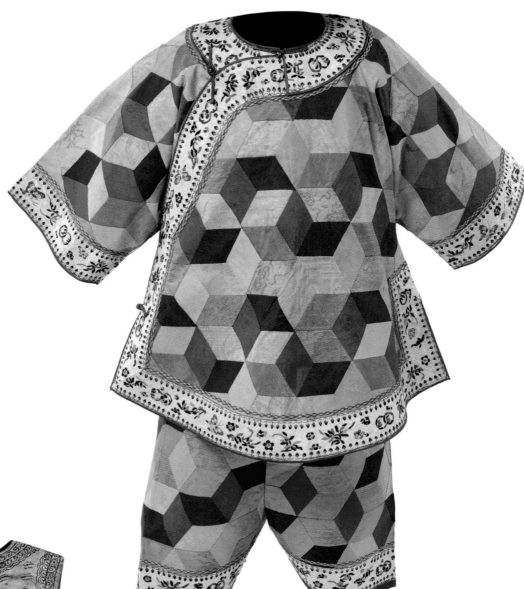

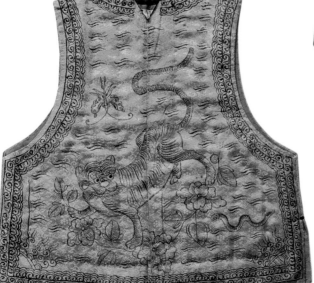

4.74

Child's vest with painted tiger design

Tigers are often seen on children's clothing as a symbol of courage and bravery, because the word for 'tiger' is pronounced the same as the word for 'to protect'; the animal also acts as a talisman to protect the child. It is very unusual to find painted designs on Chinese dress with no embroidery. It is possible that this is an outline of a design that was due to be completed later with embroidery. Alternatively, the painted design of the protective tiger on the back of this vest may just be a very rare survival.

1850–1900, China. Painted cotton. H. 34 cm, W. 35 cm. The Teresa Coleman Collection, R01626

Courtesans

A publishing boom in the late 19th century generated
new novels, illustrated magazines and newspapers,
which often included visual representations of famous
women, images of popular entertainments, products
and stories, and news.[58] Through these new media,
Shanghai, after opening as a treaty port in 1842, became
China's leading city for fashion, finance, trade and
industry – a position it still holds today. Wu Youru
吳友如 (c. 1840–1894), an immigrant from Suzhou who
had been displaced by the Taiping Civil War, moved
to Shanghai after 1860 for the relative peace and
security that the city enjoyed.[59] He adapted his art
for the burgeoning newspaper and magazine industry,
specialising in contemporary scenes of Shanghai,
and depicting modern women and in particular
courtesans (figs 4.75–4.77).

Where once courtesans could only have been seen
by their wealthy clients, now their images became
accessible, and their hair and clothing styles and
even dining habits were imitated by women outside
the sex trade. Courtesans became trendsetters, like
movie stars or even online 'influencers' today.[60] Some
were so well known that their brothels became tourist
attractions and appeared in guidebooks of cities like
Shanghai. As well as leading the fashion for dress,
they also popularised certain activities, such as playing
foreign games like billiards (see fig. 4.75). They were
seen eating in Western-style restaurants in the treaty

4.75
Wu Youru, _Shining eyes and white wrists_
This illustration is from _One Hundred Illustrated
Beauties of Shanghai_, which was first published
by Dianshizhai in 1884, and shows a group of
courtesans playing billiards, a Western game
imported into China.

c. 1884–1910 (reprinted 1983), Shanghai.
Lithograph. H. 20.7 cm, W. 28.7 cm, D. 4.3 cm.
(closed volume). SOAS University of London,
c ffh 503340

4.76
Wu Youru, _Trying a distinctive flavour_
In this illustration from _One Hundred Illustrated
Beauties of Shanghai_, courtesans are shown
dining in a foreign-style restaurant with rich
Victorian decor. The experience is exotic and
daring, as these modern women are depicted
drinking wine, showing their tiny feet and
using Western cutlery. Western-style Chinese
restaurants (番菜館), often run by Cantonese
entrepreneurs, sold overseas foods at cheaper
prices than the foreign-owned restaurants.
Some advertised the latest technology, including
electric fans to reduce the intense summer heat,
or provided entertainments, such as billiards,
pianos, or even shows with live wild animals,
such as tigers or pythons, creating a carnival
or circus-type atmosphere. Such restaurants
became popular tourist destinations for Chinese
travellers who came to Shanghai, and are
described in guidebooks to the city such as
Miscellaneous Notes on Visiting Shanghai
(滬遊雜記) from 1876. Chefs quickly adapted
Western food to Chinese taste, creating new
fusion styles of cooking with regional cuisines,
such as Cantonese, Shanghai or Ningbo.

c. 1884–1910 (reprinted 1983), Shanghai.
Lithograph. H. 20.7 cm, W. 28.7 cm, D. 4.3 cm.
(closed volume). SOAS University of London,
c ffh 503340

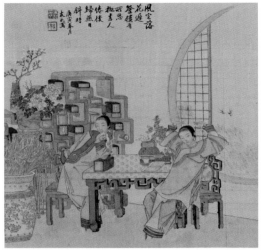

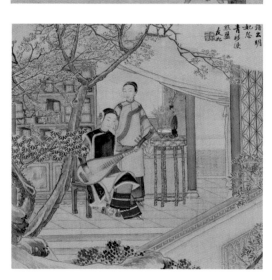

4.77

Wu Youru, *Album of beautiful women*

Wu Youru was born in Suzhou in Jiangsu. He only took up painting and became a commercial graphic artist when he migrated to Shanghai in 1860, seeking sanctuary in the relative peace of the well-protected city. He specialised in contemporary scenes of Shanghai, depicting modern women, particularly courtesans. In this album, Wu Youru depicts female figures in modern and modishly furnished interiors or garden settings, wearing contemporary costumes of the latest fashion. Courtesans were trendsetters in Shanghai fashions, for both home design and dress. Before the late 1800s, the lives of these women would have been relatively unknown to ordinary people. Only their wealthy clients would have enjoyed such intimate views. But by the 1890s, their lodgings were tourist attractions and their fame had spread far more widely. Wu was renowned as a late 19th-century illustrator and his pictures circulated widely in many illustrated magazines during the late Qing period.

1890, Shanghai. Ink and colours on silk. H. 27.2 cm, W. 33.3 cm. Shanghai Museum, 26812

Key figure: Sai Jinhua (1864–1936)

4.78

Sai Jinhua, Courtesan and concubine

Sai Jinhua 賽金花, whose name literally means 'a flower to rival gold', was born in Jiangsu and became both a local and national hero. After her father died when she was just 13, she became a sex worker on a 'pleasure boat'. Later, she married the scholar-diplomat Hong Jun 洪鈞 (1840–1893) as a concubine. As his primary wife did not want to travel abroad, Jinhua went with her husband to Europe, including Russia, Austria, the Netherlands, Britain and France. Diplomatic protocol and her bound feet gave her few opportunities for formal social engagements, but Sai Jinhua was both a consumer and commissioner of new art, including opera. She had a daughter with Hong Jun and later they lived together in Beijing, but after he died in 1893 his family would not support her and she subsequently returned to sex work.

Aged just 30, she left Beijing and went back to Suzhou, but later managed brothels in Shanghai, Tianjin and Beijing. It was popularly believed that she had an affair with the German Field Marshal Count Waldersee (1832–1904), who was the commander-in-chief of the allied forces in Beijing after the Boxer War. According to oral tradition, by offering her body to the enemy, she saved China; the affair was also dramatised in epic poetry of the early 1900s. Sai Jinhua married again, several times, and is photographed here marrying her third husband Wei Sijiong 魏斯炅 (1873–1921) in 1918, but she eventually once more fell into disrepute and even had to defend herself against a murder charge. She died aged 72.

1918, Shanghai. Photograph

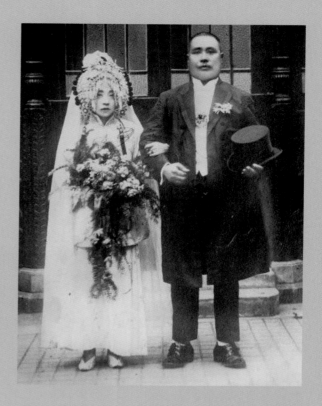

ports, where establishments selling the food of virtually every Chinese province could also be found (see fig. 4.76).[61] There was tremendous competition between these establishments, which in the 1880s and 1890s based their foreign menus mainly on British or French cooking.[62] Musical entertainments, dining and theatrical experiences were all considered part of the seduction process. By the 1870s, Shanghai had 1,500 registered brothels, and by the 1880s one in every eight women in the foreign concessions was a prostitute.[63] Sai Jinhua 賽金花 (1864–1936) became one of the most celebrated courtesans of her day, her life and affairs shrouded in romantic legend (fig. 4.78).

The imagery of courtesans in Shanghai is surprisingly restrained; unlike in contemporaneous European art, the nude female was not an acceptable genre for 'high art' in China, although there was also a long artistic tradition of producing erotic imagery for private viewing in the form of fans and album leaves, which was revitalised in the 1800s.[64] For example, in

Yin Qi's 殷奇 (active mid-19th century) *Album of erotic paintings*, a young well-to-do client is seen in various vignettes with one or more courtesans, drinking wine while enjoying sex with hostesses in elegant settings. These were painted, not printed, and were meant to be viewed by friends of the owners in intimate gatherings that were completely different from the mass circulation of printed images that appeared in newspapers and magazines.

Temples as centres for social gatherings

Popular religion in 19th-century China combined elements of Confucianism, Buddhism, Daoism and local beliefs. Its syncretic nature meant that it readily incorporated new beliefs and the pantheon of deities was enormous. The range of images of deities indicates the regional diversity of popular religious beliefs, and also shows that encounters with foreign communities

were absorbed into religious practices. For example, the writer James Dyer Ball (波乃耶, 1847–1919) – famed as an excellent speaker of Cantonese and prolific author of English-language books about China – was deified (fig. 4.79). Opportunities for celebrating festivals at diverse temples and other sites filled the calendar. These local hubs also provided a venue for people to gather, gossip and discuss local issues.

Although the emphasis of this volume is on cultural innovation in China's 'long 19th century', much of late Qing culture and daily life was continuous with the past (the violent ruptures of external and internal wars notwithstanding). In the 1800s, for both rural communities and urban dwellers, life revolved around the seasons and an annual calendar of religious worship. Seasonal festivals – many of which were accompanied by special foodstuffs – included winter celebrations, such as New Year and the Lantern Festival in February (figs 4.80–4.82). Spring brought the Festival of Qingming when Chinese people traditionally visited and tended the tombs of ancestors, and early summer the Dragon Boat Festival, which entailed celebrating a historic poet with boat races. After the summer came the Mid-Autumn Festival, with expeditions to view chrysanthemums and other flowers. All these activities were celebrated in widely circulating popular woodblock-printed imagery. Each temple was dedicated to a particular deity, whose birthday was an occasion for celebration with rituals and operas. Temple operas were how villagers and other people in rural areas most commonly experienced such performances, which combined singing, music, dance and elaborate theatrical costumes, although rural communities also watched touring troupes in open-air performances (fig. 4.83). The liberating excitement of such occasions in villages is beautifully evoked by the famous 20th-century author Lu Xun's story 'Village Opera', set in the last decade of the 19th century. All-female troupes of acrobats, jugglers and magicians could also be hired for private parties (fig. 4.84).

4.79
James Dyer Ball deity
James Dyer Ball was born in Guangzhou to an American missionary and his much younger Scottish wife, who ran a school and a dispensary there. He became an interpreter working in Hong Kong and wrote many books about life in China, Chinese religion and the Cantonese language. His opinions influenced more than one generation. Here, he is presented as a god of wealth, holding a gold ingot, but he is dressed in Western clothing, with a blue jacket, white waistcoat with brass buttons, and breeches. The writer Gertrude Bell (1868–1926) collected this figure and others when she travelled to south China as part of her round-the-world trips in 1897–8 and 1902–03.

1880–1900, Guangzhou. Painted wood. H. 17.5 cm, W. 6.9 cm. British Museum, London, 1919,0716.14. Donated by Gertrude Bell

Entertainments

In Shanghai and Beijing, many of the rowdy audiences that flocked to teahouses to view opera performances were not the moneyed or educated elites, but rather people of diverse professions who lived and worked in the city. Performances entertained but could also convey moral or didactic political messages. For example, in 1904, *Seeds of the melon, cause of the orchid* 瓜種蘭因 by Wang Xiaonong 汪笑侬 (1858–1918) was one of the first Peking operas to be based on a foreign news story. It was performed as the Russo-Japanese War was under way in Korea and focused on the partition of Poland in the 1700s. The opera depicted a Poland carved up like a melon into three parts, each claimed by another polity, resulting in the effective disappearance of the Polish state and nation. This play was designed to awaken

4.80–4.82

Unidentified artist, New Year prints with animated calligraphy

Popular prints have a long history in China; many are pasted up at the Lunar New Year. In the 19th century, manufacturers competed with each other to create innovative designs. These three prints seek novelty by filling the calligraphy with images. The first has an inscription in large, animated characters which reads, from right to left, 天地 or 'Heaven and Earth'. The second print has three large characters that read 富貴春 or 'Prosperity, wealth and long life'. The third print has three characters, 芝蘭室 or 'Irises and Orchid Room'. The phrase refers to the Confucian idea that living with good people is like existing in a room of irises and orchids; you do not appreciate the fragrance until it is gone.

1872–3, China. Printing ink on paper. H. 34.5 cm, W. 58.5 cm; H. 31.2 cm, W. 59 cm; H. 59 cm, W. 33 cm (unmounted). British Museum, London, 1954,1113,0.16–18. Donated by Mrs R.E.A. Hughes-Jones

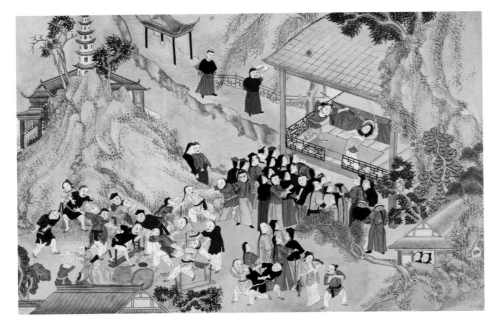

4.83
Album leaf showing an open-air theatre near Ningbo

Opera was both an elite art form and a form of popular entertainment. Basic performance conventions and a large repertoire of operatic stories and characters created a common culture that cut across divides of class, education, gender, occupation and birthplace. Opera was widespread in Chinese villages in the late Qing era. This painting comes from a commissioned set of watercolours of marriages, funerals, festivals and leisure activities. We can see the audience at a fair taking place in association with a temple, and the players on a temporary stage. The scene captures the audience's reactions; in the far left corner a group of people are fighting and drinking.

1840–77, Ningbo. Watercolour on paper. H. 40 cm, W. 65 cm. Victoria and Albert Museum, London, D.31-1898

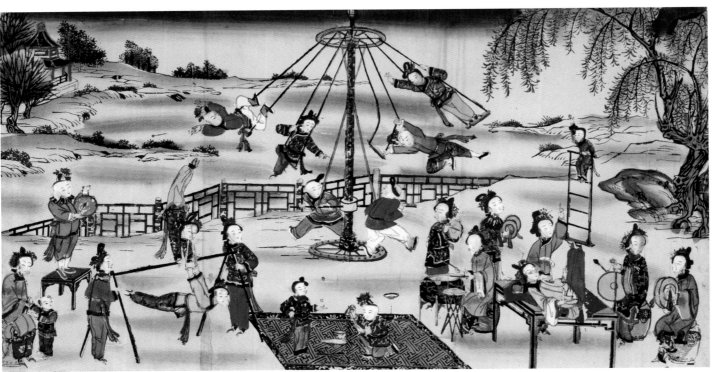

4.84
Popular print of female performers

The bright colour palette and action-packed scene make this New Year print very attractive. On the carpet in the foreground are a plate spinner and juggler, surrounded by acrobats and women playing musical instruments, all performing in a lakeside garden. Wealthy people booked such troupes to provide entertainment for family celebrations, as well as for community events. The images were pasted up at New Year and then replaced the following year when the colours had faded.

1873, Tianjin. Woodblock print on paper with ink and colours. H. 59.3 cm, W. 116 cm. British Museum, London, 1954,1113,0.1. Donated by Mrs R.E.A. Hughes-Jones

4.85

Wall hanging with scene from an opera on imported wool

Chinese opera sets were not as elaborate as many of their counterparts in 19th-century Europe. Some performances were simply held on a large carpet to mark out a stage, while others were performed on an actual stage with backdrops. Dramatic textiles such as this one may have hung like curtains at the back of the stage, to serve as a backdrop or to be drawn aside as the actors entered. The faces have been padded out to create a three-dimensional effect.

1800–1900, China. Plain weave wool and animal fibres with silk and metallic thread embroidery. H. 327 cm, W. 203.2 cm. The Metropolitan Museum of Art, New York, 59.190. Gift of Fong Chow

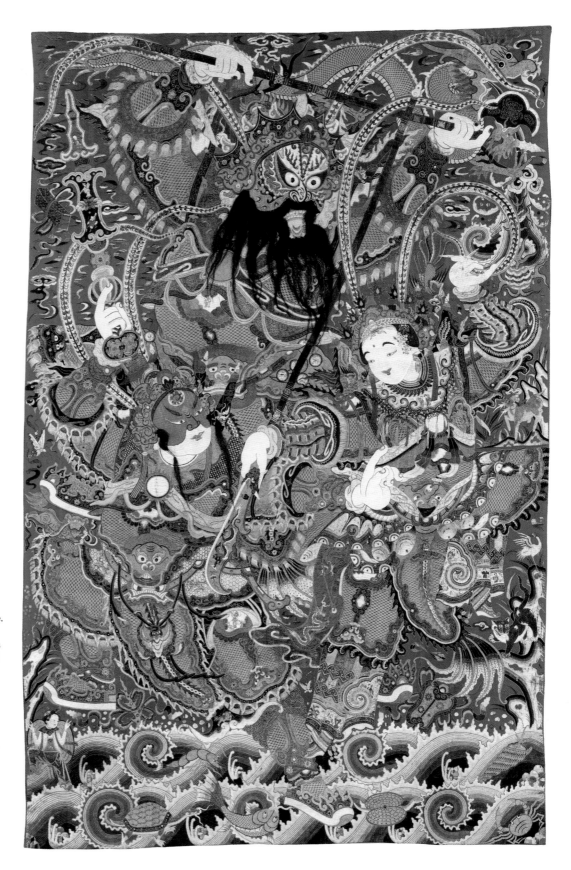

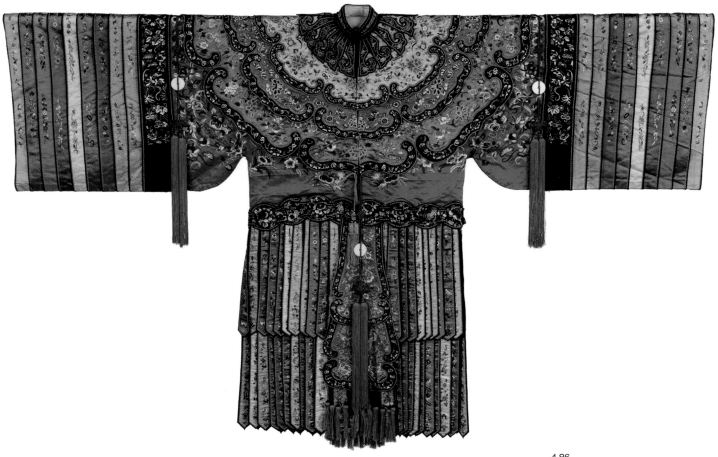

Chinese audiences to the potential loss of their own country, by making obvious parallels with other land grabs of different times and places.[65]

Key to the visual spectacle of the opera was the stage setting, make-up and costumes (figs 4.85–4.86). Peking Opera actors, such as Tan Xinpei 譚鑫培 (1847–1917) and Wang Yaoqing 王瑤卿 (1882–1954), became famous across China, their celebrity boosted by court patronage (fig. 4.87).[66] The enduring popularity of opera characters was celebrated in garments as well as in traditional architecture, for example in the form of roof elements and brick friezes (figs 4.88–4.89).

Puppetry is one of the oldest Chinese art forms. In the 1800s, there were many different kinds of puppet

4.86
Opera costume for the role of a princess
This court gown costume has a round neck and central opening, with layered cloud shoulders and collar. The sleeves have nine thin strips of embroidery, creating a multicoloured effect, and the skirt is stitched, featuring two layers of narrow streamers with pointed tips, tassels and jade pendants. From surviving half-length and full-length album paintings of opera characters, we know that this theatrical robe was made in the late Qing era, for the role of a princess or emperor's consort.

1870–1900, China. Silk satin and embroidery. H. 96.5 cm, W. 203.2 cm. The Metropolitan Museum of Art, New York, 1970.274. Gift of John A. Bross

Key figure: Tan Xinpei (1847–1917)

4.87
Ma Shaoxuan, Snuff bottle depicting the opera star Tan Xinpei

This snuff bottle is painted on one side with a portrait of the most celebrated star of the Beijing opera in around 1900, actor Tan Xinpei 譚鑫培, who was born in Hubei and died in Beijing. He trained from the age of 10 and latterly had his own troupe; he specialised in old male or *laosheng* roles. Tan's repertoire included over 300 plays and he was a favourite of Empress Dowager Cixi. In the late Qing, as in earlier periods of Chinese history, actors were at the bottom of the traditional social hierarchy, but Cixi's personal patronage of Tan Xinpei and his elevation to an honorary rank of sixth-grade official meant that he was eventually invited to give performances in many well-to-do households. His popularity endured until his death in 1917. The inscription on the other side of the bottle questions whether the general that Tan played would have been remembered if the play had not been performed at the Qing court:

[Although] his eyebrows were shaggy and his head had become hoary, no one could have matched his bravery.
[Also] as an official of long service, he had won great distinction under the Zhaolie emperor [昭烈皇帝].
[Yet] if it had not been for the [members of the] Pear Garden [Court Theatre] who were skilful musical performers,
Nowadays who would still know [anything] about this general?

1900, Beijing. Inside-painted glass. H. 6.2 cm. The Water, Pine and Stone Retreat Collection

4.88–4.89
Architectural elements based on opera figures

Shiwan (Shekwan) kilns were located within the Pearl River delta, about 65 km from Guangzhou. These kilns were relatively small compared to those in Jingdezhen, which produced imperial porcelain, and so they could experiment flexibly with glazes and forms in response to the demand from overseas Chinese communities, local Guangdong orders and for export to Europe. They made ceramic vessels, architectural elements, sculptures and utilitarian wares. In the 19th century, models of opera figures and popular deities were incorporated into local architecture, which complemented carved brick friezes depicting opera figures from well-known dramas, such as *The Water Margin*. The female figure here may be Chang'e 嫦娥, the Moon Goddess, and the male figure Hou Yi 后羿, the greatest archer of all time and husband of Chang'e. Hou Yi lives in the Sun and Chang'e in the Moon, and he visits on the 15th of every month.

1800–1900, Shiwan, Guangdong. Glazed stoneware. H. 75 cm, W. 34 cm, D. 27 cm (each figure, approx.). Victoria and Albert Museum, London, HMC CD.80:1–2

4.90–4.92
Puppets
Glove puppets and marionettes with strings were modelled with painted clay or porcelain heads. Their faces matched those of the opera stars of the day, and their costumes of silk and cotton would have been immediately recognisable to their local audience. These puppets represent a princess, a prince and a lady.

1850–1900, China. Clay, metal, textile, wood, fur, metal thread and embroidery. H. 30 cm, W. 31 cm, D. 5 cm (largest); H. 25.5 cm, W. 33 cm, D. 7 cm (smallest). Horniman Museum and Gardens, London, 10.8.56/8i–9, nn7874

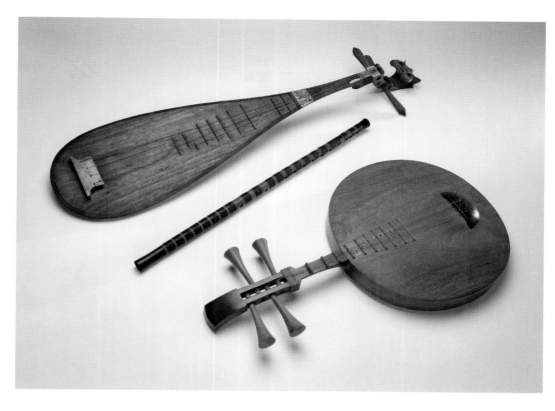

4.93
Group of musical instruments: *pipa*, *dizi* and *yueqin*
George Tradescant Lay, a British naturalist and missionary, commissioned the manufacture of these instruments in 1842 and published them in *The Chinese as They Are: Their Moral, Social and Literary Character*. The *pipa* (琵琶) or pear-shaped lute (top) was played as a solo instrument and sometimes as part of an ensemble. It accompanied the singing voice in operas and ballads, and is perhaps most closely associated with female musicians. The *yueqin* (月琴) or moon guitar (bottom) is generally tuned to the interval of a perfect fifth and was very popular in Peking Opera, a genre that came into being in the 19th century. The *dizi* (笛子) or transverse flute (centre) is made of bamboo for greater resonance.

1842, Fuzhou or Guangzhou. Wood, string and bamboo. *Pipa*: L. 93.5 cm; *dizi*: L. 64.4 cm; *yueqin*: L. 65 cm. British Museum, London, As 1843.1209.6, 8 and 13. Donated by George Tradescant Lay

performance, including glove puppets, stick puppets, marionettes with strings and shadow puppets. The Dutch sinologist J.J.M. de Groot (1854–1921) carried out fieldwork in Xiamen in the 1880s and was the first European to 'systematically collect' complete sets of puppets and stages (figs 4.90–4.92).[67] Musical accompaniment was essential in any performance; sometimes the puppeteer even played the instruments as well as manipulating the marionettes, in a repertoire that included religious, military and civil plays (fig. 4.93).[68]

Other popular pastimes included the rearing and keeping of hobby animals such as birds,[69] crickets, goldfish, cats and dogs (fig. 4.94).[70] Sports, cards and other games varied regionally and often involved gambling. Some of the new 19th-century designs of card games were linked to the printing of newspapers and magazines, and even used as advertising copy.[71] Mahjong or Majiang 麻將, a lively tile-based game that is usually played by four people, was invented in China, probably in Shanghai, in the mid- to late 19th century (fig. 4.95).[72] Shuttlecocks, made using a small weight, cloth and feathers, were kicked in a kind of 'keepy-uppy' game,

4.94
Three pigeon whistles
These whistles were tied to the feathers of pigeons so that when they flew overhead they created a distinctive whistling sound. Mei Lanfang 梅蘭芳 (1894–1961), the Chinese opera star, described their flight across the Beijing skies as a 'symphony in the heavens'. The two main types of whistle are seen here: round and made from a gourd or tubular with rows of pipes. They produce distinctive sounds. Bannermen in Beijing often kept pigeons as a leisure activity, releasing the birds into the sky twice a day to watch them fly and listen to the music they created through their whistles.

1840–88, Beijing. Painted wood. H. 6.5 cm (max). British Museum, London, As,+.4608, As,+.4609, As,+.4606. Donated by James Edge-Partington

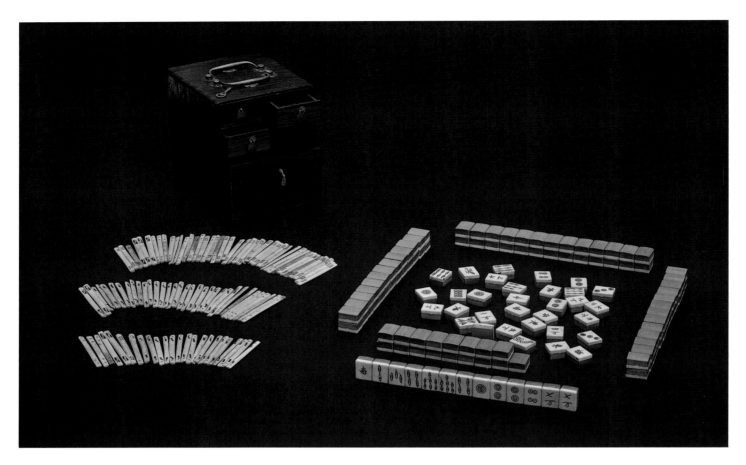

4.95
Mahjong set
This Mahjong set is incomplete and has 140 tiles,
rather than the full complement of 144, marked
with the suits, as well as counting sticks to keep
score, some printed cards, a die (to decide who
should deal) and a marker to indicate who is the
dealer and which round of the game it is.

1800–1900, China. Bone and bamboo.
H. 2.5 cm (each tile). British Museum, London,
As1908,0416.1.a–c. Donated by
Mrs M. Langenbach

4.96
Shuttlecock
This shuttlecock was kicked with the feet in a 'keepy-uppy' game (踢毽子)
played by children and adults that is still popular in China today. It is
easily made and portable and can be used anywhere, but originally it was
intended to keep soldiers limber and fit. This example was collected by the
British naval officer Sir Everard Home (1798–1853) in Wusong. There, at
the Wusong river gateway to Shanghai, British and Qing forces had joined
battle on 16 June 1842 during the First Opium War.

1800–46, Wusong, Shanghai. Feather, metal and cotton. H. 10 cm, W. 10 cm.
British Museum, London, As1847,0827.17. Donated by Sir Everard Home

which originated in training soldiers for military fitness but was also played by women and children (fig. 4.96).

Food

Regional cuisine was a strong part of regional identity. For example, Manchu preferences were for northern wild products, such as 'steppe mushrooms' and deer meat, while southern delicacies included shark's fin or seaweed soups (fig. 4.97). Although the better-off also ate millet and vegetable dishes, the poorest people ate monotonous diets of sorghum and maize. On festival days and special occasions, wealthier people ate wheat flour noodles, meat and rice.[73] As immigrants congregated in the new cities, they craved the food of their hometowns. 'Native place associations' were meeting places for people speaking the same local dialect, who wanted to enjoy food and an atmosphere that reminded them of their home regions. They were also places to stay when visitors first arrived in a big city, such as Beijing or Shanghai; candidates for the metropolitan exams in Beijing would seek accommodation in such lodges. In the reform movements of 1895–8, such lodges in the capital became important gathering places for men from different provinces to listen to lectures and debate politics.

Teahouses, restaurants and wine shops were advertised by street signs and later by printed adverts that appeared in newspapers and illustrated periodicals. Late Qing teahouses (or 茶館, *chaguan*) were not only places for consuming local snacks and drinking tea, but also performance spaces where people could simultaneously enjoy music or a play with song and dance. Within the teahouse, actors were kept separate from the different hierarchies of audience, and the well-to-do sat separately from the masses. As in many other cultures, actors in Qing China belonged to the same social strata as beggars and common prostitutes (although the celebrity attained by opera stars such as Tan Xinpei at the end of the Qing began to alter this traditional social disdain for performers). In some businesses, such as the teahouses, special forms of currency or tokens developed. Potters who made stone teawares at the Yixing kilns in Jiangsu created new teapot styles to satisfy consumers' desire for novelty (fig. 4.98). Everyday crockery that was transported over the South China Sea in vast quantities – as shown by shipwrecks such as the *Tek Sing* cargo of 1822, which carried over 100,000 pieces – only survives in relatively small numbers today. Much of this rather coarse porcelain with simple blue-and-white repeat patterns was produced in Fujian (fig. 4.99).[74] From surviving photographs, we can see how this tableware was used in groups for different dishes and drinks.

In the 1860s, the first restaurants in China offering French and English food opened, and menus began to appear. Fizzy drinks, such as lemonade, were a novelty in Shanghai restaurants, imported from Europe.[75] Foreign-style treaty port restaurants supplied diners with Western knives and forks, and had both Chinese and Western clientele. German beer was introduced

4.97
Regional foods
Deer sinew (right) was used by Chinese chefs as an ingredient in making soup. Even more surprising survivals from this period are the two varieties of seaweed (left) preserved as dry bundles that were used in soup and other dishes. Although shark's fin soup remains a delicacy in some parts of the world today, it has also more recently been criticised for its cruelty: its main ingredient (centre) is cut from live sharks, which then have little chance of survival. The ink inscription reads 魚翅 (shark's fin).

1842–6, acquired in Wusong, Shanghai. Deer sinew, seaweed and shark's fin. Shark's fin (centre): H. 11 cm, W. 10.5 cm, D. 2.5 cm. British Museum, London, As1847,0827.19–20, As1972,Q.1257, As1843,1209.17. Donated by Sir Everard Home and George Tradescant Lay

4.98

A selection of Yixing teapots

Yang Pengnian 楊彭年 (active 1796–1820), a celebrated Yixing potter, made the teapot shown at the centre out of the pottery's characteristic brown clay, then encased it in well-polished pewter, adding a jade handle and spout. Encasing Yixing stone teawares with pewter was an innovation of the early 19th century. The pot has two swallows incised on one side and a poem on the other. Such metal and ceramic teawares were popular among the Jiangnan elite in east China, as the soft metal was easy to incise, and tea-drinking often accompanied the recitation of poetry. The teapot on the upper left is in the form of a water wheel and those on the far left and far right were made by Yang Youlan 楊友蘭 (c. 1760–1820). These potters both inscribed their names on their work. Teahouses were a vital part of Manchu banner culture too, because they were venues where traditional Manchu arts could be heard, such as drum singing: the recital of a ballad, often on martial themes, to the accompaniment of a drum, clappers and occasionally other musical instruments.

1800–1900, Yixing, Jiangsu. Zisha clay, pewter and jade. H. 8.5 cm, W. 14.5 cm (smallest); H. 10 cm, W. 15 cm (largest). British Museum, London, Franks.461, Franks.2468, Franks.2450, 1888,0913.18, 2004,0625.1. Donated by Sir Augustus Wollaston Franks (Franks.461, Franks.2468, Franks.2450) and Thomas Watters (1888,0913.18)

from the newly built brewery in Qingdao, Shandong, in 1903.[76] (Qingdao beer remains a popular brand in China today.) A missionary, Justus Doolittle (1824–1880), who worked in Fujian, described the lively games that were played in elite 'wine clubs' in the mid-1800s. These included drinking while composing rhymes, reciting tongue-twisters and guessing the number of fingers held up by an opponent.[77]

Material culture enables us to evoke the lives of inhabitants of 19th-century China outside the minorities of the court and the educated elite: of 'ordinary' men, women and children who lived on the land, in small towns, and in expanding urban communities. Although these people are for the most part anonymous and have left behind few written records of their thoughts and circumstances, we can reconstruct parts of their world through objects, paintings and photographs. These can communicate the resilience of people who survived the violence of the 19th century to build new homes and social networks in uncertain times. Change was driven by warfare and natural disasters but it was also accelerated by technological advances and the increasingly conspicuous presence of foreigners. Vast migrations – often impelled by the tragic dislocations of war – enabled cities like Shanghai to flourish, shaping new businesses and new art forms across the period. Amid the accelerating modernisation and Westernisation of the republican era that followed the fall of the Qing in 1912, the intricate fashions of the late Qing seemed to fall quickly out of vogue: following the 'Republican revolution in clothing', one observer remarked, 'collars, dragon robes, and such objects were no longer used'.[78] But many of the changes to everyday life and commodities set in motion during the 'long 19th century' – the melding of traditional and modern, Chinese, Manchu and Western, and intensifying urbanisation and commercialisation – continued to set the tone for popular production and culture throughout the post-dynastic era.

4.99
Blue-and-white bowl
'Kitchen Qing' (quotidian crockery) was made in Fujian, Guangdong and Chaozhou. It is categorised as a less delicate, everyday variety of ceramics, often with underglaze blue designs that were hastily painted or stamped. Designs changed little over a 100-year period. This quality of ceramic was used domestically, but was also exported in vast quantities, particularly to countries in Southeast Asia which did not have the same access to high-firing porcelain clay deposits. Today, we are able to date 'Kitchen Qing' through a number of early 19th-century shipwrecks, including the *Diana* (1813) and *Tek Sing* (1822) cargoes.

c. 1822, Fujian. Glazed porcelain. H. 7.5 cm, diam. 16.2 cm. British Museum, London, 2001,0614.1. Donated by Captain Michael Hatcher

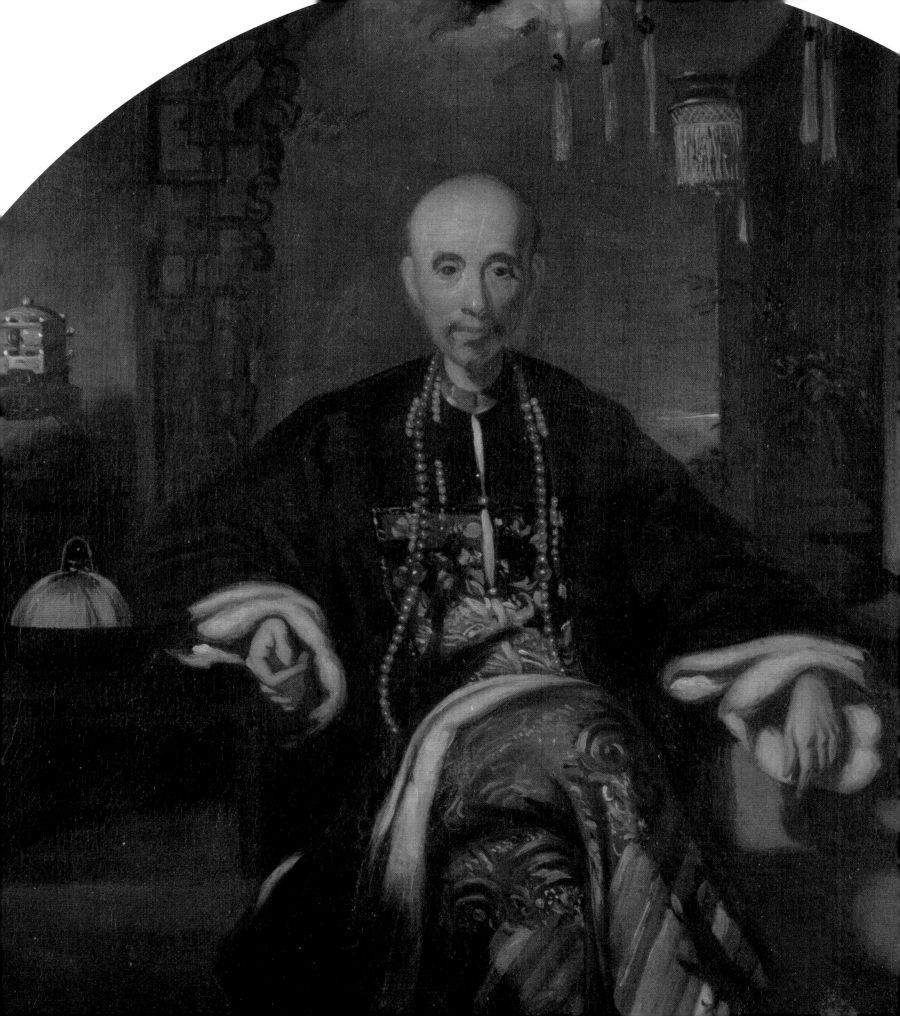

Global Qing

Anne Gerritsen

For much of the 19th and 20th centuries, a Western stereotype held that the Qing sequestered itself from the world beyond its borders. But as the previous chapters have shown, Qing China was far from an empire in isolation. Even before the founding of the Qing empire, the Manchus were involved in complex interactions with surrounding polities and peoples such as Tibetans, Koreans and the people of the Mongol federations. In 1689, during the early decades of the Qing regime, a treaty was signed at Nerchinsk between the Qing dynasty and the Tsardom of Russia, negotiated with the help of Jesuit missionaries who had obtained official positions within the imperial administration. The Manchus were deeply aware of the strategic importance of establishing workable relationships with the powers that operated on and beyond the boundaries of the territory they considered their own. Formal interactions with Joseon Korea, Tokugawa Japan and Vietnam were conducted through the so-called 'tribute system': a set of institutions and regulations that governed the exchanges between the Chinese imperial court and various non-Chinese entities, conducted on Chinese terms. During the 17th and 18th centuries, the Qing court also entertained formal visits from powers further afield, such as the Dutch and the British.

Over the course of the 18th century, however, the Qing became gradually less willing to entertain a European presence within its borders. Jesuits and other missionaries were asked to leave, for example, and a strictly regulated trade system was established as a way of claiming control over Western colonialist powers with their ever increasing pressures and demands for access. European and, later, American merchants, so keen to purchase China-made goods and trade freely on Chinese soil, were severely restricted. The 'Canton system', in place between 1757 and 1842, limited all European trade (including with inhabitants of British India and subsequently Americans) to a single port (Canton, now Guangzhou), and all interactions to a small group of merchants (the Hong merchants). Trade could only happen at a set time of year and visitors from overseas who stayed for longer were only permitted to live in a small part of the city of Guangzhou. These well-known restrictions arguably created a popular impression that the Qing was more generally shut off from all global interactions during this time.

This chapter and the next will demonstrate the opposite to be true and argue that 19th-century China was connected in multiple ways to the wider world, as it had been for millennia. The intensifying flows of people, objects and ideas that characterised the 19th century globally also brought transformations on all fronts in China. Mobile populations leaving Qing territory and becoming part of new communities created thriving sites of material and intellectual innovation throughout Southeast Asia and in the world beyond. Objects flowing in and out of China – often, in the second half of the 19th century, through the 'treaty ports' forced open by European and Japanese aggression – brought new designs, technologies and objects that transformed the worlds both of Qing China and the places that its citizens and material culture reached. The exchange of ideas that accompanied the movements of people and things created the kind of intellectual foment that eventually made the reforms and revolutions of the late 19th and early 20th centuries possible, and even arguably inevitable.

5.1

Map of Guangzhou in 1806

This map comes from a book compiled by Qiu Juchuan 仇巨川 (d. 1800) entitled *Yangcheng Ancient Manuscripts* (羊城古鈔). The book is a guide to the historic sites and culture of Lingnan – an area which covers the modern provinces of Guangdong, Guangxi, Hainan, Hong Kong and Macao as well as modern northern to central Vietnam. This page shows a map of the walled city of Guangzhou with mountains behind and the Pearl river in front.

1806, probably Guangzhou. Ink on paper.
H. 26 cm, W. 16 cm, D. 1 cm (closed book).
Harvard Library, Cambridge MA, 02138

5.2

Map of Guangzhou in 1888

There were 16 gates around the Old City of Guangzhou by the mid-19th century. Built of grey bricks on a red sandstone base, these walls were up to 6 m thick and ranged from 8 to 14 m high. Manchu and Han bannermen and their families, numbering some 5,000 people, made their homes in the western part of the city. Their houses were painted white and the edges of the walls black with symbols representing the different ranks of the occupants. The homes of Chinese people were mostly made of grey brick. Very few buildings were more than two storeys high, with the exception of pagodas and the minaret of the mosque.

1888, probably Guangzhou. Ink on paper.
Zhongshan University Library, Guangzhou

Guangzhou revisited

Guangzhou is a good starting point for exploring these global flows of people, things and ideas. It had a slightly unusual layout. The inner city walls that surrounded its main institutions were extended in the early Ming with an outer wall, as an 1806 map shows (fig. 5.1). Another map from 1888 shows the same walled city on the banks of the river, but now extended with sprawling suburbs to the west, known as Xiguan (pronounced Saikwan in Cantonese) (fig. 5.2). This was the location of the Thirteen Factories that made up the Guangzhou European trading enclave. There were sixteen access gates in the city walls, some facing the waterfront to the south, others located on the mountainous sides to the east and north, and one or two on the western side of the city.

Both maps reveal the city based on Chinese cartographic practices and within its geographical context, with its hilly surroundings, expanding suburbs and multiple entryways into the city by river or road. The waterfront buildings depicted in the painted

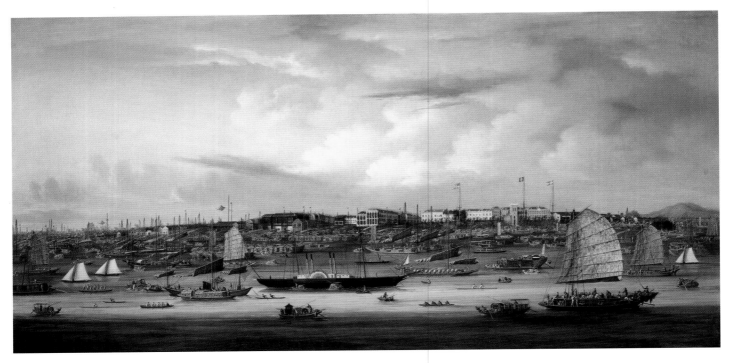

5.3

Unidentified artist, *Painting of the waterfront at Guangzhou*

This is the foreign commercial, banking and business district of Guangzhou in the mid-19th century, as seen from an approaching ship. Before the First Opium War, foreigners were restricted to living and doing business in the 'factories' (combined offices, residences and warehouses) built along the banks of the Pearl river. This area's multicultural community included Parsi merchants, English sailors and Chinese traders, all talking to each other through interpreters and a kind of hybrid business patois. There had been a mosque in the city since the 7th century AD. In 1847, a Zoroastrian cemetery served Hong Kong, Guangzhou and Macao sojourners. Business was conducted on different levels from the exchanges in bulk of commodities such as tea, porcelain, fine silks and illegal opium to sales of small-scale luxury goods, such as lacquered furniture and fans. The overall volume of trade was enormous and was a major factor in the development of the modern global economy, connecting China, South Asia, Europe and the Americas. In 1833, the British East India Company lost its monopoly on Chinese trade and private firms proliferated. Daily interactions occurred between the Qing and foreign communities through supplies of food, the maintenance of hygiene and entertainment. This oil painting can be dated by the presence of the paddle steamer, the Protestant church and the fact that it pre-dates a well-known fire in 1856.

1849–56, Guangzhou. Oil on canvas.
H. 94 cm, W. 189 cm. National Maritime Museum, Greenwich, Caird Collection BHC1777

5.4

Lamqua 關喬昌 (1801–1860) or his studio, *Portrait of the Hong Merchant Mouqua*

Lu Guanheng 盧觀恆 (1792–1843), known to Westerners as Mouqua 茂官, organised trade with foreign merchants in Guangzhou, serving as head merchant from 1807 to 1811. He suffered severe financial losses in a fire in the city in 1822. In this picture, he is dressed in the robes of a high official with a square rank badge on his chest embroidered with a golden pheasant and a red coral hat button on top of his hat. However, he actually purchased his official rank rather than earning it by passing a succession of public examinations. Nathan Dunn (1782–1844), the American businessman who created the first systematically collected and displayed group of Chinese artefacts in the United States (shown in Philadelphia in 1838), exhibited views of Mouqua's home. Mouqua spoke English, and the American society beauty Harriet Low (1809–1877) described him in a friendly fashion as 'very gallant'.

c. 1841, Guangzhou. Oil on canvas. H. 30 cm, W. 24 cm (framed).
Anthony J. Hardy

5.5

Possibly by Esther Speakman (1823–1875), in the style of George Chinnery (1774–1852), ***The Hong Merchant Wu Bingjian, known as Houqua***

Houqua was born in 1769, the same year as Napoleon and Wellington, and his death in 1843 more or less coincided with the opening of the treaty ports. In the early 1800s, he was perhaps the richest man on earth and his web of contacts spanned the world. His wealth was estimated at $26 million in 1834 (banker Nathan Rothschild, one of the richest men in the West, in 1828 possessed $5.3 million) – a vast fortune that he principally acquired through trade in luxury goods, although he also made shrewd investments in American railways and other new technologies. He was so famous outside China that Madame Tussaud's in London displayed a waxwork figure of him. George Chinnery, the British artist resident in Macao and Guangzhou in the 1820s–1840s, created a portrait of him that was exhibited in the Royal Academy in 1831 and is now housed in the HSBC collection in Hong Kong. That painting was copied by unidentified Chinese artists painting in workshops in Guangzhou but also by foreign artists such as Speakman. These portrait copies were an important branding tool displayed in the offices of businessmen throughout the world, demonstrating the reach of Houqua and his financial empire.

c. 1843, probably USA. Oil on canvas. H. 63.5 cm, W. 47.3 cm. The Metropolitan Museum of Art, New York, 41.160.405. Bequest of W. Gedney Beatty

views of Guangzhou that became so popular amongst non-Chinese audiences in the 19th century inevitably face outwards, towards the viewer, blocking the mainland from view, as if the viewer is arriving by ship (fig. 5.3). Indeed, the Chinese interior remained largely unknown to European visitors; most of those who made Guangzhou their temporary home never ventured beyond the city walls or, to be more precise, the confines of the area to which they were legally limited.[1] The contrast between the two maps made within Qing China, and the depiction of the same space as seen through Western eyes, is clear: the Western view suggests a waterfront with access to the maritime world but not to the world behind the facade of buildings; the local maps sketch a city embedded within wider surroundings, connected by land and water to what lay beyond its walls. This chapter will seek to focus less on the Western-constructed image of an empire cut off from its surroundings until the Western imperialists forced it open, and more on the ways in which Qing China – both its trading coastlines and hinterlands – engaged in multifaceted ways with the wider world.

5.6

Guan Lianchang 關聯昌 (1809–1870) (Tingqua) or his studio, ***Houqua's garden***

Houqua's lavish garden was a popular attraction for foreigners, who were restricted from travelling further inland. It was located in the Guangzhou suburbs on the opposite bank of the river to the European factories. The estate featured an ancestral hall, a shrine to the God of Literature, a 'Half-Moon Pool' and (pictured here) an ancient tree surrounded by colourful ceramic flowerpots.

c. 1825–50, Guangzhou. Watercolour and ink on paper. H. 27.5 cm, W. 35.5 cm. Peabody Essex Museum, Salem, E83532.16

The foreign residents of Guangzhou found the trade restrictions intensely frustrating. Yet, in the early 19th century, this part of the city was probably among the most diverse spaces in Asia. In the streets of Guangzhou, one might hear any number of European languages, including Russian, as well as adapted versions of Chinese and English created to facilitate the complex business transactions that were being negotiated. The most powerful figures were undoubtedly the Hong merchants, several of whom (such as Mouqua) developed excellent English-language skills and were on very familiar terms with the Westerners who resided there (fig. 5.4). In the 1830s, the most successful Hong merchant, Houqua, or Wu Bingjian 伍秉鑑 (1769–1843), was perhaps the richest man in the world and his garden became a tourist attraction (figs 5.5–5.6). But non-Chinese traders thrived too, including British, American and Indian merchants, among them several high-profile representatives of the Zoroastrian Parsi community (originally Persian merchants who had migrated to northern India and made their money in the textile trade) (fig. 5.7). There were also Muslim traders from South Asia, and Jewish and Armenian merchants, as well as American whalers who sold seal pelts to Qing customers and English midshipmen who loaded up on luxuries as part of their private trade cargo (figs 5.8–5.9). Merchant handbooks from these decades, used by traders bringing goods from the provinces to the port of Guangzhou arriving in the area via the inland waterways, show the complexities involved in negotiating these diversities and selling to Western sailors. The handbooks include, for example, detailed tables explaining the conversion rates for weights and measures in use in and around the port as well as the various monetary units they might encounter there (figs 5.10–5.12).

The varied communities of merchants residing in this cosmopolitan part of China were all there to conduct trade, but the commodities they bought and sold and the consumers they dealt with varied widely. An extensive range of goods from all over the world passed through the hands of Guangzhou traders: sea cucumbers and birds' nests from Southeast Asia, pepper from India, tea and porcelain from inland provinces like Jiangxi and Fujian, cottons from the Indian Ocean world, woollens that arrived on European ships, and so on. (Though it should also be remembered that

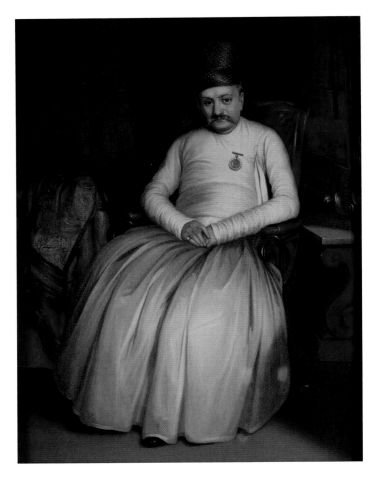

5.7

Lamqua, after John Smart (1741–1811),
Portrait of Sir Jamsetjee Jejeebhoy
Jamsetjee Jejeebhoy (1783–1859) was a Bombay-born, self-made Parsi-Indian merchant and philanthropist, who made a fortune trading with Qing China in commodities including opium, and was knighted in 1842 (the first such distinction for an Indian subject). He founded his trading firm, Jamsetjee Jejeebhoy & Co, with three partners, each from a different community: Motichund Amichund, who was Jain and had close ties to the opium producers in Malwa; Mohammed Ali Rogay, a Konkani Muslim, who was a shipowner; and the Goan Catholic Rogério de Faria, who, according to writer Nancy Adajania, was linked with the Portuguese officials that controlled the port at Daman on India's west coast.

c. 1850, Guangzhou. Oil on canvas. H. 66 cm, W. 48.3 cm. Asian Civilisations Museum, Singapore, 2020-00457

5.8
Spoilum 關作霖 (active 1785–1810), *Portrait of Sampson Dyer*

By the early 19th century, Nantucketers from the newly independent United States had sailed around the Cape of Good Hope and into the Indian Ocean to trade in Guangzhou.

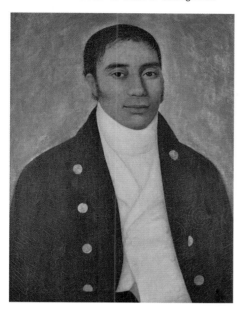

Coming from the whaling capital of the world, they sold seal pelts to Qing consumers, culled along the way, and, like their counterparts from Philadelphia, Boston and New York, returned home with luxury goods, porcelain, silk and tea. Sampson Dyer (1773–1843) was a freeman of mixed African and Whampanoag (Native American) heritage. He moved to Nantucket with his wife in 1790 and is believed to have served aboard the Nantucket ship *Active* as a steward for a trading voyage to China in the 1790s. From 1802 to 1805, he sailed with the *Lady Adams* of Nantucket on a voyage that hunted seals in the Juan Fernández Islands off Chile before continuing to China. It was probably during one of those voyages that he commissioned this portrait from the Cantonese artist Spoilum, who specialised in Western-style oil paintings of both Chinese and foreign merchants.

1790–1800, Guangzhou. Oil on canvas. H. 58.4 cm, W. 45.7 cm. Nantucket Historical Association, 2013.2.1. Gift of the Friends of the Nantucket Historical Association

5.9
Lamqua, *Portrait of a British East India Company midshipman*

Oil painting was new to China in the 19th century. Chinese entrepreneurs ran workshops producing oil paintings to record the portraits of visiting members of the East India Company and other merchants. The skilled and versatile artist Lamqua, who painted in the manner of the British artist George Chinnery, has captured the sunburn on this midshipman's face and the paler skin of his forehead that must have been protected by his hat. He has also painted the sitter as he must have appeared in the studio, with his waistcoat buttoned up the wrong way as if he had dressed in haste. Despite the immense heat in southern China, British employees of the East India Company wore uniforms designed for the cool climate of Britain. Chinese observers often remarked on their tight-fitting clothing, particularly their cream-coloured, snug-fit trousers, which were in fact made from a Chinese cloth called *nankeen*.

c. 1820, Guangzhou. Oil on canvas. H. 61 cm, W. 45.7 cm. Anthony J. Hardy

5.10–5.12
Porcelain box, silver 'Carolus peso' coin and *Overseas Coins, Silver Treatise Comprehensive Guide* (洋錢銀論全法)

Brothers Su Fuyuan 蘇富源 (n.d.) and Su Deyuan 蘇德源 (n.d.) produced this financial guidebook for Qing merchants trading with international customers in Guangzhou in 1836. From the diversity of coinage illustrated, we can visualise the multicultural nature of this important port city. By 1800, a coin nicknamed the 'Carolus peso', issued by the Spanish kings Carlos III and Carlos IV and used by foreigners to pay for Chinese goods, had become the basis of a new monetary standard in the markets of southern Qing China. These coins were so popular that their designs were reproduced on porcelain. During the unsettled years prior to the Opium Wars, merchants came to mistrust these coins as their silver content declined and forgeries multiplied. Books like the one illustrated here helped people recognise genuine coins.

1806–36, Jingdezhen; Spain; Guangzhou. Porcelain, silver and printing ink on paper. Box: diam. 6 cm; coin: diam. 3.9 cm, weight 26.7 g; book: H. 19 cm, W. 12.5 cm. British Museum, London, Franks.715.+, 1964,0216.1. Donated by Sir Augustus Wollaston Franks (Franks.715.+) and Miss W Allan (1964,0216.1)

5.13
Set of four tea caddies in a painted and gilded lacquer chest
With the advent of direct trade between China and visiting American vessels in the mid-1780s, the market for export lacquers, mostly black with gilding and some details in red, expanded greatly. Available forms included desks and dressing mirrors, jewellery, sewing boxes and chests for tea caddies. Both black and green varieties of tea – the same leaves but processed in different ways – were exported from China. This large tea chest is fitted with four pewter caddies, each boldly incised with floral, figural and landscape patterns.

1810–25, Fujian or Guangzhou. Lacquer, wood, gilding and pewter. H. 15.5 cm, W. 38.5 cm, D. 26.5 cm. British Museum, London, 2016,3064.1. Purchased with the Brooke Sewell Permanent Fund

5.14
Black and gold lacquer gaming casket
Depicted here is the inside of a lacquer chest, which contained trays that were painted to look like European playing cards such as the king, queen and jack of diamonds. Cases like this were fitted with different interiors, so that they could be used as gaming, sewing or even picnic boxes. The style of incising the black surface and then gilding the lines derives from Japanese lacquerwork. Although the technique has a longer history, lacquer-makers exercised a greater freedom in their invention of forms and designs in the 19th century.

1800–30, Fujian or Guangzhou. Lacquer, wood and gilding. H. 14.1 cm, W. 38.3 cm, D. 31.2 cm (lidded). Bristol Museum and Art Gallery, E2434

Asian traders – especially those from Japan, Korea and Southeast Asia – could do business out of a much larger number of ports on the east coast.) By far the highest quality goods, however, were the luxury commodities manufactured in Guangzhou itself and the surrounding areas of Guangdong and Fujian (figs 5.13–5.15). This high-end trade made the most of the particular combination of what was available in Guangzhou: skilled craftsmen and women, often themselves migrants, such as the ivory carvers from Fujian, Manilla and Ceylon (fig. 5.16), the finest materials such as turtle shell, precious stones and metals, as well as a wide variety of hardwoods, silk, lacquer and porcelain, and merchants with deep pockets who knew which commodities would sell well among their

own home communities of consumers (fig. 5.17). These clients included royalty and members of the aristocracy, as well as the men and women who had become very wealthy from the trade with Asia (figs 5.18–5.19). They knew what was available and expressed their desires in very detailed wish lists, which explains why we have some extraordinary one-off pieces made to the specifications of a particular person (fig. 5.20), as well as items that proved so popular with consumers in Europe and the United States that they were produced in large quantities, such as the scenes of Guangzhou harbour.

Ever since the first Europeans had travelled to parts of the world that were new to them, they had created detailed descriptions of their travels, often accompanied by visual records, including illustrations of the plants

5.15
Bracelet in a presentation box
This unusual bracelet for a woman is made of a chain of alternating plaques of finely carved peach stone, with gold mounts and gold filigree ribbons. It is enclosed in a painted lacquer presentation box. This type of bracelet was made in dozens of combinations of different materials, including ivory, turtle shell and ornamental hard stones. Such jewellery also came in sets with matching earrings and pendants.

1800–30, Guangzhou. Lacquer, wood, ivory, fruit stone and gold. Bracelet: L. 20 cm; box: L. 25 cm. The Teresa Coleman Collection, A06817

5.16
Large ivory basket
Ivory tusks were imported into China from India and Africa and worked on by local skilled artisans. The intricately carved ivory panels around the sides of this basket are decorated with figures and landscape scenes, while the ivory handle is carved in the shape of two dragons. William Fullerton Elphinstone (1740–1834), Director of the East India Company in the early 19th century, once owned the basket, which he would have shipped home at his own risk as part of his private cargo. Several identical baskets exist, including in the Hampshire Cultural Trust and at Audley End House in Essex.

1800–12, Guangzhou. Ivory. H. 56 cm, diam. 29 cm. Private Collection on loan to National Museums Scotland, Edinburgh, IL.2006.50.1

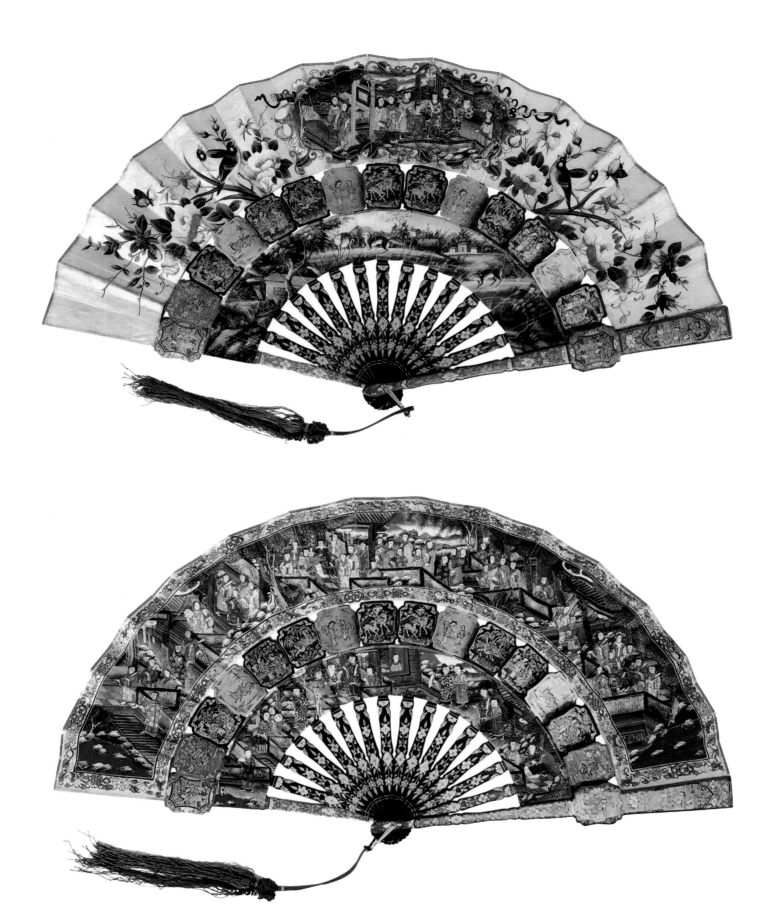

5.17 (opposite, top and bottom)
Folding fan with painted scenes
The combination of scenes in bright gouache paint on paper and sticks of gilded multicoloured lacquer was new to fans in the early 19th century. As an eye-catching accessory, fans were a perfect vehicle for the creativity of Guangzhou artisans. This example was exported in a beautifully painted lacquer box and has two completely different designs on either side.

c. 1860–70, Guangzhou. Lacquer, gilding, paper, wood, silk and ivory. H. 28 cm, W. 52.5 cm. The Teresa Coleman Collection, F01785

5.18
Painted parasol
This painted silk parasol has finely knotted silk tassels, a lacquered bamboo handle (to imitate a more luxurious material) and an interior lined in cream silk. The body has eight multicoloured silk panels; six are painted with birds, butterflies, flowers and fruits, and the yellow panels are each decorated with a well-dressed couple resting under the shade of a tree. In one scene a man is smoking a tobacco pipe and leaning on a pile of books while the woman stands and holds a fan, and in the other she is playing a lute while he sits on a porcelain drum stool. Details of the costumes and the Manchu hairstyle (with shaved sides and queue) suggest a mid-19th-century date.

1840–70, Guangzhou. Painted silk, embroidery, bamboo and lacquer. L. 76 cm, diam. 58 cm (open, max). The Teresa Coleman Collection, E08001

5.19
Parasol with figures and flowers
This cream silk parasol with multicoloured knotted silk tassels and finely carved ivory handle has an embroidered design of eight figures engaged in rural pursuits surrounded by auspicious flowers and butterflies. The interior is also lined in cream silk. The eight figures are: a woman holding a pair of cockerels; an elaborately coiffed young woman with a fan playing shuttlecock (a 'ball' of feathers stuck into a weighted base) with her feet; a woman standing near a brick oven holding a duck on a platter and a string of firecrackers; a woman with a duck in a basket; a fisherman with traditional hat and basket; a countrywoman feeding a hen; a young man dressed in a blue robe, holding a fan and rope; and a woman sitting on a stool with a fan and a standing mirror, dressing her hair with hairpins.

1840–70, Guangzhou. Silk, embroidery and ivory. L. 61 cm, diam. 51 cm (open, max). The Teresa Coleman Collection, E08000

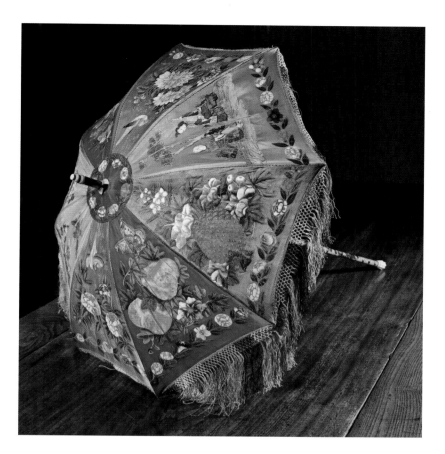

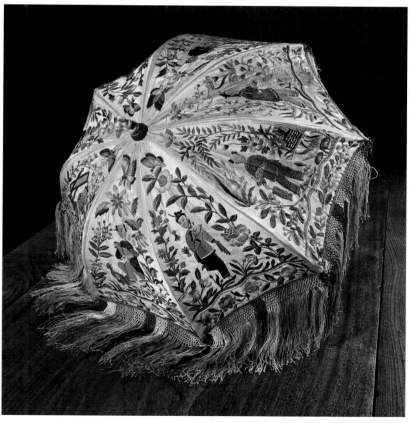

and animals they came across.[2] Such texts and illustrations generated a certain type of knowledge of these parts of the world, largely shaped by the individual experiences of the travellers in question as well as the contexts in which they travelled and the colonialist lens through which they viewed the material and immaterial worlds they encountered. Their accounts also created a hunger for more and led to the commercial production of albums of plants, animals and water creatures specifically tailored to their Western consumers. Chinese artists, trained in Chinese painting styles, but working with imported materials such as paper and pigments, and instructed by European and American botanists, produced albums that depicted the Chinese world of plants and animals (figs 5.21–5.22). As described below, such botanically accurate depictions of Chinese flowers and plants would go on to create an interest in the buying and selling of plant specimens and seeds; they would also become a favourite theme on many other

5.20
Unidentified artist, Reverse glass painting of winter court scene

Artists in Guangzhou painted two reverse glass paintings on imported English glass sheets and framed them in imported gilt-wood English frames. They are the largest specimens of Chinese glass painting known today. The winter scene shows an imagined Manchu emperor outside a tent on a raised dais and surrounded by courtiers. Beyond is a northern winter landscape. A companion piece shows court ladies and the emperor in a summer landscape. Richard Hall (1764–1834), the supercargo in charge of the East India Company's operations in China between 1785 and 1802, went to considerable trouble to commission the pair of paintings. In 1803, he sent two large panels of glass to China to be painted with pictures of the emperor and empress. The completed paintings were then shipped back, and remained in Hall's London residence in Portland Place until his death in 1834.

1804, Guangzhou. Reverse glass painting. H. 144 cm, W. 221 cm, D. 6 cm. Victoria and Albert Museum, London, P.11-1936. Bequeathed by Amyand John Hall

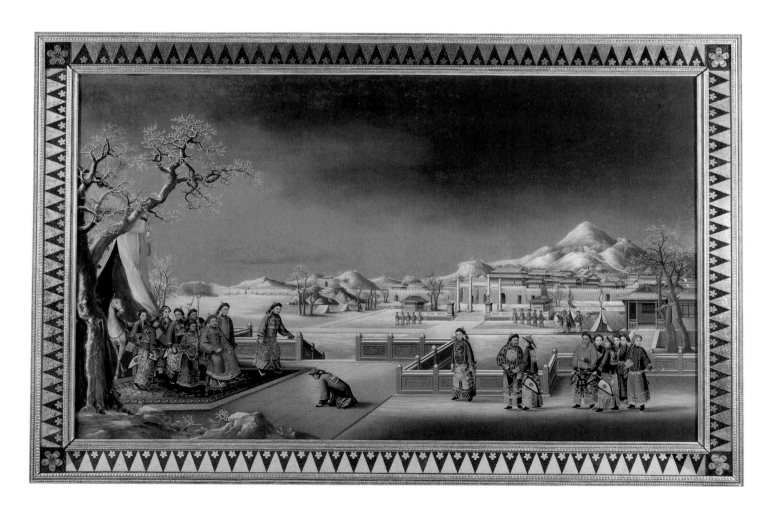

5.21

Unidentified artists, *Crabs*

John Reeves, the English naturalist, commissioned a vast group of natural history images made by artists in Guangzhou between 1822 and 1829, of which this painting is one example. There were 482 paintings in total, comprising mammals, birds, reptiles, fish, insects, molluscs and crustaceans. Victorian travellers to China were extremely curious about the natural plant and animal life there and commissioned sets of realistic paintings showing the creatures depicted as specimens rather than as part of a natural scene. See pp. 154–61 for further examples of natural history illustrations.

1822–29, Guangzhou. Watercolour and ink on European paper. H. 50.4 cm, W. 65.8 cm. Natural History Museum, London, Rare Books 88 ff R Crabs plate 94

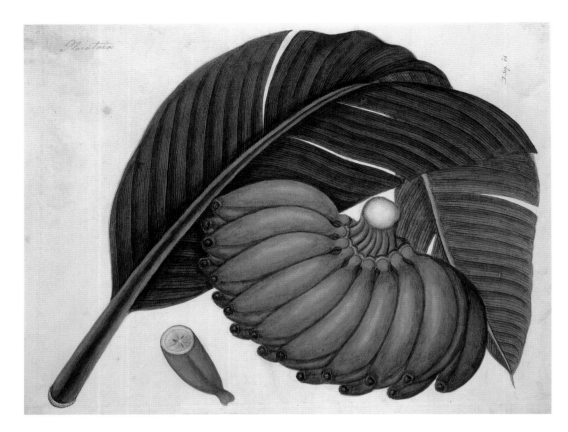

5.22
Unidentified artist, *Plantains*
This watercolour painting of plantains is drawn in a Western botanical style on European paper, specially imported into Guangzhou for its toughness. Plantains are only grown in the far south of China, for example in the tropical parts of Guangdong and Yunnan. This export watercolour style was very similar to East India Company paintings that were also made for European customers.

1800–30, Guangzhou. Watercolour and ink on European paper. H. 31 cm, W. 39 cm. Victoria and Albert Museum, London, D.319-1886

materials aside from paper, such as wallpaper, bolts of silk and colourful screens (figs 5.23–5.24).

Sometimes, the material culture produced in Guangzhou is described as 'Western taste'. Silks were embroidered with complex repeating flower patterns that to a Chinese eye look entirely Western, because of the botanical precision with which flowers, leaves and stems are depicted, but were considered 'Indian' in the eyes of the upper-class consumers in England that could afford such sumptuous textiles. In fact, of course, these silks and other objects and materials created in this context do not belong exclusively to one place but are a product of the fluidity of material and cultural boundaries and the mobility of people and designs at this time.

The material culture that is associated with Guangzhou in this period is difficult to characterise, precisely because of the particular combination of skills, materials and tastes that produced it. The terms 'export art' or 'trade art' suggest that goods were produced in Guangzhou exclusively for the global market in anonymous workshops, without any possible agency for the craftsmen and women involved. Recent research has highlighted the creativity of the Guangzhou artists

and makers, and the highly individual ways in which elements taken from a variety of cultural contexts were combined to create unique pieces. Christian elements were fused with Buddhist iconography, Chinese shapes with European designs and vice versa, and Southeast Asian forms with East Asian techniques (fig. 5.25), leading to the production of an entirely new material world. Craftsmen and women who migrated from Guangzhou spread these innovative styles across Southeast Asia (fig. 5.26).

Reverse glass painters are perhaps one of the best examples of these highly skilled people. The technique of reverse glass painting was popular in 18th-century Europe, where it was used, for example, by Thomas Gainsborough (1727–1788), and it spread to China and from there to India.[3] To achieve the effect, painters had to imagine the scene in layers, starting from the front and working backwards rather than building the layers of paint from background to foreground as was conventional in, for example, oil painting on canvas. Beginning with the highlights and foreground details that appear on the glass closest to the viewer, the painter added layer after layer to reveal the final picture.

5.23

A partial bolt of floral taffeta
The 'temple marks' (small holes
for holding the silk to the correct
width when weaving) down the
selvedges (finished edges) prove
this bolt was woven in China. Some
Chinese textiles exported to Europe
and the United States used painted
silver designs such as the flower
sprays on blue stripes seen here.
Patterns divided into columns were
particularly popular in the 1800s.

1800–30, China. Silk and
embroidery. L. 950 cm (partial
length), L. 1630 cm (original length),
W. 75.2 cm. Jacqueline Simcox Ltd

5.24

Gold and kingfisher feather screen

This colourful five-panel folding screen was bought by the Victoria and Albert Museum after it was exhibited in the International Exposition in Paris in 1867, which was held at the behest of Napoleon III (r. 1852–1870). Qing China did not formally participate in the exhibition, but a committee of French businessmen, scholars and soldiers selected Qing artefacts and organised their own China display in the main building and surrounding park. The screen is unusual and eye-catching for its lavish gold and bright blue kingfisher feather designs. Some 710,000 visitors attended the exhibition over its seven-month run, although many of them stayed in the park without entering the building. The Chinese Pavilion was surrounded by tropical plants and Chinese gardeners tended to trees and flowers imported from China. Two young Chinese girls painted fans and played dominoes in a small tea kiosk, and sold photos of themselves to tourists.

1825–65, probably Guangzhou. Wood, lacquer, embroidered silk and kingfisher feathers. H. 169 cm, W. 48.3 cm (each panel). Victoria and Albert Museum, London, 648-1869

5.25 (left)
Porcelain covered bowl for export to Thailand

The Thai court commissioned the shapes and patterns of overglaze-decorated Bencharong wares (controlled by sumptuary laws) directly from the Chinese Jingdezhen kilns. The design on this covered bowl incorporates patterns common in Thai art, which were also found on Indian trade textiles produced for the Thai market. Called Lai Nam Thong ware, a subset of Bencharong, the bowl has a distinctive palette with bright, thickly applied enamels and gold leaf in a 'gold wash' pattern. Common decorative imagery included birds, butterflies, flowers and foliage, as well as heavenly figures. This piece shows how ceramic factories diversified their products depending on their clientele.

1871–1908, Jingdezhen. Porcelain with overglaze enamels. H. 21 cm, diam. 12 cm. British Museum, London, 2004,0628.4. Donated by the Doris Duke Charitable Foundation

5.26 (below)
Vest for a Peranakan Chinese child

This sleeveless jacket has a pale blue ground and is colourfully embroidered with peonies and flying phoenixes. It is also stitched with paired grasshoppers, crabs, lobsters and butterflies. Chinese language is rich in emblems that carry double meanings, so the mother who made this jacket has embellished it with peonies representing wealth and rank, to ensure the child is clothed, as it were, in a protective visual language conveying a wish for long life, health, wealth and happiness. Qing settlers moved to the coastal towns of Indonesia, Malaysia and Singapore, where their descendants, known as Peranakan Chinese, maintained Chinese beliefs, dress and rituals while adopting local languages. The embroidery here is a distinctive style made by the Peranakan Chinese around the turn of the 20th century.

c. 1890–1920, Indonesia, Malaysia or Singapore. Silk satin embroidered with silk and metal-wrapped threads. H. 38.7 cm, W. 47.7 cm. University of Alberta Museums, Edmonton, 2005.5.169. Gift of Sandy and Cécile Mactaggart

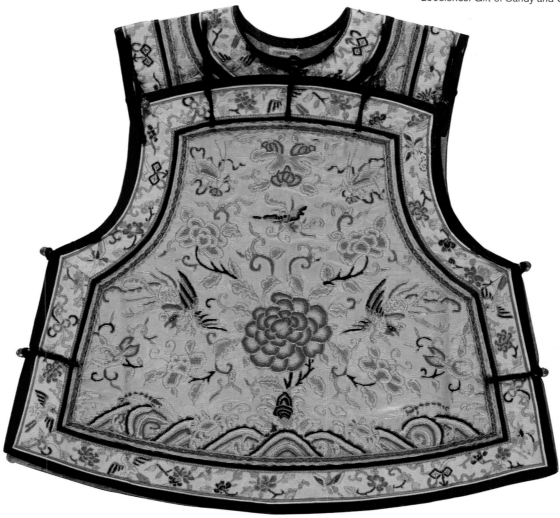

5.27–5.28
Unidentified artists, Reverse glass paintings of still-life subjects

The painting on the right is a still life of Chinese objects – including a Yixing-style teapot on a porcelain brazier, a hexagonal wine pot and cups on a wooden tray, and a colourful silk tobacco pouch with leaves and a long thin pipe. The painting on the left, however, is entirely Western in its theme, showing a hunter's catch of fish, pheasant and duck. These images are rare and mark a moment in reverse glass production when artists broadened their range of subjects and styles. Extraordinarily, given their fragility, sheets of glass were exported in bulk to China for painting in the early 19th century. In 1802, 30,000 glass sheets, weighing some 100,000 kg in total, were transported from England to China. Some were used for paintings, others for windows. Early 19th-century Guangzhou artistic production centred on Western subjects, including religious subjects and still-life images. Beautiful Chinese women were also a favoured theme. In the mid-19th century a major change in glass production made it much more widely available in China, and reverse glass painting was practised in regions beyond Guangzhou, with each developing a different style, often closely related to locally made woodblock prints.

c. 1780–1840, probably Guangzhou. Reverse painting on mirrored glass. H. 38.7 cm, W. 30 cm; H. 35.6 cm, W. 45.7 cm. Anthony J. Hardy

5.29
Unidentified Chinese artist after Gilbert Stuart (1755–1828), *Portrait of George Washington*

This portrait of the first president of the United States, George Washington, is a Cantonese product executed by Chinese artists using imported oil paints on the back of a sheet of imported glass. With immense precision, the artist began the image in reverse, starting with the details nearest the surface and then progressing to the background. This copy of a painting by Gilbert Stuart that Washington sat for in 1796 was one of many, and legal action was taken in Philadelphia against the circulation of Chinese copies in the United States. By 1822, there were 5,000 shops and studios near the foreign trading stations in Guangzhou, making and selling art and commodities; some of these studios were commissioned to replicate foreign goods at a fraction of their original cost and these were then carefully shipped to customers in Europe and the United States.

c. 1800–05, Guangzhou. Reverse glass painting. H. 82.5 cm, W. 64.8 cm. Anthony J. Hardy

Large sheets of glass were a novelty in China and were generally imported from abroad. Putting a frame around a painting, especially a gilt-wood frame, was also not common practice in China. And yet reverse glass paintings became a particular speciality of the Guangzhou craftsmen, who combined their skills with imported goods like glass and frames.

The subjects the Cantonese painters chose for their reverse glass paintings in the 18th century included seasonal landscapes and the imperial court, important merchants, Chinese women and children. Innovative images from the 19th century included still-life compositions (figs 5.27–5.28) and close copies of popular prints. The technique not only created paintings with very saturated colours but also brought highlights and foreground details even more closely to the attention of the viewer.[4] Whereas in the 18th century reverse glass painting was confined to Guangzhou, in the 19th century many other centres developed across China as glass sheet manufacture became more widespread.

The medium also lent itself to the creation of (almost) identical copies of famous oil on canvas works. Most famously, this was done with the well-known portrait of the first president of the United States, George Washington (1732–1799) by Gilbert Stuart, dated 1796; a painter, possibly Fouqua 發呱 (active 1800–1820), created a reverse glass version of this painting in around 1800–05 (fig. 5.29). The temptation might be to identify Stuart's painting as an original and to see artists from Guangzhou as copyists, but the situation is more complicated. Stuart was running off vast numbers of identical copies of his George Washington portrait in oils, while the Guangzhou-based artists, who were also producing commissioned portraits of merchants, often based on a single sitting, were in fact each time creating new pieces in an innovative medium.[5]

Migrants and merchants

Qing China was global in part because of the ways in which the Qing established formal relations with the political entities it had brought entirely under its control as well as those it regulated by way of the tribute system, including Korea, Japan and Vietnam. It was also global because of the ways in which the port of Guangzhou connected the Qing dynasty to the wider world. Arguably, however, the globality of the Qing was not limited to exchanges that took place within its own territorial realm but extended to the patterns of exchange that occurred within the wider East Asian and Southeast Asian region. The key actors in these exchanges were merchants and migrants. Merchants continued to operate between the world of the overseas Chinese and Qing-controlled territories, while migrants established themselves overseas on a more permanent basis. In the densely populated and often mountainous coastal regions, the scarcity of land and work often pushed people away from China; at the same time, opportunities for commerce and labour throughout the Asian maritime sphere attracted large numbers of migrants. Merchants from the coastal region of Chaozhou, for example, located in eastern Guangdong, operated throughout an area that has become known as 'maritime Chaozhou', stretching from coastal cities such as Shanghai and Xiamen (fig. 5.30) to mainland and insular Southeast Asia, including the Kingdom of Thailand, the Malay states and the western parts of the island of Borneo. The Chaozhouese participated in a wide variety of trades including sugar, pepper, opium and rubber, much of which was grown using a plantation-style agriculture that was only possible in the underpopulated regions of Southeast Asia where they settled (fig. 5.31).

As in all diasporic communities, connections to the homeland, in this case different regions along the south coast of China, continued to matter, and the remittances the migrants sent back to China transformed the local economies on the south China coast.[6] But as the sojourners settled into new communities, new cultural preferences and designs to cater for them emerged. Material goods produced during this time reflect the changing tastes of these mobile populations, including the Chinese migrants who established diasporas in Southeast Asia referred to as the Straits Chinese. Peranakan porcelains, for example, are immediately recognisable as different from those made for consumers within China, as they use particularly thick enamel colours in a distinctive palette, and yet they integrate some of the same motifs and materials popular in mainland China, as also seen in those made for the Thai market (see fig. 5.25).

The border area between China and Russia shows a similar fluidity due to the constant movement of goods,

5.30
Unidentified Chinese artist, *The Harbour of Amoy (Xiamen)*
Xiamen was a port in Fujian which served traders across East and Southeast Asia and once rivalled Guangzhou as a port for European trade. Called Amoy by Westerners, it was opened as a treaty port after the First Opium War and in 1853 it was occupied by the Taiping army. This painting gives a sense of the variety of shipping that could have been found in the port, from the French cutter to the coastal junks and tiny sampans.

c. 1850, probably Xiamen. Oil on canvas.
H. 44.5 cm, W. 76.2 cm. Anthony J. Hardy

people and ideas. Treaties signed in the 17th and 18th centuries governed the complex political relationship between the two empires, but with the growing popularity of tea consumption in Russia, economic interactions flourished through merchants.[7] In the first decades of the 19th century, only England was a bigger trade partner for China than Russia.[8] The traders who benefited most from this were the so-called Shanxi merchants. Hailing from an arid plateau province but with extensive networks in the north, Shanxi merchants were ideally placed to source tea and salt from other parts of China and deliver these goods to Mongolia and Russia, bringing back animals and animal products like leather, sheepskin and wool. Key to this trade was the border town of Kiakhta (or Kyakhta), near the larger administrative town of Troitskosavsk, located south of Lake Baikal, near the border between modern Russia and Mongolia (fig. 5.32).

Eventually, the Russian traders demanded a direct access route, and from 1862 they began to send

5.31

Shrine for transporting a deity

Tiered shrines were used to transport the image of a major deity between temples and around the local community during festivals. These processions enabled the deity to 'tour' the area of his or her influence, distributing blessings to devotees. The inscribed panels on this shrine allude to life at sea, and hence it was probably dedicated to Tianhou (Mazu), who is Goddess of the Sea and protector of seafarers. The decoration of this shrine suggests that it was carved by artisans in Chaozhou (Teochew) or Shantou (Swatow) in Guangdong province. It was probably commissioned by a temple in the region or else among their diasporic communities.

1800–1900, Chaozhou or Shantou. Wood, lacquer and gilding. H. 221.8 cm, W. 106 cm, D. 86 cm. Asian Civilisations Museum, Singapore, 2012-00466. Gift of Graham and Gyoengyike Honeybill

merchants by sea from their new port at Vladivostok – annexed from Qing control by treaty in 1858 – to the more southerly ports, bypassing the Shanxi merchants (and leading to the economic decline of parts of northwest China previously enriched by the Russian trade). But it was not just people and goods that traversed the land border; the Russian Orthodox Church had also gained a foothold in China. The 1727 Treaty of Kiakhta had allowed for a mission to be based in Beijing, catering to a small community made up largely of Russian students of both Manchu and Chinese. Over the course of the 19th century, this Russian Orthodox presence in Beijing grew steadily, providing translations of Russian texts into Chinese and serving as an 'informal diplomatic mission'.[9] The activities of the mission grew rapidly after the Treaty of Tianjin was signed in 1858, which gave far greater freedom to missionaries of all kinds throughout China.

Over time, Chinese merchants who based themselves throughout Southeast Asia, just like the Russians in Beijing and Guangzhou, settled into diasporic communities with close connections both to their new environments and to their old homes.[10] The material goods associated with such migrant and sojourning experiences often precisely show this interaction between old and new worlds, combining new materials or techniques with older designs, or vice versa, thereby creating entirely new styles.

The term 'hybrid' was once considered a suitable one for any blend of cultures. Textiles, furniture, paintings and Christian objects that show such distinct combinations, often of European and Asian styles, are difficult to classify because they do not quite fit in either one of the categories. But hybrid is also a problematic word: it suggests a putative purity in contrast to the hybrid form, and more often than not the pure is ranked hierarchically above the hybrid. In fact, the context of late Qing material culture demonstrates that the hybrid can be used creatively and productively (figs 5.33–5.34), so long as it is seen as an entirely new space in and of itself, where new combinations and integrations create something that is wholly fresh, as Emma Poulter has shown with her study of African objects in the Manchester Museum. By shifting away from context to the object itself, and identifying that as the 'contact zone', Poulter allows the object's innovation and creativity to come to the fore.[11]

A round Chinese fan with maps depicting the Eastern and Western hemispheres, for example, is an entirely original creation (fig. 5.35). China-made maps using Western cartographic techniques had been in circulation since the late 16th century, so that in itself was not an innovation, but to create fans from them was completely new in the 19th century.[12] Fans offered a space for experimentation with shapes, materials and designs (see fig. 5.17). Light and functional, they

5.32
Henry 'Hy' Sandham (1842–1910), Bazaar and Chinese shops in Troitskosavsk
This illustration was published in the 1891 book *Siberia and the Exile System* by American explorer George Kennan (1845–1924).

1891, London. Printing ink on paper. The British Library, London, 010055.f.3

5.33

Set of treaty port silver

This punch set in Qing dynasty export silver is comprised of a punchbowl, six beakers, a sugar bowl and tongs, all with applied dragons, the initials of a certain person named John Penniall and the year 1905. From an impressed mark on the base in Roman letters, we know that this set was commissioned through Luen Wo, the successful retail silversmiths based in Shanghai, with various offices on the Nanjing Road.

1905, Shanghai. Silver. Punchbowl: H. 30 cm, W. 28 cm (with stand). British Museum, London, 1993,0127.20.a–i. Bequeathed by Emily Penniall

5.34

Pair of rocking chairs

Carpenters created new hybrid furniture for the residents of the treaty ports, which brought together traditional Chinese materials and decoration with Western forms. Images of this type of chair in use can be found in Chinese illustrated magazines of the late 19th century, such as the *Pictorial for the Current Situation* (時事畫報). The patterned bur wood is inlaid in an oval frame contrasting with the smooth hardwood zitan frame.

c. 1905–13. Zitan and bur wood. H. 83.5 cm, W. 52 cm, D. 96 cm. Liang Yi Museum, Hong Kong

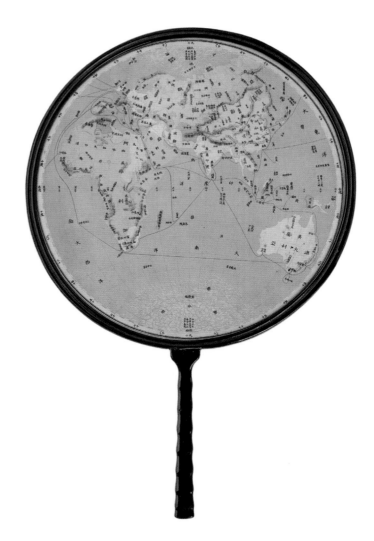

5.35

Round fan with a map of the Eastern and Western hemispheres

Fan design was extremely creative in the late 19th century. Some fans were even made with phrases in English written on them, which could be read out if the owner encountered a foreign person on their travels. The cartography of Jesuits at the Qing court notwithstanding, until the 19th century Chinese map-making conventions were very different to those of Western cartography. This fashionable round fan is printed on silk and replicates a Western globe.

1900–14, China. Five-colour printed orthographic projection on silk. H. 41.3 cm, W. 27 cm. Royal Ontario Museum, Toronto, 918.4.100. The George Crofts Collection, gift of Mrs H.D. Warren

accompanied their owners on their travels, offering protection from heat, a barrier between body and surroundings, and, in folded form, even a makeshift weapon of sorts. Decorated with foreign languages and maps of the world, such fans could provide their users, in Asia and Europe, with the tools to negotiate the complexities of a global world. In that sense, fans and other objects can be seen as spaces or 'contact zones' in which the interactions between different cultures, materials and designs were worked out.

The treaty ports

On a much larger scale than individual objects, the treaty ports were contact zones in which some of the most creative and productive interactions could occur.[13] It should simultaneously be noted that these cities

could also be sites of egregious racism directed by some of the Western inhabitants at the Chinese population. With the signing of the Treaty of Nanjing at the end of the First Opium War, Guangzhou, Ningbo, Fuzhou, Shanghai and Xiamen all became treaty ports. In 1862, following the Second Opium War, a further eleven ports were added to the list, including inland cities like Wuhan and Jiujiang (both located at strategic locations on major riverine arteries that allowed Western control over not only exports but also the inland trade routes). Jiujiang, located on the Yangzi river, just to the north of Lake Poyang, had a customs office, which gave Western oversight of all goods transported on the Gan, one of the main north–south river-based transport routes. Further river connections linked the city to Jingdezhen, and ceramics transported to the imperial capital via this route were identified as Jiujiang porcelains. Smaller ports were often far less glamorous than the well-known treaty ports such as Guangzhou and Shanghai, but with a French and English merchant community in Jiujiang, as well as a Christian missionary settlement and a missionary-led medical practice, such small inland towns became more diverse and international than much larger provincial centres nearby.[14]

Many of the technological innovations that started to appear in China in the latter half of the 19th century developed in the contact zones these treaty ports created. The first steamships (fig. 5.36), for example, had appeared in Guangzhou in 1828, as we know from a Chinese description that referred to one as a 'fire-wheel ship' (火輪船).[15] Although it took several more decades for the first China-built steam-driven ships to appear, in 1865 a 'general bureau of machinery production' (江南機器製造總局) was established by Li Hongzhang (see p. 283) in Shanghai, followed by a shipyard and a school of engineering in Fuzhou in 1866, where the first steamboat was built in 1869.[16] In 1872, the China Merchants Steam Navigation Company (輪船招商局) was founded, supervised by an official (Li Hongzhang again), but managed by merchants who had gained experience with such steamships in Guangzhou.[17] The treaty ports provided the productive combination of newly established educational institutions in which the mechanics of science and technology could be taught, the materials for the manufacture of the required tools and machines, new financial institutions that enabled the necessary investment, as well as a ready consumer base. Very soon, similar technological innovations

5.36
French clock in the form of a steamship
After 1860, a number of private foreign steamship companies established offices in treaty ports along China's eastern coast. This was several decades before the foreign mines, mills and railways came to China in the 1890s. A Chinese steamship company was also founded by Li Hongzhang and co-managed with Qing bureaucrats. Novelty clocks, made in France in the form of modern machines, were very popular in the Qing court. This one was probably collected by Empress Dowager Cixi.

1880–1911, France. Metals, marble and textile. H. 38.5 cm, W. 44 cm, D. 18 cm. Palace Museum, Beijing, Gu.00183502

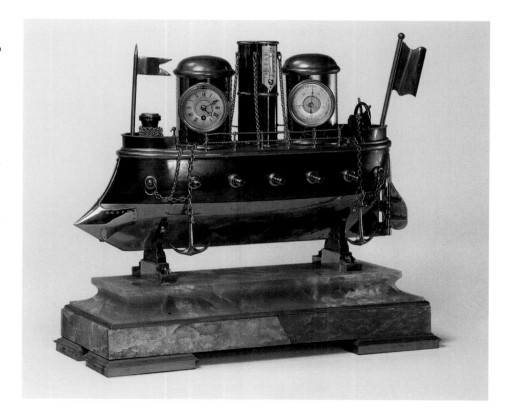

also appeared as part of new designs on textiles (figs 5.37–5.38), of posters and products (figs 5.39–5.40), in newspapers and magazines (fig. 5.41), and even on banknotes and bonds (figs 5.42–5.44).

Key to understanding this period of rapid change in China is a recognition of the diverse flows of information and transformation that characterised it. In older histories, the 19th-century technological innovations might have been described entirely as the result of a growing Western presence in China, creating the false impression that it was solely members of the European and American communities in China who drove progress forward, and that the new technologies that emerged in treaty-port China remained forever 'Western'. In recent years, scholars have become far more alert to the diversity of communities of non-Chinese residents in China, as well as the ongoing processes of adaptation and integration that make their identification as exclusively Western untenable. That diversity included members of wide-ranging diasporic communities. Silas Hardoon 哈同 (1851–1931) and his wife Liza Roos (Luo Jialing 羅迦陵, 1864–1941) (fig. 5.45), who made their home in Shanghai, were part of a mobile network of Jewish merchants and their partners, whose ability to draw on mercantile networks across the globe had precedents that stretched over nearly a thousand years but reached new heights with the arrival of faster modes of communication and transport systems.

5.37

Red jacket embroidered with steamships

Creative embroiderers were quick to embrace novelty fashions and it was not long before imagery of the new technology of trains and paddle steamers found its way onto women's clothing and accessories. This scarlet jacket has a repeating pattern that includes images of paddle steamers. Urban fashion thrived on novelty patterns created from a pool of imagery that included popular prints, advertisements, papercuts and books of designs. Using coloured ribbons in contrasting colours of varying widths to trim the collar, cuffs and edges provided an opportunity to experiment with patterns and create more individual styles.

1880–90, Suzhou or Shanghai. Silk, gold thread and embroidery. H. 94 cm, W. 117.8 cm. Cleveland Museum of Art, 1916.1357. Gift of Mr and Mrs J.H. Wade

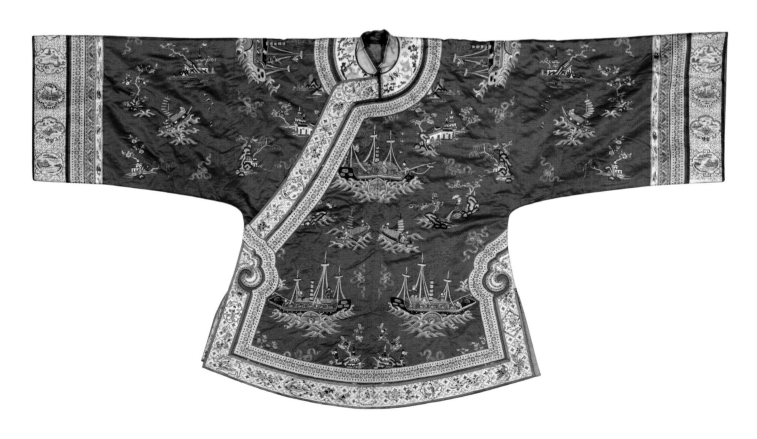

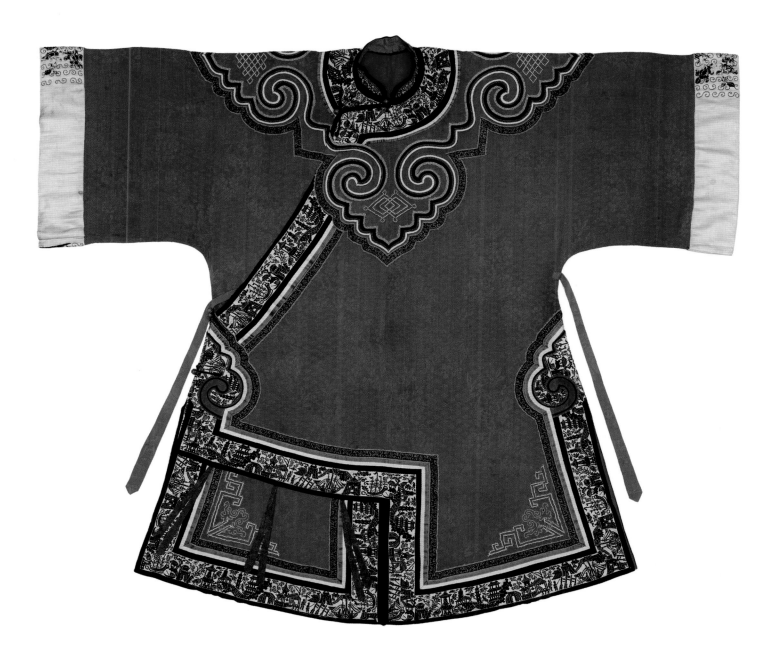

5.38
Jacket with a border of steamships
A symbol of both industrial imperialism and modernisation, newly developed foreign steamships were permitted into Chinese waters (both coastal and key river networks) in the mid-19th century as a consequence of the treaties concluding the Opium Wars, which eroded Qing China's sovereignty. In the 1860s, ships from all over the world travelled up and down the Yangzi river, but by the 1880s three companies (two British and one Chinese) emerged to dominate the market and held the Japanese, French and German competition at bay. Before the railways began to be built, steamships were the only form of modern transport in the Qing empire. Using a decorative border of steamships gave a modern edge to the red jacket.

1860–1900, China. Silk, cotton and embroidery. H. 130 cm, W. 152 cm. British Museum, London, 2022,3030.3. Purchased with the Brooke Sewell Permanent Fund

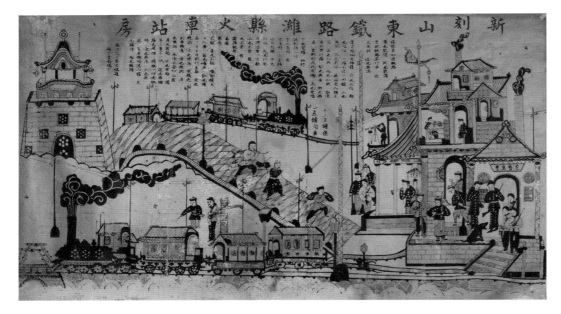

5.39
Poster for a Shandong line train
This propaganda poster promotes modernity and prosperity through new technology, and it encourages communities to accept the building of the new railways and telegraph systems. It is captioned 'New Print of the Shandong Railway Line's Wei County Railway Station (新刻山東鐵路濰縣火車站房)'. It also advertises other symbols of modernity, including women with rifles, a man looking through a telescope and new telegraph poles.

1905, Shandong. Ink and colours on paper. H. 56.5 cm, W. 100 cm (entire object). The British Library, London, Or. 15376 f001r. Bought from Elden Warrel, via Roger Keverne

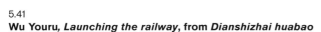

5.40
French clock in the form of a steam engine
The first railway to operate commercially in China opened in Shanghai in July 1876. This short-distance Woosung Road railway ran from the American Concession in present-day Zhabei district to Woosung in today's Baoshan district, and was built by the British trading firm, Jardine, Matheson & Co. French clocks like this one were highly prized at court in the Guangxu emperor's reign, particularly by Empress Dowager Cixi.

1880–1911, France. Metals, marble and textile. H. 46 cm, W. 52 cm, D. 24 cm. Palace Museum, Beijing, Gu.00183513

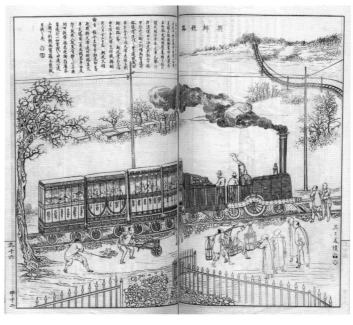

5.41
Wu Youru, *Launching the railway*, **from** *Dianshizhai huabao*
By the late 19th century, new technologies such as lithography (in *c.* 1876) for the reproduction of images had been invented. The *Dianshizhai huabao* weekly pictorial magazine was produced in Shanghai from 1884 onwards, using the photolithographic technique. It introduced to Chinese readers aspects of Western life embellished with fantasy, but it also reported on actual events such as the opening of the new railways (shown here), the launching of hot air balloons and new-fangled fire engines.

1884–5, Shanghai. Lithographic printing. H. 22 cm, W. 12 cm (approx., closed). SOAS University of London, E Per 81267

5.42–5.43 (below)
New-style banknotes printed in Shanghai
The same printing houses that produced the
Dianshizhai huabao and *Shenbao* also produced
banknotes, often combining the artistry of
traditional Chinese illustration with modern
scenes of steamships, trains and city life.

1905–12, Shanghai. Printing ink on paper.
H. 23 cm, W. 11 cm. British Museum, London,
1984,0605.8449 and 8457

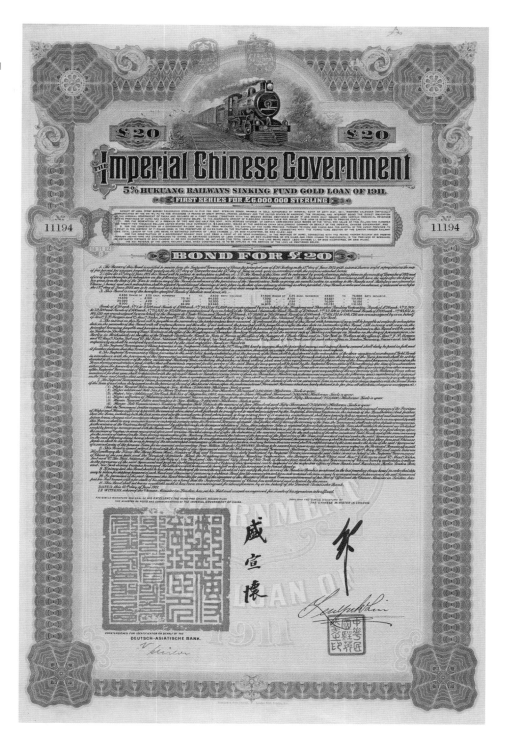

5.44 (above)
Railway bond of imperial China, 1911
Bonds were issued by the Qing state for the
building of new railways. The Canton–Hankou
Railway was the first line to be nationalised and
the Hukuang loan agreement involved British,
French, German and American participation. This
bond bears the facsimile signature and seal of
His Excellency The Kung-Pao Sheng Hsuan-huai

盛宣懷, Minister of Posts and Communications of
the Imperial Government of China and Lew Yuk
Lin 劉玉麟, the Chinese Minister in London, and is
countersigned by the Deutsch-Asiatische Bank.

1911, China. Printing ink on paper. H. 55 cm,
W. 37 cm. British Museum, London, new
acquisition. Gift of Richard Henke to the
American Friends of the British Museum

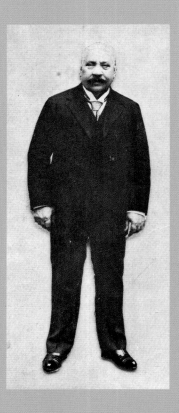

Key figures: Silas Hardoon (1851–1931) and Liza Roos (1864–1941)

5.45

Portraits of Silas Hardoon and Liza Roos (Luo Jialing)

Silas Aaron Hardoon 哈同 was once one of the richest men in Asia but he was born a poor Sephardic Jew in Iraq. He made a fortune in Shanghai through selling opium, renting out properties and investing in the new stock exchange. Hardoon has been described as both a miser and a philanthropist. He developed the now famous Nanjing Xi Lu (Nanjing West Road) and endowed Buddhist temples. With his wife, Liza Roos 羅迦陵, who had a French father and Chinese mother, Hardoon sponsored an edition of the Buddhist text, the Kalaviṅka Canon (頻伽大藏經), based on the Japanese Gukyōzō

(弘教藏), completed in four years between 1909 and 1913 and printed on his estate, overseen by the monk Zongyang 宗仰 (1861–1921). The print work was done by the Chinese Library Company (中國圖書公司), a commercial printer in Shanghai, and stands as a testament to Hardoon's mediations between multiple cultures.

1923, Shanghai. Printed photographs. H. 25 cm, W. 15 cm (closed book). SOAS University of London, RJ c 850 c. 43

Similarly, the Muslim merchants who were based in the treaty ports on the south coast of China drew on established networks of Muslim traders that had long connected the Indian Ocean and the South China Sea. Both Jewish and Muslim merchants benefited from and contributed to the new technological landscape, while Russian traders settled in Xinjiang after the signing of the Treaty of St Petersburg, bringing with them 'Russian institutions, influence and authority' to China's Inner Asian territories.[18]

Opium, medicines and missionaries

The opium trade, which brought the economies of South and East Asia closer together than ever before, certainly generated opportunities for the creation of very substantial wealth for individual traders such as Hardoon and companies like Jardine, Matheson & Co. in Hong Kong, as well as for powerful Chinese mercantile interests from centres such as Chaozhou. This narcotic commerce and the growing consumption of opium throughout China had consequences far beyond the devastation opium caused to the lives of individual addicts. While the trade created commercial opportunities that made a relatively small number of merchants exceedingly wealthy, it also made the businesses of a far larger number of small-scale producers, traders and shop owners economically viable. It makes for a difficult-to-stomach contradiction, between the exploitation and destruction that was inevitably connected to the opium trade, and the thriving sideline businesses that benefited from that exploitation. Opium syndicates from Chaoyang that succeeded in pushing even the British out of the inland Chinese drug trade, the Qing historian Melissa Macauley argues, invested their profits to benefit Chinese interests 'in banks and factories; they built schools and hospitals; they contributed a phenomenal amount of disaster relief to a home region constantly beset by natural calamities. Their financial support of the needy outstripped the support that any Chinese state managed to provide prior to 1949.'[19]

Two groups that arguably 'benefited' from the presence of opium were the Christian societies

5.46

Lamqua, *Woman with a growth on her right hand*

Between the 1830s and 1850s, the Cantonese artist Lamqua produced a series of medical portraits of patients with tumours, depicting them both before and after surgery. These were commissioned by the American physician and missionary Peter Parker (1804–1888). European viewers perceived these paintings as evidence of assumed 'Chinese characteristics' (such as insensibility to pain), the failings of Chinese medicine and of the transformative power of Western medicine and religion. Chinese Christian preachers used them to advertise the supposed curative benefits of (Christian) science. Such paintings were superseded in the 1860s by medical photographs.

1834–55, Guangzhou. Oil painting on wood. H. 61 cm, W. 47 cm. Yale Cushing/Whitney Medical Library, New Haven, 15948651

in China and medical establishments. Christian missionaries had long been aware of the damage caused by opium and had written to their audiences back home about this 'affliction', asking for financial contributions to support their ongoing work with those affected by opium consumption. The missions included medical professionals who worked both alongside and in opposition to traditional Chinese medicine doctors. Portraits of patients with life-changing illnesses were painted in full detail by artists in Guangzhou (fig. 5.46); some also had a companion image that depicted the individuals as healed and fully recovered. Such images served to generate interest and sympathy among communities back home, and provided opportunities for fundraising and the promotion of Western-style medicine.

Initially, missionaries could only work on the edges of the Chinese empire (figs 5.47–5.48), and they sometimes developed medical sidelines to enhance the appeal of the religion they were preaching. One of the earliest Protestants in China, the Scottish Robert Morrison, for example, ran a dispensary in Macao, the small enclave southwest of Guangzhou that had previously been ceded to Portugal and where foreigners could reside year-round.[20] The growing but illegal trade in opium, however, offered missionaries a way into the China that lay beyond Guangzhou. The unconventional German Lutheran Karl Gützlaff (1803–1851), for example, worked as a translator for British opium merchant William Jardine in the 1830s, when both opium traders and Christian evangelists were transgressing against existing Chinese legislation to scope out the coastal territory and its hinterland, seeking opportunities to spread both opium and religion.[21] Gützlaff would have identified the opium trade as a necessary evil to reach the potential souls that could be saved.

It was only after the signing of the Treaty of Nanjing and the opening of the first treaty ports that missionaries started to arrive in significant numbers in China, and only after the Treaty of Tianjin that they could venture beyond the confines of the treaty ports (and, even then, with difficulty until the 1880s). After Tianjin, the treaty ports remained key to the religious activities of the missionaries, but the latter's influence spread far beyond their boundaries, as proselytisers could travel throughout the empire to establish

5.47 (below)
Catholic priest's hat with Sacred Heart

Through the Treaty of Huangpu in 1844, between the Qing government and France, proselytisation of Christianity (especially Catholicism) was legalised. Missionaries targeted the general population and not just elites, offering famine relief, medicine and education as inducements. Often aware of local religious scriptures, illustrations and practices, missionaries sometimes borrowed their language and conventions. But China was sensitive to these and other forms of outside penetration into local society, especially by foreigners who were protected by treaty-given privileges. The Tianjin incident of 1870, the Yangzi river riots of 1891 and the Boxer War of 1899–1901 all demonstrated active, organised anti-Christian sentiment.

1840–1900, China. Silk, embroidery and coral beads. L. 94.5 cm, W. 19 cm. Chris Hall Collection

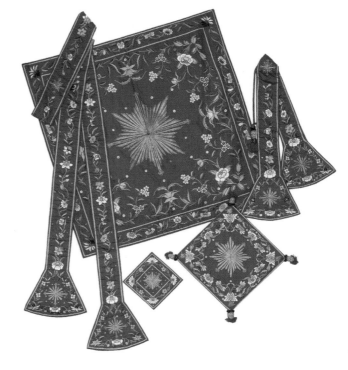

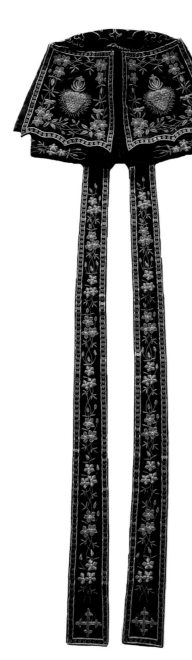

5.48 (right, top and bottom)
Catholic vestments and textiles

These scarlet silks follow prescribed forms for celebrating the Eucharist (the Christian rite commemorating Jesus' Last Supper). They include a priest's tabard to wear over a longer robe, a cover for the chalice and textiles on which to place the host (the consecrated bread). The embroidery is a Chinese design. Guangzhou and Macao, where this set was made, were the first places where missionaries could live and preach.

1800–1900, Macao. Silk and embroidery. H. 94.5 cm, W. 71 cm. Chris Hall Collection

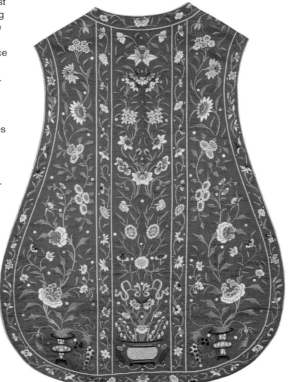

Key figure: Ida Kahn (1873–1931)

5.49
Portrait of Ida Kahn
Ida Kahn (Kang Aide) 康愛德 was a pioneering female doctor, the adopted daughter of Gertrude Howe, an American Methodist Missionary in the treaty port city of Jiujiang in southeast China, who adopted her as a small baby and brought her up to be bilingual, which was very unusual at the time. Thanks to her adoptive mother, Ida had the opportunity to study medicine in both the United States, where she obtained a medical degree from the University of Michigan, and in England. She returned to China in 1896 where she was hailed as a 'modern woman' and managed to gain the support of both local gentry and foreign missionaries. She became a great advocate for women's education and later successfully founded a hospital for women and children.

c. 1890–96, probably Michigan. Photograph. Bentley Historical Library, University of Michigan, Ann Arbor

churches, orphanages and schools, including schools for girls wherever they saw the need. In 1894, Ida Kahn became the first Chinese woman to obtain an American medical degree (fig. 5.49). She had obtained her US education through her adoptive mother, a Methodist in Jiujiang. Kahn went on to become a pathbreaking medical practitioner and administrator, and an impressive mediator between the sinophone and anglophone worlds.

But the close connection between opium and religion remained. Revealingly, the geographical spread of Christianity maps closely onto the patterns of the spread of opium consumption (fig. 5.50). Detoxification centres were often run by Western missionaries. ('How strange it was,' one observer of British anti-opium activities mused, 'that the country which sends the poison should also send the antidote.'[22]) While missionaries saw conversion to Christianity as one way to 'resolve' the opium problem, curing the health issues related to opium use was another approach they espoused. Medicine had long been key to the spread of Christianity all over the world, offering not only a very practical way to bring relief to those in need but also an effective means of drawing attention to their cause.[23] Initially, in the early decades of missionary medicine in China, it was the transformative effect of minor surgeries that impressed the most, but soon it was the opium crisis, especially where it was exacerbated by

5.50
Album leaf with Christian parable
This page from a large, traditionally illustrated Chinese-format album shows the Christian scene of the Parable of the Good Samaritan. The album was probably made for a Chinese Christian because its illustrations are captioned with Chinese texts.

1850–1912, China. Ink and colours on paper. Image: H. 22 cm, W. 24 cm; album: H. 55.5 cm, W. 40.5 cm. British Museum, London, 1938,1112,0.49-51. Donated by G. Abercromby

5.51

Model of a pharmacy in Guangzhou

In this model pharmacy, patients and doctors are shown at a table with a small dog curled up at their feet, while people prepare medicines either side of them and upstairs. The shelves are stacked with different remedies. Traditional Chinese medicines are made from plants, animals and minerals, and prescriptions often mix different substances, aiming to treat the organs affected by the disease and to strengthen the body and stop the condition from spreading. Carefully constructed display models of this type, made to order in China, were popular with museum visitors in the United Kingdom in the late 19th century.

1881–5, Guangzhou. Cotton (fibre), glass, metal, pottery, textile and wood. H. 183.5 cm, W. 87.6 cm, D. 161 cm. Science Museum, London, Sir Henry Wellcome's Museum Collection, A645084 Pt2

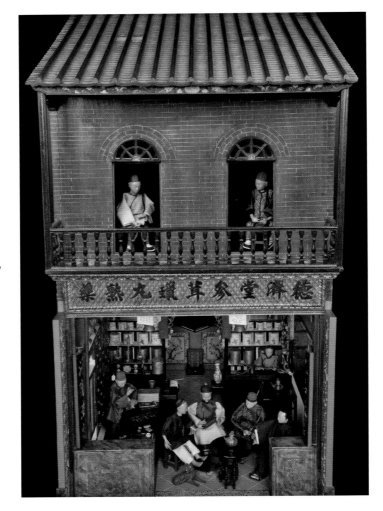

5.52

Devil's tongue, from *Poisonous Plants* (毒草)

This illustrated manuscript describes poisonous and medicinal plants. It uses knowledge derived from observation of nature rather than from past textbooks and includes local knowledge from Yunnan and Guangdong provinces. Many of the plants and other materials were used in Traditional Chinese Medicine. This page describes devil's tongue (*Amorphophallus konjac*), also known as konjac, voodoo lily or snake palm. Today, devil's tongue is used in products sold as weight-loss supplements and facial massage creams. It is a member of the same genus as the titan arum, said to be the worst-smelling plant on earth, with an odour reminiscent of rotting flesh. Although there is a long history of producing illustrated books of plants in China, particularly those used in Traditional Chinese Medicine, the illustrations here appear to draw inspiration from Guangzhou watercolours and European botanical paintings.

c. 1850–90, southern China. Ink and watercolour on paper. H. 33.3 cm, W. 23.9 cm (closed). The British Library, London, Or. 13347B ff006v–007r

5.53
Medicine chest

A doctor trained in Traditional Chinese Medicine filled this travelling medicine chest with ointments, powered plants, dried insects, lizards and seahorses, as well as written charms to speed recovery, all stored in separate compartments, some of them packed with cotton wool. In the 19th century, Chinese scholars studied both Western and Japanese medicine, in addition to their own medical heritage.

For example, during his visit to Japan from 1880 to 1884, Yang Shoujing 楊守敬 (1839–1915), the Chinese antiquarian, scholar and book collector, purchased many rare books. After returning to China, Yang transmitted the knowledge from these books by contributing to the publication of medical compendia. Along with the movement of people within and beyond China during the late 19th century, such publications helped spread new and older knowledge within the Chinese-speaking world.

1890–1910, China. Wood, organics, paper and cotton. H. 8 cm, W. 62 cm, D. 45.5 cm. Great North Museum: Hancock, Newcastle, NEWHM: D716

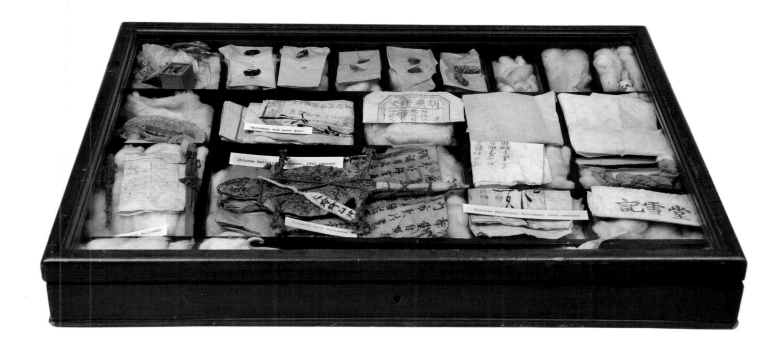

natural disasters, that seemed to create the most urgent opportunities for the intervention of Christian medics.[24] Unfortunately, their interventions were sometimes worse than the disease they sought to cure: so-called 'Jesus opium' or anti-opium pills were known to contain morphine. Such pills were being marketed in 19th-century Europe as a pain medicine but seemed to create their own kind of addiction.[25]

The same kind of hybridity that suffused the production of art and material culture also characterised missionary medicine. Working with locally trained doctors as well as those they had inducted into their own medical traditions, Western missionaries relied both on what would come to be known as Traditional Chinese Medicine practices and remedies (figs 5.51–5.53) and on the medical knowledge they had brought from home. In fact, medical practices of the late Qing and

early decades of the twentieth century often revealed the complex relationship between what most of the Chinese population considered appropriate drugs and treatments for their own bodies and the modernising medical interventions championed by intellectuals and Western doctors (figs 5.54–5.55).[26]

The idea that Chinese and Western medicine should be brought together culminated in the organisation of the School of Converging Chinese and Western Medicine (中西醫匯通學派) in the 1890s. It was short-lived, however: the effort was abandoned when the outbreak of the Manchurian plague in 1910–11 was convincingly contained by Western public health measures, after all other attempts had failed spectacularly.[27] One of the key figures in this containment was the Malaysian-born doctor Wu Liande 伍連德 (Wu Lien-teh, 1879–1960) (fig. 5.56), who

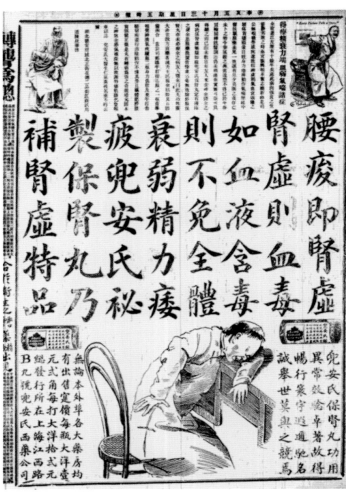

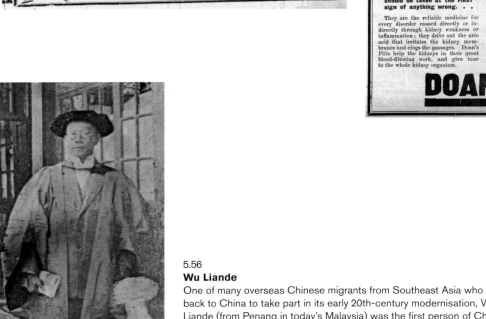

5.54–5.55

Doan's Kidney Pills advertisements in *Shenbao*, 9 June 1911 (left) and in *The Bulletin*, 20 June 1907 (below)

Patent medicine advertisements in the treaty port press combined older Chinese and newer Western ideas about the body and disease; as part of the mass media, they reached a far larger audience than did professional medical journals and institutions. Many Western and Japanese medical products were thus popularised in the late Qing. Doan's Kidney Pills were the invention of the Canadian pharmacologist James Doan (1846–1916), and began to be marketed globally at the end of the 19th century. By 1908, the company had offices in Shanghai. The company had a hybrid China marketing strategy. Advertisements like this one from a Sydney newspaper were transferred to China, substituting images of Chinese consumers for Western ones. The Chinese publicity emphasised the medicine's use of fenugreek seeds (an established ingredient in Chinese herbal medicine) and its ability to restore what the Chinese understood as 'kidney deficiency'. But they also explained to consumers Western understandings of the filtering function of the kidney, boasting that their medicine could resolve urinary problems and backache.

Shanghai, 1911; Sydney, 1907. Printing ink on paper. National Library of Australia, Canberra

5.56

Wu Liande

One of many overseas Chinese migrants from Southeast Asia who came back to China to take part in its early 20th-century modernisation, Wu Liande (from Penang in today's Malaysia) was the first person of Chinese descent to study at the University of Cambridge. He was a doctor known for his work in public health, particularly the Manchurian plague of 1910–11.

c. 1903, possibly Kuala Lumpur. Printed photograph

had trained in Cambridge, England, but returned to China to establish the North Manchurian Plague Prevention Service (東北防疫處) in 1911. What has been called 'China's first attempt at a public health service' established a firm connection between Chinese and Western health practices.[28] In identifying the bacillus causing the plague and a series of highly effective public health policies to contain it, Wu and his team in northeast China were at the cutting edge of global pandemic medicine in the early 1910s.

Just as the outbreak of plague in Manchuria should be understood not in isolation, but as part of the third pandemic of (bubonic and pneumonic) plague that affected the entire world between 1894 and 1959, the approaches to eradicating the disease cannot be understood only in their late-imperial Chinese contexts. A figure like Wu Liande was part of a globally mobile population, key to the exchange of specifically medical knowledge between Europe and China and the growth of convergences between Chinese and Western medicine.

It is these convergences of ideas and materials in many spheres that connected China to the worlds surrounding the empire. The goods that flowed in and out through ports like Guangzhou, as well as the material objects that were created within Guangzhou and attracted consumers all over the world, including within the Chinese empire, are testament to the 'global Qing'. The craftsmen and women who created these goods, and the merchants who moved them from producers to consumers, responded to the desire for 'global' consumption: products made in new materials, designs and styles that conjured associations with other places than one's domestic environment. The movement of materials, the flow of ideas and the mobility of populations created the opportunities that made the Qing global, attracting merchants like the Chaozhouese and the Parsis, a missionary like Gützlaff, or medics like Ida Kahn and Wu Liande. The desire for global goods created connections that reached across all kinds of divides: the Chinese heartland and its borderlands, the Chinese ports and China's overseas partners throughout Asia, and Qing China and the West (Europe and the United States). It also inspired the residents in all those places: the diverse communities that inhabited the treaty port cities such as Guangzhou and Shanghai; the businessmen, travellers, missionaries, medics, artists and artisans that criss-crossed such spaces; and consumers in London, Paris, New York and the inland provinces of the Chinese empire. They were all part of a complex world that was in increasingly rapid flux. Rather than being characterised by sharp contrasts or abrupt transformations from one mode of existence to another, this world was one of ongoing fluidities and transitions, in which new ideas interacted with all manner of older ones, new technologies coexisted with pre-existing methods and innovators with traditionalists – in China just as it was in other parts of the 19th-century world.

Chapter 6

Reform to Revolution

Jeffrey Wasserstrom

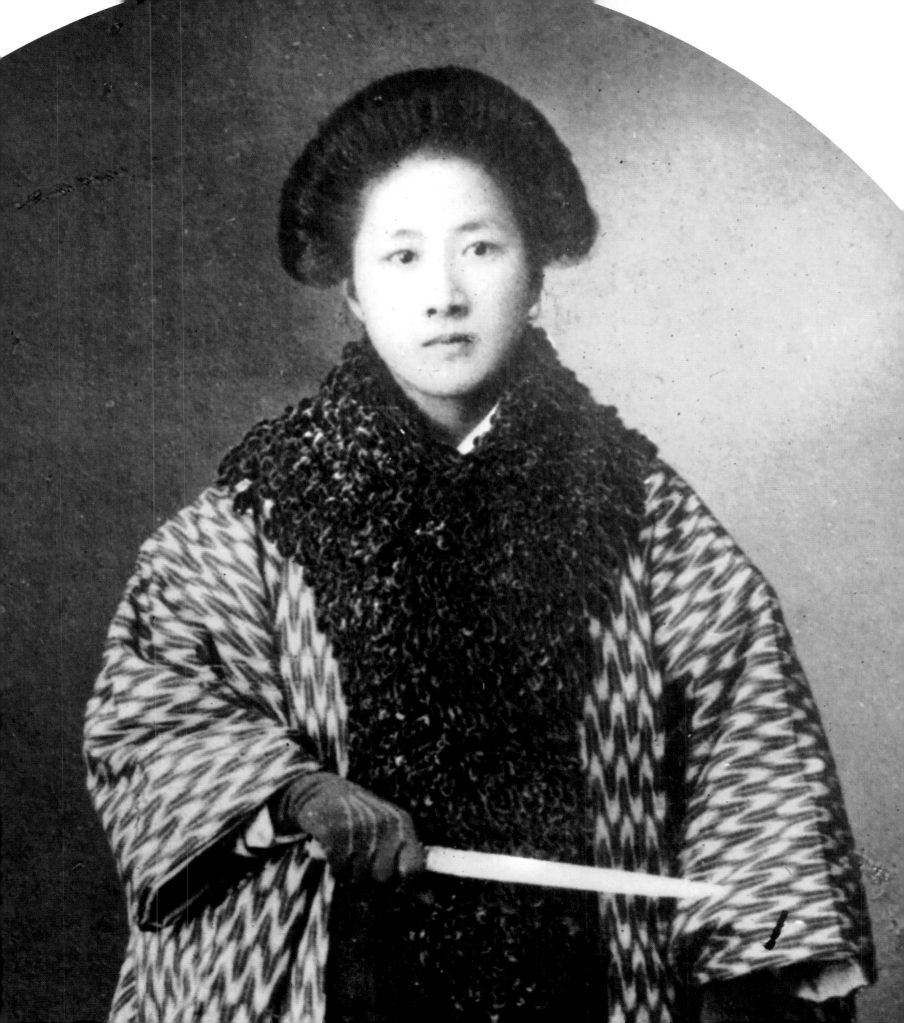

During the last decades of Qing rule the world became dramatically smaller and more tightly interconnected. The invention and spread of new modes of transportation and communication knit locales and people together in novel ways. These changes generated a complex cocktail of excitement and anxiety in varied settings, including China, not unlike the mixed emotions triggered in recent years by different sorts of world-shrinking technologies. Back then, it was not jet planes but instead ships and trains powered by steam that moved migrants, travellers, soldiers, products and weapons further and faster than ever before. Then, it was not satellite transmissions and the Internet but overland wires and undersea cables carrying Morse code messages that sent news, rumours and ideas speeding around the planet. The term 'globalisation' was not used to describe what was happening; that word would not be coined until after the Republic of China was founded at the start of 1912. We can think of the late Qing, however, as an era of globalisation *avant la lettre*. It was a time of ever more robust international flows, and the shockwaves that new technologies sent across the empire and the ways they shook up settled global geopolitical hierarchies helped set the stage of the 1911 Revolution, the fall of the Qing and, with the last emperor's abdication, the end of China's millennia of monarchical rule.

A useful framework for thinking about these processes and beginning to understand their complex impact on Chinese history is provided by the late C.A. Bayly in his magnum opus *The Birth of the Modern World, 1780–1914*. Bayly refers to more than a century of 'proto-globalisation' preceding the outbreak of the First World War. He claims further that a 'great acceleration' of globalising trends began in the late 1800s.[1] This did not result in cultural homogenisation, he argues, but it did lead to increased standardisation, such as a trend for men in different lands to dress in more interchangeable ways (top hats for bankers, military caps for soldiers, etc.) and for states to regularise the symbols they used, including flags that differed in content but were of similar size and shape (fig. 6.1).

The increasingly global nature of international affairs made its mark in many spheres. It became more common for military clashes to involve soldiers from many lands, for example, and some of these were described as real or potential 'world wars'. An early use of this phrase, and perhaps the first to refer to an event in China, came in some contemporary commentaries on the 1899–1901 Boxer War that pitted anti-Christian militants and Qing troops against soldiers sent to China by eight different foreign powers (Austro-Hungary, the British empire, France, Germany, Italy, Japan, Russia and the United States).[2] The major multi-country peacetime spectacles of the age were gatherings called International Exhibitions, Universal Expositions or World's Fairs. These brought people from different parts of the planet together more peacefully than wars, of course, but they sometimes featured military parades, which tended to involve troops from among the same cluster of rising powers and established empires that were part of the Eight-Nations Allied Army (八國聯軍) which took control of north China at the close of the Boxer War. They also frequently included displays of not just industrial machines but also novel kinds of weapons, such as breech-loading guns (see figs 2.59–2.60), which were marvelled at by visitors much as

6.1
National Qing flag
This is the flag adopted by the Qing government in 1888 and used until its downfall in 1911 as a state banner and naval ensign. The proposal to adopt this design was part of the Qing government's 'Regulations for the Beiyang Fleet' – the largest modernised naval force in the empire. The flag's rectangular shape copied those of foreigners, rather than the triangular or square ones used by Qing armies.

1898–1904, China. Embroidered cotton. H. 114.3 cm, W. 177.8 cm. National Maritime Museum, Greenwich, AAA0459. With acknowledgements to the Royal Hospital of St Bartholomew

they marvelled at non-lethal inventions such as early telephones or, at the Paris Exposition of 1900, the first moving walkway. Telegraphed reporting and the circulation of images via illustrated magazines and new, more mobile photographic technology meant that there were, for the first time in this period, global news stories and celebrities: events that were followed by, and individuals whose names and faces became familiar to, people in many lands.

When it comes to China, the earliest news stories to be followed around the world by many on a day-to-day basis were the turn-of-the-century wars. One could argue that the first truly global news story originating in China was the Sino-Japanese War of 1894–5 (see pp. 126–9). This conflict ended with a victory for Japan – a country that had previously tended to be viewed by many in China as a minor neighbouring power, but which had surged upwards in regional and even global geopolitical hierarchies after the 1868 Meiji Restoration by embracing new technologies and new military institutions more rapidly than the Qing. Japan was of particular interest to late Qing intellectuals because it had modernised while retaining the emperor system: by the time it bested the Qing on the battlefields of northeast Asia, in a war fought to determine which country would exert the most influence on Korea, Japan had reformed politically to become the first constitutional monarchy in the region.

An even stronger case can be made, however, for the Boxer War being the first truly major Chinese global news event. For during the middle months of 1900, when foreigners from around the world were trapped in a fifty-five-day siege of Beijing's walled Legation Quarter (diplomatic district), the efforts by the Eight-Nations Allied Army to vanquish the Boxer and Qing coalition garnered even more headlines in the British press than the Anglo-Boer War that began and ended the year as Europe's and indeed the world's biggest news story. The author of the first American instant history of the Boxer War, *World-Crisis in China, 1900*, which was published while the siege of Beijing was still under way, asserted that 'everybody' was eager that summer to hear the latest 'news from China'. This phrasing suggested that the Boxer War was a bigger story in the United States than the fighting between US troops and Philippine insurgents in Southeast Asia, and the author, *Baltimore Sun* reporter Allen S. Will, claimed explicitly that his compatriots were so enthralled by dramatic developments in the 'Flowery Kingdom' that even the presidential campaign under way at home had come to occupy a 'subordinate place' in their minds.[3]

In terms of global celebrities, a case could be made that the first person in China to attain that status was the Empress Dowager Cixi. Her long period as the dominant figure in the ruling family led to her being compared to Queen Victoria, even though, unlike her

6.2

Cixi's luxury motor car

Empress Dowager Cixi was the power behind the imperial throne and de facto ruler of the Qing Empire for much of the period between 1861 and 1908. 'Masculine pursuits' and Western technology fascinated her. General Yuan Shikai gave her this American-made car to drive around the Summer Palace gardens, at a top speed of 40 km per hour. The fringed silk canopy and floor carpets woven with a dragon pattern were customised additions for her. This early petrol-fuelled Duryea Surrey has many advanced features, including a three-cylinder water-cooled engine and a centrally mounted tiller control for steering, speed and gear selection. Duryea had begun as a bicycle manufacturing company, but

in 1901 it teamed up with the J. Stevens Arms and Tool Company, a top sporting firearms manufacturer, to expand its evolving automotive business. Cixi's vehicle was probably the first car imported into China and is emblematic of Qing China's fascination with technological modernity.

1901, Reading, Pennsylvania. Metal, silk and others. H. 226 cm, W. 304 cm, D. 160 cm. Yiheyuan, Beijing

Key figure: Li Hongzhang (1823–1901)

6.3

Unidentified artist, Portrait of Li Hongzhang (detail)

Li Hongzhang was born in Anhui province and was a scholar-official and diplomat who rose to fame by helping to defeat the Taiping on behalf of the Qing state. From the 1860s onwards, he modernised the army as part of the Self-Strengthening movement, training smaller, more mobile forces in the use of modern weapons made in new Qing arsenals. Over the next 40 years, ever loyal to the reigning Manchu dynasty (though breaking with them temporarily when they backed the Boxers), he held many senior positions, and was involved in the Qing's most important interactions with foreign powers. Li survived an assassination attempt in Japan when he was sent to negotiate the Shimonoseki Treaty to end the Sino-Japanese War in 1895. In 1896, he represented the Qing empire at Nikolai II's coronation in Russia as part of a tour of the world, during which he also met the Kaiser and Bismarck in Germany, and Queen Victoria in England. The culmination of his diplomatic career was the painful signing of the Boxer Protocol in Beijing in 1901 when he was 77 years old. He died two months later, some say of stress and exhaustion.

c. 1860–1901, Beijing. Ink and colours on paper. H. 63 cm, W. 75 cm. National Museum of China, Beijing

British counterpart, she did not formally reign but exerted power as first a co-regent for her son and later as regent for her nephew while he was a minor, and after that nephew's coming of age informally as a family elder. There was widespread interest in everything she did and those following the news in distant settings were fascinated by trying to figure out her stance on foreigners and foreign ideas and objects – a stance that changed over time. They were angered by reports of her central role in getting the Qing to side with the Boxers in 1900, but intrigued by stories of her many possessions including a fancy motor car – customised to suit her grandiloquent courtly aesthetic – given to her by one of her generals (fig. 6.2).

An equally strong case could be made, however, for treating the senior statesman Li Hongzhang rather than Cixi as China's first global celebrity (figs 6.3–6.4). He gained fame initially for his role working with his mentor Zeng Guofan in suppressing the Taiping Civil War, and was subsequently involved in wide-ranging modernisation projects, including heading a steamship company – founded to assert Qing control over the country's waterways and to push back against foreign

naval dominance – and taking a leading role in the creation of the Jiangnan Arsenal, which supplied the Qing with the latest weapons (see p. 123). Li also served the imperial family as an official and diplomat. He was never compared to Queen Victoria, but he met her in England; unlike Cixi, who never left the Qing empire, 'Viceroy Li', as he was called in the international press late in the century, travelled the world (globe-trotting diplomacy was a notable innovation in late Qing politics). He met and was photographed with many of the most famous Western men of the era, including Ulysses S. Grant – who stopped in China on a post-presidential trip around the world and was said to have formed a strong bond with Li while there – and William Gladstone (fig. 6.5). A trip Li took to the United States, during which he visited Grant's Tomb to pay respects to the memory of his late friend, was the subject of an early silent film. And he became so well known internationally that, at a time when it was common for fast steeds in the West to bear monikers honouring celebrated figures from history and famous living generals and politicians and entertainers, racehorses were named after him.[4]

6.4
Snuff bottle depicting Li Hongzhang
c. 1900–10, Beijing. Inside-painted rock crystal and glass. H. 6.2 cm. The Water, Pine and Stone Retreat Collection

6.5
George Watmough Webster (1842–1919), Li Hongzhang and William Gladstone
The Confucian statesman and Qing diplomat Li Hongzhang visited the United Kingdom as part of a world tour in 1896. He was hosted by William Gladstone, a veteran politician and four-time prime minister, lately retired, at his country estate in Wales, where this photograph was taken. Li's next stop was Barrow-in-Furness, then one of the largest steelworks in the world.

15 August 1896, Wales. Albumen print. H. 12.9 cm, W. 10 cm. National Portrait Gallery, London, 2012 NPG P1700(22c). Given by Martin Plaut

The Chinese response

The world growing smaller had profound and varied effects on the Qing empire that went beyond wars and celebrities. China was changed forever by the way people, products and ideas moved into and out of the realm. The struggle over how to respond to new threats and opportunities associated with global flows, new technologies and shifts in the international order triggered by these innovations defined the Qing empire's political, social and cultural history during the decades leading up to the founding of the Republic of China.

One response was negative, taking the form of late Qing waves of anti-foreign violence fuelled in part by early stages of globalisation. An example was a massacre of Catholics in Tianjin in 1870 (fig. 6.6). Another, which culminated in the Boxer War, began with attacks on Christians in northern Chinese villages in the late 1890s. These were the work of millenarian militants who sometimes called themselves the 'Righteous and Harmonious Fists' (義和拳), practised a form of martial arts known as 'spirit boxing' and had a creed that incorporated elements of various folk religions (fig. 6.7). Until the final days of 1899, these sectarians, dubbed 'Boxers' by missionaries, only attacked Chinese Christians. From that point on they sometimes attacked foreigners (figs 6.8–6.9), usually but not always missionaries, though from start to finish they killed more Chinese Catholics and Protestants than members of any other groups. Their expressions of loyalty to the Qing convinced the imperial family to shift in mid-June 1900 from suppressing to supporting the Boxers. As spring turned to summer, joint forces of members of the sect and Qing troops laid siege to the foreign quarters in Beijing, just as they had earlier to those of nearby Tianjin, where the foreign captives included the future US President and First Lady, Herbert and Lou Henry Hoover.

These outbursts were caused partly by irrational fears of the foreign rooted in rumours and supernatural beliefs. The Tianjin Massacre was triggered, for example, by claims that missionaries who cared for orphans were harming Chinese babies. The Boxers were convinced that a devastating drought had been caused by local gods withholding rain to show displeasure at the polluting presence on sacred land of new, Christian beliefs and objects. Pragmatic concerns, however, also came into play, as did the geopolitical shifts of the time associated with the expansion of old empires and the rise of new powers. Britain and France opportunistically sought and often gained control over additional parts of the empire in the late 19th century

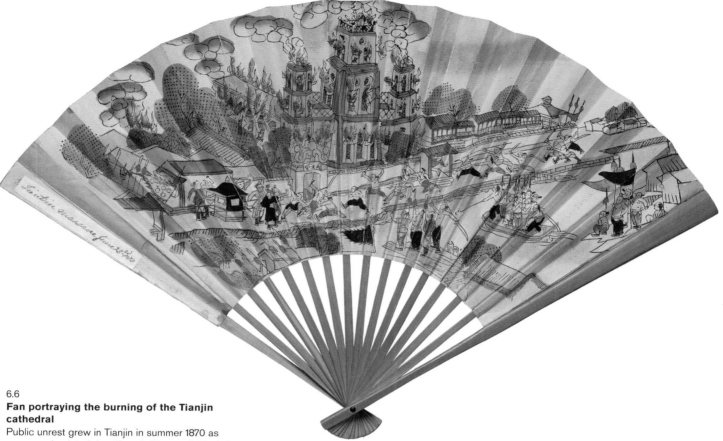

6.6

Fan portraying the burning of the Tianjin cathedral

Public unrest grew in Tianjin in summer 1870 as rumours circulated that 'French Sisters of Charity' were kidnapping and mutilating Chinese children. On 21 June, the French consul, Henri Fontanier, fired into a crowd that included local officials. A servant was killed, and in retaliation the mob killed Fontanier and some 20 other people. This fan was one of many printed in Tianjin, and enhanced with painted details, which show the turmoil of events and stirred up emotion. The violence escalated; European warships were sent to Tianjin. Western powers insisted on 16 Chinese people being executed for the crime and an official Qing delegation was sent to France to apologise. However, relations continued to deteriorate. In 1897, two German priests were killed in an incident that Germany used as justification for seizing control of Qingdao, a promising port on the coast of Shandong. Other foreign nations made similar land grabs, setting off a 'scramble for China'.

23 June 1870, Tianjin. Woodblock colour print on paper, and bamboo. H. 30 cm, W. 49.5 cm. British Museum, London, 1945,0414,0.1. Donated by Mrs C.A.M. Jamieson

6.7

Boxer soldiers

This photo depicts soldiers of the Righteous and Harmonious Fists (義和拳) organisation, also known as 'Boxers' due to their practice of a certain form of martial arts.

c. 1899–1900, Beijing. Printed photograph

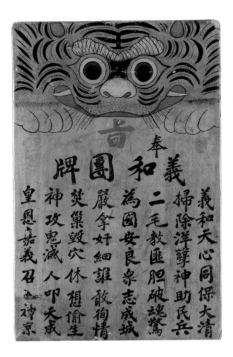

6.8
Boxer placard
This painted wooden placard warns of the harm that will come to those who fraternise with foreign enemies. Empress Dowager Cixi (and therefore the figurehead Guangxu emperor) had decided to support the Boxers, seeing them not as rebellious subjects but as their only hope of getting rid of foreigners from the capital and restoring imperial power. The placard reads: 'The Boxers followed the emperor's will to protect the Great Qing together. (義和天心, 同保大清。) Wiping out the evil foreign militia (we) had divine support at our disposal. (掃除洋孽, 神助民兵。) Chinese Christians shuddered and trembled with great fear. (二毛教匪, 胆破魂驚。) Safeguarding common people's interest for our country, this idea united people into an impregnable stronghold. (為國安良, 众志成城。) Spies should be severely punished, who dares show sympathy? (嚴拿奸細, 誰敢徇情?) Burn their nests and destroy their dens, no one can escape. (焚巢毀穴, 休想偷生。) The devils perished under the attack of divine power, sincere worship of Heaven by the Boxers made it happen. (神攻鬼滅, 人叩天成。) Infinite royal graciousness praised the Boxers for their righteousness and therefore summoned them to an audience in the capital. (皇恩嘉義, 召入神京。)'

1900, north China. Painted wood.
National Museum of China, Beijing

through wars and threats of violence, and over time Germany, Japan, Russia and the United States all became involved as well in what historian Robert Bickers has aptly called the 'scramble for China'.[5] Missionaries were understandably seen by some Chinese people, and not just the Boxers, as complicit in this process, especially when they lobbied diplomats in the capital to pressure the Qing to get local magistrates to back Christian over non-Christian communities in disputes over land and water rights.[6]

Rejections of the new and the foreign are only one part, and not the central part, of the story of responses to the 'great acceleration' of world-shrinking forces during this era. A larger role was played by what – drawing on a term from Chapter 5 (see p. 262) – will be called here 'hybrid' responses to globalisation. The most important reactions to the shock of the new and to military defeats – from those the Qing suffered during the Opium Wars of the middle of the 19th century to the Sino-Japanese and Boxer ones of the dynasty's final years – were from people who insisted that the best way to strengthen China and prevent it from being colonised, as India and other nearby states had been,

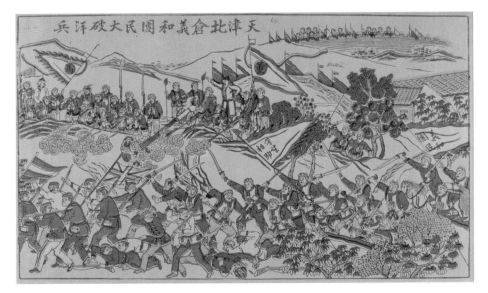

6.9
Unidentified artists, *Rout of foreign troops by Boxers at Beicang near Tianjin* (天津北倉義和團民大破洋兵)
Popular prints have a long history in China but beginning in the late 1800s they were used in a new way to celebrate victories in battles and to circulate news and propaganda, particularly war reporting. Each printmaking centre had its own style of production, but all were characterised by a fairly restricted palette of bold colours – blue, red, yellow and black. This print celebrates Qing victories over foreign soldiers in the Boxer War.

1900, Tianjin. Woodblock colour print on paper. H. 31 cm, W. 51.7 cm. British Museum, London, 1948,0710,0.7. Donated by Edward Butts Howell

6.10 (left)
Liang Qichao, calligraphy
Although Liang advocated a 'modernised' written Chinese, one that simplified the classical language and imported foreign words, this pair of scrolls is evidence of his attachment to the literary aesthetics of classical Chinese. The texts are about maintaining one's love of nature despite the corrupting influence of office-holding. They read (right): 'Turning one's head from the turbulent waters, [to gaze on] a clear moonlit stream (掉頭獨泛清谿月)', and (left): 'Resting the chin on one's tablet of office, [watching] clouds over the southern mountains (拄笏看度南山雲)'. The scrolls, the left-hand one bearing Liang's signature, were dedicated to 'my friend Ren Xian for his examination (任先老兄察書)'. Ren Xian might refer to Chen Lu 陳籙 (1877–1939), who graduated from the University of Paris and became a diplomat in the early 20th century.

c. 1913–17, China. Ink on paper. H. 168.3 cm, W. 39.6 cm (each scroll). British Museum, London, 2002,0130,0.34.a–b. Donated by Gordon and Kristen Barrass

6.11 (above)
Cover for Liang Qichao's *New Citizen's Journal* (新民叢報), 1903
Published in Yokohama, Japan, between 1902 and 1907, the *New Citizen's Journal* offered comprehensive information on current events and modern topics.

1903, Yokohama. Printing ink on paper

6.12 (above)
Ink cake in the form of a globe
Cakes of ink mixed with water for writing with a brush had long been impressed with images. This example with the pressed image of a Western globe was made from the mould of the ink cake sent for the Panama exhibition in 1915 by the Hu Kaiwen 胡開文 ink factory, a Huizhou firm in the heartland of traditional ink production.

1915, Anhui. Carbon and animal glue. Diam. 12.2 cm. Anhui Museum, Hefei

was to fuse elements of the traditional and the novel, of the domestic and the foreign (fig. 6.10). Many framed their vision of hybrid approaches around a distinction between the 'essential' (體, *ti*) and the 'useful' (用, *yong*). Some called for only 'useful' foreign technology to be borrowed while everything else remained the same, lest China lose the cultural 'essence' that made it special. Others accepted the idea that it was important to preserve some aspects of the traditional, including the monarchy, to protect China's core culture, but thought that embracing the practical strengths of foreign polities should involve changing at least some institutions, and supported translation projects and sending some youths to study in the West and Japan. Eventually, some radicals rejected the *ti/yong* formulation, at least if it preserved monarchical rule, and proposed revolutionary, republican alternatives that dispensed with the emperor altogether.

Material culture

Many objects and images in this book draw attention to the challenges and opportunities that the Qing faced during this early version of globalisation. Globes loom large in illustrations from the booming late Qing periodical press (fig. 6.11); and the globe inspired an

Key figure: Duanfang (1861–1911)

6.15
Ma Shaoxuan, Snuff bottle with a portrait of Duanfang
Duanfang 端方 was a bannerman, statesman and fine-art collector. Traditionally educated, cosmopolitan and trusted at court, he supported the 'Hundred Days' Reforms' movement but was protected (as Kang Youwei and Liang Qichao were not) by his close connections with the imperial family, including the Empress Dowager Cixi's confidant, the eunuch Li Lianying 李連英 (1848–1911). Duanfang held a number of official posts in different provinces and the capital, and in 1905 joined a delegation that travelled abroad to seek information about constitutional monarchies, with a view to reforming the Qing government. He imported animals from Germany to start the Beijing public zoo in 1907, and published a catalogue of his magnificent ancient bronze collection in 1908. In 1911, the Qing government decreed that it would take out foreign loans in order to nationalise the provincially run railways; Sichuanese elites were incensed by the autocracy of the decision and riots resulted. When the unrest merged with revolutionary mutinies in the autumn, the Qing dispatched Duanfang to suppress the turmoil in Sichuan. Instead, Duanfang's troops joined the mutiny when they reached Chongqing and murdered Duanfang. Here, he is shown in his prime aged 46, wearing a Qing-style fur hat. On the other side of the snuff bottle is an excerpt from Ouyang Xun's 'Ode to the Sweet Spring at the Palace of Nine Achievements'.

Dated 1907 (the bottle 1740–1907), Beijing. Inside-painted rock crystal. H. 6.2 cm. The Water, Pine and Stone Retreat Collection

ink cake that was part of the Chinese display at the 1915 World's Fair-like event held in Panama (fig. 6.12). Featured objects, images and individuals also showcase new modes of travel that provided people with novel means to head north, south, east and west out of China. Some did so to settle in new places but others spent time as sojourners in or investigators of foreign lands.

Most of the travellers who left records of their journeys were men, such as journalist Wang Tao 王韜 (1828–1897) (figs 6.13–6.14), who wrote the first Chinese travel book on Europe, and the Manchu scholar Duanfang 端方 (1861–1911) who eagerly joined the global marketplace of artistic connoisseurship by collecting antiquities while on an official trip to Egypt (figs 6.15–6.17).

6.13 (far left)
Portrait of Wang Tao
Writer, translator and pioneer of Chinese journalism, Wang Tao lived in Europe 1867–70 and published *Jottings from Carefree Travels* (漫遊隨錄) in 1890. This was the first travel book about Europe written by a Chinese author.

Before 1897, China. Printing ink on paper

6.14 (left)
Wang Tao, 'The Capital of Scotland (Edinburgh)', from *Jottings from Carefree Travels*
Wang was forced into exile 1862–85 because of his association with the Taiping. While in Hong Kong, he translated the Four Books and Five Classics – the key works of a traditional Chinese education – into English with James Legge (1815–1897). Wang and Legge travelled to Edinburgh together in 1880.

Facsimile of 1890 edition. Lithograph. Leiden University Libraries, SINOL. 171523

Key figure: Shan Shili (1858–1945)

6.18
Photograph of Shan Shili at the age of 81, from her book *Travels in the Year 1903* (癸卯旅行記)

Born in Xiaoshan, Zhejiang province, Shan Shili grew up in a scholarly family and received a classical education. Politically and socially, Shan was a reformist, rather than a revolutionary like some of her contemporaries such as Qiu Jin. In 1898, her husband Qian Xun 錢恂 (1853–1927) was appointed supervisor of Chinese students in Japan; Shan joined him in Tokyo the next year with her sons. From 1899 to 1902, she divided her time between Qing China and Meiji Japan. In 1903, Shan travelled with Qian throughout China, Japan, Korea and Manchuria to Russia, where he took up his new post in the Chinese legation. Shan was the first Chinese woman to travel abroad and write a book about her experiences, one intended for educated women like herself. *Travels in the Year 1903*, first published in 1904, is an account of this 70-day journey, undertaken from March to May. Shan again accompanied her husband when, in 1907, he was posted to Holland and, a year later, to Italy. Her *Writings in Retirement* (歸潛記) from 1909 is a record of what she had seen and learned in Europe, particularly Italy; it includes explanations of European art history and architecture for an educated Chinese female audience. After Qian's death in 1927, Shan devoted herself to literary work, and wrote nine more books, including the more traditional *Second Sequel to the Anthology of Correct Beginnings for Gentlewomen* (閨秀正始再續集).

c. 1939 (later edition). China. Printing ink on paper

6.16 (above)
Rubbing of an Egyptian sarcophagus from Duanfang's collection

Qing antiquarians like Duanfang eagerly embraced the global art market, introducing knowledge of ancient foreign cultures to China and establishing Chinese Egyptology. Duanfang travelled to Cairo in 1906, where he bought antiquities, some of which survive as casts in the Beijing University Museum, the Palace Museum and the National Library of China. The tradition of making rubbings of Chinese texts on stone and bronze was already long established, but Duanfang was a pioneer in applying this technique to foreign inscriptions. This rubbing is from a Ptolemaic sarcophagus and shows Egyptian figures in profile. Duanfang also had a vast collection of paintings, calligraphy, ancient Chinese bronzes and jades.

1861–1909, China. Ink rubbing on paper. H. 58.1 cm, W. 131.5 cm (mounted). Maidstone Museums, Kent, MNEMG.TEMP.2016.1003

6.17 (below)
Diplomatic credentials presented by the Great Qing Empire's Overseas Survey Envoy to the Great British Empire

Qing diplomatic documents such as this one (from a 1905 delegation that included Duanfang) were written in both Chinese and Manchu. It reads: 'We have heard that you have a long civilisation, and your political system is advanced; that it is almost perfect. As the (Guangxu) Emperor of China, I want to learn from you to revitalise my country. I want to be open and friendly to the whole world and learn from other countries. As a result, allow me to send Zaize and Shaoying [both Manchu aristocrats] and Xu Shichang [Vice Minister of Military Affairs] to your country to study your politics ...'

1905, Beijing. Ink and colours on paper with silk mount. H. 34.5 cm, W. 269 cm. National Palace Museum, Taipei, 故閣000059

One rare woman in this category, Shan Shili 單士釐 (1858–1945) (fig. 6.18), not only travelled internationally but also published works reflecting on differing histories, customs and societies in countries such as Russia, Korea and Japan.

The material culture of the late Qing also reflects the ways that some residents of the Qing empire who never left the realm were exposed to images of and stories about new kinds of marvellous products being developed in distant lands, and to the customs of foreign populations. The people most likely to be familiar with the new were those living in the cosmopolitan treaty ports, places marked by the intermingling of foreign and Chinese populations – albeit within settings where the latter were often discriminated against and excluded from entrance to certain privileged spaces – and where hybridity characterised the flourishing publishing industry, as well as material culture, architecture and ideologies. There were newspapers run by multinational teams: Shanghai's leading Chinese-language daily, *Shenbao*

(fig. 6.19), though in an important sense a 'newspaper for China', to use phrasing that German Sinologist Barbara Mittler deploys in the title of her definitive study of the periodical, was founded by Ernest Major, a British businessman.[7] There were also pictorial magazines that fused domestic and imported approaches to information, entertainment and communication. The popular and influential pictorial *Dianshizhai huabao* (again founded by Major), for example, was modelled on established foreign publications such as the *Illustrated London News*, yet made extensive use of Chinese artistic styles and literary forms, and alternated foreign and domestic scenes: a spread on ballooning in France in one issue (see fig. 3.56), a representation of the Qing civil service in another (fig. 6.20).

When introducing readers to novelties, such hybrid publications sometimes combined descriptions of how new technologies worked with editorial comments about the need for China to make use of foreign techniques. These new media forms intersected with and infused diverse debates about strengthening the country.

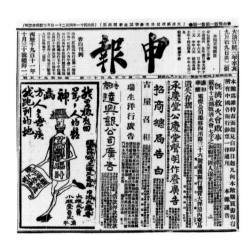

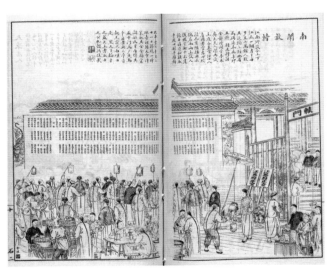

6.19

Page from *Shenbao*, 10 October 1911
This Chinese newspaper based in Shanghai was founded by the British businessman Ernest Major. It carried news stories as well as advertisements for Chinese and foreign products. This page includes an advertisement for Ailuo Brain Tonic.

1911, Shanghai. Printing ink on paper

6.20

Wu Youru, *Complete record of successful candidates at the Jiangnan provincial examinations*, from *Dianshizhai huabao*
This detailed illustration, published in *Dianshizhai huabao*, shows agitated candidates gathering to look for their names on a proclamation of those who had passed the official exams. During the 19th century, successful candidates struggled to find posts: by 1800, although 1.4 million had passed the relevant exams, the number of government posts stagnated at around 20,000.

Frustrated exam candidates could be a major source of discontent. The leader of the Taiping Civil War failed the exams three times, and the visions that underpinned the Taiping ideology followed his physical and mental collapse suffered after one of these failures. The civil service exams, in their old form, were abolished in 1905.

1888, Shanghai. Lithograph. H. 22 cm, W. 12 cm (approx., closed). SOAS University of London, E Per 81267 vol.11

A commentary in the *Dianshizhai huabao* accompanying an image of a train began by noting that, in recent decades, it had 'grown increasingly popular' in China 'to emulate Western ways' (see fig. 5.41). It was true, the author continued, that 'not all stereotypes and prejudices have been discarded', but 'the era of meticulously observing rigid conventions' had ended and there was 'a new climate' more open to innovation. The author, expressing a view found throughout the pages of that and many other treaty port publications issued in both Chinese and English, clearly saw this as a turn for the better. After mentioning where the first rail line in China was built and giving some details about trains, the text concludes: 'With their gradual promotion in other provinces, railways, like electric wires leading everywhere, will eventually run through the whole land without obstacles. I cannot help looking forward to the arrival of that day.'[8] (In 1895, China had a little over 300 kilometres of track; another 5,636 kilometres were laid over the next decade.)

Competing approaches to challenges

The late Qing era was a time of contestation, in which various groups adopted a range of strategies for dealing with a brave new world of not just globe-shrinking inventions but a geopolitical order in flux in which established and rising powers sought to increase their influence in and control over parts of the Qing empire. Different communities within China contended for power using a variety of means: Western, Qing Chinese, and beliefs and structures drawn from more distant parts of China's imperial past. Loyalist xenophobes such as the Boxers expressed support for the Qing and claimed only to want to help the ruling family rid the realm of Chinese Christians and 'devils from across the sea' (洋鬼). Conservatives in the imperial family, such as Prince Duan 端郡王 (1856–1923, also known as Prince Tuan, an adviser to the Empress Dowager), saw no reason to radically change the status quo, yet had no objection to certain new technologies – Cixi's embrace of the motorcar (see fig. 6.2) is one of the more flamboyant examples. Other sectarians and members of organised groups – with administrative structures and beliefs going back centuries – thought the country could best be strengthened by restoring Han Chinese Ming

rule, and viewed the Manchu ruling family itself, as Taiping forces had, as a polluting foreign presence.

In many ways, however, the divide that mattered most during the final years of the Qing dynasty was that between those who embraced either reformist or revolutionary positions. This period saw passionate debate about whether minor or major changes were required to enable China to survive in a ruthless, Western- and increasingly Japanese-dominated international world. Members of competing camps agreed that a hybrid approach, of varying degrees of radicalism, was required. There was a broad consensus that more was needed than new machines and technologies; new political ideas for organising society, government and the economy were essential to keep China from being destroyed by competing foreign powers. Many people avidly read translations of foreign ideas by intellectuals such as Yan Fu (fig. 6.21) and the reformer Liang Qichao (fig. 6.22), an active organiser, speaker and publisher within the reform movement. Translation from European languages and Japanese into Chinese became an increasingly standard pursuit for literati, both for cultural conservatives and radicals; it reached 'into nearly every corner of cultural production by the first decade of the twentieth century'.[9] (Translation between Chinese and the languages of Inner Asia had long been a central part of Qing governance.)

But the community of late Qing reformers was fractious. They broke ranks with one another – and sometimes shifted positions – when it came to which kind of mix-and-match strategy was best and which foreign lands to look to for inspiration. Some reformers looked only to the West for models, others looked instead to Japan; Liang expressed admiration at times for each of these parts of the world, as well as others. In 1899, for example, he wrote in a single essay about the positive shock to conservative sensibilities provided by Japan's 1868 Meiji Restoration, recent Filipino actions against the Spanish empire and American efforts to transfer the archipelago from domination by one foreign power to another, and Boer resistance to the British empire. 'Thirty years ago in Japan', impressive events had taken place, in his view, 'and now in the Philippines and the Transvaal' there were 'struggles against … great countries' under way that 'demonstrated that strength and weakness cannot be

determined' only by the physical strength of particular states, for in those settings 'the sharp edge' of Euro-American might had 'been blunted' by insurgents.[10] Different constituencies of reformers disagreed among themselves and sometimes changed their minds over the question of which parts of the Qing system and which parts of Confucian statecraft and social organisation should be preserved. Revolutionaries, meanwhile, also found varied foreign places and ideas appealing but broke with advocates of reform when it came to the imperial system: they wanted to see the dynasty not changed but overturned.

A representative trio

One way to bring these diverse divides into clearer view is to look at three important figures associated with distinctive hybrid strategies, and the way that each of their approaches was influenced in part by an international war. Firstly, to represent moderate

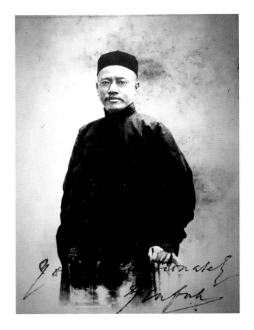

6.21
Portrait of Yan Fu with his English signature 'Yen Fuk', 1905
Reformers sought solutions to Qing China's weakness by translating foreign works about national and international affairs. Yan Fu, born in Fuzhou, Fujian, was a major intellectual figure in the late Qing Self-Strengthening and reform movements. Educated in both classical Confucian texts and in modern Western science, he translated works arguing that Western strength derived from political organisation and ideas, as well as from superior military technology. Between 1877 and 1879, Yan studied naval command at the Royal Naval College at Greenwich. He became superintendent of the Naval College at Tianjin in 1893, and president of China's first modern college, Peking University, in 1912. His translations, in much-admired classical Chinese, had a deep impact on intellectuals and statesmen across the late Qing and early Republican eras. He translated *Evolution and Ethics* by the English biologist Thomas Huxley as well as Adam Smith's *The Wealth of Nations*. Through these translations and his own writings, he popularised the idea to his and subsequent generations of Chinese intellectuals that in order to compete in the international arena, the Qing Chinese empire needed to be reorganised into a strong, cohesive nation of citizens.

1905, England. Photograph

6.22
Photograph of Liang Qichao
Liang Qichao was a Confucian scholar, disciple of Kang Youwei, participant in the 'Hundred Days' Reforms' movement of 1898, which sought radical modernisation of the Qing state, and a founder of and contributor to many periodicals. When conservatives crushed the movement, Liang fled to Japan, and it was there he became a pioneering figure in journalism and publishing. Over the next four years, he launched three new journals, which became important vehicles for literary and political reform in the late Qing period.

c. 1900–29. Photograph

reform, let us return to Li Hongzhang. He felt that some but by no means all Qing institutions could be preserved as long as a serious effort was made not just to use new technologies but to learn as much as possible about Western political and military systems, and to ensure that there were institutions that could support the spread of both technological innovation and novel ways of engaging in diplomacy and war. His focus on learning practical techniques from the West was deeply shaped by witnessing, early in his career, a joint British

6.23
Calling card of Li Gui
Li Gui was a Chinese clerk in the Qing Imperial Maritime Customs Service. He travelled to Japan and the United States, where he stayed in Philadelphia for several months. While there, he had his photograph taken for a calling card. The picture was shot at the studio of photographers Gerlach

& Fromhagen, signed by Li Gui and given to his colleague Edward Bangs Drew when he was back in China in the port city of Ningbo on 23 August 1879.

1879, Philadelphia, Pennsylvania. Photograph. H. 11 cm, W. 7 cm. Edward Bangs Drew Collection, Harvard-Yenching Library, Cambridge MA, Hv35-32

and French force defeat the Qing during the Second Opium War, following which a group of military reformers – Zeng Guofan, Zuo Zongtang, himself and others – succeeded in ending the Taiping Civil War (and preserving the Qing) by learning from and at times working with Western forces. (Although, as is discussed in Chapter 2, much of the post-1860 success of Qing forces against the Taiping rested on newly localised patterns of military organisation and recruitment.)

A good sense of Li's worldview is provided by the foreword he wrote for *A New Account of a Trip around the Globe* (環遊地球新錄), a book about an 1876 trip around the world by Li Gui 李圭 (1842–1903) (fig. 6.23), a real-life Chinese counterpart to Jules Verne's fictional Phileas Fogg. Li Gui, a protégé of but no relation to 'Viceroy Li', stopped everywhere from San Francisco to Saigon, part of a country that had fallen under French control in a process that the traveller thought the Qing should take as a warning. He was impressed by London's postal service and by the electric devices displayed at the Philadelphia Centennial Exhibition, the first World's Fair held outside Europe. Writing his foreword in April 1878, Li Hongzhang expressed his sense of the epoch, with clear implications for how Li Gui's book could help the Qing navigate it safely:

Since the inauguration of commercial relations, the various countries of the West have daily exerted their intelligence, talents, and efforts in mutual competition. In pursuing their plans for wealth and power, they have followed each other in vying for the newest railroads, telegraphs, warships, and weapons … At present, friendly Sino-foreign relations are in some respects like those of a family. For example, the imperial court has already sent special envoys to serve in the capitals of England, Germany, France, and America and has also sent students abroad to study. The many nations of the world are thus in a sense like the thresholds of homes between which light carriages come and go unceasingly on the road. Ambitious gentlemen, if they exert themselves to the utmost in their investigations, can derive much from their strong points while avoiding their shortcomings. The benefits of this to the entire nation will thus be extensive.[11]

Key figure: Kang Youwei (1858–1927)

6.24

Xu Beihong, *Celebration for Kang Youwei's 60th birthday* (南海先生六十行樂圖)

Kang Youwei was a *jinshi* (holder of the top civil service degree), scholar, reformer, politician and utopian. He believed in reform organised around a constitutional monarchy, inspired by Meiji Japan's successful adoption of Western technology while maintaining the authority of the emperor. Together with Liang Qichao, he persuaded the Guangxu emperor to back their reforms and tried to oust the semi-retired Empress Dowager Cixi. Furious and afraid, Cixi regained control at court after only 100 days (June–September 1898) and issued Kang's death sentence. Kang fled China and tried to raise money in diaspora communities. He founded the Protect the Emperor Society, which had 103 branches in North America alone. Kang spent two years in Japan and also travelled to India in 1901–03, where he wrote his utopian vision, *The Book of Great Unity* (大同書). Despite the establishment of the Republic in 1912, Kang remained a staunch monarchist and launched a failed coup d'état to return the last emperor, Xuantong, to power in 1917. Although he advocated an end to traditional family structures, including marriage, Kang himself was married six times, having 16 children, at a time when polygamy remained the norm for well-to-do men; this portrait in Xu Beihong's ultra-realistic style proudly depicts Kang's enormous family.

1916, China. Ink and colours on paper. H. 86 cm, W. 120 cm. Private Collection

The second figure to consider, representing radical reform, is Kang Youwei (figs 6.24–6.26), a mentor to his fellow Cantonese Liang Qichao. (The fact that both grew up in Guangdong reminds us of the importance of the province and its capital Guangzhou/Canton as a contact point between China and the rest of the world.) Kang was an eccentric scholar whose controversial claims included the notion that Confucius, often portrayed as a defender of received tradition, should be understood as a progressive thinker who felt that philosophy needed to adjust to the times. Kang was a true cosmopolitan who found Japan's transition to a constitutional monarchy after 1868 laudable and at times tried to garner support for his cause in Chinese diaspora communities in Australia and other Pacific Rim settings.

The most influential moment in Kang's career came when the Qing were defeated by Japanese forces in 1895, as this event seemed to many within the empire's intellectual elite, including the young Guangxu emperor, to indicate that Japan had discovered a hybrid approach to the challenges of globalising times far more effective than limited Qing attempts at modernisation and Westernisation. In 1898, Kang and his fellow radical reformers convinced the young emperor to work with them in introducing a series of sweeping initiatives that would transform the empire through a range

6.25 (below)
Kang Youwei, Calligraphy

Kang Youwei was a calligraphy connoisseur and champion of the 'stele school' of writing, which advocated taking inspiration from inscriptions on antique objects such as stone steles or bronze vessels, rather than from silk or paper copies of calligraphy. In this, he followed the lead of influential antiquarians Ruan Yuan and Bao Shichen. The calligraphy illustrated here carries six phrases of three characters each, in Kang's eccentric style of semi-cursive or running script (行書). Referring to the failed 'Hundred Days' Reforms' movement of 1898, Kang writes that he was at peace and had no regrets: 'Climbing to the top of the mountain, I look at the floating clouds. Wind cannot shake me, rain cannot disgrace me. My heart is comfortable, at peace; I have no worries or guilt. (躡華巔，觀浮雲。風不搖，雨不薄。心安吉，無患咎。)'.

1914, China. Ink on paper. H. 171 cm, W. 104.8 cm (entire scroll). British Museum, London, 2002,0130,0.32. Donated by Gordon and Kristen Barrass

6.26 (above)
Xu Beihong, *Portrait of He Zhanli* 何旃理 (1891–1915)

This almost life-sized portrait is of Kang Youwei's third wife, a Chinese-American woman called Lily Haw (He Zhanli), whom he met in the United States when she was 15 and he was in his late 40s. Lily's parents were Hakka immigrants who managed Californian vineyards. She spoke Chinese, English and Spanish, and travelled the world with her husband, taking an active part in his official business. They had two children, Kang Tongning 康同凝 (1909–1978) and Kang Tongyan 康同琰 (1911–1928). Xu Beihong painted the portrait in a Western realistic style, with gouache face and hands and watercolour dress and setting, innovations in Chinese painting. Xu had been commissioned to represent her just as she

had appeared to Kang, in a dream 10 days after her death from scarlet fever, aged only 24.

1915, Shanghai. Watercolour and gouache on paper. H. 127.1 cm, W. 65 cm. Shanghai Museum. Given in 1981 by Kang Tongning, 66200

6.27
Chinese civil service examination specimen paper
This exam sheet is the last of three papers of the final Triennial Examinations held in September 1902. The millennia-old examination system was abolished in 1905.

1902, Nanjing. Ink on paper. H. 56 cm, W. 123 cm. Cambridge University Library, FH.311.473

6.28
Cheat's vest for exams
Around 2 million candidates competed in the lowest level of civil service exams held twice every three years. Almost all official positions were appointed to men who had passed these exams. People who failed could retake them at the next sitting. Bribes to pass the exams were not uncommon, although the penalties for corruption were harsh. Not surprisingly, cheating was a perennial problem, even though being caught dashed all further hope for ascent on this ladder of success. Here, key texts were copied in tiny characters onto this vest (more than 45,000 characters in total or nine characters per sq cm), which could be looked at secretly during the exams. By the 19th century, many degrees and honorary positions could be purchased outright, bypassing the exams altogether: the powerful Qing statesman and general Yuan Shikai bought himself a degree after several failures.

Nonetheless, the abolition of the exams in 1905 was a profound cultural shock to generations who had devoted their lives to preparing for them.

1800–1900, China. Ink on linen. H. 50 cm, W. 55 cm. Jiading Museum, Shanghai

6.29
Official's box for peacock plumes
This rectangular painted lacquer box is divided
into two compartments, made to contain
peacock plumes (a mark of official merit), which
are wrapped in yellow paper with a red stamp
indicating where the plumes were sold.

1800–1900, China. Wood, lacquer, paper and
feathers. Box: L. 41 cm, W. 9.9 cm. British
Museum, London, As1944,07.1.a–c

6.30
**Official's hat box and conical summer hat
on porcelain stand**
For Qing officials, the *liang mao* (a 'shade' or
'cool hat') was formally designated summer
attire. It was conical, made of rattan, bamboo,
reeds, straw and grass, and covered in thin
silk. This example has a chinstrap inside and is
decorated on the outside with a tassel. Awarded
for meritorious service, peacock plumes could be
attached while a finial made of coloured glass or

semi-precious stones indicated rank. The stand
was made at Jingdezhen and is decorated with
pale enamels.

1800–1900, China. Leather, textile, feathers and
porcelain. Diam. 36 cm (box). British Museum,
London, 1909,0609.1.a-c; Trevor Ford

of institutions inspired by both Japan and Western
countries – an example of the latter was founding
Western-style universities.

Kang was a utopian dreamer who wrote works that
conjured up images of an ideal society in which children
were raised and educated communally rather than
in individual families, and the earth's many countries
collaborated in a grand international fraternity so that a
universal state of peace would prevail. In 1898, however,
he kept his utopianism in check and focused on working
to persuade the emperor to introduce pragmatic specific
initiatives. For example, he argued for abolishing the
outmoded eight-legged essay format of civil service
exams, which placed emphasis on memorisation and
mastering traditional views (fig. 6.27–6.31). In addition,
as historian Peter Zarrow notes, Kang 'advocated' for a
'separation of powers' and 'memorialised the emperor
to establish a parliament so that "the rulers and the

6.31
'The New Person', *Shibao*, **18 August 1908**
After the exams based on traditional Confucian texts were
abolished, Chinese literati strove to reinvent themselves. In the
newspaper *Shibao*, this man is depicted wearing traditional clothes
such as a hat with peacock plume, but he is reading a book about
modern economics and wearing a pair of fashionable sunglasses.

1908, Shanghai. Ink on paper

citizens discuss the nation's politics together'".[12] This approach might seem to suggest an interest in European models, but Kang drew inspiration from a setting closer to China. In a different memorial to the throne Kang urged the emperor 'to take the Meiji Reform of Japan as the model of our reform' because 'Japan's reforms are not remote', either in space or time, as they were recently implemented in a country whose 'religions and customs are somewhat similar to ours'.[13]

The bold move to transform the realm that Kang spearheaded with fellow radical thinkers lasted just over three months and went down in history as the 'Hundred Days' Reforms'. It ended with a palace coup by conservative elders in the ruling family, including Cixi and Prince Duan. They placed the emperor under house arrest and executed some of the radicals working with him while driving others, such as Kang and Liang, into exile. While many initiatives launched during the 'Hundred Days' were halted, some had lasting effects. An institution of higher learning that was founded in 1898, for example, played a major role as a centre for the circulation of new ideas throughout the final years of the Qing dynasty and first years of the Republican era (1912–49), with the translator Yan Fu serving as its rector at the cusp of those periods. It lives on today as Peking University (fig. 6.32).

Finally, representing calls for revolutionary change rather than reform, we come to Qiu Jin, a woman who posed – in famous representations – as a cross-dressing weapon-bearing warrior (figs 6.33–6.34). After receiving a conventional literary education, she was radicalised in the early 1900s by her anger at the

6.33
Photograph of Qiu Jin wearing a Western man's suit
April 1904. Photograph. National Museum of China, Beijing

6.32
Peking University staff
American missionary and translator W.A.P. Martin and the teaching staff and faculty heads of what would become Peking University stand in front of the commandeered mansion of a high-ranking Qing princess's family.

1901, Beijing. Photograph

Key figure: Qiu Jin (1875–1907)

6.34
Photograph of Qiu Jin carrying a knife
Qiu Jin was a female revolutionary, feminist and writer who was executed by the Qing state at the age of 32. Well-educated by her affluent family, she suffered an unhappy arranged marriage, within which she gave birth to two children. After going to Japan to study in 1903 (a rebellious choice for a young Chinese woman), Qiu Jin became a member of several organisations banned by the Qing dynasty, including the Tongmenghui, the first, quasi-unified Chinese revolutionary association founded by Sun Yat-sen and others in 1905 in Japan. After returning to China in 1905, her involvement in revolutionary plots led to her death two years later. Today, she is a cult hero in China and her writings are much quoted, including: 'The young intellectuals are all chanting, "Revolution, Revolution", but I say the revolution will have to start in our homes, by achieving equal rights for women.' Another now-famous line of her poetry declaimed 'Don't speak of how women can't become heroes (漫云女子不英雄).'

1906, Japan. Photograph.
H. 10.2 cm, W. 7.6 cm. Wisconsin Historical Society, Madison

treatment of women in traditional society and by experiencing first-hand, after she moved to Beijing in 1902, new ideas about freedom and equality (figs 6.35–6.37), and the crisis in which the empire seemed mired after the Boxer War. Li Hongzhang came from a generation whose worldview was shaped by the Second Opium War; Kang Youwei was among those whose politics were galvanised and radicalised by the First Sino-Japanese War. Qiu Jin was also shaped by epochal conflicts, belonging to a revolutionary cohort influenced by the calamity of the Boxers, and the role played therein by Qing mismanagement. She wrote poems in 1900 lamenting the suffering of women during the war, for which she held the Qing largely responsible. The ruling dynasty's weakness in the face of foreign threats and its short-sighted readiness to work with xenophobic militants was viewed by Qiu Jin, and many like her who moved over to the revolutionary camp in these years, as proof that there was no point in thinking about a future that kept the Manchu ruling family in power.

The Qing's implementation of reforms similar to those originally proposed in the abortive 1898 movement, and its move towards a constitutional monarchy after returning to Beijing from temporary exile in Xi'an during the Boxer War, was seen as too little too late. The dynasty's prestige and legitimacy had, moreover, been badly dented by its acceptance of a 1901 treaty, known as the Boxer Protocol, that imposed a punitive indemnity on it (the payment of which remained a drain on national finances into the 1920s) for all losses of foreign lives and property, without requiring any foreign power to compensate for the many Chinese lives taken and settlements destroyed during the often brutal military occupation of north China by the Eight-Nations Allied Army.

In 1903, Qiu became one of a very few Chinese women to leave the Qing empire to study in Japan (many more men made the journey), and was influenced by the country's intellectual vibrancy and martial traditions. She did not limit her purview to any one country, however, and cited an eclectic and

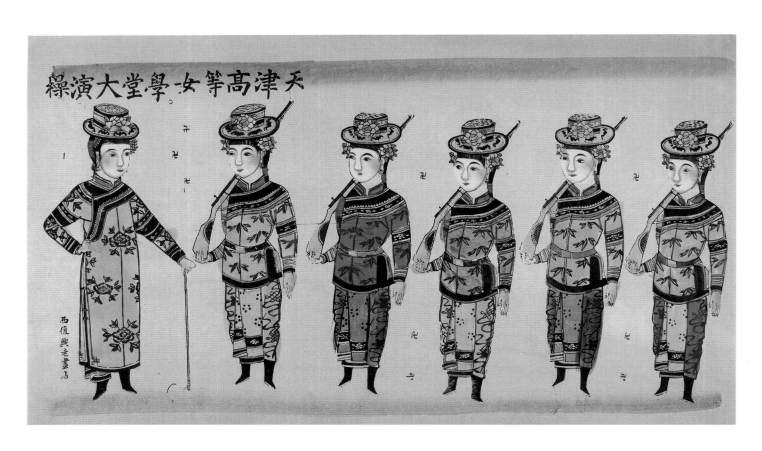

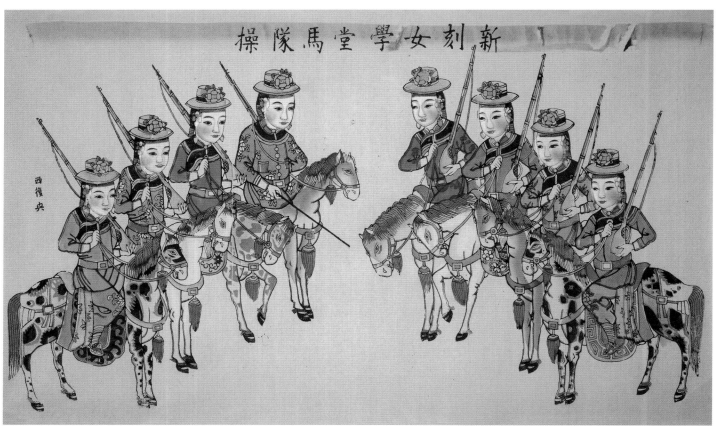

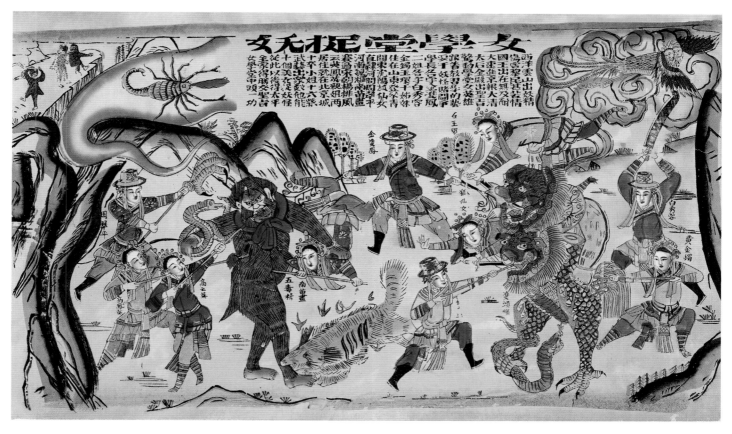

6.35–6.37

Training at the Tianjin girls' high school (天津高等女學堂大演操)**_, A new print of the girls' school equestrian team_** (新刻女學堂馬隊操) **and** _Girls' high school catching demons_ (女學堂捉妖)

These young women are depicted training with guns and horses in late 19th- to early 20th-century fashions. In the fighting that erupted at the time of the 1911 Revolution, seasoned female activists physically fought for the republic; when the post-imperial regime broke its promise to give women the vote, an enraged veteran revolutionary stormed the republican congress and struck the double-crossing politician in question hard on the head with her fan. _Girls' high school catching demons_ (above) shows four modern girls and six traditional heroines fighting together and has an inscription which may refer to the foreign aggression of the late Qing and the Empress Dowager Cixi:

'Demons emerged from cloudy mountains in the Western Ocean, harming the people in great distress. (西洋雲山出妖精, 傷害黎民甚苦情。) The king can't bear it anymore, so he quickly goes to the capital to report to the Qing court. (國王出在無及耐, 大速進京報大清。) The empress dowager in the golden palace issued an imperial decree which alerted the heroines in the girls' school. (太后金殿出聖旨, 驚動學堂女英雄。) They decided to use the skills that they learned from their tutor to fight against the demons. (跟著教習學的藝, 要于妖怪賭鬥爭。) The name of the senior is Jin Shuangfeng and the name of the second eldest sister is Bai Xiurong. (學長名字金雙鳳, 二姐名字白秀容。) Jin Zhuo and Yu Huan are sworn sisters, who live in Denglaiqing, Shandong Province. (金鐲玉環干姐妹, 住在山東登來青。) Fox fairy from Shenyang in the Northeast region and Zhou Cuiping in Hejian in Zhili. (關東沈陽狐仙女, 直隸河間周翠平。) Nan Miaohua from Weihui in Henan province is even better than Yang Paifeng [a fictional character from the Generals of the Yang Family legends who was portrayed as a decisive and fearless maid] in the Song dynasty. (河南魏輝南苗畫, 賽過宋朝楊排風。) Yunying and Fengying are two sisters who live in the city of Beijing. (雲英鳳英親姐兩, 居住就在北京城。) The youngest is only 16 years old and she is the best in martial arts. (十卒小姐十六歲, 武藝出眾數他能。) Ten beautiful girls caught the demons and from then on the world was at peace. (十個美女捉妖怪, 從此以後得太平。) The victory was reported to the court and Chinese girls' school got the most credit. (全家得勝交聖旨, 女學堂中頭一功。)'

1905–20, Yangliuqing, Tianjin. Woodblock print, ink and colours on paper. H. 95 cm (max), W. 53 cm (each sheet). British Museum, London, 1982,1217,0.286, 296 and 297

cosmopolitan mix of radical women as sources of inspiration. Some of these were associated with violent revolutions. Often called China's Joan of Arc – in part, because she died a martyr's death, executed for her role in an assassination plan – Qiu cited that 15th-century French firebrand but also the cross-dressing Mulan – a legendary female Chinese warrior – as role models, as well as the 19th-century Russian anarchist Sophia Perovskaya and Anita Garibaldi, the Brazilian-born wife of 19th-century Italian Republican leader Giuseppe Garibaldi, and still others. 'I live in an era of transition', she once wrote, and every day she would 'burn incense, praying that women' would 'emancipate themselves from their slavish confines and arise as female gallants on the stage of liberty, following in the footsteps of Madame Roland [a famous figure associated with the French Revolution], Anita [Garibaldi], Sophia [Perovskaya], Harriet Beecher Stowe [the abolitionist author of *Uncle Tom's Cabin*], and Joan of Arc'.[14] One of her most famous poems, written to a Japanese friend, also referred to a tradition of valiant female activists: 'Don't speak of how women can't become heroes: alone I rode the winds eastward for ten thousand leagues.' It went on to explain that, while living in Japan was enjoyable for her, there were forces drawing her back to China (to which she returned in 1905, spending her remaining years planning anti-government insurrections): 'As my heart shatters with rage over my homeland's troubles, how can I linger, a guest abroad, savoring spring winds.'[15]

Despite their notable differences, it is also worth stressing the commonalities between Li, Kang and Qiu. All were cosmopolitan and forward-looking, even as they sometimes drew inspiration from mythic or real figures from the past, Mulan for Qiu and Confucius for Kang. None sought to restore China to Ming rule. None rejected foreign technologies the way that the Boxers did in the lines of doggerel they used to promote their cause, which paired calls to attack people with calls to attack novel objects: 'Push aside the railway tracks, Pull out the telegraph poles. Immediately after this destroy the steamers. The great France will grow cold. The English and French will certainly disperse. Let the "Foreign Devils" all be killed. May the whole elegant empire of the Great Qing Dynasty be ever prosperous.'[16] Li, Kang and Qiu were linked as well by their desire to work with like-minded foreigners. The Boxers,

by contrast, have been described as quintessentially xenophobic – indeed, according to a recent history of the term 'xenophobia' (made up of Greek terms for 'fear' and 'stranger'), coverage of the Boxers helped popularise the use of that term, previously only common in specialised circles.[17]

This *fin-de-siècle* epoch of dramatic changes, however, often blurred differences between factions and approaches, even between xenophobic, traditionalist and restoration-minded actors, on the one hand, and cosmopolitan and forward-looking ones, on the other. For example, as cosmopolitan as Li Hongzhang was in some regards, he could also strike traditionalist stances (witness his clothing). His goals were to strengthen China to help it stand up against foreigners, and while he distanced himself from the methods of the Boxers, his overriding aim was not entirely dissimilar: to strengthen his homeland so that it could hold its own in the world. He also fitted the mould of a Confucian scholar-official, albeit one who engaged with less conventional policy spheres, such as military affairs and business enterprises. Li did not approve of the Qing embrace of the Boxers, but he did not break with the imperial family over it, and his last important political act was to help broker the deal for the court to return to Beijing. The Boxers, meanwhile, despite their conspicuous xenophobia, killed far more Chinese Christians than foreigners, and collaborated with a foreign dynasty, the Manchu Qing. They despised Christianity as a foreign creed but some of their beliefs had links to Buddhism which, in the early centuries of the first millennium, had also been a foreign religion, entering China from India.

It is worth noting that, while the discussion above of Li, Kang and Qiu has introduced diverse Chinese responses to globalising trends and imperialism, it does not exhaust the range of hybrid strategies and types of hybrid figures. Here, we might consider the cosmopolitan ultra-conservative Gu Hongming 辜鴻銘 (1857–1928) (fig. 6.38). The subject of an important recent biography by Du Chunmei, who presents him as one of the most controversial and eccentric figures in modern Chinese intellectual history, Gu was born in the British colony of Penang.[18] A graduate of the University of Edinburgh, he became private secretary to the senior Qing official Zhang Zhidong 張之洞 (1837–1909) and a lifelong Qing loyalist. Unsurprisingly, perhaps, he

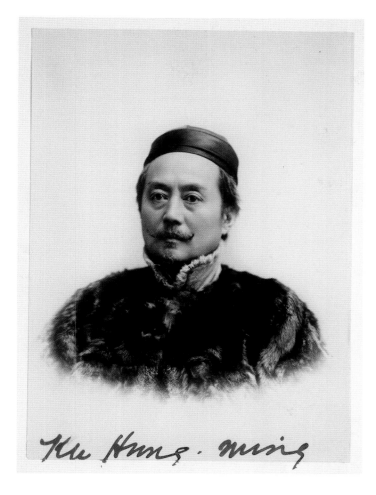

6.38
Gu Hongming, 'Chinese man of letters'
The contemporary scholar Du Chunmei has
described Gu Hongming as one of the most
controversial figures in modern Chinese
intellectual history; others continue to debate
whether he was 'Confucian or Western,
nationalist or cosmopolitan, anachronistic or
prophetic'. He was born in Penang, then a British
colony, and educated at Edinburgh University,
graduating in 1877. After travelling in Europe,
he returned to China to work for Qing Viceroy
Zhang Zhidong.

c. 1917. Photograph. Mitchell Library, State Library
of New South Wales, Sydney, PX*D 156 / vol. 2

backed the Boxers and Cixi's support of them. When
he wrote in praise of Cixi and the Boxers at the cusp of
the 19th and 20th centuries, he did so in works likening
them to celebrated patriots from Western countries.
He even wrote a poem, in English, describing 'bonnie
Boxer lads' following 'bonnie Prince Tuan' (the
conservative adviser to Cixi), equating the anti-Christian
militants with patriotic Scots who had followed Bonnie
Prince Charles into battle to defend their homeland.[19]

Cosmopolitan patriots and a new nation

An apt figure to close this chapter with, who arguably
embodies the globalised hybridity and interconnectedness
of the late Qing more than any other individual, is Sun
Yat-sen, a rare figure who became a global celebrity
during the Qing era (thanks to the dramatic events
that took place in London, when agents of the dynasty
briefly held him captive) and remained so subsequently.

Sun was nothing if not multifaceted. He flirted with
reform in the early 1890s, then suddenly embraced
revolution (fig. 6.39). He drew inspiration from figures
from the Chinese past, including the Taiping insurgents
whose struggle was crushed just before he was born,
and also from foreign ones, finding much to like about
the non-Marxist socialism of Henry George (1839–1897)
and Vladimir Lenin's highly disciplined, vanguard
parties and fervent anti-imperialism. Like Liang
Qichao, he found inspiration in the actions of fighters
for Philippine independence who took up arms against
first the Spanish empire and then the American army
(when the Americans shifted from claiming to want
to liberate the archipelago to turning it into a US-
dominated locale), but he also admired the two most
celebrated American presidents: George Washington
and Abraham Lincoln. In 1912, Sun was inaugurated
as China's first President, and he sometimes styled
himself and was seen by others as a figure comparable
to Washington, but he also led a pilgrimage of officials
to the tombs of the Ming emperors near Beijing early
in 1912, as if to ceremonially communicate to revered
imperial forebears that they had rid the country of
Manchu rulers and carried out a restoration of rule
by Han Chinese (fig. 6.40).

Sun was photographed sometimes wearing
Western suits or military uniform, sometimes

6.39

Japanese people watching war pictorial
(日人觀戰攝影快畫报)

This page from a lithograph-printed Shanghai newspaper shows scenes of soldiers fighting on foot, on horseback and from a train, along with inscriptions and inserted portraits of well-known Chinese figures associated with the 1911 Revolution (Wu Sheng Pass, a 1911 battle site, is mentioned). Portrayed here are Li Yuanhong, who later became President of the Republic of China between 1916 and 1917, and between 1922 and 1923; Huang Xing, co-founder of the Republic of China; Sun Yat-sen, provisional first president of the Republic of China and the first leader of the Kuomintang (Nationalist Party); and Yinchang, who was appointed the first Minister of War in 1910.

1911, Shanghai. Ink on paper. H. 63.5 cm, W. 56 cm. British Museum, London, 1967,1016,0.5.2. Donated by E.S.A. Mathie

wearing a distinctive form of national clothing that he championed, which was inspired partly by Russian and Japanese fashions. He dreamed of uniting the provinces of China via a vast railway network and had other plans that, in line with some of Li's moderate reform ideas, saw technological fixes using new and imported machines to rapidly modernise the country; yet he also felt an emotional bond with sworn brotherhoods celebrated in stories of earlier rebellions (and as an itinerant revolutionary, throughout his sixteen years of exile from China 1895–1911, regularly tried to recruit them into attempted insurrections). He was a Christian and a patriot, someone who made the same kinds of fundraising circuits across the world to speak to diaspora groups that Kang did.

His life and networks were as cosmopolitan as his views were eclectic. This complexity makes him a fitting symbol of not only China's struggles and transformation out of the imperial era but also of a world undergoing globalisation. Born in the southern part of the Qing empire, he was educated partly in territory claimed by a rising imperial power, American Hawaii, partly in territory that was an outpost of a long-established one, British Hong Kong. As a planner of revolution, he worked with Japanese and Filipino radicals.

Soon after the Republic of China was founded, Sun began collaborating with someone who was, if anything, even more an emblem of global times than he was. This was the Trinidad-born and Cambridge-educated Eugene Chen (also known as Chen Youren

陳友仁, 1878–1944), whose father had fled the Qing empire after taking part in the Taiping Civil War. Chen stayed in China after Sun fled back into exile in 1913, following Yuan Shikai's suppression of a nascent democracy; Chen edited a bilingual Beijing newspaper and then founded an English-language paper in Shanghai. In the 1920s, after reconnecting with Sun in southern China, Chen served as an adviser to Sun on foreign affairs and a key contact point between the multifaceted revolutionary and a global network of contacts and influences, in their joint effort to restart a stalled and derailed revolution.[20]

In Bayly's account of 'proto-globalisation', the start of the First World War marks an end point for the phase of global flows that he describes. It was a time when the acceleration of forces tightening the interconnections between disparate parts of the planet slowed or in some cases screeched to a halt, before ramping up again later in the century. This paradigm, however, does not work for China. The 1910s saw the beginning of a new Republican era during which political thinkers borrowed from across the world arguably more freely than ever before. From this point on, building on the transnational currents of the late Qing (in which leading figures such as Liang Qichao and Li Hongzhang had

encountered cosmopolitanism as adults), Chinese history would increasingly be shaped by figures who were exposed to global ideas (the experience of living abroad, reading translations, and consuming foreign products and their advertisements) in their childhoods during the dynasty's twilight years.

Sun Yat-sen and Eugene Chen were educated in different parts of the world beyond China's borders in the closing decades of the 19th century, and met in London in 1911 when the former gave a speech about revolution to local members of the Chinese diaspora. They began working together in 1912 in a newly founded state that, for all its flaws and troubles, was more in step with international geopolitics than the Qing had ever been. Their story is that of a pair of cosmopolitan patriots making common cause in an era during which the citizens of China continued, in the style of their late Qing forebears, to seek creative ways of fusing the traditional and the modern, the domestic and the foreign.

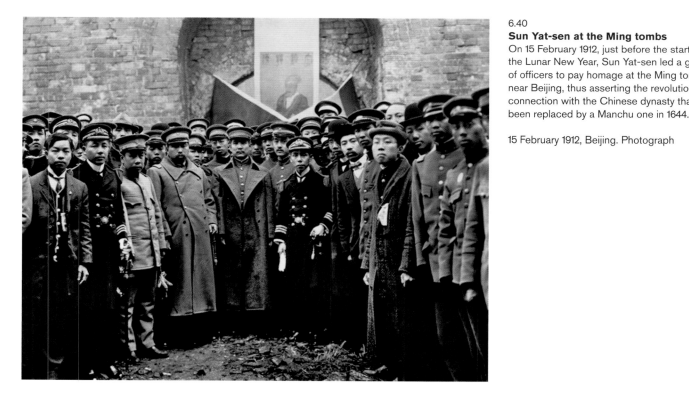

6.40
Sun Yat-sen at the Ming tombs
On 15 February 1912, just before the start of the Lunar New Year, Sun Yat-sen led a group of officers to pay homage at the Ming tombs near Beijing, thus asserting the revolutionary connection with the Chinese dynasty that had been replaced by a Manchu one in 1644.

15 February 1912, Beijing. Photograph

Xugu, *Bronze gui with three friends of winter* (格伯簋拓片、歲寒三友)
c. 1850–96, Shanghai, Yangzhou or Suzhou. Ink and colours on paper.
H. 242 cm, W. 87.5 cm (mounted).
Nanshun Shanfang, Singapore

Appendix 2
**Ren Xiong, *Autumn shadow in Liangxi
(Wuxi)*** (梁谿秋影圖)
1840–57, China. Ink and colours on silk.
H. 126 cm, W. 60 cm. Michael Yun-Wen Shih

Appendix 3
**Ren Xun, *Magu gives her birthday
greetings*** (麻姑獻壽圖)
c. 1850–93, Shanghai. Ink, colours
and gold on paper. H. 176 cm, W. 92 cm.
Michael Yun-Wen Shih

Notes

Introduction

1. This observation is indebted to an unpublished lecture by Tobie Meyer-Fong, 'China, ca. 1800', given at the workshop 'Chinese Painting, around 1800', at the Institute of Fine Arts and The Metropolitan Museum of Art, New York, June 2019.

2. Xi Jinping, current Party General Secretary, summed up the official reading of the 19th century in his July 2021 address to mark the centenary of the Chinese Communist Party: 'China was gradually reduced to a semi-colonial, semi-feudal society … The country endured intense humiliation, the people were subjected to great pain, and the Chinese civilisation was plunged into darkness … The victory of the [Communist] revolution put an end … to the state of total disunity that existed in old China, and to all the unequal treaties imposed on our country by foreign powers and all the privileges that imperialist powers enjoyed in China. It created the fundamental social conditions for realising national rejuvenation.' Xi Jinping, speech at the ceremony of the centenary of the Communist Party of China, 1 July 2021, available at www.fmprc.gov.cn/ce/celv/eng/xwdt/t1889004.htm (accessed 7 April 2022).

3. Gertraude Roth Li, 'State Building before 1644', in *The Cambridge History of China, Volume 9, Part 1: The Ch'ing Empire to 1800*, ed. Willard J. Peterson (Cambridge: Cambridge University Press, 2002), p. 10.

4. Pamela Kyle Crossley, *The Manchus* (Oxford: Blackwell Publishers, 1997), p. 113.

5. James L. Hevia, *Cherishing Men from Afar: Qing Guest Ritual and the Macartney Embassy of 1793* (Durham: Duke University Press, 1995), p. 201.

6. Joanna Waley-Cohen, *The Sextants of Beijing: Global Currents in Chinese History* (New York: Norton, 1999), p. 97.

7. William Rowe, *China's Last Empire: The Great Qing* (Cambridge: Harvard University Press, 2009), p. 122.

8. Ibid., p. 66.

9. Ibid., p. 150.

10. Ibid., p. 152.

11. Susan Mann Jones & Philip A. Kuhn, 'Dynastic Decline and the Roots of Rebellion', in *The Cambridge History of China, Volume 10, Part 1: Late Ch'ing 1800–1911*, ed. John K. Fairbank (Cambridge: Cambridge University Press, 1978), p. 127.

12. Quoted in Wan Yi 萬依 et al., 清代宮廷史 (A history of the Qing court) (Tianjin: Baihua wenyi chubanshe, 2004), p. 334.

13. See the superb account in Dai Yingcong, *The White Lotus War: Rebellion and Suppression in Late Imperial China* (Seattle: University of Washington Press, 2019).

14. Ibid., p. 370.

15. Ibid., p. 11.

16. Wensheng Wang, *White Lotus Rebels and South China Pirates: Crisis and Reform in the Qing Empire* (Cambridge: Harvard University Press, 2014), p. 243.

17. This point is indebted to analysis in Rowe, *China's Last Empire*, p. 169.

18. Ibid., p. 170.

19. See Matthew W. Mosca, *From Frontier Policy to Foreign Policy: The Question of India and the Transformation of Geopolitics in Qing China* (Stanford: Stanford University Press, 2013).

20. John K. Fairbank, 'The Early Treaty System in the Chinese World Order', in *The Chinese World Order: Traditional China's Foreign Relations*, ed. John K. Fairbank (Cambridge: Harvard University Press, 1968), pp. 265–6.

21. Sean Hsiang-lin Lei, *Neither Donkey nor Horse: Medicine in the Struggle over China's Modernity* (Chicago: University of Chicago Press, 2014), p. 47.

22. See David Der-Wei Wang, *Fin-de-Siècle Splendor: Repressed Modernities of Late Qing Fiction, 1849–1911* (Stanford: Stanford University Press, 1997).

23. Steven B. Miles, *Chinese Diasporas: A Social History of Global Migration* (Cambridge: Cambridge University Press, 2010), p. 93. This is an excellent overview of modern Chinese migration.

24. Ibid., p. 143.

25. Leo Oufan Lee & Andrew J. Nathan, 'The Beginnings of Mass Culture: Journalism and Fiction in the Late Ch'ing and Beyond', in *Popular Culture in Late Imperial China*, ed. David Johnson et al. (Berkeley: University of California Press, 1985), pp. 378–95.

26. Cited in Amy Dooling, *Women's Literary Feminism in Twentieth-Century China* (New York: Springer, 2005), p. 47.

27. Quoted in Wah-kwan Cheng, 'Vox Populi: Language, Literature and Ideology in Modern China', unpublished Ph.D. thesis, University of Chicago, 1989, pp. 84–90.

28. 1868 'Charter Oath' cited in Christopher Goto-Jones, *Modern Japan: A Very Short Introduction* (Oxford: Oxford University Press, 2009), p. 43.

29. Peter Zarrow, *Educating China: Knowledge, Society, and Textbooks in a Modernising World, 1902–1937* (Cambridge: Cambridge University Press, 2015), p. 13.

30. See Elisabeth Kaske, *The Politics of Language in Chinese Education, 1895–1919* (Boston: Brill, 2008) and Henrietta Harrison, *China* (London: Arnold, 2001).

31. Harrison, *China*, p. 129.

32. Ibid., p. 101.

33. See the extraordinary account in David Strand, *An Unfinished Republic: Leading by Word and Deed in Modern China* (Berkeley: University of California Press, 2011).

34. Cited in Marie-Claire Bergère, *Sun Yat-sen*, trans. Janet Lloyd (Stanford: Stanford University Press, 1998), p. 108.

35. With thanks to Stephen Lovell for permitting me to borrow a turn of phrase he applied to Russia in the 1990s.

Chapter 1

1. Evelyn S. Rawski, *The Last Emperors: A Social History of Qing Imperial Institutions* (Berkeley: University of California Press, 1998), p. 13.

2. Ibid., pp. 300–01.

3. Ibid., pp. 29–31.

4. Ibid., pp. 28–9.

5. Ibid., pp. 23–4.

6. Liu Chang 劉暢 & Wang Shiwei 王時偉, '從現存圖樣資料看清代晚期長春宮改造工程 (Reconstruction plans for the late Qing dynasty Changchun Palace as seen from the surviving visual materials)', *Gugong bowuyuan yuankan* no. 5 (2005), pp. 193–6.

7. Zhu Chengru 朱誠如 (ed.), 清史圖典：嘉慶朝 (Illustrated Qing history: the Jiaqing reign), vol. 8 (Beijing: Zijincheng chubanshe, 2002), p. 54.

8. Lo Yun-chih 羅運治, 清代木蘭圍場的探討 (Studies on the Mulan hunt during the Qing dynasty) (Taipei: Wenshizhe chubanshe, 1989), p. 123.

9. William Rowe, *China's Last Empire: The Great Qing* (Cambridge: Harvard University Press, 2009), p. 193.

10. Ibid., p. 34.

11. Ibid., p. 40; Martina Siebert, Kai Jun Chen & Dorothy Ko, 'Introduction', in *Making the Palace Machine Work: Mobilizing People, Objects, and Nature in the Qing Empire*, ed. Martina Siebert, Kai Jun Chen & Dorothy Ko (Amsterdam: Amsterdam University Press, 2021), p. 28.

12. Siebert et al., 'Introduction', p. 26.

13. See Wu Zhaoqing 吳兆清, '清代造辦處的機構和匠役 (The institution and personnel of the Imperial Workshops of the Qing dynasty)', *Lishi dang'an* no. 4 (1991), pp. 79–86, 89.

14. Ibid., p. 82.

15. Ibid., pp. 83–6.

16. Emily Byrne Curtis, 'A Plan of the Emperor's Glassworks', *Arts Asiatiques* vol. 56 (2001), p. 87.

17. Wu, 'The institution', p. 84.

18. For Cixi's biography, see Zuo Shu'e 左書諤, 慈禧太后 (Empress Dowager Cixi) (Changchun: Jilin wenshi chubanshe, 1993); Jung Chang, *Empress Dowager Cixi: The Concubine Who Launched Modern China* (New York: Knopf, 2013); Ying-chen Peng, 'Empresses and Qing Court Politics', in *Empresses of China's Forbidden City, 1644–1912*, ed. Daisy Yiyou Wang & Jan Stuart (Salem: Peabody Essex Museum; Washington, D.C.: Freer/Sackler Smithsonian Institution; New Haven: Yale University Press, 2018), pp. 132–7; Ying-chen Peng, *Artful Subversion: Empress Dowager Cixi's Image Making* (New Haven and London: Yale University Press, 2023).

19. Rowe, *China's Last Empire*, pp. 153–4.

20. Ibid., pp. 153, 158.

21. Ibid., p. 202.

22. Ibid., pp. 202–04.

23. On the relationship between Cixi and Prince Gong, see Wu Hsiang-hsiang 吳相湘, 晚清宮廷實紀 (Realistic records of late Qing court politics) (Taipei: Zhengzhong shuju, 1952), vol. 1, pp. 101–09.

24. On this war, see Rowe, *China's Last Empire*, pp. 224–30.

25. Ibid., pp. 237–43; Luke S. Kwong, 'Chinese Politics at the Cross-roads: Reflections on the Hundred Days Reform of 1898', *Modern Asian Studies* vol. 34, no. 3 (2000), pp. 663–95.

26. Rowe, *China's Last Empire*, pp. 243–5.

27. Ibid., pp. 256–62.

28. Evelyn S. Rawski, 'Qing Empresses and their Place in History', in *Empresses*, ed. Wang & Stuart, p. 48.

29. Rowe, *China's Last Empire*, p. 283.

30. On palace servants, see Rawski, *The Last Emperors*, pp. 160–94; on their working conditions and labour relations, see Christine Moll-Murata, 'Working the Qing Palace Machine', in *Making*, ed. Siebert et al., pp. 47–72.

31. Rawski, *The Last Emperors*, p. 160.

32. Ibid., pp. 161–2.

33. Vincent Goossaert, *The Taoists of Peking, 1800–1949: A Social History of Urban Clerics* (Cambridge: Harvard University Asia Center, 2007), p. 210; for further discussions on eunuch Daoists, see pp. 210–29.

34. Evelyn S. Rawski, 'Ch'ing Imperial Marriage and Problems of Rulership', in *Marriage and Inequality in Chinese Society*, ed. Rubie S. Watson & Patricia Buckley Ebrey (Berkeley: University of California Press, 1991), p. 184.

35. Rawski, *The Last Emperors*, pp. 170–71.

36. See Palace Museum, Beijing, accession numbers Gu.6411 (Kangxi), Gu.6446 (Yongzheng), Gu.6530 (Qianlong) and Gu.6592 (Xianfeng).

37. On Daoguang's portraits by Shen Zhenlin, see Li Shi 李湜, '如意館畫士沈振麟及其御容像 (Court painter Shen Zhenlin in the Painting Academy and his imperial portraiture)', *Wenwu* no. 4 (2012), pp. 75–82.

38. Maids are often included in this type of painting, holding fans behind Qianlong. For discussions on Qianlong's family portraits for New Year, see Chen Pao-chen 陳葆真, '從四幅「歲朝圖」的表現問題談到乾隆皇帝的親子關係 (On four paintings showing Emperor Qianlong and his children celebrating the New Year and their related problems)', *Meishushi yanjiu jikan* vol. 28 (2010), pp. 123–84.

39. See Wang Cheng-hua 王正華, '走向公開化：慈禧肖像的風格形式、政治運作與形象塑造 (Portraits of the Empress Dowager Cixi and their public roles)', *Guoli Taiwan daxue meishushi yanjiu jikan* vol. 32 (2012), pp. 244–51.

40. Yuhang Li, 'Oneself as a Female Deity: Representations of Empress Dowager Cixi as Guanyin', *Nan Nü* 14 (2012), p. 117.

41. On Cixi's portrait projects, see Wang, 'Portraits'; Ying-chen Peng, 'Lingering between Tradition and Innovation: Photographic Portraits of Empress Dowager Cixi', *Ars Orientalis* 43 (2013), pp. 157–75.

42. See Wang, 'Portraits', pp. 149–61.

43. Rawski, *The Last Emperors*, p. 10.

44. In the 18th century, the Qianlong emperor also sanctioned and supported Islam, the religion of the Turkic-speaking Muslims of Central Asia. But in the 19th century the policy was much less favoured. See ibid., p. 199. For discussion of Qing policies towards Muslims in southwest China, see David Atwill, *The Chinese Sultanate: Islam, Ethnicity and the Panthey Rebellion in Southwest China, 1856–1873* (Stanford: Stanford University Press, 2005).

45. For discussions of virtue and heredity as two ruling principles, see Rawski, *The Last Emperors*, pp. 201–03.

46. Ibid., p. 203.

47. Susan Mann, *Precious Records: Women in China's Long Eighteenth-Century* (Stanford: Stanford University Press, 1997), p. 152.

48. Rawski, *The Last Emperors*, p. 213.

49. Rawski, 'Ch'ing Imperial Marriage', p. 170.

50. Peng, 'Empresses', p. 136.

51. Rawski, *The Last Emperors*, pp. 274–6; Ren Wanping, 'Qing Empress and Grand Imperial Weddings', in *Empresses*, ed. Wang & Stuart, pp. 54–7.

52. Rawski, *The Last Emperors*, pp. 231–45; Luk Yu-ping, 'Qing Empresses as Religious Patrons', in *Empresses*, ed. Wang & Stuart, pp. 111–12.

53. Rawski, *The Last Emperors*, p. 238.

54. Ibid., pp. 248–9.

55. Ibid., p. 252.

56. Lang Fengxia 郎豐霞, '清代滿洲喇嘛廟的興衰及其背後的政治文化意義 (The rise and fall of Manchu Lama temples in the Qing dynasty and the political cultural significance behind them)', *Beijing shehui kexue* no. 12 (2018), pp. 21–5.

57. Rawski, *The Last Emperors*, p. 255.

58. See Max Oidtmann, *Forging the Golden Urn: The Qing Empire and the Politics of Reincarnation in Tibet* (New York: Columbia University Press, 2018), p. 201.

59. Rawski, *The Last Emperors*, p. 262; Luk, 'Qing Empresses', pp. 125–6.

60. Goossaert, *The Taoists*, p. 191; for further discussion on Daoism and the Qing Court, see ibid., pp. 188–235.

61. For further information on Cixi's relationship with the White Cloud Monastery, see Xun Liu, 'Visualizing Perfection: Daoist Paintings of Our Lady, Court Patronage, and Elite Female Piety in the Late Qing', *Harvard Journal of Asiatic Studies*, vol. 64, no. 1 (2004), pp. 57–115.

62. Ibid.

63. On the Qing court's dharma boat, see Yuhang Li, 'Burning Big Dharma Boats: Paper as an Efficacious Medium', in *The Allure of Matter: Materiality across Chinese Art*, ed. Orianna Cacchione & Wei-cheng Lin (Chicago: Center for the Art of East Asia of the University of Chicago and Smart Museum of Art, 2021), pp. 159–69.

64. Cited in ibid, pp. 162–3.

65. Mark C. Elliott, *The Manchu Way: The Eight Banners and Ethnic Identity in Late Imperial China* (Stanford: Stanford University Press, 2006), pp. 276–7.

66. For the varieties of furs in the Russian trade, see Lai Hui-min 賴惠敏 & Wang Shih-ming 王士銘, '清中葉迄民初的毛皮貿易與京城消費 (Fur trade and Beijing's consumption from the mid-Qing to the early republic)', *Gugong xueshu jikan* vol. 31, no. 2 (2013), p. 143–4. For more discussions of fur in the Qing empire, see Jonathan Schlesinger, *A World Trimmed with Fur: Wild Things, Pristine Places, and the Natural Fringes of Qing* (Stanford: Stanford University Press, 2017), pp. 129–66.

67. Lai & Wang, 'Fur trade', p. 152.

68. Rachel Silberstein, 'Fashioning the Foreign: Using British Woolens in Nineteenth-Century China', in *Fashion, Identity, and Power in Modern Asia*, eds. Kyunghee Pyun & Aida Yuen Wong (New York: Palgrave Macmillan, 2019), p. 236.

69. Lianming Wang, 'A World Dotted with Kingfisher Blue: Feather Tributes and the Qing Court', in *The Social Lives of Chinese Objects*, ed. Alice Bianchi and Lyce Jankowski (Leiden: Brill, 2022), pp. 233–4, 242–6.

70. Zong Fengying 宗鳳英, 清代宮廷服飾 (Qing court dress) (Beijing: Zijincheng chubanshe, 2004), p. 16. For detailed regulations of court dress, see Yunlu 允祿 & Jiang Pu 蔣溥 (eds), 皇朝禮器圖式 (Illustrated ritual implements of the imperial dynasty), 1759–1795, volumes on Hats and Dress (冠服). For a coloured version of Hat and Dress, see the Palace Museum, Beijing, accession number Gu.6116-1, vols 30–42.

71. Hou Yi-li 侯怡利 (ed.), 通嚏輕揚:鼻煙壺文化特展 (Lifting the spirit and body: the art and culture of snuff bottles) (Taipei: National Palace Museum, 2012), p. 38.

72. See Wu Weiping 吳偉蘋, '乾隆皇帝與玉扳指 (The Qianlong emperor and jade thumb ring)', *Gugong wenwu yuekan* no. 10 (2013), pp. 94–109.

73. Hou, *Lifting the spirit*, p. 37.

74. Rachel Silberstein, *A Fashionable Century: Textile Artistry and Commerce in the Late Qing* (Seattle: University of Washington Press, 2020), p. 154.

75. Ibid., pp. 40–41.

76. Zong Fengying 宗鳳英, '慈禧的小織造:綺華館 (Cixi's private textile manufactory: the Pavilion of Magnificent Flowers)', *Gugong wenwu yuekan* (August 1996), pp. 42–55.

77. Li, 'Oneself as a Female Deity', pp. 92–3.

78. Ibid., p. 93.

79. Yuhang Li, 'Gendered Materialization: An Investigation of Women's Artistic and Literary Reproductions of Guanyin in Late Imperial China', Ph.D. thesis, University of Chicago, 2011, pp. 163–4; Ying-chen Peng, 'Staging Sovereignty: Empress Dowager Cixi (1835–1908) and Late Qing Court Art Production,' Ph.D. thesis, University of California, 2014, pp. 90–96.

80. Mei Mei Rado, 'The Empress Dowager Cixi's Japanese Screen and Late Qing Imperial Cosmopolitanism', *Burlington Magazine* vol. 163, no. 1423 (October 2021), pp. 886–97.

81. Chen Hui-hsia 陳慧霞, '清代宮廷婦女簪飾之流變 (The development of Qing court ladies' hair ornaments)', *Jindai Zhongguo funüshi yanjiu* no. 28 (December 2016), p. 66.

82. Gary Wang, 'Affecting Grandiosity: Manchuness and the *Liangbatou* Hairdo-Turned-Headpiece, Circa 1870s–1930s', in *Fashion*, ed. Pyun & Wong, p. 177.

83. See the Imperial Records of Cixi's Photograph (聖容帳) partially transcribed in Lin Jing 林京, '慈禧攝影史話 (History of Cixi and photography)', *Gugong bowuyuan yuankan* no. 3 (1988), p. 83.

84. Chen, 'The development', p. 70.

85. Ibid., p. 97.

86. Princess Der Ling (Yu Deling), *Two Years in the Forbidden City* (New York: Moffat, Yard and Company, 1917), p. 66.

87. Chen Hsia-sheng 陳夏生, 明清琺瑯器展覽圖錄 (Enamel ware in the Ming and Qing dynasties), (Taipei: National Palace Museum, 1999), p. 32.

88. On the new concept of kōgei in the Meiji period, see Dōshin Satō, *Modern Japanese Art and Meiji State: The Politics of Beauty*, trans. Hiroshi Nara (Los Angeles: Getty Research Institute, 2011), pp. 67–72.

89. Béatrice Quette, 'The Emergence of Cloisonné Enamels in China', in *Cloisonné: Chinese Enamels from the Yuan, Ming and Qing Dynasties*, ed. Béatrice Quette (New Haven: Yale University Press; New York: Bard Graduate Center, 2011), p. 4.

90. Katherine A. Carl, *With the Empress Dowager of China* (London: E. Nash, 1906), pp. 52–6.

91. Chen, *Enamel ware*, p. 32.

92. Béatrice Quette, 'Cloisonné Form and Decoration from the Yuan through the Qing Dynasty', in *Cloisonné*, ed. Quette, p. 59.

93. Xue Fucheng 薛福成, 出使日記續刻 (The ambassador's diary, second printing) [1898] (Taipei: Huawen shuju, 1968), p. 1118.

94. John Ayers et al., *Chinese and Japanese Works of Art in the Collection of Her Majesty The Queen*, vol. 3 (London: Royal Collection Trust, 2016), cat. no. 2128, 950.

95. See Rado, 'The Empress Dowager', pp. 893–5.

96. Ibid.

97. Dorothy Ko, 'Between the Boudoir and the Global Market: Shen Shou, Embroidery, and Modernity at the Turn of the Twentieth Century', in *Looking Modern: East Asian Visual Culture: Treaty Ports to World War II*, eds. Jennifer Purtle & Hans B. Thomsen (Chicago: Center for the Art of East Asia of the University of Chicago and Art Media Resources, 2009), pp. 45–6.

98. Ibid., p. 51.

99. Sun Yue 孫悅, '清代帝后萬壽用瓷流變概述 (Changes in Qing imperial birthday wares)', conference paper, the Palace Museum, Beijing, November 2017.

100. Zhao Congyue 趙聰月, '慎德堂與慎德堂款瓷器 (The Hall of Prudent Virtue and the porcelains with this mark)', *Gugong bowuyuan yuankan* no. 2 (2010), pp. 113–29.

101. Peng, 'Staging Sovereignty', p. 111.

102. Ibid., p. 112.

103. Ibid., p. 130.

104. Ibid., pp. 108–09; Peng, 'Empresses', pp. 134–5.

105. Zhang Shuxian 張淑嫻, 金窗繡戶：清代皇宮內檐裝修研究 (Golden windows, embroidered doors: studies of Qing court interior architecture and decorations) (Beijing: Gugong chubanshe, 2019), pp. 277–300.

106. Ibid., pp. 278, 280–82.

107. See Zhang Shuxian 張淑嫻, '紅樓一夢：長春宮遊廊《紅樓夢》壁畫 (Dream of the Red Chamber: mural paintings featuring this novel in the corridors of the Palace of Eternal Spring)', Zijincheng no. 1 (2020), pp. 88–105.

108. Zhang, Golden windows, pp. 216–22, 277–310.

109. Liana Chen, Staging for the Emperors: A History of Qing Court Theatre, 1683–1923 (Amherst: Cambria Press, 2021), pp. 62–4. On interior stages in the Qing palaces, see Zhang, Golden windows, pp. 395–428.

110. Chen, Staging for the Emperors, pp. 117–57.

111. Ibid., pp. 168–74.

112. Ibid., p. 51.

113. Ibid., p. 58.

114. Ibid., p. 59.

115. Ibid., pp. 29, 221–30.

116. Ibid., pp. 230–31.

117. Zhu Jiajin 朱家溍 (ed.), '清代亂彈戲在宮中發展的史料 (Historical records on the development of Luantan dramas at the Qing court)', in 故宮退食錄 (Upon retirement from the Palace Museum), ed. Zhu Jiajin (Beijing: Zijincheng chubanshe, 2009), vol. 2, pp. 586–621.

118. See Zhou Yibai 周貽白, 中國戲劇史長編 (History of Chinese theatre, long version) (Shanghai: Shanghai shudian, 2004), pp. 469–91; Ma Shaobo 馬少波 et al., 中國京劇發展史 (The development of Chinese Peking Opera) (Taipei: Shangding, 1992), vol. 1, pp. 24–34.

119. There was an exception: in late Qing court theatre, Liao and Jin female characters wore contemporary Manchu style (informal women's robes) to mark their non-Han ethnicities.

120. Yu Rongling 裕容齡, '清末舞蹈家裕容齡回憶錄 (The memoirs of Yu Rongling, a dancer of the late Qing)', Wudao (March 1958), pp. 44–5; Princess Der Ling (Yu Deling), Lotus Petals (New York: Dodd, Mead, and Company, 1930), p. 236.

121. Carl, With the Empress Dowager, p. 176; Yu, Two Years, p. 102.

122. Yu Rongling 裕容齡, 清宮瑣記 (Chronicles of the Qing palace) (Beijing: Beijing chubanshe, 1957), p. 77.

123. For the 1902 garden party, see Isaac Taylor Headland, Court Life in China: The Capital, its Officials and People (New York, Chicago: F.H. Revell Company, 1909), pp. 69–72; for the 1903 garden party, see Yu, Two Years, pp. 140–43; Carl, With the Empress Dowager, pp. 165–9.

124. Yu, Two Years, p. 141; Carl, With the Empress Dowager, p. 170.

Chapter 2

1. Joanna Waley-Cohen, The Culture of War in China: Empire and the Military under the Qing Dynasty (London: I.B. Tauris, 2006).

2. Ibid.

3. Stephen R. Platt, Autumn in the Heavenly Kingdom: China, the West, and the Epic Story of the Taiping Civil War (New York: Alfred A. Knopf, 2012), p. 119; Tonio Andrade, The Gunpowder Age: China, Military Innovation, and the Rise of the West in World History (Princeton: Princeton University Press, 2016), p. 241.

4. Dai Yingcong, The White Lotus War: Rebellion and Suppression in Late Imperial China (Seattle: University of Washington Press, 2019).

5. 'China: The High Commissioner's Second Letter to the Queen of England', The Times, 11 June 1840.

6. Julia Lovell, The Opium War: Drugs, Dreams, and the Making of China (London: Picador, 2011).

7. Andrade, The Gunpowder Age, p. 238.

8. Ibid., pp. 237–56.

9. Ibid.

10. Stephen R. Platt, Imperial Twilight: The Opium War and the End of China's Last Golden Age (New York: Alfred A. Knopf, 2018), p. 423.

11. Lovell, The Opium War; Andrade, The Gunpowder Age, p. 249.

12. Zhao Liewen 趙烈文, Neng jing ju riji 能静居日記, entry for XF10/9/4 (17 October 1860), in Taiping Tianguo 太平天國, vol. 7, ed. Luo Ergang 羅爾綱 & Wang Qingcheng 王慶成 (Guilin shi: Guangxi shifan daxue chubanshe, 2004), p. 69; Platt, Autumn, p. 153.

13. Eric Schluessel, Land of Strangers: The Civilizing Project in Qing Central Asia (New York: Columbia University Press, 2020); Peter Lavelle, The Profits of Nature: Colonial Development and the Quest for Resources in Nineteenth-Century China (New York: Columbia University Press, 2020).

14. Zhang Hongxing, 'Wu Youru's "The Victory over the Taiping": Painting and Censorship in 1886 China,' Ph.D. thesis, University of London, 1999.

15. Zeng Guofan 曾國藩, Fuchen goumai waiyang chuanpao zhe 復陳購買外洋船炮折, memorial dated XF11/7/18 (23 August, 1861), in Zeng Guofan quanji 曾國藩全集 (The complete works of Zeng Guofan) (Beijing: Zhongguo zhigong chubanshe, 2001), vol. 3, p. 948.

16. Zeng Guofan family letter on TZ1/9/11 (2 November, 1862), in Zeng, Zeng Guofan, vol. 7, pp. 2628–9.

17. Richard Horowitz, 'Beyond the Marble Boat: The Transformation of the Chinese Military, 1850–1911', in A Military History of China, ed. David A. Graff & Robin Higham (Boulder: Westview, 2002), p. 162.

18. Immanuel C.Y. Hsü, 'The Great Policy Debate in China, 1874: Maritime Defense vs. Frontier Defense', Harvard Journal of Asiatic Studies vol. 25 (1964–5), pp. 212–28; Zhiqing Hu, 'China's Banker: Hu Xueyan and Financialisation in Late Nineteenth-Century China,' Ph.D. thesis, Birkbeck, University of London, forthcoming.

19. Andrade, The Gunpowder Age, p. 275.

20. Ibid., p. 273; Horowitz, 'Beyond', p. 159.

Chapter 3

1. Edgar Morin, 'Un Festival d'incertitudes', Collection Tracts, Série Tracts de crise, no. 54 (Paris: Gallimard, 2020). Available at www.tracts.gallimard.fr/en/products/tracts-de-crise-n-54-un-festival-d-incertitudes (accessed 13 December 2022). Author's own translation.

2. Immanuel C.Y. Hsü, The Rise of Modern China (New York: Oxford University Press, 1975), pp. 111–26.

3. Gu Yanwu 顧炎武, '金石文字集序 (Preface of Notes on Epigraphic Inscriptions)', reprinted in 景印文淵閣四庫全書 (Photocopied version of the Complete Library of the Four Branches of the Treasuries, Wenyuange edition), vol. 683 (Taipei: Shangwu yinshuguan, 1983), p. 703; and Liang Qichao 梁啟超, 清代學術概論 (Overview of scholarship in the Qing dynasty) [1920] (Taipei: Taiwan Commercial Press, 2008), chapters 4 and 12.

4. Bai Qianshen, 傅山的世界 (Fu Shan's world) (Taipei: Shitou chubanshe, 2005), pp. 226–231.

5. Zhang Zhidong 張之洞, 書目答問 (The Q and A of Bibliography) [1875], ed. Chen Juyuan 陳居淵 (Hong Kong: Sanlian shudian, 1998), lines 497–570, 133–142.

6. Wu Yu, 完白山人篆書雙鉤記 (Note on tracing-copying the seal script by Wanbai Mountain Man), cited in Dai Jiamiao 戴家妙, 鄧石如經典印作技法解析 (Analysis of technique in seal carving by Deng Shiru) (Chongqing: Chingqing chubanshe, 2006), p. 10.

7. Shana Brown, Pastimes: From Art and Antiquarianism to Modern Chinese Historiography (Honolulu: University Press of Hawai'i, 2011), p. 19.

8. Huang Dun, 'Two Schools of Calligraphy Join Hands: *Tiepai* and *Beipai* in the Qing Dynasty', in *Chinese Calligraphy*, ed. Ouyang Zhongshi & Wen C. Fong (New Haven and London: Yale University Press; Beijing: Foreign Languages Press, 2008), p. 350.

9. Dai, *Analysis of technique*, pp. 24–9; Xiling Seal Engravers' Society (ed.), 西泠印社藏品集 (Collection of Xiling Seal Society) (Hangzhou: Xiling Seal Engravers' Society, 2003), p. 199.

10. Dai, *Analysis of technique*, pp. 63–6.

11. Ban Zhiming 班志銘 (ed.), 鄧石如弟子職 (*Essay on the duty of disciples* by Deng Shiru) (Harbin: Helongjiang chubanshe, 2005).

12. Shen Shuyong's inscription on the seal 'Songjiang Shen Shuyong kaocang yinji', 1863; Zhejiang guji chubanshe 浙江古籍出版社 (ed.), 中國歷代篆刻集粹 (8)：趙之謙·徐三庚 (Selected works of seal carving from Chinese dynasties (8): Zhao Zhiqian and Xu Sangeng) (Hangzhou: Zhejiang guji chubanshe, 2007), p. 66.

13. Ibid., p. 54.

14. Shanghai Painting and Calligraphy Publisher (ed.), 吳昌碩印譜 (Seals of Wu Changshi) (Shanghai: Shanghai shuhua chubanshe, 1998), p. 69.

15. Gérard Genette, *Paratexts: Thresholds of Interpretation*, trans. Jane E. Lewin (Cambridge: Cambridge University Press, 1997).

16. Sang Shen 桑椹, 青銅器全形拓技術發展的分期研究 (Study of the phases of technological development in composite rubbing of bronze), *Dongfang bowu* vol. 12, no. 3 (2004), pp. 32–9. See also Kenneth Starr, *Black Tigers: A Grammar of Chinese Rubbings* (Seattle: University of Washington Press, 2008), p. 128.

17. Michele Matteini, 'Liuzhou', in *Creators of Modern China: 100 Lives from Empire to Republic*, ed. Jessica Harrison-Hall & Julia Lovell (London and New York: Thames & Hudson, 2023), entry 30.

18. Thomas Lawton, 'Rubbings of Chinese Bronzes', *Bulletin of the Museum of Far Eastern Antiquities* vol. 67 (1995), pp. 7–48.

19. For detailed studies of each object, see Lu Yi 陸易, '視覺的遊戲六舟《百歲圖》釋讀 (Visual game: an interpretation of "One Hundred Years" by Liuzhou)', *Dongfang bowu* vol. 41 (April 2011), pp. 5–14.

20. Dashou 達受, 寶素室金石書畫編年錄 (Register of bronze and stone, calligraphy and painting in the Studio of Precious Simplicity) [1851], vol. 1, pp. 49–50; 105/234–107/234. Zhejiang University Cadal Digital Library, www.cadal.zju.edu.cn/book/02021431/1/search@query=u%20寶素室金石書畫編年錄%20,type=all,tag=,publisher= (accessed 3 March 2022).

21. Qian Xuan, *Jinhuidui Painting*, undated. National Palace Museum, Taipei. See http://catalog.digitalarchives.tw/item/00/31/ac/d2.html (accessed 4 December 2021).

22. Nancy Berliner, 'The "Eight Brokens": Chinese Trompe-L'Oeil Painting', *Orientations* vol. 23 (February 1992), pp. 61–70, and 'Questions of Authorship in *Bapo*-Trompe L'oeil in Twentieth-Century Shanghai', *Apollo* vol. 3 (1998), pp. 17–22.

23. Mei Yün-ch'iu 梅韻秋, '張崟《京口三山圖卷》：道光年間新經世學風下的江山圖像 (Zhang Yin's handscroll "Jingkou sanshan tu": landscape imagery and the new statecraft school of the Daoguang period (1821–1850))', *Taida Journal of Art History* vol. 6, no. 3 (1999), pp. 195–239.

24. Wan Qingli 萬青力, 並非衰弱的百年：十九世紀中國繪畫史 (It was not a century in decline: a history of 19th-century Chinese painting) (Taipei: Xiongshi meishu chubanshe, 2005), p. 72.

25. Tang Yifen 湯貽芬, '王硯農之佐徵君索題癸未水災冊' (Wang Yannong, known as Zhizuo, asks people to provide colophons for the *Album of Flood in Year Guiwei* [1823])', in 琴隱園詩集 (Collection of poems from the garden of hiding behind the qin), 1875, *juan* 6, 81/83. See www.ctext.org/library.pl?if=gb&file=43154&page=81 (accessed 4 January 2022).

26. Guo Pu 郭璞, 爾雅注 (Commentary on *Erya*), reprinted in 爾雅註疏 (Commentaries on *Erya*), ed. Li Xueqin 李學勤 (Beijing: Beijing University Press, 1999), *juan* 1, 3–4.

27. Zhao Zhiqian, *Zhang'an zashuo* (Miscellanea from Zhang'an) [1861] (Shanghai: Shanghai renmin meishu chubanshe, 1989), pp. 19, 22.

28. Scholars have suggested that Zhao Zhiqian might have planned a series of paintings on local products, but somehow only the first version exists. Wu Chao-jen 吳超然, '趙之謙1861年的三件作品：異魚圖、甌中物產圖卷、甌中草木四屏—金石派與海派歸屬之商榷 (Three works by Zhao Zhiqian in 1861: Discussion on whether *Strange Ocean Species*, *The First Version of Local Products from Wenzhou*, and *Four Panels of Vegetation in Wenzhou* belong to the Epigraphic School or Shanghai School)', in 世變、形象、流風：中國近代繪畫 1796–1949 (Turmoil, representation and trends: modern Chinese painting, 1796–1949), ed. Liao Guiying 廖桂英 (Taipei: The Chang Foundation, 2008), pp. 451–69.

29. J. Qu et al., *Global International Waters Assessment: East China Sea*, Annex VII, pp. 77–80; M. Amano, 'Finless Porpoise: *Neophocaena Phocaenoides*', in ed. W.F. Perrin, B. Würsig & J.G.M. Thewissen, *Encyclopedia of Marine Mammals*, 2nd edn, pp. 437–9; Temminck & Schlegel, 'Caranx Trachurus Japonicus,' 1844, in *Fauna Japonica*, ed. Ph.F. von Siebold, Pisces Descriptio (1833–1850), pp. 109–110, P1. LIX, Fig. 3.1; H. Ishihara, Y. Wang & C.H. Jeong, *Gymnura Japonica*, (2009), in IUCN 2012, IUCN Red List of Threatened Species, available at www.iucnredlist.org (accessed 15 June 2021).

30. Robert Morrison, *Memoirs of the Life and Labours of Robert Morrison*, comp. Eliza Morrison, vol. 2 (London: Longman, Orme, Brown, and Longmans, 1839), p. 427; Rogério Miguel Puga, 'The British Museum of Macao (1829–1834) and its Contribution to Nineteenth-Century British Natural Science', *Journal of the Royal Asiatic Society (Third Series)* vol. 22 (October 2012), pp. 575–86.

31. Fa-ti Fan, *British Naturalists in Qing China: Science, Empire and Cultural Encounter* (Cambridge: Harvard University Press, 2004), pp. 163–5; Judith Magee, *Images of Nature: Chinese Art and the Reeve Collection* (London: Natural History Museum, 2011), p. 13, and *Art and Nature: Three Centuries of Natural History Art from around the World* (London: Greystone Books, 2010), pp. 146–9.

32. Pamela H. Smith, 'Art, Science, and Visual Culture in Early Modern Europe', *Isis* vol. 97 (2006), pp. 83–100.

33. David Wright, 'Careers in Western Science in Nineteenth-Century China: Xu Shou and Xu Jianyin', *Journal of the Royal Asiatic Society (Third Series)* vol. 5, no. 1 (1995), p. 55.

34. Yü Ying-shih 余英時, 歷史與思想 (History and philosophy) (Taipei: Lianjing chubanshe, 1982), pp. 121–56.

35. Ssu-yu Teng & John K. Fairbank, *China's Response to the West: A Documentary Survey, 1839–1923* (Cambridge: Harvard University Press, 1954), pp. 137–42; Paul A. Cohen, *Between Tradition and Modernity: Wang T'ao and Reform in Late Ch'ing China* (Cambridge: Harvard University Press, 1987); Paul A. Cohen, 'Joseph Edkins', in *Biographical Dictionary of Christian Missions*, ed. Gerald H. Anderson (Michigan: William B. Eerdmans Publishing Co., 1999), pp. 194–5.

36. Gu Xueguang 顧燮光 (ed.), 譯書經眼錄 (Records on available translated books) (Hangzhou: Jinjia shihao lou, 1934), *juan* 6, reprinted in 晚清新學書目提要 (List of books on Western learning in the late Qing), ed. Xiong Yuezhi 熊月之 (Shanghai: Shanghai shudian chubanshe, 2007), p. 319.

37. Fei Danxu 費丹旭, 費丹旭集 (Collected works of Fei Danxu) (Hangzhou: Zhejiang renmin chubanshe, 2016), p. 195.

38. Ibid., pp. 113–97.

39. Goyama Kiwamu, 明清時代的女性與文學 (Women and literature in the Ming–Qing periods), trans. Xiao Yanwan 蕭燕婉 (Taipei: Linking Publishing Company, 2016), p. 576.

40. Ellen Widmer, *The Beauty and the Book: Women and Fiction of Nineteenth-Century*

(Cambridge, Harvard University Asia Center, 2006), p. 12.

41. Guan Tingfen 管庭芬, 管庭芬日記 (Diary of Guan Tingfen), reprinted in Zhang Tingyin 張廷銀 (ed.), 管庭芬日记 (Guan Tingfen's Diary) (Beijing: Zhonghua shuju 中華書局, 2013), vol. 4, pp. 1662, 1670 and 1673.

42. Ibid., pp. 1600–75.

43. Ibid., pp. 1700–01.

44. 'Tang Yifen 湯貽芬', in 清史稿 (Draft of Qing history), ed. Zhao Erxun 趙爾巽 et al. (Taipei: Shangwu yinshuguan 商務印書館, 1999), vol. 12, juan 406, 9997.

45. Ibid., 'Dai Xi', vol. 12, juan 406, 9996–7; 'Dai Keheng qi Zhu 戴可恆妻朱' (Zhu, the wife of Dai Keheng), vol. 15, juan 517, 11712.

46. Yang Yi 楊逸, 海上墨林 (Ink forest of Shanghai) (1919; reprinted Taipei: Wenshizhe Publishing, 1988), entry 609, juan 4, 11.

47. Chia-ling Yang, *New Wine and Old Bottles: The Art of Ren Bonian in Nineteenth-Century Shanghai* (London: Saffron, 2007), pp. 33–5.

48. See Wu Changshi 吳昌碩, 'Yixi' 憶昔 (Remembrance) & 'Ganmeng' 感夢 (Dream with sentiment), 缶廬詩 (Poems by Foulu [Wu Changshi]), 1893, juan 2, 8–9, in 清代詩文集彙編 (Compilation of poems and essays from the Qing Dynasty), eds. Ji Baocheng 紀寶成 et al. (Shanghai: Shanghai guji chubanshe, 2011), vol. 757, pp. 601–02.

49. Wang Jiacheng 王家誠, 吳昌碩傳 (Biography of Wu Changshi) (Taipei: National Palace Museum, 1998), pp. 23–4, 154–6.

50. Zhang Tingyin (ed.), *Guan Tingfen's Diary*, vol. 4, p. 1683.

51. Shan Guolin, 'The Cultural Significance of the Shanghai School', in *Chinese Paintings from the Shanghai Museum 1851–1911*, ed. Anita Chung (Edinburgh: National Museum of Scotland), p. 11.

52. Ibid., pp. 10–11.

53. Ge Yuanxu 葛元煦, 'Jianshan 牋扇' (Stationery and fans), in 滬游雜記 (Notes on journeys to Shanghai) [1876] (Taipei: Guangwen shuju, 1989), juan 2, 1.

54. Ibid., 'Shen Bao guan 申報館' (The offices of *Shenbao*), juan 1, 20.

55. Rudolf G. Wagner, '進入全球想像圖景：上海的《點石齋畫報》 (Entering the world of fantasy: *Dianshizhai Illustrated News* of Shanghai)', *Zhongguo xueshu* vol. 8, no. 9 (2001), note 21.

56. Rudolf G. Wagner, 'The Role of the Foreign Community in the Chinese Public Sphere', *China Quarterly* vol. 142, no. 6 (1995), pp. 423–43; Roswells Britton, *The Chinese Periodical Press, 1800–1912* (Shanghai: Kelly & Walsh, 1933), pp. 48–75.

57. F.C. Jones, *Shanghai and Tientsin* (London: Oxford University Press and Humphrey Milford, 1940), pp. 3–24; on foreign communities and populations in the foreign settlements at Shanghai, see Zou Yiren 鄒依仁, 舊上海人口變遷的研究 (A study of the changes in population of old Shanghai) (Shanghai: Shanghai renmin chubanshe, 1980), pp. 68 and 81; on foreign architecture in Shanghai, see Jon W. Huebner, 'Architecture on the Shanghai Bund', *Papers on Far Eastern History* vol. 39, no. 3 (1989), pp. 127–65, and 'Architecture and History in Shanghai's Central District', *Journal of Oriental Studies* vol. 26, no. 2 (1988), pp. 209–69.

58. Chen Bohai 陳伯海 (ed.), 上海文化通史 (Cultural history of Shanghai) (Shanghai: Shanghai wenyi chubanshe, 1995), vol. 2, p. 1418.

59. Zhang Hongxing 張弘星, '中國最早的西洋美術搖籃：上海土山灣孤兒工藝院的藝術事業 (On the earliest cradle of Western arts and crafts in China: the art studio of Tushanwan Orphanage in Shanghai)', *Dongnan wenhua* vol. 87 (1991), pp. 127–8.

60. Lin Zou 林騶, 徐匯記略 (Short history of Xuhui) (Shanghai: Tushanwan yinshuguan, 1933).

61. 'Libaiyi paimai' 禮拜一拍賣 (Auction on Monday), *Shenbao*, 20 October 1878.

62. Yu Feian 于飛闇, 中國畫顏色的研究 (Chinese painting colours) (Beijing: Zhaohua meishu chubanshe, 1955), pp. 72–3.

63. Xu Jianrong 徐建融 (ed.), 潘天壽藝術隨筆 (Pan Tianshou's notes on art) (Shanghai: Wenyi chubanshe, 2001), p. 112.

64. Jonathan Spence, *The Search for Modern China* (New York: Norton, 1990), pp. 228–9, and 'The Formidable Empress Dowager Cixi in an Outing', in *The Chinese Century: A Photographic History of the Last Hundred Years*, ed. Jonathan Spence & Annping Chin (New York: Random House, 1996), pp. 28–9.

65. Chen Shen 陳申, 清代攝影史料瑣輯 (Collected notes on the history of Qing photography) (Beijing: Zhongguo hying xiehui, 1990); Photographic Association of Shanghai and Faculty of Literature (ed.), 上海攝影史 (History of Photography in Shanghai) (Shanghai University, Shanghai: Renmin meishu chubanshe, 1992).

66. Régine Thiriez, 'Ligelang: A French Photographer in 1850s Shanghai', *Orientations* vol. 32, no. 9 (2001), pp. 49–54.

67. Jian Shaoshu 姜紹書, '西域畫,' in 畫史叢書, ed. Yu Anlan (Shanghai: Renmin meishu chubanshe, 1962), vol. 2–4–2, p. 133.

68. Wang Tao 王韜, 瀛壖雜誌 (Miscellany on Shanghai) [1862] (Taipei: Guangwen shuju, 1966), pp. 174–5.

69. Ge, *Notes on Journeys*, vol. 1, chapter 2, p. 2.

70. Ibid., vol. 2, chapter 3, p. 26.

71. L. Carrington Goodrich & Nigel Cameron, *The Face of China 1860–1912: As Seen by Photographers and Travelers* (New York: Aperture Foundation, 1978), pp. 71, 97.

72. Wagner, 'Entering the world', pp. 63–8.

73. Kang Youwei 康有為, Preface to 萬目草堂藏中國畫目 (List of paintings in the collection of the thatched hut of ten thousand trees) [1917], ed. Jiang Guilin蔣貴麟 (Taipei: Wenshizhe chubanshe, 1977).

74. Ibid., p. 94.

75. Nagasaki kakyō kenkyūkai 長崎華僑研究会 (ed.), 續長崎華僑史稿 (Second report on Chinese immigrants in Nagasaki) (Nagasaki: Nagasaki kakyō kenkyūkai, 1987), pp. 14–15, Chart II–1; Junghee Moon, 'Modern Art Education in China', *Art History Forum* vol. 6 (1998), pp. 51–78; Takeyoshi Tsuruta 鶴田武良, '資料1: 清國 民國赴任日本人美術教員一覽 (Document 1: list of Japanese art teachers who taught in China during the Qing and the Republican eras)', *Bijutsu kenkyū* 美術研究 vol. 365 (1996), pp. 16–20.

Chapter 4

1. Rachel Silberstein, *A Fashionable Century: Textile Artistry and Commerce in the Late Qing* (Seattle: University of Washington Press, 2020), p. 7.

2. Lingbo Xiao, Yu Ye & Benyong Wei, 'Revolts Frequency during 1644–1911 in North China Plain and its Relationship with Climate', *Advances in Climate Change Research* vol. 2, no. 4 (2011), pp. 218–24.

3. Xianshuai Zhai et al., 'Regional Interactions in Social Responses to Extreme Climate Events: A Case Study of the North China Famine of 1876–1879', *Atmosphere*, vol. 11, no. 4 (2020), p. 393.

4. William Rowe, *China's Last Empire: The Great Qing* (Cambridge: Harvard University Press, 2009), p. 150.

5. Carol Benedict, 'Bubonic Plague in Nineteenth-Century China', *Modern China* vol. 14, no. 2 (1988), pp. 107–55.

6. Francesca Bray, *Technology and Gender: Fabrics of Power in Late Imperial China* (Berkeley: University of California Press, 1997).

7. Albert Feuerwerker, 'Handicraft and Manufactured Cotton Textiles in China, 1871–1910', *Journal of Economic History* vol. 30, no. 2 (1970), pp. 338–78.

8. Evelyn S. Rawski, *Education and Popular Literacy in Ch'ing China* (Ann Arbor: University of Michigan Press, 1979), p. 140.

9. Robert C. Allen et al., *Wages, Prices, and Living Standards in China, 1738–1925: In Comparison with Europe, Japan and India,* CEI Working Paper Series 03 (2009) (Center

for Economic Institutions, Institute of Economic Research, Hitotsubashi University); Kenneth Pomeranz, *The Great Divergence: China, Europe, and the Making of the Modern World Economy* (Princeton: Princeton University Press, 2000).

10. Ye Ma & Tianshu Chu, 'Living Standards in China between 1840 and 1912: A New Estimation of Gross Domestic Product Per Capita'. Groningen Growth and Development Centre, University of Groningen, prepared for the European Historical Economics Society Conference, 6–7 September 2013, LSE, London.

11. Lin Man-houng, *China Upside Down: Currency, Society and Ideologies, 1808–1856* (Cambridge: Harvard University Press, 2007), p. 13.

12. Frederic Wakeman Jr, 'The Canton Trade and the Opium War', in *The Cambridge History of China, Volume 10, Part 1: Late Ch'ing 1800–1911*, ed. John K. Fairbank (Cambridge: Cambridge University Press, 1978), p. 173.

13. Lothar Ledderose (ed.), *Orchideen und Felsen: Chinesische Bilder im Museum für Ostasiatische Kunst Berlin* (Berlin: G+H Verlag, 1998), pp. 274–304, cat. no. 40.

14. Rowe, *China's Last Empire*, pp. 119–21.

15. Kathryn Edgerton-Tarpley, '"Pictures to Draw Tears from Iron": The North China Famine 1876–1879,' www.visualizingcultures.mit.edu/tears_from_iron/tfi_essay01 (accessed 8 April 2022); and *Tears from Iron: Cultural Responses to Famine in Nineteenth-Century China* (Berkeley: University of California Press), 2008.

16. Alison Dray-Novey, 'Spatial Order and Police in Imperial Beijing', *Journal of Asian Studies* vol. 52, no. 4 (1993), pp. 885–922.

17. Susan Naquin, *Peking: Temples and City Life, 1400–1900* (Berkeley: University of California Press, 2000).

18. Silberstein, *A Fashionable Century*, p. 154.

19. Ibid., p. 7.

20. Zheng Linfan 鄭麟蕃, Wu Shaopeng 吳紹鵬 & Li Huibeng 李輝菶, 中國口腔醫學發展史 (History of the development of dentistry/stomatology in China) (Beijing: Beijing yikedaxue, Zhongguo xieheyike daxue lianhe chubanshe, 1998), pp. 37–43; Zhou Dacheng, 中国口腔医学史考 (Studies on the history of Chinese dentistry) (Beijing: Renmin weisheng chubanshe, 1991), pp. 155–85.

21. Régine Thiriez, 'Photography and Portraiture in Nineteenth Century China', *East Asian History* vol. 17/18 (June–December 1999), pp. 77–102.

22. Wen-Chien Cheng & Yanwen Jiang, *Gods in my Home: Chinese Ancestor Portraits and Popular Prints* (Toronto: Royal Ontario Museum, 2019); Jan Stuart & Evelyn S. Rawski, *Worshiping the Ancestors: Chinese Commemorative Portraits* (Washington, D.C.: Arthur M. Sackler Gallery, Smithsonian Institution, 2001).

23. Klaas Ruitenbeek (ed.), *Faces of China: Portrait Painting of the Ming and Qing Dynasties 1368–1912* (Berlin: Museum für Asiatische Kunst, Staatliche Museen zu Berlin; Petersberg: Michael Imhof Verlag, 2017), cat. nos. 86a–b.

24. Chun Shan, 'Marriage Law and Confucian Ethics in the Qing Dynasty', *Frontiers of Law in China* vol. 8, no. 4 (2013), pp. 823–4.

25. See the excellent description in Edward J.M. Rhoads, *Manchu and Han: Ethnic Relations and Political Power in Late Qing and Early Republican China, 1861–1928* (Seattle: University of Washington Press, 2000), p. 62.

26. Wu Hung, *Zooming in: Histories of Photography in China* (London: Reaktion Books, 2016), pp. 19–47.

27. I-fen Huang, 'Gender, Technical Innovation and Gu Family Embroidery in late Ming Shanghai', *East Asian Science, Technology and Medicine* vol. 36, no. 1 (2012), pp. 77–129.

28. Jeffrey W. Cody & Frances Terpak (eds), *Brush & Shutter: Early Photography in China* (Los Angeles: Getty Research Institute, 2011).

29. Terry Bennett, *History of Photography in China: Chinese Photographers 1844–1879* (London: Quaritch, 2013), p. 188.

30. Rudolf G. Wagner (ed.), *Joining the Global Public: Word, Image, and City in Early Chinese Newspapers, 1870–1910* (Albany: State University of New York Press, 2007).

31. Zheng Yangwen, *The Social Life of Opium in China* (Cambridge: Cambridge University Press, 2005).

32. Craig Clunas, *Chinese Export Watercolours* (London: Victoria and Albert Museum, 1984), pp. 57–60, ill. 35.

33. Silberstein, *A Fashionable Century*, pp. 19–22.

34. Nicky Levell, 'The Translation of Objects: R and M Davidson and the Friends' Foreign Mission Association, China, 1890–1894', in *Collectors: Individuals and Institutions*, ed. Anthony Shelton (London: Horniman Museum and Gardens, 2001), pp. 129–62.

35. Antonia Finnane, 'Chinese Domestic Interiors and "Consumer Constraint" in Qing China: Evidence from Yangzhou', *Journal of the Economic and Social History of the Orient* vol. 57, no. 1 (2014), pp. 112–44.

36. Christine Moll-Murata, *State and Crafts in the Qing Dynasty (1644–1911)* (Amsterdam: Amsterdam University Press, 2018).

37. Lai Yu-chih, '晚清中日交流下的圖像、技術與性別:《鏡影簫聲初集》研究 (Image, technology, and gender in Sino-Japanese exchanges during the late Qing: a study of the *Jingying xiaosheng chuji*)', *Jindai Zhongguo funüshi yanjiu* no. 28 (December 2016), pp. 125–214; Jonathan Hay, 'Painters and Publishing in Late Nineteenth-Century Shanghai', in *Phoebus 8: Art at the Close of China's Empire*, ed. Ju-hsi Chou (Tempe: Arizona State University Press, 1998), pp. 148–9.

38. Wang Yijun, 'From Tin to Pewter: Craft and Statecraft in China, 1700–1844', Ph.D. thesis, Columbia University, 2019; 'Tin and Pewter in the Age of Silver', in *The Silver Age: Origins and Trade of Chinese Export Silver* (Hong Kong: Hong Kong Maritime Museum, 2017).

39. Michel Lee, 'Subduing the "Foreign Devils"', *Transactions of the Oriental Ceramics Society* vol. 74 (2009–10), pp. 35–45.

40. Joyce Madancy, 'Unearthing Popular Attitudes toward the Opium Trade and Opium Suppression in Late Qing and Early Republican Fujian', *Modern China* vol. 27, no. 4 (2001), pp. 436–83.

41. Zhang Daye, *The World of a Tiny Insect: A Memoir of the Taiping Rebellion and its Aftermath*, trans. and ed. Xiaofei Tian (Seattle: University of Washington Press, 2013), p. 66.

42. Li Xiaoxin, 'Revisiting Guang shi jiaju (Cantonese-style Furniture): A Design History of the Mid-18th Century to the Early 20th Century', Ph.D. thesis, SOAS, 2020.

43. 'Aniline dyes,' *Scientific American* vol. 4, no. 10 (1861), p. 150.

44. Grace Fong, 'Female Hands: Embroidery as a Knowledge Field in Women's Everyday Life in Late Imperial and Early Republican China', *Late Imperial China* vol. 25, no. 1 (2004), pp. 1–58.

45. Li Yuhang, 'Embroidering Guanyin: Constructions of the Divine through Hair', *East Asian Science, Technology, and Medicine* vol. 36 (2012), pp. 131–66; Dorothy Ko, 'Epilogue: Textiles, Technology, and Gender in China', *East Asian Science, Technology, and Medicine* vol. 36 (2012), pp. 167–76.

46. Verity Wilson, *Chinese Dress* (London: Victoria and Albert Museum, 1986), pp. 64, 74.

47. Rachel Silberstein, 'Fashioning the Foreign: Using British Woolens in Nineteenth-Century China', in *Fashion, Identity, and Power in Modern Asia*, ed. Kyunghee Pyun & Aida Yuen Wong (New York: Palgrave Macmillan, 2019), pp. 231–58.

48. Luk Yu-ping, 'Collecting Chinese Jewellery at the Victoria and Albert Museum', *Transactions of the Oriental Ceramics Society* vol. 81 (2016–17), pp. 31–43; Cao Qin, 'Displaying China in the National Museum of Scotland', *Orientations* (January/February 2018), pp. 90–95.

49. Chris Hall, 'Chinese Handkerchiefs', *Textiles Asia* vol. 11, no. 2 (September 2019), pp. 22–7.

50. Helena Heroldová, 'Sleevebands: Neglected Element in Chinese Adornment', *Annals of the Náprstek Museum* vol. 41 (2020), pp. 93–111.

51. Dorothy Ko, *Every Step a Lotus: Shoes for Bound Feet* (Berkeley: University of California Press, 2001) and *Cinderella's Sisters: A Revisionist History of Footbinding* (Berkeley: University of California Press, 2005).

52. Jackie Yoong, *Fashion Revolution: Chinese Dress from the Late Qing to 1976* (Singapore: Asian Civilisations Museum, 2020).

53. John E. Vollmer, 'Clothed to Rule the Universe', *Art Institute of Chicago Museum Studies* vol. 26, no. 2 (2000), pp. 13–105.

54. Rachel Silberstein, 'Eight Scenes of Suzhou: Landscape Embroidery, Urban Courtesans, and Nineteenth-Century Chinese Women's Fashions', *Late Imperial China* vol. 36, no. 1 (June 2015), pp. 1–52.

55. Silberstein, *A Fashionable Century*, p. 161.

56. Mei Mei Rado, 'Images of Opera Characters Relating to the Qing Court', in *Performing Images: Opera in Chinese Visual Culture*, ed. Li Yuhang & Judith Zeitlin (Chicago: University of Chicago Press, 2014), p. 70.

57. Nancy Andrews Wreath, 'Weaves in Hand-Loom Fabrics', *Bulletin of the Pennsylvania Museum* vol. 22, no. 112 (1927), pp. 358–66.

58. Ye Xiaoqing, *The Dianshizhai Pictorial: Shanghai Urban Life, 1884–1898* (Ann Arbor: University of Michigan Press, 2003); and Wagner, *Joining the Global Public.*

59. Ellen Johnston Laing, *Selling Happiness: Calendar Posters and Visual Culture in Early-Twentieth-Century Shanghai* (Honolulu: University Press of Hawai'i, 2004).

60. Catherine Yeh, *Shanghai Love, Courtesans, Intellectuals and Entertainment Culture 1850–1910* (Seattle: University of Washington Press, 2006).

61. Song Gang 宋剛, '洋味競嘗：晚清上海與香港之西餐 (Trying the different *Yang* taste: Western cuisine in late-Qing Shanghai and Hong Kong)', *Journal of Oriental Studies* vol. 45, no. 1/2 (2012), pp. 45–66.

62. Mark Swislocki, *Culinary Nostalgia: Regional Food Culture and the Urban Experience in Shanghai* (Stanford: Stanford University Press, 2009), p. 97.

63. David Der-Wei Wang, *Fin-de-Siècle Splendor: Repressed Modernities of Late Qing Fiction, 1849–1911* (Stanford: Stanford University Press, 1997), p. 97.

64. Aki Ishigami, 'Chinese *chunhua* and Japanese *shunga'*, in *Shunga: Sex and Pleasure in Japanese Art*, ed. Timothy Clark, C. Andrew Gerstle, Aki Ishigami & Akiko Yano (London: British Museum Press, 2013), pp. 92–103.

65. Rebecca E. Karl, *Staging the World, Chinese Nationalism at the Turn of the Twentieth Century* (Durham: Duke University Press, 2002).

66. Emily Byrne Curtis, *Reflected Glory in a Bottle* (New York: Soho Bodhi, 1980), pp. 89–90; Ulf Birbaumer, Michael Hüttler & Guido di Palma (eds), *Corps du Théâtre / Il Corpo del Teatro: organicité, contemporanéité, interculturalité / organicità, contemporaneità, interculturalità* (Vienna: Hollitzer Wissenschaftsverlag, 2011).

67. Inge C. Orr, 'Puppet Theatre in Asia', *Asian Folklore Studies* vol. 33, no. 1 (1974), pp. 69–84.

68. Gong Hongyu 宫宏宇, '基督教新教传教士与中国音乐:以李太郭为例 (Protestant missionaries and Chinese music: Li Taiguo as an example)', *Zhongguo yinyue* vol. 1 (2013), pp. 43–50.

69. Stephen Markbreiter, 'Anatomy of the Chinese Birdcage', *Arts of Asia* (May–June 1985), pp. 57–71; Gloria W. Lannom, 'Chinese Bird Cages: A New Study Based on the Donegan Collection', *Arts of Asia* (September–October 1989), pp. 159–65.

70. Rose Kerr, Philip Allen & Shih Ching-fei, *Chinese Ivory Carvings: The Sir Victor Sassoon Collection* (London: Scala, 2016), p. 142; Yutaka Suga, 'Chinese Cricket-Fighting', *International Journal of Asian Studies* vol. 3, no. 1 (2006), pp. 77–93.

71. W.H. Wilkinson, 'Chinese Origin of Playing Cards', *American Anthropologist* vol. 8, no. 1 (January 1895), pp. 61–78.

72. Andrew Lo, 'China's Passion for Pai: Playing Cards, Dominoes, and Mahjong', in *Asian Games: The Art of Contest*, ed. Colin Mackenzie and Irving Finkel (New York: Asia Society, 2004), pp. 227–9.

73. Henrietta Harrison, *The Man Awakened from Dreams: One Man's Life in a North China Village, 1857–1942* (Stanford: Stanford University Press, 2005), p. 33.

74. Suan Poh Lim & William Y. Willetts, *Nonya Ware and Kitchen Ch'ing: Ceremonial and Domestic Pottery* (Selangor: Southeast Asian Ceramic Society, West Malaysia Chapter, 1981); Dorian Bell, *The Diana Adventure* (Kuala Lumpur: Malaysian Historical Salvors, 1995); Nigel Pickford & Michael Hatcher, *The Legacy of the Tek Sing: China's Titanic – its Tragedy and its Treasure* (London: Granta, 2000).

75. Thomas Hollmann, *The Land of the Five Flavors: A Cultural History of Chinese Cuisine* (New York: Columbia University Press, 2013), p. 149.

76. Ibid., p. 92.

77. Ibid., p. 99.

78. Silberstein, *A Fashionable Century*, p. 183.

Chapter 5

1. Lisa Hellman, *This House Is Not a Home: European Everyday Life in Canton and Macao 1730–1830* (Leiden: Brill, 2018).

2. Josepha Richard, 'Collecting Chinese Flora: Eighteenth- to Nineteenth-Century Sino-British Scientific and Cultural Exchanges as Seen through British Collections of China Trade Botanical Paintings', *Ming Qing Yanjiu* vol. 24, no. 2 (2020), pp. 209–44.

3. Anna Dallapiccola, *Reverse Glass Painting in India* (Delhi: Niyogi Books, 2017).

4. Thierry Audric, *Chinese Reverse Glass Painting 1720–1820: An Artistic Meeting between China and the West* (Bern: Peter Lang, 2020).

5. Winnie Won Yin Wong, 'After the Copy: Creativity, Originality and the Labor of Appropriation: Dafen Village, Shenzhen, China (1989–2010)', Ph.D. thesis, Massachusetts Institute of Technology, 2010, pp. 90–92.

6. Melissa Macauley, *Distant Shores: Colonial Encounters on China's Maritime Frontier* (Princeton: Princeton University Press, 2021).

7. Henrietta Harrison, *The Man Awakened from Dreams: One Man's Life in a North China Village, 1857–1942* (Stanford: Stanford University Press, 2005), p. 42.

8. Ibid., p. 22.

9. Alexander Lomanov, 'The Russian Orthodox Church', in *Handbook of Christianity in China*, vol. 2, ed. Gary Tiedemann (Leiden: Brill, 2009), p. 200.

10. Steven B. Miles, *Upriver Journeys: Diaspora and Empire in Southern China, 1570–1850* (Cambridge: Harvard University Asia Center, 2017).

11. Emma K. Poulter, 'Hybridity – Objects as Contact Zones: A Critical Analysis of Objects in the West African Collections at the Manchester Museum', *Museum Worlds* vol. 2, no. 1 (2014), pp. 25–41; the term 'contact zones' is from the work of Mary-Louse Pratt, *Imperial Eyes: Travel Writing and Transculturation* (London: Routledge, 1991).

12. Cordell Yee, 'Traditional Chinese Cartography and the Myth of Westernization', in *The History of Cartography*, vol. 2, ed. J.B. Harley & David Woodward (Chicago: University of Chicago Press, 1994), pp. 170–202.

13. Donna Brunero & Stephanie Villalta Puig (eds.), *Life in Treaty Port China and Japan* (Basingstoke: Palgrave Macmillan, 2018).

14. Connie A. Shemo, *The Chinese Medical Ministries of Kang Cheng and Shi Meiyu, 1872–1937: On a Cross-Cultural Frontier of Gender, Race, and Nation* (Lanham: Rowman & Littlefield, 2011).

15. Hsien-Chun Wang, 'Discovering Steam Power in China, 1840s–1860s', *Technology and Culture* vol. 51, no. 1 (2010), p. 37.

16. Wang, 'Discovering', p. 53.

17. Anne Reinhardt, *Navigating Semi-Colonialism: Shipping, Sovereignty, and Nation-Building in China, 1860–1937* (Cambridge: Harvard University Asia Center, 2018), p. 79.

18. Jagjeet Lally, *India and the Silk Roads: The History of a Trading World* (London: Hurst & Company, 2021), p. 175.

19. Macauley, *Distant Shores*, p. 183.

20. Yi-Li Wu, 'The Qing Period', in *Chinese Medicine and Healing: An Illustrated History*, ed. T.J. Hinrichs & Linda Barnes (Cambridge: Harvard University Press, 2013), p. 194.

21. Tiedemann (ed.), *Handbook of Christianity in China*, vol. 2, p. 143.

22. R. Bin Wong, 'Opium and Modern Chinese State-making', in *Opium Regimes*, ed. Timothy Brook & Bob Wakabayashi (Berkeley: University of California Press, 2000), p. 201.

23. David Hardiman (ed.), *Healing Bodies, Saving Souls: Medical Missions in Asia and Africa* (Amsterdam: Rodopi, 2006).

24. Paul Unschuld, *Traditional Chinese Medicine: Heritage and Adaptation*, trans. Bridie Andrews (New York: Columbia University Press, 2018), p. 95.

25. Kathleen L. Lodwick, *Crusaders against Opium: Protestant Missionaries in China, 1874–1917* (Lexington: University Press of Kentucky, 1996), p. 35.

26. Emily Baum, 'Health by the Bottle: The Dr. Williams' Medicine Company and the Commodification of Well-Being in Liangyou', in *Liangyou: Kaleidoscopic Modernity and the Shanghai Global Metropolis, 1926–1945*, ed. Paul Pickowicz, Kuiyi Shen & Yingjin Zhang (Leiden: Brill, 2013), p. 75.

27. Sean Hsiang-lin Lei, *Neither Donkey nor Horse: Medicine in the Struggle over China's Modernity* (Chicago: University of Chicago Press, 2014), pp. 21–24, 70; Mark Gamsa, 'The Epidemic of Pneumonic Plague in Manchuria 1910–1911', *Past & Present* no. 190 (2006), pp. 147–83; see also Ruth Rogaski, *Knowing Manchuria: Environments, the Senses, and Natural Knowledge on an Asian Borderland* (Chicago: University of Chicago Press, 2022).

28. Bridie Andrews, *The Making of Modern Chinese Medicine, 1850–1960* (Vancouver: University of British Columbia Press, 2014), p. 103.

Chapter 6

1. C.A. Bayly, *The Birth of the Modern World, 1780–1914* (London: Wiley-Blackwell, 2003).

2. Allen S. Will, *World-Crisis in China, 1900* (Baltimore: John Murphy, 1900), pp. 1–2: 'Fleets and armies are ready to meet in the clash of battle for possession of the ancient empire's soil … A world-war greater than any in modern times is the imminent and awful possibility that looms up.'

3. Ibid., p. vii.

4. On horses, see *The General Stud Book, Containing Pedigrees of Race Horses, &c. &c., volume XVIII* (London: Weatherby and Sons, 1897), p. 83. The film of Li's 1896 trip to New York is available at www.//archive.org/details/Li_mutoscope (accessed 1 August 2022)

5. Robert Bickers, *The Scramble for China: Foreign Devils in the Qing Empire, 1832–1914* (London: Allen Lane, 2011).

6. Paul A. Cohen, *History in Three Keys: The Boxers as History, Experience, and Myth* (Berkeley: University of California Press, 1997); Joseph W. Esherick, *The Origins of the Boxer Uprising* (Berkeley: University of California Press, 1988).

7. Barbara Mittler, *A Newspaper for China? Power, Identity, and Change in Shanghai's News Media, 1872–1912* (Cambridge: Harvard East Asian Studies Monographs, 2004).

8. Translation by Flora Shao, revised by Peter C. Perdue, for *Visualizing Cultures*, MIT, available at www.//visualizingcultures.mit.edu/dianshizhai/dz_v02_048 (accessed 12 June 2022).

9. Michael Gibbs Hill, *Lin Shu Inc.: Translation and the Making of Modern Chinese Culture* (Oxford: Oxford University Press, 2013), p. 11.

10. Rebecca E. Karl, *Staging the World: Chinese Nationalism at the Turn of the Twentieth Century* (Durham: Duke University Press, 2002), p. 89.

11. Li Gui, *A Journey to the East: Li Gui's A New Account of a Trip around the Globe*, trans. and ed. Charles Desnoyers (Ann Arbor: University of Michigan Press, 2004), pp. 76–7.

12. Peter Zarrow, 'The Reform Movement, the Monarchy, and Political Modernity', in *Rethinking the 1898 Reform Period: Political and Cultural Change in Late Qing China*, ed. Rebecca E. Karl & Peter Zarrow, (Cambridge: Harvard University Asia Center, 2002), p. 32.

13. 29 January 1898 memorial to the throne, 'Comprehensive Consideration of the Whole Situation', translated in *Sources of Chinese Tradition, Volume 2: From 1600 through the Twentieth Century*, ed. William Theodore de Bary & Richard Lufrano (New York: Columbia University Press, 2000), pp. 269–70.

14. Amy Dooling & Kristina Torgeson (eds.), *Writing Women in Modern China: An Anthology of Women's Literature from the Early Twentieth Century* (New York: Columbia University Press, 1997), pp. 43–4.

15. Qiu Jin, 'Five Poems', trans. Yilin Wang, *Asymptote*, 2021, and available at www.asymptotejournal.com/poetry/qiu-jin-five-poems (accessed 7 June 2022).

16. 'Chinese Boxer Placards in Rhyme that Have Caused the Uprisings', *San Francisco Call*, 7 July 1900, p. 6. As a sign of the large shadow that Viceroy Li cast on thinking about China at the time, the article published just beneath this one was titled 'Li Hung Chang's Unique Personality'. For an alternative translation of the lines of doggerel, which is less strictly literal but preserves the rhyme scheme of the original, see Esherick, *Origins*, p. 300.

17. George Makari, *Of Fear and Strangers: A History of Xenophobia* (New York: Norton, 2021), pp. 49–61.

18. Du Chunmei, *Gu Hongming's Eccentric Chinese Odyssey* (Philadelphia: University of Pennsylvania Press, 2019).

19. Ku Hung-ming, *Papers from a Viceroy's Yamen* (Shanghai: Shanghai Mercury, 1901), p. 96.

20. Yuan-stung Chen, *Return to the Middle Kingdom: One Family, Three Revolutionaries, and the Birth of Modern China* (New York: Union Press, 2008).

Bibliography

Allen, Robert C. et al., *Wages, Prices, and Living Standards in China, 1738–1925: In Comparison with Europe, Japan and India*, CEI Working Paper Series 03 (Center for Economic Institutions, Institute of Economic Research, Hitotsubashi University, 2009).

Andrade, Tonio, *The Gunpowder Age: China, Military Innovation, and the Rise of the West in World History* (Princeton: Princeton University Press, 2016).

Andrews, Bridie, *The Making of Modern Chinese Medicine, 1850–1960* (Vancouver: University of British Columbia Press, 2014).

Andrews, Julia F. & Kuiyi Shen, *The Art of Modern China* (Berkeley: University of California Press, 2012).

'Aniline Dyes', *Scientific American* vol. 4, no. 10 (1861), p. 150.

Atwill, David, *The Chinese Sultanate: Islam, Ethnicity and the Panthey Rebellion in Southwest China, 1856–1873* (Stanford: Stanford University Press, 2005).

Audric, Thierry, *Chinese Reverse Glass Painting 1720–1820: An Artistic Meeting between China and the West* (Bern: Peter Lang, 2020).

Ayers, John et al., *Chinese and Japanese Works of Art in the Collection of Her Majesty The Queen*, 3 vols (London: Royal Collection Trust, 2016).

Bai, Qianshen, *Fu Shan's World* (Cambridge: Harvard University Press, 2003).

__, 'From Composite Rubbing to Pictures of Antiques and Flowers (Bogu huahui): The Case of Wu Yun', *Orientations* vol. 38, no. 3 (April 2007), pp. 52–60.

Ban, Zhiming 班志銘 (ed.), 鄧石如弟子職 (*Essay on the duty of disciples* by Deng Shiru) (Harbin: Helongjiang chubanshe, 2005).

Baum, Emily, 'Health by the Bottle: The Dr. Williams' Medicine Company and the Commodification of Well-Being in Liangyou', in *Liangyou: Kaleidoscopic Modernity and the Shanghai Global Metropolis, 1926–1945*, ed. Paul Pickowicz, Kuiyi Shen & Yingjin Zhang (Leiden: Brill, 2013), pp. 69–94.

Baumler, Alan, *Modern China and Opium: A Reader* (Ann Arbor: University of Michigan Press, 2001).

__, *Worse than Floods and Wild Beasts* (Albany: State University of New York Press, 2007).

Bayly, C.A., *The Birth of the Modern World, 1780–1914* (London: Wiley-Blackwell, 2003).

Bell, Dorian, *The Diana Adventure* (Kuala Lumpur: Malaysian Historical Salvors, 1995).

Bello, David Anthony, *Opium and the Limits of Empire: Drug Prohibition in the Chinese Interior, 1729–1850* (Cambridge: Harvard University Press, 2005).

Benedict, Carol, 'Bubonic Plague in Nineteenth-Century China', *Modern China* vol. 14, no. 2 (1988), pp. 107–55.

Bennett, Natasha, *Chinese Arms and Armour* (Leeds: Trustees of the Royal Armouries, 2018).

Bennett, Terry, *History of Photography in China: Chinese Photographers 1844–1879* (London: Quaritch, 2013).

Bergère, Marie-Claire, *Sun Yat-sen*, trans. Janet Lloyd (Stanford: Stanford University Press, 1998).

Berliner, Nancy, *Chinese Folk Art* (Boston: New York Graphic Society, 1986).

__, 'The "Eight Brokens": Chinese Trompe-L'Oeil Painting', *Orientations* vol. 23, no. 2 (February 1992), pp. 61–70.

__, 'Questions of Authorship in *Bapo*: Trompe L'oeil in Twentieth-Century Shanghai', *Apollo* vol. 3 (1998), pp. 17–22.

__, *The 8 Brokens: Chinese Bapo Painting* (Boston: MFA Publications, 2018).

Betta, Chiara, 'Silas Aaron Hardoon and Cross-Cultural Adaptation in Shanghai', in *The Jews of China* (vol. 1), ed. Jonathan Goldstein (Armonk: M.E. Sharpe, 1999), pp. 216–29.

Bickers, Robert, *The Scramble for China: Foreign Devils in the Qing Empire, 1832–1914* (London: Allen Lane, 2011).

__ & Gary Tiedemann (eds.), *The Boxers, China, and the World* (Lanham: Rowman & Littlefield, 2007).

Birbaumer, Ulf, Michael Hüttler & Guido di Palma (eds), *Corps du Théâtre / Il Corpo del Teatro: organicité, contemporanéité, interculturalité / organicità, contemporaneità, interculturalità* (Vienna: Hollitzer Wissenschaftsverlag, 2011).

Bonk, James, 'Chinese Military Men and Cultural Practice in the Early Nineteenth-Century Qing Empire (1800–1840)', Ph.D. thesis, Princeton, 2014.

__, 'Mobile Monuments: Literati Collectors of Military Artefacts in the 19th Century', Paper presented at the Conference of the Chinese Military History Society, Columbus, Ohio, 9 May 2019.

Bray, Francesca, *Technology and Gender: Fabrics of Power in Late Imperial China* (Berkeley: University of California Press, 1997).

Brezzi, Alessandra, 'Some Artistic Descriptions and Ethical Dilemmas in Shan Shili's Travel Notes on Italy (1909)', *International Communication of Chinese Culture* vol. 3, no. 1 (2016), pp. 175–89.

Britton, Roswells, *The Chinese Periodical Press, 1800–1912* (Shanghai: Kelly & Walsh, 1933).

Brook, Timothy, 'Censorship in Eighteenth-Century China: A View from the Book Trade', *Canadian Journal of History* vol. 22 (1988), pp. 177–96.

Brown, Claudia & Ju-hsi Chou, *Transcending: Turmoil Painting at the Close of Chinese Empire 1796–1911* (Phoenix: Phoenix Art Museum, 1992).

Brown, Shana, *Pastimes: From Art and Antiquarianism to Modern Chinese Historiography* (Honolulu: University Press of Hawai'i, 2011).

Brunero, Donna & Stephanie Villalta Puig (eds), *Life in Treaty Port China and Japan* (Basingstoke: Palgrave Macmillan, 2018).

Buckland, Rosina, 'Displaying East Asia at the National Museum of Scotland', *Orientations* vol. 50, no. 2 (March/April 2019), pp. 64–73.

Cahill, James, 'Ren Xiong and His Self-Portrait', *Ars Orientalis* vol. 25 (1995), pp. 119–32.

Cao, Maggie M., 'Copying in Reverse: China Trade Paintings on Glass', in *Beyond Chinoiserie: Artistic Exchange between China and the West during the Late Qing Dynasty (1796–1911)*, ed. Petra ten-Doesschate Chu & Jennifer Milam (Leiden: Brill, 2019), pp. 72–92.

Cao, Qin, 'By the Mandate of Heaven: A Kingfisher Headdress in the National Museum of Scotland', *Orientations* vol. 50, no. 2 (March/April 2019), pp. 74–81.

Carl, Katherine A., *With the Empress Dowager of China* (London: E. Nash, 1906).

Carroll, John M., 'The Canton System: Conflict and Accommodation in the Contact Zone', *Journal of the Royal Asiatic Society Hong Kong Branch* vol. 50 (2010), pp. 51–66.

Chang, Jung, *Empress Dowager Cixi: The Concubine Who Launched Modern China* (New York: Knopf, 2013).

Chang, Willow, Weilan Hai, Yang Renkai & David Ake Sensabaugh (eds), 末帝寶鑒: 遼寧省博物館藏清宮散逸明清書畫 (The Last Emperor's collection: masterpieces of painting and calligraphy from the Liaoning Provincial Museum) (New York: China Institute, 2008).

Cheang, Sarah, 'Women, Pets, and Imperialism: The British Pekingese Dog and Nostalgia for Old China', *Journal of British Studies* vol. 45, no. 2 (2006), pp. 359–87.

Chen, Bohai 陳伯海 (ed.), 上海文化通史 (Cultural history of Shanghai) (Shanghai: Shanghai wenyi chubanshe, 1995).

Chen, Hsia-sheng 陳夏生, 明清琺瑯器展覽圖錄 (Enamelware in the Ming and Qing dynasties) (Taipei: National Palace Museum, 1999).

Chen, Hui-hsia 陳慧霞, '清代宮廷婦女簪飾之流變 (The development of Qing court ladies' hair ornaments)', *Jindai Zhongguo funüshi yanjiu* no. 28 (December 2016), pp. 53–122.

Chen, Liana, *Staging for the Emperors: A History of Qing Court Theatre, 1683–1923* (Amherst: Cambria Press, 2021).

Chen, Pao-chen 陳葆真, '從四幅《歲朝圖》的表現問題談到乾隆皇帝的親子關係 (On four paintings showing Emperor Qianlong and his children celebrating the New Year and their related problems)', *Meishushi yanjiu jikan* vol. 28 (2010), pp. 123–84.

Chen, Pingyuan 陳平原 & Xia Xiaohong 夏曉虹, 圖像晚清:《點石齋畫報》(Late Qing images: *Dianshizhai Pictorial*) (Beijing: Dongfang chubanshe, 2014).

Chen, Shen 陳申, 清代攝影史料瑣輯 (Collected notes on the history of Qing photography) (Beijing: Zhongguo sheying xiehui, 1990).

Chen, Yin-Jen, 'Roaming Nüxia: Female Knights-errant in Jin Yong's Fiction', M.A. thesis, University of Victoria, 2015.

Chen, Yuan-tsung, *Return to the Middle Kingdom: One Family, Three Revolutionaries, and the Birth of Modern China* (New York: Union Press, 2008).

Cheng, Wen-chien & Yanwen Jiang, *Gods in my home: Chinese Ancestor Portraits and Popular Prints* (Toronto: Royal Ontario Museum, 2019).

Chu, Christina & Chuang Shen, *Early Masters of the Lingnan School* (Hong Kong: Hong Kong Urban Council and Hong Kong Museum of Art, 1983).

Chung, Anita, *Chinese Paintings from the Shanghai Museum, 1851–1911* (Edinburgh: National Museum of Scotland, 2000).

Clarke, Prescott & J.S. Gregory, *Western Reports on the Taiping: A Selection of Documents* (Honolulu: University Press of Hawai'i, 1982).

Clunas, Craig, *Chinese Export Watercolours* (London: Victoria and Albert Museum, 1984).

__, *Chinese Painting and its Audiences* (Princeton: Princeton University Press, 2017).

Cody, Jeffrey W. & Frances Terpak (eds), *Brush & Shutter: Early Photography in China* (Los Angeles: Getty Research Institute, 2011).

Cohen, Paul A., *Discovering History in China* (New York: Columbia University Press, 1986).

__, *Between Tradition and Modernity: Wang T'ao and Reform in Late Ch'ing China* (Cambridge: Harvard University Press, 1987).

__, *History in Three Keys: The Boxers as History, Experience, and Myth* (Berkeley: University of California Press, 1997).

__, 'Joseph Edkins', in *Biographical Dictionary of Christian Missions*, ed. Gerald H. Anderson (Michigan: William B. Eerdmans Publishing Co., 1999), pp. 194–5.

Conner, Patrick, *Paintings of the China Trade: The Sze Yuan Tang Collection of Historic Paintings* (Hong Kong: Hong Kong Maritime Museum, 2013).

Crossley, Pamela Kyle, *Orphan Warriors: Three Manchu Generations and the End of the Qing World* (Princeton: Princeton University Press, 1990).

__, *The Manchus* (Oxford: Blackwell Publishers, 1997).

__, *A Translucent Mirror: History and Identity in Qing Imperial Ideology* (Berkeley: University of California Press, 2006).

Curtis, Emily Byrne, *Reflected Glory in a Bottle* (New York: Soho Bodhi, 1980).

__, 'A Plan of the Emperor's Glassworks', *Arts Asiatiques* vol. 56 (2001), pp. 81–90.

Curwen, C.A., *Taiping Rebel: The Deposition of Li Hsiu-Ch'eng* (Cambridge: Cambridge University Press, 1977).

Dai, Jiamiao 戴家妙, 鄧石如經典印作技法解析 (Analysis of technique in seal carvings by Deng Shiru) (Chongqing: Chingqing chubanshe, 2006).

Dai, Yingcong, *The White Lotus War: Rebellion and Suppression in Late Imperial China* (Seattle: University of Washington Press, 2019).

Dallapiccola, Anna, *Reverse Glass Painting in India* (Delhi: Niyogi Books, 2017).

Dalrymple, William (ed.), *Forgotten Masters: Indian Painting for the East India Company* (London: Philip Wilson Publishers Ltd, 2019).

Dashou 達受, 寶素室金石書畫編年錄 (Register of bronze and stone, calligraphy and painting in the Studio of Precious Simplicity) [1851], in 六舟集 (Collected writings of Liuzhou), ed. Sang Shen 桑椹 (Hangzhou: Zhejiang guji chubanshe, 2015), pp. 1–104.

Day, Jenny Huangfu, *Qing Travellers to the Far West: Diplomacy and the Information Order in Late Imperial China* (Cambridge: Cambridge University Press, 2018).

De Bary, William Theodore & Richard Lufrano (eds), *Sources of Chinese Tradition, Volume 2: From 1600 through the Twentieth Century* (New York: Columbia University Press, 2000).

Dooling, Amy, *Women's Literary Feminism in Twentieth-Century China* (New York: Springer, 2005).

__ & Kristina Torgeson (eds), *Writing Women in Modern China: An Anthology of Women's Literature from the Early Twentieth Century* (New York: Columbia University Press, 1997).

Dray-Novey, Alison, 'Spatial Order and Police in Imperial Beijing', *Journal of Asian Studies* vol. 52, no. 4 (1993), pp. 885–922.

Edgerton-Tarpley, Kathryn, *Tears from Iron: Cultural Responses to Famine in Nineteenth-Century China* (London and Berkeley: University of California Press, 2008).

Elliott, Mark C., *The Manchu Way: The Eight Banners and Ethnic Identity in Late Imperial China* (Stanford: Stanford University Press, 2006).

Elman, Benjamin A., *A Cultural History of Civil Examinations in Late Imperial China* (Berkeley: University of California Press, 2000).

__, 'Naval Warfare and the Refraction of China's Self-Strengthening Reforms into Scientific and Technological Failure, 1865–1895', *Modern Asian Studies* vol. 38, no. 2 (2004), pp. 283–326.

Entract, J.P., 'Looty: A Small Chinese Dog, Belonging to Her Majesty', *Journal of the Society for Army Historical Research* vol. 50, no. 204 (Winter 1972), pp. 237–8.

Erickson, Britta Lee & J. May Lee Barrett, 'Zhou Xian's Fabulous Construct: The Thatched Cottage of Fan Lake', in *Phoebus 8: Art at the Close of China's Empire*, ed. Ju-hsi Chou (Tempe: Arizona State University Press, 1998), pp. 67–93.

__, *Modern Ink: The Art of Wu Changshi* (Berkeley: Mozhai Foundation, 2018).

Esherick, Joseph W., *The Origins of the Boxer Uprising* (Berkeley: University of California Press, 1988).

Fairbank, John K. (ed.), *The Chinese World Order: Traditional China's Foreign Relations* (Cambridge: Harvard University Press, 1968).

__ (ed.), *The Cambridge History of China, Volume 10, Part 1: Late Ch'ing* (Cambridge: Cambridge University Press, 1978).

Fan, Fa-ti, *British Naturalists in Qing China: Science, Empire, and Cultural Encounter* (Cambridge: Harvard University Press, 2004).

Fei, Danxu 費丹旭, 費丹旭集 (Collected works of Fei Danxu) (Hangzhou: Zhejiang renmin chubanshe, 2016).

Feuerwerker, Albert, 'Handicraft and Manufactured Cotton Textiles in China, 1871–1910', *Journal of Economic History* vol. 30, no. 2 (1970), pp. 338–78.

Finlay, Skip, 'Freedom and Whaling in Nantucket', *Sea History* vol. 172 (Autumn 2020), pp. 16–21.

Finnane, Antonia, *Changing Clothes in China: Fashion, History, Nation* (New York: Columbia University Press, 2008).

__, 'Chinese Domestic Interiors and "Consumer Constraint" in Qing China: Evidence from Yangzhou', *Journal of the Economic and Social History of the Orient* vol. 57, no. 1 (2014), pp. 112–44.

Fogel, Joshua (ed.), *The Role of Japan in Modern Chinese Art* (Berkeley: University of California Press, 2012).

Fong, Grace S., 'Female Hands: Embroidery as a Knowledge Field in Women's Everyday Life in Late Imperial and Early Republican China', *Late Imperial China* vol. 25, no. 1 (2004), pp. 1–58.

__ & Ellen Widmer (eds), *The Inner Quarters and Beyond: Women Writers from Ming through Qing* (Leiden: Brill, 2010).

Fong, Wen C., *Between Two Cultures: Late Nineteenth- and Twentieth-Century Chinese Paintings from the Robert H. Ellsworth Collection in The Metropolitan Museum of Art* (New York: The Metropolitan Museum of Art, 2001).

Forbes, H.A. Crosby, John Devereux Kernan & Ruth S. Wilkins, *Chinese Export Silver, 1785 to 1885* (Milton: Museum of the American China Trade, 1975).

Fröhlich, Judith, 'Pictures of the Sino-Japanese War of 1894–1895', *War in History* vol. 21, no. 2 (April 2014), pp. 214–50.

Gamsa, Mark, 'The Epidemic of Pneumonic Plague in Manchuria 1910–1911', *Past & Present* vol. 190 (2006), pp. 147–83.

Garrett, Stephen, 'The Shamanic Empire and the Heavenly Astute Khan: Analysis of the Shamanic Empire of the Early Qing, Its Role in Inner Asian Hegemony, the Nature of Shamanic Khanship, and Implications for Manchu Identity', Ph.D. thesis, University of Hawai'i, 2020.

Garrett, Valery, *Chinese Dress: From the Qing Dynasty to the Present Day* (Rutland: Tuttle, 2008).

Ge, Yuanxu 葛元煦, 滬游雜記 (Notes on journeys to Shanghai) [1876] (Taipei: Guangwen shuju, 1989).

Genette, Gérard, *Paratexts: Thresholds of Interpretation*, trans. Jane E. Lewin (Cambridge: Cambridge University Press, 1997).

Glahn, Richard von, 'Foreign Silver Coins in the Market Culture of Nineteenth Century China', *International Journal of Asian Studies* vol. 4, no. 1 (2007), pp. 51–78.

Goldman, Andrea, *Opera and the City: The Politics of Culture in Beijing, 1770–1900* (Stanford: Stanford University Press, 2013).

Gong, Hongyu 宮宏宇, '基督教新教傳教士與中國音樂:以李太郭為例 (Protestant missionaries and Chinese music: Li Taiguo as an example)', *Zhongguo yinyue* vol. 1 (2013), pp. 43–50.

Goodrich, L. Carrington & Nigel Cameron, *The Face of China 1860–1912: As Seen by Photographers and Travelers* (New York: Aperture Foundation, 1978).

Goossaert, Vincent, *The Taoists of Peking, 1800–1949: A Social History of Urban Clerics* (Cambridge: Harvard University Asia Center, 2007).

Goto-Jones, Christopher, *Modern Japan: A Very Short Introduction* (Oxford: Oxford University Press, 2009).

Gu, Xueguang 顧燮光 (ed.), 譯書經眼錄 (Records on available translated books) (Hangzhou: Jinjia shihao lou, 1934).

Gu, Yanwu 顧炎武, '金石文字集序 (Preface of *Notes on Epigraphic Inscriptions*)', in 景印文淵閣四庫全書 (Photocopied version of the Complete Library of the Four Branches of the Treasuries, Wenyuange edition), vol. 683 (Taipei: Shangwu yinshuguan, 1983).

Gu, Yi, 'Prince Chun through the Lens: Negotiating the Photographic Medium in Royal Images', *Ars Orientalis* vol. 43 (2013), pp. 125–38.

Guan, Tingfen 管庭芬, 管庭芬日記 (Diary of Guan Tingfen), ed. Zhang Tingyin 張廷銀 (Beijing: Zhonghua shuju, 2013).

Guo, Pu 郭璞, 爾雅注 (Commentary on *Erya*), reprinted in 爾雅註疏 (Commentaries on *Erya*), ed. Li Xueqin 李學勤 (Beijing: Beijing University Press, 1999).

Guo, Yingjie & Baogang He, 'Reimagining the Chinese Nation: The "Zeng Guofan Phenomenon"', *Modern China* vol. 25, no. 2 (1999), pp. 142–70.

Haddad, John Rogers, *America's First Adventure in China: Trade, Treaties, Opium, and Salvation* (Philadelphia: Temple University Press, 2014).

Hall, Chris, 'Chinese Handkerchiefs', *Textiles Asia* vol. 11, no. 2 (2019), pp. 22–7.

Hardiman, David (ed.), *Healing Bodies, Saving Souls: Medical Missions in Asia and Africa* (Amsterdam: Rodopi, 2006).

Harrison, Henrietta, *China* (London: Arnold, 2001).

__, *The Man Awakened from Dreams: One Man's Life in a North China Village, 1857–1942* (Stanford: Stanford University Press, 2005).

__, *The Perils of Interpreting: The Extraordinary Lives of Two Translators between Qing China and the British Empire* (Princeton: Princeton University Press, 2021).

Harrison-Hall, Jessica & Julia Lovell (eds), *Creators of Modern China: 100 Lives from Empire to Republic* (London: Thames & Hudson, 2023).

Hatch, Michael, 'Qian Du (1763–1844) and the Senses in Early Nineteenth-Century Chinese Literati Painting', Ph.D. thesis, Princeton University, 2015.

Hay, Jonathan, 'Painters and Publishing in Late Nineteenth-century Shanghai', in *Phoebus 8: Art at the Close of China's Empire*, ed. Ju-hsi Chou (Tempe: Arizona State University Press, 1998), pp. 134–88.

__, *Sensuous Surfaces: The Decorative Object in Early Modern China* (London: Reaktion, 2009).

__, 'The Worldly Eye', in *What Images Do*, ed. Jan Backluund, Henrik Oxvig, Michael Renner & Martin Søberg (Aarhus: Aarhus University Press, 2019), pp. 113–43.

Hayter-Menzies, Grant, *Imperial Masquerade* (Hong Kong: Hong Kong University Press, 2008).

Headland, Isaac Taylor, *Court Life in China: The Capital, its Officials and People* (New York, Chicago: F.H. Revell Company, 1909).

Heinrich, Ari Larissa, *The Afterlife of Images: Translating the Pathological Body between China and the West* (Durham: Duke University Press, 2008).

Hellman, Lisa, *This House Is Not a Home: European Everyday Life in Canton and Macao 1730–1830* (Leiden: Brill, 2018).

Heroldova, Helena, 'Sleevebands: Neglected Element in Chinese Adornment', *Annals of the Náprstek Museum* vol. 41 (2020), pp. 93–111.

Hevia, James, *Cherishing Men from Afar: Qing Guest Ritual and the Macartney Embassy of 1793* (Durham: Duke University Press, 1995).

__, 'Looting Beijing: 1860, 1900', in *Tokens of Exchange: The Problem of Translation in Global Circulations*, ed. Lydia H. Liu (Durham: Duke University Press, 1999), pp. 192–213.

__, *English Lessons: The Pedagogy of Imperialism in Nineteenth-Century China* (Durham: Duke University Press, 2003).

Hill, Michael Gibbs, *Lin Shu Inc.: Translation and the Making of Modern Chinese Culture* (Oxford: Oxford University Press, 2013).

Hollmann, Thomas, *The Land of the Five Flavors: A Cultural History of Chinese Cuisine* (New York: Columbia University Press, 2013).

Hong, Zaixin, 'Florence Ayscough: Pioneer Promoter of Modern Chinese Painting in America', in *Collectors, Collections & Collecting the Arts of China: Histories & Challenges*, ed. Jason Steuber & Guolong Lai (Gainesville: University Press of Florida, 2014), pp. 119–50.

Horowitz, Richard S., 'Beyond the Marble Boat: The Transformation of the Chinese Military, 1850–1911', in *A Military History of China*, ed. David A. Graff & Robin Higham (Boulder: Westview, 2002), pp. 153–74.

Hou, Yi-li 侯怡利 (ed.), 通嚏輕揚: 鼻煙壺文化特展 (Lifting the spirit and body: the art and culture of snuff bottles) (Taipei: National Palace Museum, 2012).

Howard, David, *The Choice of the Private Trader: The Private Market in Chinese Export Porcelain Illustrated from the Hodroff Collection* (London: Zwemmer, 1994).

Hsü, Immanuel C.Y., 'The Great Policy Debate in China, 1874: Maritime Defense vs. Frontier Defense', *Harvard Journal of Asiatic Studies* vol. 25 (1964–1965), pp. 212–28.

__, *The Rise of Modern China* (New York: Oxford University Press, 1975).

Hsueh, Chun-tu, *Huang Hsing and the Chinese Revolution* (Stanford: Stanford University Press, 1961).

Hu, Xianghan 胡祥翰, 上海小志 (Annotated history of Shanghai) (Shanghai: Shanghai guji chubanshe, 1989).

Hu, Ying, *Tales of Translation: Composing the New Woman in China, 1898–1918* (Stanford: Stanford University Press, 2000).

Hu, Zhiqing, 'China's Banker: Hu Xueyan and Financialisation in Late Nineteenth-Century China', Ph.D. thesis, Birkbeck University of London, forthcoming.

Huang, Dun, 'Two Schools of Calligraphy Join Hands: *Tiepai* and *Beipai* in the Qing Dynasty', in *Chinese Calligraphy*, ed. Ouyang Zhongshi & Wen C. Fong (New Haven: Yale University Press; Beijing: Foreign Languages Press, 2008), pp. 339–77.

Huang, I-fen 黃逸芬, 'Gender, Technical Innovation and Gu Family Embroidery in Late Ming Shanghai', *East Asian Science, Technology, and Medicine* vol. 36, no. 1 (2012), pp. 77–129.

Huebner, Jon W., 'Architecture and History in Shanghai's Central District', *Journal of Oriental Studies* vol. 26, no. 2 (1988), pp. 209–69.

__, 'Architecture on the Shanghai Bund', *Papers on Far Eastern History* vol. 39 (March 1989), pp. 127–65.

Hui, Humphrey & Peter Lam (ed.), *Elegance and Radiance: Grandeur in Qing Glass: The Andrew K.F. Lee Collection* (Hong Kong: Art Museum, the Chinese University of Hong Kong, 2000).

Hummel, Arthur W. (ed.), *Eminent Chinese of the Ch'ing Period, 1644–1912*, 2 vols (Washington: Library of Congress, 1943).

Huntington, Rania, 'The Captive's Revenge: The Taiping Civil War as Drama', *Late Imperial China* vol. 35, no. 2 (2014), pp. 1–26.

Ishigami, Aki, 'Chinese *chunhua* and Japanese *shunga*', in *Shunga: Sex and Pleasure in Japanese Art*, ed. Timothy Clark, C. Andrew Gerstle, Aki Ishigami & Akiko Yano (London: British Museum Press, 2013), pp. 92–103.

Jackson, Anna, *Kimono: Kyoto to Catwalk* (London: Victoria and Albert Museum, 2020).

Ji, Baocheng 紀寶成 & He Fangchuan 何芳川 (eds), 清代詩文集彙編 (Compilation of poems and essays of the Qing dynasty) (Shanghai: Shanghai guji chubanshe, 2011).

Jiang, Shaoshu 姜紹書, '西域畫 (Painting from the West)', in畫史叢書 (Compilation of painting history), ed. Yu Anlan, vol. 2-4-2 (Shanghai: Renmin meishu chubanshe, 1962), p. 133.

Johnson, David et al. (eds), *Popular Culture in Late Imperial China* (Berkeley: University of California Press, 1985).

Jones, F.C., *Shanghai and Tientsin* (London: Oxford University Press and Humphrey Milford, 1940).

Jones, Susan Mann & Philip A. Kuhn, 'Dynastic Decline and the Roots of Rebellion', in *The Cambridge History of China, Volume 10, Part 1: Late Ch'ing*, ed. John K. Fairbank (Cambridge: Cambridge University Press, 1978), pp. 107–62.

Jong, Koos de, *Dragon and Horse: Saddle Rugs and Other Horse Tack from China and Beyond* (Hong Kong: CA Design, 2013).

Judge, Joan, *Print and Politics: Shibao and the Culture of Reform in Late Qing China* (Stanford: Stanford University Press, 1996).

Kang, Youwei 康有為, Preface to 萬目草堂藏中國畫目 (List of paintings in the collection of the thatched hut of ten thousand trees) [1917], ed. Jiang Guilin 蔣貴麟 (Taipei: Wenshizhe chubanshe, 1977).

Karl, Rebecca E., *Staging the World: Chinese Nationalism at the Turn of the Twentieth Century* (Durham: Duke University Press, 2002).

__ & Peter Zarrow (eds), *Rethinking the 1898 Reform Period: Political and Cultural Change in Late Qing China* (Cambridge: Harvard University Asia Center, 2002).

Karlsson, Kim, Alfreda Murck & Michele Matteini (eds), *Eccentric Visions: The Worlds of Luo Ping* (Zurich: Museum Rietberg Zürich, 2009).

Kaske, Elisabeth, *The Politics of Language in Chinese Education, 1895–1919* (Leiden: Brill, 2008).

__, 'The Pitfalls of Transnational Distinction: A Royal Exchange of Honours and Contested Sovereignty in Late Qing China', in *China and the World – the World and China*, ed. Natascha Gentz & Catherine Vance Yeh, vol. 2 (Heidelberg: Universitätsverlag, 2019), pp. 137–69.

Kerr, Rose, Philip Allen & Shih Ching-fei, *Chinese Ivory Carvings: The Sir Victor Sassoon Collection* (London: Scala, 2016).

Kinoshita, Hiromi, *Art of China: Highlights from the Philadelphia Museum of Art* (Philadelphia: Philadelphia Museum of Art, 2018).

Kiwamu, Goyama, 明清時代の女性と文學 (Women and literature in the Ming–Qing periods), trans. Xiao Yanwan 蕭燕婉 (Taipei: Linking Publishing Company, 2016).

Kleughten, Kristina, 'One or Two, Repictured', *Archives of Asian Art* vol. 62, no. 1 (2012), pp. 25–46.

Ko, Dorothy, *Every Step a Lotus: Shoes for Bound Feet* (Berkeley: University of California Press, 2001).

__, *Cinderella's Sisters: A Revisionist History of Footbinding* (Berkeley: University of California Press, 2005).

__, 'Between the Boudoir and the Global Market: Shen Shou, Embroidery, and Modernity at the Turn of the Twentieth Century', in *Looking Modern: East Asian Visual Culture: Treaty Ports to World War II*, ed. Jennifer Purtle & Hans B. Thomsen (Chicago: Center for the Art of East Asia of the University of Chicago and Art Media Resources, 2009), pp. 38–61.

__, 'Epilogue: Textiles, Technology, and Gender in China', *East Asian Science, Technology, and Medicine* vol. 36 (2012), pp. 167–76.

Köll, Elisabeth, *Railroads and the Transformation of China* (Cambridge: Harvard University Press, 2019).

Koon, Yeewan, *A Defiant Brush: Su Renshan and the Politics of Painting in Early 19th-Century Guangdong* (Hong Kong: Hong Kong University Press, 2014).

Ku, Hung-ming [Gu Hongming 辜鴻銘], *Papers from a Viceroy's Yamen* (Shanghai: Shanghai Mercury, 1901).

Kuhn, Philip, *Soul-Stealers: The Chinese Sorcery Scare of 1768* (Cambridge: Harvard University Press, 2006).

Kwong, Luke S., 'Chinese Politics at the Cross-roads: Reflections on the Hundred Days Reform of 1898', *Modern Asian Studies* vol. 34, no. 3 (2000), pp. 663–95.

Laamann, Lars, *Christian Heretics in Late Imperial China: Christian Inculturation and State Control, 1720–1850* (London: Routledge, 2006).

Lai, Hui-min 賴惠敏 & Wang Shih-ming 王士銘, '清中葉迄民初的毛皮貿易與京城消費 (Fur trade and Beijing consumption from the mid-Qing to the early republic)', *Gugong xueshu jikan* vol. 31, no. 2 (2013), pp. 139–78.

Lai, Libby, Pik Chan, Nina Lai & Na Wan (eds.), *The Dragon and the Eagle: American Traders in China: A Century of Trade from 1784 to 1900*, 2 vols (Hong Kong: Hong Kong Maritime Museum, 2018).

Lai, Yu-chih, 'Remapping Borders: Ren Bonian's Frontier Paintings and Urban Life in 1880s Shanghai', *Art Bulletin* vol. 86, no. 3 (2004), pp. 550–72.

__, '晚清中日交流下的圖像、技術與性別:《鏡影簫聲初集》研究 (Image, technology, and gender in Sino-Japanese exchanges during the late Qing: a study of the *Jingying xiaosheng chuji*)', *Jindai Zhongguo funüshi yanjiu* no. 28 (December 2016), pp. 125–214.

Laing, Ellen Johnston, *Selling Happiness: Calendar Posters and Visual Culture in Early-Twentieth-Century Shanghai* (Honolulu: University Press of Hawai'i, 2004).

Lally, Jagjeet, *India and the Silk Roads: The History of a Trading World* (London: Hurst & Company, 2021).

Lang, Fengxia 郎豐霞, '清代滿洲喇嘛廟的興衰及其背後的政治文化意義 (The rise and fall of Manchu Lama temples in the Qing dynasty and the political cultural significance behind them)', *Beijing shehui kexue* no. 12 (2018), pp. 17–30.

Lannom, Gloria W., 'Chinese Bird Cages: A New Study Based on the Donegan Collection', *Arts of Asia* (September–October 1989), pp. 159–65.

Lavelle, Peter, *The Profits of Nature: Colonial Development and the Quest for Resources in Nineteenth-Century China* (New York: Columbia University Press, 2020).

Lawton, Thomas, 'Rubbings of Chinese Bronzes', *Bulletin of the Museum of Far Eastern Antiquities* vol. 67 (1995), pp. 7–48.

Ledderose, Lothar (ed.), *Orchideen und Felsen: Chinesische Bilder im Museum für Ostasiatische Kunst Berlin* (Berlin: G+H Verlag, 1998).

Lee, Gregory, *China Imagined: From European Fantasy to Spectacular Power* (London: Hurst, 2018).

Lee, Leo Oufan & Andrew J. Nathan, 'The Beginnings of Mass Culture: Journalism and Fiction in the Late Ch'ing and Beyond', in *Popular Culture in Late Imperial China*, ed. David Johnson et al. (Berkeley: University of California Press, 1985), pp. 378–95.

Lee, Michel, 'Subduing the "Foreign Devils"', *Transactions of the Oriental Ceramics Society* vol. 74 (2009–10), pp. 35–45.

Lefebvre, Eric, *Six siècles de peinture chinoise, œuvres restaurées du Musée Cernuschi* (Paris: Paris Musées, 2008).

Legouix, Susan, *Image of China: William Alexander* (London: Jupiter Books, 1980).

Lei, Sean Hsiang-lin, *Neither Donkey nor Horse: Medicine in the Struggle over China's Modernity* (Chicago: University of Chicago Press, 2014).

Leung, Shuk Man, 'The Public Sphere and Literary Journals: An Investigation of the Discursive Formation of New Fiction's Utopian Imagination in Late Qing', *Comparative Literature Studies* vol. 51, no. 4 (2014), pp. 557–86.

Levell, Nicky, 'The Translation of Objects: R and M Davidson and the Friends' Foreign Mission Association, China, 1890–1894', in *Collectors: Individuals and Institutions*, ed. Anthony Shelton (London: Horniman Museum and Gardens, 2001), pp. 129–62.

Li, Gui, *A Journey to the East: Li Gui's A New Account of a Trip around the Globe*, trans. and ed. Charles Desnoyers (Ann Arbor: University of Michigan Press, 2004).

Li, Ruru, *Soul of Beijing Opera: Theatrical Creativity and Continuity in the Changing World* (Hong Kong: Hong Kong University Press, 2010).

Li, Shi 李湜, '如意館畫士沈振麟及其御容像 (Court painter Shen Zhenlin in the Painting Academy and his imperial portraiture)', *Wenwu* no. 4 (2012), pp. 75–82.

Li, Xiaoxin, 'Revisiting Guang shi jiaju (Cantonese-style Furniture): A Design History of the Mid-18th Century to the Early 20th Century', Ph.D. thesis, SOAS, 2020.

Li, Yuhang, 'Gendered Materialization: An Investigation of Women's Artistic and Literary Reproductions of Guanyin in Late Imperial China', Ph.D. thesis, University of Chicago, 2011.

__, 'Embroidering Guanyin: Constructions of the Divine through Hair', *East Asian Science, Technology, and Medicine* vol. 36 (2012), pp. 131–66.

__, 'Oneself as a Female Deity: Representations of Empress Dowager Cixi as Guanyin', *Nan Nü* vol. 14 (2012), pp. 75–118.

__, 'Producing Empress Dowager Cixi as Guanyin for Missionaries' Eyes', *Orientations* vol. 46, no. 6 (2018), pp. 62–73.

__, *Becoming Guanyin: Artistic Devotion of Buddhist Women in Late Imperial China* (New York: Columbia University Press, 2020).

__, 'Burning Big Dharma Boats: Paper as an Efficacious Medium', in *The Allure of Matter: Materiality across Chinese Art*, ed. Orianna Cacchione & Wei-cheng Lin (Chicago: Center for the Art of East Asia of the University of Chicago and Smart Museum of Art, 2021), pp. 146–75.

__ & Harriet Zurndorfer, 'Rethinking Empress Dowager Cixi through the Production of Art', *Nan Nü* vol. 14 (2012), pp. 1–20.

Liang, Qichao 梁啟超, 梁啟超全集 (Collected works of Liang Qichao) (Beijing: Beijing chubanshe, 1999).

__, 清代學術概論 (Overview of scholarship in the Qing dynasty) [1920] (Taipei: Taiwan Commercial Press, 2008).

Lim, Suan Poh & William Y. Willetts, *Nonya Ware and Kitchen Ch'ing: Ceremonial and Domestic Pottery* (Selangor: Southeast Asian Ceramic Society, West Malaysia Chapter, 1981).

Lin, Jing 林京, '慈禧攝影史話 (History of Cixi and photography)', *Gugong bowuyuan yuankan* no. 3 (1988), pp. 82–9.

Lin, Man-houng, *China Upside Down: Currency, Society, and Ideologies, 1808–1856* (Cambridge: Harvard University Press, 2007).

Lin, Zou 林騶, 徐匯記略 (Short history of Xuhui) (Shanghai: Tushanwan yinshuguan, 1933).

Lindley, Augustus, *Ti-Ping Tien-Kwoh: The History of the Ti-ping Revolution* (London: Day & Son Ltd, 1866).

Little, Stephen (ed.), *New Songs on Ancient Tunes: 19th–20th Century Chinese Paintings and Calligraphy from the Richard Fabian Collection* (Honolulu: Honolulu Academy of Arts, 2007).

Liu, Chang 劉暢 & Wang Shiwei 王時偉, '從現存圖樣資料看清代晚期長春宮改造工程 (Reconstruction plans for the late Qing

dynasty Changchun Palace as seen from the surviving visual materials)', *Gugong bowuyuan yuankan* no. 5 (2005), pp. 190–206.

Liu, Kwang-Ching, 'Steamship Enterprise in Nineteenth-Century China', *Journal of Asian Studies* vol. 18, no. 4 (1959), pp. 435–55.

Liu, Lydia H., *The Clash of Empires: The Invention of China in Modern World-Making* (Cambridge: Harvard University Press, 2004).

Liu, Xun, 'Visualizing Perfection: Daoist Paintings of Our Lady, Court Patronage, and Elite Female Piety in the Late Qing', *Harvard Journal of Asiatic Studies* vol. 64, no. 1 (2004), pp. 57–115.

__, 'Immortals and Patriarchs: The Daoist World of a Manchu Official and his Family in Nineteenth Century China', *Asia Major (Third Series)* vol. 17, no. 2 (2004): pp. 161–218.

Lo, Andrew, 'China's Passion for Pai: Playing Cards, Dominoes, and Mahjong', in *Asian Games: The Art of Contest*, ed. Colin Mackenzie and Irving Finkel (New York: Asia Society, 2004), pp. 227–9.

Lo, Yun-chih 羅運治, 清代木蘭圍場的探討 (Studies on the Mulan hunt during the Qing dynasty) (Taipei: Wenshizhe chubanshe, 1989).

Lodwick, Kathleen L., *Crusaders against Opium: Protestant Missionaries in China, 1874–1917* (Lexington: University Press of Kentucky, 1996).

Lomanov, Alexander, 'The Russian Orthodox Church', in *Handbook of Christianity in China*, vol. 2, ed. Gary Tiedemann (Leiden: Brill, 2009), pp. 193–211.

Lovell, Julia, *The Opium War: Drugs, Dreams, and the Making of China* (London: Picador, 2011).

Low, Harriet, *A Young Lady's Diary of Five Years in China: 1829–1834* (Boston: G.H. Ellis, 1900).

Lu, Yi 陸易, '視覺的遊戲:六舟《百歲圖》釋讀 (Visual game: an interpretation of "One Hundred Years" by Liuzhou)', *Dongfang bowu* vol. 41 (April 2011), pp. 5–14.

Luk, Yu-ping, 'Collecting Chinese Jewellery at the Victoria and Albert Museum', *Transactions of the Oriental Ceramics Society* vol. 81 (2016–17), pp. 31–43.

__, 'Qing Empresses as Religious Patrons', in *Empresses of China's Forbidden City, 1644–1912*, ed. Daisy Yiyou Wang & Jan Stuart (Salem: Peabody Essex Museum; Washington, D.C.: Freer/Sackler Smithsonian Institution; New Haven: Yale University Press, 2018), pp. 110–27.

Luo, Ergang 羅爾綱 & Wang Qingcheng 王慶成 (ed.), 太平天国 (The Taiping Heavenly Kingdom), 10 vols (Guilin: Guangxi Normal University Press, 2004).

Ma, Shaobo 馬少波 et al., 中國京劇發展史 (The development of Chinese Peking Opera) (Taipei: Shangding, 1992).

Ma, Ye & Tianshu Chu, 'Living Standards in China between 1840 and 1912: A New Estimation of Gross Domestic Product Per Capita', Groningen Growth and Development Centre,

University of Groningen, prepared for the European Historical Economics Society Conference, 6–7 September 2013, LSE, London.

Macauley, Melissa, *Distant Shores: Colonial Encounters on China's Maritime Frontier* (Princeton: Princeton University Press, 2021).

Madancy, Joyce, 'Unearthing Popular Attitudes toward the Opium Trade and Opium Suppression in Late Qing and Early Republican Fujian', *Modern China* vol. 27, no. 4 (2001), pp. 436–83.

Magee, Judith, *Art and Nature: Three Centuries of Natural History Art from around the World* (London: Greystone Books, 2010).

__, *Images of Nature: Chinese Art and the Reeve Collection* (London: Natural History Museum, 2011).

Makari, George, *Of Fear and Strangers: A History of Xenophobia* (New York: Norton, 2021).

Mamiya, Rinzō 間宮林蔵, 東韃地方紀行 (An account of travels in eastern Mongolia and Manchuria) (Tokyo: Heibonsha, 1988).

Mann, Susan, *Precious Records: Women in China's Long Eighteenth Century* (Stanford: Stanford University Press, 1997).

Mao, Haijian, *The Qing Empire and the Opium War: The Collapse of the Heavenly Dynasty*, trans. Peter Lavelle, Joseph Lawson & Craig Smith (Cambridge: Cambridge University Press, 2018).

Markbreiter, Stephen, 'Anatomy of the Chinese Birdcage', *Arts of Asia* (May–June 1985), pp. 57–71.

Martimyanova, Alina, 'Regarding the Transfer of Vernacular Motifs and Other Common Features of Chinese New Year Prints and Chinese Reverse Glass Painting', China and the West: Reconsidering Chinese Reverse Glass Painting, International Workshop, 14–16 February 2020, Switzerland: Romont Museum, 2020.

Martin, Meredith, 'Staging China, Japan, and Siam at the Paris Universal Exhibition of 1867', in *Beyond Chinoiserie: Artistic Exchange between China and the West during the Late Qing Dynasty (1796–1911)*, ed. Petra ten-Doesschate Chu & Jennifer Milam (Leiden: Brill, 2019), pp. 122–48.

Matteini, Michele, 'Liuzhou', in *Creators of Modern China: 100 Lives from Empire to Republic*, ed. Jessica Harrison-Hall & Julia Lovell (London: Thames & Hudson, 2023).

Mayer, Rupprecht, *Bolihua: Chinese Reverse Glass Painting from the Mei Lin Collection* (Munich: Hirmer, 2018).

McKeown, Adam, *Chinese Migrant Networks and Cultural Change: Peru, Chicago, Hawaii, 1900–1936* (Chicago: University of Chicago Press, 2001).

__, *Melancholy Order: Asian Migration and the Globalization of Borders* (New York: Columbia University Press, 2008).

McMahon, Daniel, *Rethinking the Decline of China's Qing Dynasty: Imperial Activism and Borderland Management at the Turn of the Nineteenth Century* (London: Routledge, 2015).

Mead, Virginia, 'Snuff Bottle Portraits', *Arts of Asia* vol. 8, no. 5 (September–October 1978), pp. 59–66.

Mei, Yün-ch'iu 梅韻秋, '張崟《京口三山圖卷》：道光年間新經世學風下的江山圖像 (Zhang Yin's handscroll "Jingkou sanshan tu": landscape imagery and the new statecraft school of the Daoguang period (1821–1850))', *Taida Journal of Art History* vol. 6, no. 3 (1999), pp. 195–239.

Meyer-Fong, Tobie, *Building Culture in Early Qing Yangzhou* (Stanford: Stanford University Press, 2003).

__, *What Remains: Coming to Terms with Civil War in Nineteenth-Century China* (Stanford: Stanford University Press, 2013).

__, 'China, ca. 1800', unpublished lecture given at the workshop 'Chinese Painting, around 1800', at the Institute of Fine Arts and The Metropolitan Museum of Art, New York, June 2019.

Miles, Steven B., *The Sea of Learning: Mobility and Identity in Nineteenth-Century Guangzhou* (Cambridge: Harvard University Press, 2006).

__, *Upriver Journeys: Diaspora and Empire in Southern China, 1570–1850* (Cambridge: Harvard University Asia Center, 2017).

__, *Chinese Diasporas: A Social History of Global Migration* (Cambridge: Cambridge University Press, 2020).

Millward, James, *Beyond the Pass: Economy, Ethnicity, and Empire in Qing Central Asia, 1759–1864* (Stanford: Stanford University Press, 1998).

Mitchell, Sarah, 'A Tiger Cap in the Ashmolean's Collection', *Asian Textiles* (February 2015), pp. 4–9.

Mittler, Barbara, *A Newspaper for China? Power, Identity, and Change in Shanghai's News Media, 1872–1912* (Cambridge: Harvard East Asian Studies Monographs, 2004).

Mokros, Emily, 'Capital Defense: Confronting Threats to Money and the City in Taiping-Era Beijing', unpublished paper for the Chinese Military History Conference, Columbus, Ohio, May 2019.

Moll-Murata, Christine, *State and Crafts in the Qing Dynasty (1644–1911)* (Amsterdam: Amsterdam University Press, 2018).

__, 'Working the Qing Palace Machine', in *Making the Palace Machine Work: Mobilizing People, Objects, and Nature in the Qing Empire*, ed. Martina Siebert, Kai Jun Chen & Dorothy Ko (Amsterdam: Amsterdam University Press, 2021), pp. 42–72.

Moon, Junghee, 'Modern Art Education in China', *Art History Forum* vol. 6 (1998), pp. 51–78.

Morin, Edgar, 'Un Festival d'incertitudes', *Collection Tracts, Série Tracts de crise*, no. 54 (Paris: Gallimard, 2020). Available at www.tracts.gallimard.fr/en/products/tracts-de-crise-n-54-un-festival-d-incertitudes (accessed 13 December 2022).

Morrison, Robert, *Memoirs of the Life and Labours of Robert Morrison*, ed. Eliza Morrison (London: Longman, Orme, Brown, and Longmans, 1839).

Mosca, Matthew W., 'Empire and the Circulation of Frontier Intelligence: Qing Conceptions of the Ottomans', *Harvard Journal of Asiatic Studies* vol. 70, no. 1 (June 2010), pp. 147–207.

__, *From Frontier Policy to Foreign Policy: The Question of India and the Transformation of Geopolitics in Qing China* (Stanford: Stanford University Press, 2013).

Nagasaki kakyō kenkyūkai 長崎華僑研究会 (ed.), 續長崎華僑史稿 (Second report on Chinese immigrants in Nagasaki) (Nagasaki: Nagasaki kakyō kenkyūkai, 1987).

Naquin, Susan, *Peking: Temples and City Life, 1400–1900* (Berkeley: University of California Press, 2000).

National Palace Museum, 嘉慶君・遊臺灣: 清仁宗文物特展 (Lord Jiaqing and the journey to Taiwan: a special exhibition on cultural artifacts of the Qing emperor Renzong) (Taipei: National Palace Museum, 2016).

O'Donoghue, Freeman Marius, *Catalogue of the Collection of Playing Cards Bequeathed to the Trustees of the British Museum by the Late Lady Charlotte Schreiber* (London: British Museum, 1901).

Oidtmann, Max, *Forging the Golden Urn: The Qing Empire and the Politics of Reincarnation in Tibet* (New York: Columbia University Press, 2018).

Orr, Inge C., 'Puppet Theatre in Asia', *Asian Folklore Studies* vol. 33, no. 1 (1974), pp. 69–84.

Peng, Ying-chen, 'Lingering between Tradition and Innovation: Photographic Portraits of Empress Dowager Cixi', *Ars Orientalis*, vol. 43 (2013), pp. 157–75.

__, 'Staging Sovereignty: Empress Dowager Cixi (1835–1908) and Late Qing Court Art Production', Ph.D. thesis, University of California, Los Angeles, 2014.

__, 'Empresses and Qing Court Politics', in *Empresses of China's Forbidden City, 1644–1912*, ed. Daisy Yiyou Wang & Jan Stuart (Salem: Peabody Essex Museum; Washington, D.C.: Freer/Sackler Smithsonian Institution; New Haven: Yale University Press, 2018), pp. 128–41.

__, *Artful Subversion: Empress Dowager Cixi's Image Making* (New Haven and London: Yale University Press, 2023).

Perdue, Peter C., *China Marches West: The Qing Conquest of Central Eurasia* (Cambridge: Harvard University Press, 2010).

Persson, Helen, *Shoes: Pleasure and Pain* (London: Victoria and Albert Museum, 2015).

Peterson, Willard J. (ed.), *The Cambridge History of China, Volume 9, Part 1: The Ch'ing Empire to 1800* (Cambridge: Cambridge University Press, 2002).

Photographic Association of Shanghai and Faculty of Literature (ed.), 上海攝影史 (History of photography in Shanghai) (Shanghai: Renmin meishu chubanshe, 1992).

Pickford, Nigel & Michael Hatcher, *The Legacy of the Tek Sing: China's Titanic – its Tragedy and its Treasure* (London: Granta, 2000).

Pierson, Stacey, '"True Beauty of Form and Chaste Embellishment": Summer Palace Loot and Chinese Porcelain Collecting in Nineteenth-Century Britain', in *Collecting and Displaying China's 'Summer Palace' in the West: The Yuanmingyuan in Britain and France*, ed. Louise Tythacott (London and New York: Routledge, 2018), pp. 72–86.

Platt, Stephen R., *Autumn in the Heavenly Kingdom: China, the West, and the Epic Story of the Taiping Civil War* (New York: Alfred A. Knopf, 2012).

__, *Imperial Twilight: The Opium War and the End of China's Last Golden Age* (New York: Alfred A. Knopf, 2018).

Po, Ronald C., 'Mapping Maritime Power and Control: A Study of the Late Eighteenth Century *Qisheng Yanhai Tu* (A Coastal Map of the Seven Provinces', *Late Imperial China* vol. 37, no. 2 (2016), pp. 93–136.

__, *The Blue Frontier: Maritime Vision and Power in the Qing Empire* (Cambridge: Cambridge University Press, 2018).

Polachek, James, *The Inner Opium War* (Cambridge: Harvard University Press, 1992).

Pomeranz, Kenneth, *The Great Divergence: China, Europe, and the Making of the Modern World Economy* (Princeton: Princeton University Press, 2000).

Poulter, Emma K., 'Hybridity – Objects as Contact Zones: A Critical Analysis of Objects in the West African Collections at the Manchester Museum', *Museum Worlds* vol. 2, no. 1 (2014), pp. 25–41.

Pratt, Mary Louise, *Imperial Eyes: Travel Writing and Transculturation* (London: Routledge, 1991).

Price, George Uvedale, *Costumes in 'The Kingdom of the Great Pure'* (Yokohama: Kelly & Walsh, 1895).

Princess Der Ling (Yu Deling 裕德齡), *Two Years in the Forbidden City: Memoirs from the Manchu Court* (New York: Moffat, Yard and Company, 1917).

__, *Lotus Petals* (New York: Dodd, Mead, and Company, 1930).

Puga, Rogério Miguel, 'The British Museum of Macao (1829–1834) and its Contribution to Nineteenth-Century British Natural Science', *Journal of the Royal Asiatic Society (Third Series)* vol. 22 (October 2012), pp. 575–86.

Qi Yuan 齊淵 (ed.), 趙之謙書畫編年圖目 (Compilation of calligraphy and painting by Zhao Zhiqian in chronological order) (Shanghai: Shanghai guji chubanshe, 2005).

Quette, Béatrice, 'Cloisonné Form and Decoration from the Yuan through the Qing Dynasty', in *Cloisonné: Chinese Enamels from the Yuan, Ming, and Qing Dynasties*, ed. Béatrice Quette (New Haven: Yale University Press; New York: Bard Graduate Center, 2011), pp. 31–61.

__, 'The Emergence of Cloisonné Enamels in China', in *Cloisonné: Chinese Enamels from the Yuan, Ming and Qing Dynasties*, ed. Béatrice Quette (New Haven: Yale University Press; New York: Bard Graduate Center, 2011), pp. 3–17.

Rado, Mei Mei, 'The Empress Dowager Cixi's Japanese Screen and Late Qing Imperial Cosmopolitanism', *Burlington Magazine* vol. 163, no. 1423 (October 2021), pp. 886–97.

Rawski, Evelyn S., *Education and Popular Literacy in Ch'ing China* (Ann Arbor: University of Michigan Press, 1979).

__, 'Ch'ing Imperial Marriage and Problems of Rulership', in *Marriage and Inequality in Chinese Society*, ed. Rubie S. Watson & Patricia Buckley Ebrey (Berkeley: University of California Press, 1991), pp. 170–203.

__, *The Last Emperors: A Social History of Qing Imperial Institutions* (Berkeley: University of California Press, 1998).

__, 'Qing Empresses and their Place in History', in *Empresses of China's Forbidden City, 1644–1912*, ed. Daisy Yiyou Wang & Jan Stuart (Salem: Peabody Essex Museum; Washington, D.C.: Freer/Sackler Smithsonian Institution; New Haven: Yale University Press, 2018), pp. 32–50.

Reinhardt, Anne, *Navigating Semi-Colonialism: Shipping, Sovereignty, and Nation-Building in China, 1860–1937* (Cambridge: Harvard University Asia Center, 2018).

Ren, Wanping, 'Qing Empress and Grand Imperial Weddings', in *Empresses of China's Forbidden City, 1644–1912*, ed. Daisy Yiyou Wang & Jan Stuart (Salem: Peabody Essex Museum; Washington, D.C.: Freer/Sackler Smithsonian Institution; New Haven: Yale University Press, 2018), pp. 51–59.

Rhoads, Edward J.M., *Manchu and Han: Ethnic Relations and Political Power in Late Qing and Early Republican China, 1861–1928* (Seattle: University of Washington Press, 2000).

Richard, Josepha, 'Collecting Chinese Flora: Eighteenth- to Nineteenth-Century Sino-British Scientific and Cultural Exchanges as Seen through British Collections of China Trade Botanical Paintings', *Ming Qing Yanjiu* vol. 24, no. 2 (2020), pp. 209–44.

__, 'Uncovering the Garden of the Richest Man on Earth in Nineteenth-Century Canton: Howqua's Garden in Honam, China', *Garden History* vol. 43, no. 2 (2015), pp. 168–81.

Robert, Antony, *Elusive Pirates, Pervasive Smugglers: Violence and Clandestine Trade in the Greater China Seas* (Hong Kong: Hong Kong University Press, 2010).

Roberts, Claire, 'The Empress Dowager's Birthday: The Photographs of Cixi's Long Life Without End', *Ars Orientalis* vol. 43 (2013), pp. 176–95.

Rogaski, Ruth, *Knowing Manchuria: Environments, the Senses, and Natural Knowledge on an Asian Borderland* (Chicago: University of Chicago Press, 2022).

Rowe, William T., *China's Last Empire: The Great Qing* (Cambridge: Harvard University Press, 2009).

__, *Speaking of Profit: Bao Shichen and Reform in Nineteenth-Century China* (Cambridge: Harvard University Asia Center, 2018).

Ruitenbeek, Klaas (ed.), *Faces of China: Portrait Painting of the Ming and Qing Dynasties (1368–1912)* (Berlin: Museum für Asiatische Kunst, Staatliche Museen zu Berlin; Petersberg: Michael Imhof Verlag, 2017).

Sang, Shen 桑椹, '青銅器全形拓技術發展的分期研究 (Study of the phases of technological development in composite rubbing of bronze)' *Dongfang bowu* vol. 12, no. 3 (2004), pp. 32–9.

Satō, Dōshin, *Modern Japanese Art and the Meiji State: The Politics of Beauty*, trans. Hiroshi Nara (Los Angeles: Getty Research Institute, 2011).

Schlesinger, Jonathan, *A World Trimmed with Fur: Wild Things, Pristine Places, and the Natural Fringes of Qing Rule* (Stanford: Stanford University Press, 2017).

Schluessel, Eric, *Land of Strangers: The Civilizing Project in Qing Central Asia* (New York: Columbia University Press, 2020).

Scott, Gregory Adam, 'Conversion by the Book: Buddhist Print Culture in Early Republican China', Ph.D. thesis, Columbia University, 2013.

Shan, Chun, 'Marriage Law and Confucian Ethics in the Qing Dynasty', *Frontiers of Law in China* vol. 8, no. 4 (2013), pp. 823–4.

Shan, Guolin, 'The Cultural Significance of the Shanghai School', in *Chinese Paintings from the Shanghai Museum, 1851–1911*, ed. Anita Chung (Edinburgh: National Museum of Scotland, 2000), pp. 9–24.

Shanghai Painting and Calligraphy Publishing House 上海書畫出版社 (ed.), 吳昌碩印譜 (Seals of Wu Changshi) (Shanghai: Shanghai shuhua chubanshe, 1998).

Shemo, Connie A., *The Chinese Medical Ministries of Kang Cheng and Shi Meiyu, 1872–1937: On a Cross-Cultural Frontier of Gender, Race, and Nation* (Lanham: Rowman & Littlefield, 2011).

Siebert, Martina, Kai Jun Chen & Dorothy Ko (eds.), *Making the Palace Machine Work: Mobilizing People, Objects, and Nature in the Qing Empire* (Amsterdam: Amsterdam University Press, 2021).

Silberstein, Rachel, 'Eight Scenes of Suzhou: Landscape Embroidery, Urban Courtesans, and Nineteenth-Century Chinese Women's Fashions', *Late Imperial China* vol. 36, no. 1 (June 2015), pp. 1–52.

__, 'Fashioning the Foreign: Using British Woolens in Nineteenth-Century China', in *Fashion, Identity, and Power in Modern Asia,*

eds. Kyunghee Pyun & Aida Yuen Wong (New York: Palgrave Macmillan, 2019), pp. 231–58.

__, *A Fashionable Century: Textile Artistry and Commerce in the Late Qing* (Seattle: University of Washington Press, 2020).

Sinn, Elizabeth, *Pacific Crossing: California Gold, Chinese Migration, and the Making of Hong Kong* (Hong Kong: Hong Kong University Press, 2013).

Smith, Pamela H., 'Art, Science, and Visual Culture in Early Modern Europe', *Isis* vol. 97 (2006), pp. 83–100.

Söderblom Saarela, Mårten, *The Early Modern Travels of Manchu: A Script and its Study in East Asia and Europe* (Philadelphia: University of Pennsylvania Press, 2020).

Sommer, Matthew, *Polyandry and Wife-Selling in Qing Dynasty China: Survival Strategies and Judicial Interventions* (Berkeley: University of California Press, 2015).

Song, Gang 宋剛, '洋味競嘗：晚清上海與香港之西餐 (Trying the different *yang* taste: Western cuisine in late-Qing Shanghai and Hong Kong)', *Journal of Oriental Studies* vol. 45, no. 1/2 (2012), pp. 45–66.

Spence, Jonathan, *The Search for Modern China* (New York: Norton, 1990).

__, *God's Chinese Son* (New York: W.W. Norton, 1996).

__ & Annping Chin, *The Chinese Century: A Photographic History of the Last Hundred Years* (New York: Random House, 1996).

Starr, Kenneth, *Black Tigers: A Grammar of Chinese Rubbings* (Seattle: University of Washington Press, 2008).

Steuber, Jason, 'Politics and Art in Qing China: The Duanfang Collection', *Apollo* vol. 162 (2005), pp. 56–67.

Stevens, Keith, 'The Yangzi Port of Zhenjiang down the Centuries: 鎮江: Part I', *Journal of the Hong Kong Branch of the Royal Asiatic Society* vol. 42 (2002), pp. 255–321.

Strand, David, *An Unfinished Republic: Leading by Word and Deed in Modern China* (Berkeley: University of California Press, 2011).

Stuart, Jan & Evelyn S. Rawski, *Worshiping the Ancestors: Chinese Commemorative Portraits* (Washington, D.C.: Arthur M. Sackler Gallery, Smithsonian Institution, 2001).

Suga, Yutaka, 'Chinese Cricket-Fighting', *International Journal of Asian Studies* vol. 3, no. 1 (2006), pp. 77–93.

Sun, Yue 孫悅, '清代帝后萬壽用瓷流變概述 (Changes in Qing imperial birthday wares)', conference paper, the Palace Museum, Beijing, November 2017.

Swislocki, Mark, *Culinary Nostalgia: Regional Food Culture and the Urban Experience in Shanghai* (Stanford: Stanford University Press, 2009).

Takeyoshi, Tsuruta 鶴田武良, '資料1：清と中華民国における日本の美術教師名簿(Document 1: list of Japanese art teachers who taught in China during the Qing and the Republican eras)', *Bijutsu kenkyū* vol. 365 (1996), pp. 16–20.

Tang, Yifen 湯貽芬, '王硯農之佐徵君索題癸未水災冊 (Wang Yannong, known as Zhizuo, asks people to provide colophons for the *Album of Flood in the Guiwei year* [1823])', in 琴隱園詩集 (Collection of Poems from the Garden of Hiding behind *Qin* Music Instrument), *juan* 6.81/83 (1875).

Teng, Ssu-yu & John K. Fairbank, *China's Response to the West: A Documentary Survey, 1839–1923* (Cambridge: Harvard University Press, 1954).

Ter Haar, Barend, *Ritual and Mythology of the Chinese Triads: Creating an Identity* (Leiden: Brill, 2000).

Thiriez, Régine, 'Photography and Portraiture in Nineteenth-Century China', *East Asian History* vol. 17/18 (June–December 1999), pp. 77–102.

__, 'Ligelang: A French Photographer in 1850s Shanghai', *Orientations* vol. 32, no. 9 (2001), pp. 49–54.

Tiedemann, Gary (ed.), *Handbook of Christianity in China*, vol. 2 (Leiden: Brill, 2009).

Tsai, Mei-fen 蔡玫芬, 皇家風尚：清代宮廷與西方貴族珠寶 (Royal style: the Qing Dynasty and Western court jewellery) (Taipei: The National Palace Museum, 2012).

Tsang, Ka Bo, *More Than Keeping Cool: Chinese Fans and Fan Paintings* (Toronto: Royal Ontario Museum, 2002).

__, *Brilliant Strokes: Chinese Paintings from the Mactaggart Art Collection* (Edmonton: University of Alberta Press, 2008).

Tythacott, Louise (ed.), *Collecting and Displaying China's 'Summer Palace' in the West: The Yuanmingyuan in Britain and France* (London and New York: Routledge, 2018).

Unschuld, Paul, *Traditional Chinese Medicine: Heritage and Adaptation*, trans. Bridie Andrews (New York: Columbia University Press, 2018).

Van de Ven, Hans, *Breaking with the Past: The Maritime Customs Service and the Global Origins of Modernity in China* (New York: Columbia University Press, 2014).

Van Dyke, Paul, *The Canton Trade: Life and Enterprise on the China Coast, 1700–1845* (Hong Kong: Hong Kong University Press, 2005).

Vinograd, Richard, 'Satire and Situation: Images of the Artist in Late Nineteenth-Century China', in *Phoebus 8: Art at the Close of China's Empire*, ed. Ju-hsi Chou (Tempe: Arizona State University Press, 1998), pp. 110–33.

__, *Boundaries of the Self: Chinese Portraits 1600–1900* (Cambridge: Cambridge University Press, 1992).

Vollmer, John E., 'Clothed to Rule the Universe', *Art Institute of Chicago Museum Studies* vol. 26, no. 2 (2000), pp. 13–105.

Wagner, Rudolf G., 'The Role of the Foreign Community in the Chinese Public Sphere', *China Quarterly* vol. 142, no. 6 (June 1995), pp. 423–43.

__, '進入全球想像圖景：上海的《點石齋畫報》 (Entering the world of fantasy: *Dianshizhai Illustrated News* of Shanghai)', *Zhongguo xueshu* vol. 8, no. 9 (2001), pp. 1–96.

__ (ed.), *Joining the Global Public: Word, Image, and City in Early Chinese Newspapers, 1870–1910* (Albany: State University of New York Press, 2007).

Wakeman, Frederic Jr, 'The Canton Trade and the Opium War', in *The Cambridge History of China, Volume 10, Part 1: Late Ch'ing 1800–1911*, ed. John K. Fairbank (Cambridge: Cambridge University Press, 1978).

Waley-Cohen, Joanna, *The Sextants of Beijing: Global Currents in Chinese History* (New York: W.W. Norton, 1999).

__, *The Culture of War in China: Empire and the Military under the Qing Dynasty* (London: I.B. Tauris, 2006).

__, 'Militarization of Culture in Eighteenth-Century China', in *Military Culture in Imperial China*, ed. Nicola di Cosmo (Cambridge: Harvard University Press, 2009), pp. 278–395.

Wan, Qingli 萬青力, 並非衰弱的百年：十九世紀中國繪畫史 (It was not a century in decline: a history of 19th-century Chinese painting) (Taipei: Xiongshi meishu chubanshe, 2005).

Wan, Yi 萬依 et al., 清代宮廷史 (A history of the Qing court) (Tianjin: Baihua wenyi chubanshe, 2004).

Wang, Cheng-hua 王正華, '走向公開化：慈禧肖像的風格形式、政治運作與形象塑造 (Portraits of the Empress Dowager Cixi and their public roles)', *Guoli Taiwan daxue meishushi yanjiu jikan* vol. 32 (2012), pp. 239–316.

Wang, Daisy Yiyou & Jan Stuart (eds), *Empresses of China's Forbidden City, 1644–1912* (Salem: Peabody Essex Museum; Washington, D.C.: Freer/Sackler Smithsonian Institution; New Haven: Yale University Press, 2018).

Wang, David Der-Wei, *Fin-de-Siècle Splendor: Repressed Modernities of Late Qing Fiction, 1849–1911* (Stanford: Stanford University Press, 1997).

Wang, Gary, 'Affecting Grandiosity: Manchuness and the *Liangbatou* Hairdo-Turned-Headpiece, Circa 1870s–1930s', in *Fashion, Identity, and Power in Modern Asia*, ed. Kyunghee Pyun & Aida Yuen Wong (New York: Palgrave Macmillan, 2019), pp. 167–92.

Wang, Helen, 'Coins and Membership Tokens of the Heaven and Earth Society', *Numismatic Chronicle (1966–)* vol. 154 (1994), pp. 167–90.

__, 'Late Qing Paper Money from Dianshizhai and Other Printing Houses in Shanghai, 1905–1912', in *The Banker's Art: Studies in Paper Money*, ed. Virginia Hewitt (London: British Museum Press, 1995), pp. 94–117.

Wang, Hsien-Chun, 'Discovering Steam Power in China, 1840s–1860s', *Technology and Culture* vol. 51, no. 1 (2010), pp. 31–54.

Wang, Jiacheng 王家誠, 吳昌碩傳 (Biography of Wu Changshi) (Taipei: National Palace Museum, 1998).

__, 趙之謙傳 (Biography of Zhao Zhiqian) (Taipei: National History Museum, 2002).

Wang, Lianming, 'A World Dotted with Kingfisher Blue: Feather Tributes and the Qing Court', in *The Social Lives of Chinese Objects*, eds. Alice Bianchi & Lyce Jankowski (Leiden: Brill, 2022), pp. 228–67.

Wang, Shu-Chin, 'Realist Agency in the Art Field of Twentieth-Century China: Realism in the Art and Writing of Xu Beihong (1895–1953)', Ph.D. thesis, School of Oriental and African Studies, University of London, 2009.

Wang, Tao 王韜, 瀛壖雜誌 (Miscellany on Shanghai) [1862] (Taipei: Guangwen shuju, 1966).

Wang, Wensheng, *White Lotus Rebels and South China Pirates: Crisis and Reform in the Qing Empire* (Cambridge: Harvard University Press, 2014).

Wang, Yijun, 'Tin and Pewter in the Age of Silver', in *The Silver Age: Origins and Trade of Chinese Export Silver* (Hong Kong: Hong Kong Maritime Museum, 2017).

__, 'From Tin to Pewter: Craft and Statecraft in China, 1700–1844', Ph.D. thesis, Columbia University, 2019.

Wasserstrom, Jeffrey, *Global Shanghai, 1850–2010* (London: Routledge, 2009).

Wei, Betty Peh-T'i, *Ruan Yuan, 1764–1849: The Life and Work of a Major Scholar-Official in Nineteenth-Century China before the Opium War* (Hong Kong: Hong Kong University Press, 2006).

Widmer, Ellen, 'Foreign Travel through a Woman's Eyes: Shan Shili's *Guimao lüxing ji* in Local and Global Perspective', *Journal of Asian Studies* vol. 65, no. 4 (2006), pp. 763–91.

__, *The Beauty and the Book: Women and Fiction in Nineteenth-Century China* (Cambridge: Harvard University Asia Center, 2006).

Wilkinson, W.H., 'Chinese Origin of Playing Cards', *American Anthropologist* vol. 8, no. 1 (1895), pp. 61–78.

Will, Allen S., *World-Crisis in China, 1900* (Baltimore: John Murphy, 1900).

Wilson, Ming, *Rare Marks on Chinese Ceramics* (London: School of Oriental and African Studies, University of London, in association with the Victoria and Albert Museum, 1998).

__, Verity Wilson & the Palace Museum, Beijing (eds.), *Imperial Chinese Robes from the Forbidden City* (London: Victoria and Albert Museum, 2010).

Wilson, Verity, *Chinese Dress* (London: Victoria and Albert Museum, 1986).

Witchard, Anne, 'Dancing Modern China', *Modernism/modernity Print+* vol. 4, no. 3 (2019).

Wong, Aida Yuen, *Parting the Mists: Discovering Japan and the Rise of National-Style Painting in Modern China* (Honolulu: University Press of Hawai'i, 2006).

__, *The Other Kang Youwei, Calligrapher, Art Activist, and Aesthetic Reformer in Modern China* (Leiden: Brill, 2016).

Wong, J. Y., *Deadly Dreams: Opium, Imperialism and the* Arrow *War (1856–1860) in China* (Cambridge: Cambridge University Press, 1998).

Wong, John D., *Global Trade in the Nineteenth Century: The House of Houqua and the Canton System* (Cambridge: Cambridge University Press, 2016).

Wong, R. Bin, 'Opium and Modern Chinese State-making', in *Opium Regimes*, ed. Timothy Brook & Bob Wakabayashi (Berkeley: University of California Press, 2000), pp. 189–211.

Wong, Winnie Won Yin, 'After the Copy: Creativity, Originality and the Labor of Appropriation: Dafen Village, Shenzhen, China (1989–2010)', Ph.D. thesis, Massachusetts Institute of Technology, 2010.

Wood, Frances, *Chinese Illustration* (London: British Library, 1985).

__, *No Dogs and Not Many Chinese* (London: John Murray, 2000).

Wooldridge, William, *City of Virtues: Nanjing in an Age of Utopian Visions* (Seattle: University of Washington Press, 2015).

Wreath, Nancy Andrews, 'Weaves in Hand-Loom Fabrics', *Bulletin of the Pennsylvania Museum* vol. 22, no. 112 (1927), pp. 358–66.

Wright, David, 'Careers in Western Science in Nineteenth-Century China: Xu Shou and Xu Jianyin', *Journal of the Royal Asiatic Society (Third Series)* vol. 5, no. 1 (1995), pp. 49–90.

Wright, Mary, *The Last Stand of Chinese Conservatism: The T'ung-chih Restoration, 1862–1874* (Stanford: Stanford University Press, 1962).

__ (ed.), *China in Revolution: The First Phase 1900–1913* (New Haven: Yale University Press, 1971).

Wu, Changshi 吳昌碩, 'Yixi' 憶昔 (Remembrance) and 'Ganmeng' 感夢 (Dream with sentiment), 缶廬詩 (Poems by Foulu [Wu Changshi]), 1893, *juan* 2, 8–9, in 清代詩文集彙編 (Compilation of poems and essays from the Qing Dynasty), eds. Ji Baocheng 紀寶成 et al. (Shanghai: Shanghai guji chubanshe, 2011), vol. 757.

Wu, Chao-jen 吳超然, 'Between Tradition and Modernity: Strange Fish of Different Species, Products of Wenzhou by Zhao Zhiqian (1829–1884) and their Relationship to the Epigraphic Studies of Late Qing', Ph.D. thesis, University of Kansas, 2002.

__, '趙之謙1861年的三件作品:異魚圖、甌中物產圖卷、甌中草木四屏—金石派與海派歸屬之商榷 (Three works by Zhao Zhiqian dated 1861: *The Strange Fish, The First Version of Local Products of Wenzhou,* and *Four Panels of Vegetation in Wenzhou* – concerning Zhao's relationship with the school of epigraphic painting)', in 世變、形象、流風—中國近代繪畫 1796–1949 (Turmoil, representation and trends – modern Chinese painting, 1796–1949),

ed. Liao Guiying 廖桂英 (Taipei: The Chang Foundation, 2008), pp. 451–69.

Wu, Hung, 'On Rubbings: Their Materiality and Historicity', in *Writing and Materiality in China*, ed. Judith T. Zeitlin & Lydia H. Liu (Cambridge: Harvard University Press, 2003), pp. 29–72.

__, *Zooming In: Histories of Photography in China* (London: Reaktion, 2016).

Wu, Weiping 吳偉蘋, '乾隆皇帝與玉扳指 (The Qianlong emperor and the jade thumb ring)', *Gugong wenwu yuekan* no. 10 (2013), pp. 94–109.

Wu, Hsiang-hsiang 吳相湘, 晚清宮廷實紀 (Realistic records of late-Qing court politics), vol. 1 (Taipei: Zhengzhong shuju, 1952).

Wu, Yi-Li, 'The Qing Period', in *Chinese Medicine and Healing: An Illustrated History*, ed. T.J. Hinrichs & Linda Barnes (Cambridge: Harvard University Press, 2013), pp. 161–207.

Wu, Zhaoqing 吳兆清, '清代造辦處的機構和匠役 (The institution and personnel of the Imperial Workshops of the Qing dynasty)', *Lishi dang'an* no. 4 (1991), pp. 79–86, 89.

Wue, Roberta, 'Selling the Artist: Advertising, Art, and Audience in Nineteenth-Century Shanghai', *Art Bulletin* vol. 91, no. 4 (2009), pp. 463–80.

__, *Art Worlds: Artists, Images, and Audiences in Late Nineteenth-Century Shanghai* (Honolulu: University Press of Hawai'i, 2014).

Xiao, Lingbo, Yu Ye & Benyong Wei, 'Revolts Frequency during 1644–1911 in North China Plain and its Relationship with Climate', *Advances in Climate Change Research* vol. 2, no. 4 (2011), pp. 218–24.

Xiao, Yishan 蕭一山, 曾國藩全书 (The complete book of Zeng Guofan) (Kunming: Yunnan People's Publishing House, 2011).

Xiling Seal Engravers' Society 西泠印社 (ed.), 西泠印社藏品集 (Collection of Xiling Seal Society) (Hangzhou: Xiling Seal Engravers' Society, 2003).

Xiong, Yuezhi 熊月之 (ed.), 晚清新學書目提要 (List of books on Western learning in the late Qing) (Shanghai: Shanghai shudian chubanshe, 2007).

Xu, Jianrong 徐建融 (ed.), 潘天壽藝術隨筆 (Pan Tianshou's notes on art) (Shanghai: Wenyi chubanshe, 2001).

Xue, Fucheng 薛福成, 出史日記續刻 (The ambassador's diary, second printing) [1898] (Taipei: Huawen shuju, 1968).

Xue, Shelly, 'The Snowflake Warrior Vase: A Glass Object Inspired by the Chinese Beijing Opera', *Journal of Glass Studies* vol. 63 (2021), pp. 283–94.

Yang, Chia-Ling, *New Wine and Old Bottles: The Art of Ren Bonian in Nineteenth-Century Shanghai* (London: Saffron, 2007).

__, 'Identity and Antiquarian Approaches in Modern Chinese Art', *Journal of Art Historiography* vol. 10 (June 2014).

__, *Appropriating Antiquity for Modern Chinese Painting* (London: Bloomsbury, 2023).

Yang, Xin, Richard M. Barnhart, Nie Chongzheng, James Cahill, Lang Shaojun & Wu Hung, *Three Thousand Years of Chinese Painting* (New Haven: Yale University Press, 1997).

Yang, Yi 楊逸, 海上墨林 (Ink forest of Shanghai) [1919] (Taipei: Wenshizhe chubanshe, 1988).

Yap, Melanie & Dianne Leong Man, *Colour, Confusion and Concessions: The History of the Chinese in South Africa* (Hong Kong: Hong Kong University Press, 1996).

Ye, Xiaoqing, *The Dianshizhai Pictorial: Shanghai Urban Life, 1884–1898* (Ann Arbor: University of Michigan Press, 2003).

Yee, Cordell, 'Traditional Chinese Cartography and the Myth of Westernization', in *The History of Cartography* (vol. 2), ed. J.B. Harley & David Woodward (Chicago: University of Chicago Press, 1994), pp. 170–202.

Yeh, Catherine, *Shanghai Love: Courtesans, Intellectuals, and Entertainment Culture 1850–1910* (Seattle: University of Washington Press, 2006).

Yoong, Jackie, *Fashion Revolution: Chinese Dress from the Late Qing to 1976* (Singapore: Asian Civilisations Museum, 2020).

Yu, Feian 于飛闇, 中國畫顏色的研究 (Research on Chinese painting colours) (Beijing: Zhaohua meishu chubanshe, 1955).

Yu, Rongling 裕容齡, 清宮瑣記 (Chronicles of the Qing palace) (Beijing: Beijing chubanshe, 1957).

__, '清末舞蹈家裕容齡回憶錄 (The memoirs of Yu Rongling, a dancer of the late Qing)', *Wudao* (March 1958), pp. 44–5.

Yü, Ying-shih 余英時, 歷史與思想 (History and philosophy) (Taipei: Lianjing chubanshe, 1982).

Yuan, Hongqi 苑洪琪 & Liu Baojian 劉寶建 (eds), 故宮藏毯圖典 (Carpets in the collection of the Palace Museum) (Beijing: Zijincheng chubanshe, 2010).

Yunlu 允祿 & Jiang Pu 蔣溥 (eds), 皇朝禮器圖式 (Illustrated ritual implements of the imperial dynasty), 1759–1795.

Zarrow, Peter, 'The Reform Movement, the Monarchy, and Political Modernity', in *Rethinking the 1898 Reform Period: Political and Cultural Change in Late Qing China*, ed. Rebecca E. Karl & Peter Zarrow (Cambridge: Harvard University Asia Center, 2002), pp. 17–47.

__, *After Empire: The Conceptual Transformation of the Chinese State, 1885–1924* (Stanford: Stanford University Press, 2012).

__, *Educating China: Knowledge, Society and Textbooks in a Modernizing World, 1902–1937* (Cambridge: Cambridge University Press, 2015).

__ & Rebecca E. Karl (eds), *Rethinking the 1898 Reform Period: Political and Cultural Change in Late Qing China* (Cambridge: Harvard University Asia Center, 2002).

Zeitlin, Judith T. & Li Yuhang (eds), *Performing Images: Opera in Chinese Visual Culture* (Chicago: Smart Museum of Art, 2014).

Zeng, Guofan 曾國藩, 曾國藩全集 (The complete works of Zeng Guofan), 16 vols (Beijing: Zhongguo zhigong chubanshe, 2001).

Zhai, Xianshuai et al., 'Regional Interactions in Social Responses to Extreme Climate Events: A Case Study of the North China Famine of 1876–1879', *Atmosphere* vol. 11, no. 4 (2020), p. 393.

Zhang, Anzhi, '任熊和他的自畫像 (Ren Xiong and his self-portrait)', *Gugong bowuyuan yuankan* no. 2 (1979), pp. 13–18.

Zhang, Daye, *The World of a Tiny Insect: A Memoir of the Taiping Rebellion and its Aftermath*, ed. and trans. Xiaofei Tian (Seattle: University of Washington Press, 2013).

Zhang, Hongxing 張弘星, '中國最早的西洋美術搖籃—上海土山灣孤兒工藝院的藝術事業 (On the earliest cradle of Western arts and crafts in China – the art studio of Tushanwan Orphanage in Shanghai)', *Dongnan wenhua* vol. 87 (1991), pp. 127–8.

__, 'Wu Youru's "The Victory over the Taiping": Painting and Censorship in 1886 China', Ph.D. thesis, University of London, 1999.

__, 'Studies in Late Qing Dynasty Battle Paintings', *Artibus Asiae* vol. LX (2000), pp. 265–96.

Zhang, Shuxian 張淑嫻, 金窗繡戶：清代皇宮內檐裝修研究 (Golden windows, embroidered doors: studies of Qing court interior architecture and decorations) (Beijing: Gugong chubanshe, 2019).

__, '紅樓夢：長春宮遊廊《紅樓夢》壁畫 (Dream of the Red Chamber: mural paintings featuring this novel in the corridors of the Palace of Eternal Spring)', *Zijincheng* no. 1 (2020), pp. 88–105.

Zhang, Zhidong 張之洞, 書目答問 (The Q and A of bibliography) [1875], ed. Chen Juyuan 陳居淵 (Hong Kong: Sanlian shudian, 1998).

Zhao, Congyue 趙聰月, '慎德堂與慎德堂款瓷器 (The Hall of Prudent Virtue and the porcelains with this mark)', *Gugong bowuyuan yuankan* no. 2 (2010), pp. 113–29.

Zhao, Erxun 趙爾巽 et al. (ed.), 清史稿 (Draft of Qing history) (Taipei: Shangwu yinshuguan, 1999).

Zhao, Liewen 趙烈文, 能静居日記, entry for XF10/9/4 (17 October 1860), in 太平天国 (Taiping Heavenly Kingdom) (vol. 7), ed. Luo Ergang 羅爾綱 & Wang Qingcheng 王慶成 (Guilin shi: Guangxi shifan daxue chubanshe, 2004).

Zhao, Zhiqian 趙之謙, 章安雜說 (Miscellanea from Zhang'an) [1861] (Shanghai: Shanghai renmin meishu chubanshe, 1989).

Zhejiang guji chubanshe 浙江古籍出版社 (ed.), 中國歷代篆刻集粹 (8)：趙之謙、徐三庚 (Selected works of seal carving from Chinese dynasties (8): Zhao Zhiqian and Xu Sangeng) (Hangzhou: Zhejiang guji chubanshe, 2007).

Zhejiang Provincial Museum (ed.), 六舟：一位金石僧的藝術世界 (Liuzhou: the artistic world of a monk of epigraphy) (Hangzhou: Xiling Seal Engravers' Society, 2014).

Zheng, Linfan 鄭麟蕃, Wu Shaopeng 吳紹鵬 & Li Huibeng 李輝菶, 中國口腔醫學發展史 (History of the development of dentistry/stomatology in China) (Beijing: Beijing yikedaxue, Zhongguo xieheyike daxue lianhe chubanshe, 1998).

Zheng, Yangwen, 'The Social Life of Opium in China, 1483–1999', *Modern Asian Studies* vol. 37, no. 1 (2003), pp. 1–39.

__, *The Social Life of Opium in China* (Cambridge: Cambridge University Press, 2005).

Zhou, Dacheng 周大成, 中國口腔醫學史考 (Studies on the history of Chinese dentistry) (Beijing: Renmin weisheng chubanshe, 1991).

Zhou, Yibai 周貽白, 中國戲劇史長編 (History of Chinese theatre, long version) (Shanghai: Shanghai shudian, 2004).

Zhu, Chengru 朱誠如 (ed.), 清史圖典：嘉慶朝 (Illustrated Qing history: the Jiaqing reign), vol. 8 (Beijing: Zijincheng chubanshe, 2002).

Zhu, Jiajin 朱家溍, '清代亂彈戲在宮中發展的史料 (Historical records on the development of Luantan dramas at the Qing court)', in 故宮退食錄 (Upon retirement from the Palace Museum), Zhu Jiajin, vol. 2 (Beijing: Zijincheng chubanshe, 2009), pp. 586–621.

Zong, Fengying 宗鳳英, '慈禧的小織造：綺華館 (Cixi's personal textile manufactory: the Pavilion of Magnificent Flowers)', *Gugong wenwu yuekan* (August 1996), pp. 42–55.

__, 清代宮廷服飾 (Qing court dress) (Beijing: Zijincheng chubanshe, 2004).

Zou, Yiren 鄒依仁, 舊上海人口變遷的研究 (A study of the changes in population of old Shanghai) (Shanghai: Shanghai renmin chubanshe, 1980).

Zuo, Shu'e 左書諤, 慈禧太后 (Empress Dowager Cixi) (Changchun: Jilin wenshi chubanshe, 1993).

Picture credits

0.1	© The Trustees of the Chester Beatty Library, Dublin
0.2	The Palace Museum/ Image © The Palace Museum
0.3	© British Library Board (Maps X.490)
0.4	Image courtesy of the National Army Museum, London
0.5	Loewentheil Collection of Early China Photography
0.7	Zhejiang Provincial Museum
0.8	David M. Rubenstein Rare Book & Manuscript Library, Duke University
0.9	The Metropolitan Museum of Art, New York, Gilman Collection, Museum Purchase, 2005, www.metmuseum.org
0.10	Professor Bridie Andrews
0.11	Chronicle / Alamy Stock Photo
0.12	Library of Congress, Geography and Map Division
0.13	The Shen Bao Digital Archive
0.14	History and Art Collection / Alamy Stock Photo
0.15	© British Library Board (Murray Collection Vol 1 f058r detail)
0.16	National Library of China
0.18	Courtesy of Princeton University Library
1.1–3	© British Library Board (1540.b.14 ff1-8, Or 4574 f006r, Or. 8147 ff2453v-2454r)
1.4–5	The Palace Museum/ Image © The Palace Museum
1.6	Library of Congress, Geography and Map Division
1.7–8	The Palace Museum/ Image © The Palace Museum
1.9	© 2019 Christie's Images Limited
1.10–14	The Palace Museum/ Image © The Palace Museum
1.15	Freer Gallery of Art and Arthur M. Sackler Gallery Archives, Photographer: Xunling, FSA A.13 SC-GR-243
1.16	Robert Hall Photography © 2023. Author: Robert Hall
1.17–18	The Palace Museum/ Image © The Palace Museum
1.19	With permission of ROM (Royal Ontario Museum), Toronto, Canada. © ROM
1.21	Photo © President and Fellows of Harvard College
1.23	Jacqueline Simcox Ltd
1.24	The John R. Van Derlip Fund. Photo © Minneapolis Institute of Art.
1.26	© Illustrated London News Ltd/Mary Evans
1.27	National Archives of Japan Digital Archive
1.28	The Palace Museum/ Image © The Palace Museum
1.29	The Teresa Coleman Collection
1.30	The Chris Hall Collection
1.31	The Palace Museum/ Image © The Palace Museum
1.44	CPA Media Pte Ltd / Alamy Stock Photo
1.45	The Palace Museum/ Image © The Palace Museum
1.46	University of Alberta Museums; The Palace Museum/ Image © The Palace Museum
1.47	The Palace Museum/ Image © The Palace Museum
1.48	University of Alberta Museums
1.49	© The Metropolitan Museum of Art/Art Resource/Scala, Florence
1.50	Photo © Asian Art Museum of San Francisco
1.51–3	The Palace Museum/ Image © The Palace Museum
1.55–6	The Teresa Coleman Collection
1.57	The Palace Museum/ Image © The Palace Museum
1.58–9	Image licensed by The Corning Museum of Glass, Corning, NY (www.cmog.org), under CC BY-NC-SA 4.0.
1.60	Bristol Museums: Bristol Museum and Art Gallery
1.61	© Fondation Baur Musée des arts d'Extrême-Orient / Marian Gérard
1.62–3	Image © National Museums Scotland
1.64	© Victoria and Albert Museum, London
1.65	Philadelphia Museum of Art: Gift of the Friends of the Philadelphia Museum of Art, 1964, 1964-205-1
1.66–7	The Palace Museum/ Image © The Palace Museum
1.68	Royal Collection Trust / © His Majesty King Charles III 2023
1.69	The Palace Museum/ Image © The Palace Museum
1.74	Royal Albert Memorial Museum & Art Gallery, Exeter City Council
1.75–6	The Palace Museum/ Image © The Palace Museum
1.77	SOAS Library
1.78	Freer Gallery of Art and Arthur M. Sackler Gallery Archives, Photographer: Xunling, FSA A.13 SC-GR-249

2.1 Photo: © Rheinisches Bildarchiv Cologne. rba_d012732

2.2 With permission of ROM (Royal Ontario Museum), Toronto, Canada. © ROM

2.3 © The Metropolitan Museum of Art/Art Resource/Scala, Florence

2.8 The Teresa Coleman Collection

2.9 © The University of Manchester

2.10 © Victoria and Albert Museum, London

2.15 The Palace Museum/ Image © The Palace Museum

2.17 © British Library Board (Maps 162.o.2 f003r, f004r & detail 001)

2.18 © Hong Kong Maritime Museum

2.19 © Victoria and Albert Museum, London

2.20 Wellcome Collection and Science Museum, London

2.21 Photo Wellcome Collection

2.22 The Palace Museum/ Image © The Palace Museum

2.23 The National Archives, UK

2.25 © British Library Board (15275.a.5)

2.27 Pitt Rivers Museum, University of Oxford

2.28 Wah Lee, Doctor of Osteopathic Medicine. Photo: Peter Dekker

2.29 © British Library Board (Or.70.bbb.16)

2.32 Image courtesy of the National Army Museum, London

2.33 The Bodleian Libraries, University of Oxford, (OC) 246 c.83, frontispiece

2.34 SOAS Library

2.36 Cincinnati Art Museum, Ohio, USA © Cincinnati Art Museum /Gift of Mrs. James Handasyde Perkins/Bridgeman Images

2.37–8 Courtesy of the Royal Engineers Collection: GGC284, 8201.1.23

2.39 © Nanjing Museum Administration

2.40 Royal Albert Memorial Museum & Art Gallery, Exeter City Council

2.41 © British Library Board (Or. 12501 f001v)

2.42 Reproduced by kind permission of the Syndics of Cambridge University Library

2.43–4 © British Library Board (Or. 8143, 15116.b.8 Imperial seal)

2.45 Royal Collection Trust / © His Majesty King Charles III 2023

2.47 © Victoria and Albert Museum, London

2.48 Hsu Chung Mao Studio 徐宗懋圖文館

2.49 History and Art Collection / Alamy Stock Photo

2.50 Royal Engineers Headquarters Mess, Kent

2.51–2 © National Palace Museum

2.53 University of Alberta Museums

2.54 Royal Collection Trust / © His Majesty King Charles III 2023

2.57 The Box, Plymouth

2.59 Photo © Paris – Musée de l'Armée, Dist. RMN–Grand Palais / Philippe Fuzeau

2.60 Digital image courtesy of Getty's Open Content Program

2.61 Collection Centre Canadien d'Architecture/Canadian Centre for Architecture, Montréal

2.62 Zhejiang Provincial Museum

2.63 Photo: Yale University Art Gallery

2.65 © John Cloake. Photo by the British Museum's Photography team

2.66 © British Library Board (16126.d.4 (13))

3.1 National Library of China

3.2 The Palace Museum/ Image © The Palace Museum

3.3 Anhui Museum

3.4 Photo © Asian Art Museum of San Francisco

3.6 The Palace Museum/ Image © The Palace Museum

3.7 Shanghai Museum

3.8–9 Collection of Art Museum, The Chinese University of Hong Kong. Gift of Mr Ho Iu-kwong, Mr Huo Pao-tsai, Mr Lai Tak and others

3.10 Shanghai Museum

3.11 Xiling Seal Engravers' Society

3.12 Jinmotang Calligraphy Research Foundation

3.14–16 Zhejiang Provincial Museum

3.17 Michael Yun-Wen Shih

3.18 Photo: China Guardian Auctions

3.21 © SOAS. Photo by the British Museum's Photography team

3.22 © The Metropolitan Museum of Art/Art Resource/Scala, Florence

3.23–4 The Palace Museum/ Image © The Palace Museum

3.25 Nanjing Museum

3.26 The Palace Museum/ Image © The Palace Museum

3.27 Shanghai Museum

3.28 The Metropolitan Museum of Art, New York, Gift of Robert Hatfield Ellsworth, in memory of La Ferne Hatfield Ellsworth, 1986, www.metmuseum.org

3.29 On loan from Wenzhou Yanyuan Museum

3.30 Zhejiang Provincial Museum

3.31 Shanghai Museum

3.32–3 The Palace Museum/ Image © The Palace Museum

3.34 Shanghai Museum

3.35 The Palace Museum/ Image © The Palace Museum

3.36 The Metropolitan Museum of Art, New York, Purchase, Bequests of Edna H. Sachs and Flora E. Whiting, by exchange; Fletcher Fund, by exchange; Gifts of Mrs. Harry Payne Bingham and Mrs. Henry J. Bernheim, by exchange; and funds from various donors, by exchange, 2016, www.metmuseum.org

3.37 Shanghai Museum

3.38 The Palace Museum/ Image © The Palace Museum

3.39 Zhejiang Provincial Museum

3.41 Shanghai Museum

3.42–3 The Palace Museum/ Image © The Palace Museum

3.45 The Palace Museum/ Image © The Palace Museum

3.47 Michael Yun-Wen Shih

3.48 Liaoning Provincial Museum

3.49 National Art Museum of China

3.50 Guangzhou Museum of Art

3.51 The Metropolitan Museum of Art, New York, Gift of Robert Hatfield Ellsworth, in memory of La Ferne Hatfield Ellsworth, 1986, www.metmuseum.org

3.52–3 The Palace Museum/ Image © The Palace Museum

3.54–5 Zhejiang Provincial Museum

3.56 SOAS Library

4.3 10.5.51/1 © Horniman Museum and Gardens

4.4 Pitt Rivers Museum, University of Oxford

4.5 bpk / Museum für Asiatische Kunst, SMB / Jörg von Bruchhausen

4.6 The Bodleian Libraries, University of Oxford, Backhouse 630, leaf 6

4.7 The Metropolitan Museum of Art, New York, Gilman Collection, Museum Purchase, 2005, www.metmuseum.org

4.8 © Victoria and Albert Museum, London

4.9 Loewentheil Collection of Early China Photography

4.10–12 With permission of ROM (Royal Ontario Museum), Toronto, Canada. © ROM

4.14 Image courtesy of Wolverhampton Art Gallery

4.15 Courtesy of the Alan Klotz Gallery

4.16 © The Teresa Coleman Collection. Photo by the British Museum's Photography team

4.17 Scottish National Portrait Gallery

4.18 © Victoria and Albert Museum, London

4.19 University of Alberta Museums

4.20 Wellcome Collection

4.25 Library of Congress

4.27 © Victoria and Albert Museum, London

4.28 Private Collection – Anne and Albert Cheng

4.29 Guangdong Museum

4.30 Courtesy of Peabody Essex Museum. Photo by Kathy Tarantola

4.33 © Victoria and Albert Museum, London

4.34 The Chris Hall Collection

4.35 Philadelphia Museum of Art: Purchased with the John T. Morris Fund from the Carl Schuster Collection, 1940, 1940-4-730

4.36 The Chris Hall Collection

4.37 © Victoria and Albert Museum, London

4.38 Image © National Museums Scotland

4.39 © Victoria and Albert Museum, London

4.41–2 Royal Albert Memorial Museum & Art Gallery, Exeter City Council

4.43 Image © National Museums Scotland

Lenders

Anthony J. Hardy

Bristol Museums: Bristol Museum and Art Gallery

Chris Hall Collection

Great North Museum: Hancock

His Majesty The King

Horniman Museum and Gardens

Jacqueline Simcox

Michael Yun-Wen Shih

Nanshun Shanfang, Singapore

National Maritime Museum, Greenwich

National Museums Scotland

Natural History Museum, London

Natural History Society of Northumbria

Oriental Club

Plymouth City Council, The Box

Private Collection

Royal Albert Memorial Museum & Art Gallery,
Exeter City Council

Royal Engineers Museum

Royal Ontario Museum

SOAS University of London

The British Library

The Metropolitan Museum of Art

The National Archives, UK

The Syndics of Cambridge University Library

The Teresa Coleman Collection

The Trustees of The Sir Percival David Foundation
of Chinese Art

The University of Manchester

The Water, Pine and Stone Retreat Collection

Trevor Ford

Victoria and Albert Museum

Wolverhampton Art Gallery

Acknowledgements

The idea that underpinned this research project, exhibition and book was to investigate cultural creativity and resilience in 19th-century China. General histories of late imperial China have often regarded this period as one of cultural stagnation and turmoil. Until relatively recently, it was often omitted from studies of Chinese art altogether. We wanted to explore this lacuna.

When we began the project, we had no idea that our own world (including the work on this project) would undergo a period of turmoil, first because of the Covid pandemic and then Russia's invasion of Ukraine. We feel profound sympathy for all those who continue to be affected by the devastation of disease and war.

This project was supported from the outset by the UKRI Arts and Humanities Research Council-funded project 'Cultural Creativity in Qing China 1796–1912' (AH/T001895/1). We are also grateful for grants from the British Museum Research Fund and The Sir Percival David Foundation Academic and Research Fund, which greatly enhanced our research. We are indebted to our supporters, particularly Citi and the Huo Family Foundation, who made the exhibition possible. We are extremely grateful for the advice of Professor Craig Clunas, Professor Jonathan Hay and Dr JD Hill.

Many scholars from around the world provided invaluable assistance, information and advice, which shaped the book and exhibition. While all errors are our own, we thank Professor Susan Naquin for her close reading of the manuscript and her many improvements of the text. We also thank the authors – Professor Anne Gerritsen, Professor Stephen Platt, Professor Mei Mei Rado, Professor Jeffrey Wasserstrom and Professor Chia-ling Yang – for their dedication to the project and their suggestions for people, places and objects to include in the book. Wenyuan Xin's hard work and expertise cannot be overstated. As Project Curator, her ability to adapt to constantly changing circumstances was extraordinary.

At the British Museum, a remarkable and expert team made this book and exhibition possible. Special thanks must go to Project Manager, Alice Low; Senior Interpretation Manager, Natalie Buy; Senior Designer, Victoria Ward; and Loans Co-ordinators, Sophie Szynaka and Sarah Kavanagh, who were instrumental in bringing the project into being. The exhibition's beautiful design is thanks to the designers at Nissen Richards Studios, including the innovative graphic design work. The lighting was the work of Beam Lighting Design.

For the publication of this book, we are very grateful to Head of Publishing, Claudia Bloch; Project Editor, Yvonne Thouroude; Sales and Marketing Manager, Toni Allum; Designer, James Alexander; Production Manager, Marina Asenjo; Copyeditor, Ben Plumridge; Proofreader, Robert Sargant; and Indexer, Amanda Speake. Joanna Fernandes, Saul Peckham, David Agar, Stephen Dodd, Bradley Timms and Isabel Marshall wonderfully prepared images for the book. Wenyuan Xin, Yvonne Thouroude and Katie Anderson managed and coordinated a vast number of external images. We are very grateful to Xu Liyi and her colleagues at the Shanghai Museum, Lu Jia and colleagues from the Zhejiang Museum, the Palace Museum, the National Museum of China and Hu Ying from China Guardian.

From the British Museum, we are grateful to: Gavin Bell, Rachel Berridge, Richard Blurton, Emily Castles, Alice Ceiriog-Hughes, Paul Chirnside, Sarah Choy, Lydia Cooper, Eliza Doherty, Mary Ginsburg, Gina Grassi, Anna Harrison, Francesca Hillier, Loretta Hogan, Katharine Kelland, Deklan Kilfeather, Alice Kirk, Imogen Laing, Valentina Marabini, Sean McParland, Kayte McSweeney, Carol Michaelson, Alison Mills, Shoun Obana, Emma Pattinson, Pippa Pearce, Steven Pearson, Stephanie Piechowiak, Clara Potter, Angela Pountney, Simon Prentice, Monique Pullan, Nicole Rode, Helen Rowland, Hannah Scully, Sophie Sorrondegui, Christopher Stewart, Sophie Tregent, Myriam Upton, Helen Wang, Connor Watson, Benjamin Watts, Rachel Weatherall, Ellie Welch, Hilary Williams, Keeley Wilson and Stella Yeung. For the audio, language, film and musical elements of the project, we are grateful to Sian Toogood, Lars Laarmann, Clark Ho, Yitong Qiu, Lai Dongxiang, Betty Yao, Wenyuan Xin, Wandejia, Mukaddes Muhata'er, Teringele, Rachel Harris, Xuejiao Fu, Bo Wang, Yee Cheung Hui and the London Chinese Philharmonic Choir.

Jane Portal, Jill Maggs, Rosalind Winton, Jonathan Williams and Hartwig Fischer guided and championed the project throughout, for which we are enormously grateful. The Department of History, Classics and Archaeology at Birkbeck, University of London, have been hugely supportive; particular thanks to Matt Cook, Jan Rüger, Hilary Sapire, Frank Trentmann and Filippo de Vivo.

Finally, we would like to thank our families: Martin, Beatrice, Alexander and Eleanor Keady; Robert, Lily, Tom and Will Macfarlane, and Thelma Lovell; Chen Ze and Chen Lezhi.

Jessica Harrison-Hall and Julia Lovell

Index

Page references in *italics* indicate either an image or information in the caption.

Western dress, 217, *298*
women's court wear, 60, 64–6, *66*, *67*, *68*, *69*
woollen fabrics, 61–2, 206, 209–10, *210*
see also accessories; textiles
coinage, 109, *110*, 189, *247*
Confucianism, 13–14, 15, 16, 30, 42, 53, 123, 125, 132, *137*, 227
'coolie' trade, 28, *29*
court
dogs, 72, *75*
dress and accessories, 59–71
entertainments, 82–5
hunting and archery, 42, *44*, 46, *61*
Imperial Workshops, 43–4, 72
palaces, 41–2, 79–80
reverse glass painting of, *252*, 259
shamanism, 13, 55
state rituals, 53–9
weddings, 54–5
see also clothing; Empress Dowager Cixi
courtesans
depictions by male artists, 164, *164*, *177*
as fashion trendsetters, 181, 209, 225
print images, 181, 199, *203*, 225–7, *225–6*
Shanghai courtesans, *177*, 203, *203*
social visibility, 194, 199, 225, *225–6*
culture
celebrity culture, 281–3
globalisation and hybrid material culture, 203–5, *203*, *204*, *205*, 262–4
missionary education, 23–5
post-Taiping boom, 26, 169–72, 225
socio-economic context, 186–7, 193
see also print culture

D
Dai Xi, 151, *151*
Dalai Lamas, 12, 15, 56, *56*
Daoguang
court theatre, 82
decorative arts, 76–8, *78*
family portraits, 47–9, *48*, 72
portraits, 46–7
reign, 42, 43, 44–5
suppression of the opium trade, 19, 20, 101–2, *102*
Daoism, 57–9, *57*, *58*, 227
decorative arts
Bureau of Crafts, 72
cloisonné enamel, 43, 72–3, *75*
court production of, 72
diplomatic gifts, 68, 72–6, *76*, *77*, 79, *79*
embroidery, 43, 76, 198–9, *198*, 206–9, *208*, *209*, *210*, 215, *215–16*
glasswork, 43, 72, *73*
handicrafts, 16, 72
Imperial Workshops, 43–4, 72
jade, 72, *74*
lacquer, 72, *74*, 248–9, *297*
see also ceramics
Deng Shiru, *135*, 136–8, *136*, 141, *142*
dharma boats, 59, *59*
Ding Jing, 141, *142*
dogs, 72, *114*, 235

dragon motifs, *76*, *92*, *93*, *111*, *281*
dragon robes (*jifu*), *42*, 46, 62, *62*
Duanfang, *288*, *289*

E
East India Company, 19, *94*, 100–1, *106*, 160, *247*
education
in the Chinese vernacular, 31–2
literacy levels, 187–9, *189*, *216*, 218
medicine, 25, *25*, *34*, 273, *273*
by missionaries, 23–5, 26, 160
overseas, 24, 25, 32, 33, *34*, 299
Peking University, 298, *298*
elite art
advertising of works, 179
antiquarianism, 132, 133, 134, *137*, 138–49, 154
bapo style, 143–5, *144*, *148*, 149, *149*, *208*
bird-and-flower painting, 143, *158–9*, 164, 172–3, *177*, *178*, 180
and the commercial press, 179–83
epigraphic studies, 134–6
evidential scholarship, *132*, 133, 134
female artists, 161–2
impact of the Taiping Civil War, 165–8, *166*, *167*
landscape painting, 150–4, *150*, *151*, *152*, *153*, *190*
literary societies, 161–2
modernisation, 182–3
natural-history drawing, 154–61, *156–9*, *160*, *161*, *252*, 253–4, *254*
during the nineteenth century, 132–4
Orthodox School, 132
political contexts, 153–4
rubbing, 143–9
Shanghai School, 143, 168–83
stele studies, 134, *135*
use of photography, 180–2
Western influences, 179–80, 182
see also calligraphy
embroidery, 43, 76, 198–9, *198*, 206–9, *208*, *209*, *210*, 215, *215–16*
Empress Dowager Cixi
celebrity status, 281–3
clothing, 7, 67–9
court theatre, 82, 84–5
Daoism, 57–9, *57*, *58*
the death of Guangxu, *50*
dharma boat, 59, *59*
diplomatic gifts, 68, 79, *79*
dogs, 72
flower imagery, 67, *79*
Garden of Nurtured Harmony (New Summer Palace, Yiheyuan), 42, *43*, 79–80
Guanyin images, 50, *51*, 57
influence on architecture, 79–82
luxury motor car, *282*, 283, 291
New Policies reforms, 31, 52
patronage of the arts, 44, 46, 50–2, 78–9, *78*, 80, 133
photographs of, 51–2, *52*, 58, 68, 76, *77*, *85*, 180–1

political influence, 45–6, 50, *51*, 54
portrait, *51*
regency of, 22, 23, 30, 37, 44, 45, *49*, *51*, 281–3
sponsorship of Tibetan Buddhism, 56–7, *56*
support for the Boxers, *286*, 302–3
enamelling, 43, 72–3, *75*, *76*
environmental disasters, *120*, 152, *152*, 154, *154*, 186, 187, 191, 192, 284
eunuchs, 43, 46, *57*, 82, *288*

F
fans, 172, *172*, *196*, *197*, 215, *250*, 262–4, *264*, *285*
Fei Danxu, 164–5, *164–5*, 167
flags, 280, *281*
flower painting
alongside rubbings, 146, *146*, *147*
elite bird-and-flower painting, 143, *158–9*, 164, 172–3, *177*, *178*, 180
female artists, 162–4, *163*
imagery in Cixi's clothing, 67, *79*
food, 227, 228, 237–9, *237*
foot-binding, 32, 33, 197, 201, 215–16, *216*
Forbidden City palace, *13*, 41–2, 46, 79, 82
Fuzhou Shipyard, *118*, 123, *125*, *126*

G
Gao Rentong, *57*, 59
games
Mahjong, 235, *236*
shuttlecocks, 235–7, *236*
Garden of Nurtured Harmony (New Summer Palace, Yiheyuan), 42, *43*, 79–80
Genghis Khan, 14–15
glassmaking, 43, 72
global commerce
Chinese-Russian trade, 259–62, *262*
demand for frontier products, 60, 61–2
hybrid material culture, 203–5, *203*, *204*, *205*, 262–4
imported luxury good, 203–4, *203*
migrants and merchants, 259–64, 266–70
of the Qing empire, 16, 18–21, 242, 259, 277
silver, 15, 19, 100, 189, *247*
tea, 15, 19, 100, *101*, 248
technological innovation and, 265–9, *267*, 280
Western access to China, 16, 19, 20–1, *21*, 23, *24*, 27, 100, 102, *103*
see also Guangzhou; opium; treaty ports
globalisation
hybrid responses to, 286–91
material culture, 287–91
nationalistic reform, 30
reformers, 291–302
religious tensions, 280, 284–6
revolutionary changes, 298–9
Gordon, Charles, 117, *117*
Great Britain
access to Chinese markets, 16, 19–21, *21*, *24*, 100, 102, *103*
East India Company, 19, *94*, 100–1, *106*, 160, *247*
military and naval strength, 104–7
natural history collecting, 160